DATE DUE

OCT 24 '00			

DEMCO 38-296

STUDIES IN BRITISH ART

THE LATER PAINTINGS
AND DRAWINGS OF
JOHN CONSTABLE

GRAHAM REYNOLDS

Plates

Published for the Paul Mellon Centre
for Studies in British Art by
YALE UNIVERSITY PRESS
NEW HAVEN AND LONDON · 1984

Text filmset in Monophoto Ehrhardt by
BAS Printers Limited, Over Wallop, Hampshire

Printed in Italy by
Amilcare Pizzi, s.p.a., Milan

Illustrations originated and printed by
Amilcare Pizzi, s.p.a., Milan

Library of Congress Cataloging in Publication Data

Reynolds, Graham.
 The later paintings and drawings of John Constable.

 (Studies in British art)
 Bibliography: v. 1, p.
 Includes index.
 1. Constable, John, 1776–1837—Catalogs. I. Paul
Mellon Centre for Studies in British Art. II. Title
III. Series.
N6797.C63A4 1984 759.2 84-40186
ISBN 0-300-03151-3 (v. 1)

List of Plates

Museum (Courtesy of the Trustees of the British Museum).

828. (32.12) *Jaques and the wounded stag*, Private collection.

829. (32.18) *A farmhouse*, High Museum of Art, Atlanta, Georgia (Gift of Mr and Mrs Alfred W. Jones. Permanent collection).

830. (32.20) *A barn, trees and a grey horse near East Bergholt*, Victoria and Albert Museum (Crown Copyright).

831. (32.21) *Cottages at East Bergholt*, Victoria and Albert Museum (Crown Copyright).

832. (32.22) *Cottages at East Bergholt*, British Museum (Courtesy of the Trustees of the British Museum).

833. (32.19) *Salisbury Cathedral from the meadows*, Henry E. Huntington Library and Art Gallery, San Marino.

834. (32.23) *Englefield House, Berkshire*, Victoria and Albert Museum (Courtesy of the Victoria and Albert Museum).

835. (32.24) *Englefield House, Berkshire*, Victoria and Albert Museum (Crown Copyright).

836. (32.25) *Englefield House, Berkshire*, Victoria and Albert Museum (Crown Copyright).

837. (32.26) *Englefield House, Berkshire*, Victoria and Albert Museum (Crown Copyright).

838. (32.27) *Englefield House, Berkshire: detail of the left-hand turret*, Victoria and Albert Museum (Crown Copyright).

839. (32.28) *Theal, Berkshire*, British Museum (Courtesy of the Trustees of the British Museum).

840. (32.30) *London from Hampstead*, British Museum (Courtesy of the Trustees of the British Museum).

841. (32.31) *View over London from Hampstead (?)*, Victoria and Albert Museum (Crown Copyright).

842. (32.32) *Bridge Cottage, Flatford*, Victoria and Albert Museum (Crown Copyright).

843. (32.33) *A barge on the Stour*, Victoria and Albert Museum (Courtesy of the Victoria and Albert Museum).

844. (32.36) *A thatched house by a cornfield*, Victoria and Albert Museum (Courtesy of the Victoria and Albert Museum).

845. (32.34) *A barge on the Stour*, Private collection (Courtesy of Lawrence Fine Art of Crewkerne).

846. (32.35) *A thatched cottage near East Bergholt*, Victoria and Albert Museum (Crown Copyright).

847. (32.37) *Octagon House, Dedham*, Victoria and Albert Museum (Courtesy of the Victoria and Albert Museum).

848. (32.38) *Men loading a cart*, British Museum (Courtesy of the Trustees of the British Museum).

849. (32.39) *A house amongst trees*, British Museum (Courtesy of the Trustees of the British Museum).

850. (32.40) *Landscape with trees and cattle*, British Museum (Courtesy of the Trustees of the British Museum).

851. (32.41) *A country road with houses at East Bergholt*, Private collection (Courtesy of Lawrence Fine Art of Crewkerne).

852. (33.42) *A windmill, with a house beyond (Stanway Mill)*, Yale Center for British Art, New Haven (Paul Mellon Collection).

853. (32.45) *Castle Acre Priory*, Mezzotint (Courtesy of the Fitzwilliam Museum, Cambridge).

854. (32.43) *Winter, after Jacob van Ruysdael*, Trustees of the will of H. G. Howe, on loan to the Minories, Colchester.

855. (32.44) *Landscape with Windmills, after Jacob van Ruysdael*, Private collection.

856. (32.46) *Stonehenge*, Whereabouts unknown (Reproduced from the mezzotint. Courtesy of the Fitzwilliam Museum, Cambridge).

857-8. (32.47) *A girl's head; and a copy from an old master painting*, Private collection.

859. (32.50) *Study of three parrot tulips*, Paul Mellon Collection, Upperville, Virginia.

860. (32.51) *Flowers in a basket*, Ipswich Museum and Galleries, Christchurch Mansion Museum.

861. (35.52) *A country road with elm trees*, Victoria and Albert Museum (Crown Copyright).

862. (32.48) *Study of poppies*, Paul Mellon Collection, Upperville, Virginia.

863. (32.49) *Study of poppies*, Victoria and Albert Museum (Courtesy of the Victoria and Albert Museum).

864. (33.1) *Englefield House, Berkshire*, Private collection (Courtesy of the Tate Gallery, London).

865. (33.9) *Milford Bridge*, Philadelphia Museum of Art (Department of Prints and Drawings).

866. (33.10) *Netley Abbey: the west end*, Philadelphia Museum of Art (Department of Prints and Drawings) (Purchased by funds given by Miss Anna W. Ingersoll. Photographed by Eric Mitchell, 1980).

867. (33.12) *Trees in West End Fields, Hampstead*, Victoria and Albert Museum (Courtesy of the Victoria and Albert Museum).

868. (33.3) *The Cottage in a Cornfield*, Victoria and Albert Museum (Courtesy of the Victoria and Albert Museum).

869. (33.13) *Stoke Poges Church*, Victoria and Albert Museum (Courtesy of the Victoria and Albert Museum).

870. (33.11) *The Holy Spirit: illustration to Watts's 'Songs, Divine and Moral'*, Victoria and Albert Museum (The National Art Library) (Courtesy of the Victoria and Albert Museum).

871. (33.14) *Stoke Poges Church*, Private collection.

872. (33.15) *Design for Gray's 'Elegy', Stanza III*, Victoria and Albert Museum (Crown Copyright).

873. (33.19) *A churchyard*, Dr David Darby (Courtesy of William Darby).

874. (33.16) *Design for Gray's 'Elegy', Stanza V,*

British Museum (Courtesy of the Trustees of the British Museum).

875. (33.17) *Design for Gray's 'Elegy', Stanza V*, British Museum (Courtesy of the Trustees of the British Museum).

876. (33.18) *Design for Gray's 'Elegy', Stanza XI*, Younger daughter of R. B. Beckett.

877. (33.20) *Study of sky and trees*, Victoria and Albert Museum (Crown Copyright).

878. (33.21) *Folkestone Harbour*, Victoria and Albert Museum (Courtesy of the Victoria and Albert Museum).

879. (33.22) *Folkestone from the sea*, British Museum (Courtesy of the Trustees of the British Museum).

880. (33.23) *Folkestone Harbour*, British Museum (Courtesy of the Trustees of the British Museum).

881. (33.24) *Folkestone Harbour, with a rainbow*, British Museum (Courtesy of the Trustees of the British Museum).

882. (33.25) *Folkestone from the beach*, British Museum (Courtesy of the Trustees of the British Museum).

883. (33.26) *Folkestone*, British Museum (Courtesy of the Trustees of the British Museum).

884. (33.27) *Folkestone: the harbour*, Fitzwilliam Museum, Cambridge.

885. (33.28) *Folkestone: Ford Road and the Ropewalk*, Fitzwilliam Museum, Cambridge.

886. (33.29) *Cock Point, near Folkestone*, Oldham Art Gallery (Charles E. Lees Collection).

887. (33.30) *Between Folkestone and Sandgate*, Private collection (Courtesy of the Paul Mellon Centre for Studies in British Art).

888. (33.31) *Cliffs near Folkestone*, Private collection.

889. (33.32) *View at Hampstead, looking towards London*, Victoria and Albert Museum (Courtesy of the Victoria and Albert Museum).

890. (33.34) *A mill near Colchester (Stanway Mill)*, Whereabouts unknown.

891. (33.35) *Stanway Mill*, Private collection (Courtesy of Thos. Agnew & Sons Ltd).

892. (33.36) *View over London from Hampstead*, British Museum (Courtesy of the Trustees of the British Museum).

893. (33.37) *London from Hampstead*, British Museum (Courtesy of the Trustees of the British Museum).

894. (33.38) *View from Hampstead*, Victoria and Albert Museum (Crown Copyright).

895. (33.39) *The lock*, Fitzwilliam Museum, Cambridge.

896. (33.40) *Flatford Lock*, Fitzwilliam Museum, Cambridge.

897. (33.41) *A heath scene*, Fitzwilliam Museum, Cambridge.

898. (33.42) *A heath scene*, Fitzwilliam Museum, Cambridge.

899. (33.43) *Cottages*, Fitzwilliam Museum, Cambridge.

900. (33.44) *A thatched cottage*, Philadelphia Museum of Art (Department of Prints and Drawings) (Purchased: Harrison Fund).

901. (33.45) *A country cottage amid trees*, Victoria and Albert Museum (Crown Copyright).

902. (33.46) *Landscape: dawn*, Yale Center for British Art, New Haven (Paul Mellon Collection).

903. (33.47) *Cloud study with verses from Bloomfield*, Tate Gallery, London.

904. (33.48) *Storm clouds: two studies on one sheet*, Private collection (Courtesy of the Paul Mellon Centre for Studies in British Art).

905. (33.49) *Diagram of the formation of a rainbow*, Executors of the late Lieutenant-Colonel J. H. Constable (Courtesy of the Tate Gallery, London).

906. (33.50) *Diagram of the formation of a rainbow*, Executors of the late Lieutenant-Colonel J. H. Constable (Courtesy of the Tate Gallery, London).

907. (33.51) *Diagram of the formation of a rainbow*, Executors of the late Lieutenant-Colonel J. H. Constable (Courtesy of the Tate Gallery, London).

908. (33.52) *Diagram of the formation of a rainbow*, Executors of the late Lieutenant-Colonel J. H. Constable (Courtesy of the Tate Gallery, London).

909. (33.53) Entry deleted.

910. (33.54) *Warwick Castle*, Whereabouts unknown (Reproduced from the engraving. Courtesy of the Trustees of the British Museum).

911. (33.55) *Netley Abbey by moonlight*, David Goodstein Collection, Los Angeles (Courtesy of Leggatt Brothers, London).

912. (33.56) *Netley Abbey by moonlight*, Tate Gallery, London.

913. (34.1) *Old Sarum*, Victoria and Albert Museum (Crown Copyright).

914. (34.3) *Study of trees at Hampstead*, Cecil Higgins Art Gallery, Bedford (Courtesy of the Trustees, The Cecil Higgins Art Gallery, Bedford, England).

915. (34.8) *A church, with a willow beside a stream*, Yale Center for British Art, New Haven (Paul Mellon Collection).

916. (34.9) *A church, with a willow beside a stream*, Private collection (Courtesy of the Tate Gallery, London).

917. (34.10) *A cottage, with a willow beside a stream*, Private collection (Courtesy of Sotheby's, London).

918. (34.6) *Hampstead Heath from near Well Walk*, Victoria and Albert Museum (Courtesy of the Victoria and Albert Museum).

919. (34.7) *Cows at Hampstead*, Victoria and Albert Museum (Crown Copyright).

920. (34.11) *Emily on a sofa*, Courtauld Institute Galleries (Witt Collection), London.

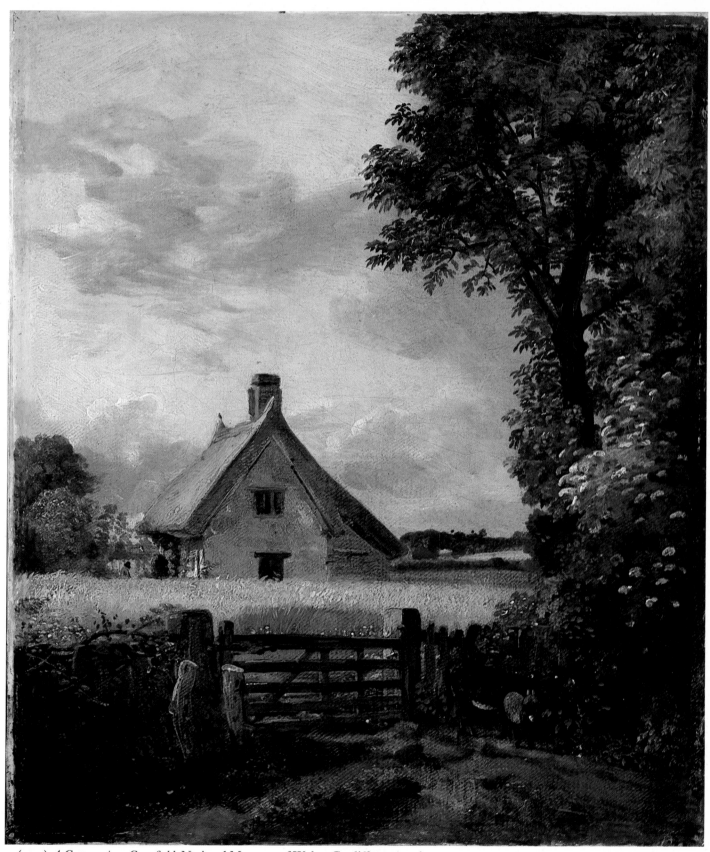

1. (17.2) *A Cottage in a Cornfield*, National Museum of Wales, Cardiff, 31·5 × 26·5cm.

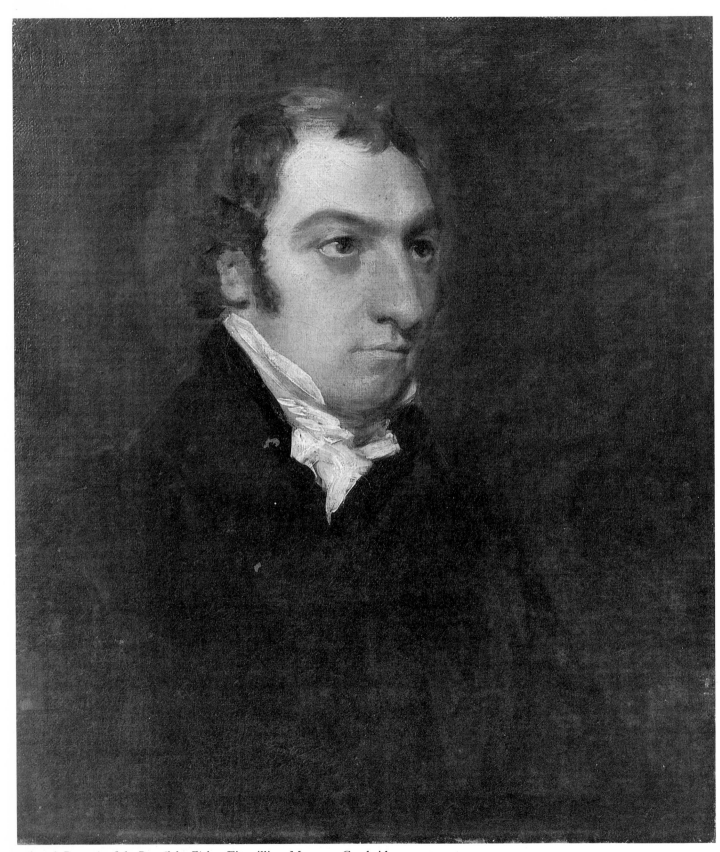

2. (17.3) *Portrait of the Rev. John Fisher*, Fitzwilliam Museum, Cambridge, 35·9 × 30·3cm.

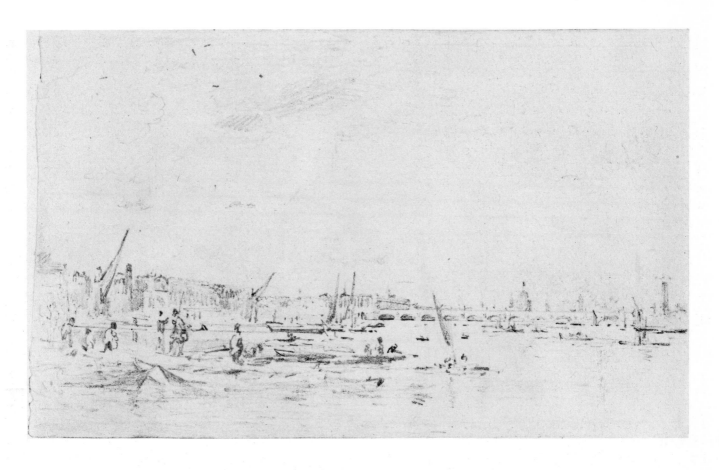

3. (above) (17.5)
*Waterloo Bridge from
near Whitehall Stairs*,
Private collection,
11·4 × 18·4cm.

4. (17.6) *Whitehall
Stairs: the opening
ceremony for Waterloo
Bridge on 18 June 1817*,
Private collection,
11·4 × 9·3cm.

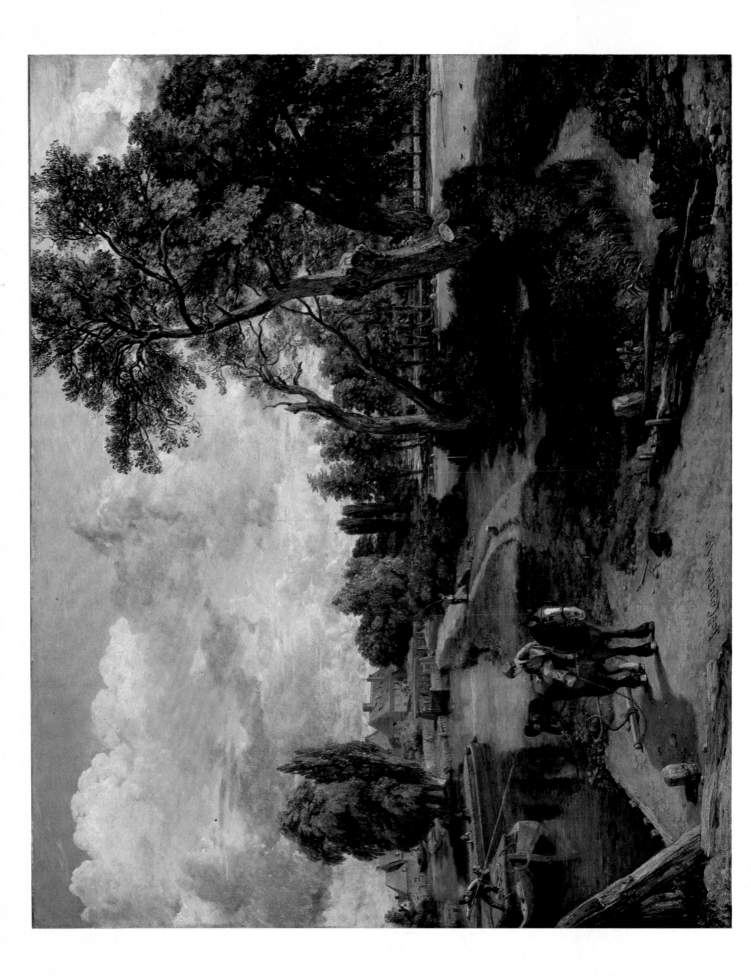

5. (above) (17.1) *Flatford Mill*, Tate Gallery, 101·7 × 127cm.

6. (17.4) *Wivenhoe Park, Essex*, National Gallery of Art, Washington, D.C., 56·1 × 101·2cm.

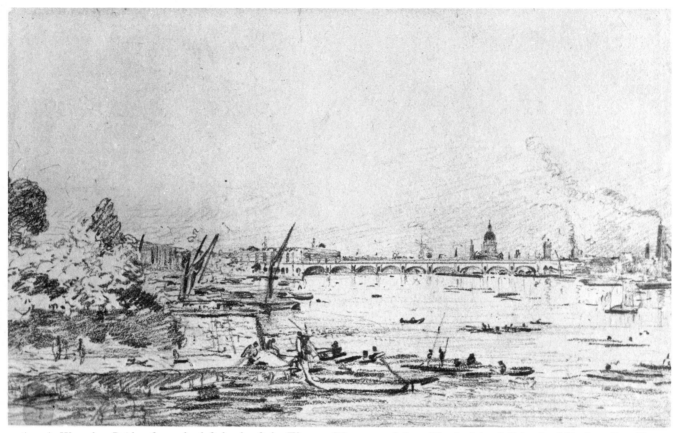

7. (17.7) *Waterloo Bridge from the left bank of the Thames*, Museum of Art, Rhode Island School of Design, Providence, 11·2 × 17·8cm.

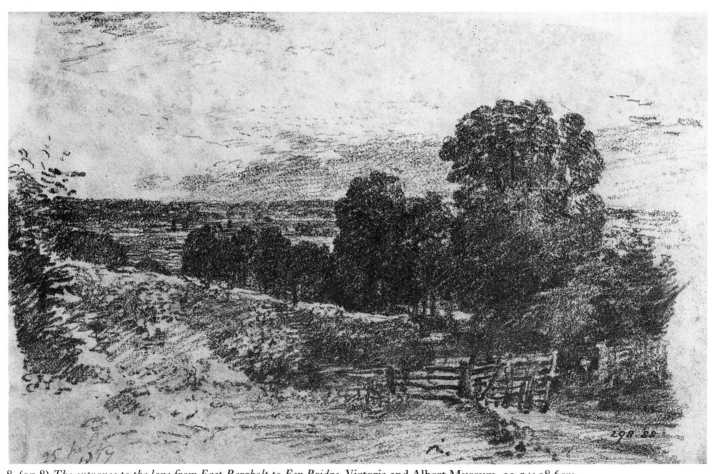

8. (17.8) *The entrance to the lane from East Bergholt to Fen Bridge*, Victoria and Albert Museum, 11·5 × 18·6cm.

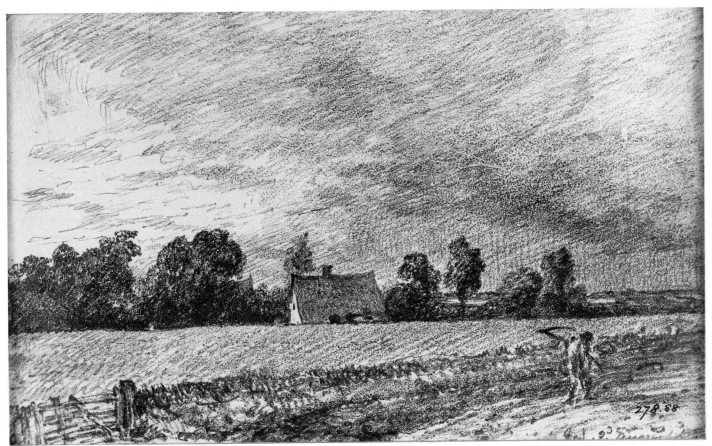

9. (17.9) *A reaper passing a cottage on a lane at East Bergholt*, Victoria and Albert Museum, 11·5 × 18·6cm.

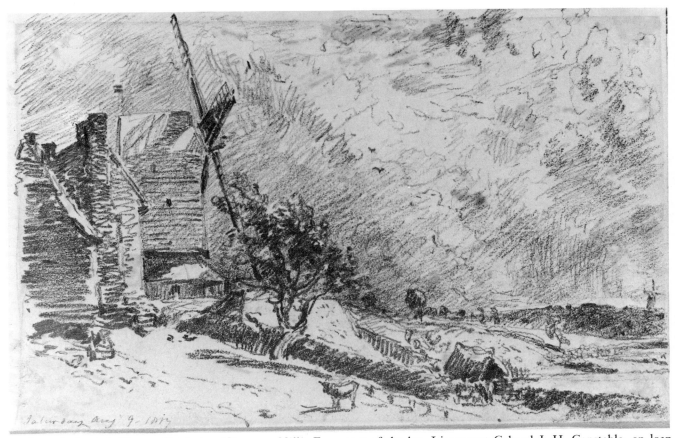

10. (17.10) *A windmill near Colchester (Stanway Mill)*, Executors of the late Lieutenant-Colonel J. H. Constable, on loan to the Tate Gallery, 11·5 × 17.8cm.

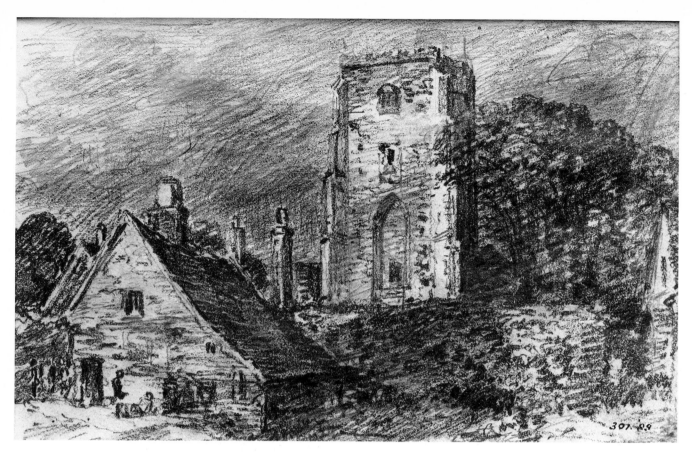

11. (above) (17.11) *St Mary-ad-Murum Church, Colchester*, Victoria and Albert Museum, 11·5 × 18·6cm.

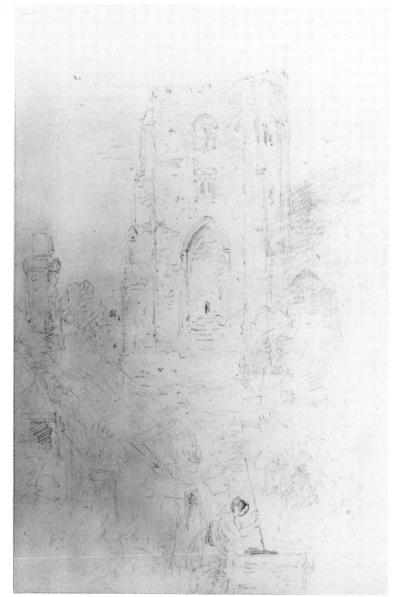

12. (17.12) *St Mary-ad-Murum Church, Colchester*, Fogg Art Museum, Harvard University, Cambridge, Massachusetts, 18 × 11·3cm.

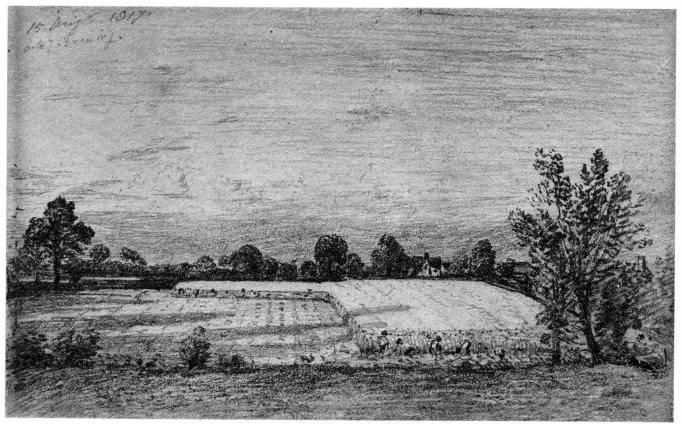

13. (17.13) *Reapers at East Bergholt on a summer evening*, Private collection, 11·1 × 17·9cm.

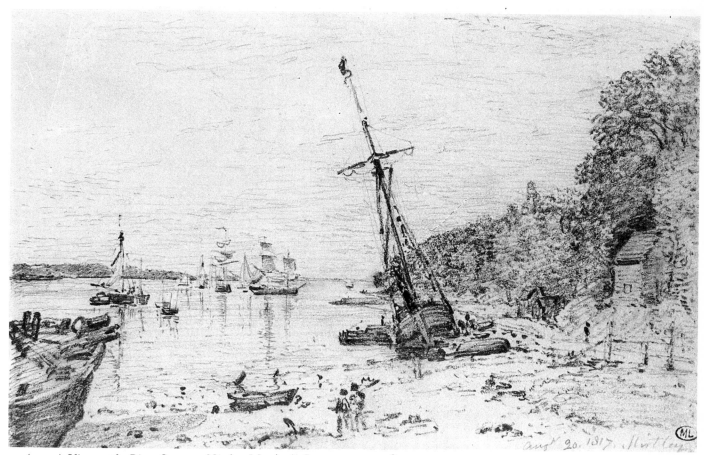

14. (17.14) *View on the River Stour at Mistley*, Musée du Louvre, 11·4 × 18·4cm.

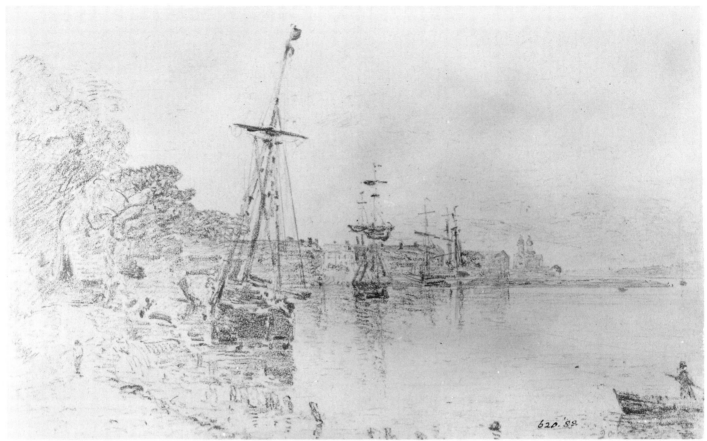

15. (17.15) *View on the River Stour at Mistley*, Victoria and Albert Museum, 11·6 × 18·6cm.

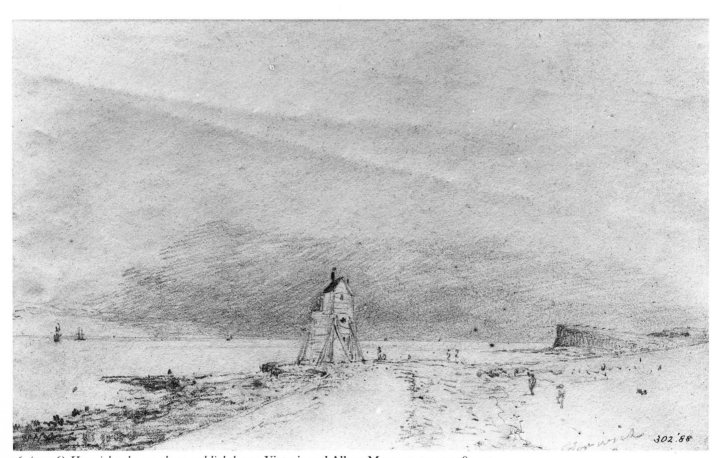

16. (17.16) *Harwich: the sea-shore and lighthouse*, Victoria and Albert Museum, 11·5 × 18·7cm.

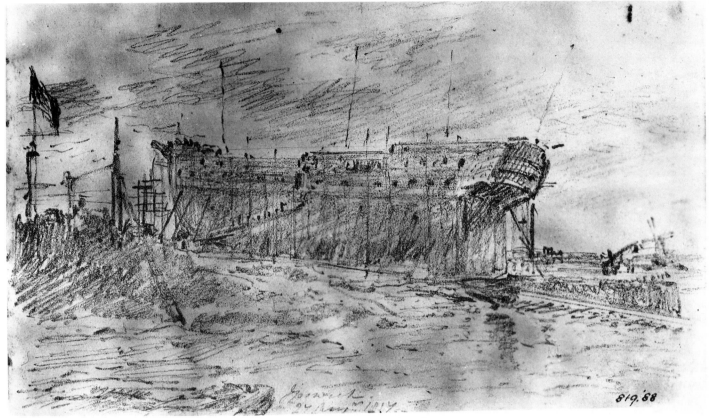

17. (17.17) *A ship on the stocks at Ipswich*, Victoria and Albert Museum, 11·6 × 18·7cm.

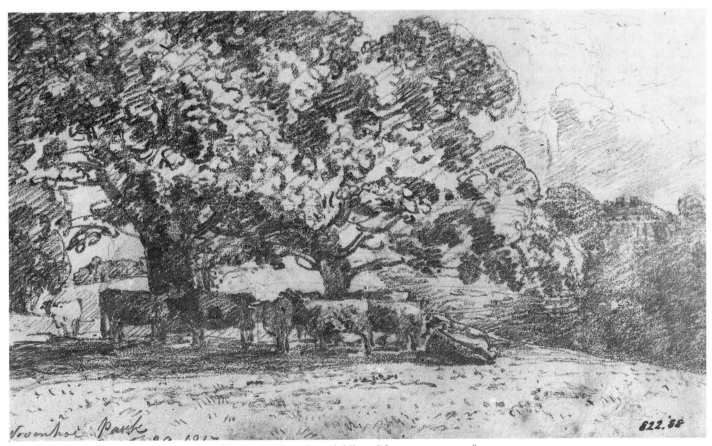

18. (17.18) *Cattle under the trees in Wivenhoe Park*, Victoria and Albert Museum, 11·5 × 18·7cm.

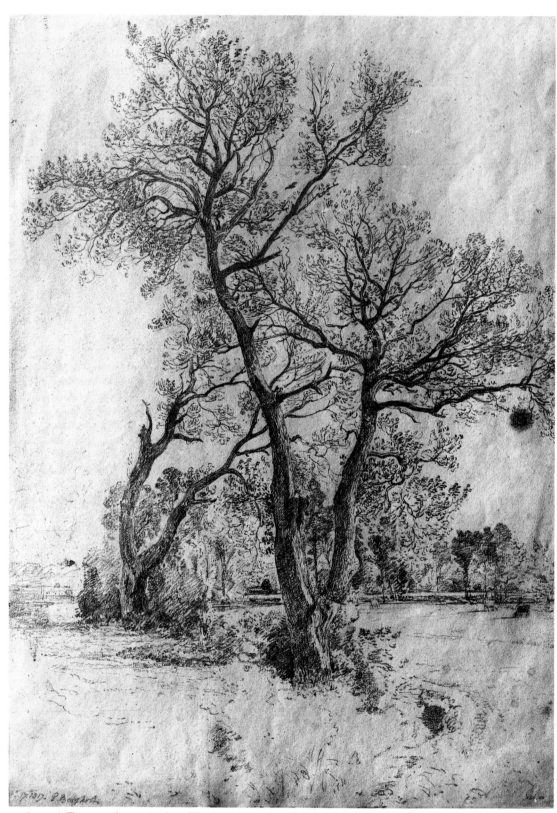

19. (17.20) *Trees on the tow path at Flatford*, Victoria and Albert Museum, 55·2 × 38·5cm.

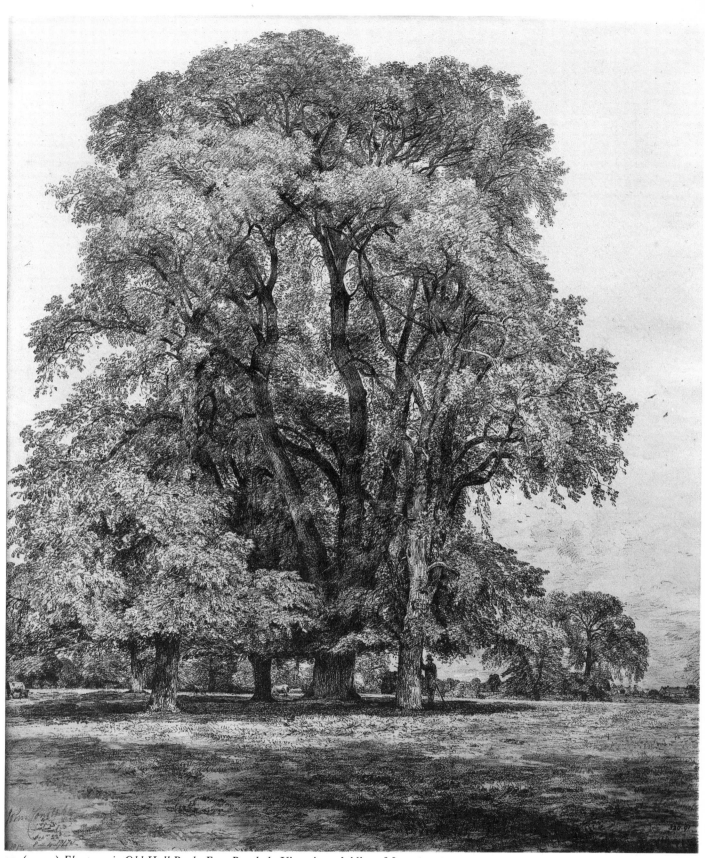

20. (17.21) *Elm trees in Old Hall Park, East Bergholt*, Victoria and Albert Museum, 59·2 × 49·4cm.

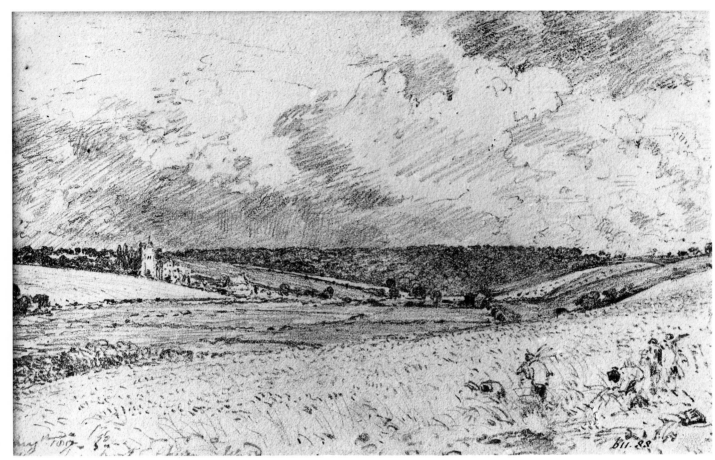

21. (17.19) *Church Wood and Greenstead Church*, Victoria and Albert Museum, 11·5 × 18·7cm.

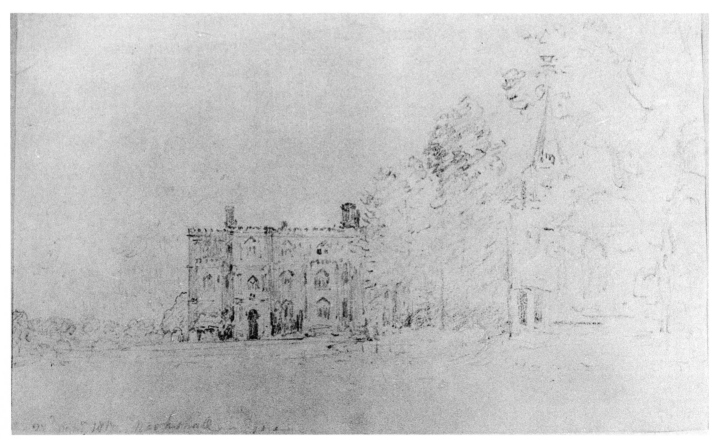

22. (17.22) *Markshall, Essex*, Private collection, 11·5 × 18·5cm.

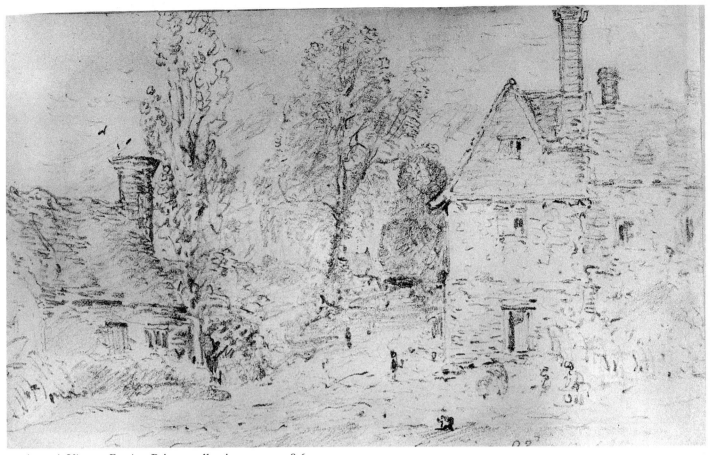

23. (17.23) *View at Feering*, Private collection, 11·5 × 18·6cm.

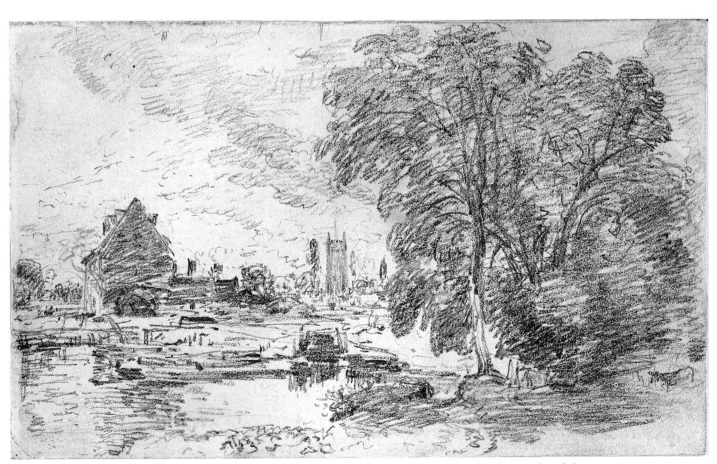

24. (17.25) *Dedham Church and Mill*, Henry E. Huntington Library and Art Gallery, San Marino, 11·6 × 18·6cm.

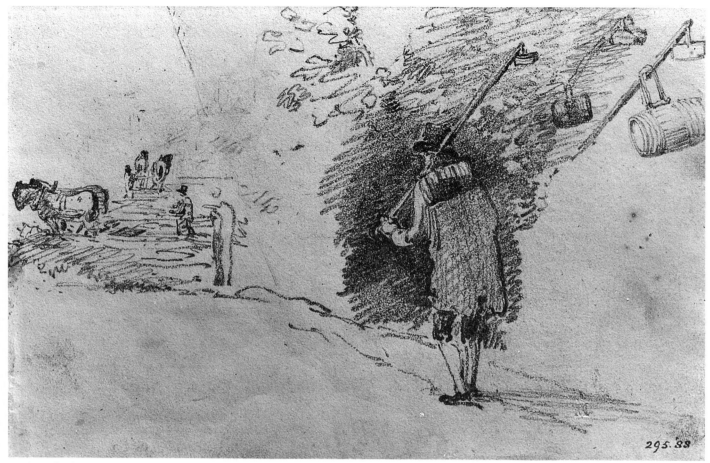

25. (17.26) *A countryman going to work; and two teams harrowing*, Victoria and Albert Museum, 11·6 × 18·7cm.

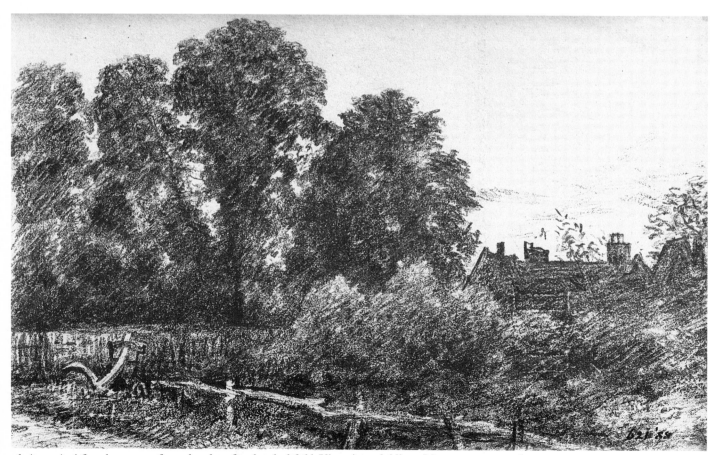

26. (17.27) *A farmhouse seen from the edge of a ploughed field*, Victoria and Albert Museum, 11·5 × 18·7cm.

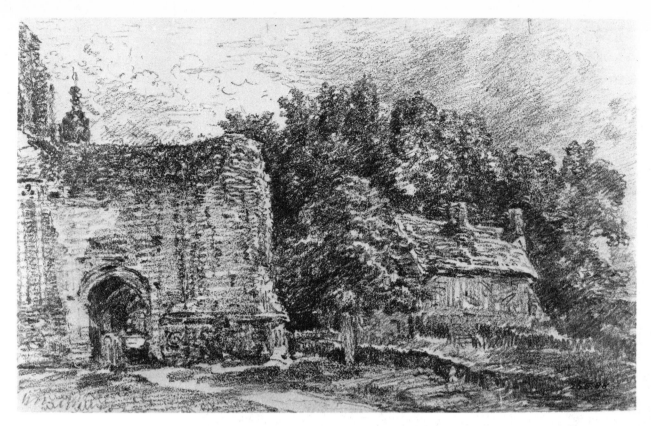

27. (above) (17.28) *East Bergholt Church: the ruined tower*, Victoria and Albert Museum, 11·5 × 18·6cm.

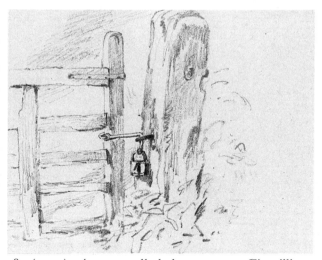

28. (17.34) *A gate padlocked to a post*, Fitzwilliam Museum, Cambridge, 9·2 × 11·8cm.

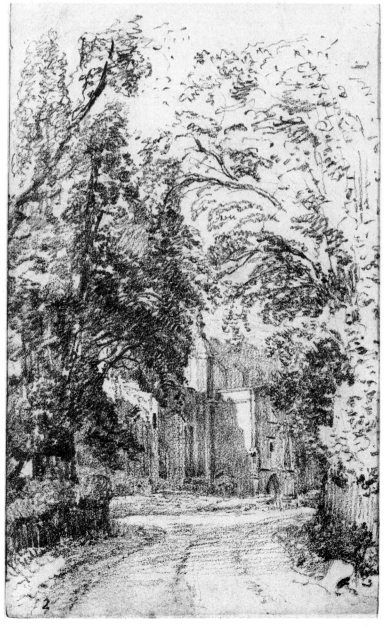

29. (17.29) *East Bergholt Church: the approach through trees from the south-west*, Private collection, 18·6 × 11·5cm.

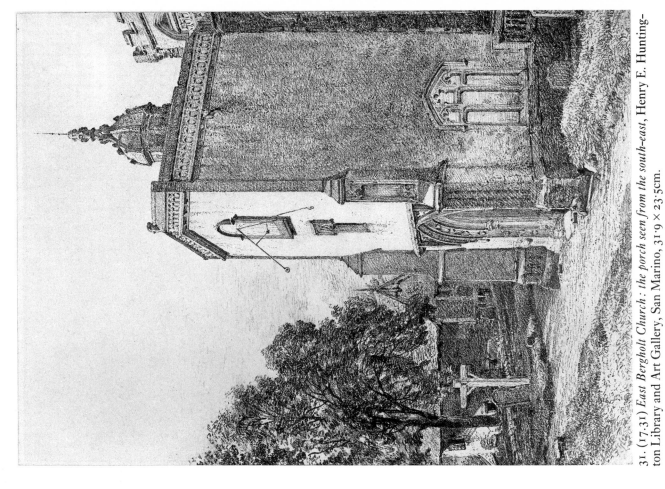

31. (17.31) *East Bergholt Church: the porch seen from the south-east*, Henry E. Huntington Library and Art Gallery, San Marino, 31·9 × 23·5cm.

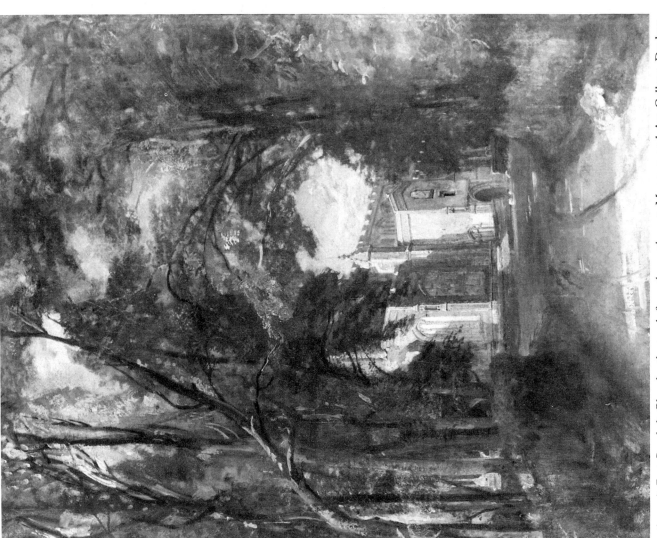

30. (17.30) *East Bergholt Church: the porch from the south-west*, Museum and Art Gallery, Durban, 52·6 × 43·8cm.

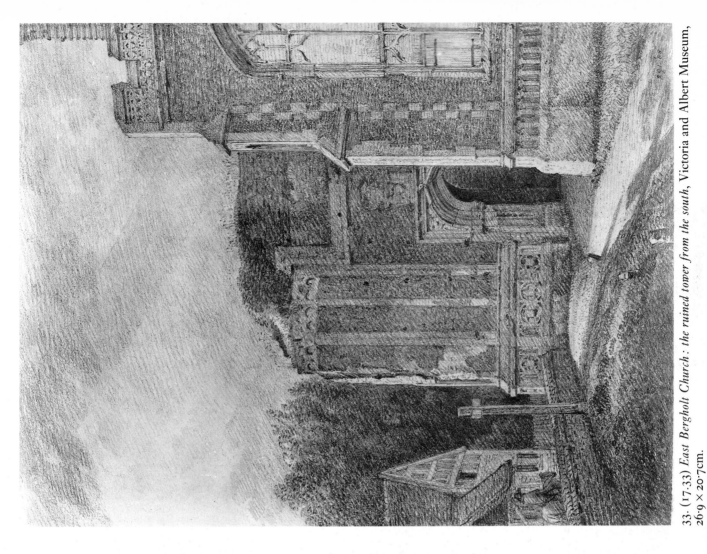

32. (17.32) *East Bergholt Church: the ruined tower from the south-west*, Courtauld Institute
Galleries (Spooner Collection), London, 31·7 × 23·8cm.

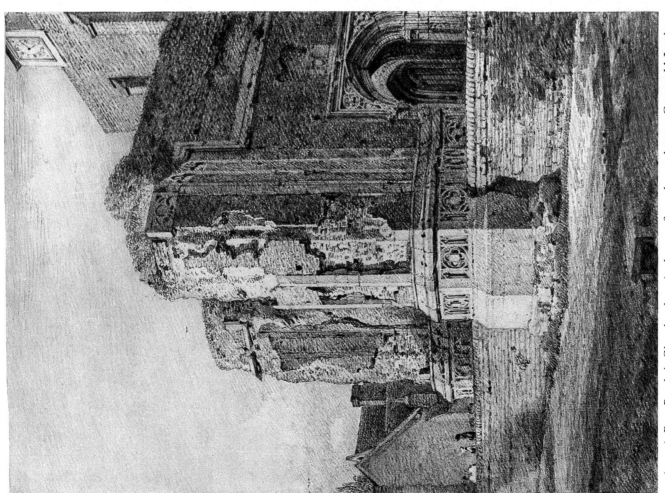

33. (17.33) *East Bergholt Church: the ruined tower from the south*, Victoria and Albert Museum,
26·9 × 20·7cm.

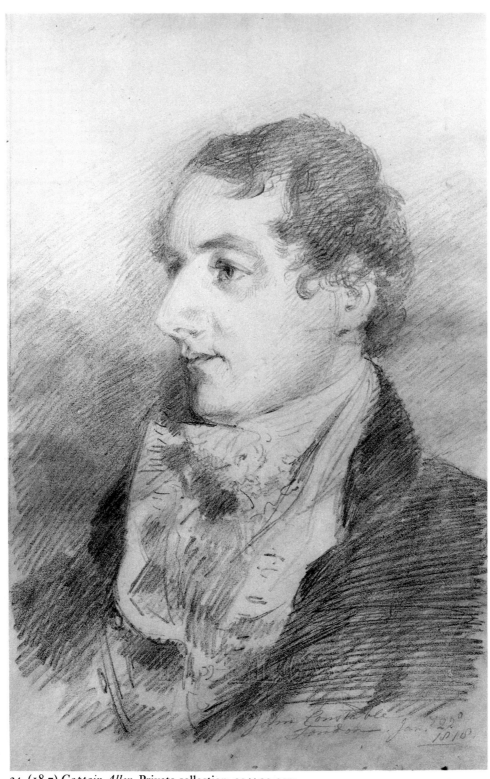

34. (18.7) *Captain Allen*, Private collection, 32 × 20·2cm.

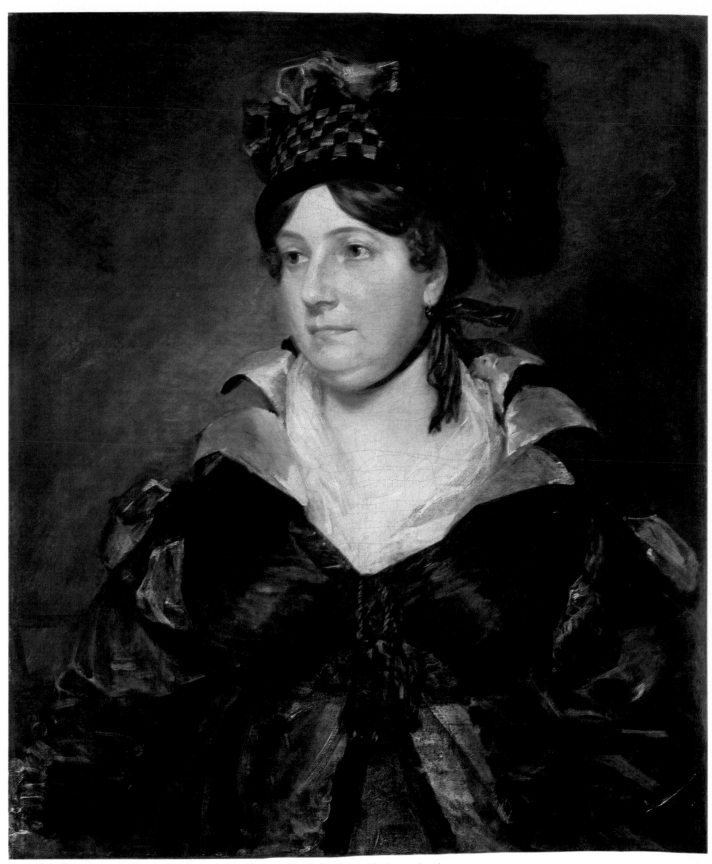

35. (18.8) *Mrs James Pulham Sr*, Metropolitan Museum of Art, New York, 75·6 × 62·9cm.

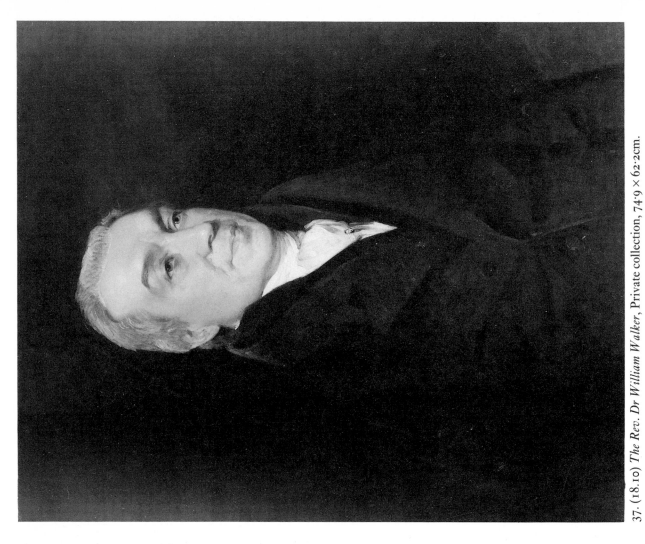

37. (18.10) *The Rev. Dr William Walker*, Private collection, 74·9 × 62·2cm.

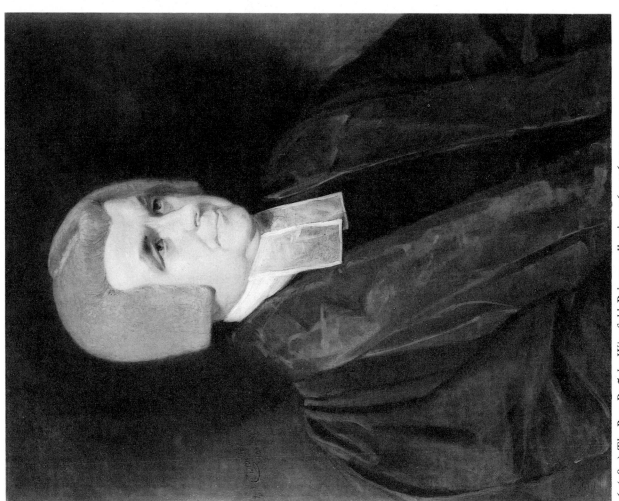

36. (18.9) *The Rev. Dr John Wingfield*, Private collection, 76·2 × 63·7cm.

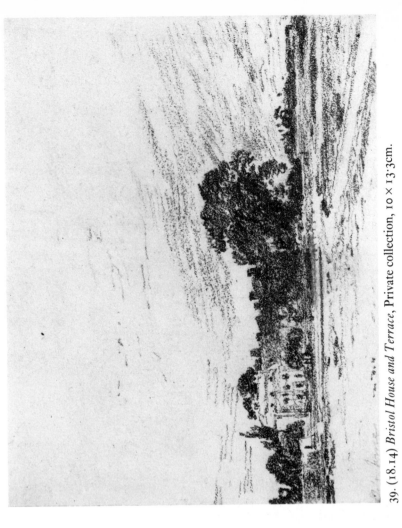

39. (18.14) *Bristol House and Terrace*, Private collection, 10 × 13·3cm.

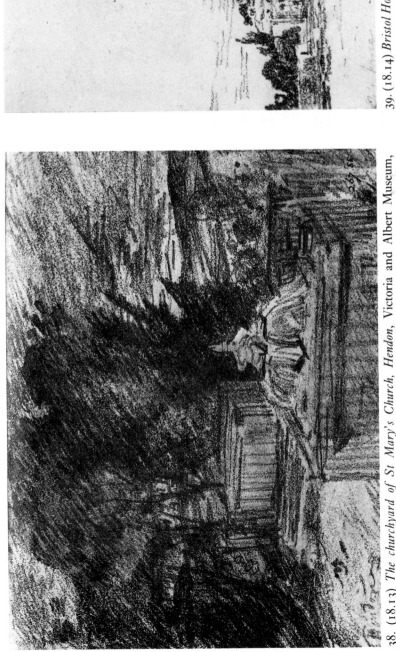

38. (18.13) *The churchyard of St Mary's Church, Hendon*, Victoria and Albert Museum, 10 × 13·3cm.

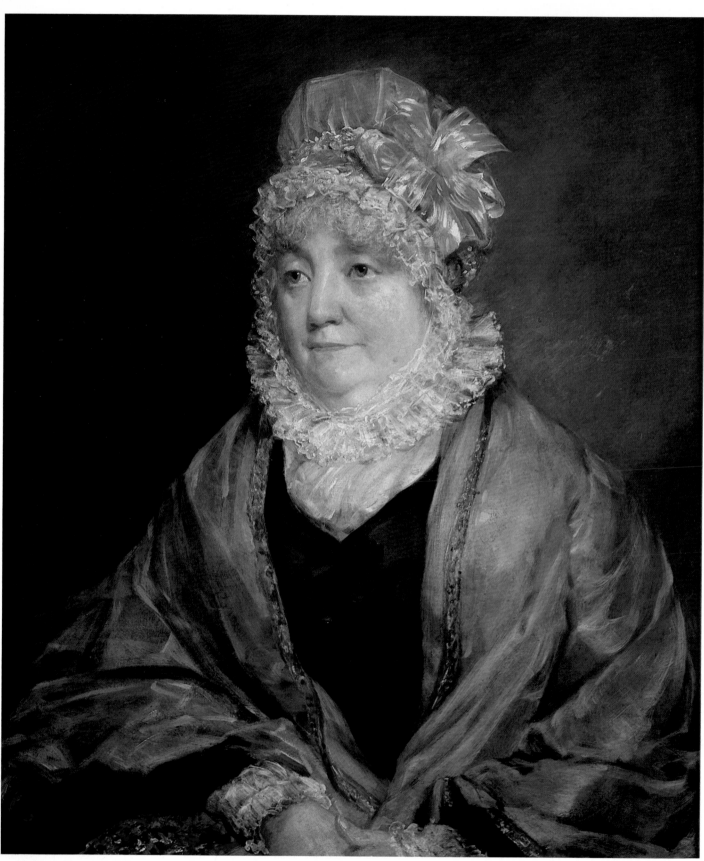

40. (18.11) *Mrs Tuder*, Cannon Hall Museum, Barnsley, 74·8 × 62·2cm.

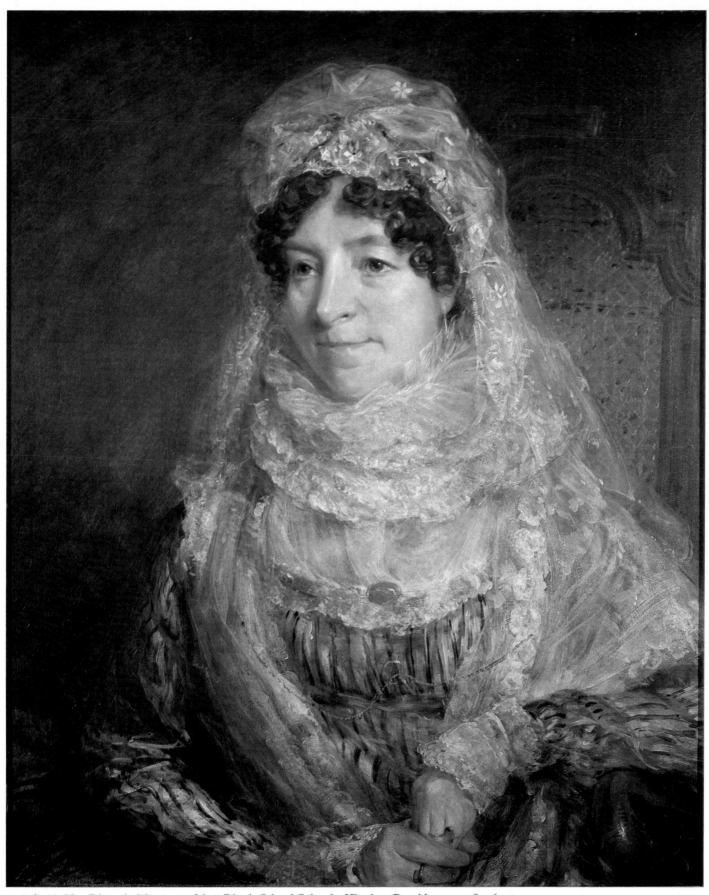

41. (18.12) *Mrs Edwards*, Museum of Art, Rhode Island School of Design, Providence, 75·8 × 63·5cm.

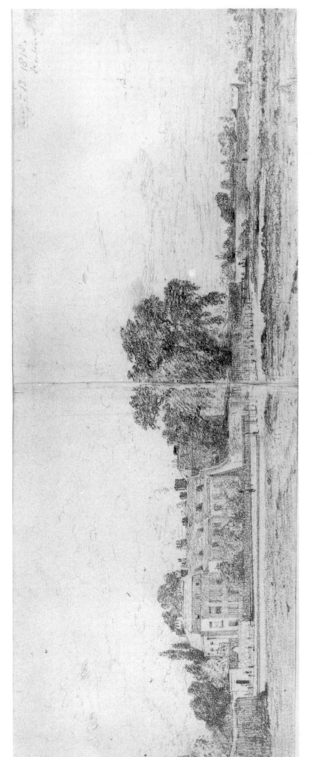

42. (18.15) *Bristol House and Terrace, Putney Heath,* Fitzwilliam Museum, Cambridge, 10 × 13cm. (each sheet); 10 × 26·1cm. (overall size).

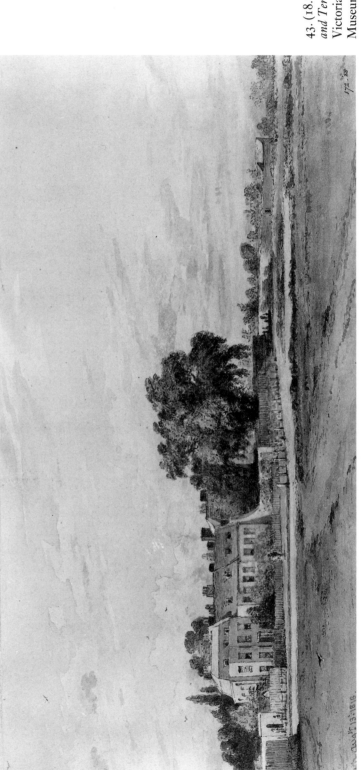

43. (18.16) *Bristol House and Terrace, Putney Heath,* Victoria and Albert Museum, 12.1 × 27cm.

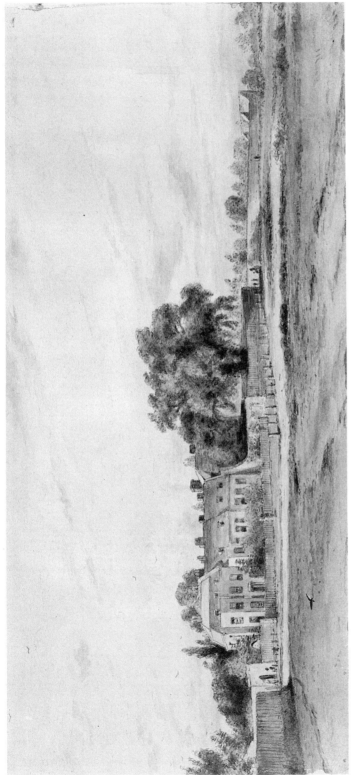

44. (18.17) *Bristol House and Terrace, Putney Heath,* Whitworth Art Gallery, Manchester, 12·2 × 27cm.

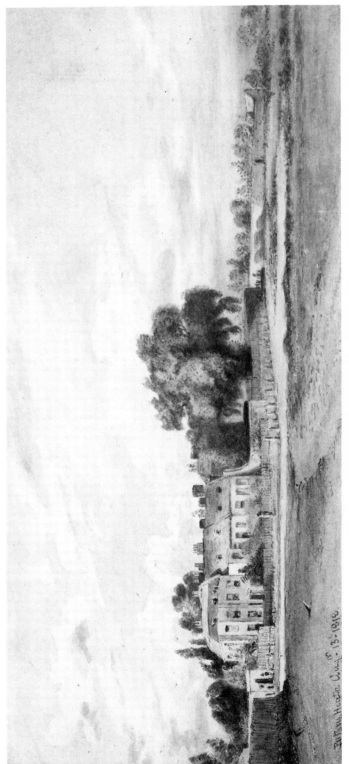

45. (18.18) *Bristol House and Terrace, Putney Heath,* Private collection, 12·2 × 27cm.

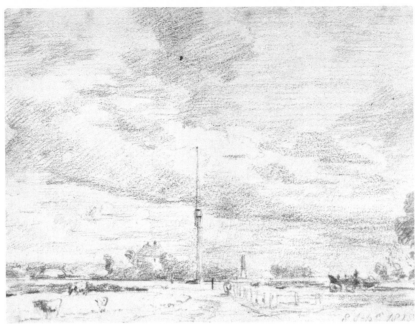

46. (18.19) *The flagstaff and telegraph on Putney Heath*, Fitzwilliam Museum, Cambridge, 10 × 13·1cm.

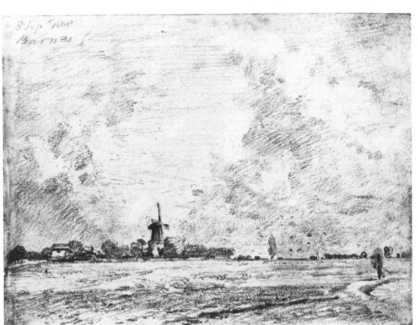

47. (18.20) *A windmill at Barnes*, Private collection, 9·9 × 13·3cm.

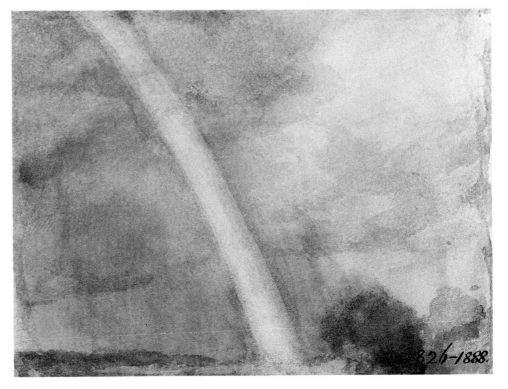

48. (18.23) *A rainbow above trees*, Victoria and Albert Museum, 9·7 × 12·9cm.

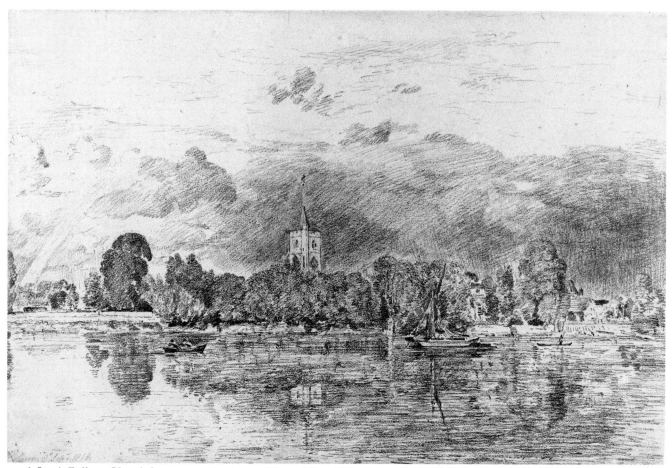

49. (18.21) *Fulham Church from across the river, with a rainbow*, Yale Center for British Art, New Haven, 29·8 × 44·5cm.

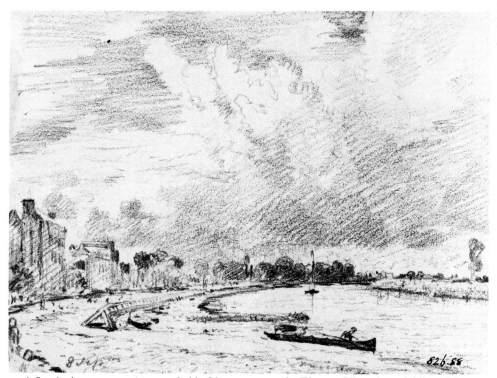

50. (18.22) *A scene on a river, probably Shepperton on the Thames*, Victoria and Albert Museum, 9·7 × 12·9cm.

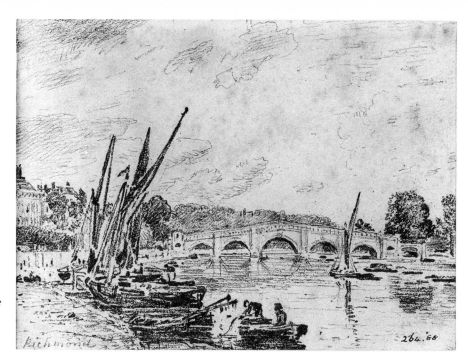

51. (18.24) *Richmond Bridge with barges on the Thames*, Victoria and Albert Museum, 10 × 13·4cm.

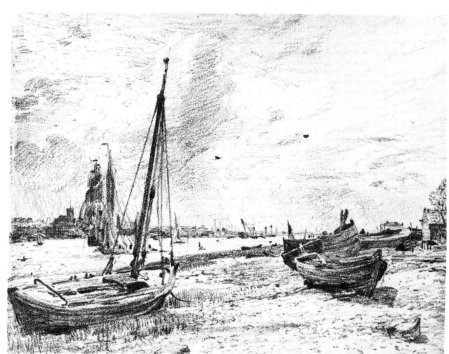

52. (18.25) *Shipping on the Thames*, Yale Center for British Art, New Haven, 9·8 × 13cm.

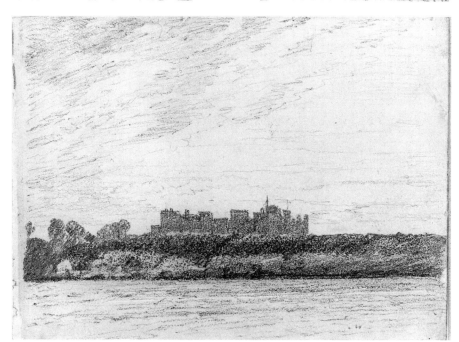

53. (18.28) *Windsor Castle from the river*, Fitzwilliam Museum, Cambridge, 10 × 13·2cm.

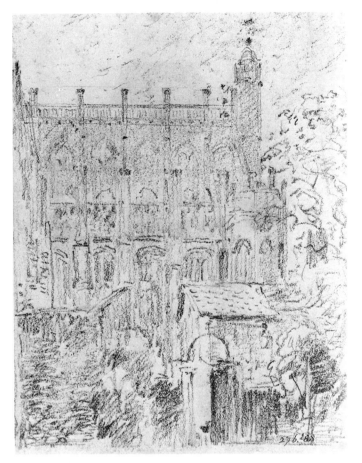

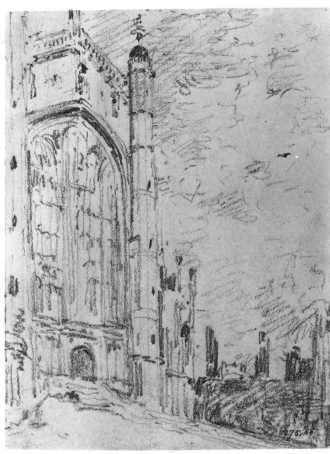

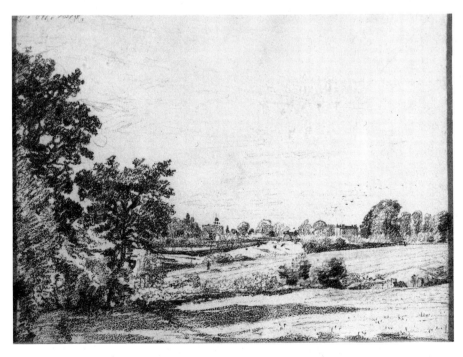

54. (above left) (18.26) *St George's Chapel, Windsor*, Victoria and Albert Museum, 13·4 × 10cm.

55. (above) (18.27) *St George's Chapel, Windsor: the west end*, Victoria and Albert Museum, 13·5 × 10cm.

56. (18.29) *Golding Constable's house and East Bergholt Church*, Executors of the late Lieutenant–Colonel J. H. Constable, 10·2 × 12·7cm.

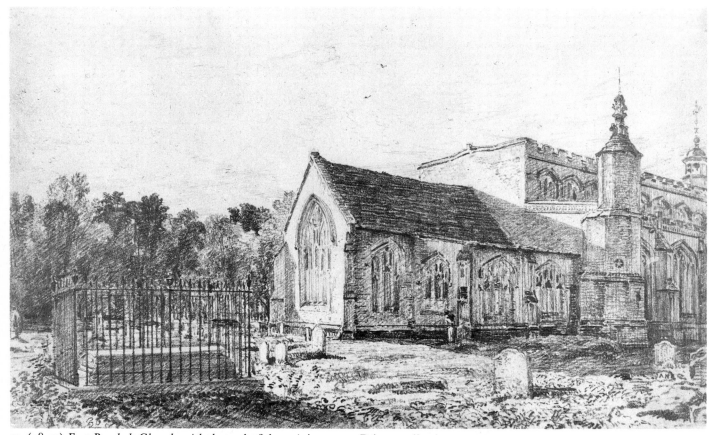

57. (18.30) *East Bergholt Church, with the tomb of the artist's parents*, Private collection, 19·9 × 32·1cm.

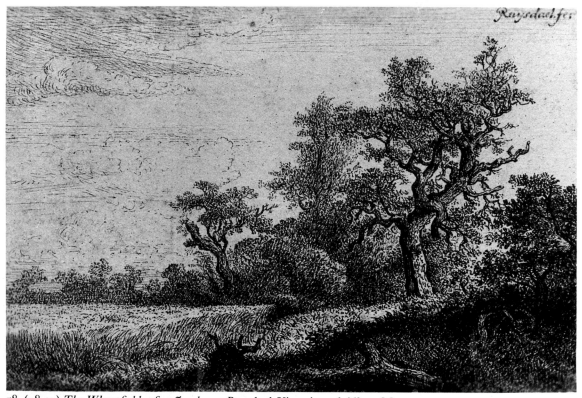

58. (18.31) *The Wheatfield, after Jacob van Ruysdael*, Victoria and Albert Museum, 10·3 × 15·2cm.

60. (right) (18.33) *Landscape with Cattle, after Aelbert Cuyp*, Musée du Louvre, 12·4 × 10cm.

59. (18.32) *A Herdsman with Cows and a Horse in Hilly Country, after Aelbert Cuyp*, Victoria and Albert Museum, 10 × 12·5cm.

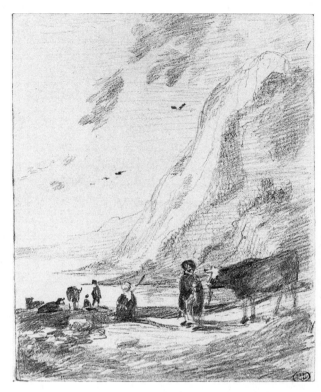

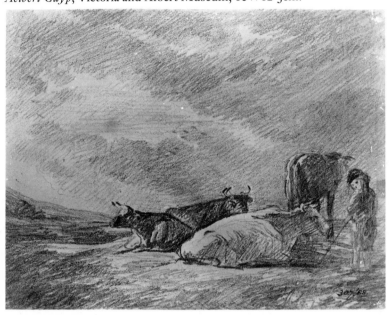

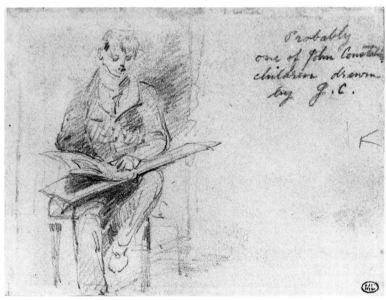

61. (18.34) *A boy with a book of engravings on his knee*, Musée du Louvre, 10 × 13·3cm.

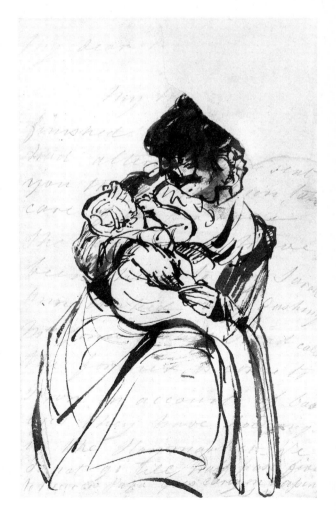

62. (right) (18.40) *A child being nursed*, British Museum, 18·1 × 11·2cm.

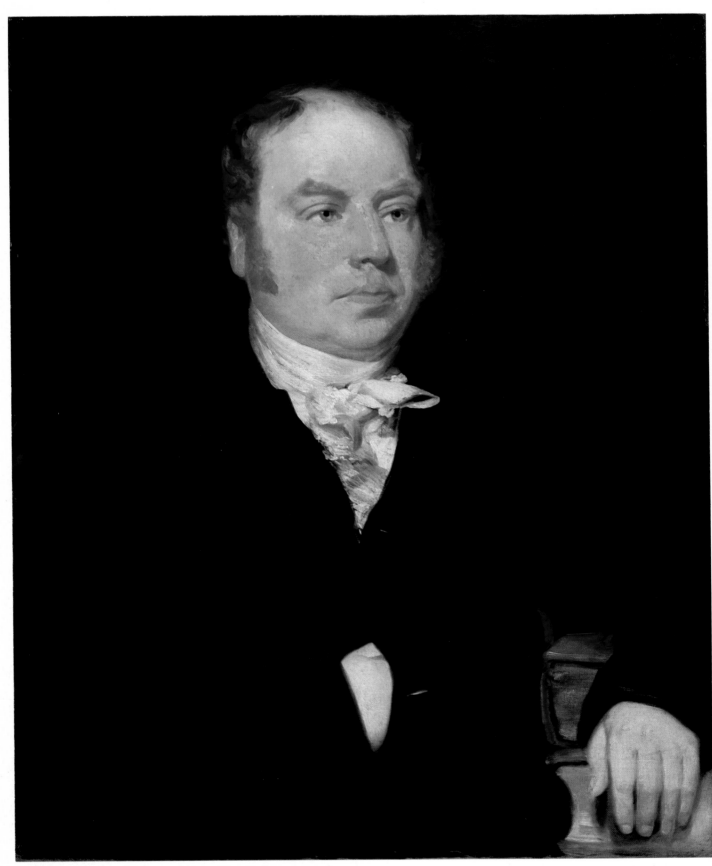

63. (18.35) *The Rev. Dr James Andrew*, Tate Gallery, 77·5 × 64·5cm.

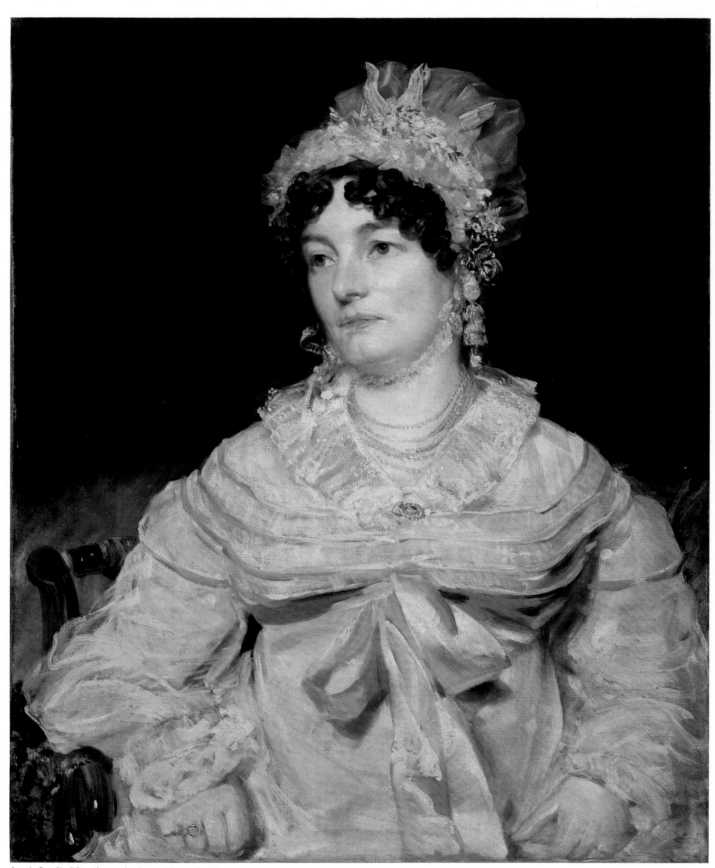

64. (18.36) *Mrs Jane Andrew*, Tate Gallery, 77·5 × 64·5cm.

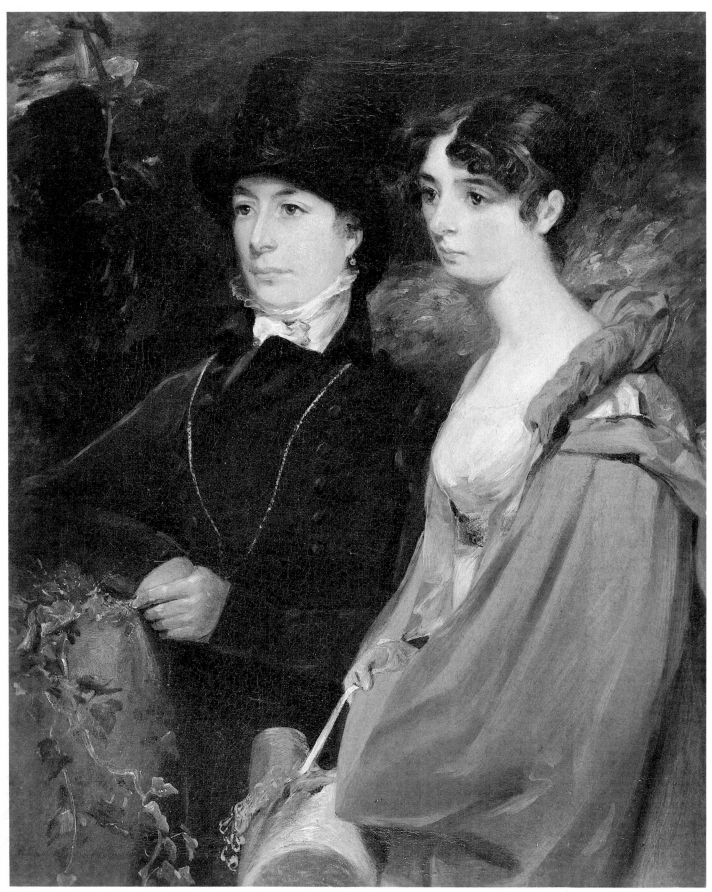

65. (18.37) *Ann and Mary Constable, the artist's sisters*, Henry E. Huntington Library and Art Gallery, San Marino, 38 × 29cm.

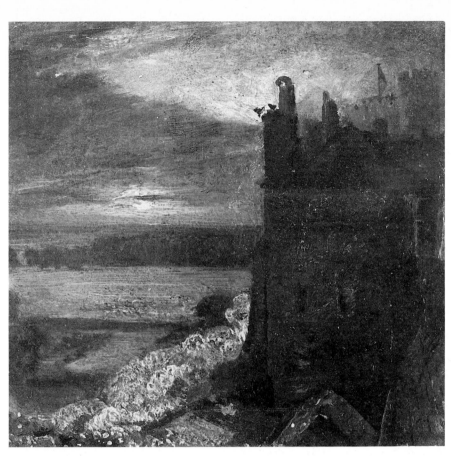

66. (18.38) *A turreted castle at sunset*, Whereabouts unknown, $5\frac{3}{4} \times 6$in.

67. (below) (18.39) *On the Thames near Battersea Bridge*, Private collection, $25 \cdot 4 \times 30 \cdot 4$cm.

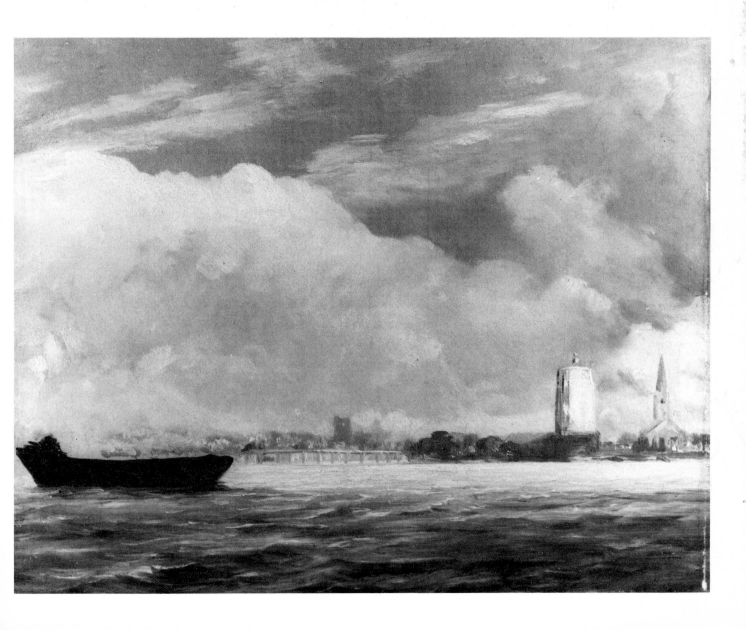

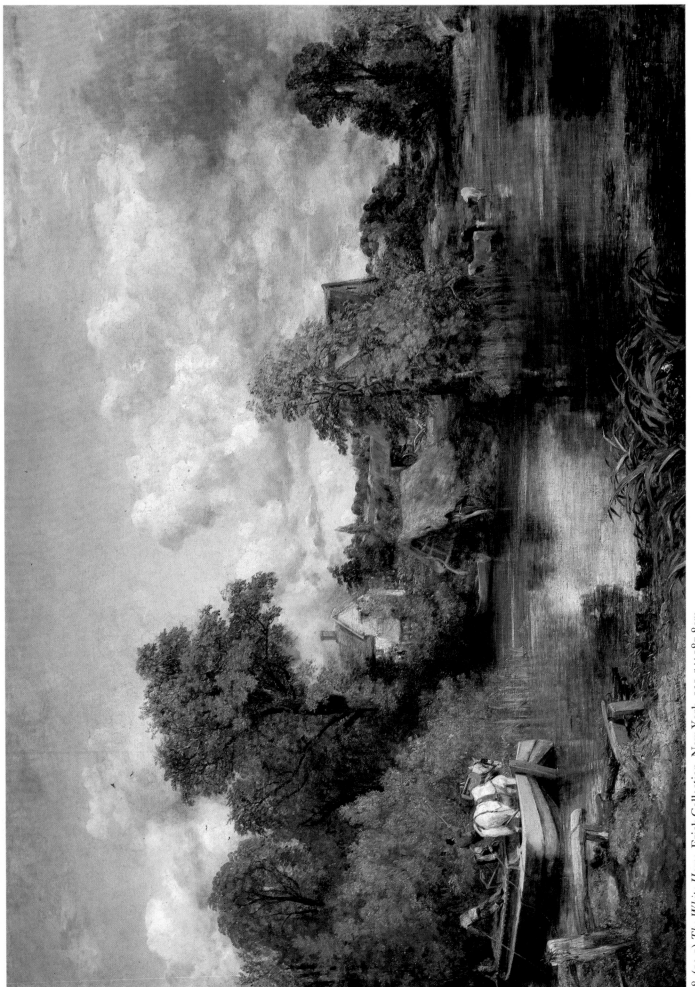

68. (19.1) *The White Horse*, Frick Collection, New York, 131·5 × 187·8cm.

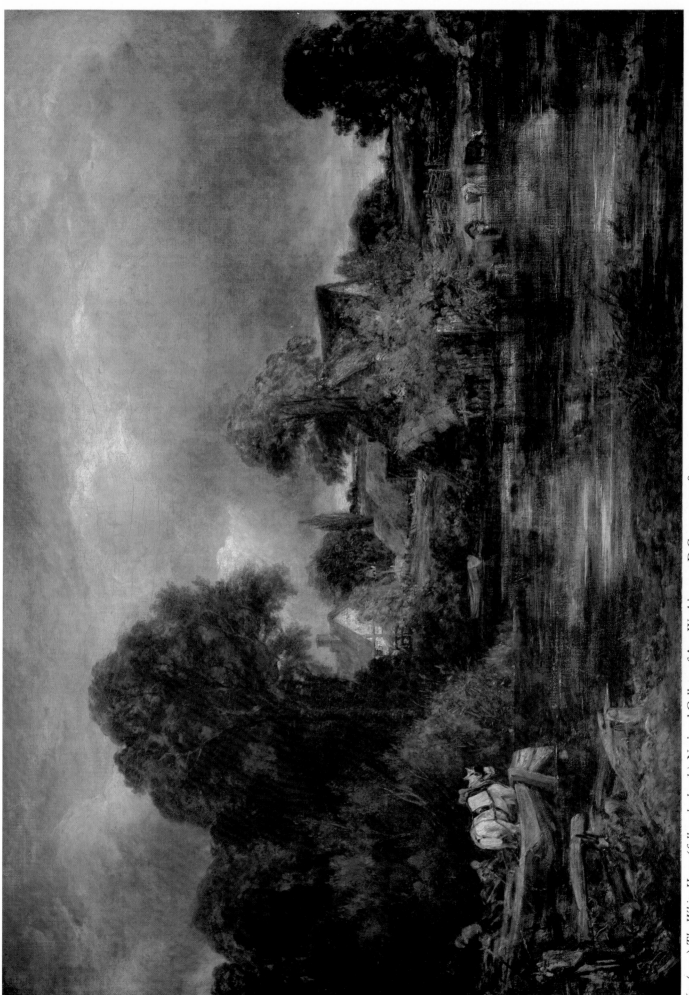

69. (19.2) *The White Horse (full-scale sketch)*, National Gallery of Art, Washington, D.C., 127·5 × 183cm.

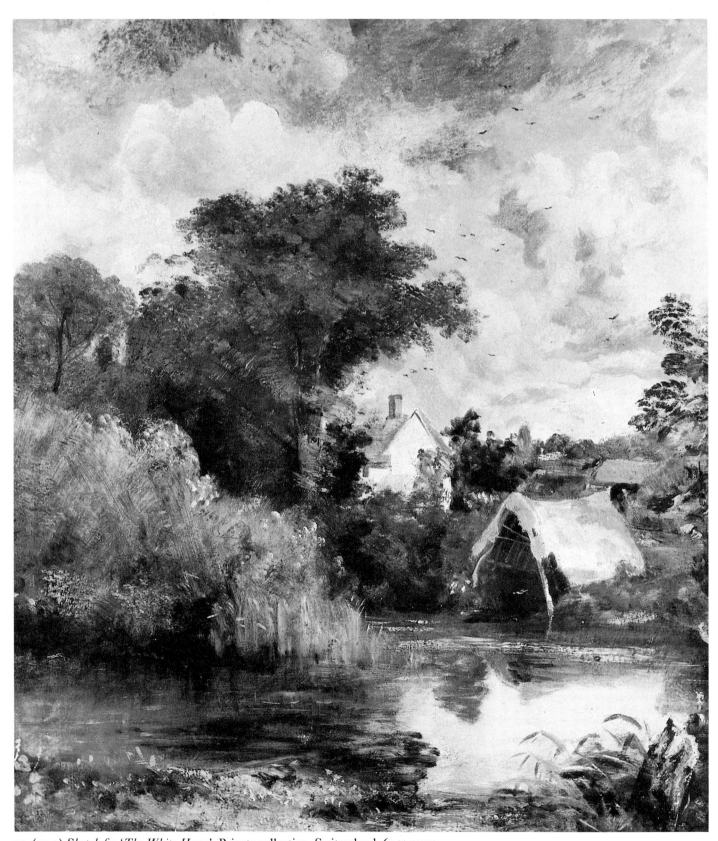

70. (19.3) *Sketch for 'The White Horse'*, Private collection, Switzerland, 61 × 50cm.

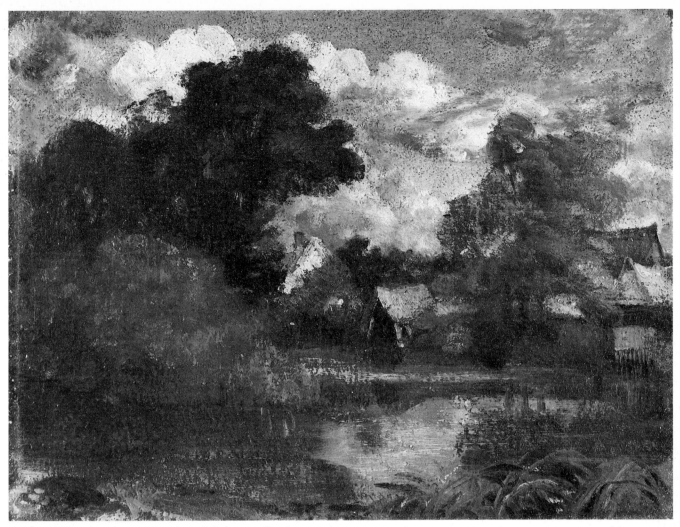

71. (19.4) *Sketch for 'The White Horse'*, Private collection, 23·5 × 30·2cm.

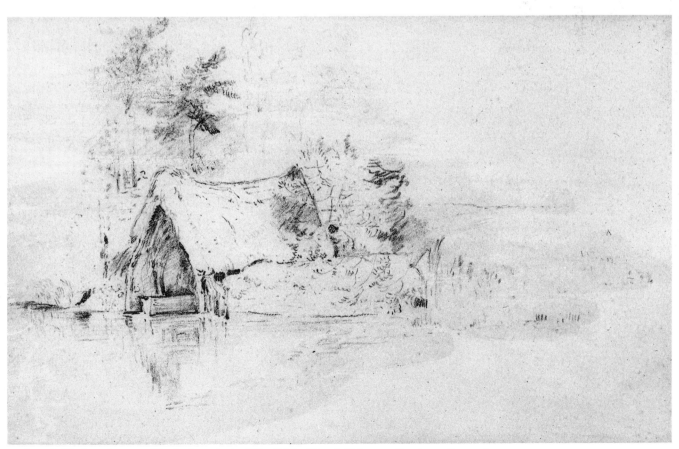

72. (19·5) *The boat house at Flatford, study for 'The White Horse'*, Private collection, 18·5 × 28cm.

73. (19.9)
Weymouth Bay,
Musée du Louvre,
88 × 112cm.

74. (below) (19.10)
Weymouth Bay,
National Gallery,
London,
53 × 75cm.

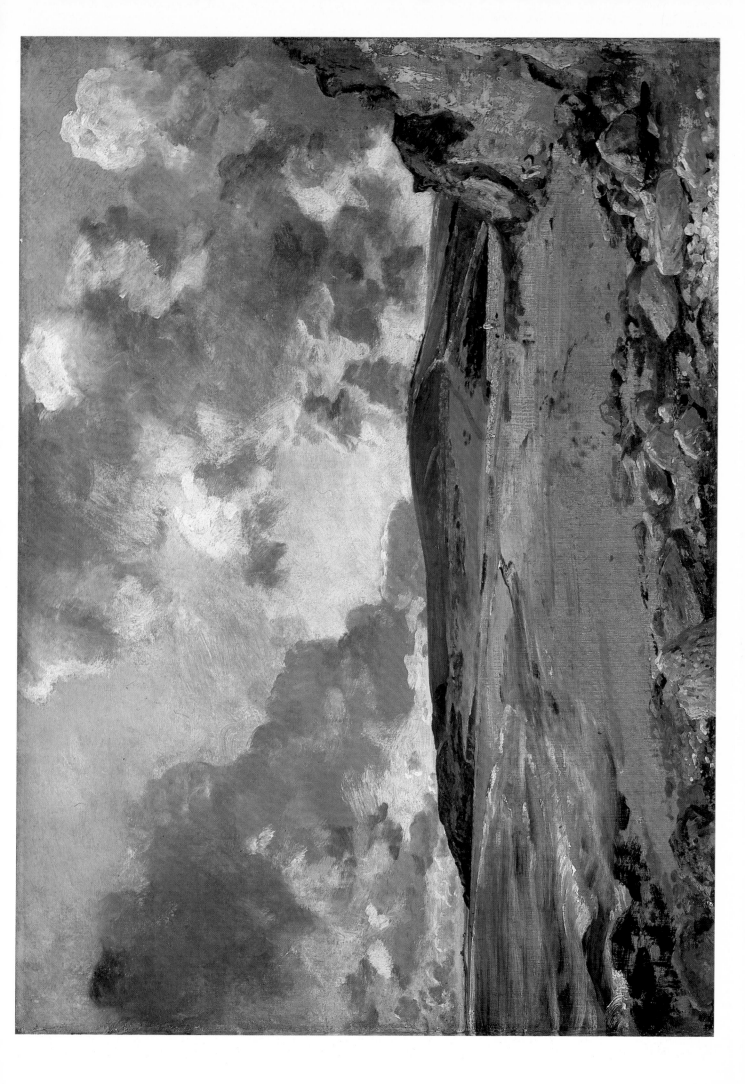

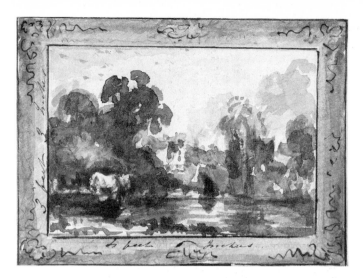

75. (19.6) *Sketch for a frame for 'The White Horse'*, Fitzwilliam Museum, Cambridge, 10·9 × 14·3cm.

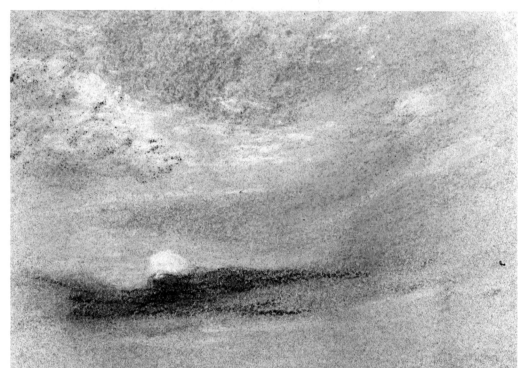

76. (19.12) *Sky study*, Private collection, 12·5 × 18·5cm.

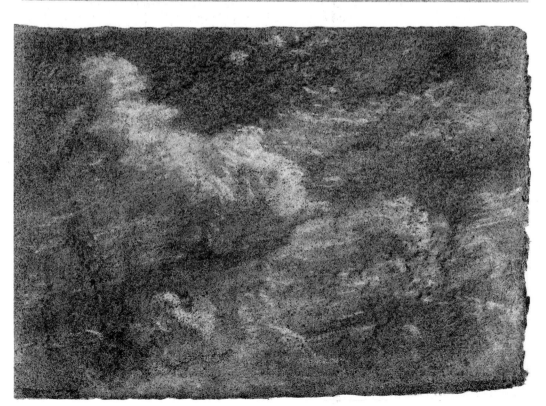

77. (19.13) *Sky study*, Private collection, 12·5 × 18·5cm.

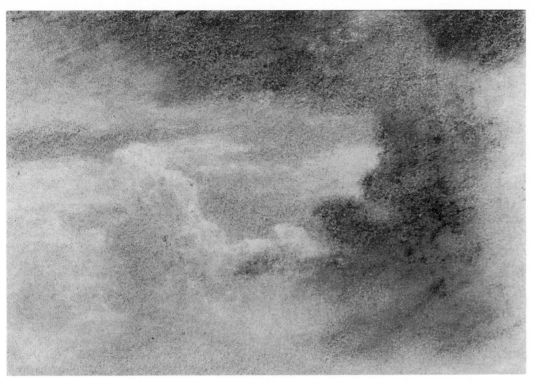

78. (19.14) *Sky study*,
Private collection,
13 × 18·5cm.

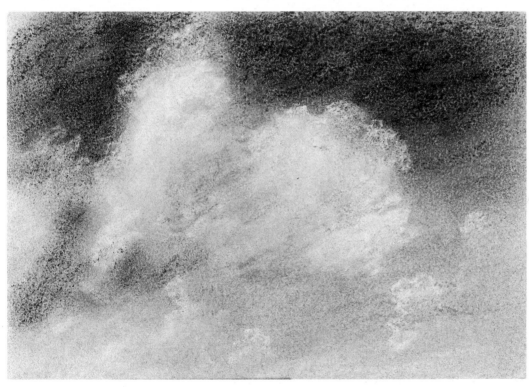

79. (19.15) *Sky study*,
Private collection,
13 × 18·5cm.

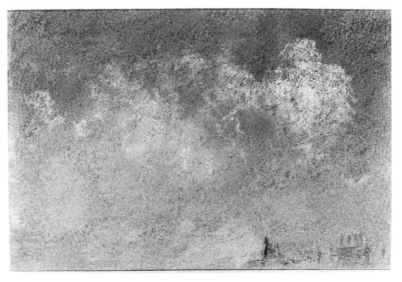

80. (19.16) *Sky study,
with chimney pots*,
Private collection,
9 × 13·5cm.

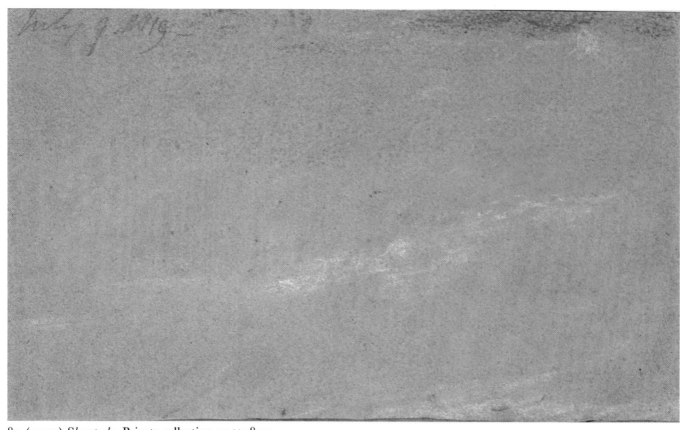

81. (19.11) *Sky study*, Private collection, 11 × 18cm.

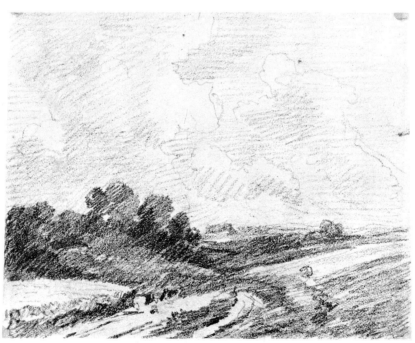

82. (19.18) *A Landscape with a Cornfield, after Jacob van Ruysdael*, Executors of the late Lieutenant-Colonel J. H. Constable, 8·9 × 11cm.

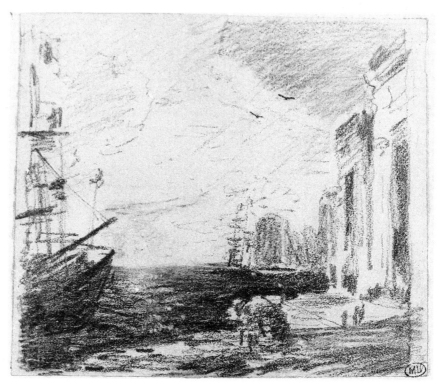

83. (19.19) *A Seaport, after Claude*, Musée du Louvre, 9·5 × 11·1cm.

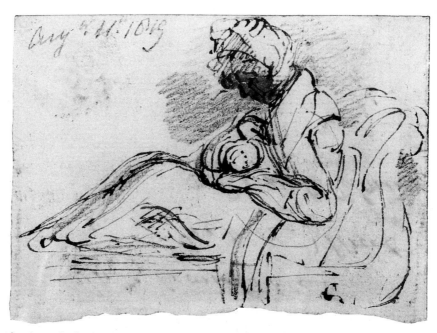

84. (19.20) *A woman nursing a child*, Private collection, 7·6 × 11cm.

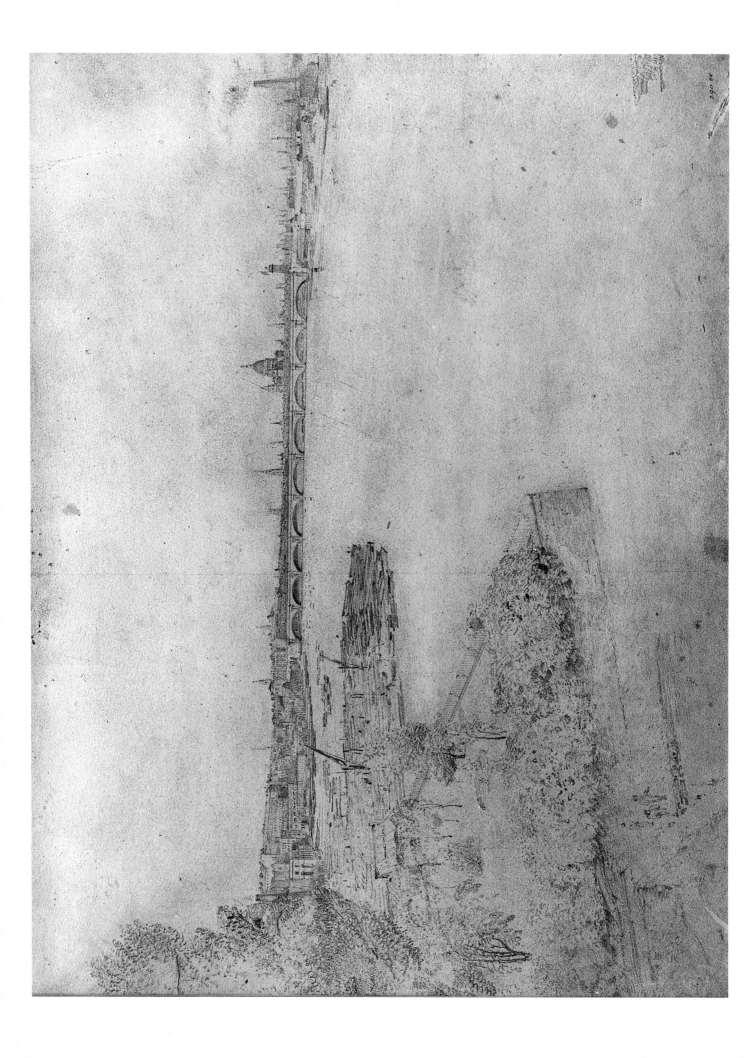

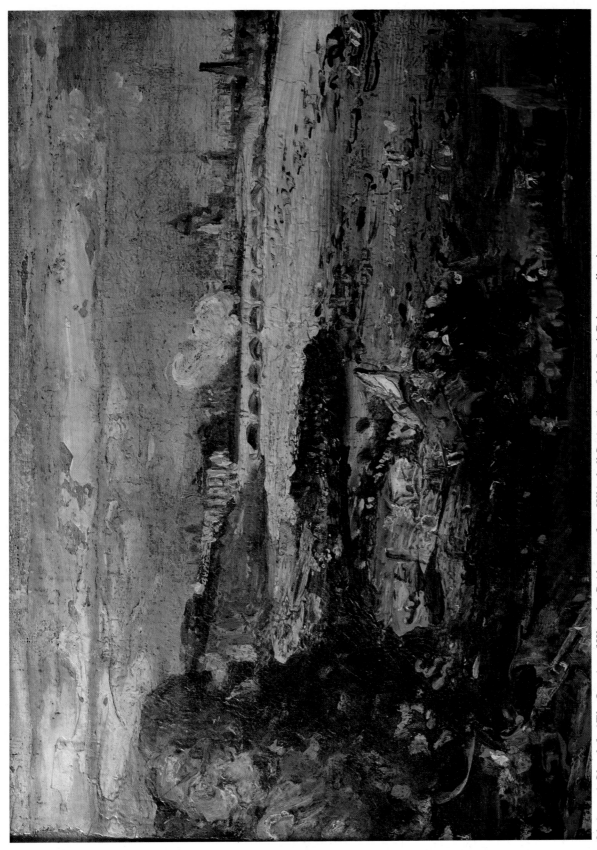

85. (above) (19.24) *Waterloo Bridge from above Whitehall Stairs*, Victoria and Albert Museum, 30·6 × 41cm.

86. (19.22) *Sketch for 'The Opening of Waterloo Bridge seen from Whitehall Stairs, June 18th 1817'*, Private collection, 15.2 × 22.3cm.

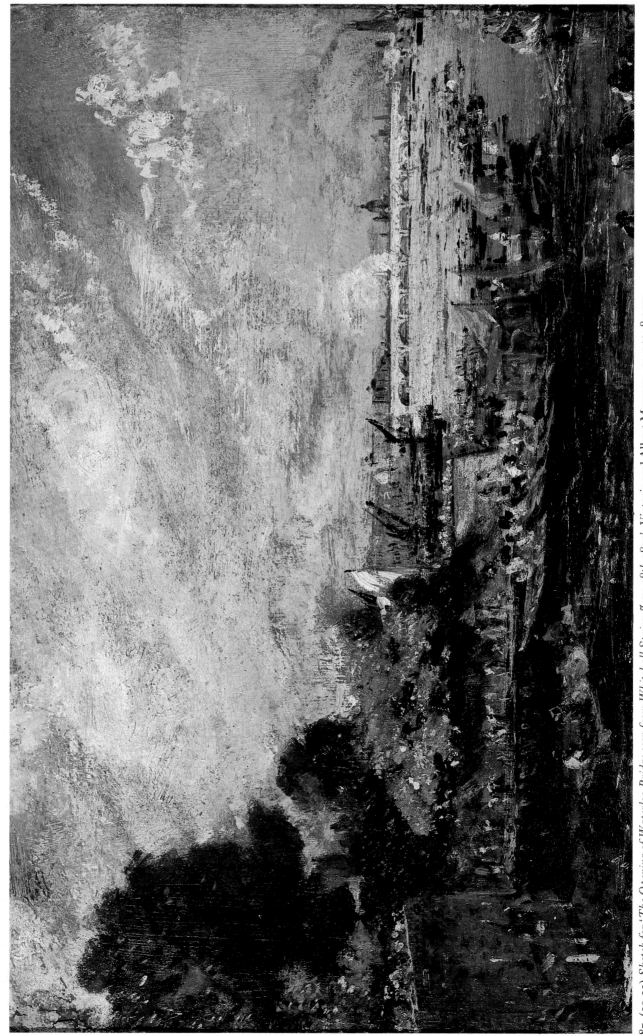

87. (19.23) *Sketch for 'The Opening of Waterloo Bridge seen from Whitehall Stairs, June 18th 1817'*, Victoria and Albert Museum, 29.2 × 48.3 cm.

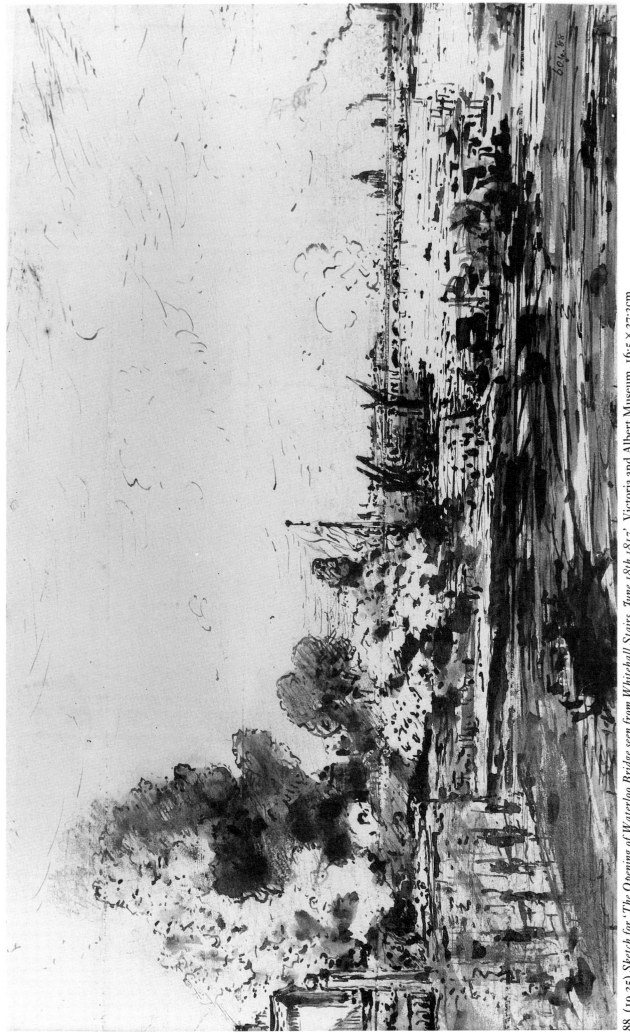

88. (19.25) *Sketch for 'The Opening of Waterloo Bridge seen from Whitehall Stairs, June 18th 1817'*, Victoria and Albert Museum, 16·5 × 27·3cm.

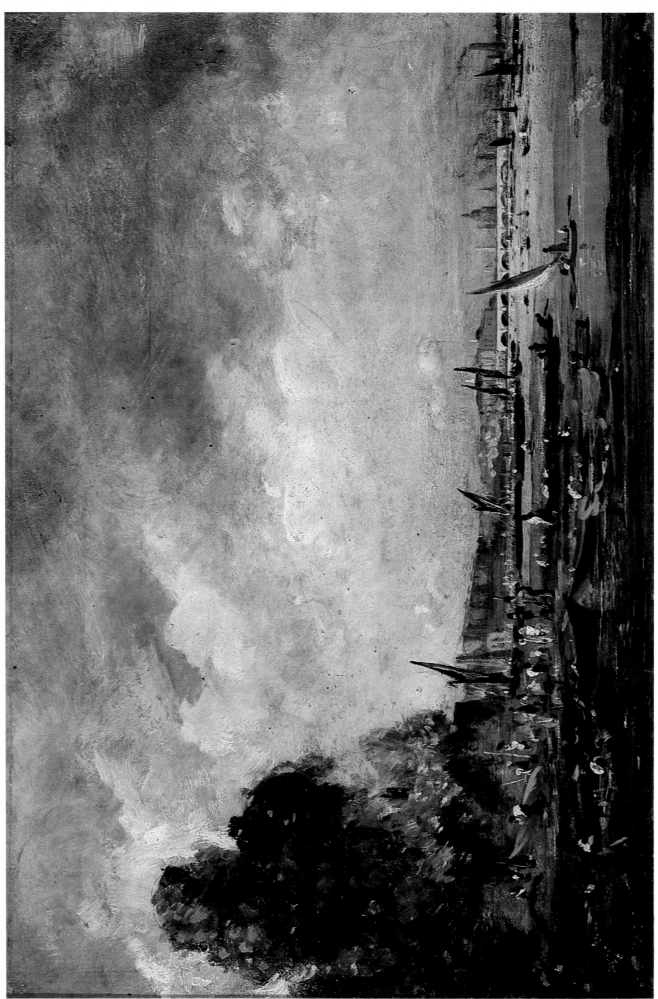

89. (19.26) *Waterloo Bridge from the left bank of the Thames*, Royal Academy of Arts, London, 21 × 31·7cm.

90. (below) (19.27) *The Thames and Waterloo Bridge*, Cincinnati Art Museum, Ohio, 55·2 × 78·1cm.

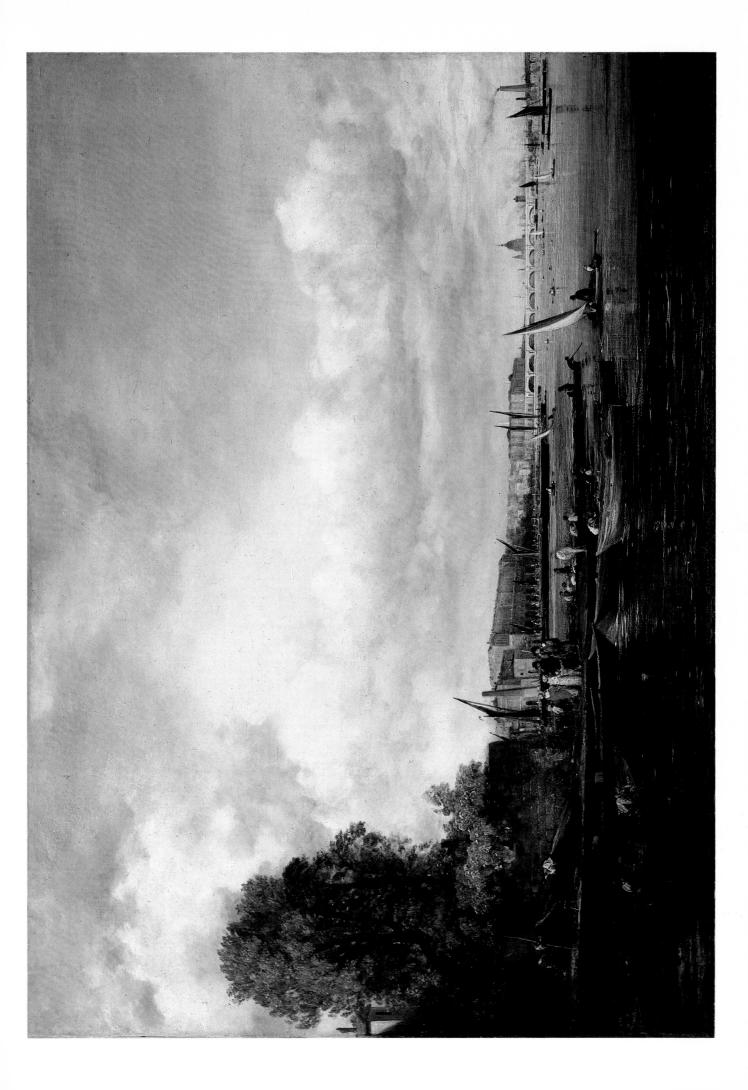

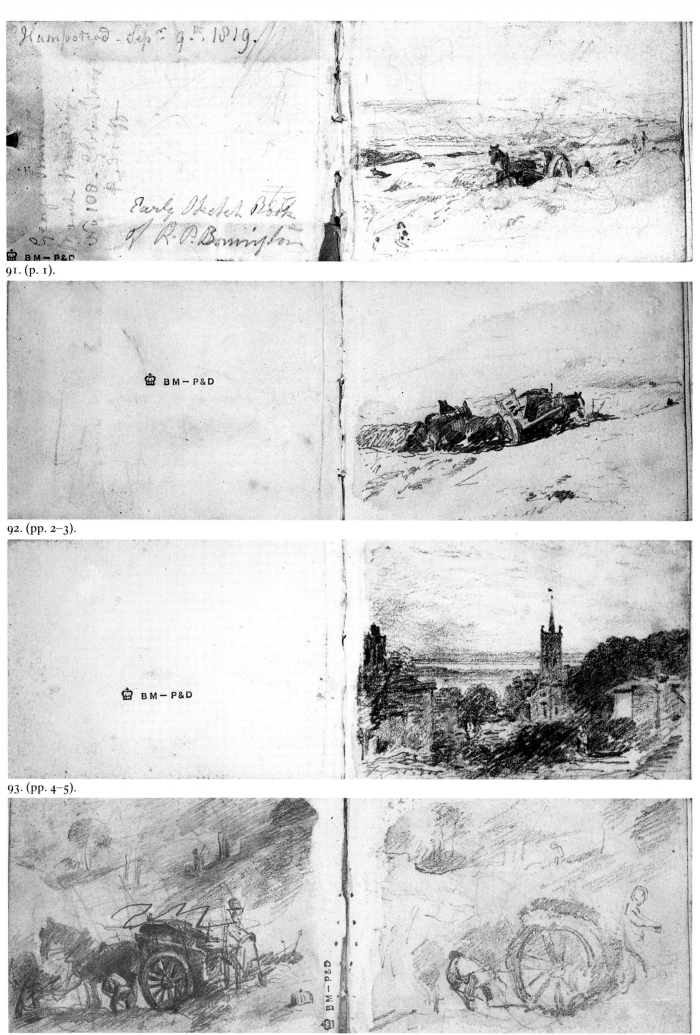

91. (p. 1).

92. (pp. 2–3).

93. (pp. 4–5).

94. (pp. 6–7).

91–118. (19.28) *Intact sketch-book used in 1819*, British Museum, 6·7 × 9·3cm.

95. (pp. 8–9).

96. (pp. 10–11).

97. (pp. 12–13).

98. (pp. 14–15).

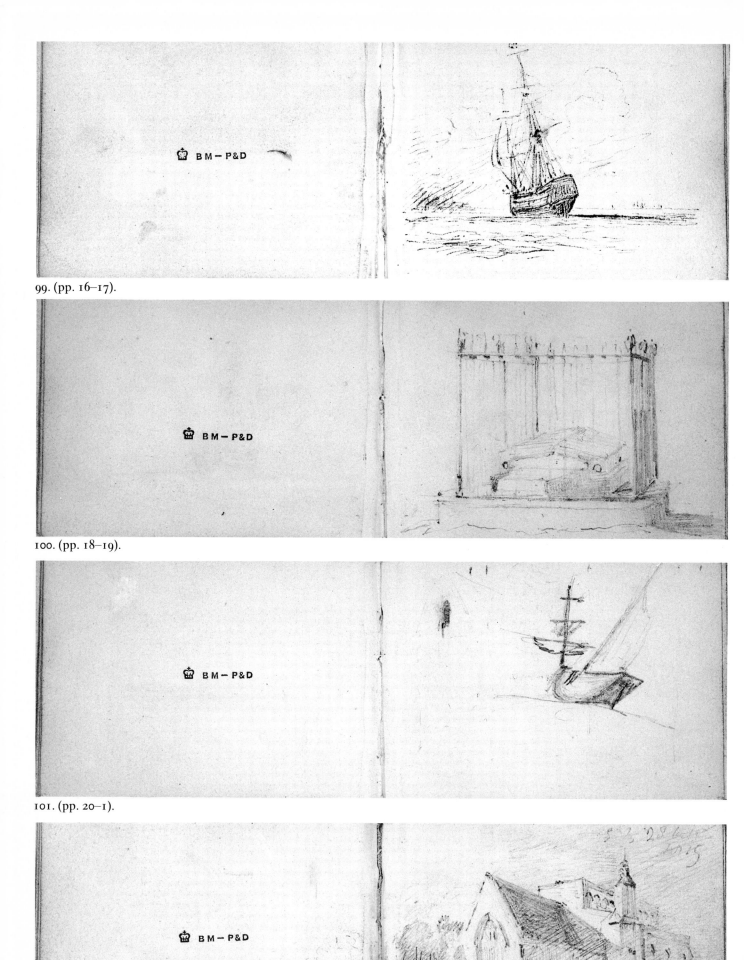

99. (pp. 16–17).

100. (pp. 18–19).

101. (pp. 20–1).

102. (pp. 22–3).

103. (pp. 24–5).

104. (pp. 26–7).

105. (pp. 28–9).

106. (pp. 30–1).

107. (pp. 32–3).

108. (pp. 34–5).

109. (pp. 36–7).

110. (pp. 38–9).

111. (pp. 40–1).

112. (pp. 42–3).

113. (pp. 44–5).

Rapes. Murders. Thunders do my steps invite,
And human Carnage is my souls delight!

114. (pp. 46–7).

115. (pp. 48–9).

116. (pp. 50–1).

117. (pp. 52–3).

118. (p. 54).

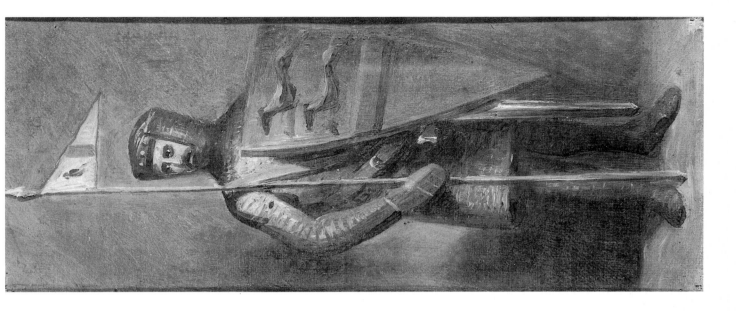

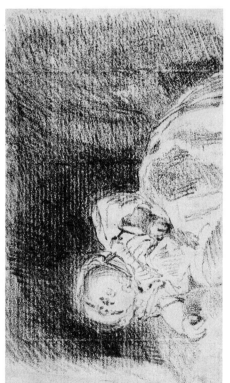

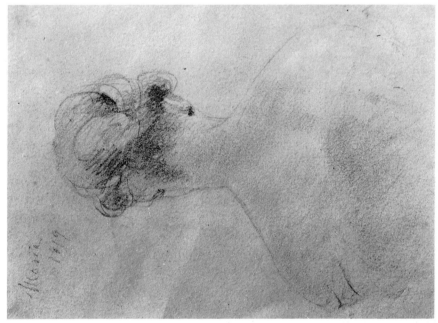

123. (left) (19.33) *A baby, perhaps Maria Louisa Constable,* Victoria and Albert Museum, 5·9 × 10·5cm.

126. (right) (19.36) *Humphri de Grousewolde,* Executors of the late Lieutenant-Colonel J. H. Constable, 22·9 × 8·9cm.

124. (19.39) *A seated woman with a girl kneeling before her,* Private collection, 7·8 × 8·3cm.

125. (right) (19.34) *Mrs Maria Constable, seen from the back,* Whereabouts unknown, 11·5 × 8·3cm.

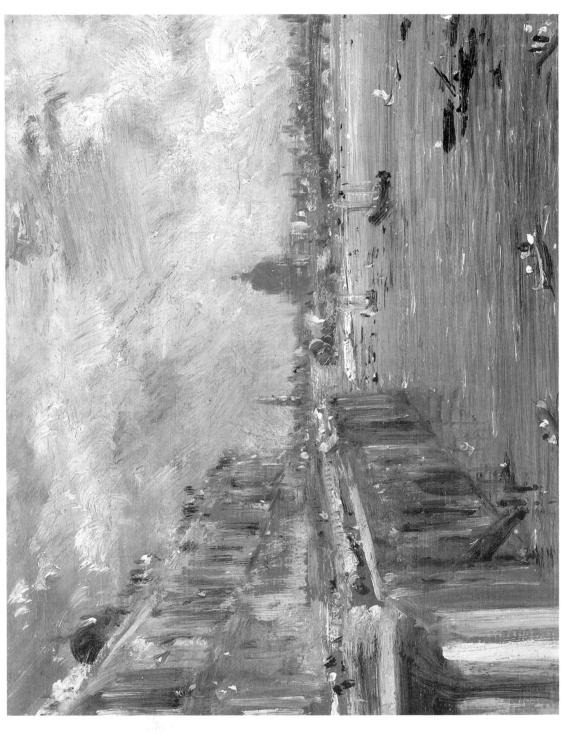

127. (19.37) *Somerset House Terrace from Waterloo Bridge*, Paul Mellon Collection, Upperville, Virginia, 15·5 × 18·7cm.

128. (19.38) *Somerset House*, Whereabouts unknown, 8 × 10in.

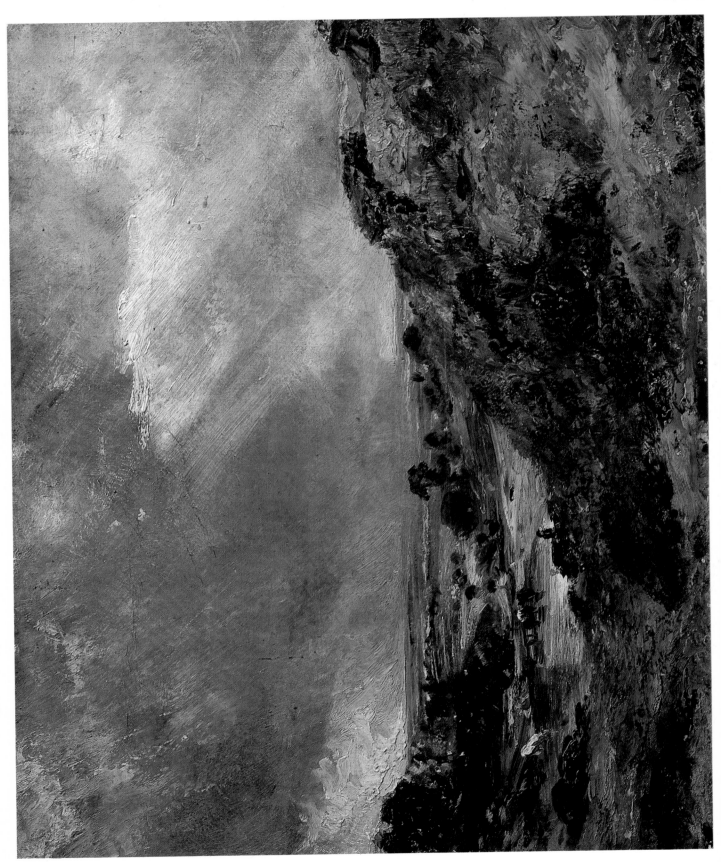

122. (19.32) *Branch Hill Pond, Hampstead, Victoria and Albert Museum, 25·4 × 30cm.*

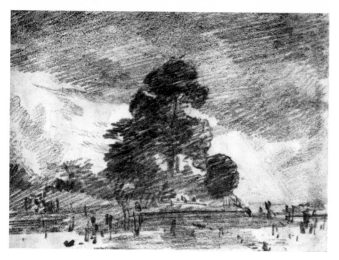

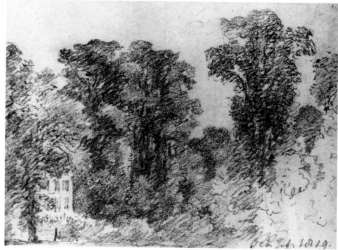

119. (above) (19.29)
Landscape with a large tree near water, Private collection,
6·5 × 8·7cm.

120. (above) (19.30) *A house seen amidst trees*, Private collection,
6·7 × 8·9cm.

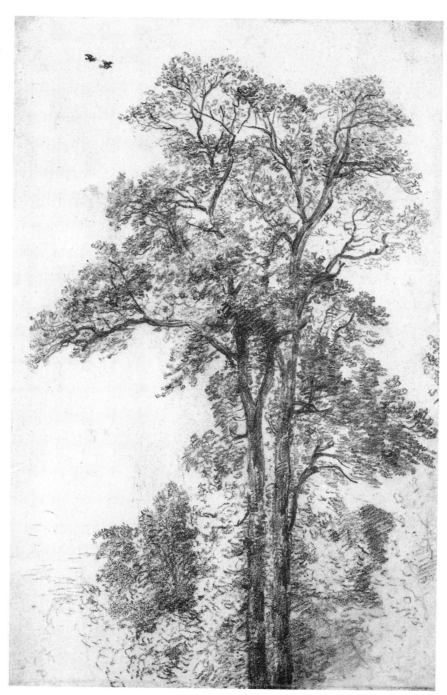

121. (19.31) *Study of a tree*, Private collection,
18 × 11·5cm.

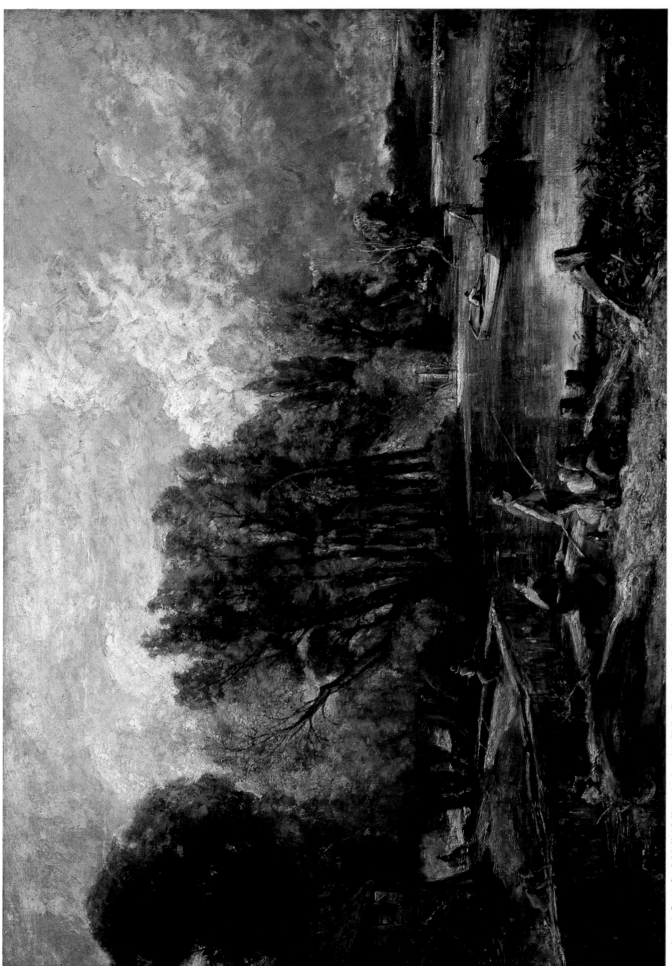

130. (20.2) *Stratford Mill (full-scale sketch)*, Yale Center for British Art, New Haven, 131 × 184cm.

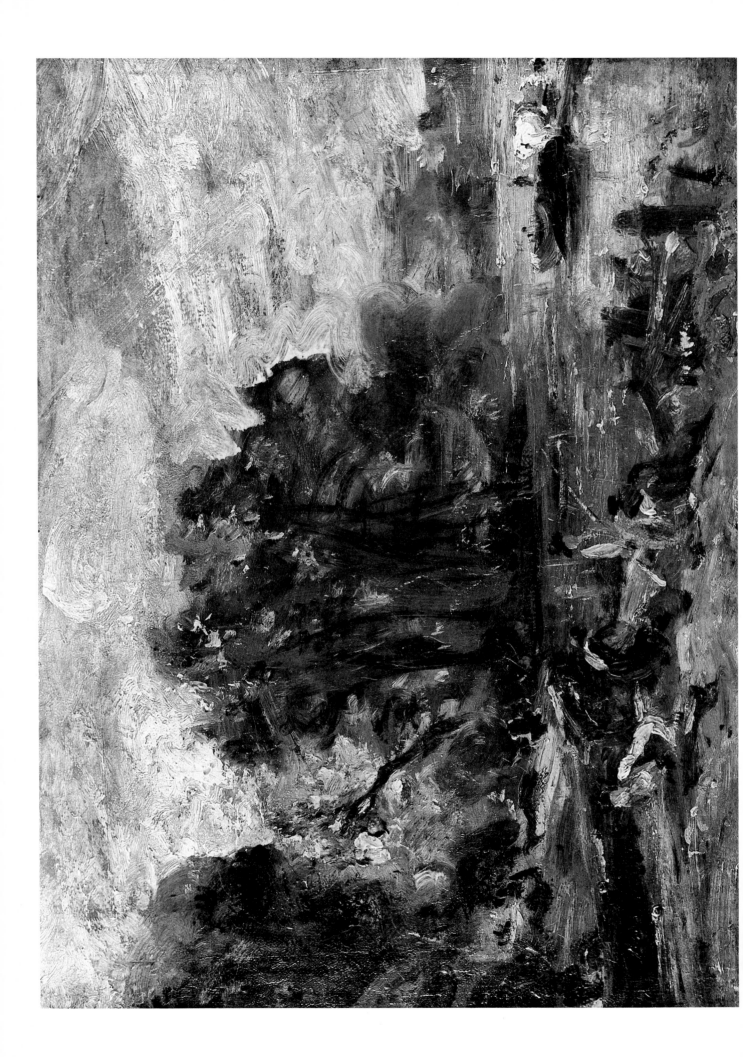

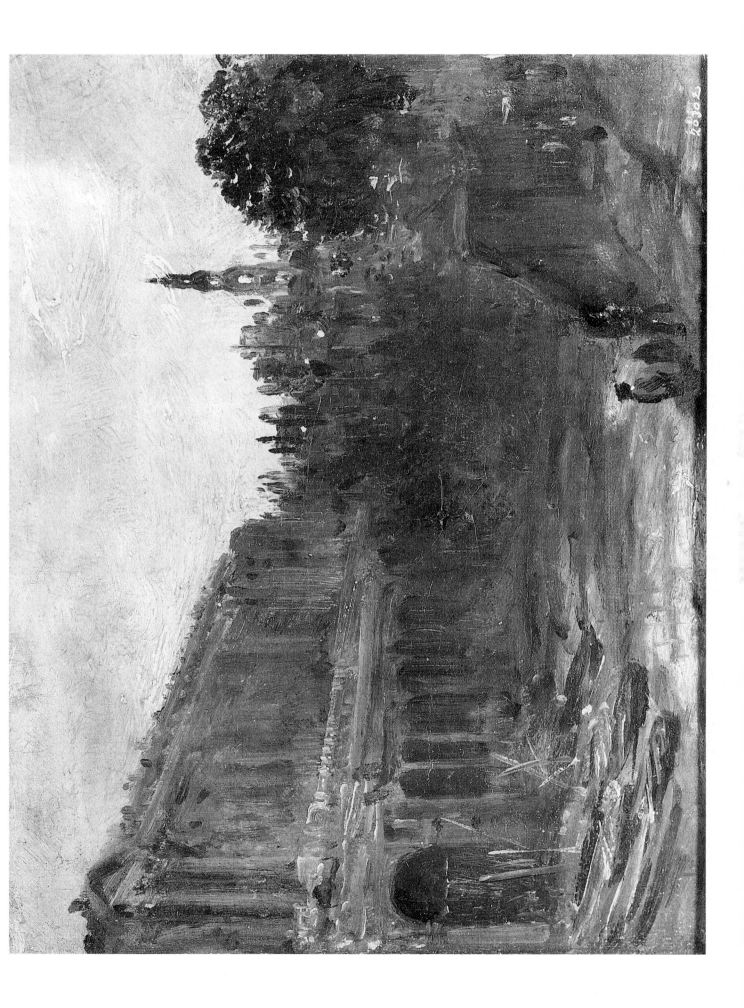

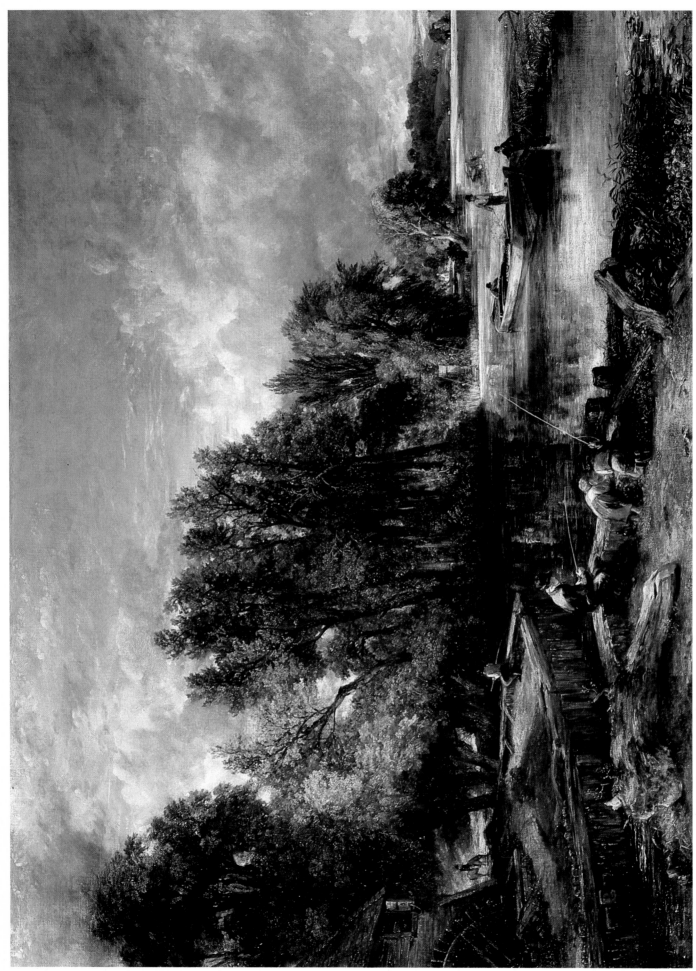

129. (20.1) *Stratford Mill*, Private collection, 127 × 182·9cm.

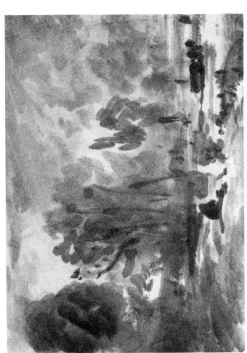

131. (above) (20.3) *Sketch for 'Stratford Mill'*, Private collection, 30·5 × 42cm.

132. (left) (20.4) *Sketch of 'Stratford Mill'*, Private collection, 6·5 × 9·1cm.

133. (right) (20.5) *Stratford Mill*, Private collection, 10·1 × 14cm.

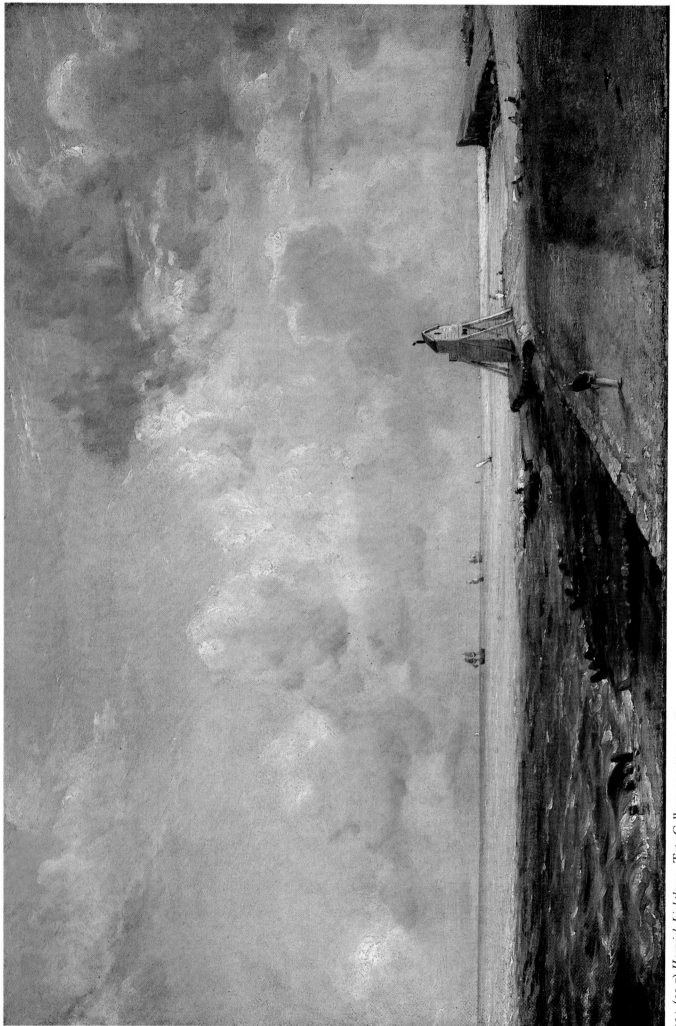

134. (20.7) *Harwich Lighthouse*, Tate Gallery, 32·7 × 50·2cm.

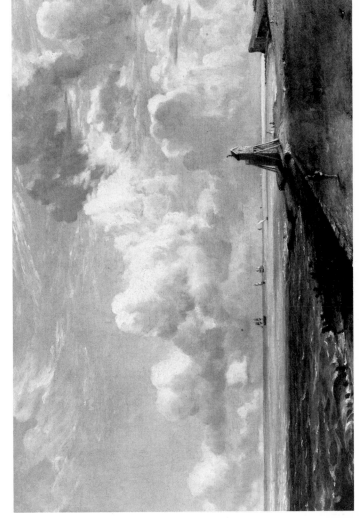

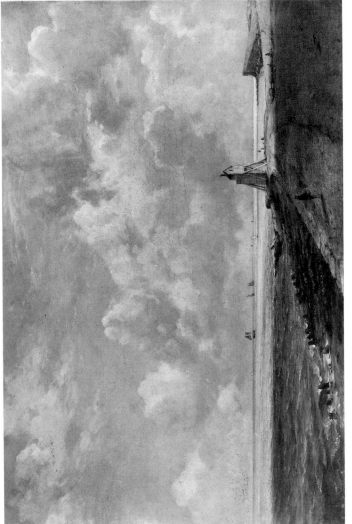

135. (left) (20.8)
Harwich Lighthouse,
Private collection, on
loan to City Museums
and Art Gallery,
Birmingham,
33 × 50·8cm.

136. (right) (20.9)
Harwich Lighthouse,
Yale Center for British
Art, New Haven,
33 × 50·8cm.

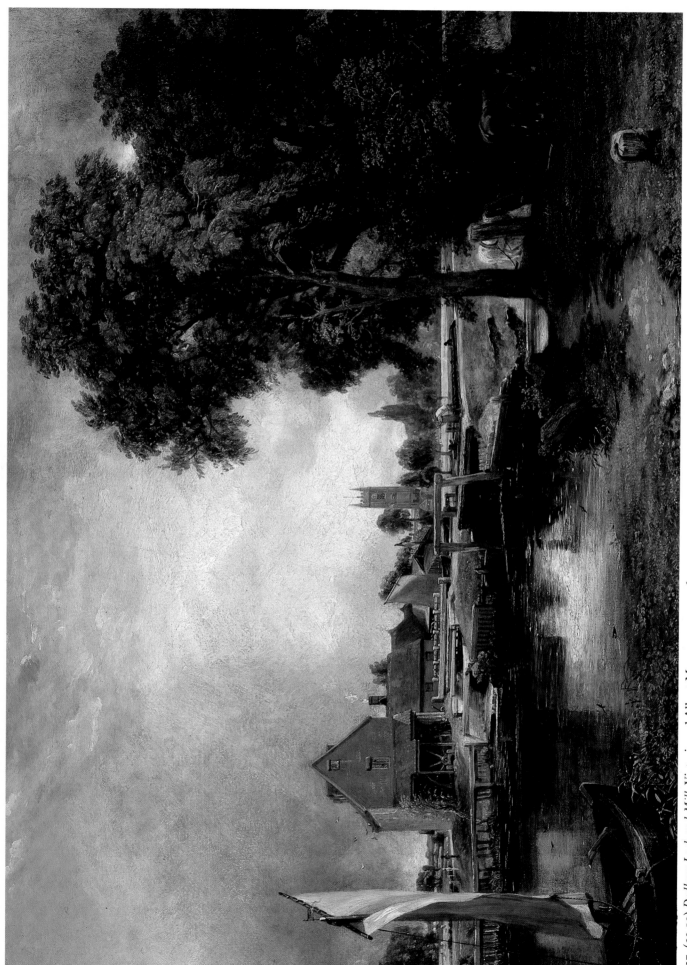

137. (20.10) *Dedham Lock and Mill*, Victoria and Albert Museum, 53·7 × 76·2cm.

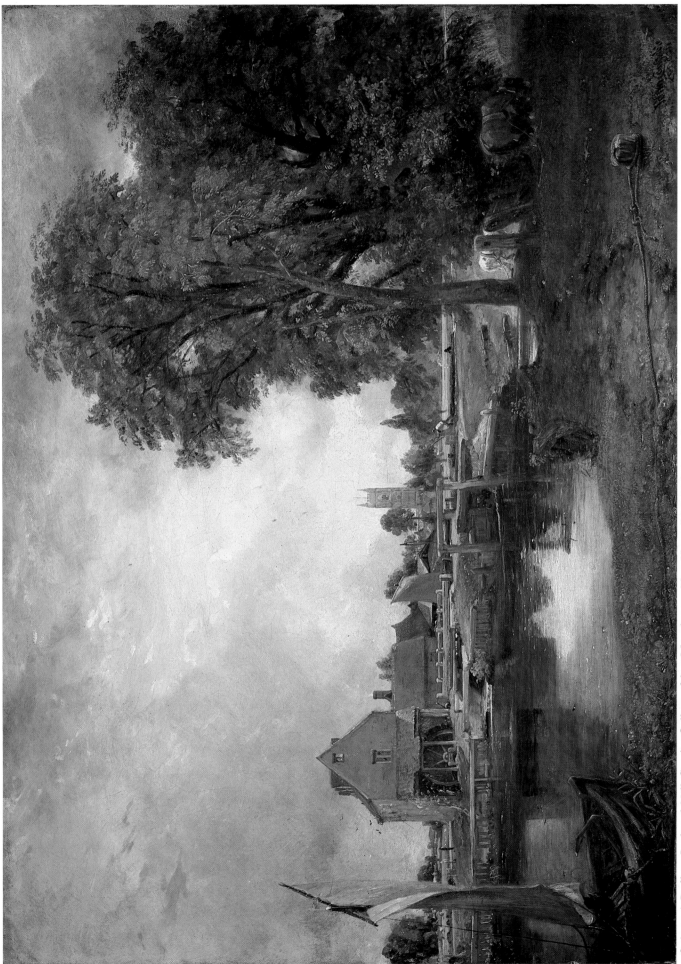

138. (20.11) *Dedham Lock and Mill*, Currier Gallery of Art, Manchester, New Hampshire, U.S.A., 54·6 × 77·5cm.

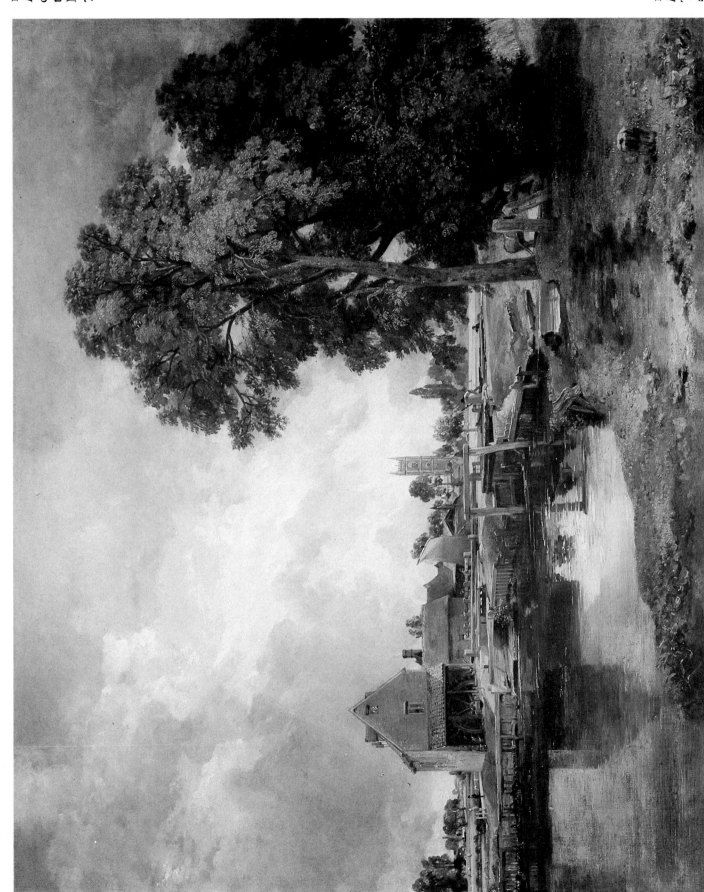

139. (20.12) *Dedham Lock and Mill*, Private collection, on loan to the Fitzwilliam Museum, Cambridge, 71 × 90·2cm.

140. (below) (20.13) *Dedham Lock and Mill*, Tate Gallery, 54·6 × 76·5cm.

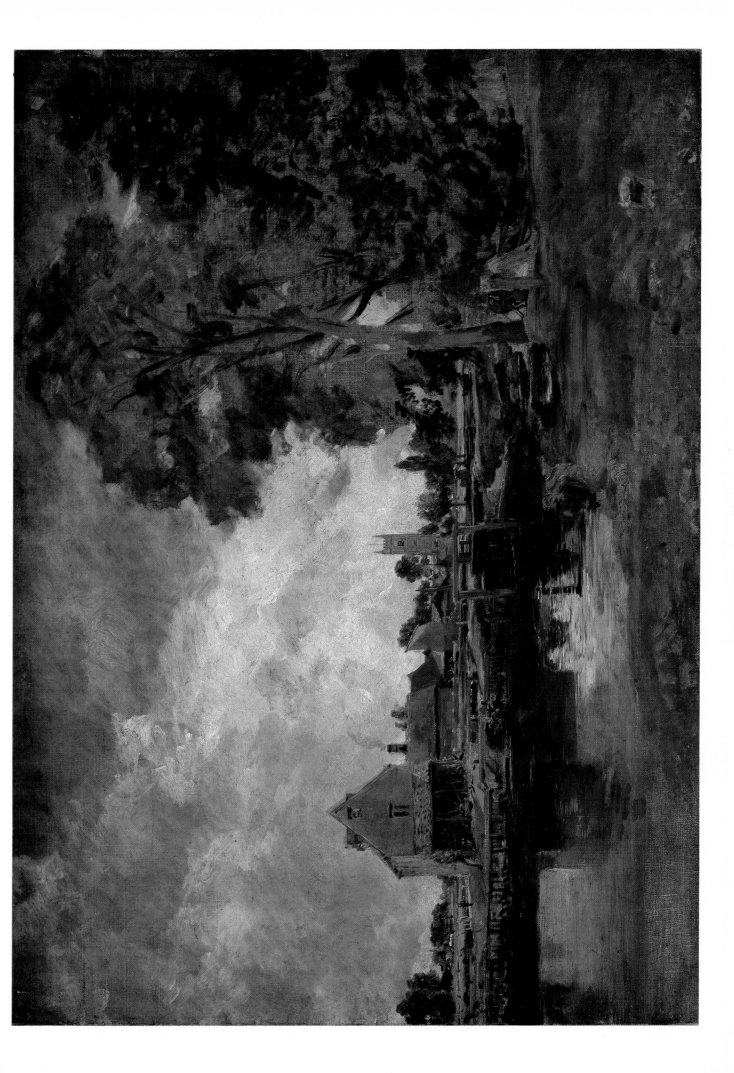

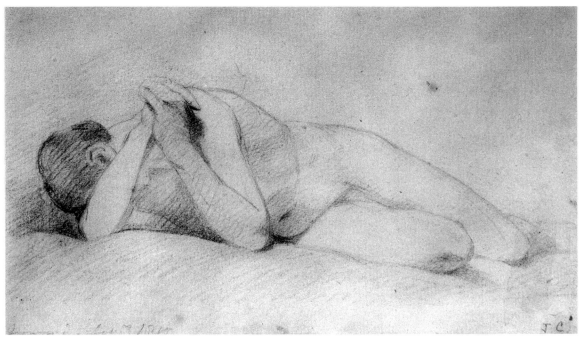

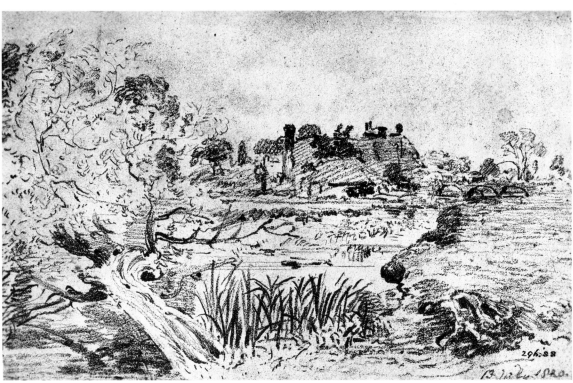

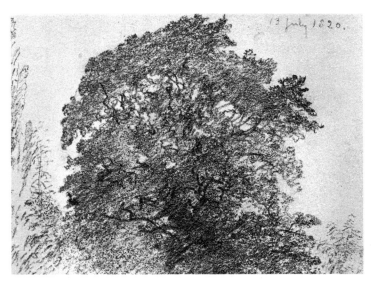

141. (above) (20.14)
*Female figure study,
lying*, Executors of the
late Lieutenant-
Colonel J. H.
Constable,
11 × 17·8cm.

142. (20.15) *Milford
Bridge and farm
buildings*, Victoria and
Albert Museum,
11·5 × 18cm.

143. (20.16) *A tree in
full leaf*, Thos. Agnew
& Sons Ltd,
8·5 × 11·4cm.

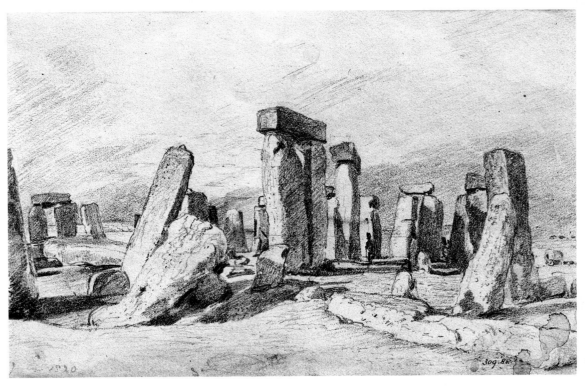

144. (above) (20.17)
Stonehenge, Victoria
and Albert Museum,
11·5 × 18·7cm.

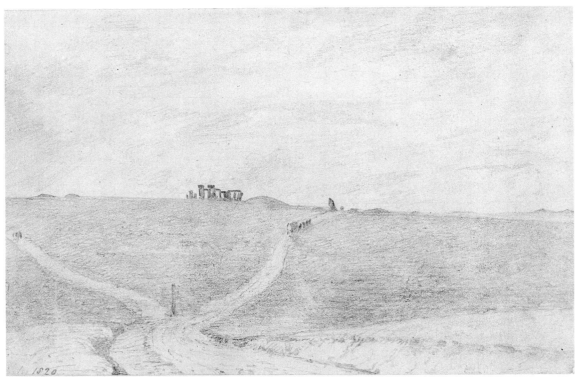

145. (20·18) *Distant
view of Stonehenge*,
Private collection,
11·5 × 18cm.

146. (20.19) *Distant
view of Stonehenge*,
Private collection,
7·5 × 11·4cm.

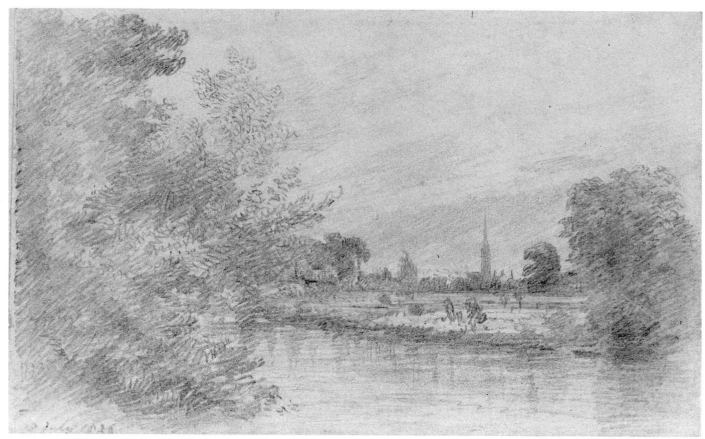

147. (20.20) *Salisbury Cathedral from the river*, Private collection, 11·4 × 18·4cm.

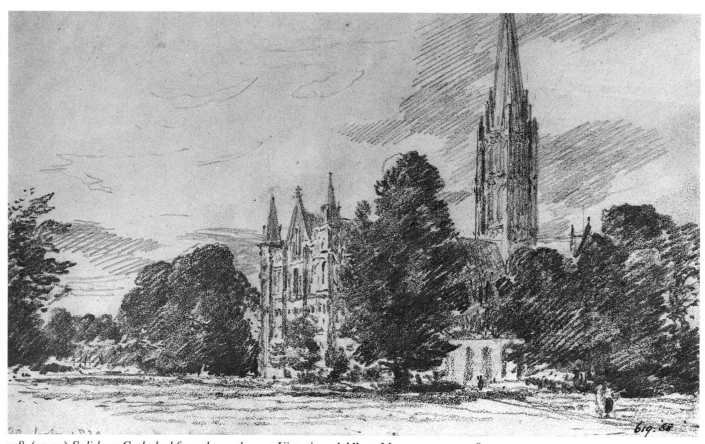

148. (20.21) *Salisbury Cathedral from the south-west*, Victoria and Albert Museum, 11·5 × 18·4cm.

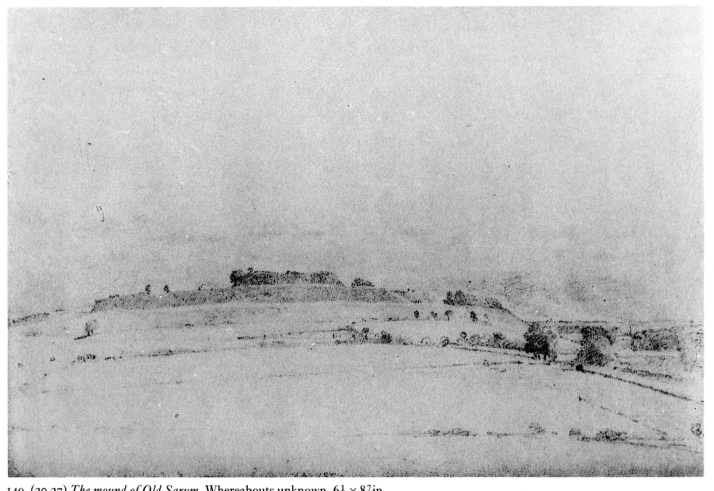

149. (20.27) *The mound of Old Sarum*, Whereabouts unknown, $6\frac{1}{8} \times 8\frac{7}{8}$in.

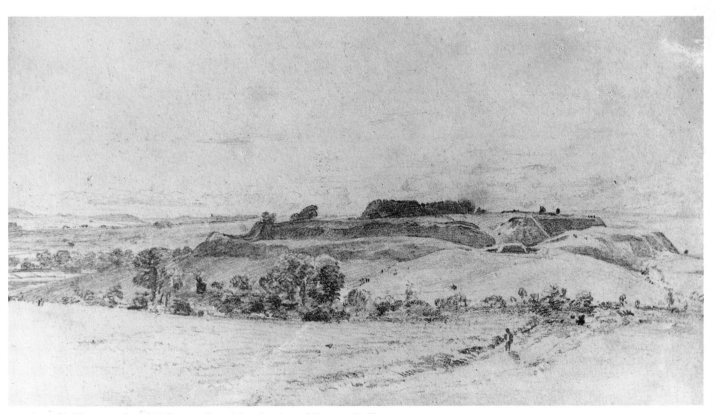

150. (20.28) *The mound of Old Sarum*, Royal Institution of Cornwall, Truro, 15·4 × 23cm.

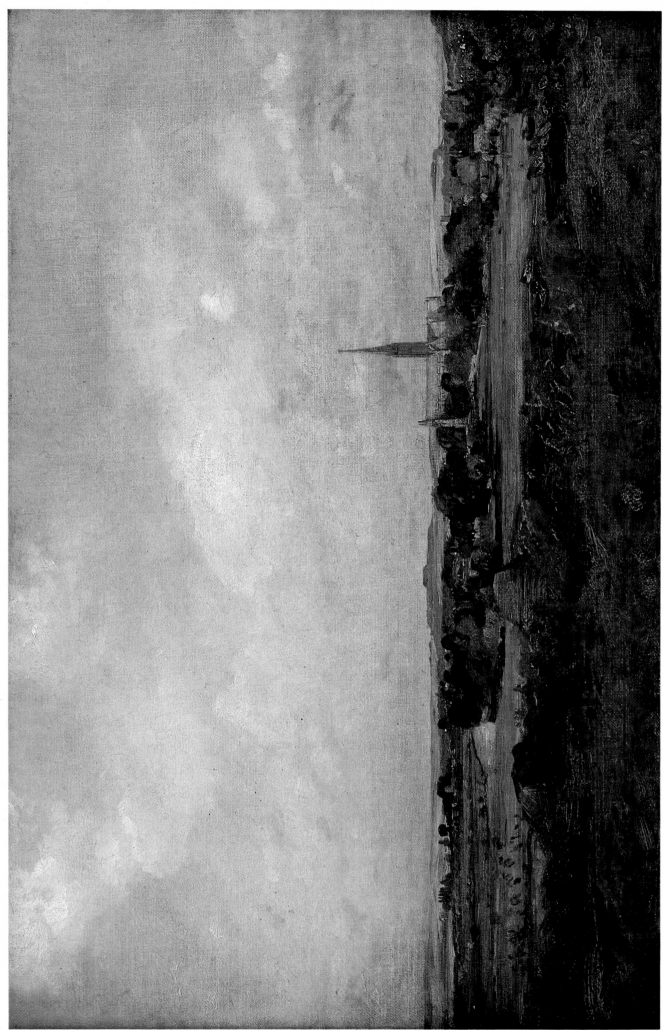

151. (20.24) *A view of Salisbury from the south*, Musée du Louvre, 35·5 × 51·1cm.

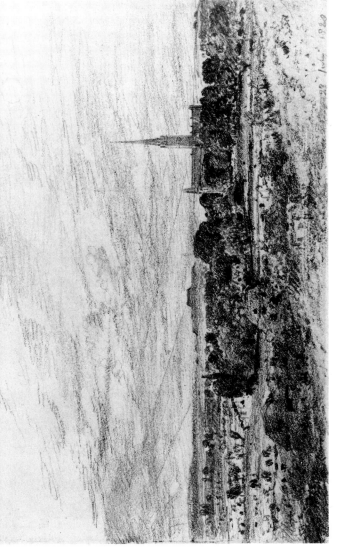

152. (right) (20.23) *A view of Salisbury from the south*, Victoria and Albert Museum, 11·5 × 18·5cm.

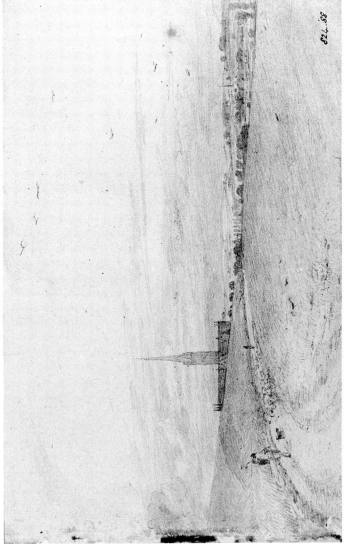

153. (left) (20.25) *Distant view of Salisbury from the north*, Victoria and Albert Museum, 11·5 × 18·5cm.

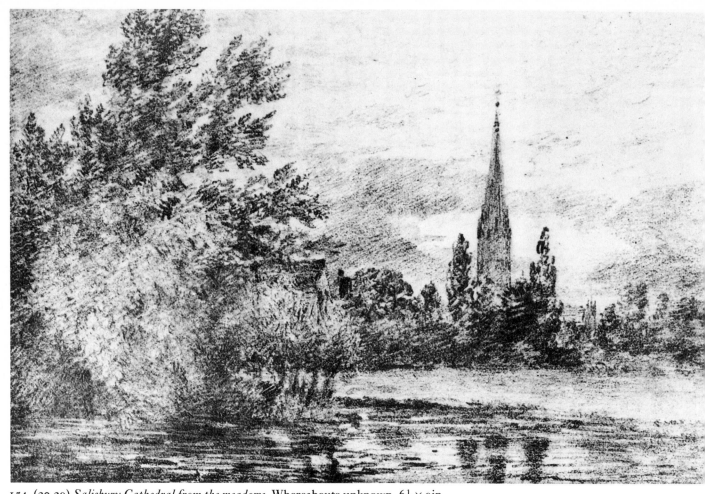

154. (20.29) *Salisbury Cathedral from the meadows*, Whereabouts unknown, $6\frac{1}{2} \times 9$in.

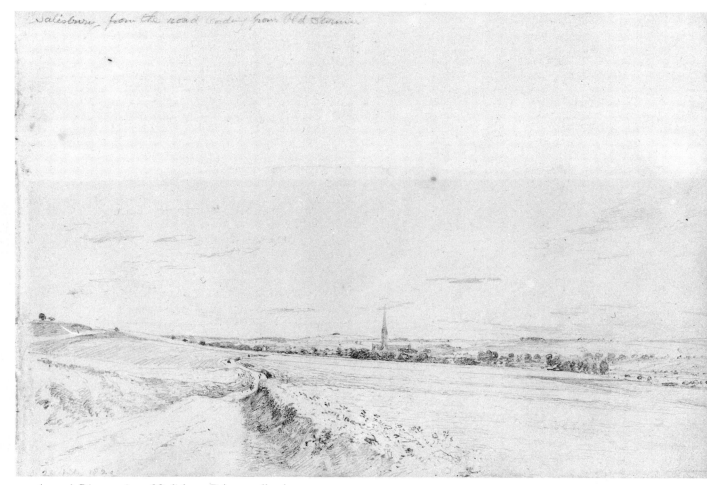

155. (20.30) *Distant view of Salisbury*, Private collection, 15·5 × 24cm.

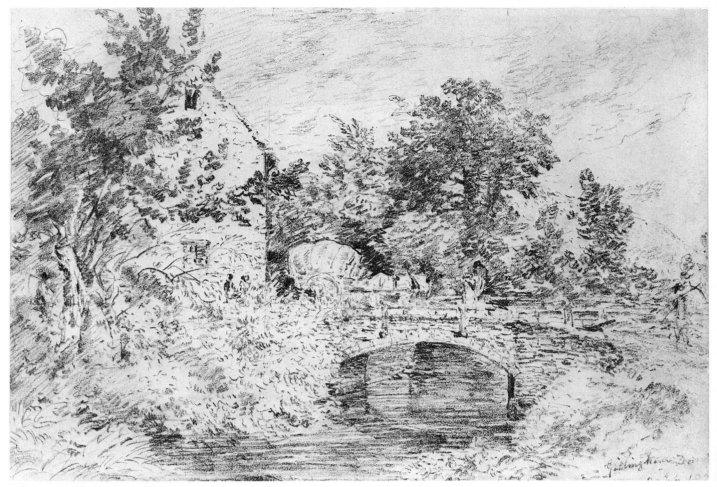

156. (20.31) *The bridge at Gillingham, with a cart*, British Museum, 15·6 × 22·9cm.

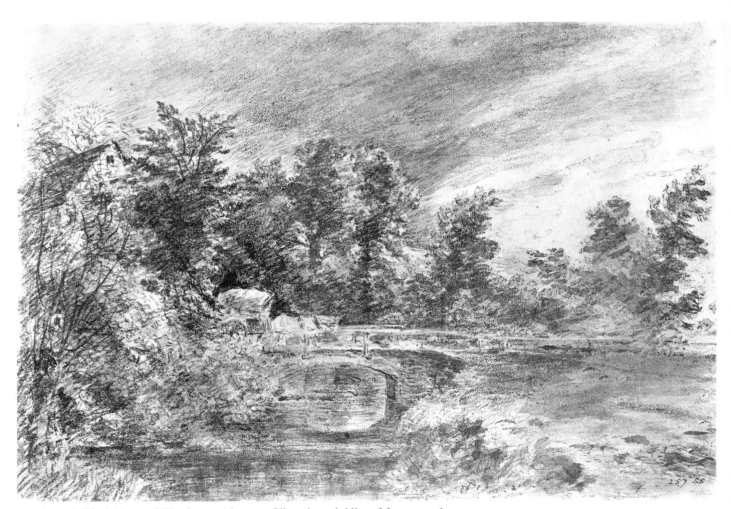

157. (20.32) *The bridge at Gillingham, with a cart*, Victoria and Albert Museum, 16·1 × 23·7cm.

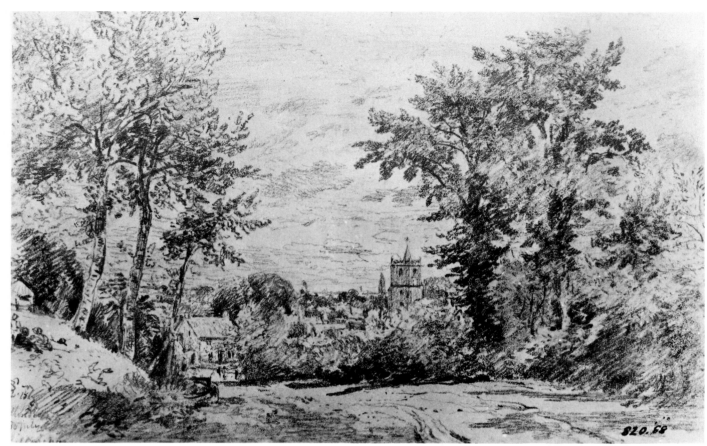

158. (20.33) *The entrance to Gillingham, with the church in the background*, Victoria and Albert Museum, 11·5 × 18·5cm.

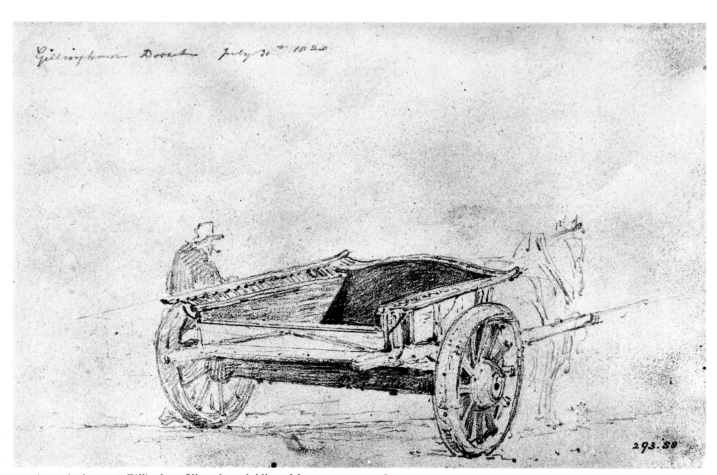

159. (20.34) *A cart at Gillingham*, Victoria and Albert Museum, 11·5 × 18·5cm.

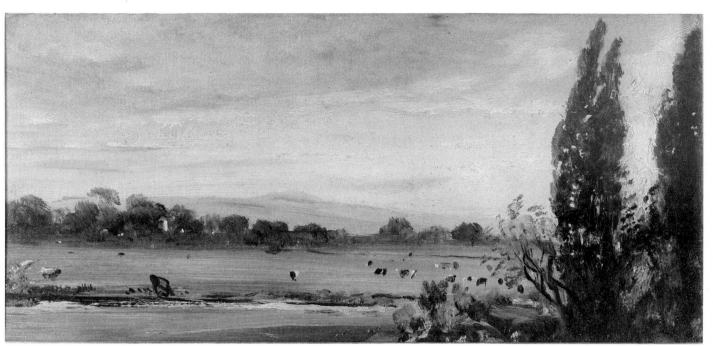

160. (20.36) *A view of Harnham Church*, Private collection, 10·8 × 24·1cm.

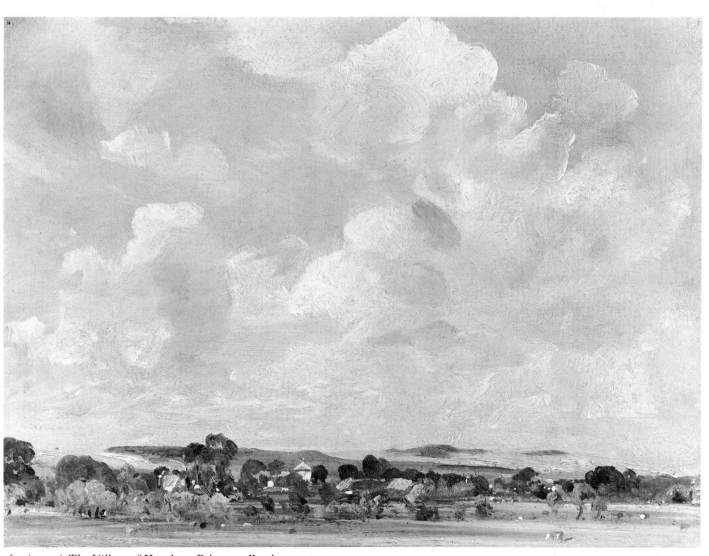

161. (20.37) *The Village of Harnham*, Private collection, 17·5 × 23·5cm.

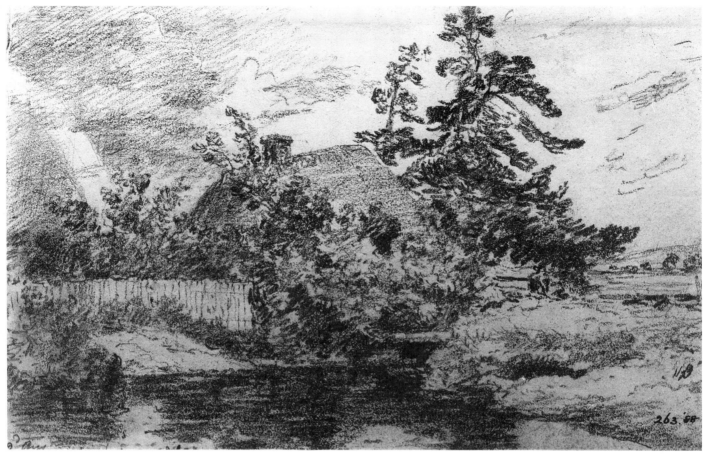

162. (20.38) *A pond and cottage at Salisbury*, Victoria and Albert Museum, 11·5 × 18·6cm.

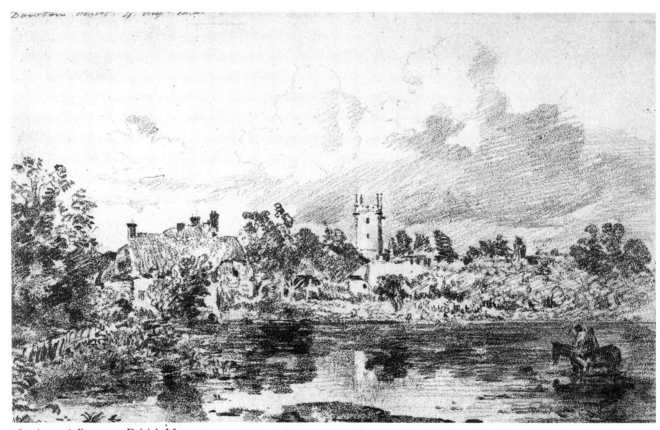

163. (20.40) *Downton*, British Museum, 11·2 × 17·4cm.

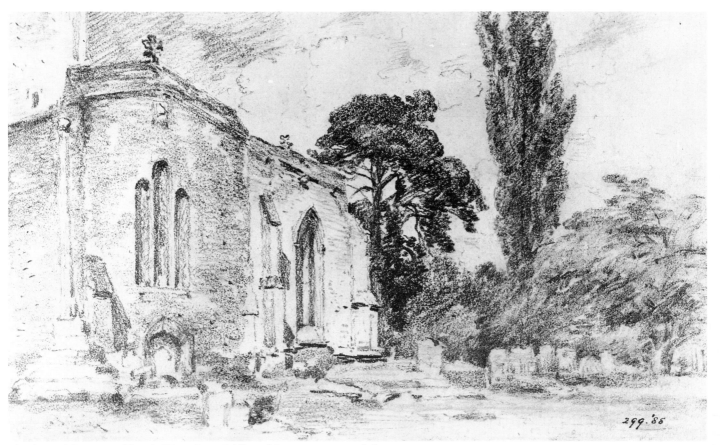

164. (20.41) *Downton Church*, Victoria and Albert Museum, 11·5 × 18·6cm.

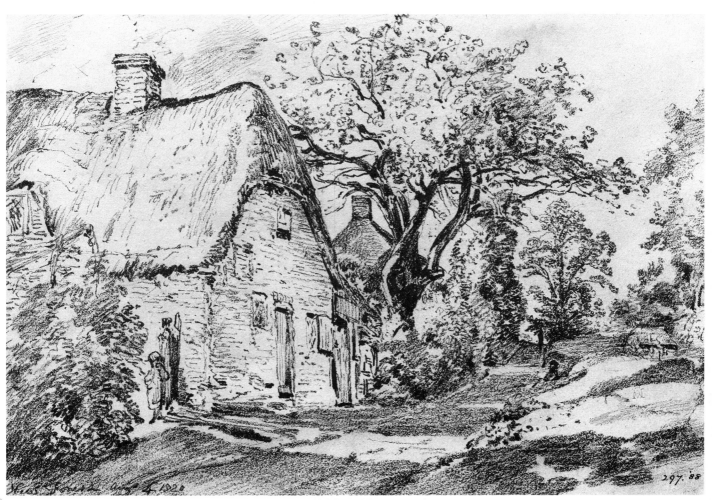

165. (20.42) *Cottages and trees in the New Forest*, Victoria and Albert Museum, 16·1 × 23·7cm.

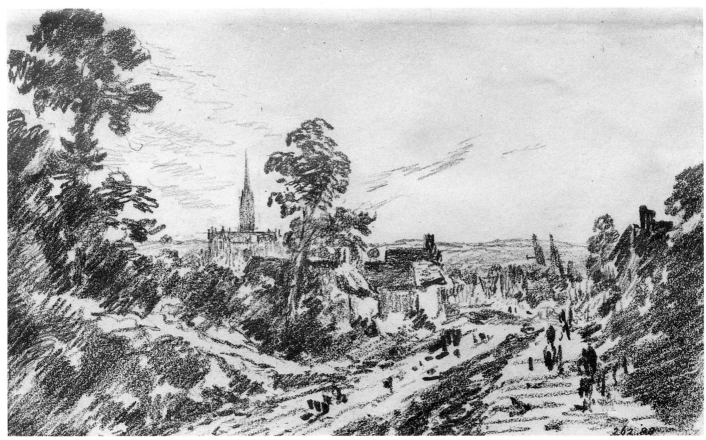

166. (20.44) *A road leading into Salisbury*, Victoria and Albert Museum, 11·5 × 18·5cm.

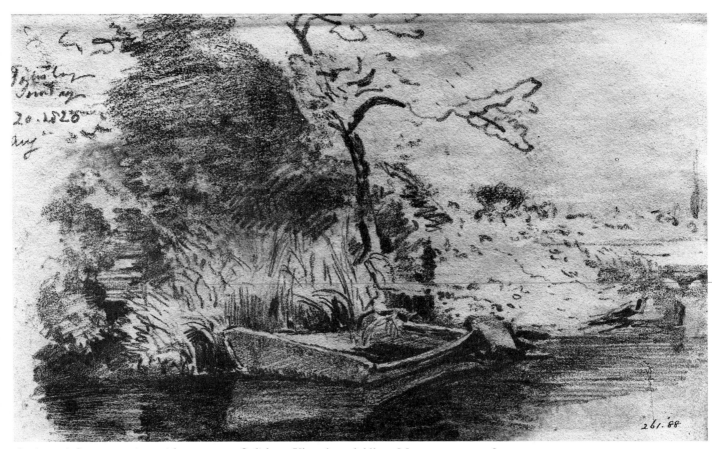

167. (20.45) *Scene on a river with a punt near Salisbury*, Victoria and Albert Museum, 11·5 × 18·5cm.

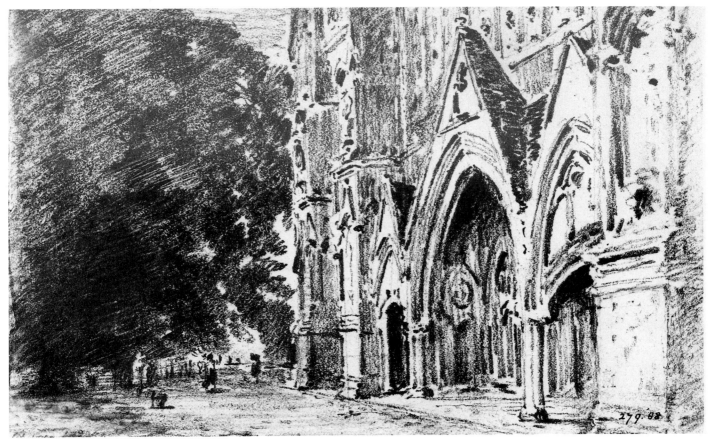

168. (20.46) *Salisbury Cathedral: the west door*, Victoria and Albert Museum, 11·5 × 18·5cm.

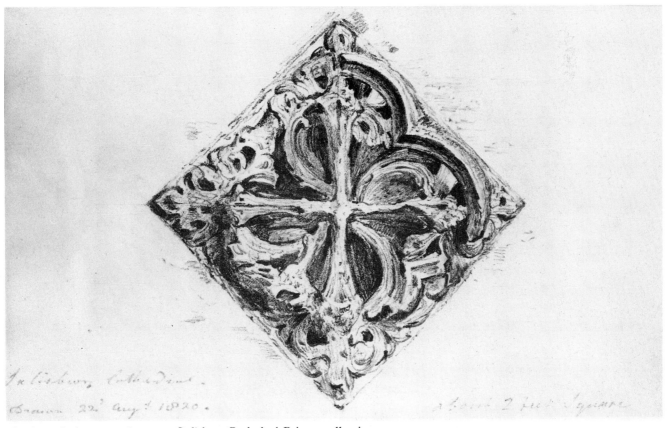

169. (20.47) *A consecration cross, Salisbury Cathedral*, Private collection, 11 × 17·5cm.

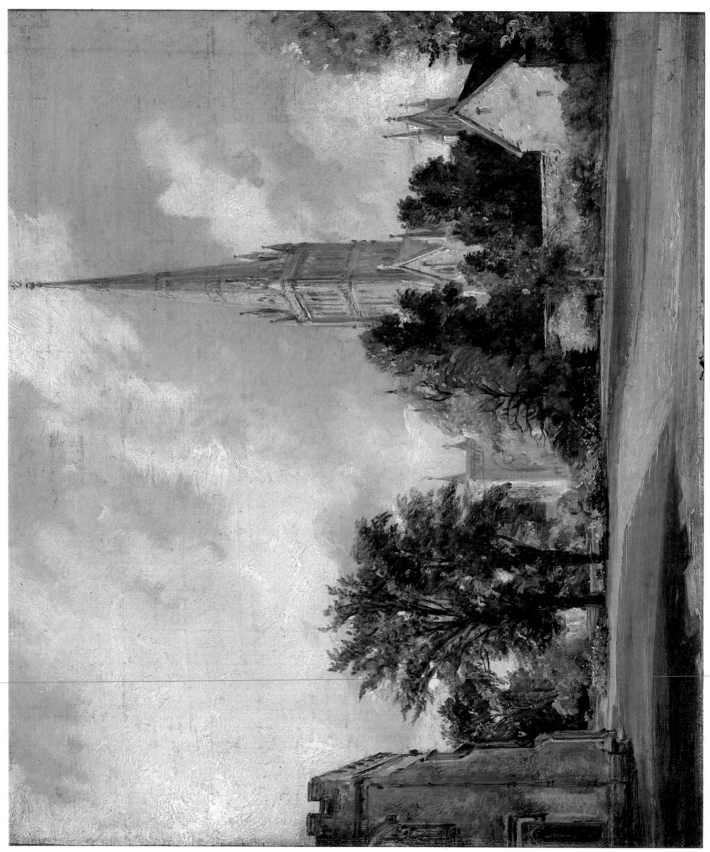

170. (20.48) *Salisbury Cathedral from the Close*, Victoria and Albert Museum, 25·1 × 30·2cm.

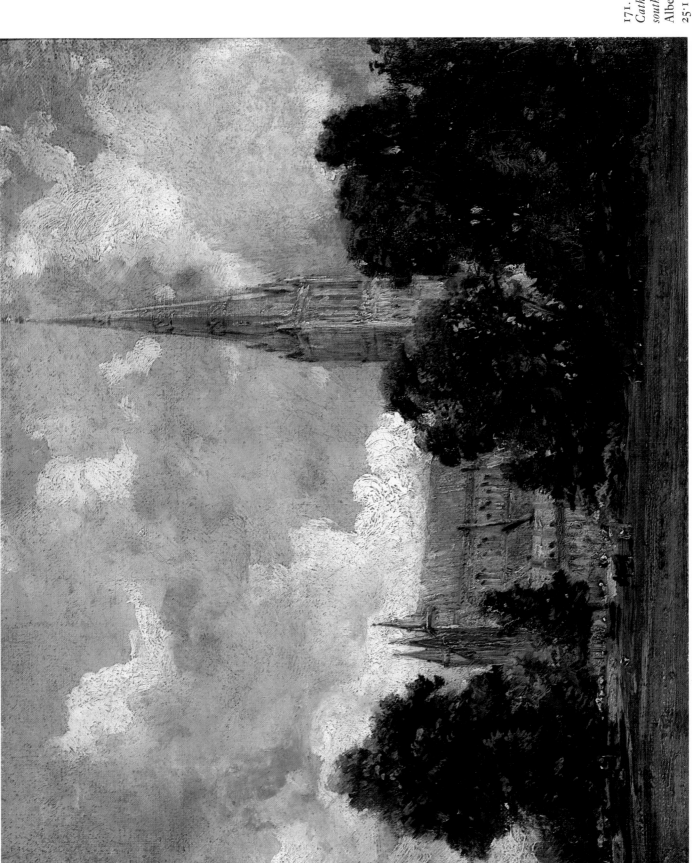

171. (20.49) *Salisbury Cathedral from the south-west*, Victoria and Albert Museum, 25·1 × 30·2cm.

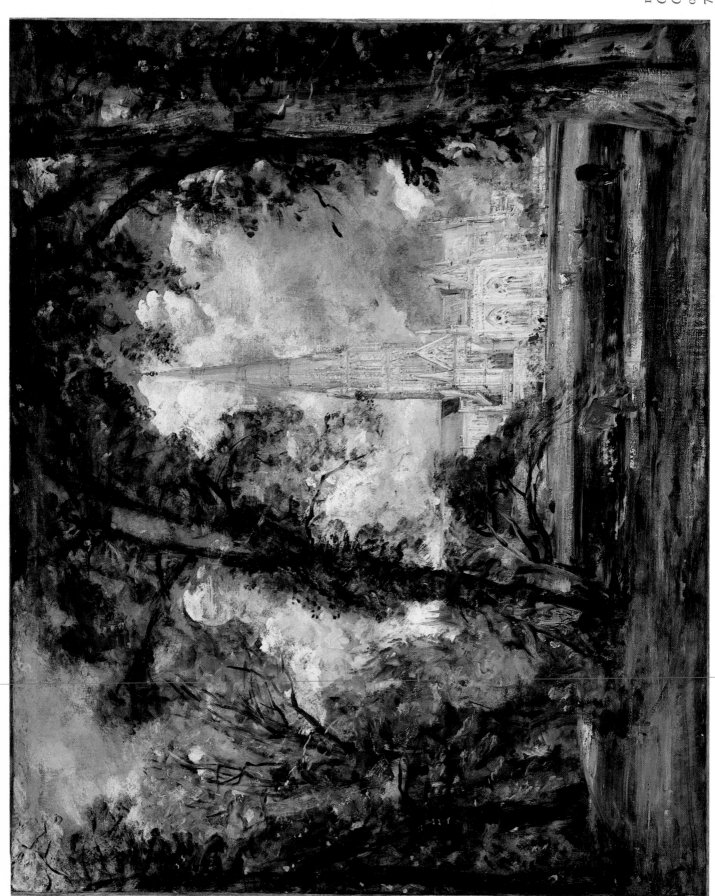

172. (20.50) *Salisbury Cathedral from the Bishop's Grounds*, National Gallery of Canada, Ottawa, 74·3 × 92·4cm.

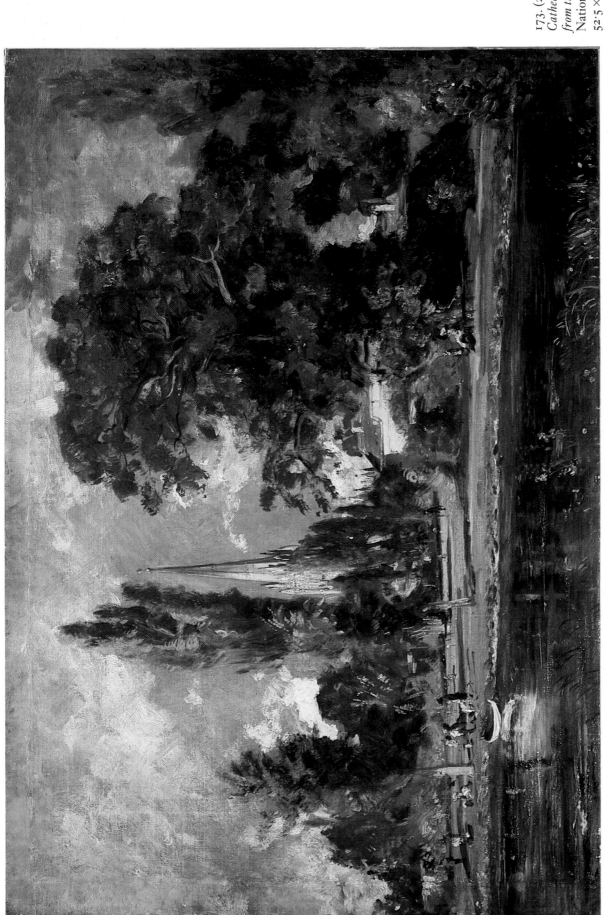

173. (20.51) *Salisbury Cathedral and Leydenhall from the River Avon*, National Gallery, London, 52·5 × 77cm.

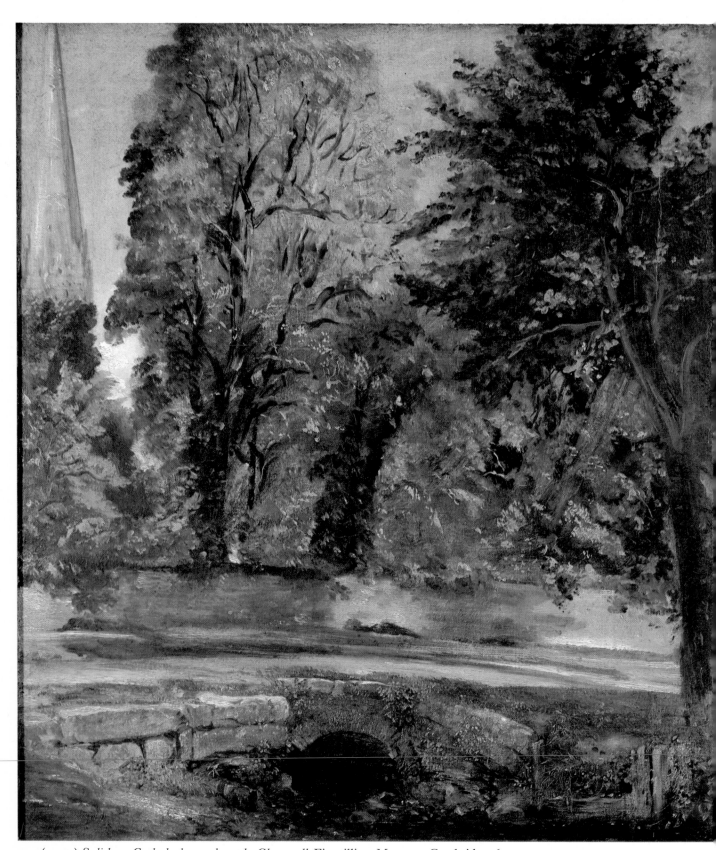

174. (20.52) *Salisbury Cathedral seen above the Close wall*, Fitzwilliam Museum, Cambridge, 60·3 × 51·4cm.

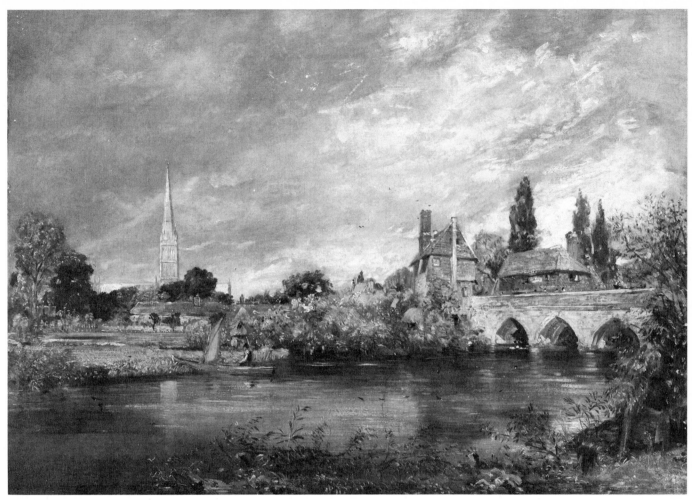

175. (20.54) *Harnham Bridge*, The Wernher Collection, Luton Hoo, 56 × 77·5cm.

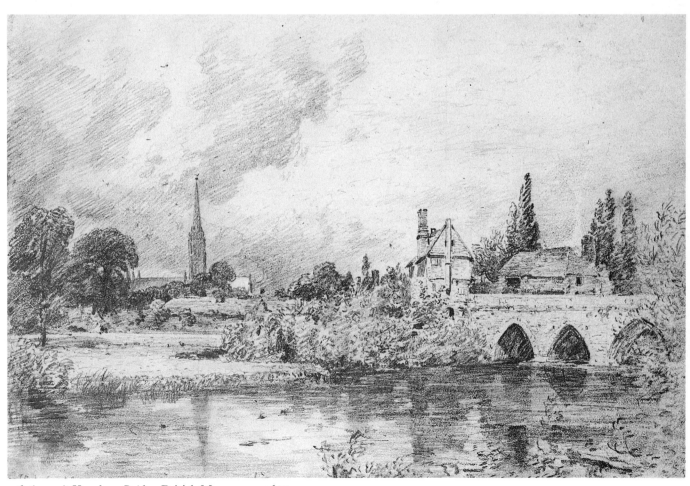

176. (20.55) *Harnham Bridge*, British Museum, 15·6 × 23cm.

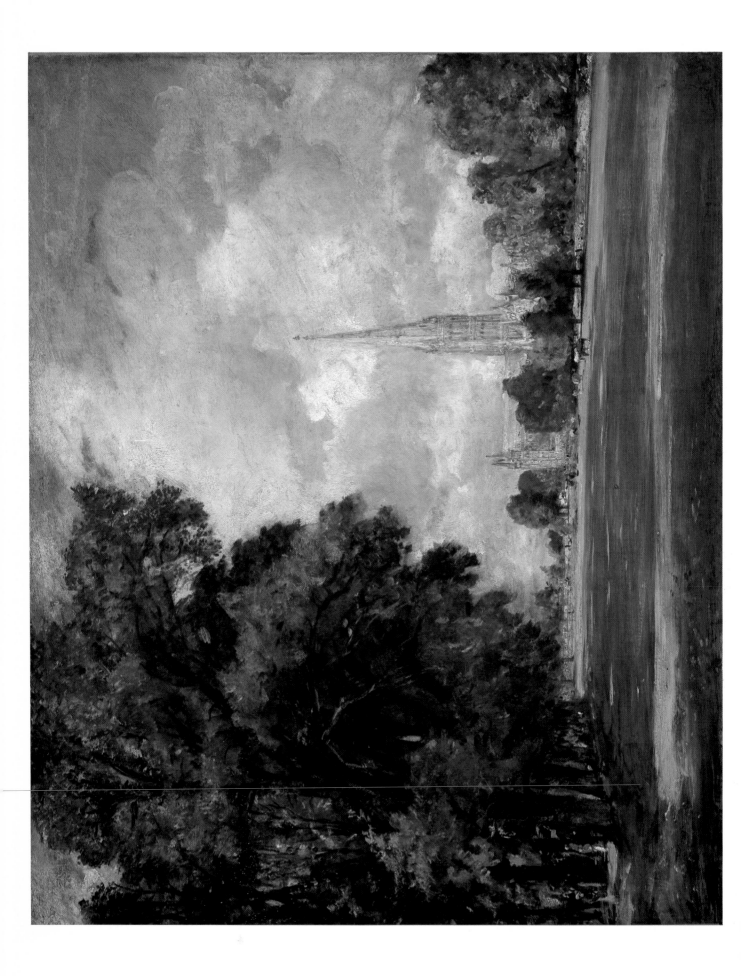

177. (above) (20.53) *Salisbury Cathedral from the South-west*, National Gallery of Art, Washington, D.C., 73 × 91cm.

178. (right) (20.57) *St Martin's Church, Salisbury*, Private collection, 11·2 × 18·4cm.

179. (left) (20.59) *Milford Bridge*, Executors of the late Lieutenant-Colonel J. H. Constable, 11·5 × 17·8cm.

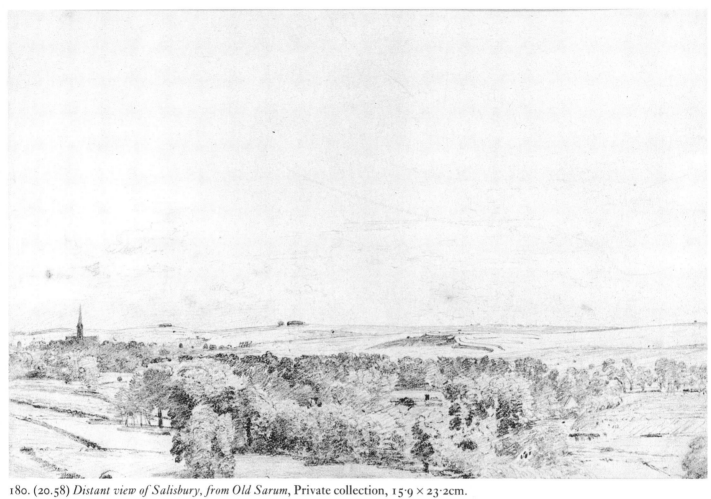

180. (20.58) *Distant view of Salisbury, from Old Sarum*, Private collection, 15·9 × 23·2cm.

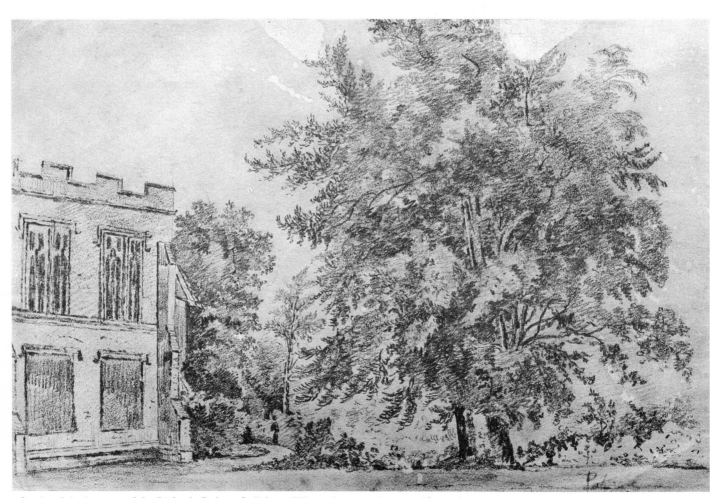

181. (20.60) *A corner of the Bishop's Palace, Salisbury*, Whereabouts unknown, 6¾ × 10in.

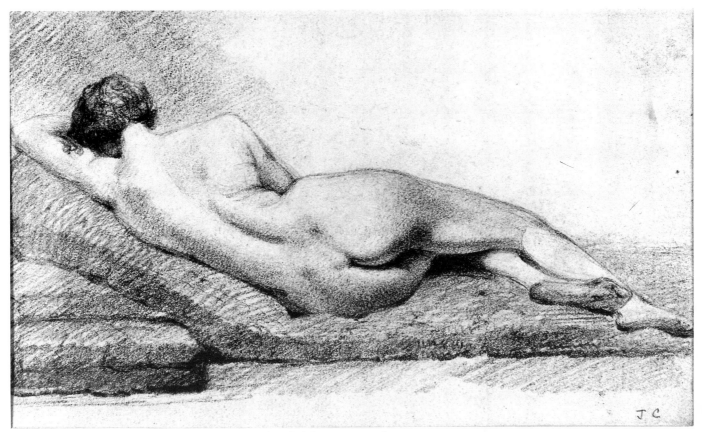

182. (20.64) *Female figure study, lying,* The Minories, Colchester, 11 × 18·2cm.

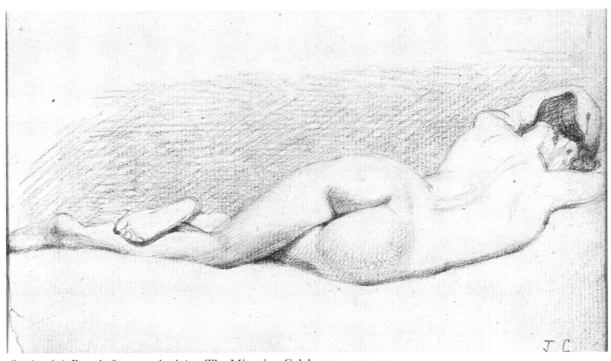

183. (20.65) *Female figure study, lying,* The Minories, Colchester, 9 × 15·9cm.

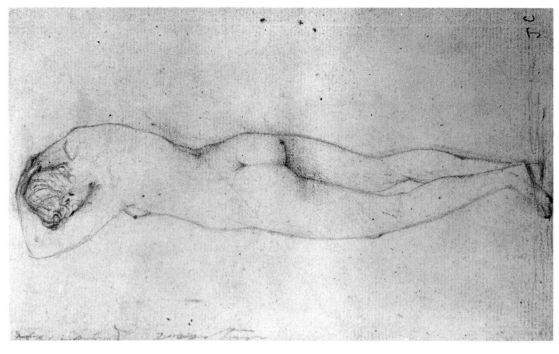

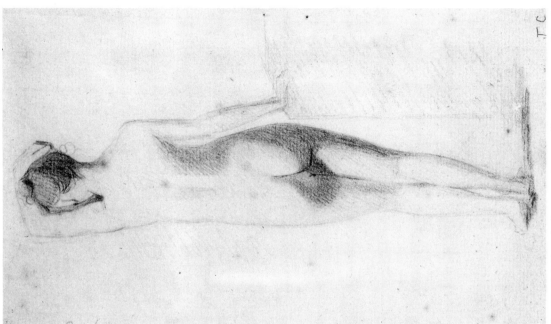

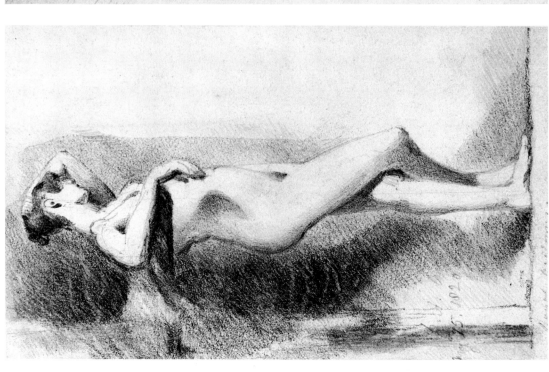

184. (20.61) *Female figure study*, The Minories, Colchester, 17·7 × 11·1cm.

185. (20.62) *Female figure study, standing*, Executors of the late Lieutenant-Colonel J. H. Constable, 17·8 × 11cm.

186. (20.63) *Female figure study, standing*, The Minories, Colchester, 17·6 × 11cm.

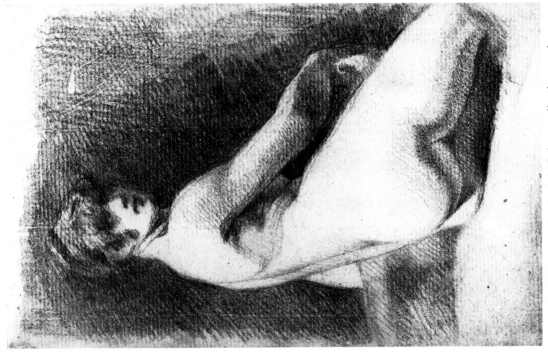
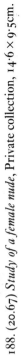

188. (20.67) *Study of a female nude*, Private collection, 14·6 × 9·5cm.

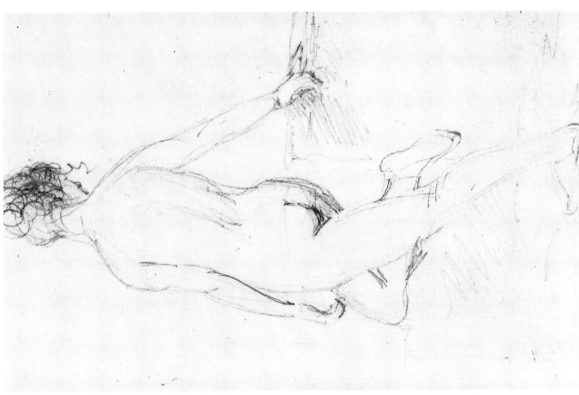

187. (20.66) *Female figure study, standing*, Private collection, 15·5 × 10·3cm.

189. (above) (20.68) *Trees and wattle hurdles at Hampstead*, Victoria and Albert Museum, 11·5 × 18·5cm.

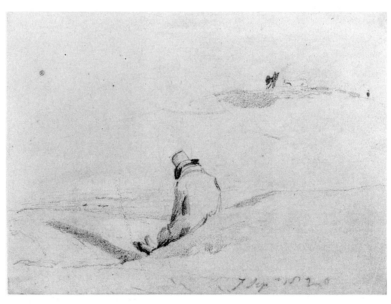

190. (right) (20.69) *A man reclining on a bank*, Yale Center for British Art, New Haven, 9·1 × 12·4cm.

191. (left) (20.75) *A landscape with buildings and a tower seen over water*, Private collection, 8·8 × 11·3cm.

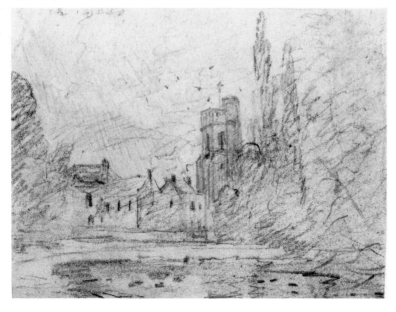

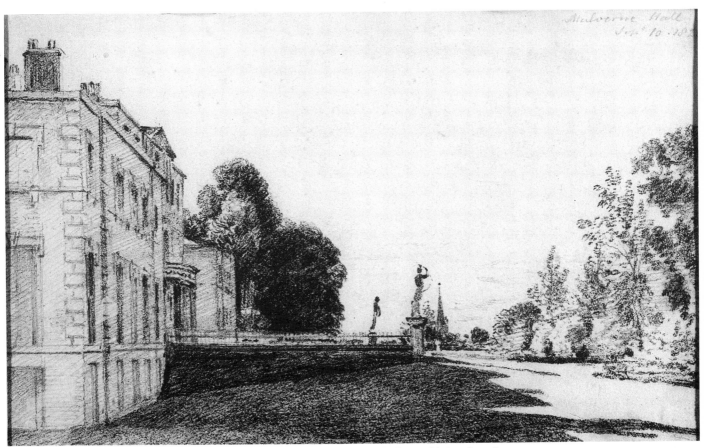

192. (20.70) *Malvern Hall*, Executors of the late Lieutenant-Colonel J. H. Constable, 11·8 × 18·4cm.

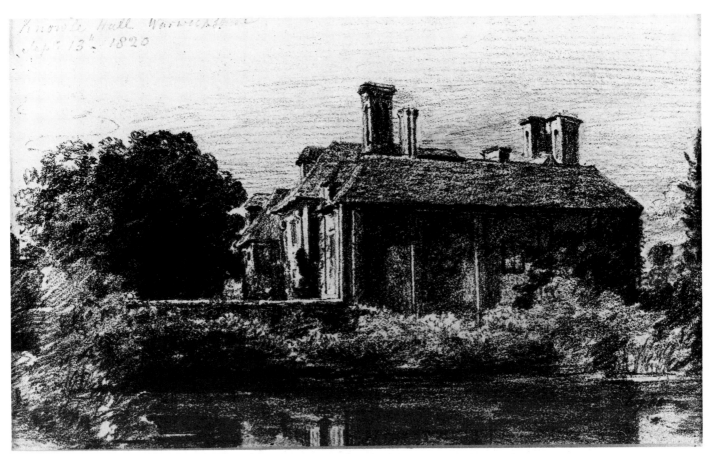

193. (20.72) *Knowle Hall*, Victoria and Albert Museum, 11·5 × 18·4cm.

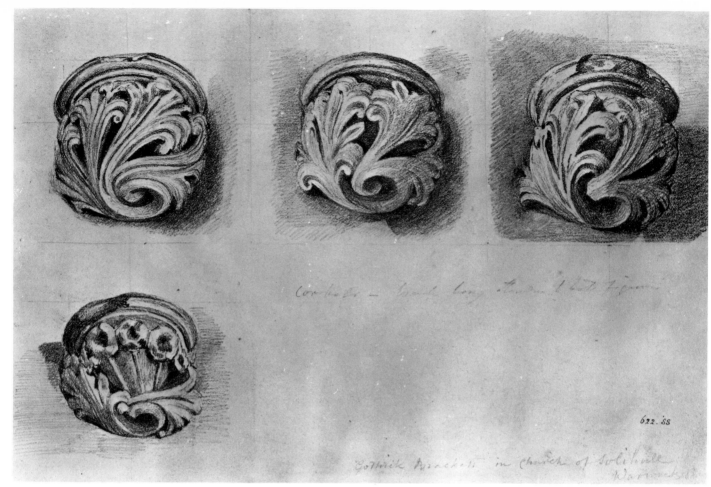

194. (20.73) *Corbels in Solihull Church*, Victoria and Albert Museum, 15·8 × 23·3cm.

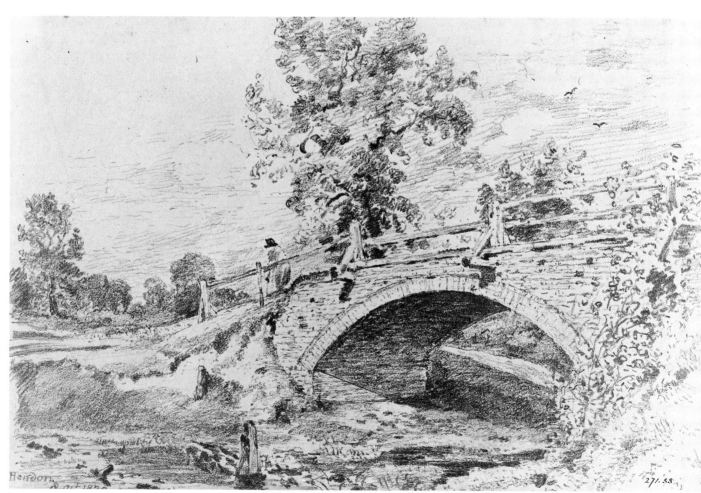

195. (20.76) *The bridge at Hendon*, Victoria and Albert Museum, 16 × 23·5cm.

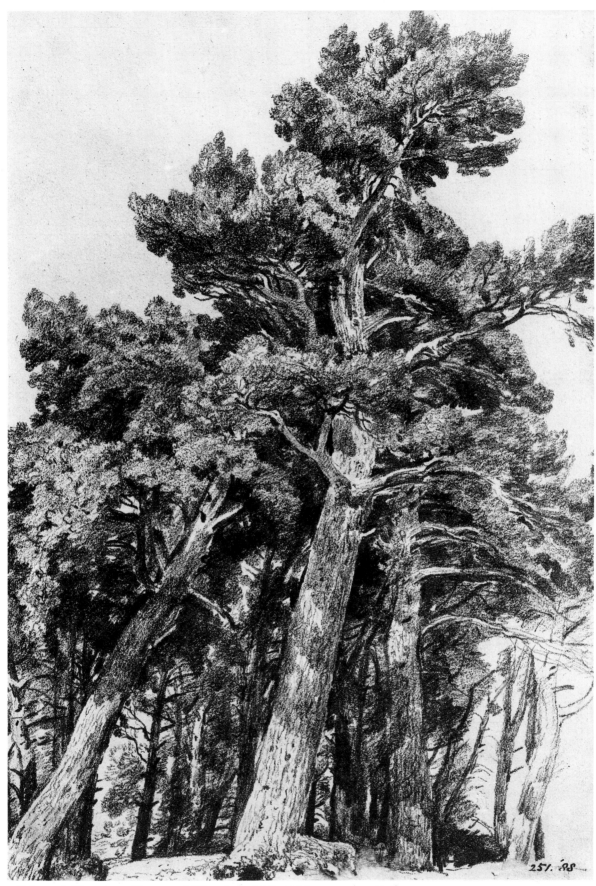

196. (20.74) *Fir trees at Hampstead*, Victoria and Albert Museum, 23·3 × 16cm.

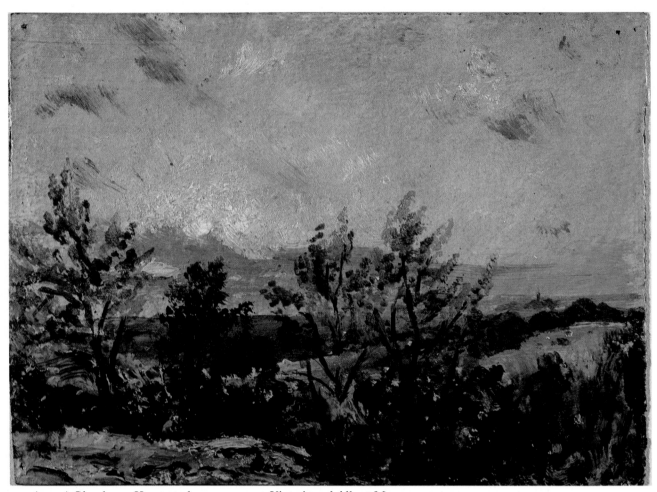

197. (20.77) *Sketches at Hampstead: stormy sunset*, Victoria and Albert Museum, 12·7 × 17·1cm.

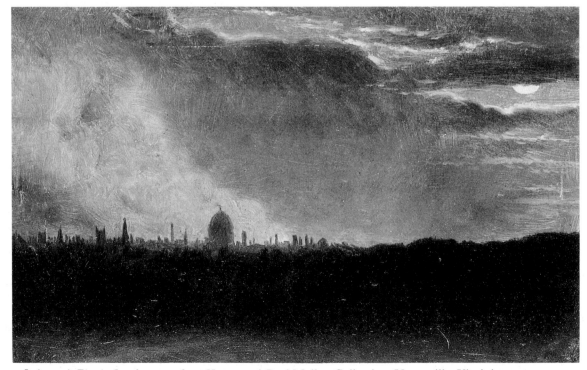

198. (20.79) *Fire in London, seen from Hampstead*, Paul Mellon Collection, Upperville, Virginia, 9·5 × 15·2cm.

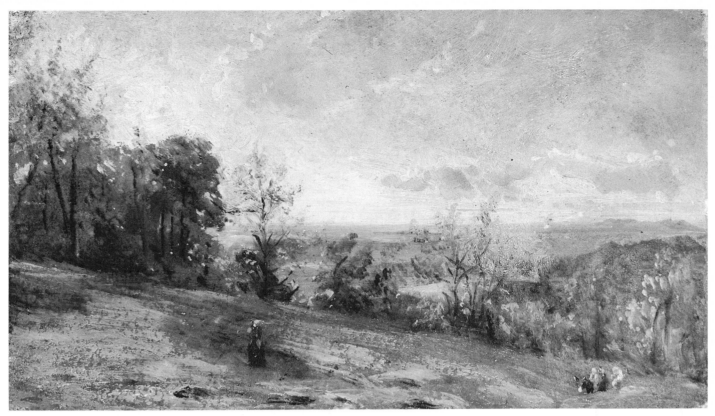

199. (20.81) *Hampstead Heath: evening*, Private collection, 14 × 24·5cm.

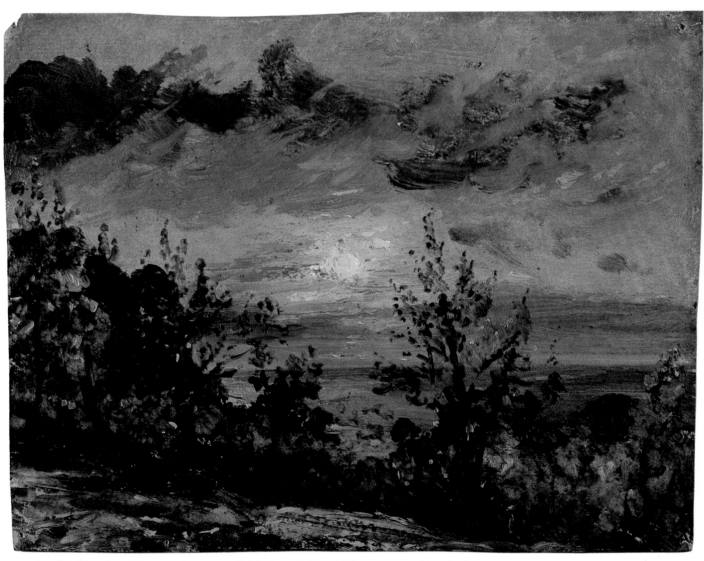

200. (20.82) *Sketch at Hampstead: evening*, Victoria and Albert Museum, 15·9 × 20·3cm.

202. (20.84) *Elm trees*, Private collection, 13·7 × 12·3cm.

201. (left) (20.83) *Elm trees*, Victoria and Albert Museum, 23·4 × 16cm.

203. (below left) (20.85) *Study of ash trees*, Victoria and Albert Museum, 32·8 × 23·8cm.

204. (below) (20.89) *A birch tree*, British Museum, 23·1 × 15·9cm.

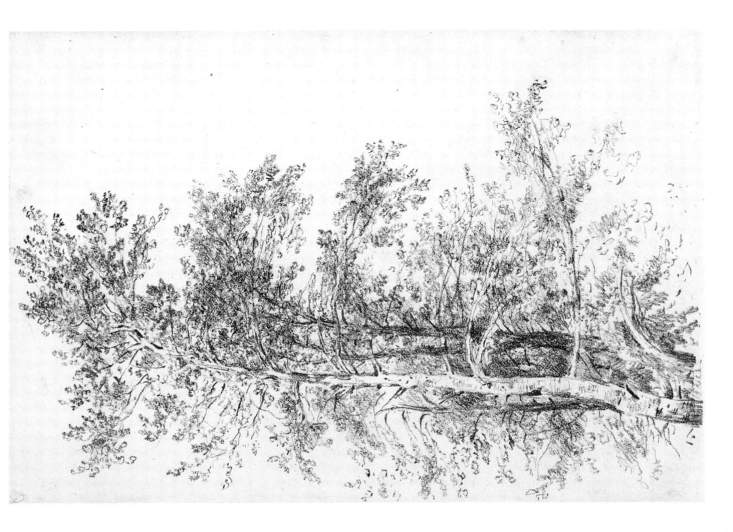

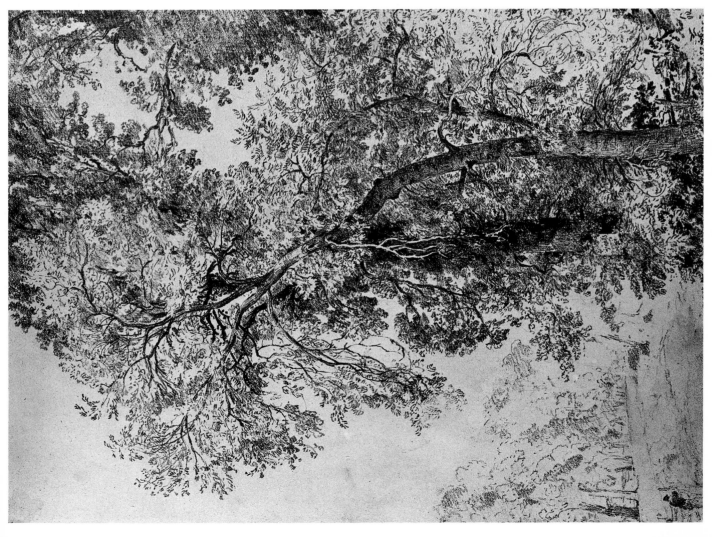

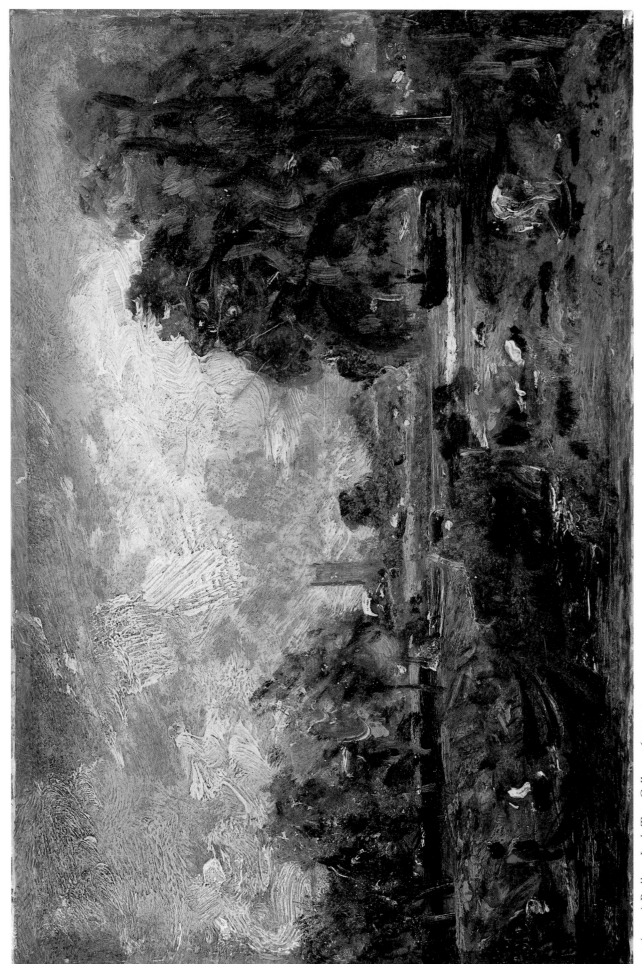

205. (20.90) *Dedham Lock*, Tate Gallery, 16·5 × 25·4cm.

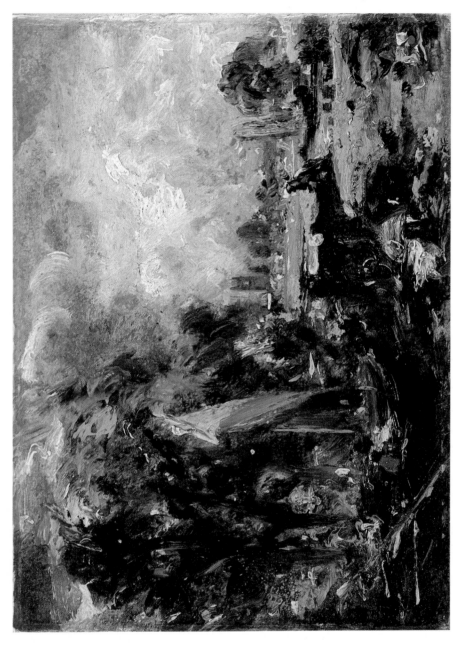

206. (20.91) *Dedham Lock*, Yale Center for British Art, New Haven, 11·5 × 16·5cm.

207. (far left) (20.87)
*Maria Constable with
two children and a
birdcage*, Private
collection, 8·4 × 7·6cm.

208. (left) (20.88) *A
child with a birdcage*,
Private collection,
8·4 × 7·6cm.

209. (right) (20.94) *A
bridge over a stream*,
Executors of the late
Lieutenant-Colonel
J. H. Constable,
15·9 × 25·9cm.

210. (20.86) *Maria Constable with two of her children*, Executors of the late Lieutenant-Colonel J. H. Constable, on loan to the Tate Gallery, 16·5 × 21·5cm.

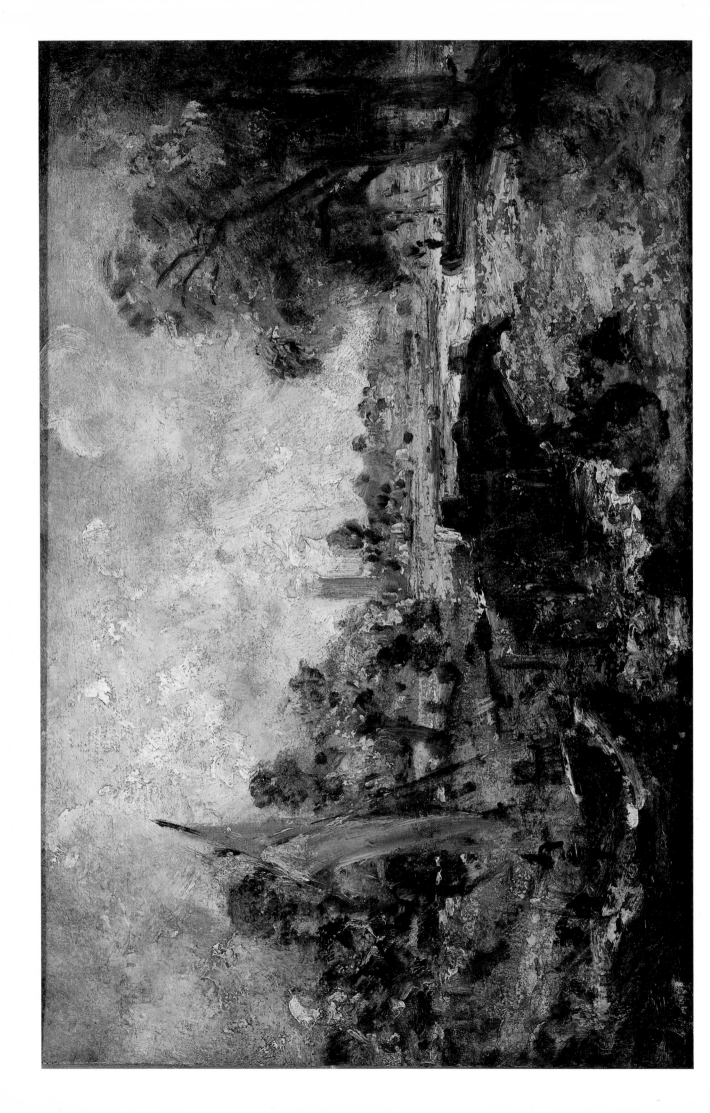

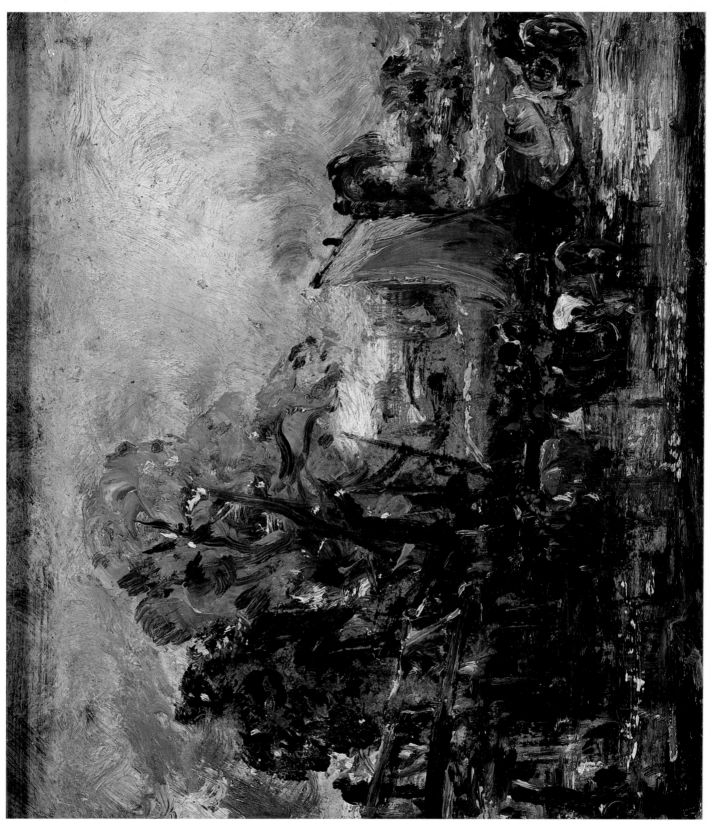

211. (above) (20.92)
Dedham Lock, Yale
Center for British Art,
New Haven,
33·7 × 49·8cm.

212. (20.93) *View on the
Stour*, National Gallery
of Scotland, Edinburgh,
20·3 × 23·5cm.

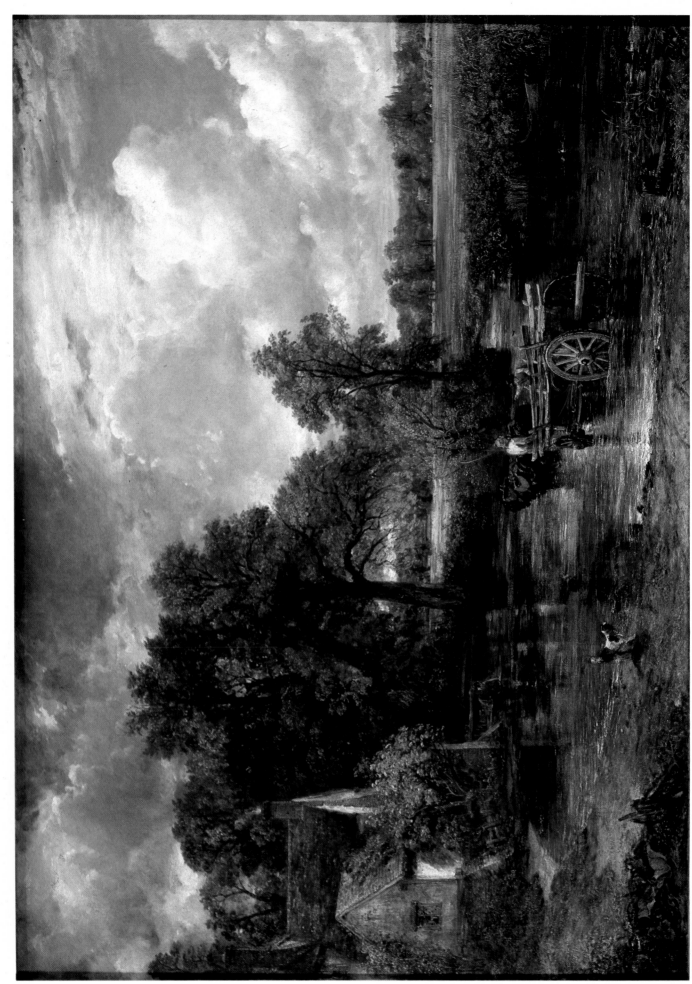

213. (21.1) *The Hay Wain*, National Gallery, London, 130·5 × 185·5cm.

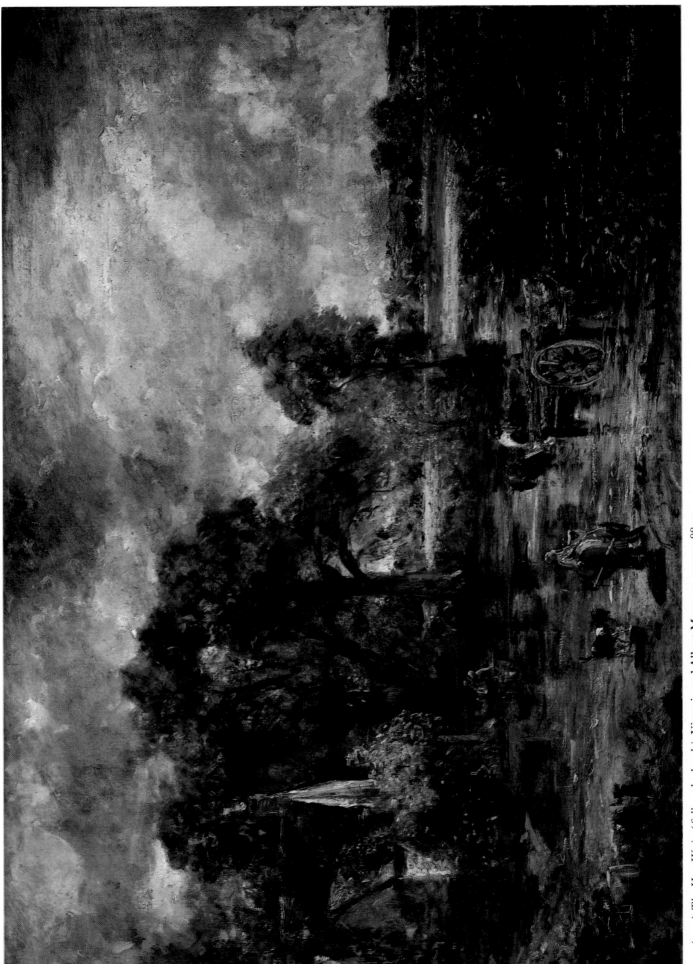

214. (21.2) *The Hay Wain (full-scale sketch)*, Victoria and Albert Museum, 137 × 188cm.

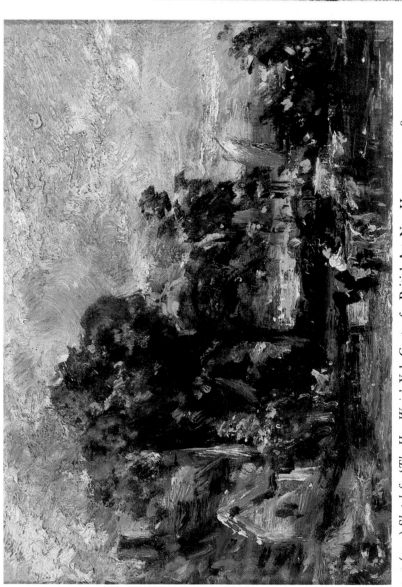

215. (21.3) *Sketch for 'The Hay Wain'*, Yale Center for British Art, New Haven, 12·5 × 18cm.

216. (right) (21.9) *Hampstead Heath with sandcarts*, Fitzwilliam Museum, Cambridge, 18·4 × 24·8cm.

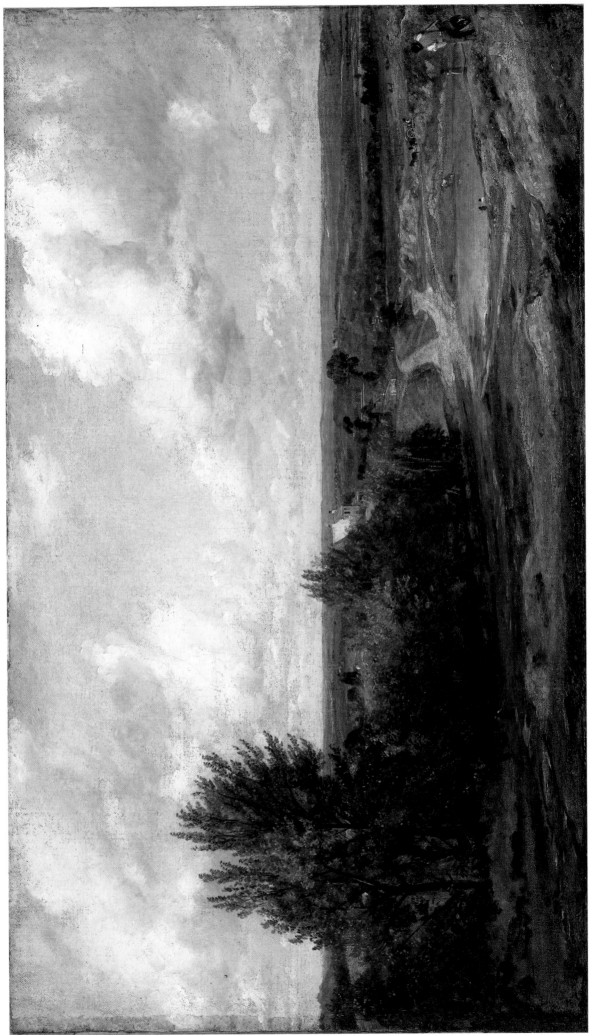

217. (21.7) *Hampstead Heath: The House called the Salt Box in the Distance*, Tate Gallery, 38·4 × 66·8cm.

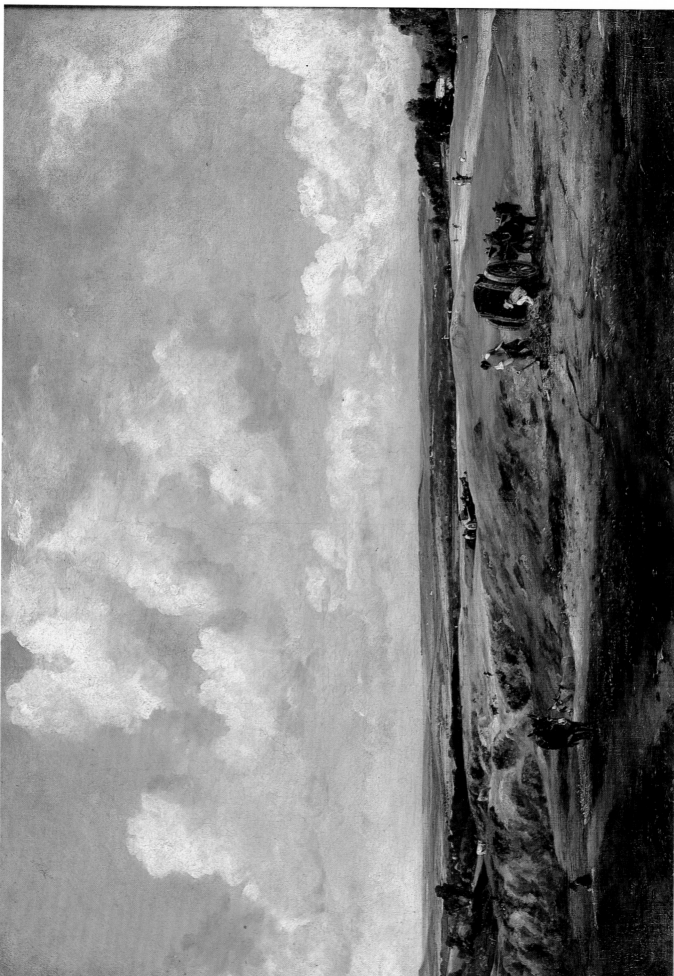

218. (218) *Hampstead Heath, Fitzwilliam Museum, Cambridge, 54 × 76.0cm*

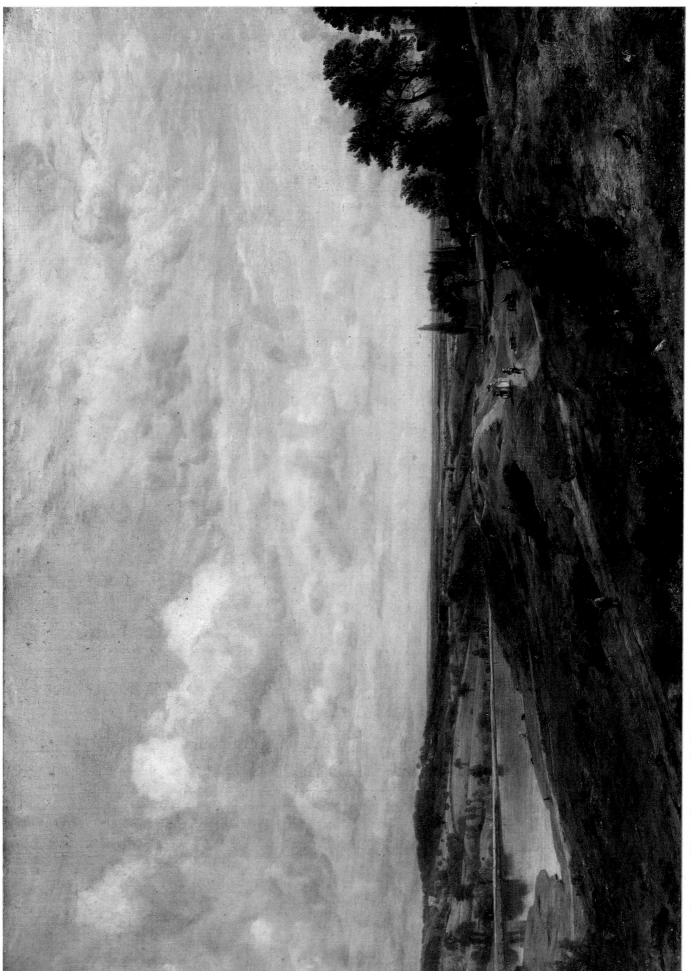

219. (21.10) *Hampstead Heath*, Victoria and Albert Museum, 53·3 × 77·6cm.

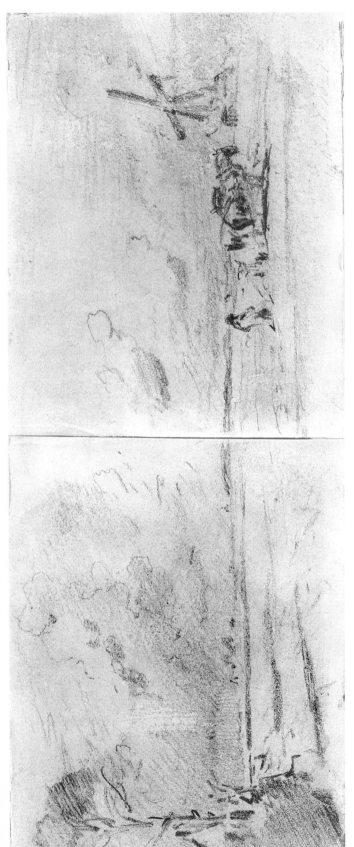

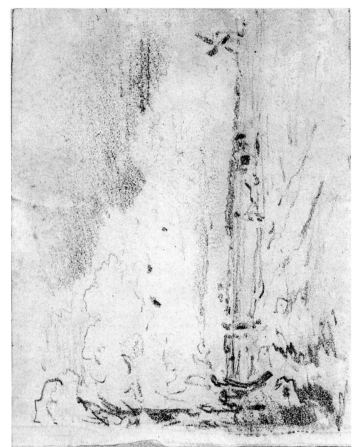

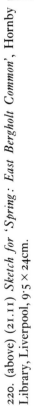

220. (above) (21.11) *Sketch for 'Spring: East Bergholt Common'*, Hornby Library, Liverpool, 9·5 × 24cm.

221. (21.12) *Spring: East Bergholt Common*, Fitzwilliam Museum, Cambridge, 9·5 × 12·3cm.

222. (21.13) *Spring: East Bergholt Common*, Victoria and Albert Museum, 19 × 36·2cm.

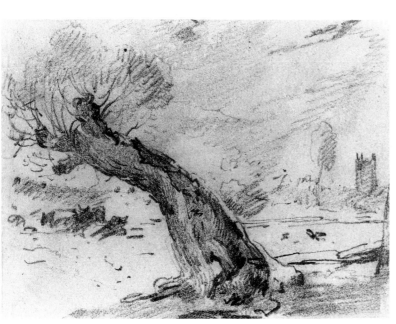

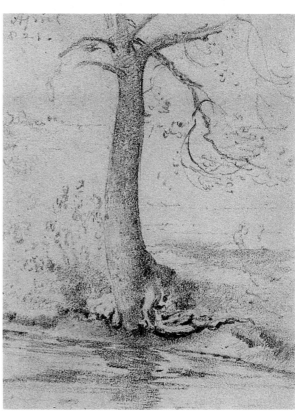

223. (21.14) *A willow stump*, Courtauld Institute Galleries (Witt Collection), London, 9·3 × 11·9cm.

224. (21.15) *Study of trees*, Whereabouts unknown, 4½ × 3½in.

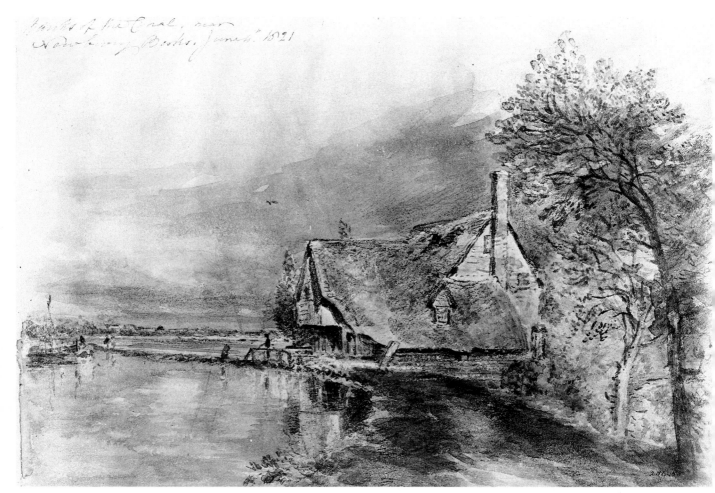

225. (21.16) *Banks of the canal near Newbury*, Victoria and Albert Museum, 17·3 × 26cm.

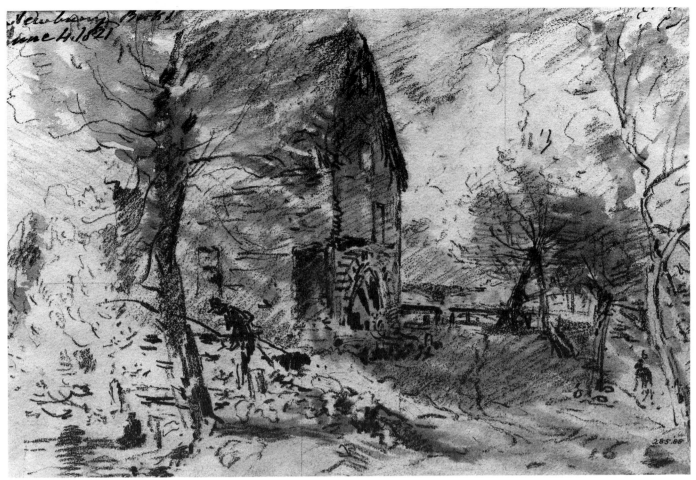

226. (21.17) *A water-mill at Newbury*, Victoria and Albert Museum, 17·3 × 26cm.

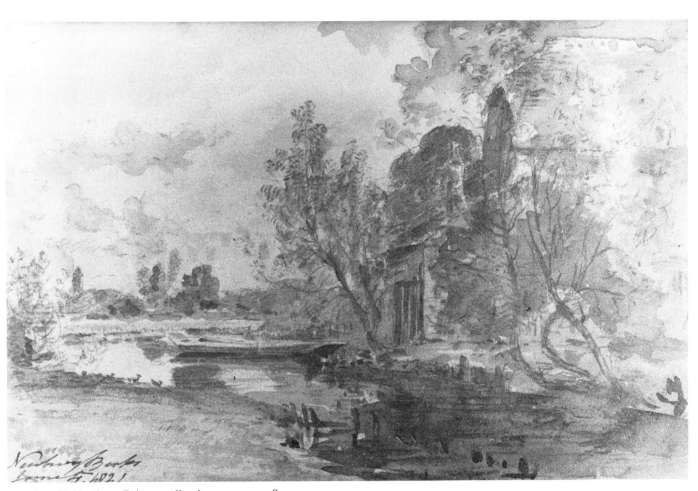

227. (21.18) *Newbury*, Private collection, 17·3 × 24·8cm.

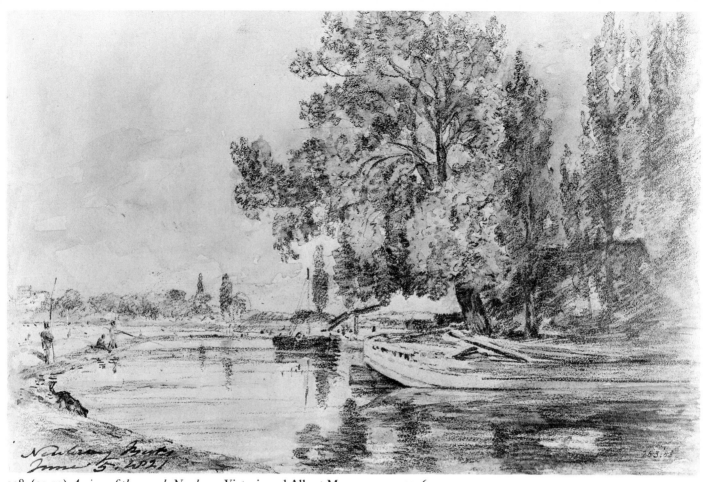

228. (21.19) *A view of the canal, Newbury*, Victoria and Albert Museum, 17·3 × 26·1cm.

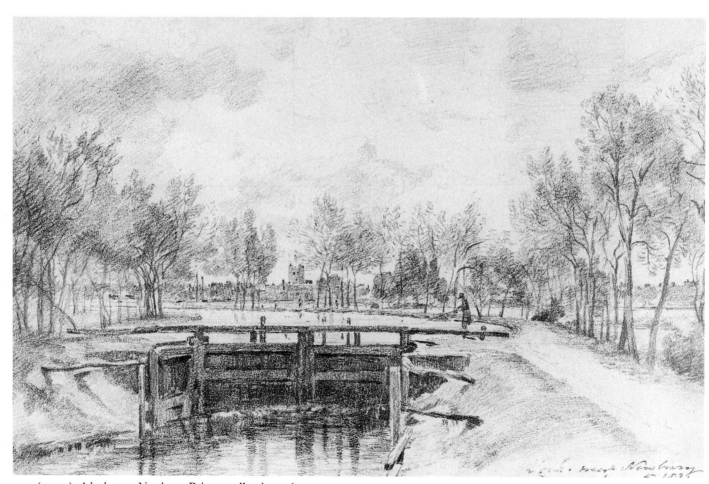

229. (21.20) *A lock near Newbury*, Private collection, 16·5 × 25·1cm.

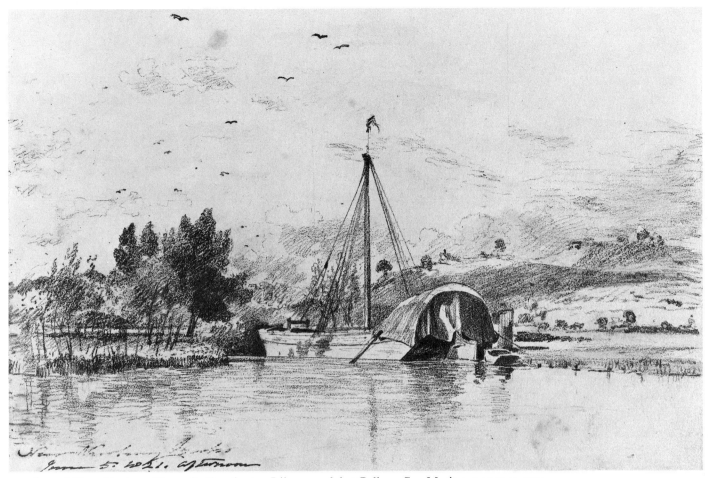

230. (21.21) *Near Newbury*, Henry E. Huntington Library and Art Gallery, San Marino, 17·3 × 25·9cm.

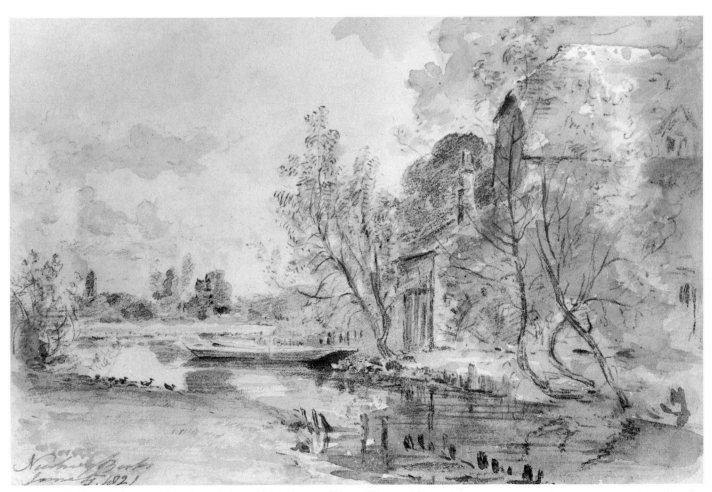

231. (21.22) *View of the canal, Newbury*, Mr and Mrs Eugene Victor Thaw, 16·8 × 25·4cm.

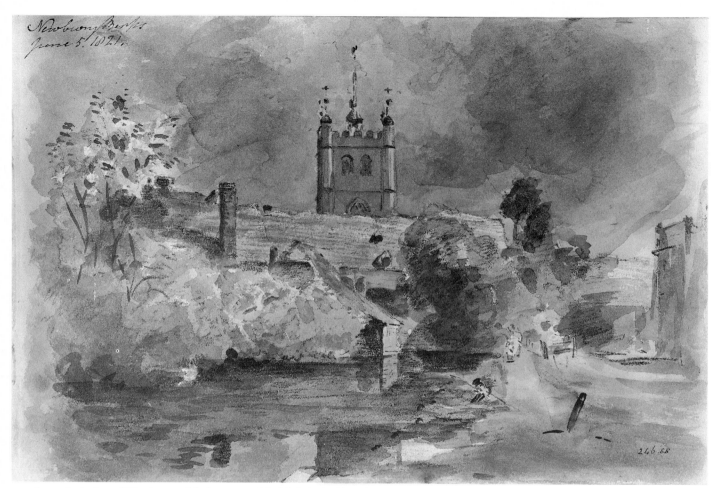

232. (21.23) *A view of Newbury, with the tower of St Nicholas's Church*, Victoria and Albert Museum, 17·3 × 26·1cm.

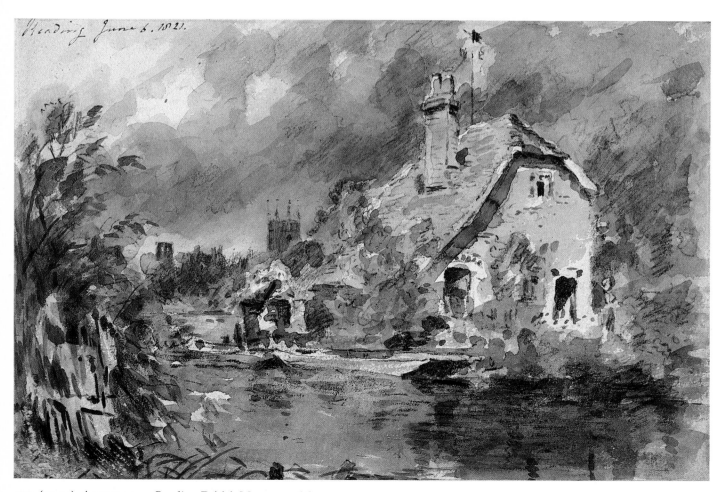

233. (21.24) *A cottage near Reading*, British Museum, 16·8 × 25·7cm.

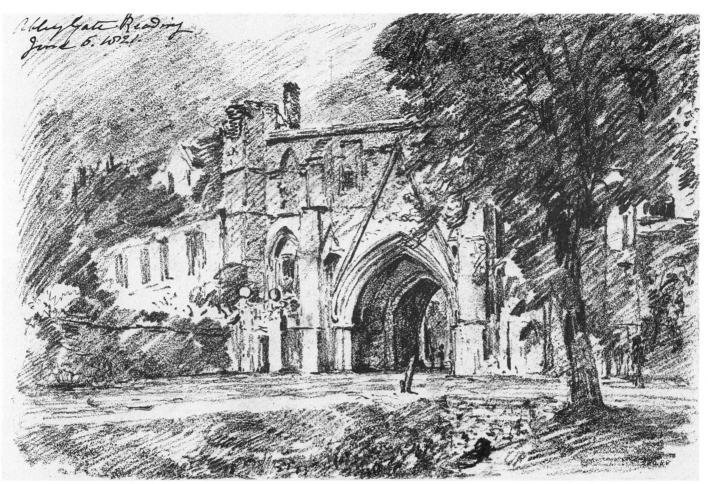

234. (21.25) *The Abbey Gate, Reading*, Victoria and Albert Museum, 17·3 × 26cm.

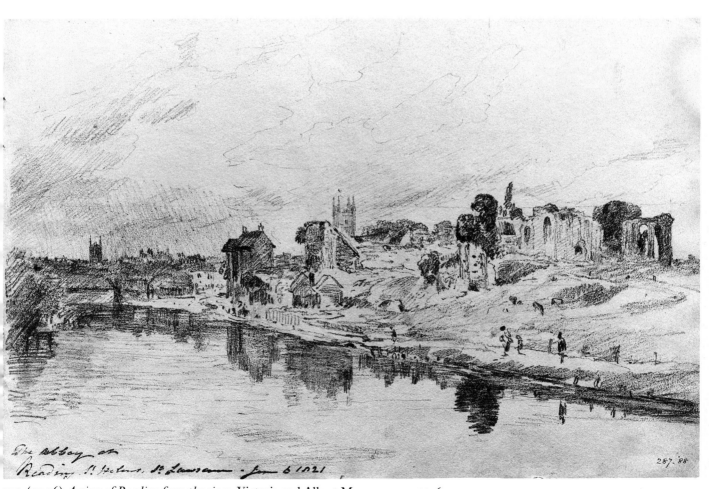

235. (21.26) *A view of Reading from the river*, Victoria and Albert Museum, 17·3 × 26cm.

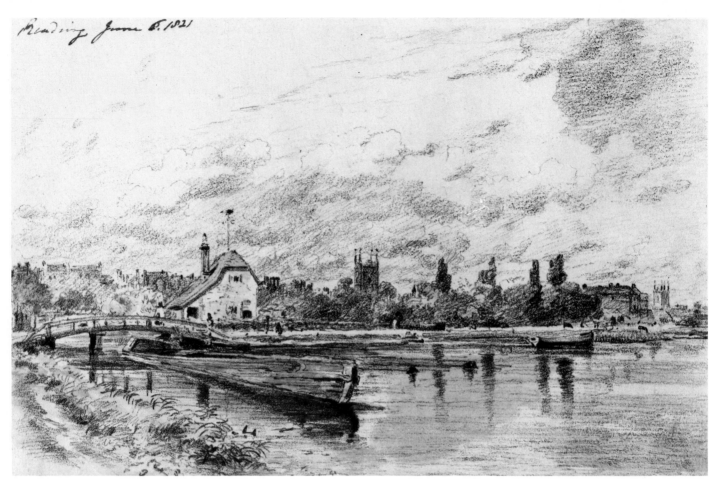

236. (21.27) *A view of Reading from the river*, Private collection, 17·2 × 25·7cm.

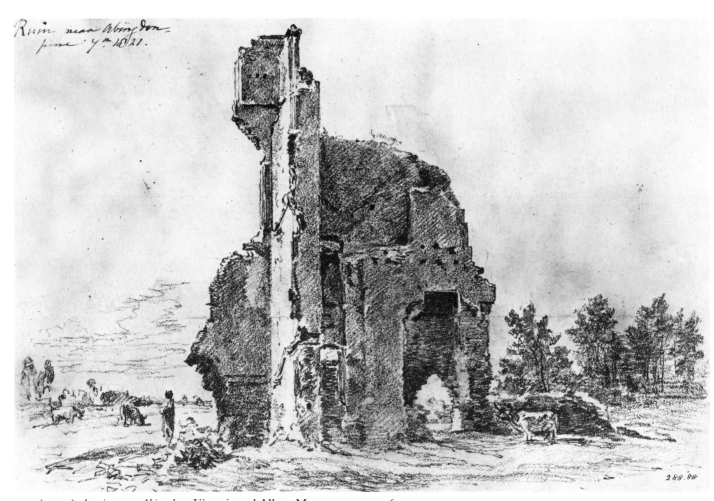

237. (21.29) *A ruin near Abingdon*, Victoria and Albert Museum, 17·3 × 26·1cm.

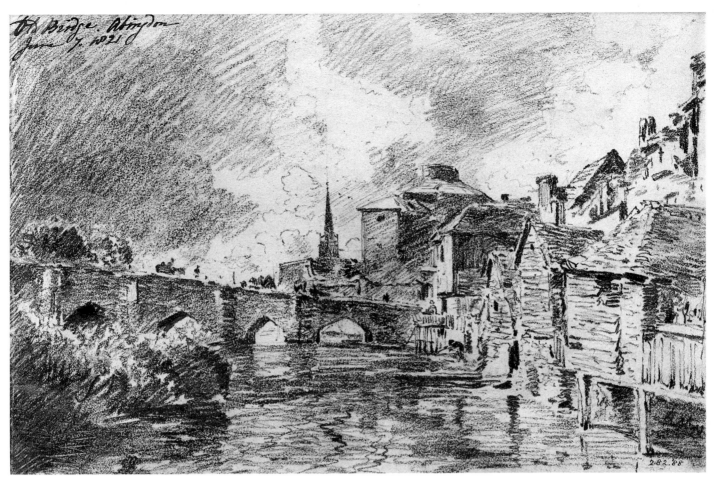

238. (21.30) *The old bridge at Abingdon*, Victoria and Albert Museum, 17·3 × 26·1cm.

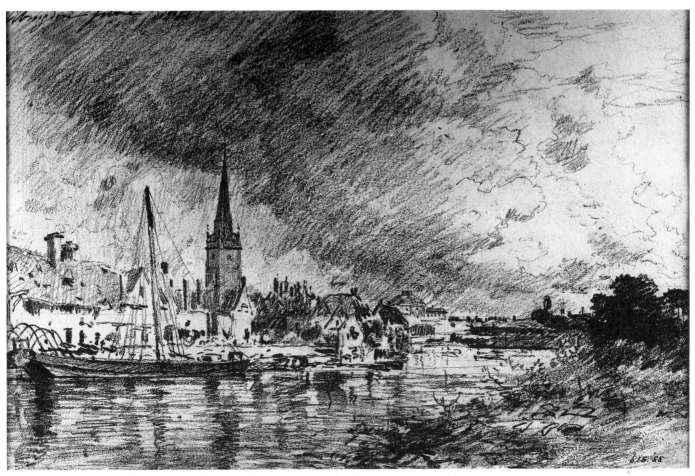

239. (21.31) *A view of Abingdon from the river*, Victoria and Albert Museum, 17·3 × 26·1cm.

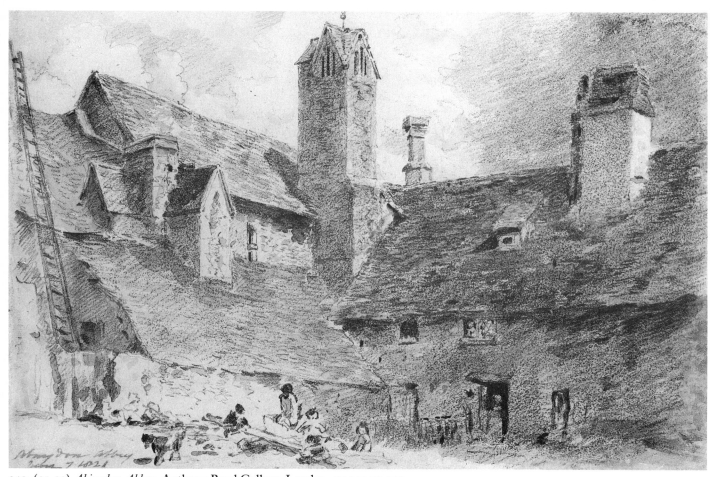

240. (21.32) *Abingdon Abbey*, Anthony Reed Gallery, London, 17·3 × 25·4cm.

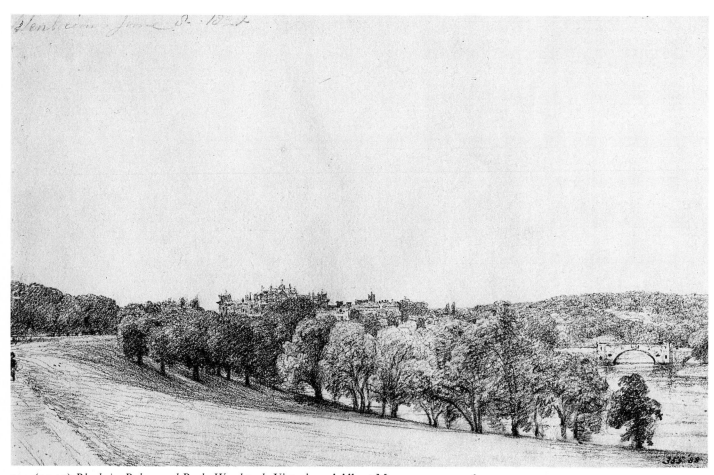

241. (21.33) *Blenheim Palace and Park, Woodstock*, Victoria and Albert Museum, 17·3 × 26·1cm.

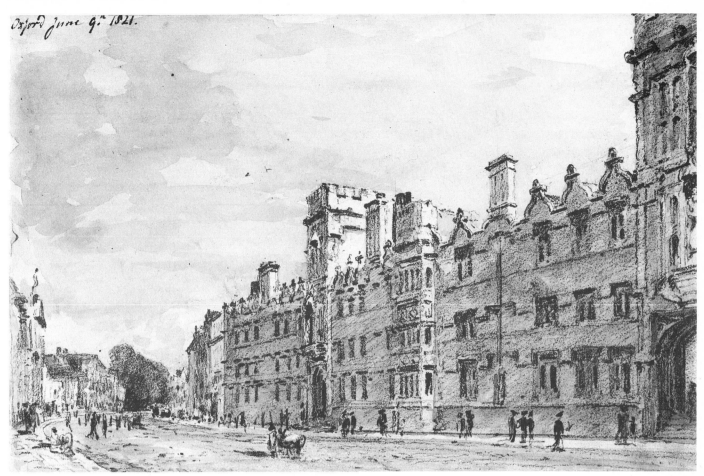

242. (21.34) *High Street, Oxford, with University College*, British Museum, 17 × 25·7cm.

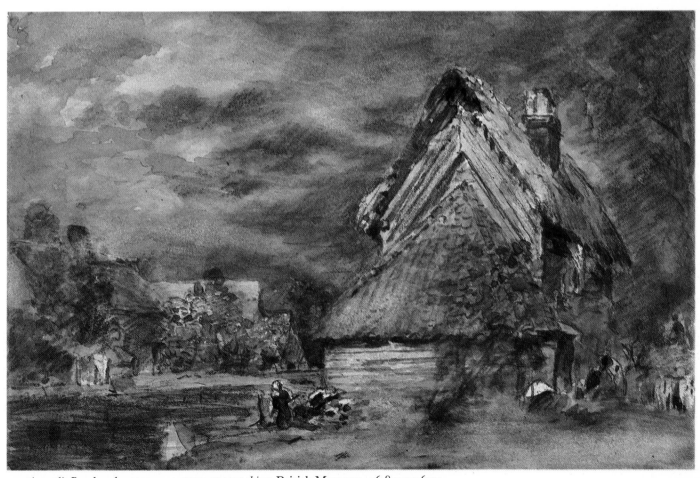

243. (21.36) *Pond and cottages: a storm approaching*, British Museum, 16·8 × 25·6cm.

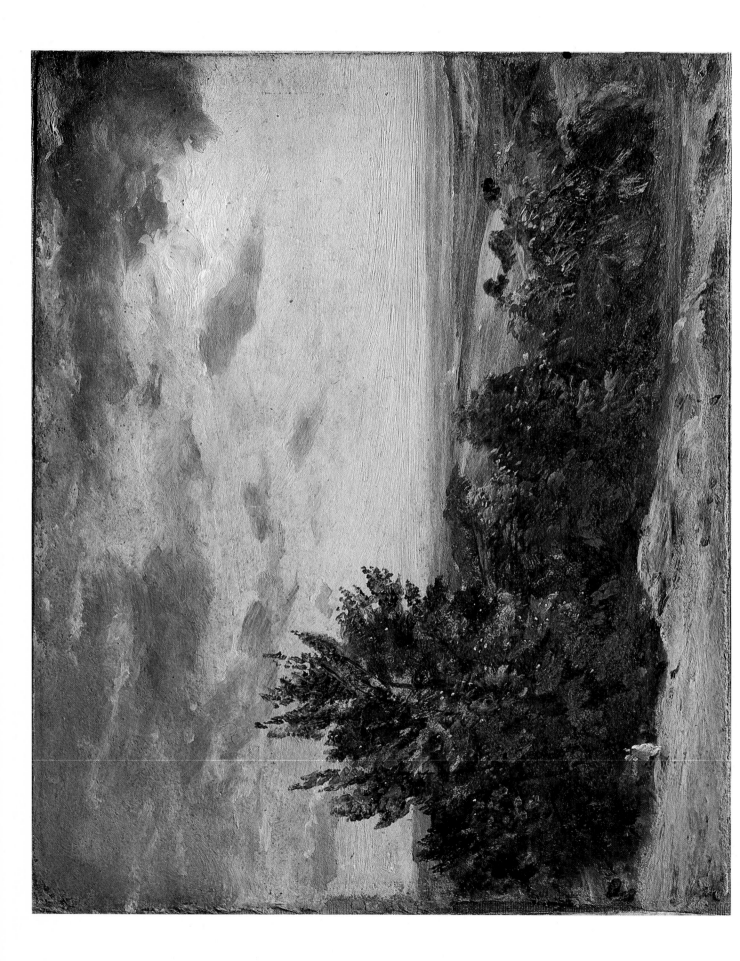

244. (21·37) *View from Hampstead Heath, looking west*, Royal Academy of Arts, London, 25·4 × 27·4cm.

245. (21·39) *View over Hampstead Heath, looking east*, Yale Center for British Art, New Haven, 14·5 × 32·5cm.

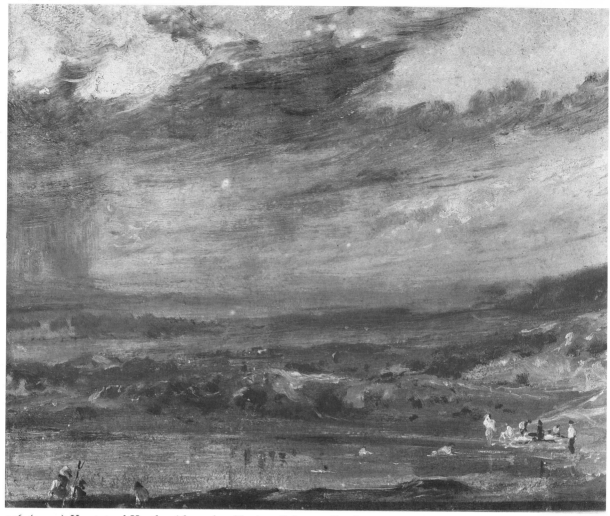

246. (21.40) *Hampstead Heath, with pond and bathers,* Private collection, 24·1 × 29·2cm.

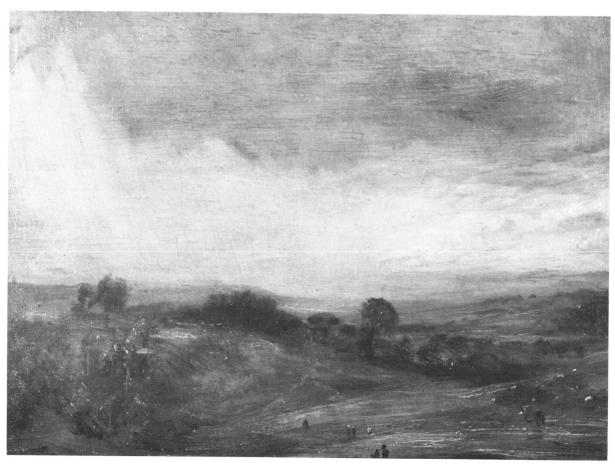

247. (21.41) *Hampstead Fields, looking west,* Private collection, 16·7 × 22·2cm.

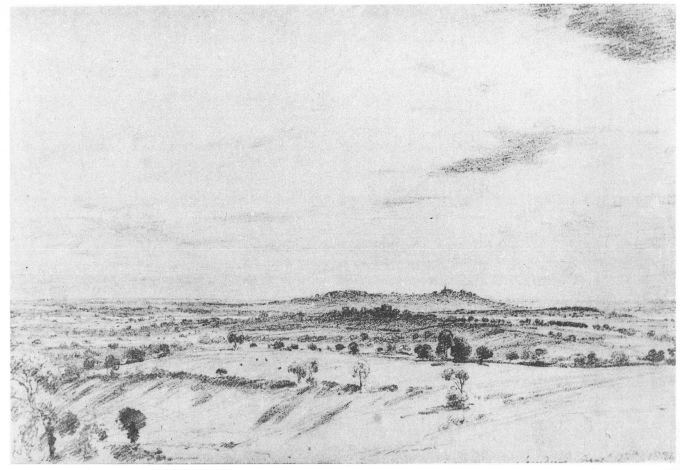

248. (21.42) *Harrow from the fields at Child's Hill*, Whereabouts unknown, 15 × 22cm.

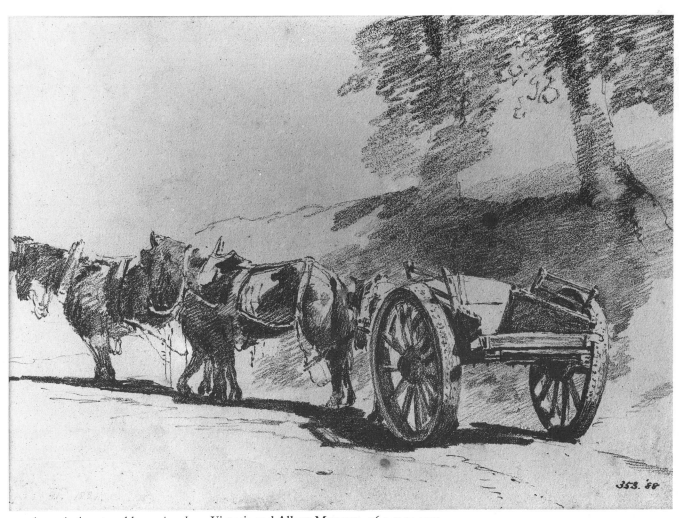

249. (21.43) *A cart and horses in a lane*, Victoria and Albert Museum, 16·1 × 23·7cm.

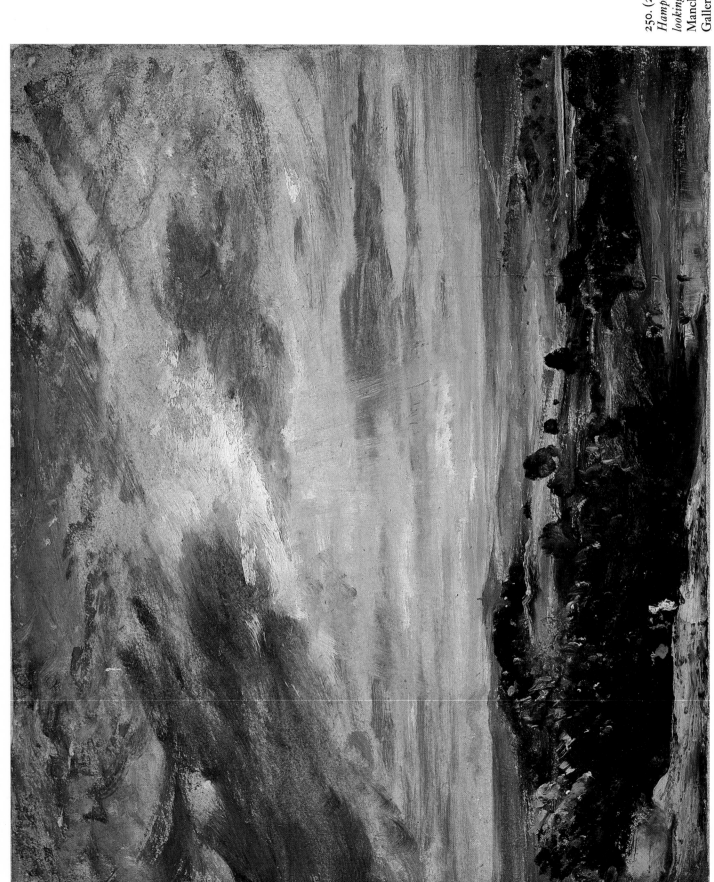

250. (21.44) *View from Hampstead Heath, looking towards Harrow,* Manchester City Art Galleries, 25 × 29·8cm.

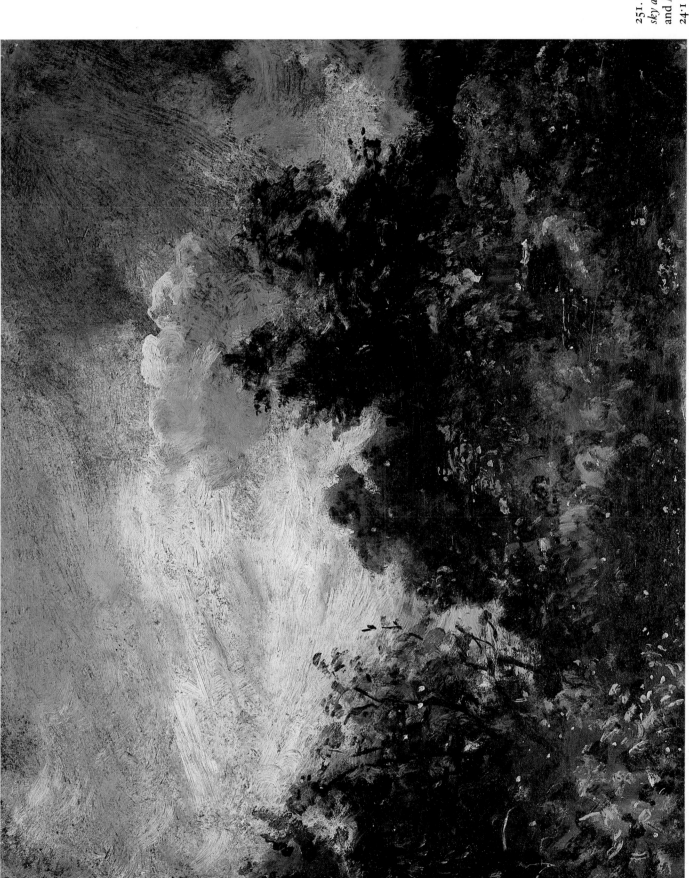

252. (21.47) *Study of clouds at Hampstead,* Royal Academy of Arts, London, 24·2 × 29·8cm.

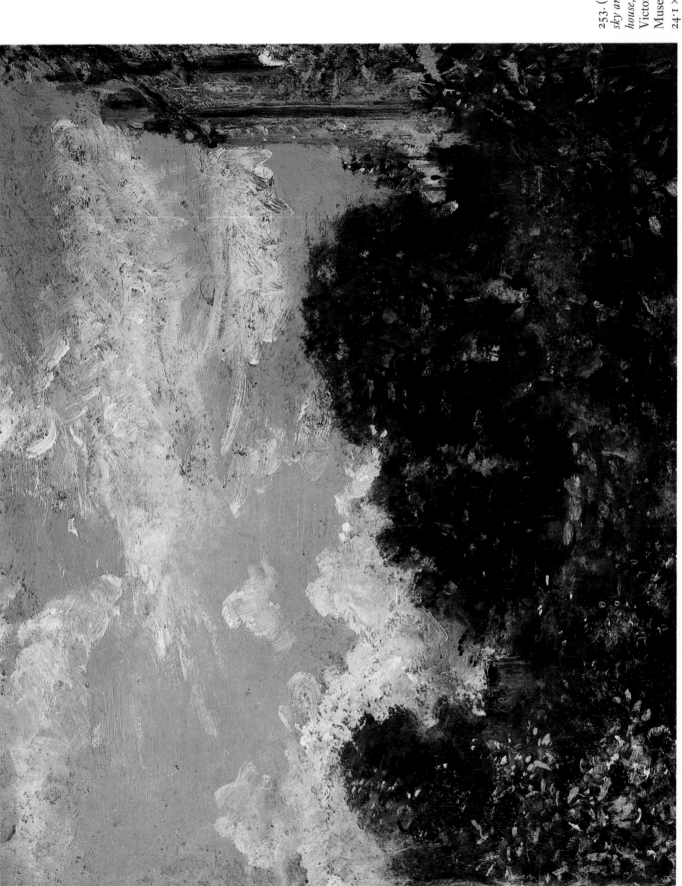

253. (21.48) *Study of sky and trees, with a red house, at Hampstead.* Victoria and Albert Museum, 24·1 × 29·8cm.

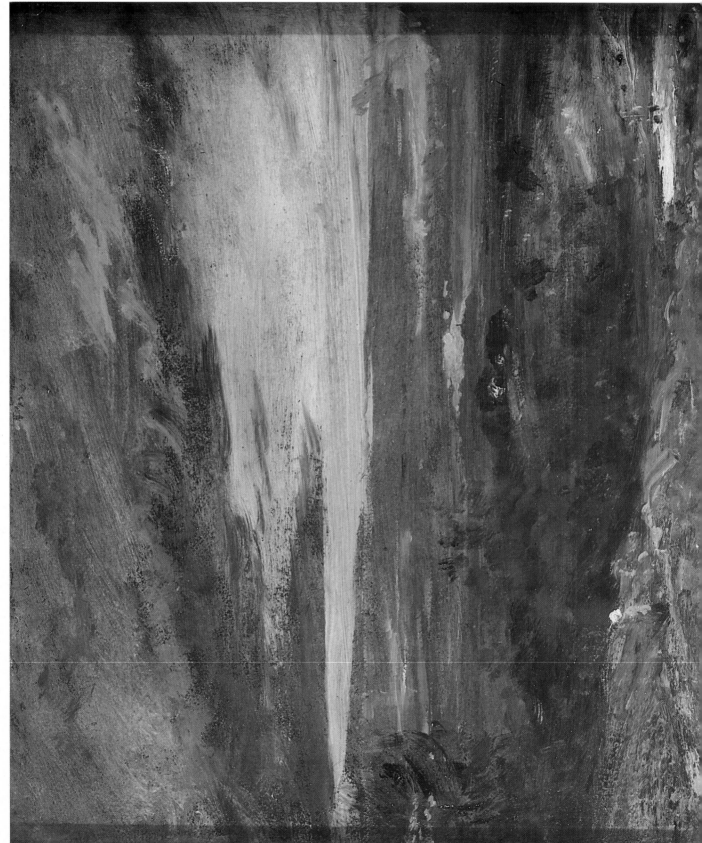

254. (21.49) *Hampstead Heath, looking towards Harrow, at sunset*, Private collection, 24.1 x 20.2cm

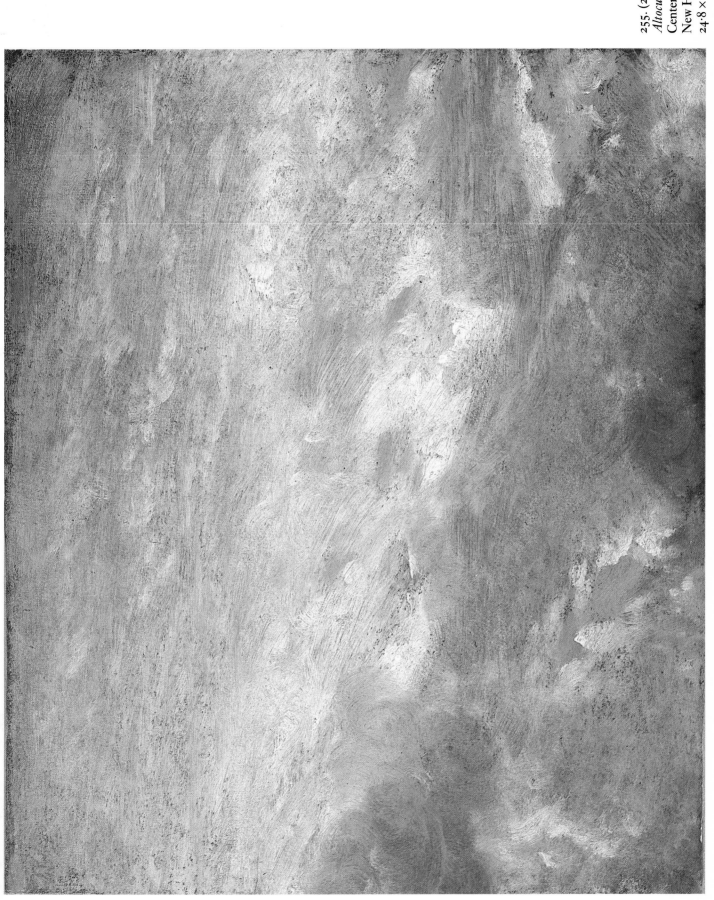

255. (21.50) *Study of Altocumulus clouds*, Yale Center for British Art, New Haven, 24·8 × 30·3cm.

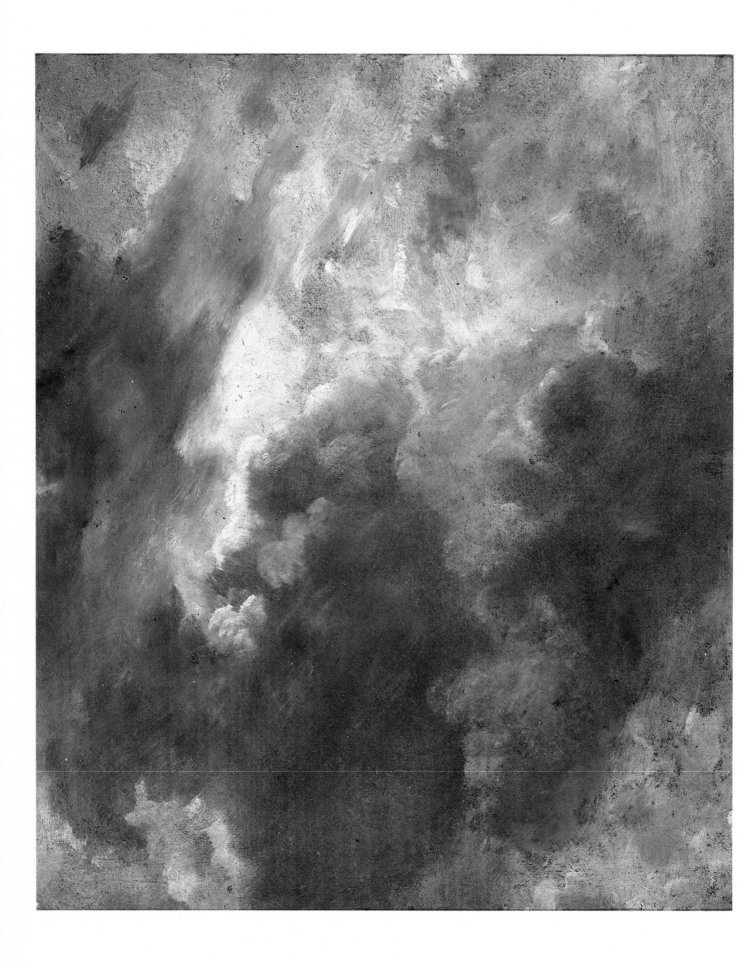

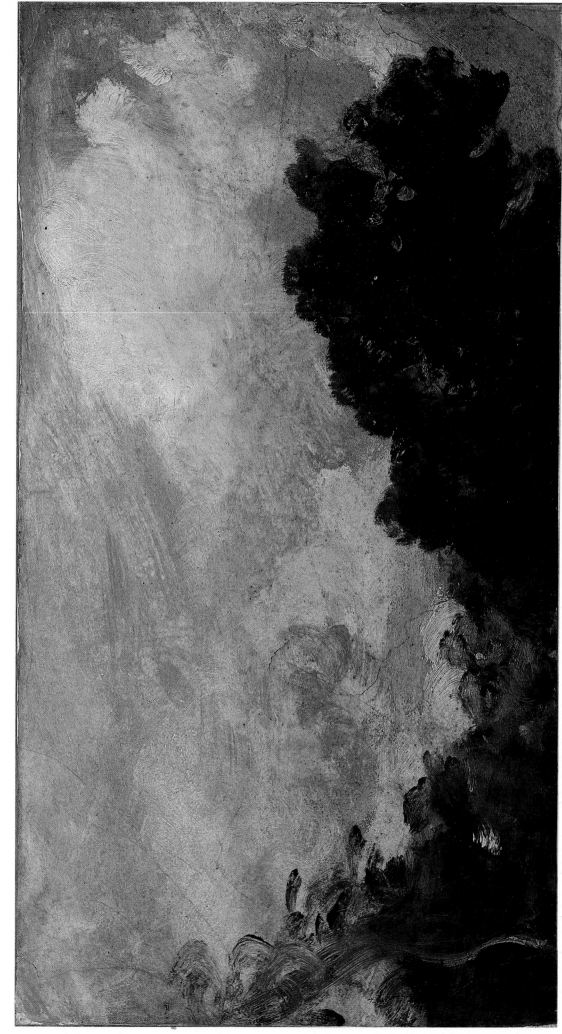

257. (21·53) *Cloud study with trees*, Yale Center for British Art, New Haven, 16·5 × 31cm.

258. (21.54) *Cloud study over an horizon of trees*, Royal Academy of Arts, London, 24·8 × 29·2cm.

259. (21.55) *Hampstead Heath, looking over towards Harrow*, Royal Academy of Arts, London, 23·5 × 28·6cm.

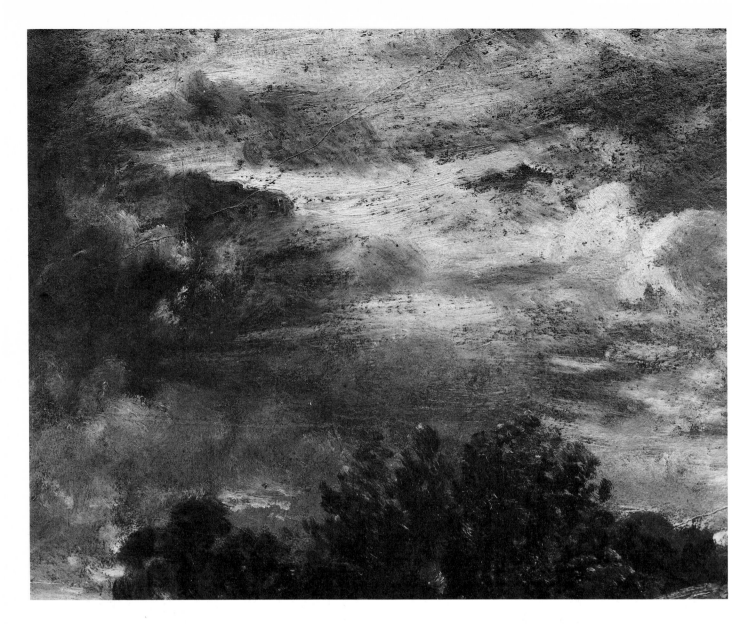

260. (above) (21.51) *Study of sky and trees*, Victoria and Albert Museum, 24·8 × 30·5cm.

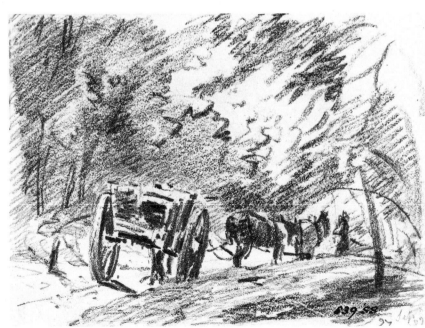

261. (21.56) *A cart and team of two horses at Hampstead*, Victoria and Albert Museum, 8·4 × 11·3cm.

262. (facing page top) (21.57) *Stratocumulus clouds*, Yale Center for British Art, New Haven, 25·5 × 30·5cm.

263. (facing page bottom) (21.60) *Hampstead Heath, looking towards Harrow*, David Goodstein Collection, Los Angeles, 24·7 × 28·5cm.

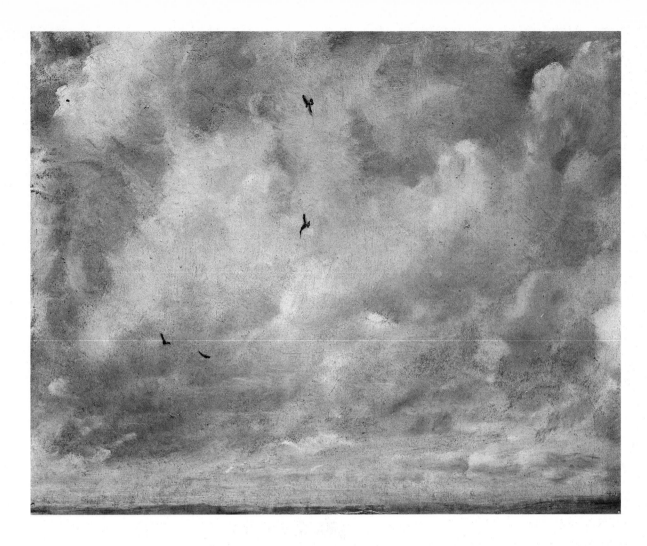

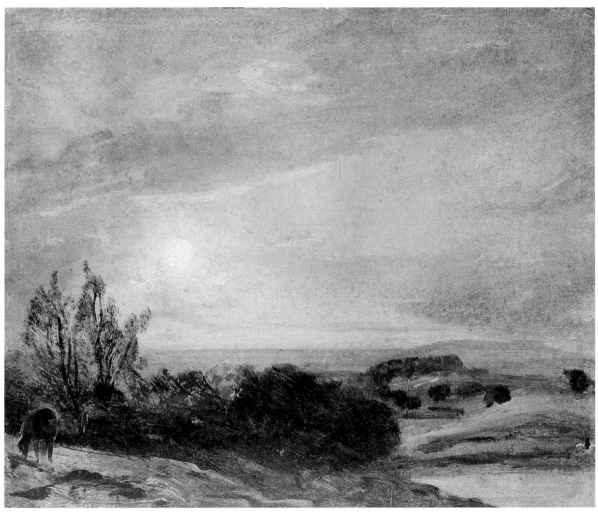

264. (21.58) *Study of sky and trees at Hampstead,* Victoria and Albert Museum, 24·5 × 29·8cm.

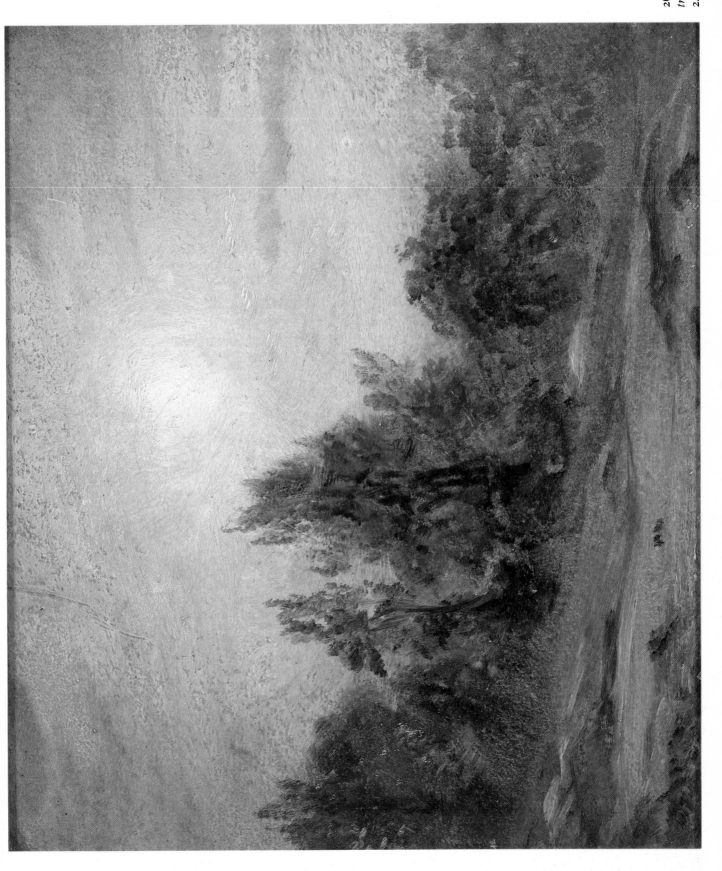

265. (21.59) *A lane through trees*, Private collection, 24·7 × 29·2 cm.

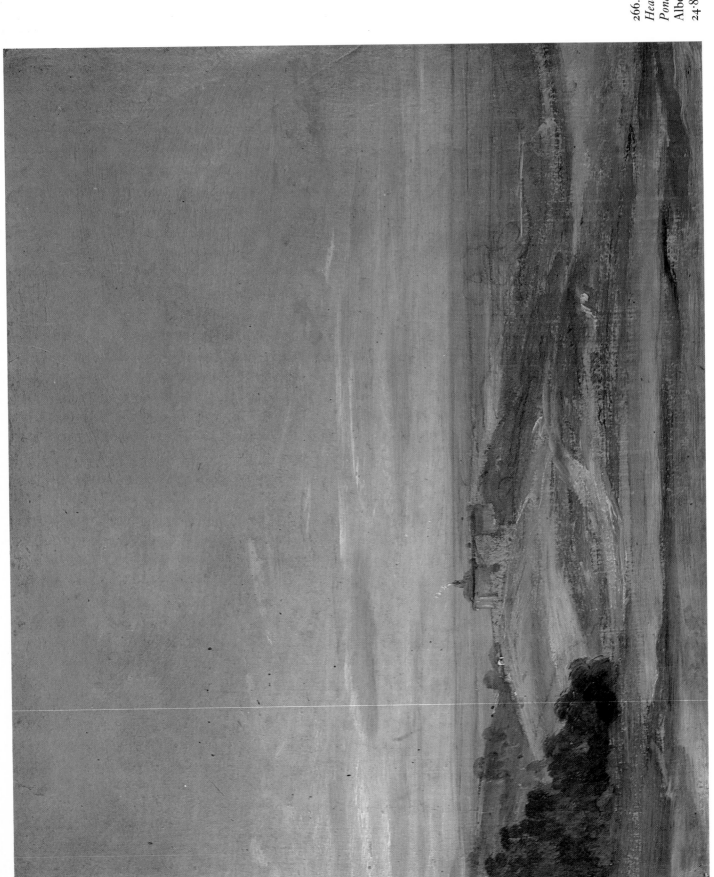

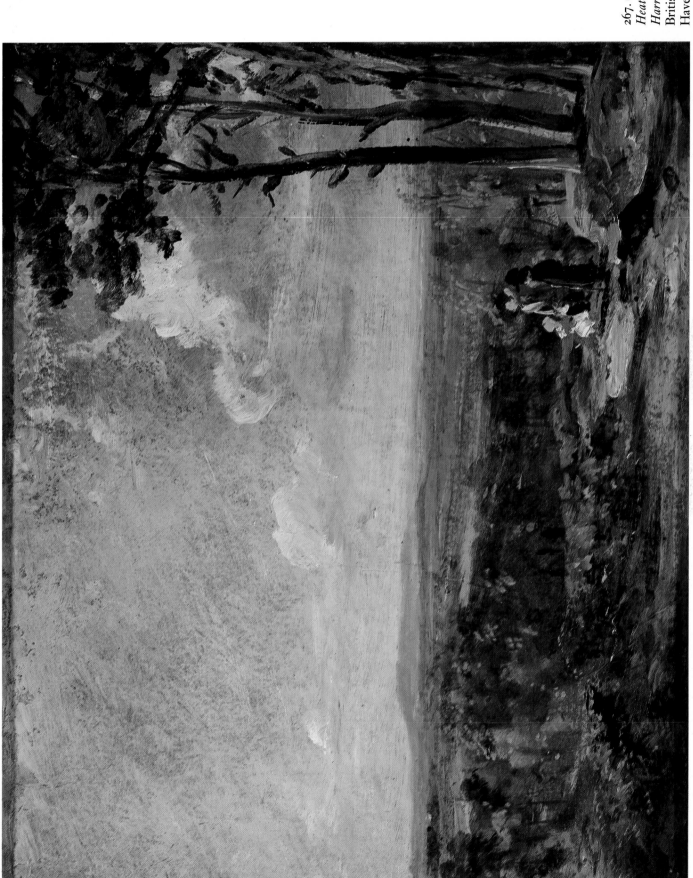

267. (21.64) *Hampstead Heath, looking towards Harrow*, Yale Center for British Art, New Haven, 26 × 32·5cm.

268. (21.66) *A sandbank at Hampstead Heath*, Victoria and Albert Museum, 24·8 × 29·8cm.

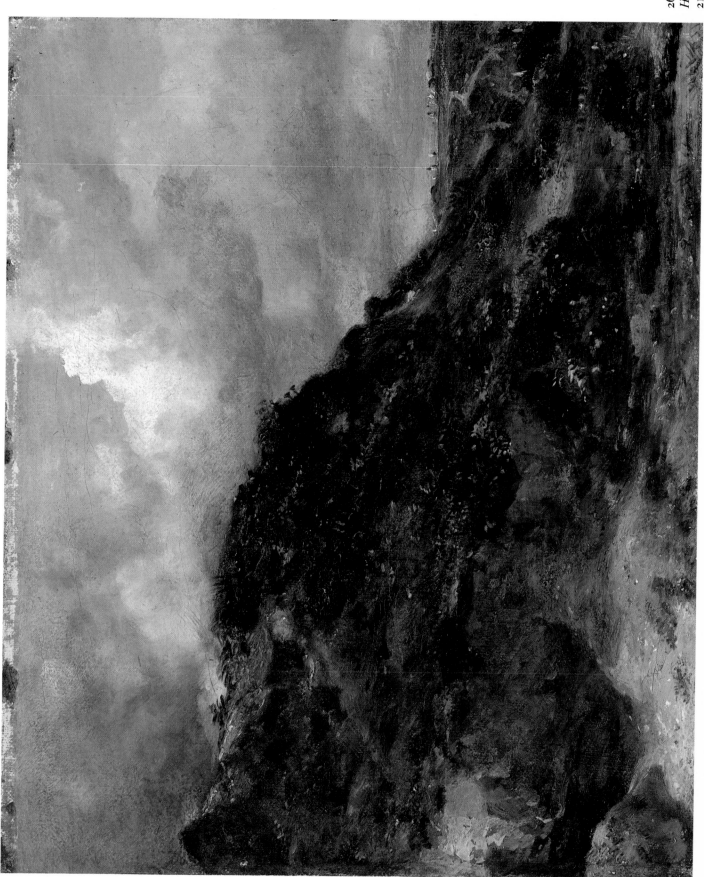

269. (21.67) *A sandbank at Hampstead*, Tate Gallery, 21·6 × 25·4cm.

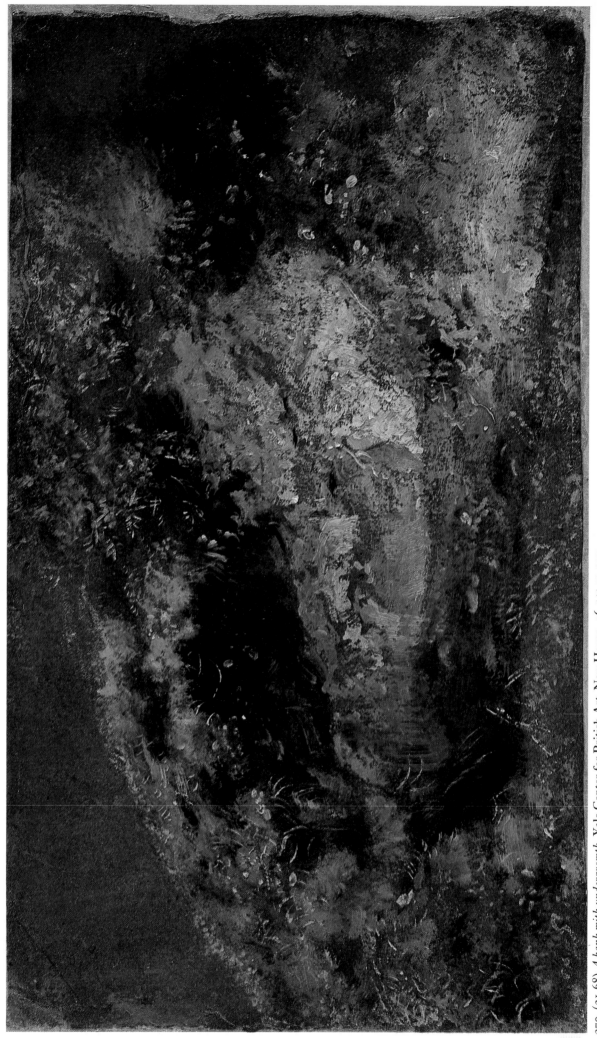

270. (21.68) *A bank with undergrowth*, Yale Center for British Art, New Haven, 16·5 × 29·5cm.

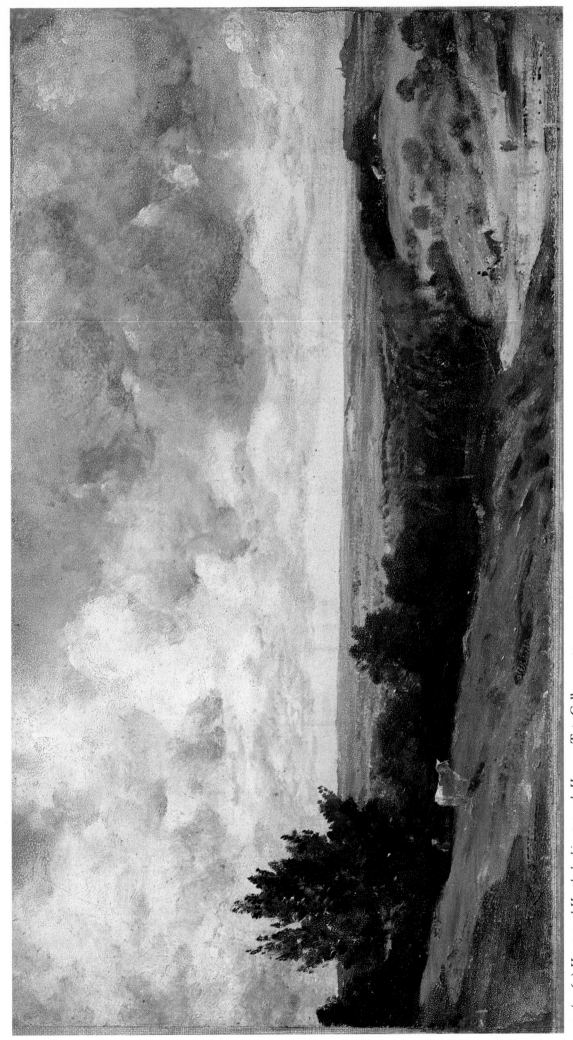

271. (21.69) *Hampstead Heath, looking towards Harrow*, Tate Gallery, 17 × 31·3cm.

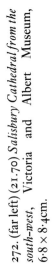

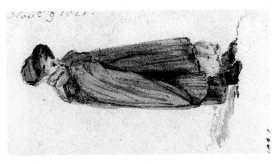

272. (far left) (21.70) *Salisbury Cathedral from the south-west*, Victoria and Albert Museum, 6·8 × 8·4cm.

273. (left) (21.71) *A woman in a red cloak*, Executors of the late Lieutenant-Colonel J. H. Constable, 7·1 × 3·9cm.

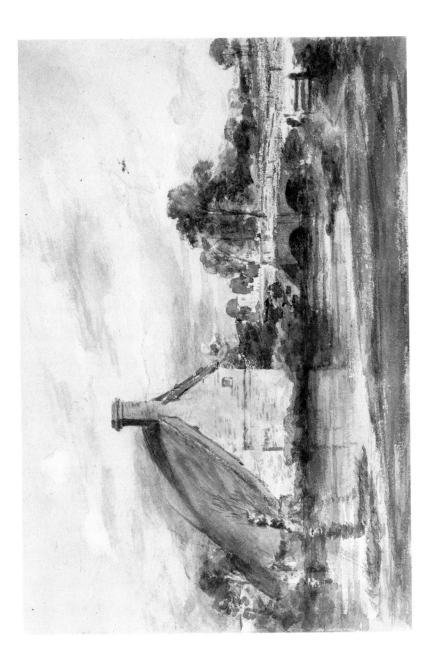

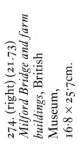

274. (right) (21.73) *Milford Bridge and farm buildings*, British Museum, 16·8 × 25·7cm.

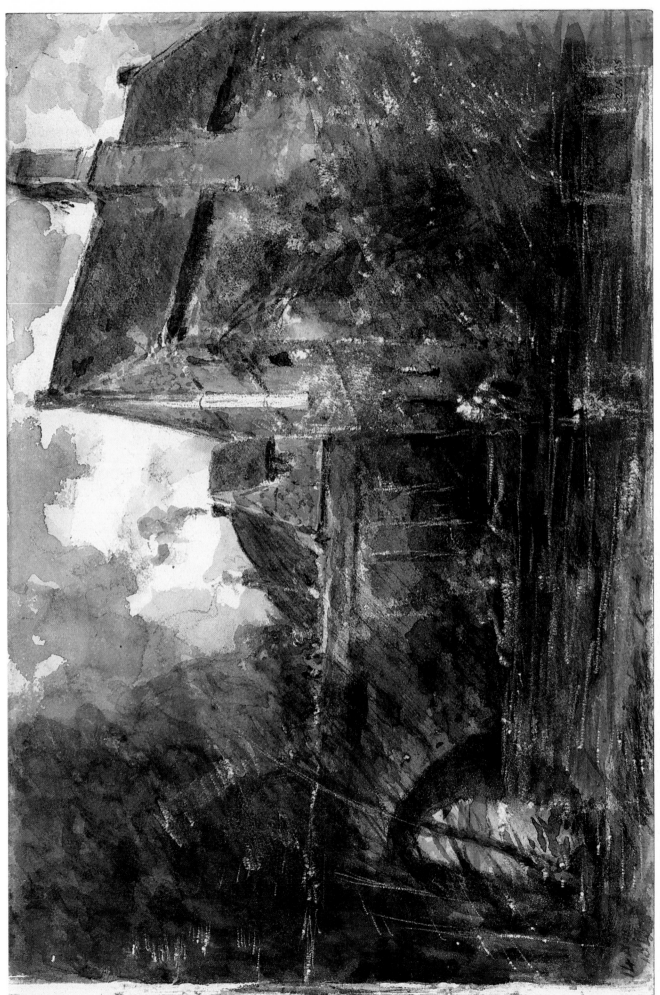

275. (21.72) *Old houses on Harnham Bridge, Salisbury*, Victoria and Albert Museum, 17·3 × 26·2cm.

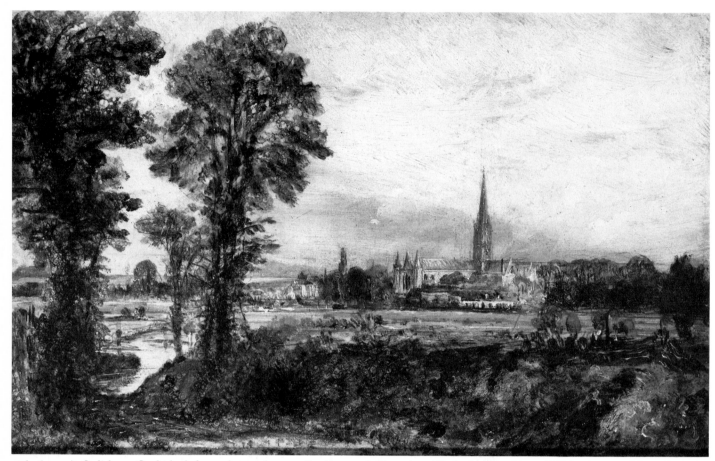

276. (21.74) *Salisbury Cathedral from the south-west*, Sterling and Francine Clark Art Institute, Williamstown, Massachusetts, 17·2 × 25·5cm.

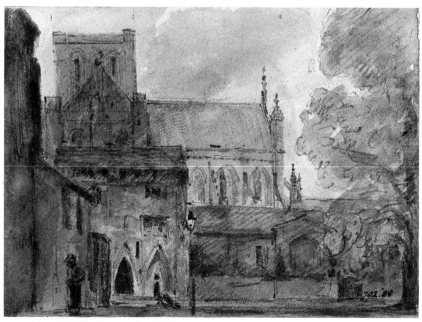

277. (21.76) *Winchester Cathedral: the entrance to the Deanery from the south*, Victoria and Albert Museum, 8·4 × 11·2cm.

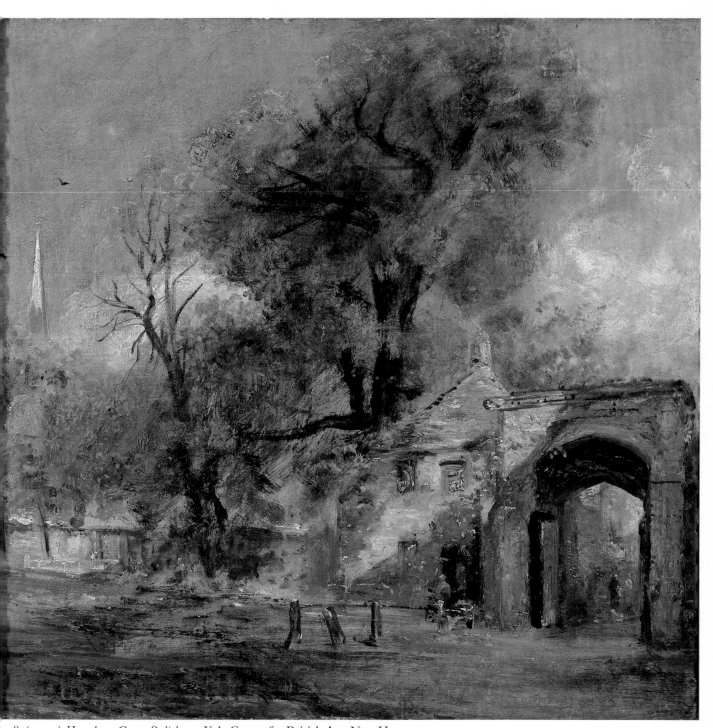

278. (21.75) *Harnham Gate, Salisbury*, Yale Center for British Art, New Haven, 53·3 × 52·1cm.

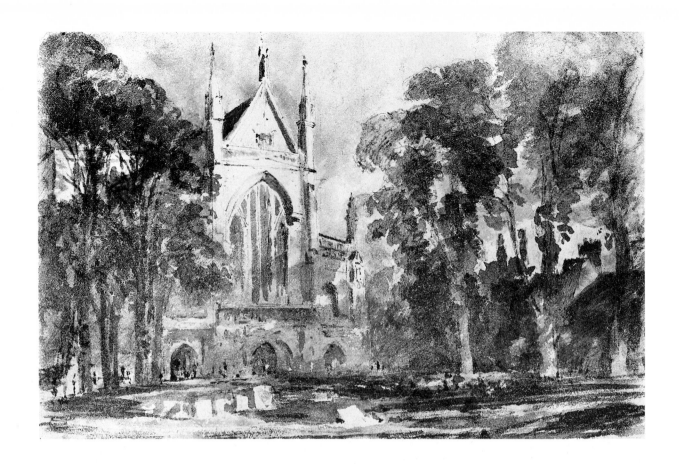

279. (above) (21.77) *Winchester Cathedral: the west front*, Victoria and Albert Museum, 15·9 × 23·4cm.

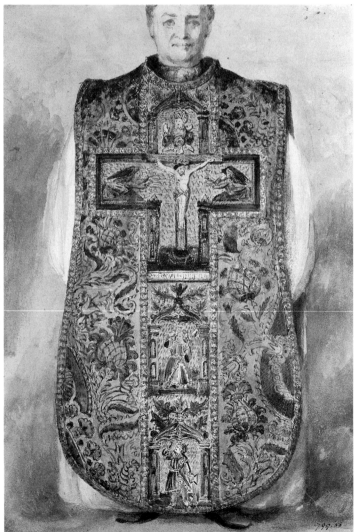

280. (middle) (21.78) *A portion of the head of the Rev. Edmund Benson*, Victoria and Albert Museum, 23·4 × 15·9cm.

281. (right) (21.79) *Portrait of the Rev. Edmund Benson wearing a medieval chasuble*, Victoria and Albert Museum, 23·7 × 16·1cm.

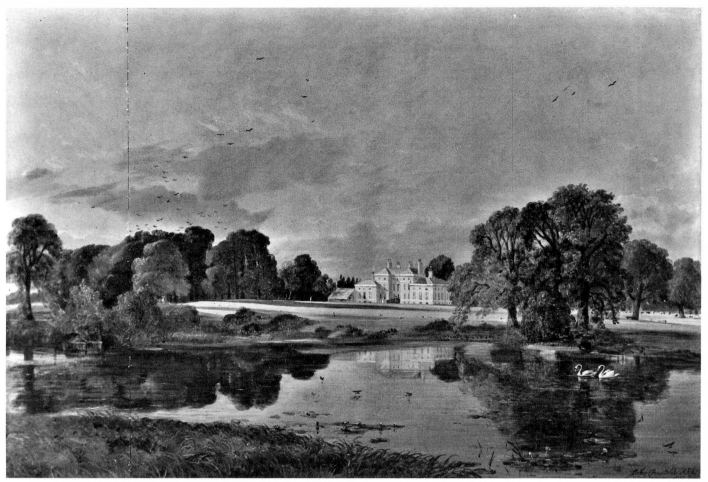

282. (21.80) *Malvern Hall from the Lake*, Museo Nacional de Bellas Artes, Havana, 61 × 76·2cm.

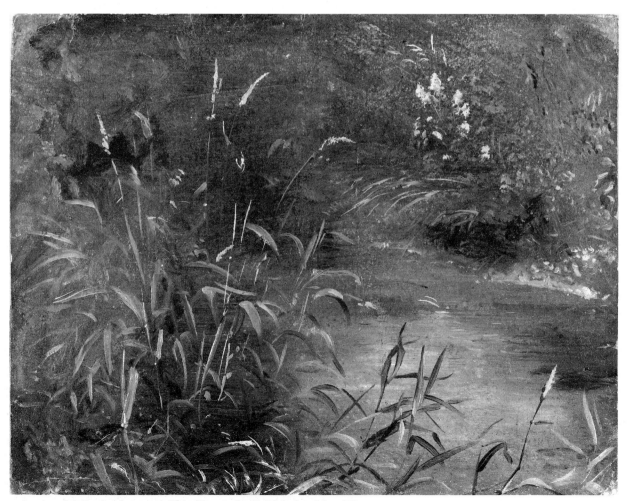

283. (21.84) *Rushes by a pool*, Yale Center for British Art, New Haven, 22·7 × 29cm.

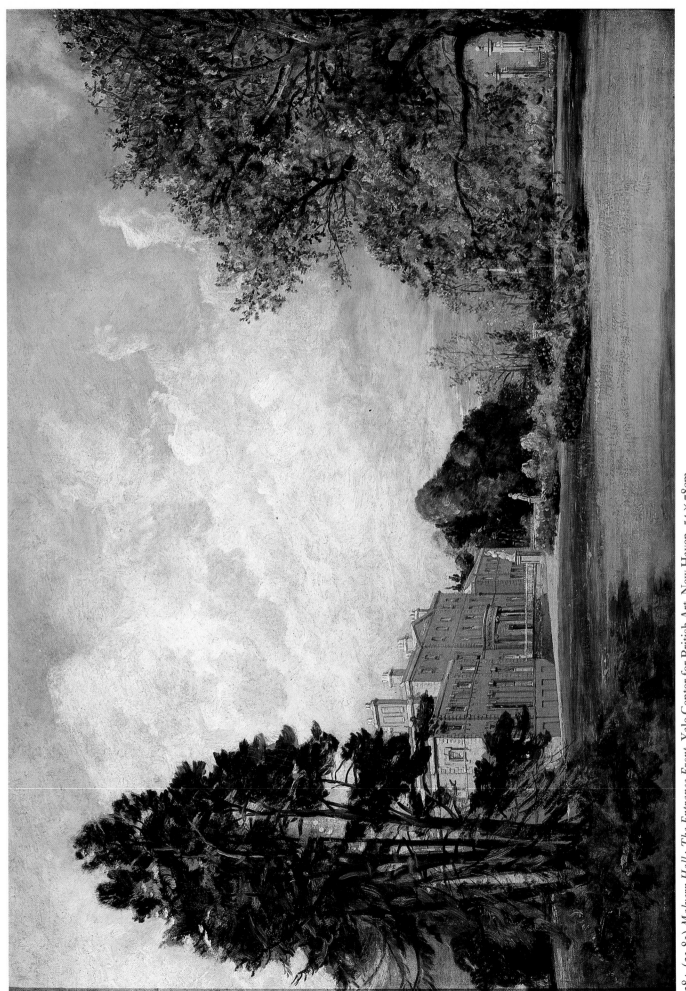

284. (21.81) *Malvern Hall: The Entrance Front*, Yale Center for British Art, New Haven, 54 × 78cm.

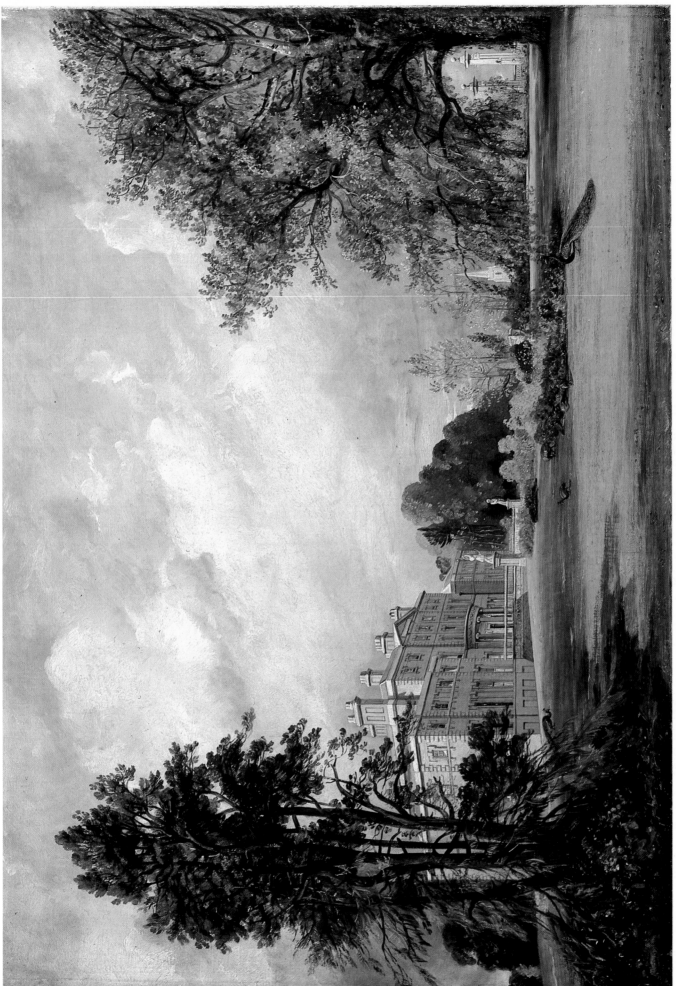

285. (21.82) *Malvern Hall: The Entrance Front*, Sterling and Francine Clark Art Institute, Williamstown, Massachusetts, 54 × 78cm.

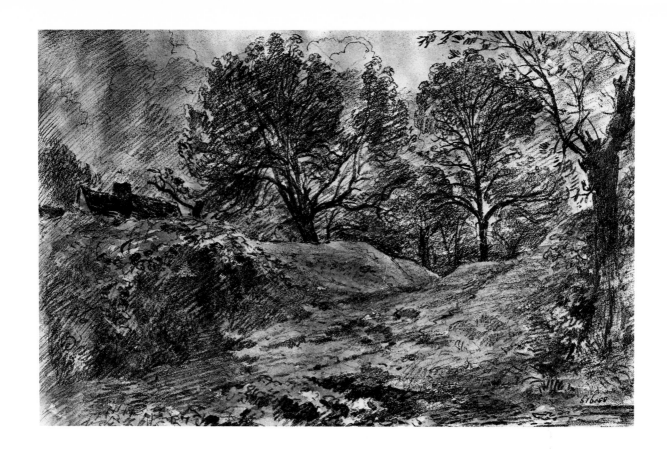

286. (above) (21.85) *A group of trees on broken ground*, Victoria and Albert Museum, 17.3 × 25.5cm.

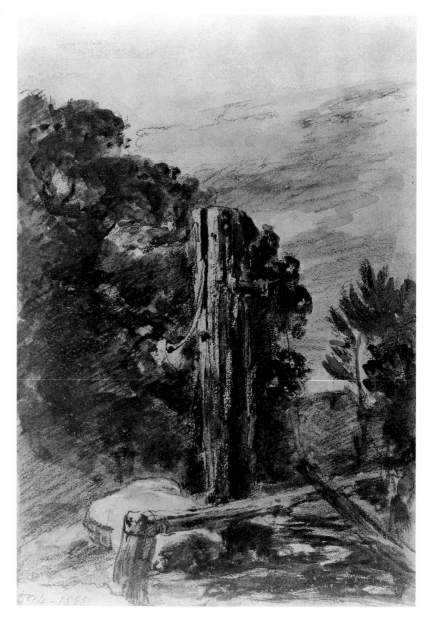

287. (21.87) *A pump*, Victoria and Albert Museum, 25.5 × 17.3cm.

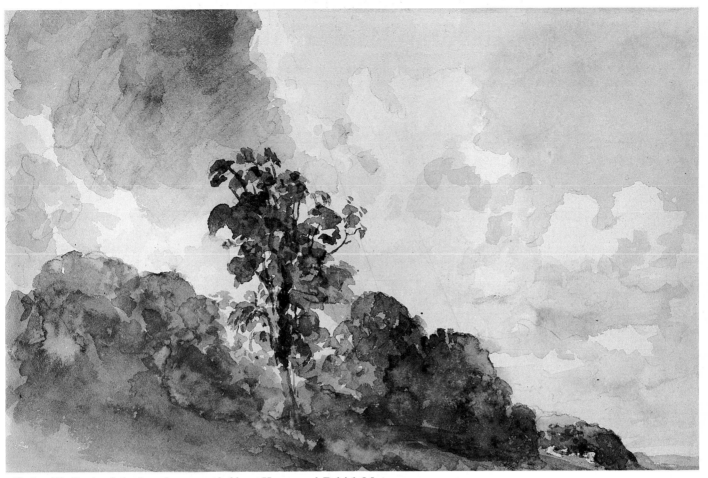

288. (21.88) *Study of clouds and trees, probably at Hampstead*, British Museum, 17 × 25·4cm.

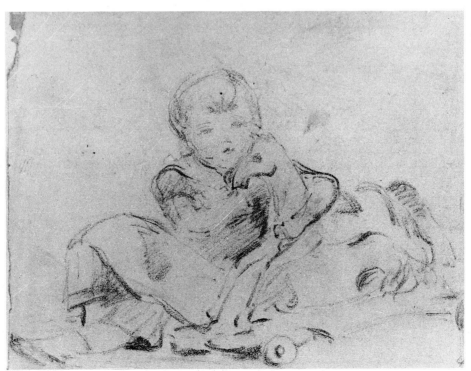

289. (21.89) *A child embracing a toy horse on wheels*, Musée du Louvre, 9·5 × 12·2cm.

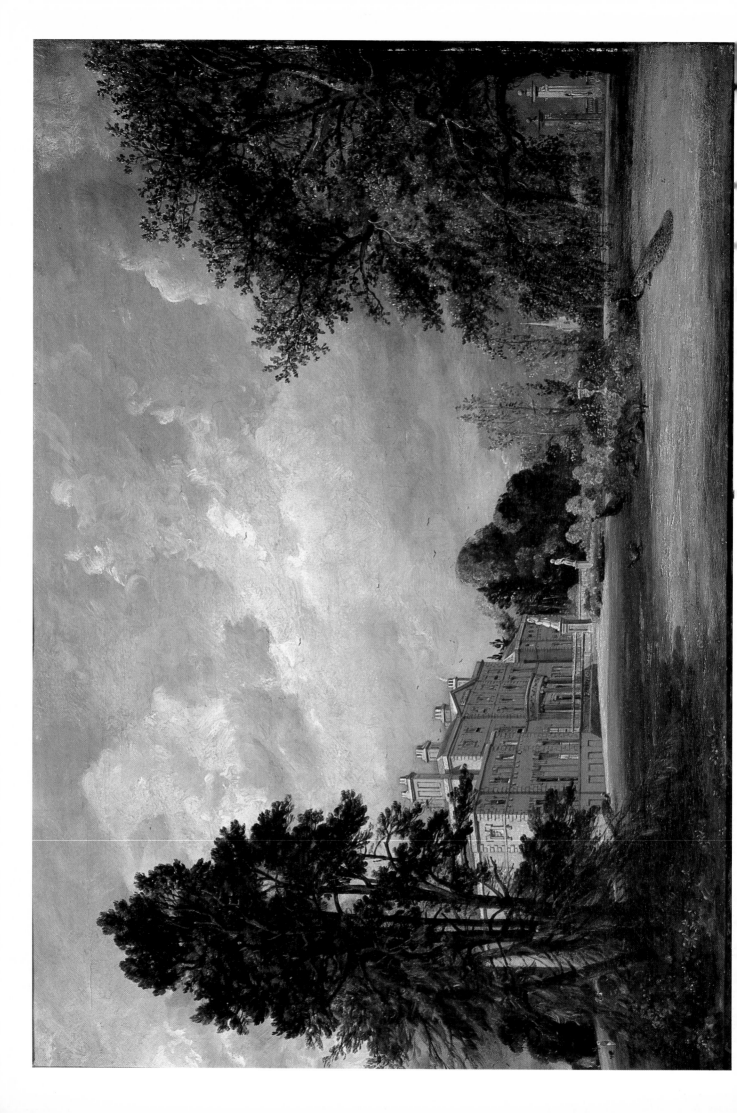

290. (above) (21.83) *Malvern Hall: The Entrance Front*, Musées du Mans, Le Mans, 54·5 × 78·7cm.

291. (21.86) *Trees, sky and a red house, at Hampstead*, Victoria and Albert Museum, 17·3 × 25·5cm.

292. (21.90) *A sandbank with trees beyond*, Victoria and Albert Museum, 8·4 × 11·3cm.

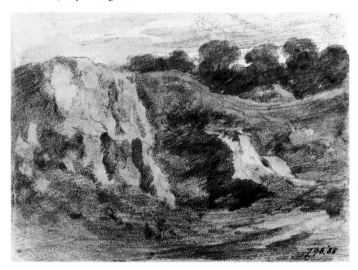

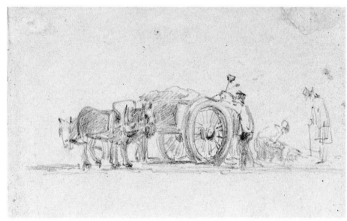

293. (21.91) *A Man watching workmen loading a cart*, Victoria and Albert Museum, 8·4 × 11·3cm.

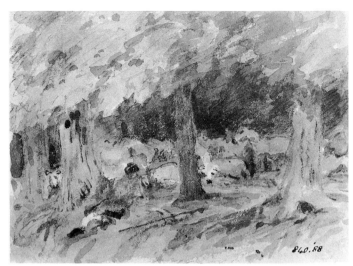

294. (21.92) *Scene in a wood : shepherd lying under the trees*, Victoria and Albert Museum, 8·4 × 11·2cm.

295. (21.93) *A countryman walking ; and a group round two donkeys*, Victoria and Albert Museum, 8·4 × 11·2cm.

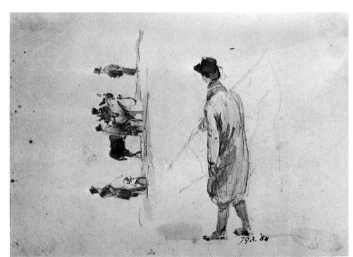

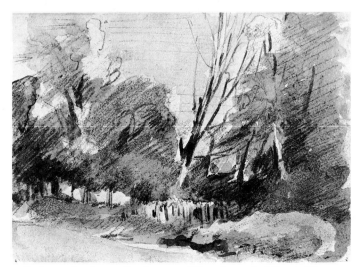

296. (21.94) *A woodland scene*, Victoria and Albert Museum, 8·4 × 11·2cm.

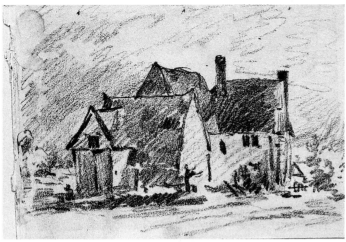

297. (21.95) *Cottage landscape*, Henry E. Huntington Library and Art Gallery, San Marino, 8·2 × 11·5cm.

298. (21.96) *Landscape with haystacks*, Henry E. Huntington Library and Art Gallery, San Marino, 8·3 × 11·3cm.

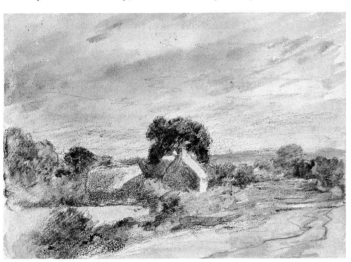

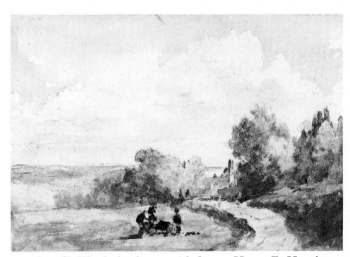

300. (21.98) *Woody landscape with figures*, Henry E. Huntington Library and Art Gallery, San Marino, 7·9 × 11·2cm.

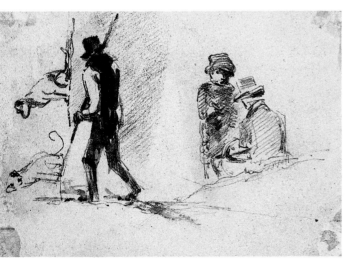

299. (21.97) *Studies of men and dogs*, Henry E. Huntington Library and Art Gallery, San Marino, 8·3 × 11·3cm.

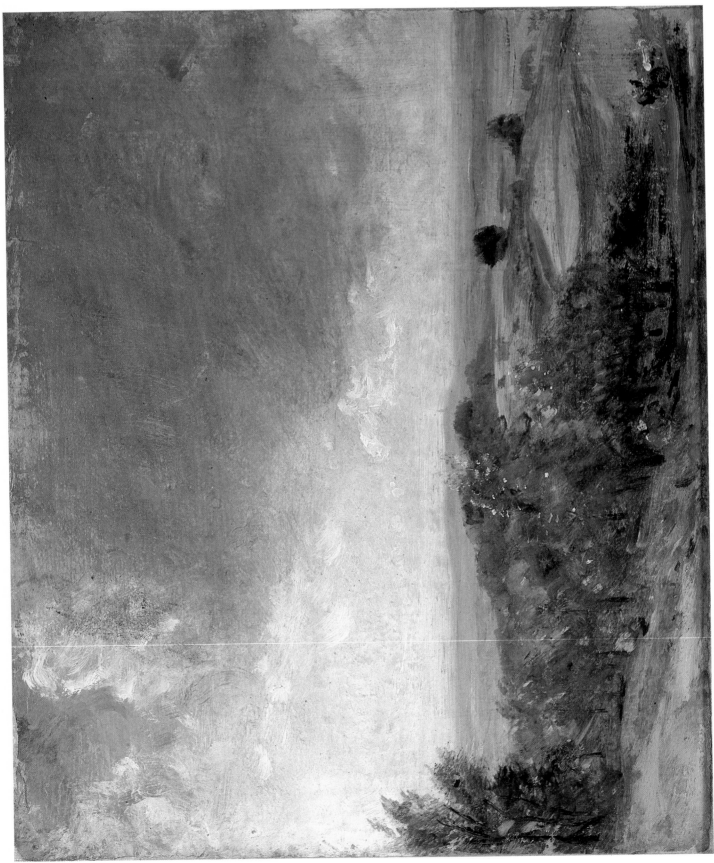

301. (21.99) *Hampstead Heath, looking towards Harrow*, Royal Academy of Arts, London, 24·5 × 29·8cm.

302. (below) (21.105) *Lower Terrace, Hampstead*, Victoria and Albert Museum, 24·8 × 35·2cm.

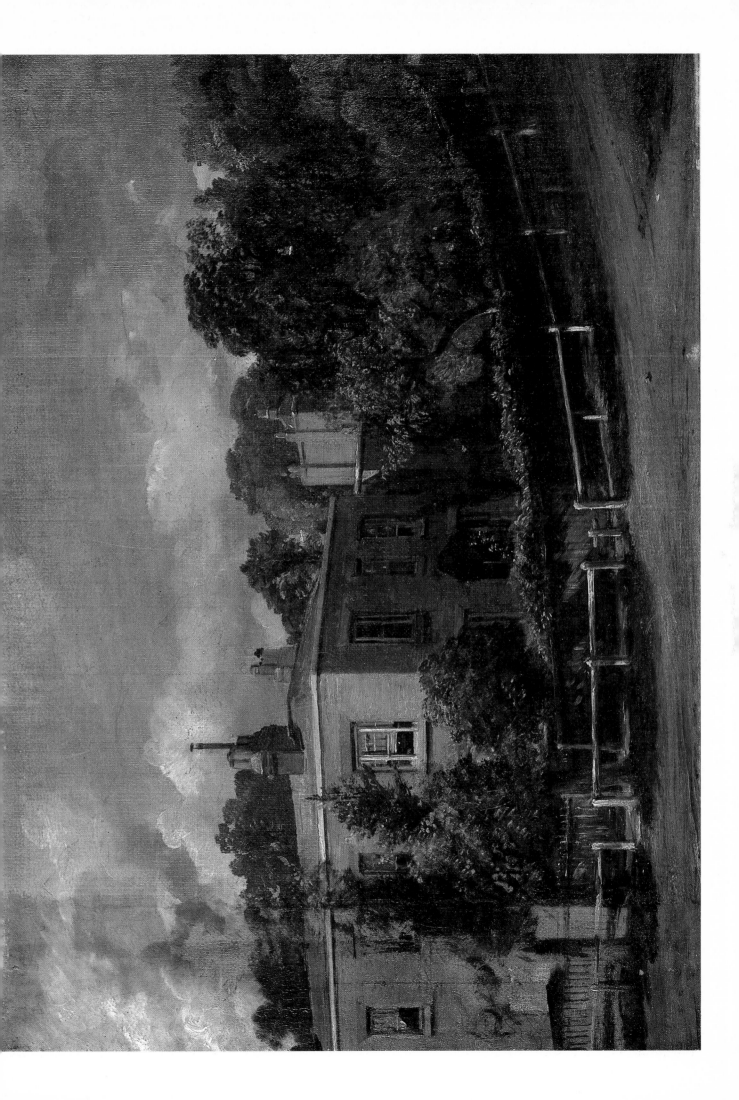

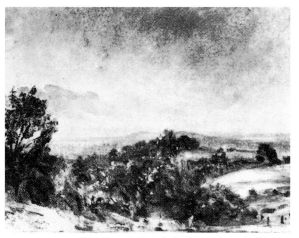

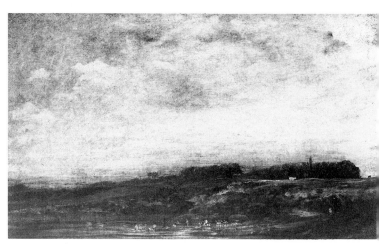

303. (21.100) *Hampstead Heath, looking towards Harrow*, Private collection, 24·1 × 29·8cm.

303a. (22.45) *Hampstead Heath*, Private collection, 24·7 × 40cm.

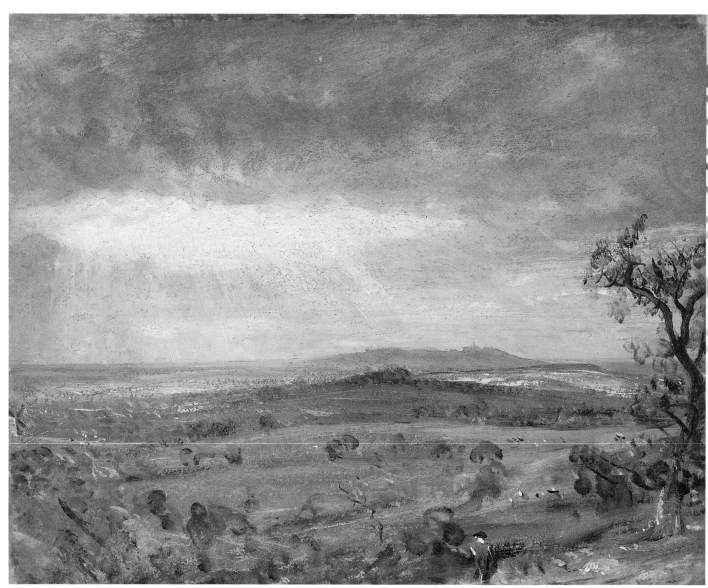

304. (21.101) *Hampstead Heath, looking towards Harrow*, Cleveland Museum of Art, Ohio, 25·1 × 30·5cm.

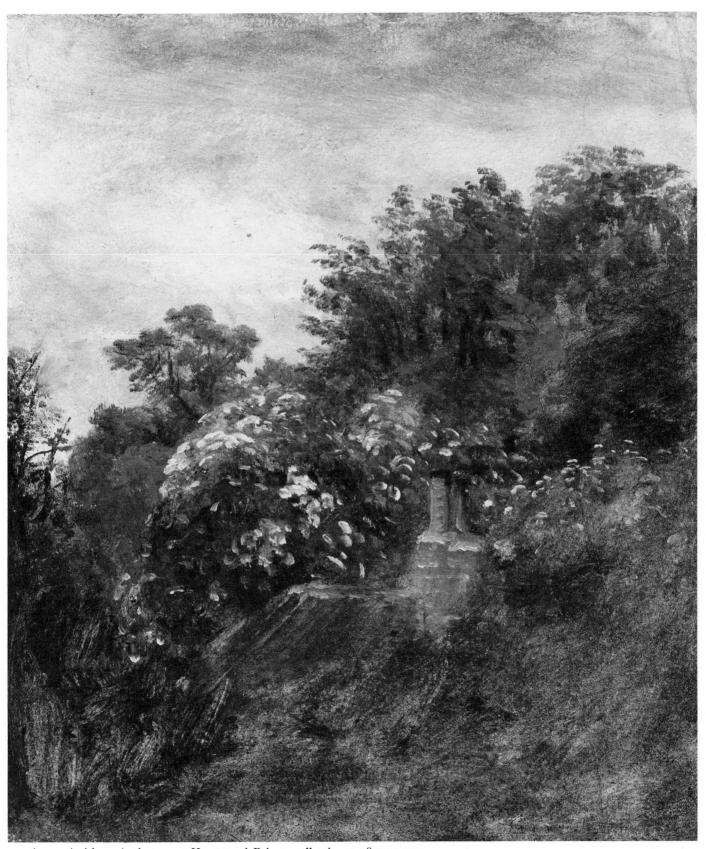

305. (21.102) *A house in the trees at Hampstead*, Private collection, 29·8 × 24·1cm.

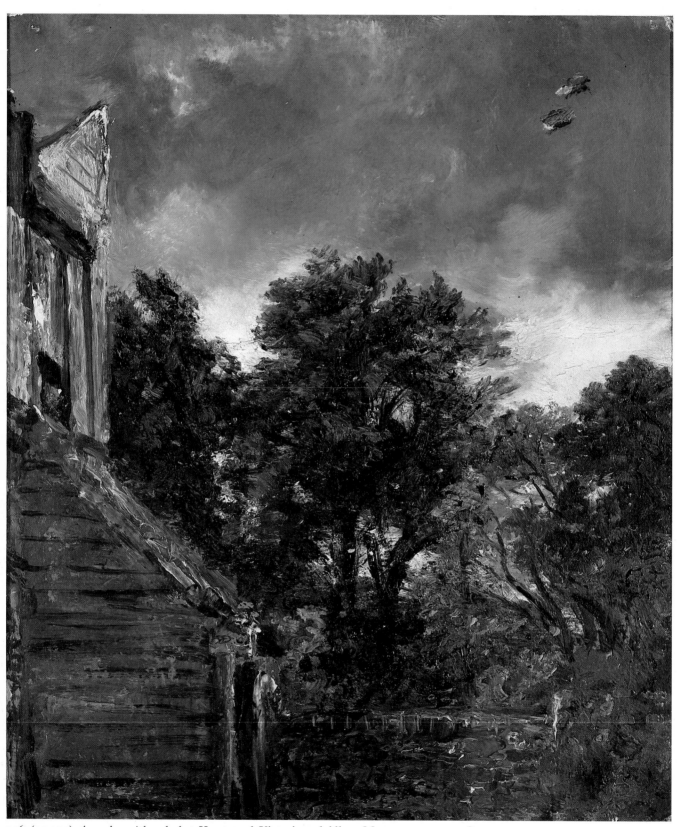

306. (21.103) *A garden with a shed at Hampstead*, Victoria and Albert Museum, 30·2 × 23·8cm.

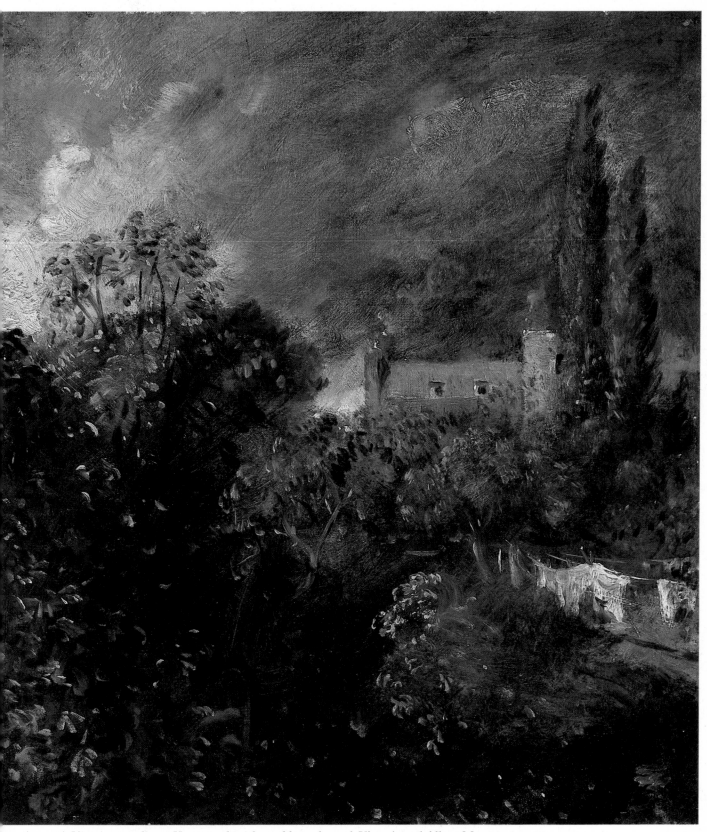

207. (21.104) *View in a garden at Hampstead, with a red house beyond*, Victoria and Albert Museum, 35·5 × 30·5cm.

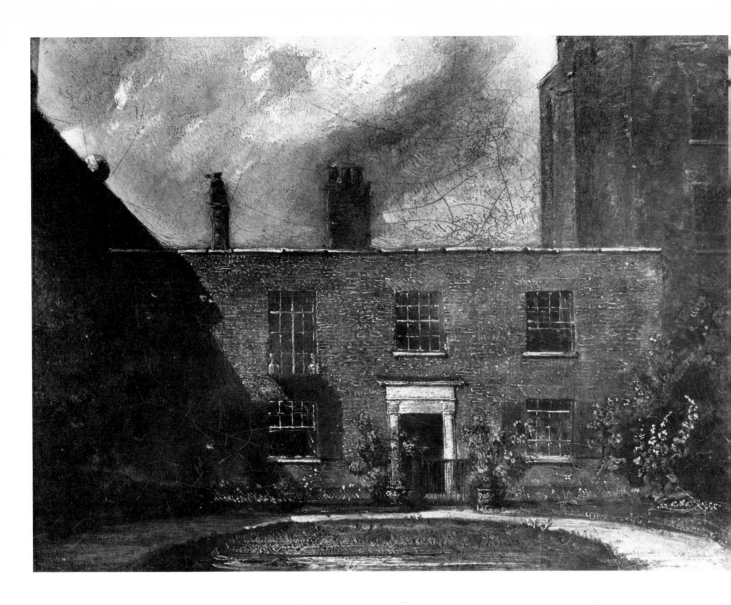

308. (above) (21.106)
*Lower Terrace,
Hampstead*, South
African National
Gallery, Cape Town,
24 × 30cm.

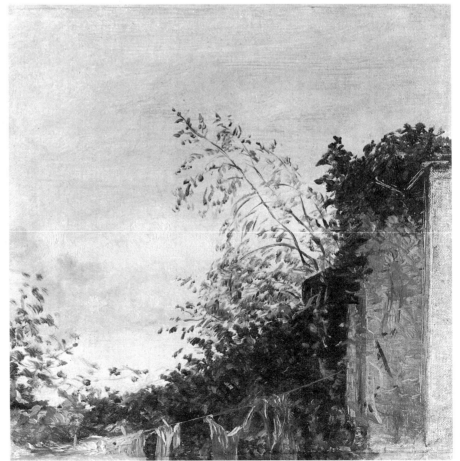

309. (21.109) *A garden
scene with washing on a
clothes line*, Private
collection,
17·2 × 17·2cm.

310. (21.110) *The roof of a house seen through trees*, Private collection, 17 × 23·5cm.

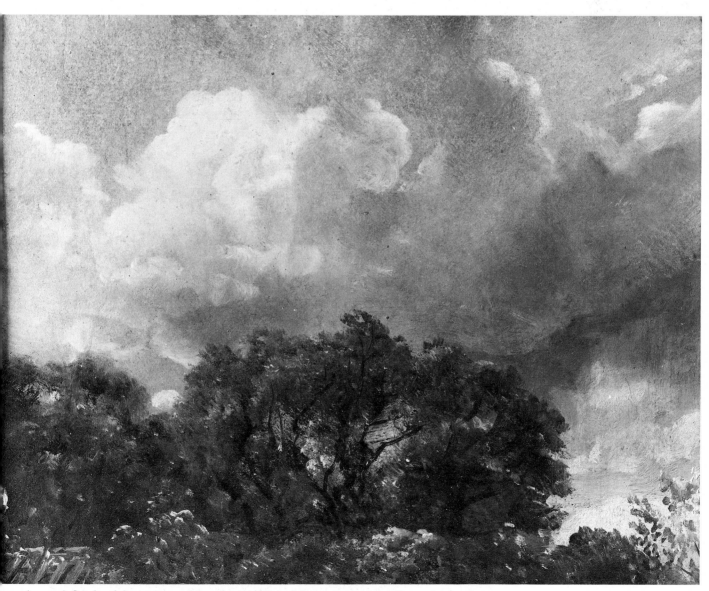

311. (21.111) *Study of sky and trees*, Victoria and Albert Museum, 25·4 × 29·8cm.

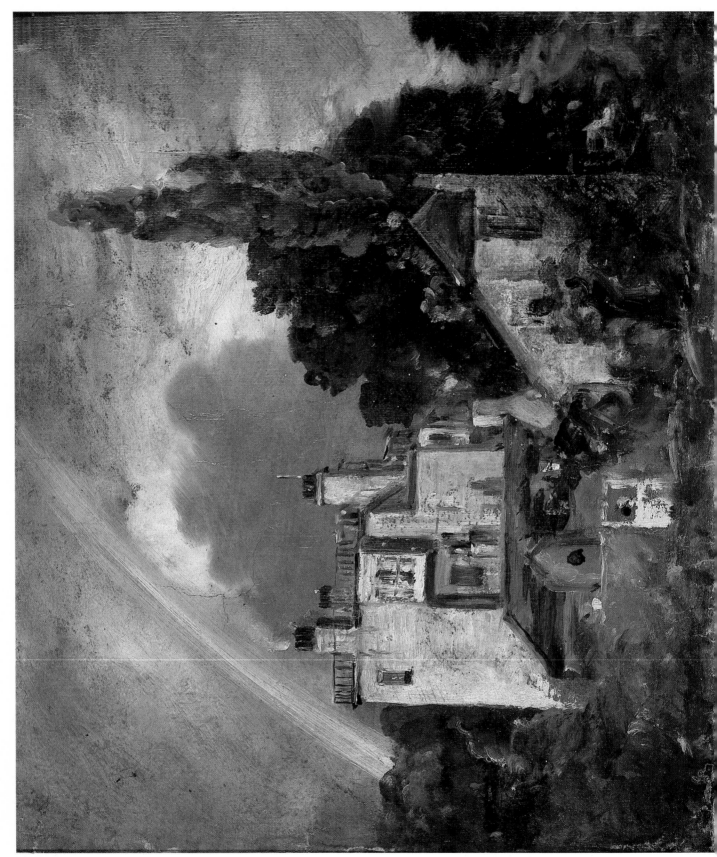

312. (21.107) *The Grove, Hampstead,* Victoria and Albert Museum, 24·5 × 20·2cm.

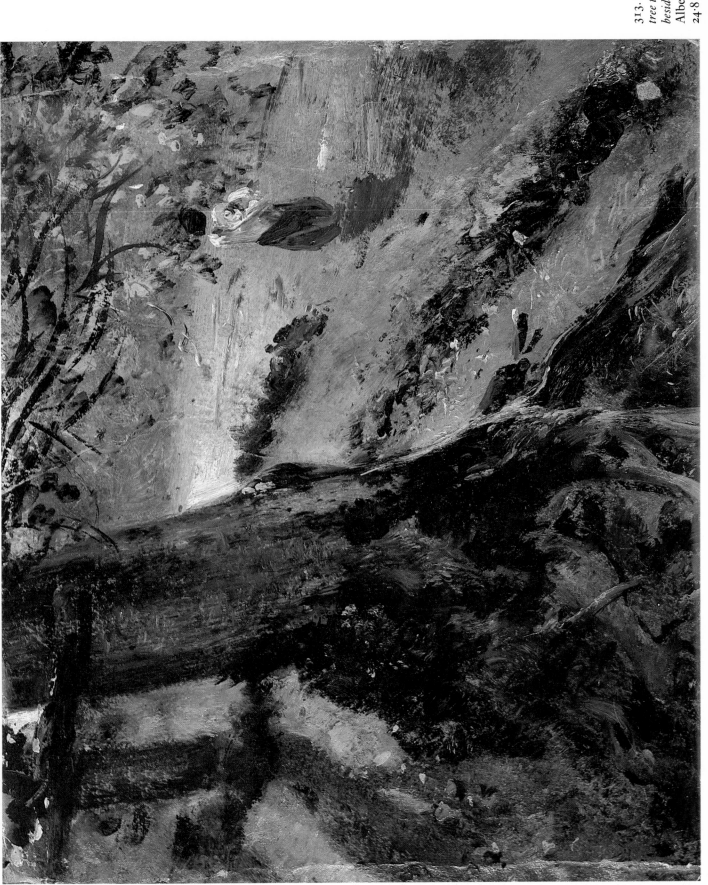

313. (21.114) *Study of tree trunks, with a figure beside them*, Victoria and Albert Museum, 24·8 × 29·2 cm.

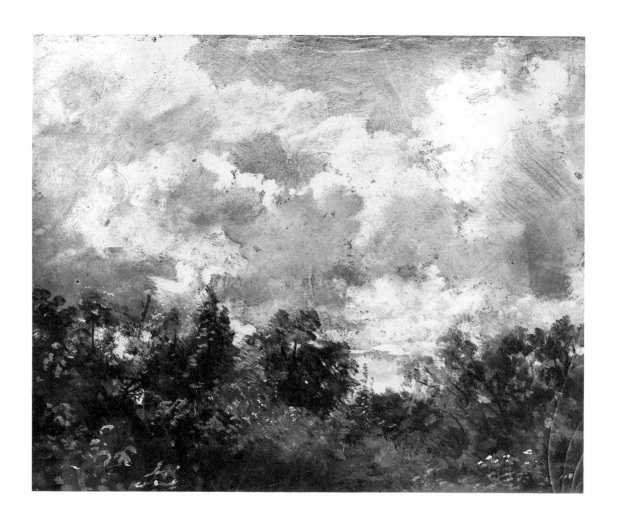

314. (above) (21.112)
*Study of sky and
trees*, Victoria and
Albert Museum,
24·8 × 29·8cm.

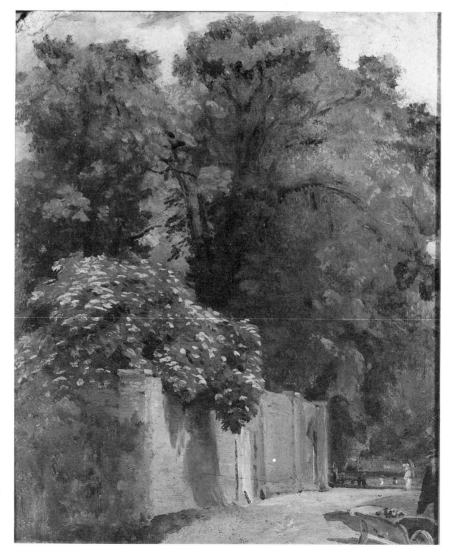

315. (21.115) *An
elder tree in blossom
over a garden wall*,
Hugh Lane
Municipal Gallery of
Modern Art,
Dublin,
28·6 × 22·2cm.

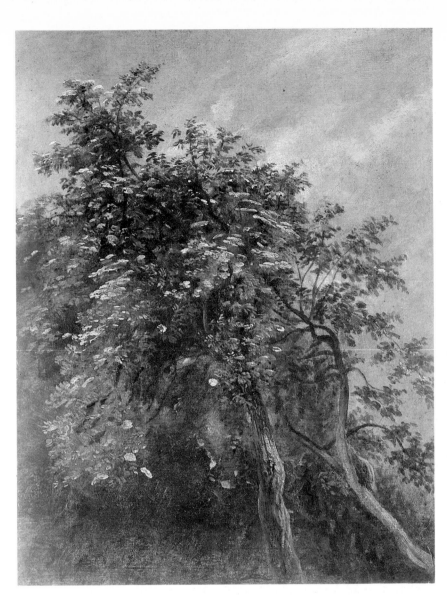

316. (21.116) *Two elder trees in blossom*, Private collection, 32·4 × 26·7cm.

317. (below) (21.117) *A view on Hampstead Heath*, John G. Johnson Collection, Philadelphia, 25 × 28cm.

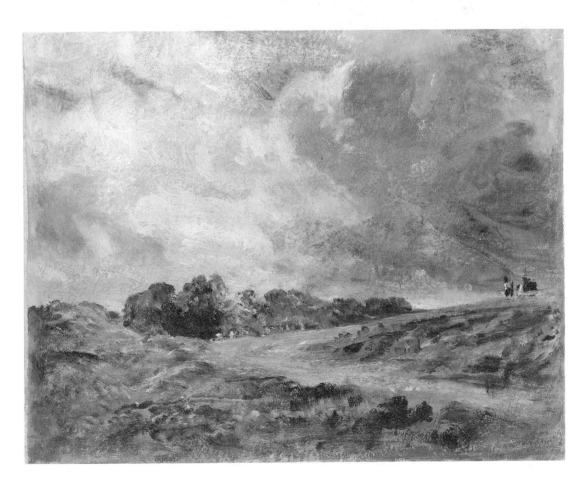

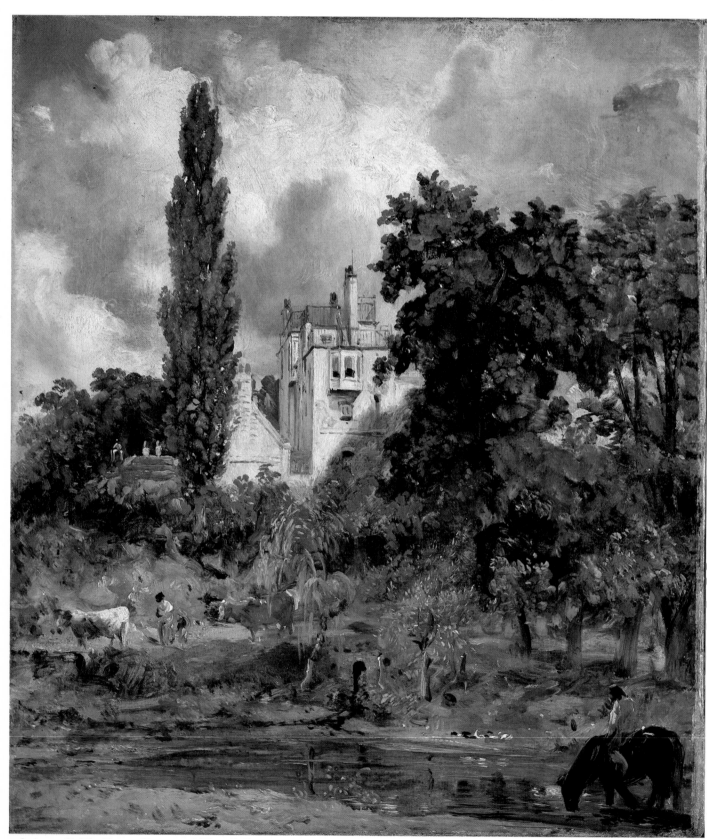

318. (21.108) *The Grove, Hampstead*, Tate Gallery, 35·6 × 30·2cm.

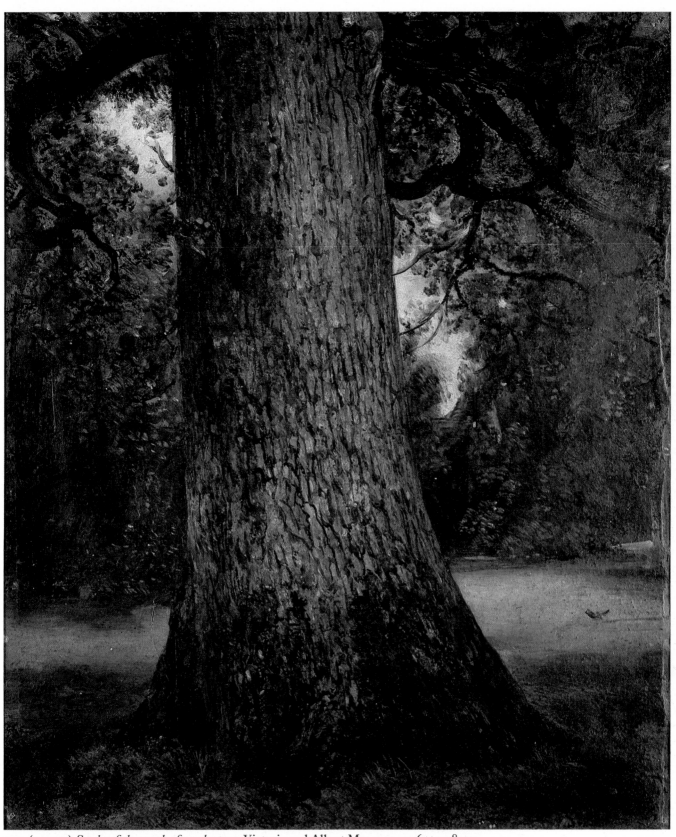

319. (21.113) *Study of the trunk of an elm tree*, Victoria and Albert Museum, 30·6 × 24·8cm.

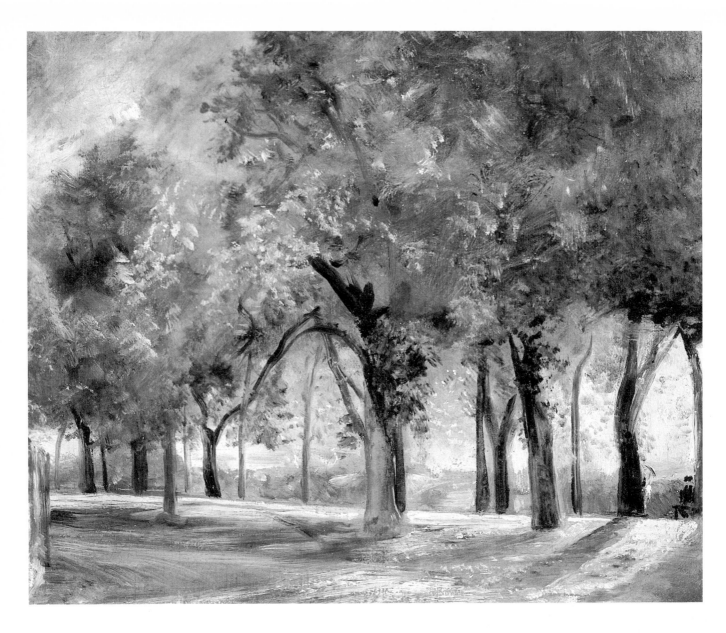

320. (above) (21.118)
*Judges' Walk,
Hampstead*, Private
collection, 30 × 35cm.

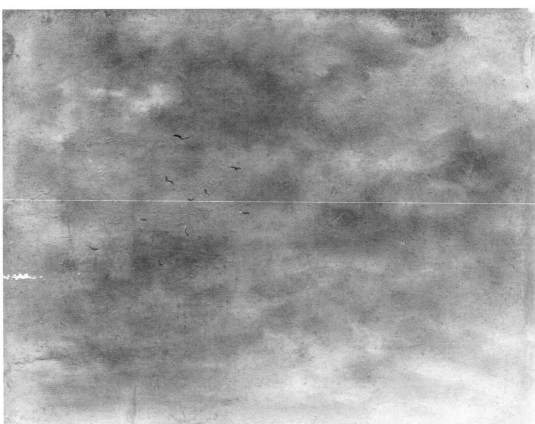

321. (21.120) *Cloud
study*, Private
collection,
24·7 × 30·2cm.

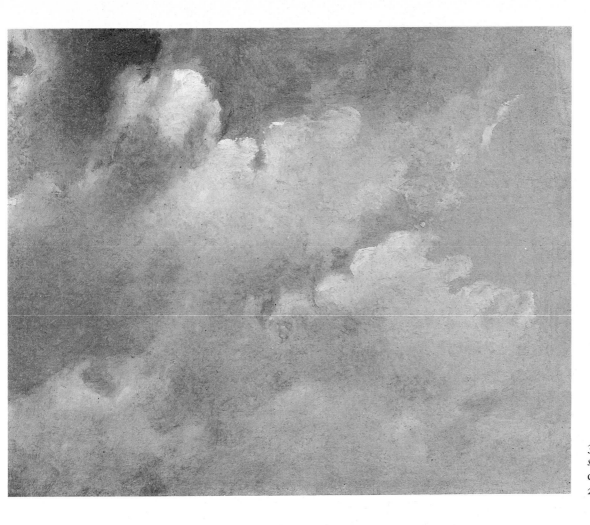

322. (21.121) *Cloud study*, Private collection, 24·1 × 29·2cm.

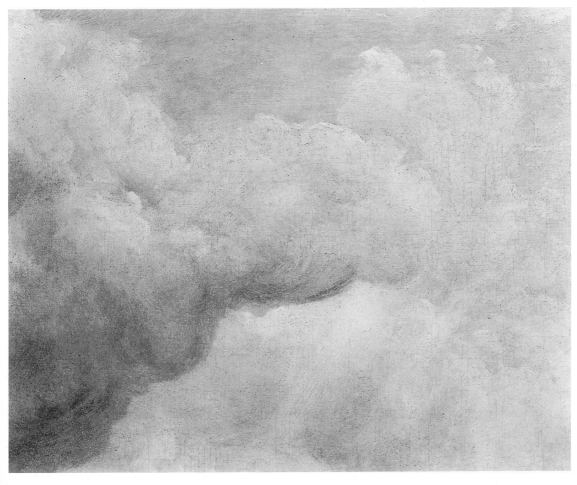

323. (21.122) *Cloud study*, Yale Center for British Art, New Haven, 19·3 × 24cm.

324. (21.119) *Cloud study*, Yale Center for British Art, New Haven, 25·3 × 30·5cm.

325. (below) (21.128) *Cloud study*, Whitworth Art Gallery, Manchester, 23·8 × 33cm.

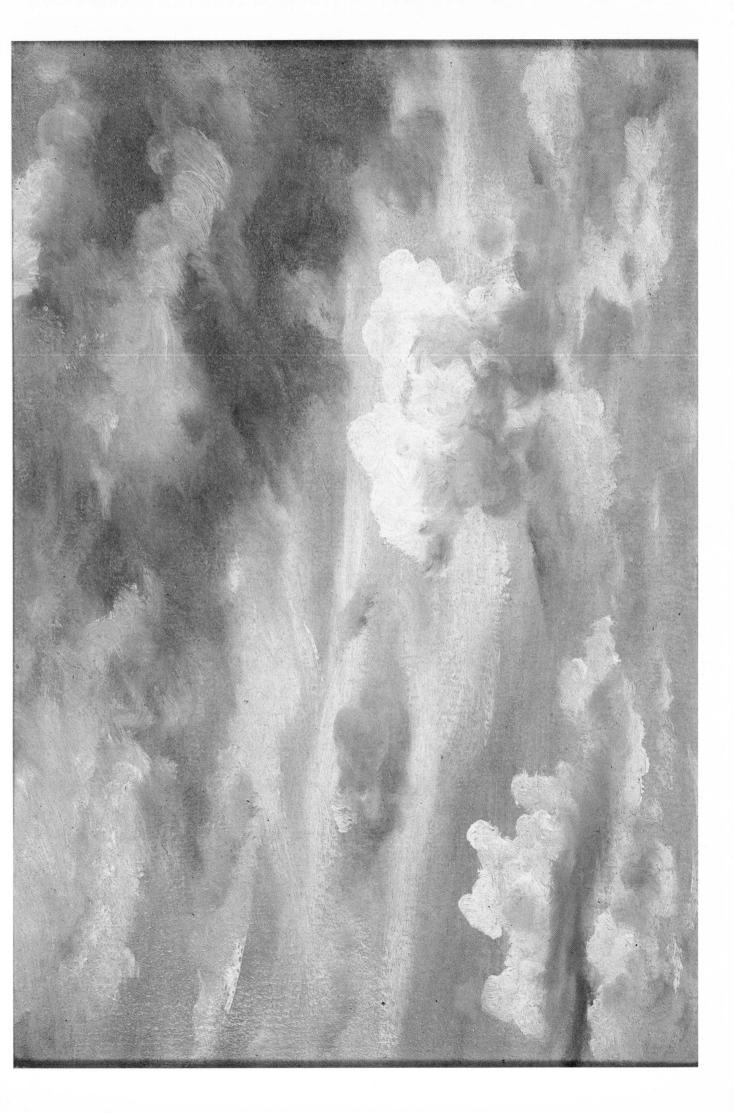

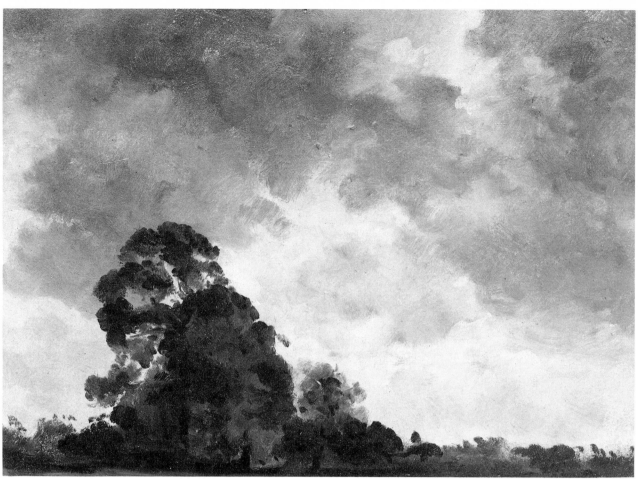

326. (21.123) *Clouds over a landscape with a tall tree*, Yale Center for British Art, New Haven, 21 × 28·5cm.

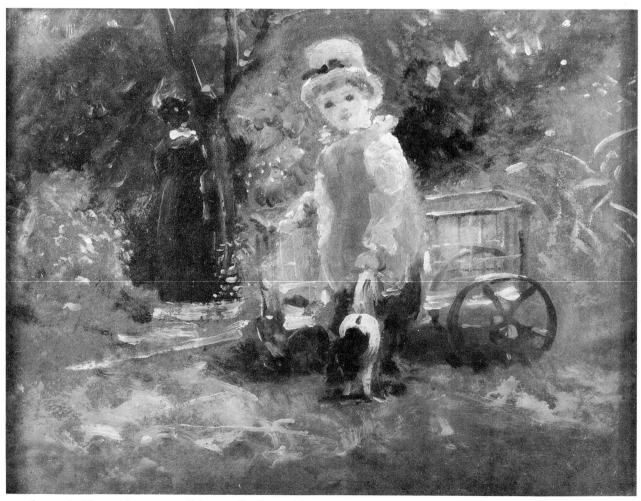

327. (21.124) *A boy with a toy cart*, Private collection, 19·6 × 24·1cm.

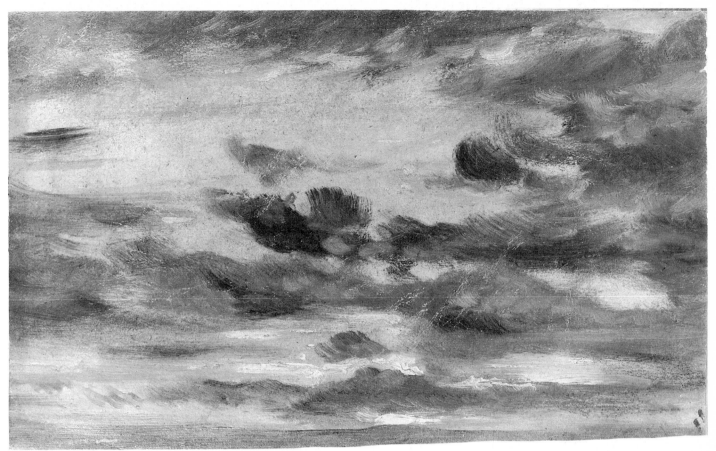

328. (21.125) *Cloud study*, Fitzwilliam Museum, Cambridge, 14·6 × 22·3cm.

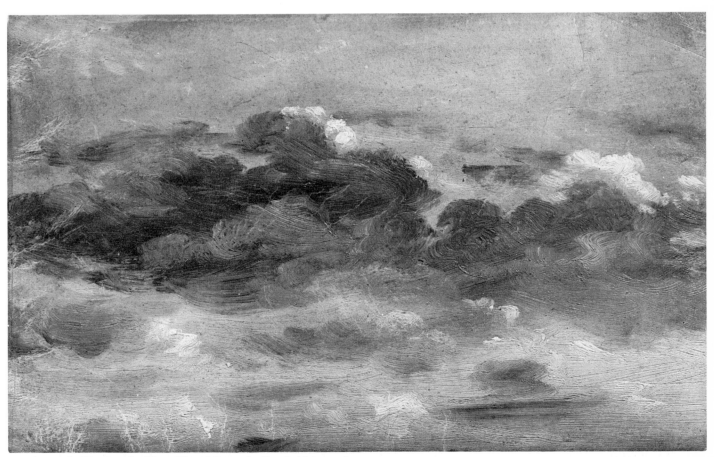

329. (21.126) *Cloud study*, Fitzwilliam Museum, Cambridge, 14·6 × 22·3cm.

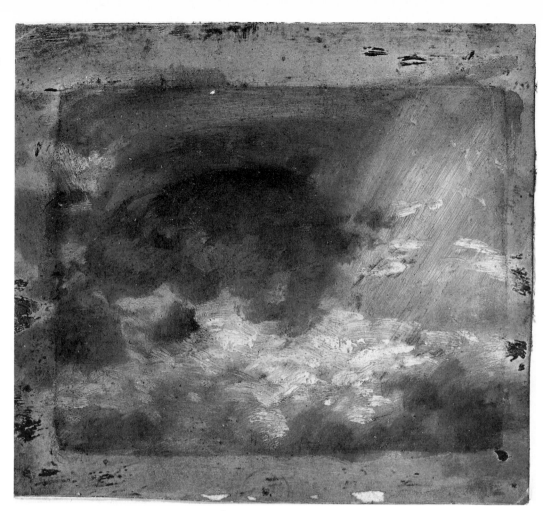

330. (21.127) *Cloud study*, Fitzwilliam Museum, Cambridge, 13·3 × 14·9cm.

331. (21.129) *Cloud study*, Private collection, 22 × 29·2cm.

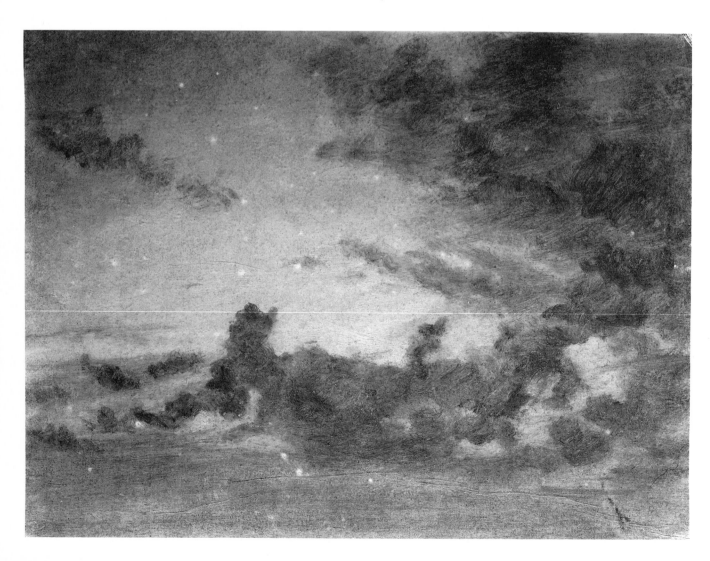

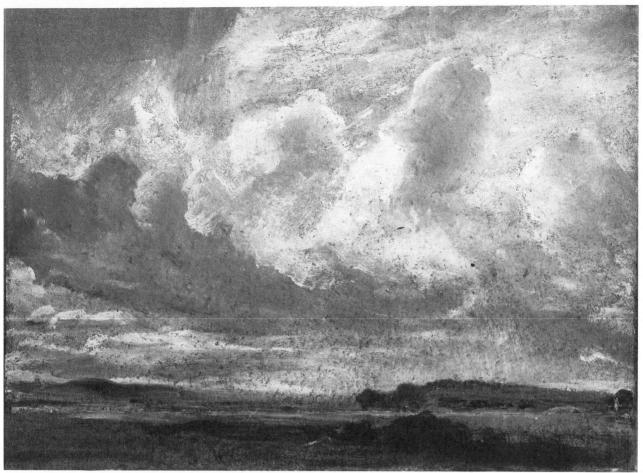

332. (21.130) *Study of clouds over a landscape*, Private collection, 21 × 27cm.

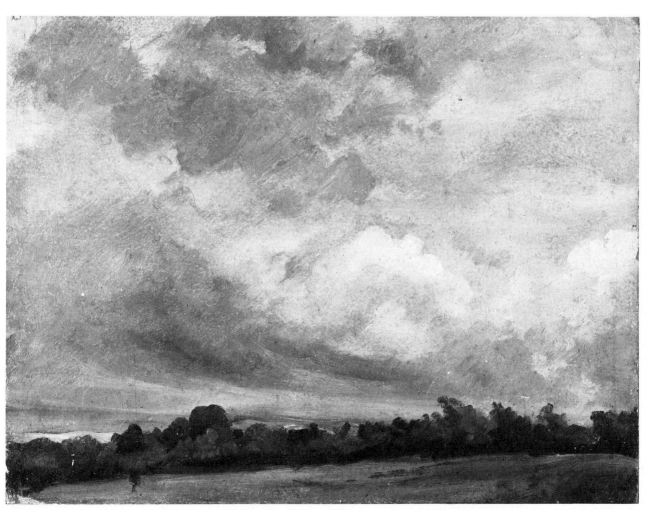

333. (21.131) *Clouds over a wide landscape*, Ferens Art Gallery, Kingston-upon-Hull, 23·3 × 30·5cm.

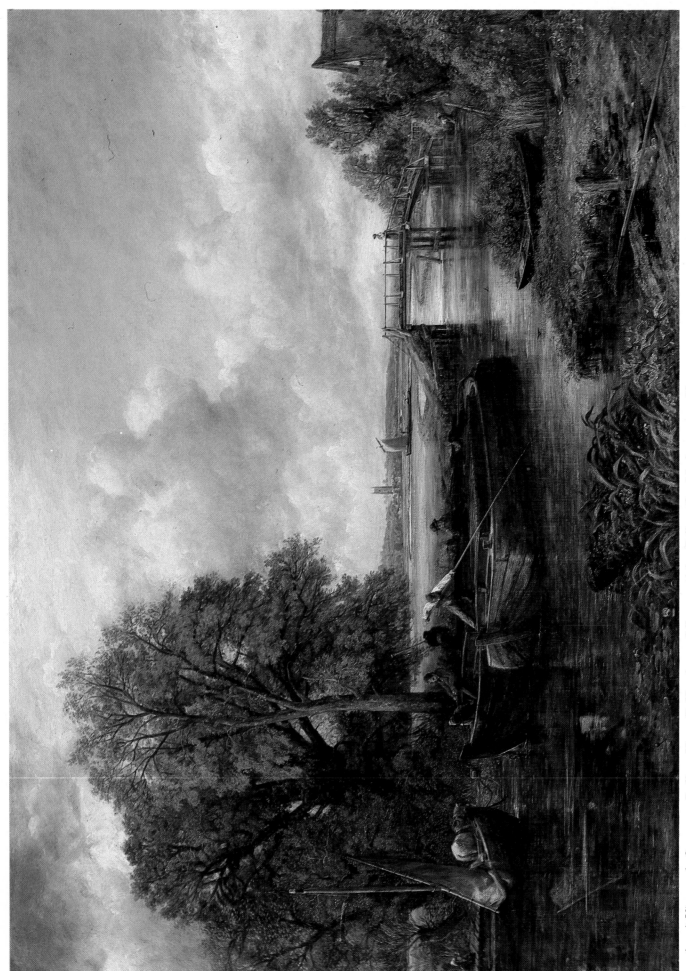

334. (22.1) *View on the Stour near Dedham*, Henry E. Huntington Library and Art Gallery, San Marino, 130 × 188cm.

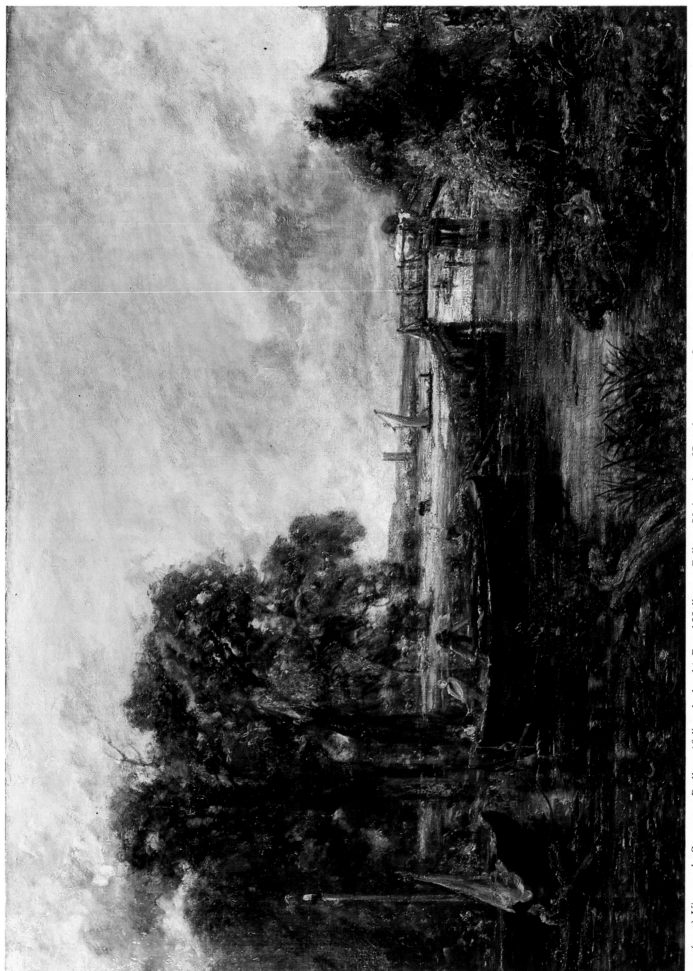

335. (22.2) *View on the Stour near Dedham (full-scale sketch)*, Royal Holloway College, University of London, 129·4 × 185·3cm.

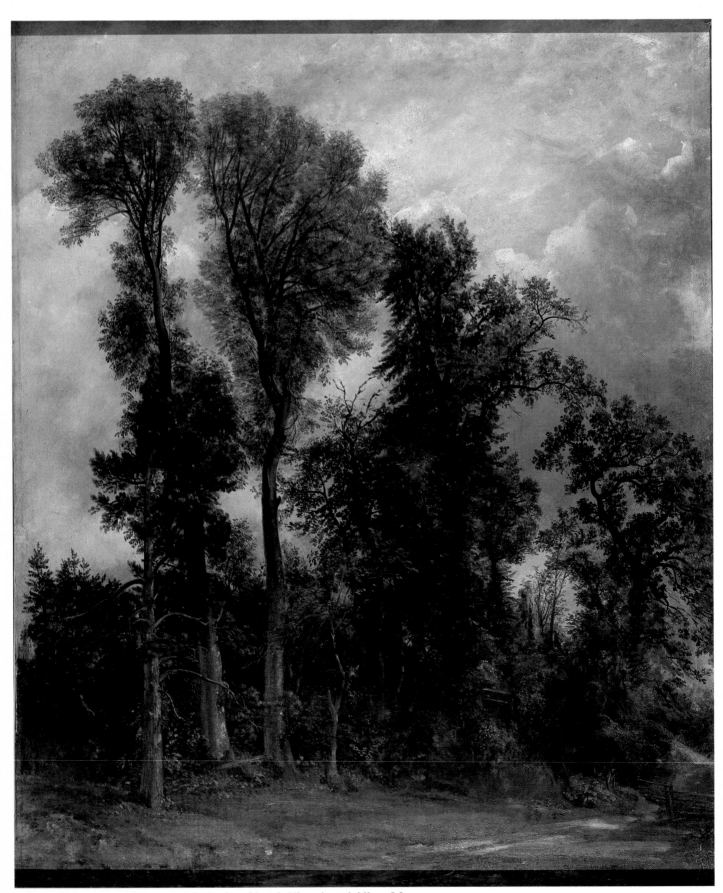

336. (22.6) *Trees at Hampstead: The Path to Church*, Victoria and Albert Museum, 91·4 × 72·4cm.

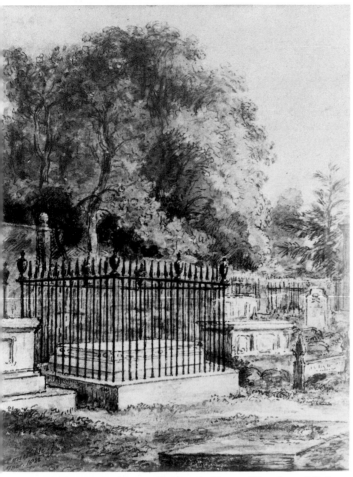

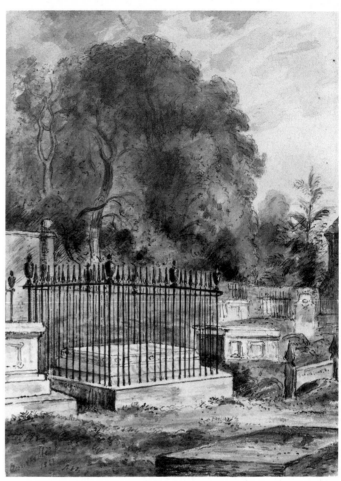

337. (22.7) *The tomb of James Gubbins in Epsom Churchyard*, Private
collection, 19·7 × 14·6cm.

338. (22.8) *The tomb of James Gubbins in Epsom Churchyard*,
Private collection, 19·7 × 14·6cm.

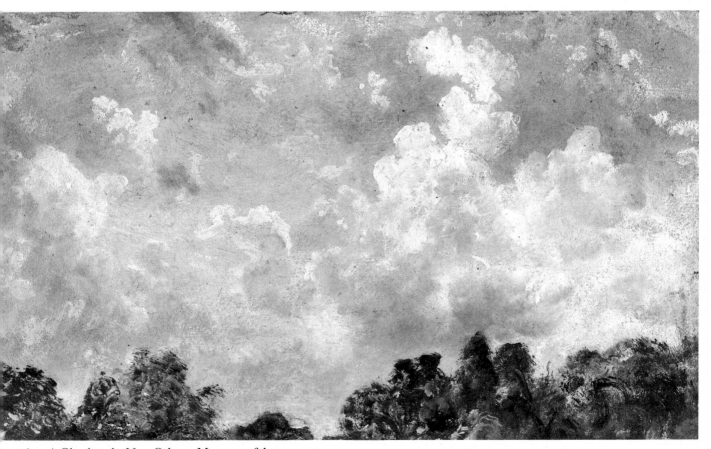

339. (22.9) *Cloud study*, New Orleans Museum of Art, 32·1 × 49·5cm.

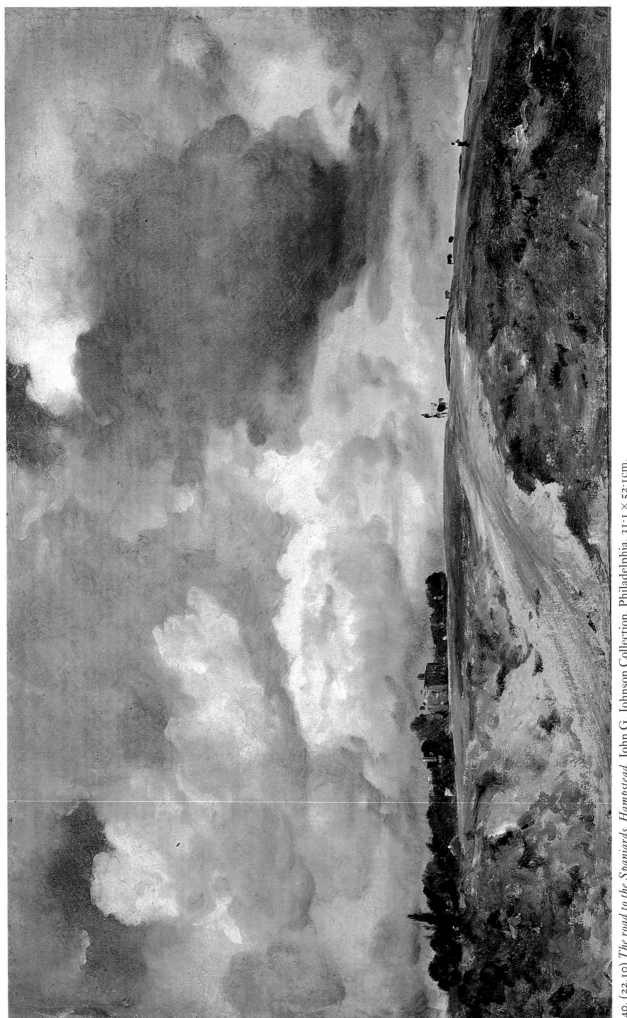

340. (22.10) *The road to the Spaniards, Hampstead*, John G. Johnson Collection, Philadelphia, 31·1 × 52·1 cm.

341. (left) (22.11) *Study of clouds*, Private collection, N.Y., 29 × 48cm.

342. (bottom left) (22.13) *A view on Hampstead Heath with trees and figures*, Victoria and Albert Museum, 24·2 × 29·8cm.

343. (22.18) *Cloud study*, Dr Charles Warren, 25·4 × 22·2cm.

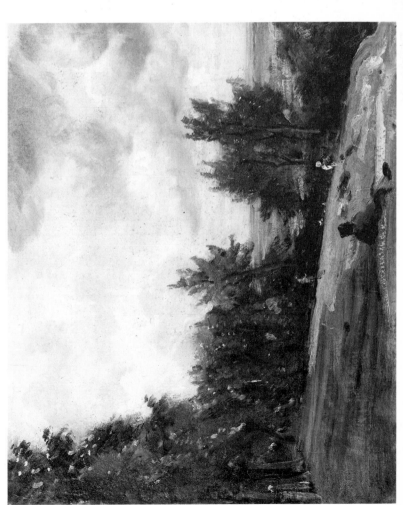

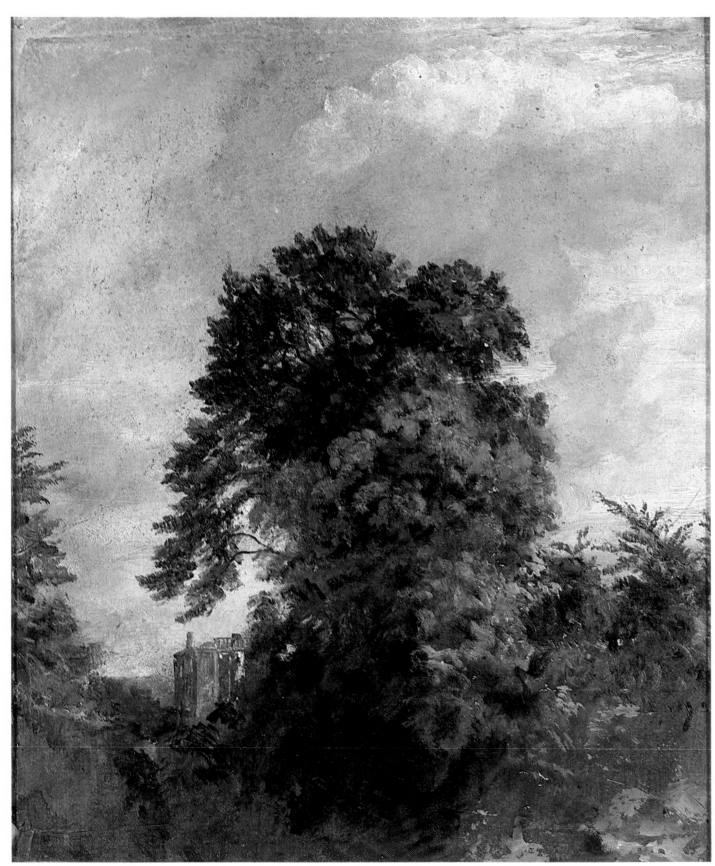

344. (22.12) *Distant view of the Grove, Hampstead*, Royal Academy of Arts, London, 29·2 × 24·1cm.

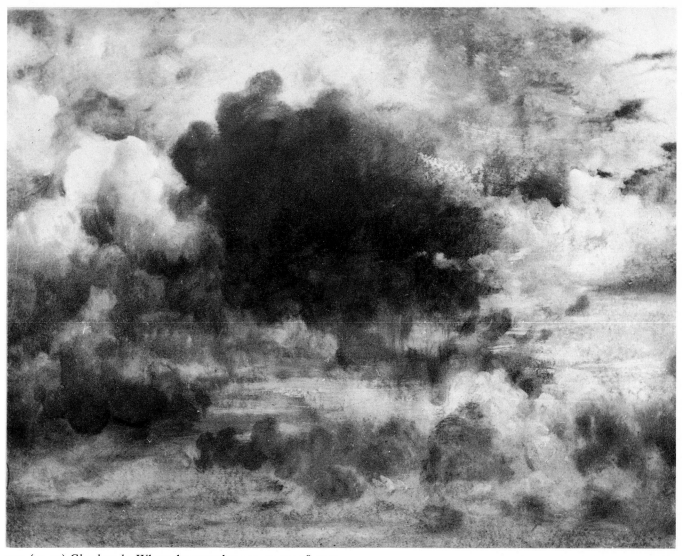

345. (22.17) *Cloud study*, Whereabouts unknown, 47·2 × 58·4cm.

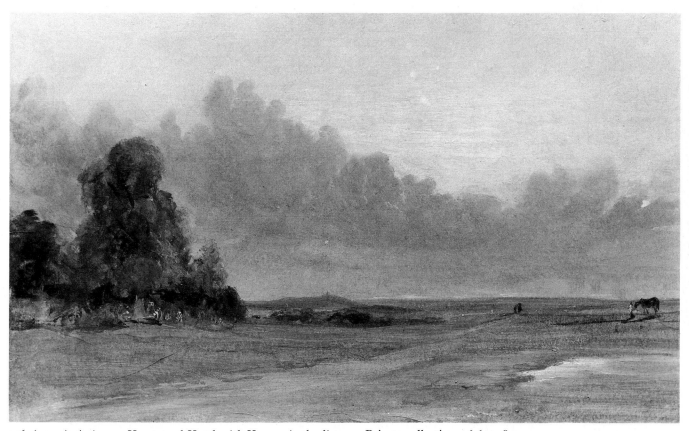

346. (22.19) *A view on Hampstead Heath with Harrow in the distance*, Private collection, 26·6 × 48·2cm.

347. (22.14) *A view at Hampstead : evening*, Victoria and Albert Museum, 16·5 × 29·8cm.

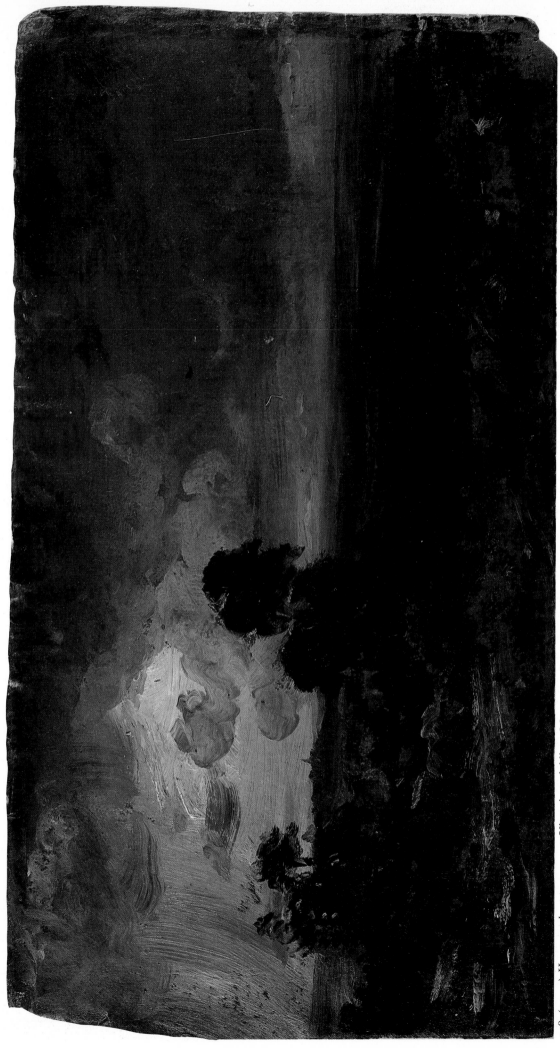

348. (22.15) *Hampstead: stormy sunset*, Victoria and Albert Museum, 16·2 × 30·5cm.

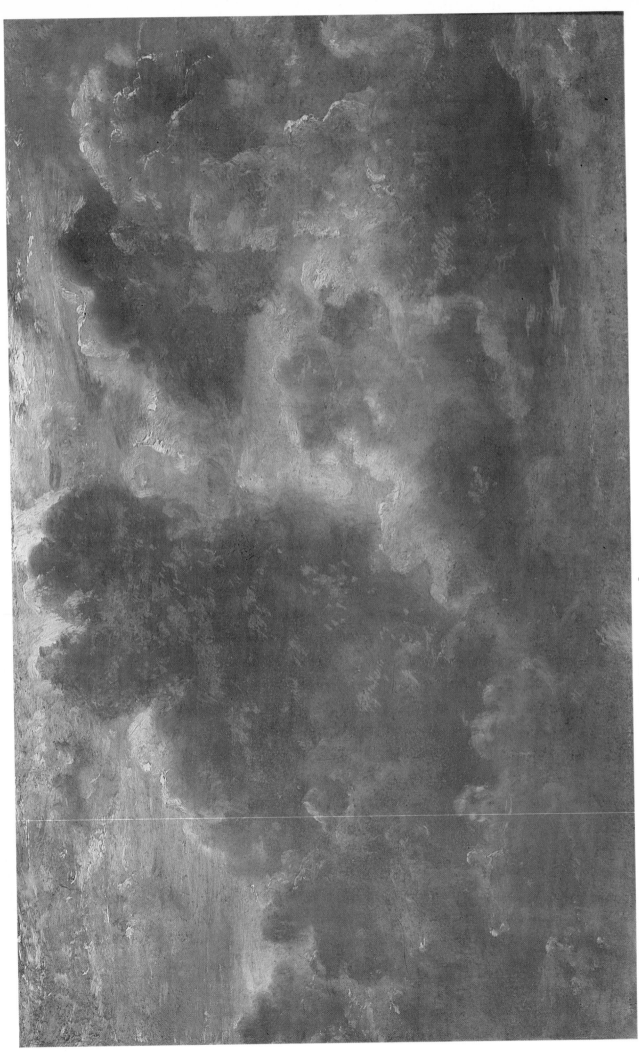

349. (22.16) *Study of cumulus clouds*, Yale Center for British Art, New Haven, 30·5 × 50·8cm.

350. (below) (22.21) *Cloud study*, Tate Gallery, 47·5 × 57·5cm.

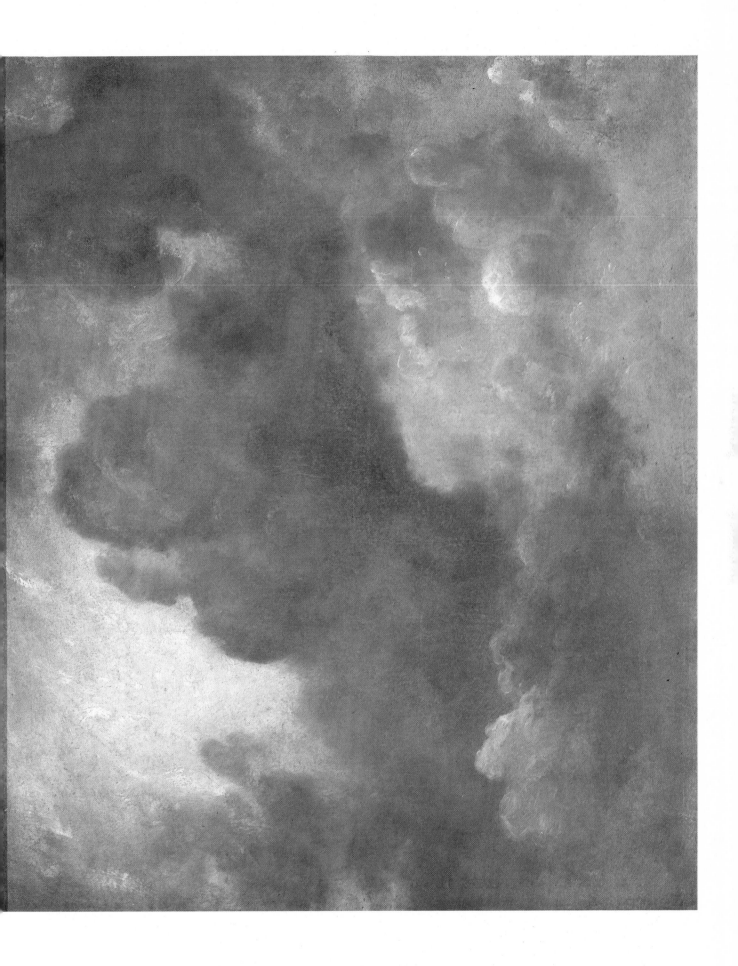

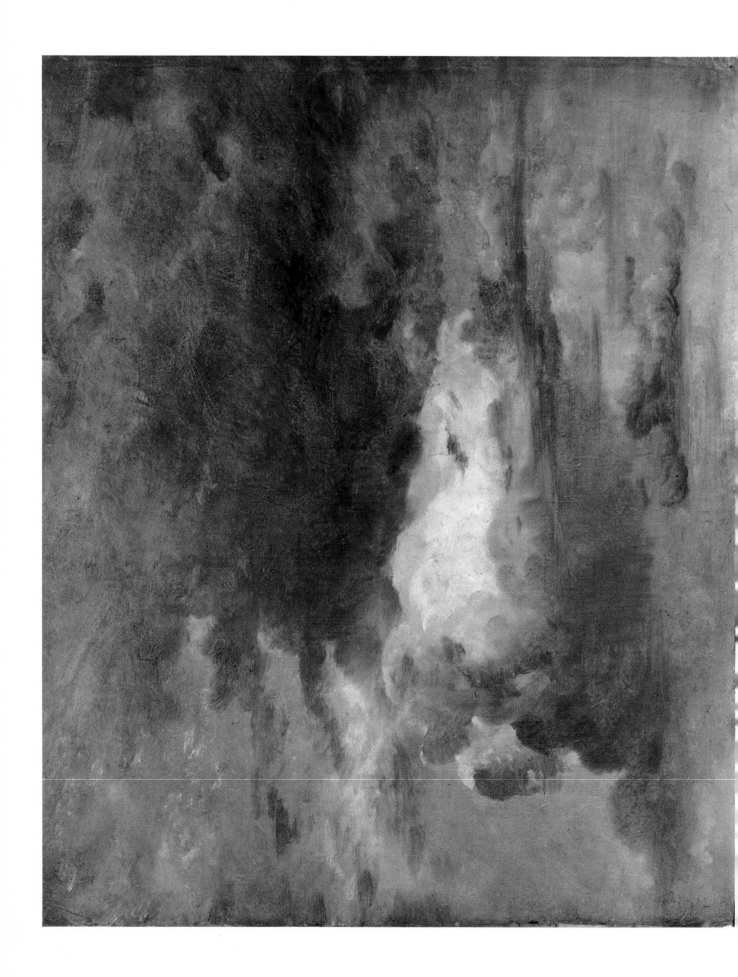

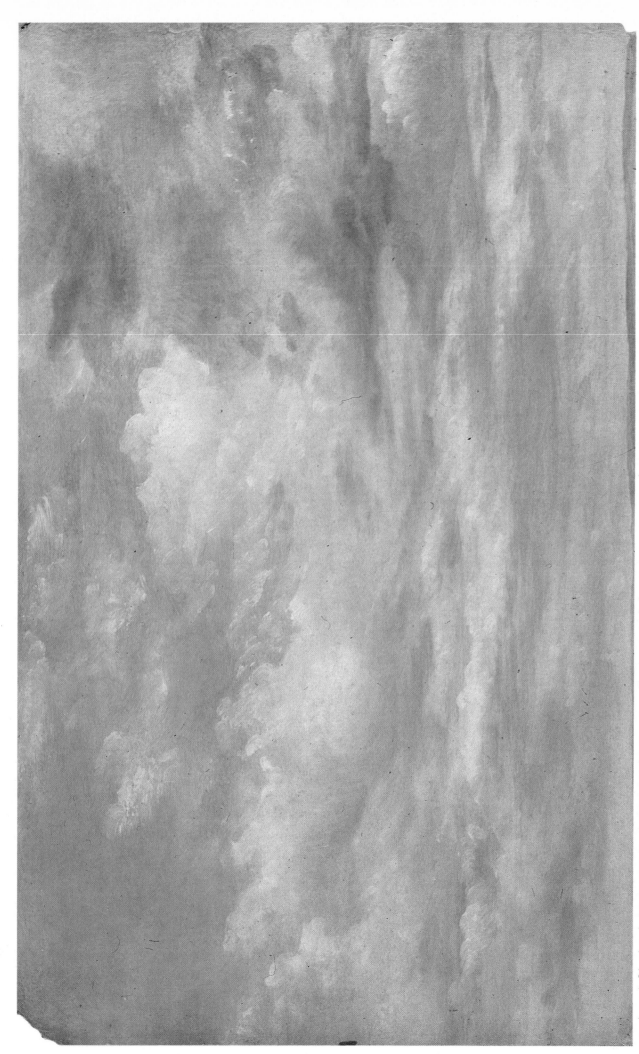

351. (above) (22.22) *Cloud study: evening*, City Museums and Art Gallery, Birmingham, 47 × 58cm.

352. (22.23) *Cloud study*, National Gallery of Victoria, Melbourne, 37 × 49cm.

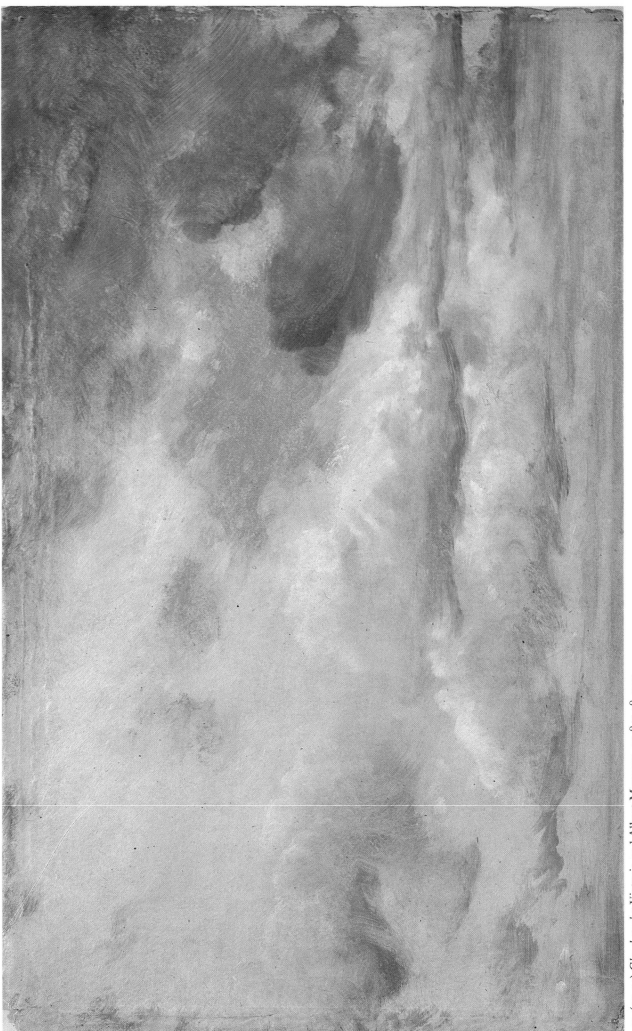

353. (22.24) *Cloud study*, Victoria and Albert Museum, 29·8 × 48·3cm.

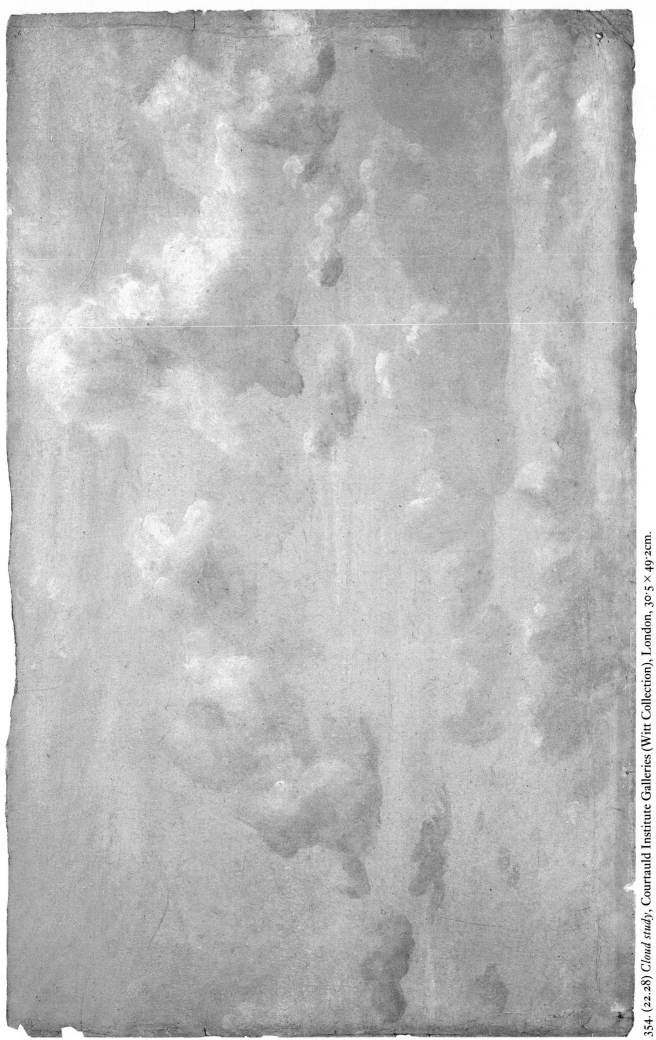

354. (22.28) *Cloud study*, Courtauld Institute Galleries (Witt Collection), London, 30·5 × 49·2cm.

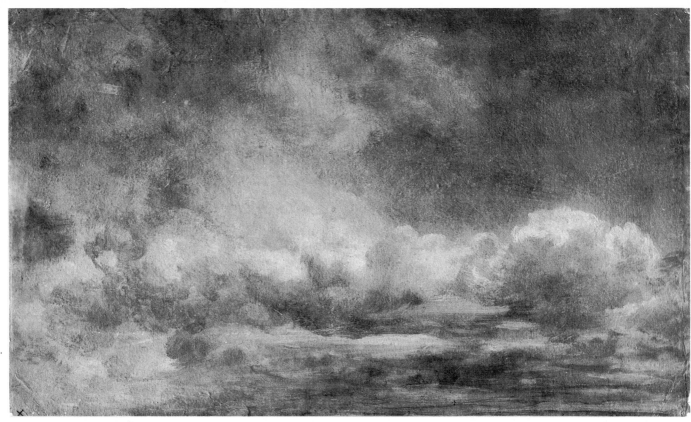

355. (22.25) *Cloud study*, Private collection, (?) *c*30 × 50cm.

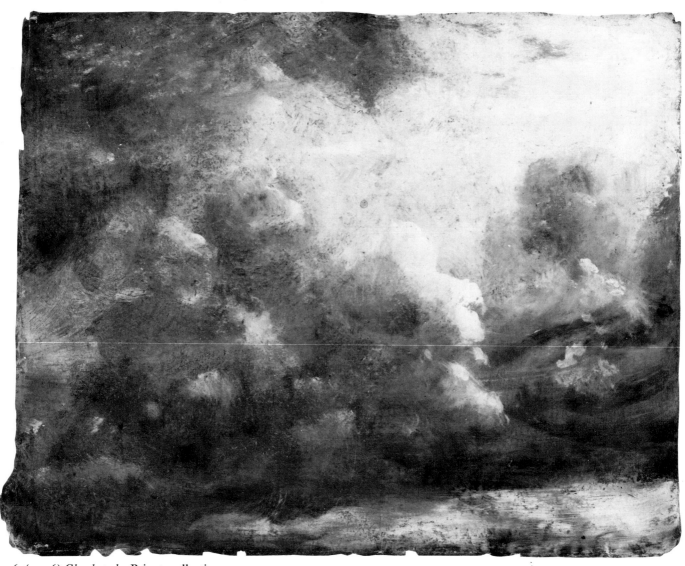

356. (22.26) *Cloud study*, Private collection.

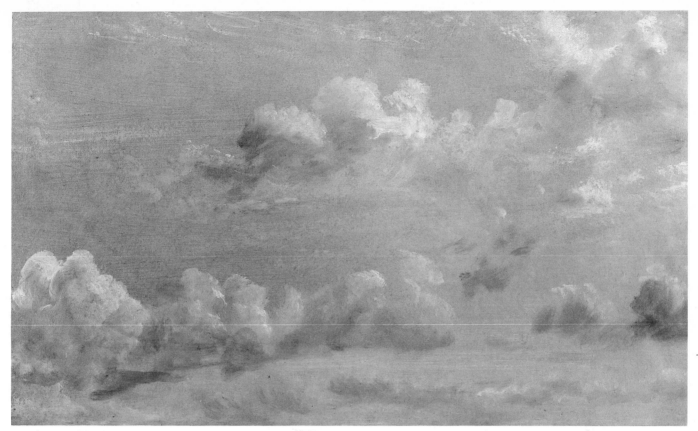

357. (22.27) *Cloud study*, Yale Center for British Art, New Haven, 28·7 × 48·3cm.

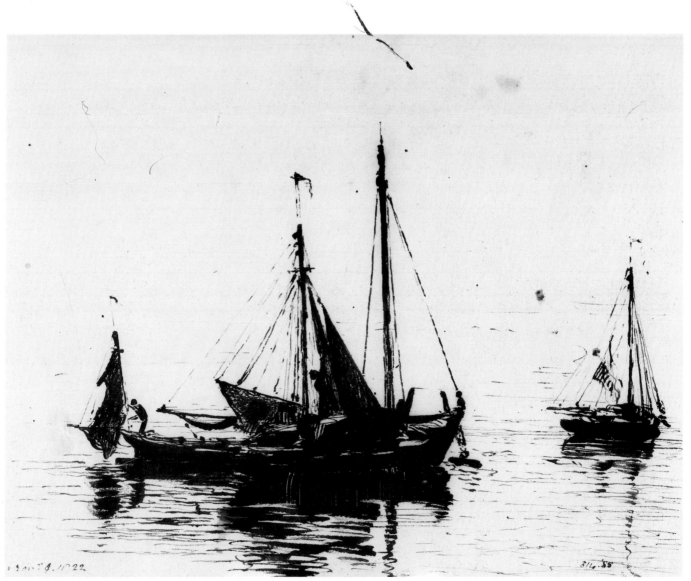

358. (22.32) *Fishing boats at anchor*, Victoria and Albert Museum, 18·5 × 22·4cm.

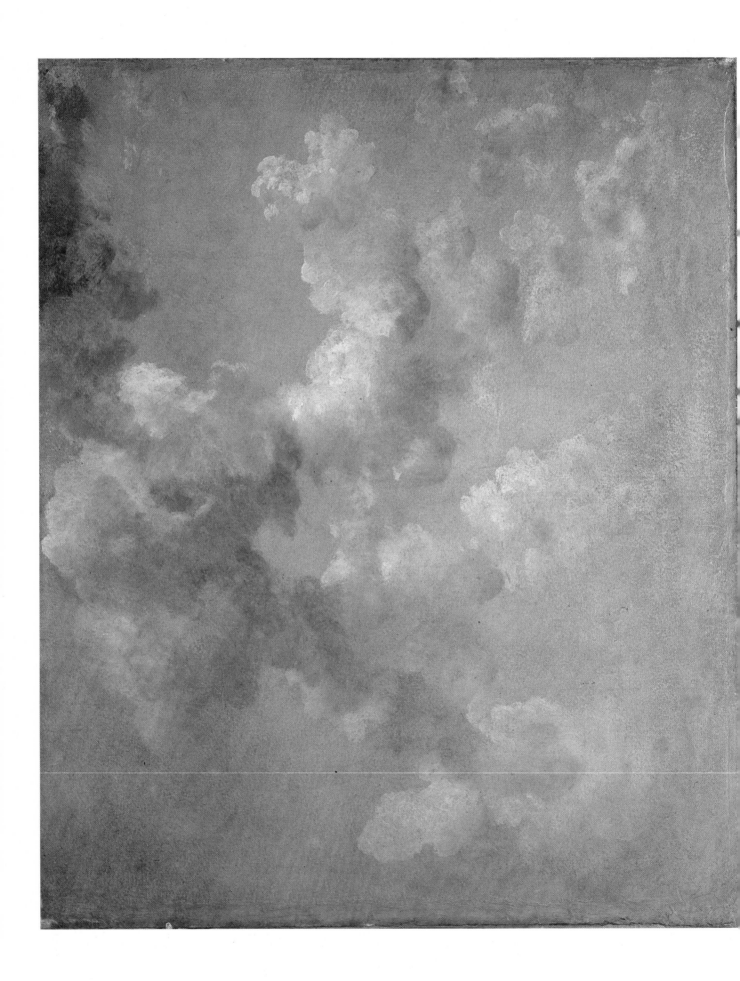

359. (above) (22.30) *Cloud study*, Ashmolean Museum, Oxford, 48 × 59cm.

360. (22.42) *Hampstead Heath, looking towards Harrow*, Yale Center for British Art, New Haven, 29·5 × 48·5cm.

361. (22.33) *Lady Lucy Digby, after Catherine Read*, Private collection, 45·1 × 36·2cm.

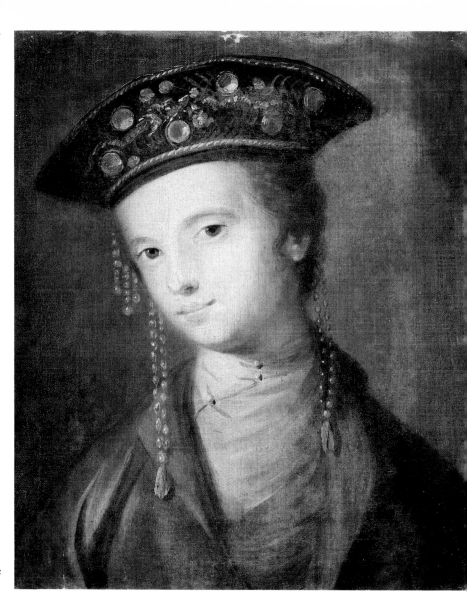

362. (below) (22·36) *Yarmouth Jetty*, Private collection, 31·7 × 50·8cm.

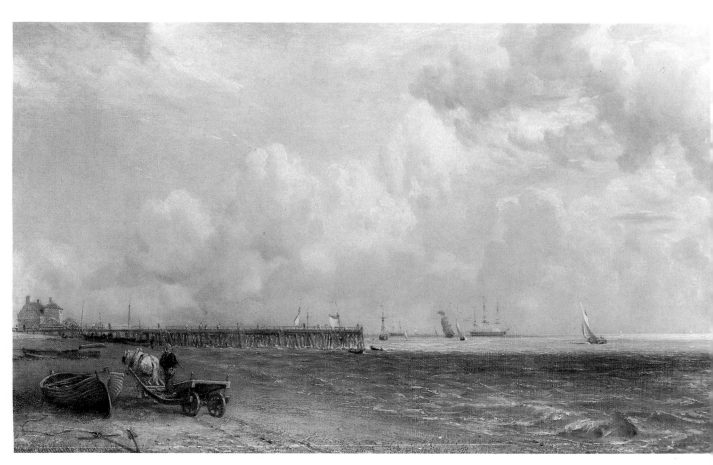

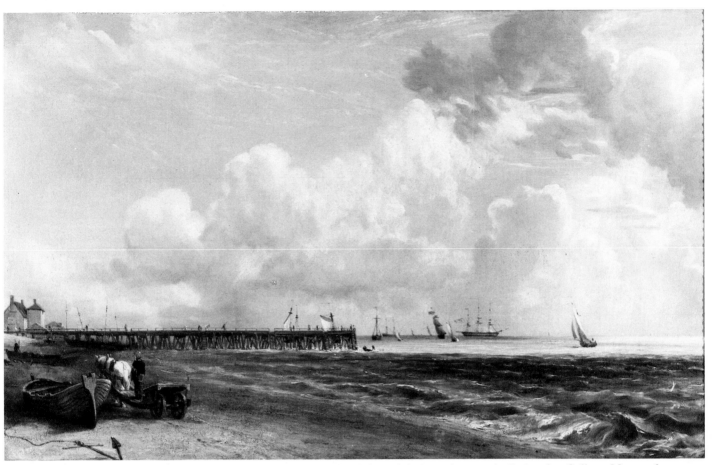

363. (22.37) *Yarmouth Jetty*, From the collection of the late Hon. Moira Nivison, on loan to the Laing Art Gallery, Newcastle-upon-Tyne, 33 × 52·1cm.

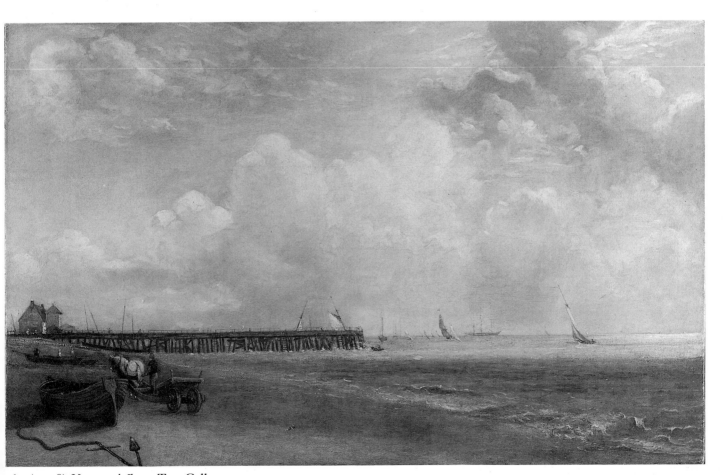

364. (22.38) *Yarmouth Jetty*, Tate Gallery, 32·2 × 50·5cm.

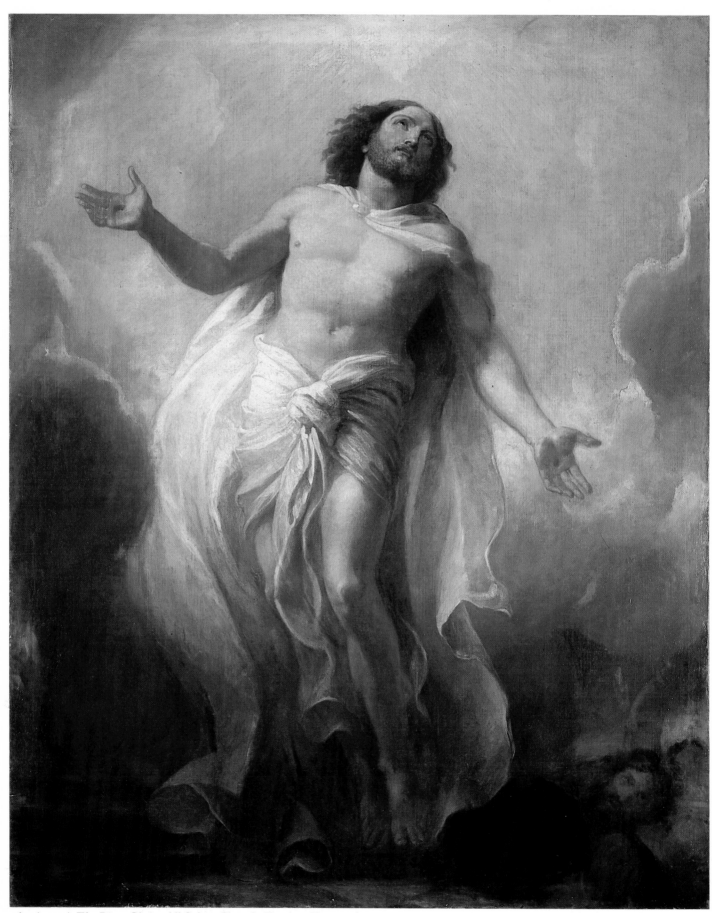

365. (22.35) *The Risen Christ*, All Saints Church, Feering, Essex, 160 × 127cm.

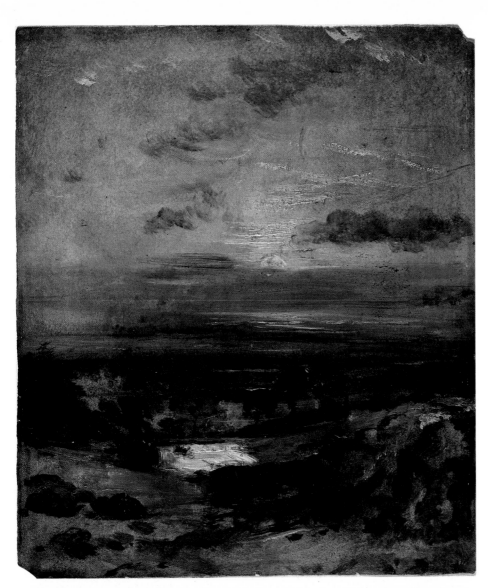

366. (22.44) *Branch Hill Pond: evening*, Victoria and Albert Museum, 22·9 × 19cm.

367. (below) (22.48) *Heath House, Hampstead*, John Fryer-Spedding, 17·8 × 22·8cm.

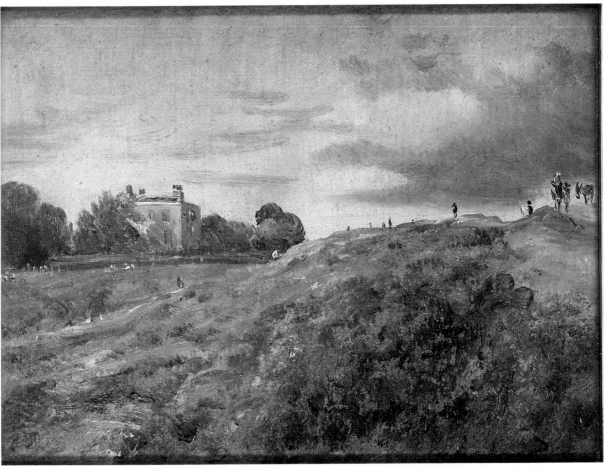

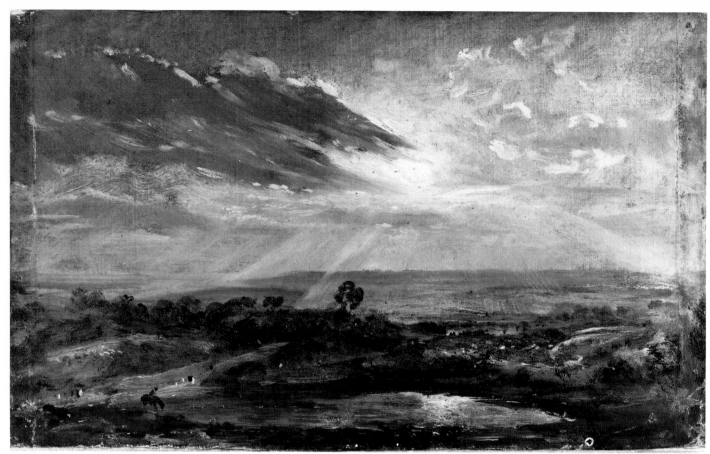

368. (22.43) *Branch Hill Pond, Hampstead*, Victoria and Albert Museum, 24·5 × 39·4cm.

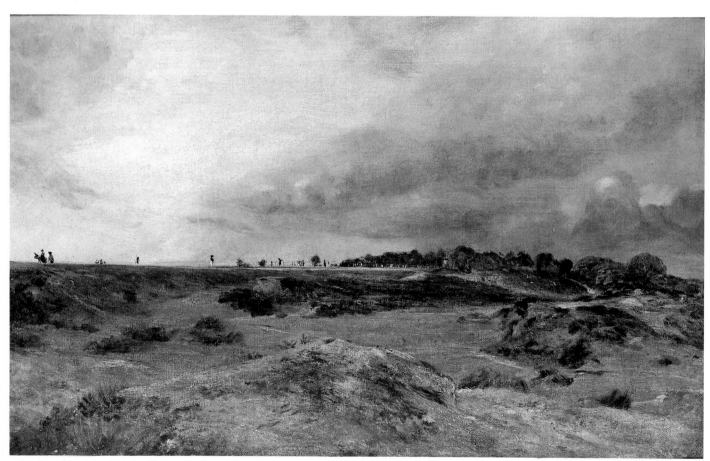

369. (22.47) *A road across Hampstead Heath*, Yale University Art Gallery, New Haven, 32·8 × 50cm.

370. (facing page top) (22.49) *Hampstead Heath, with figures round a bonfire*, Private collection, 29·6 × 35·5cm.

371. (facing page bottom) (22.50) *Hampstead Heath*, Private collection, 26·7 × 34·3cm.

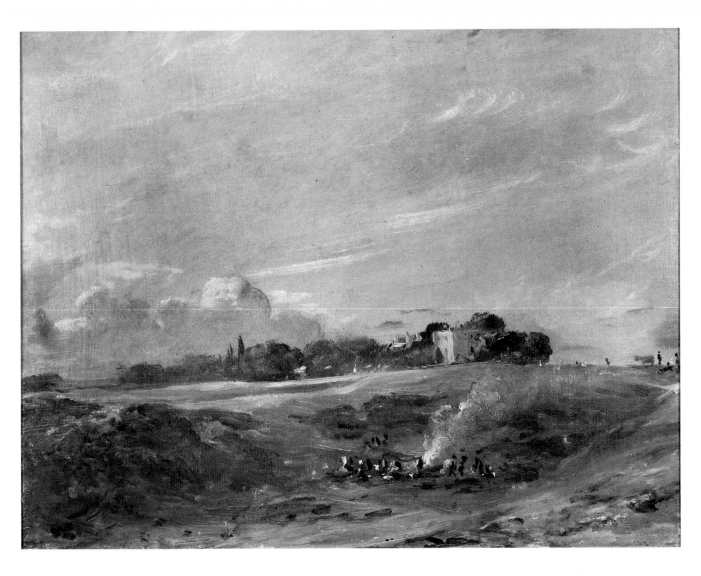

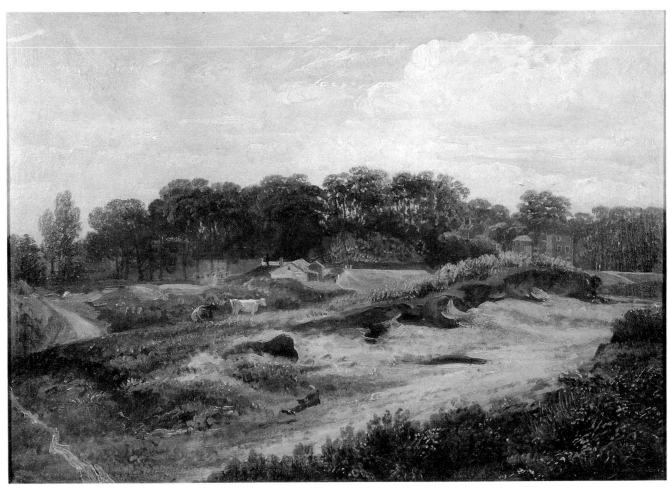

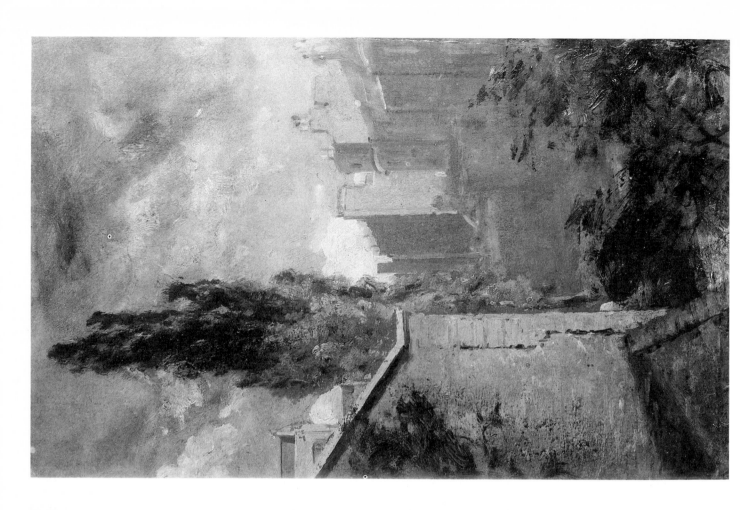
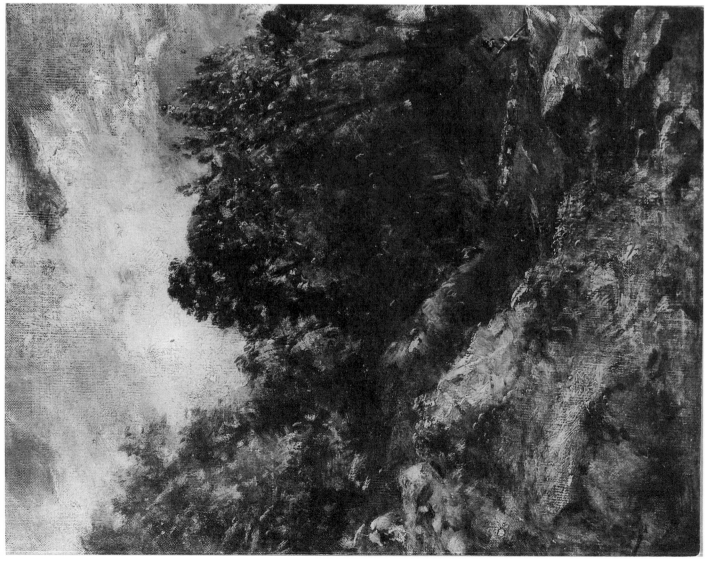

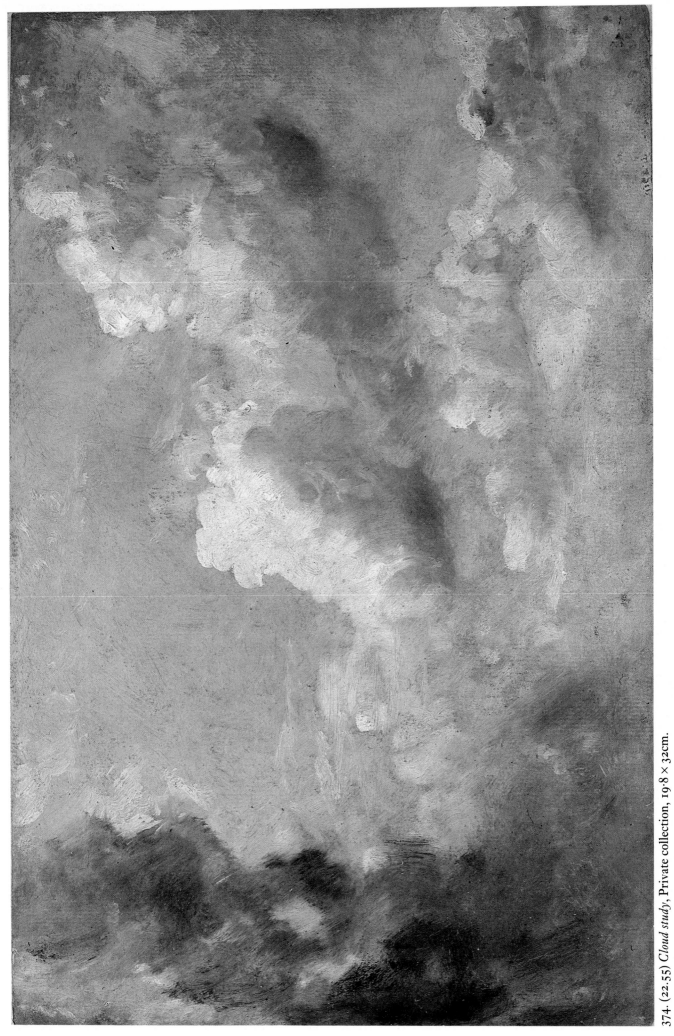

372. (above) (22.46) *A bank and trees at Hampstead*, Private collection, 45 × 35·2cm.

373. (22.51) *Houses at Hampstead*, Private collection, 28 × 18·1cm.

374. (22.55) *Cloud study*, Private collection, 19·8 × 32cm.

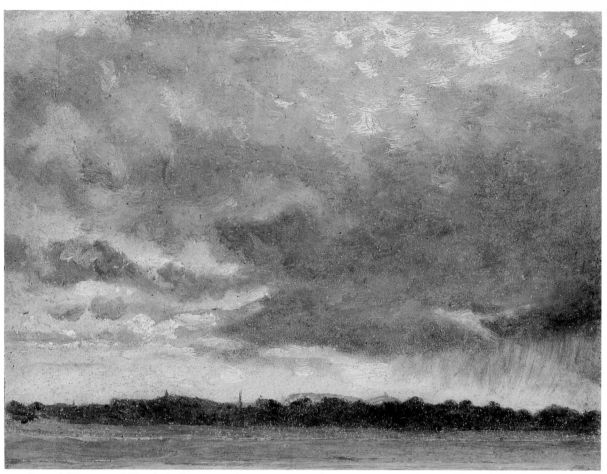

375. (22.52) *Hampstead Heath, looking towards Harrow*, Fitzwilliam Museum, Cambridge, 17·5 × 23cm.

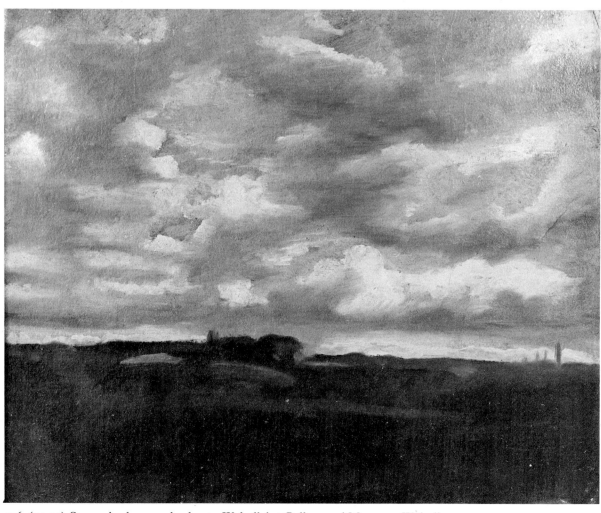

376. (22.53) *Storm clouds over a landscape*, Walsall Art Gallery and Museum, Walsall, 47·5 × 57·5cm.

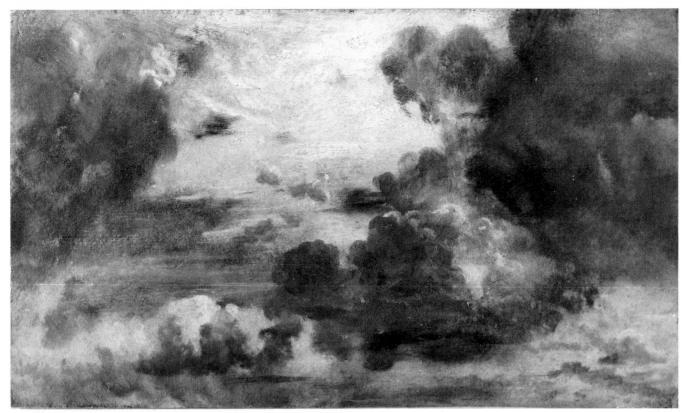

377. (22.54) *Cloud study*, Private collection, New York, 29·2 × 48·2cm.

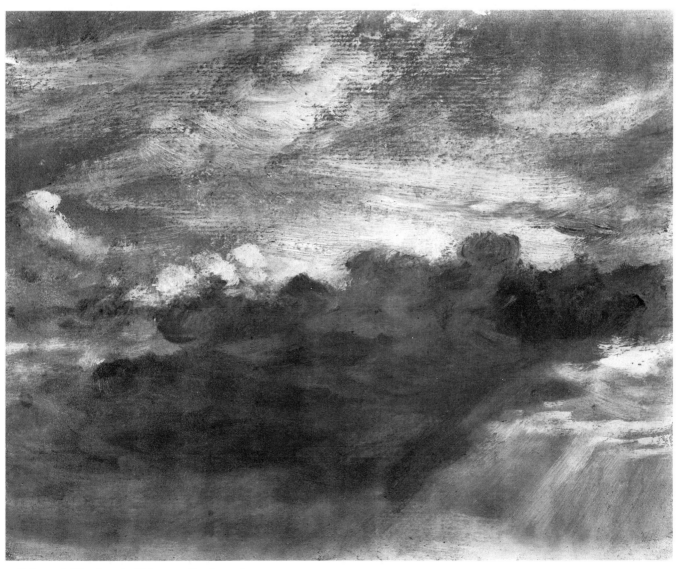

378. (22.57) *Cloud study*, Private collection, 26·5 × 32cm.

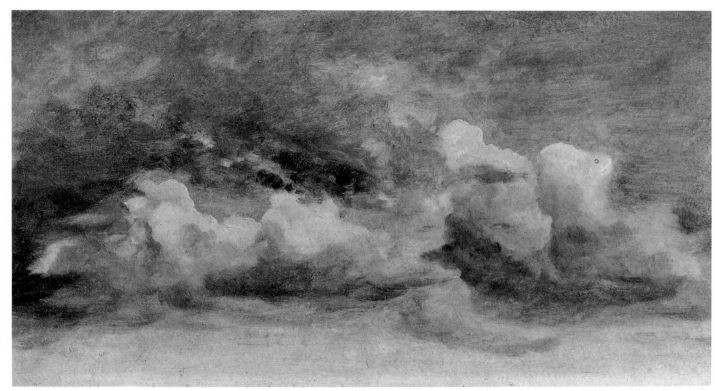

379. (22.58) *Cloud study*, Yale Center for British Art, New Haven, 24·7 × 47cm.

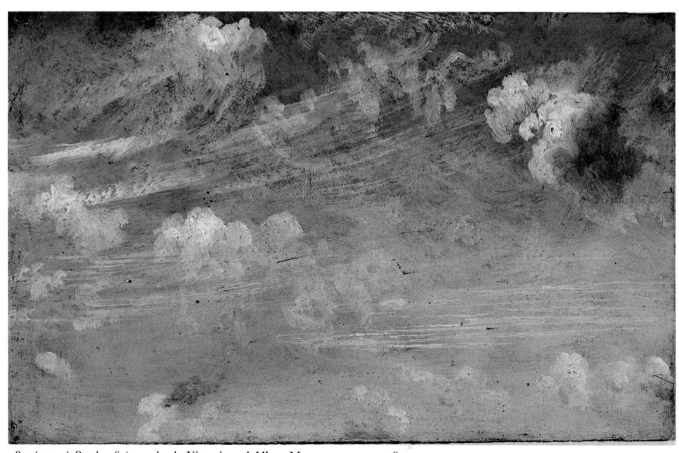

380. (22.59) *Study of cirrus clouds*, Victoria and Albert Museum, 11·4 × 17·8cm.

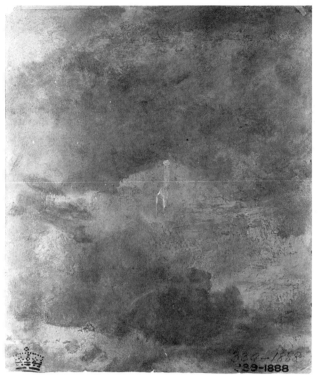

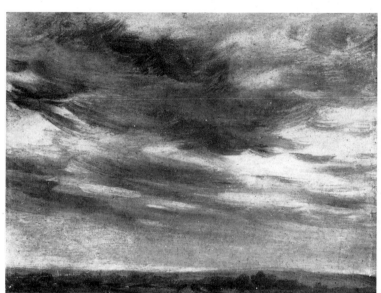

381. (22.56) *Cloud study*, Victoria and Albert Museum, 22.9 × 19cm.

382. (22.60) *Cloud study*, Private collection, 11·5 × 15cm.

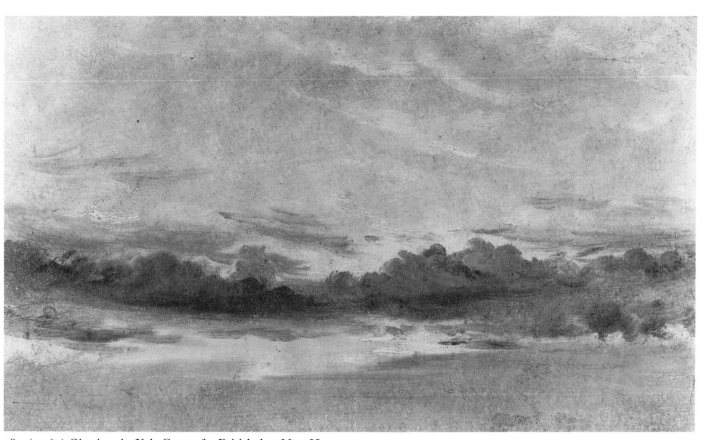

383. (22.61) *Cloud study*, Yale Center for British Art, New Haven, 15·2 × 24cm.

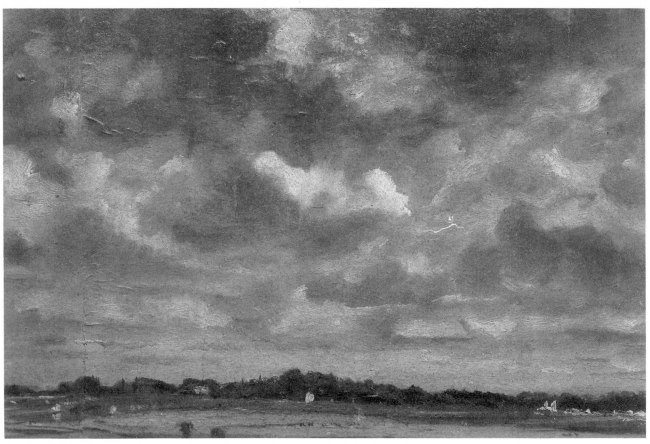

384. (22.62) *Study of clouds over a wide landscape*, Yale Center for British Art, New Haven, 19·4 × 28cm.

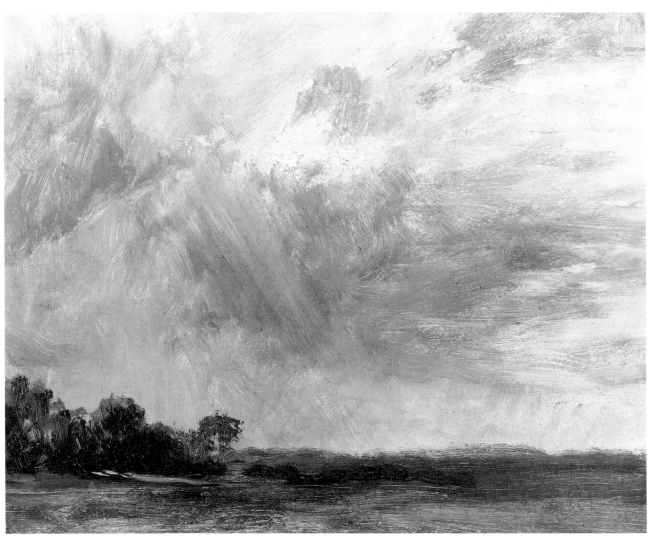

385. (22.63) *Study of clouds over a landscape*, Yale Center for British Art, New Haven, 26·5 × 33cm.

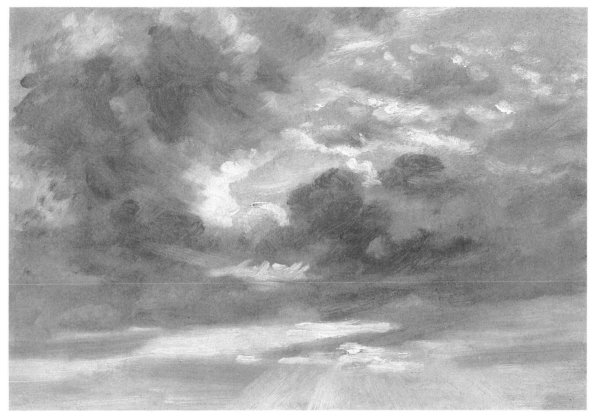

386. (22.64) *Stormy sunset*, Whereabouts unknown, 6¾ × 10in.

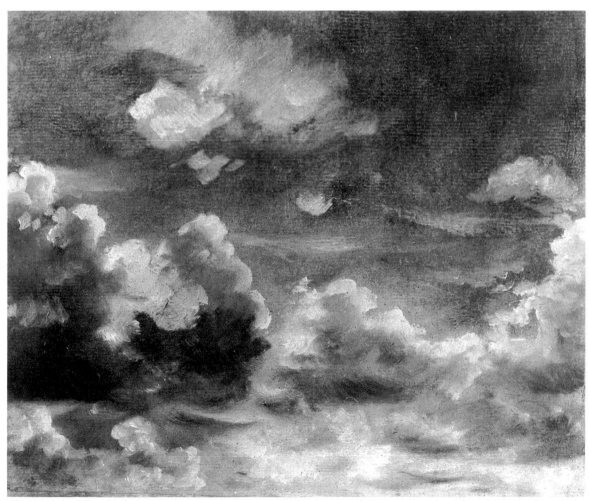

387. (22.65) *Cumulus clouds*, Whereabouts unknown, 10 × 13¼in.

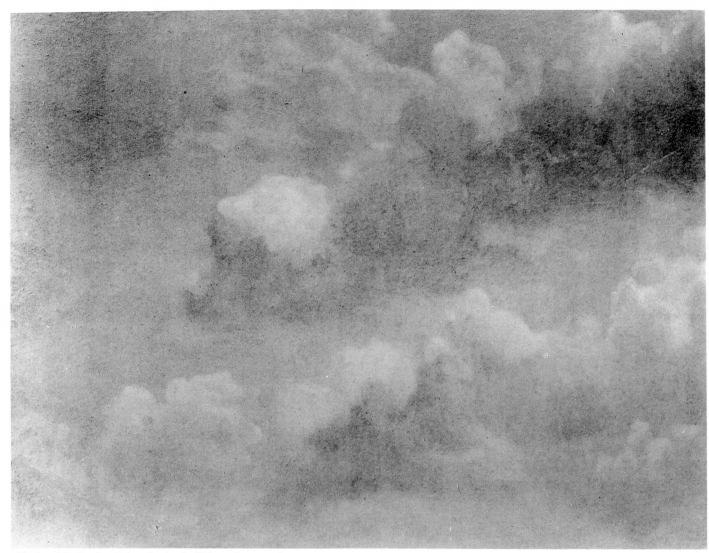

388. (22.66) *Study of electric clouds*, Whereabouts unknown.

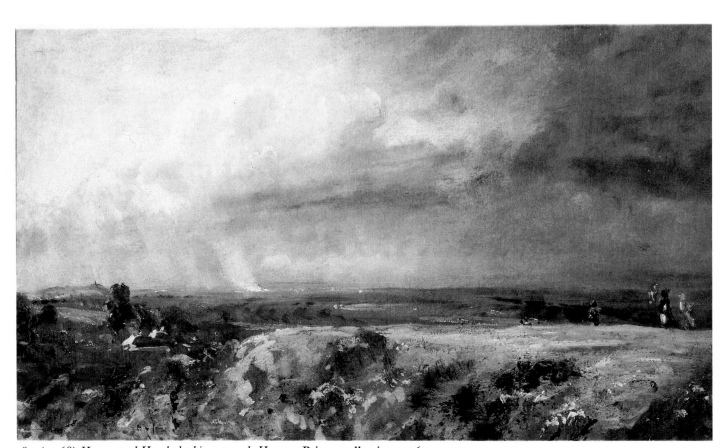

389. (22.68) *Hampstead Heath, looking towards Harrow*, Private collection, 31·6 × 50·2cm.

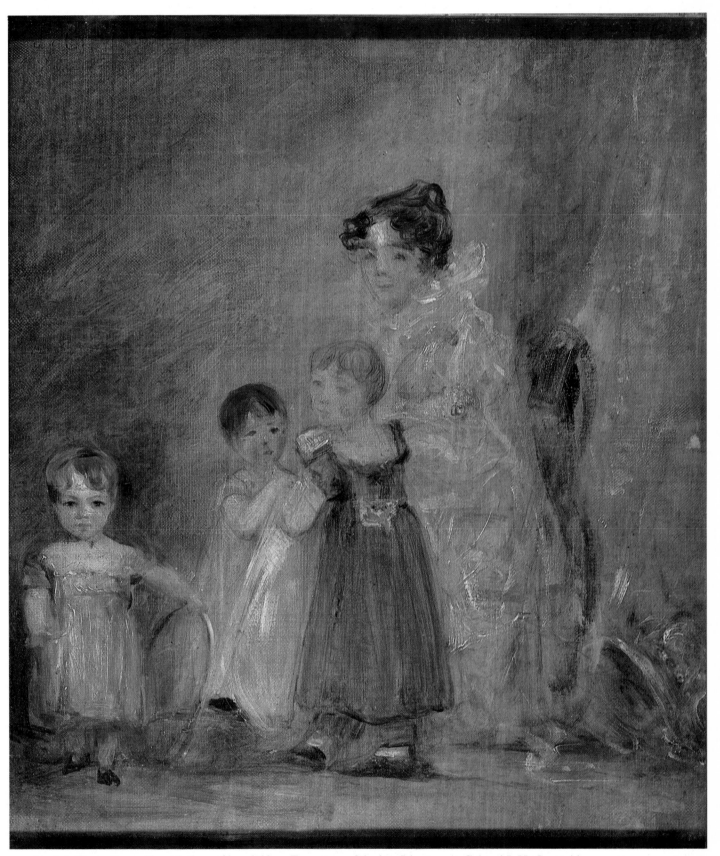

390. (22.67) *Maria Constable with three of her children*, Executors of the late Lieutenant-Colonel J. H. Constable, 35·5 × 29·5cm.

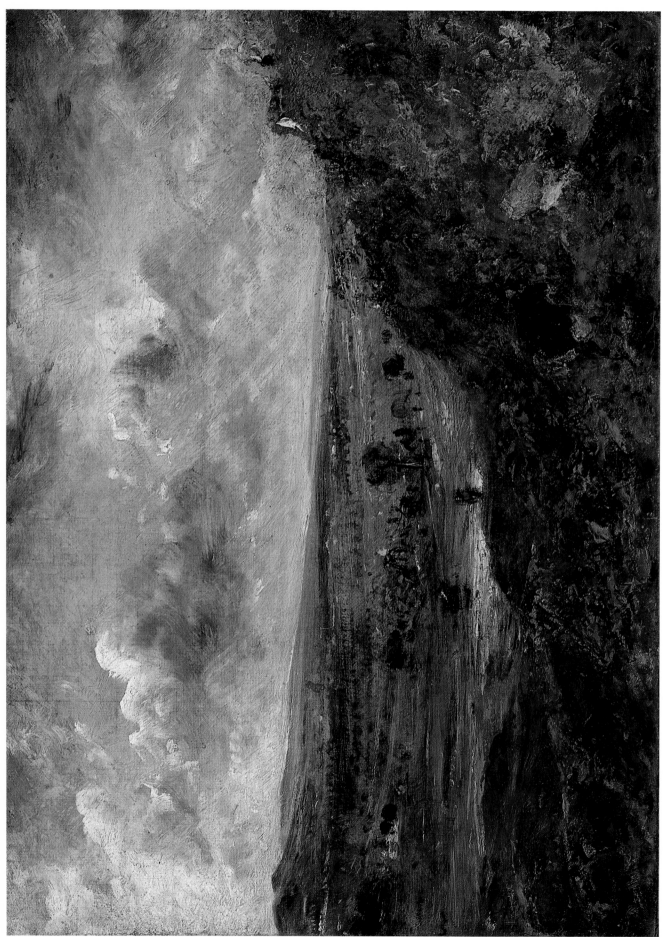

391. (22.69) *Hampstead Heath: Branch Hill Pond*, Musée du Louvre, 26 × 36cm.

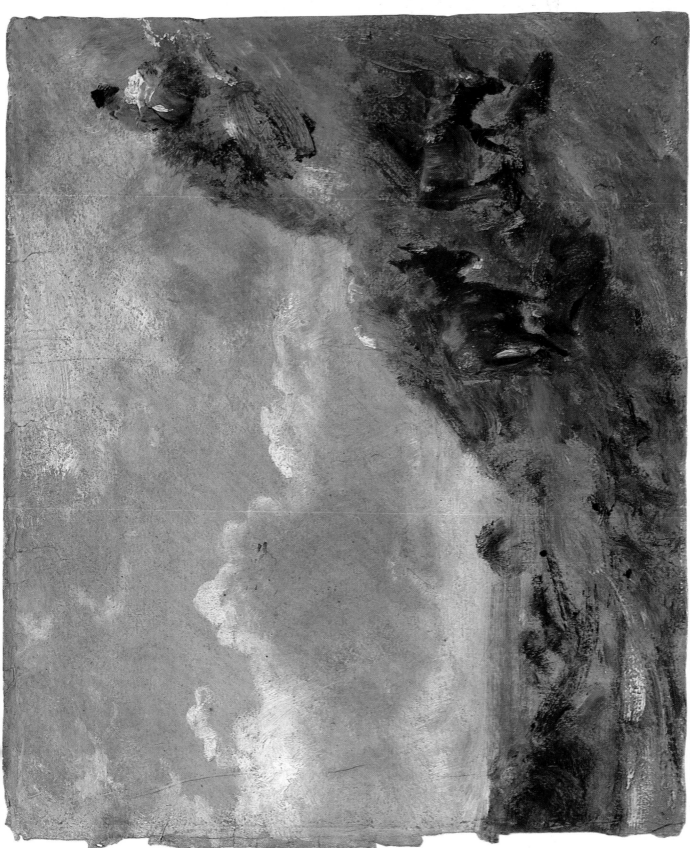

392. (22.70) *Hampstead Heath: Branch Hill Pond*, Private collection, 24·1 × 29·2 cm.

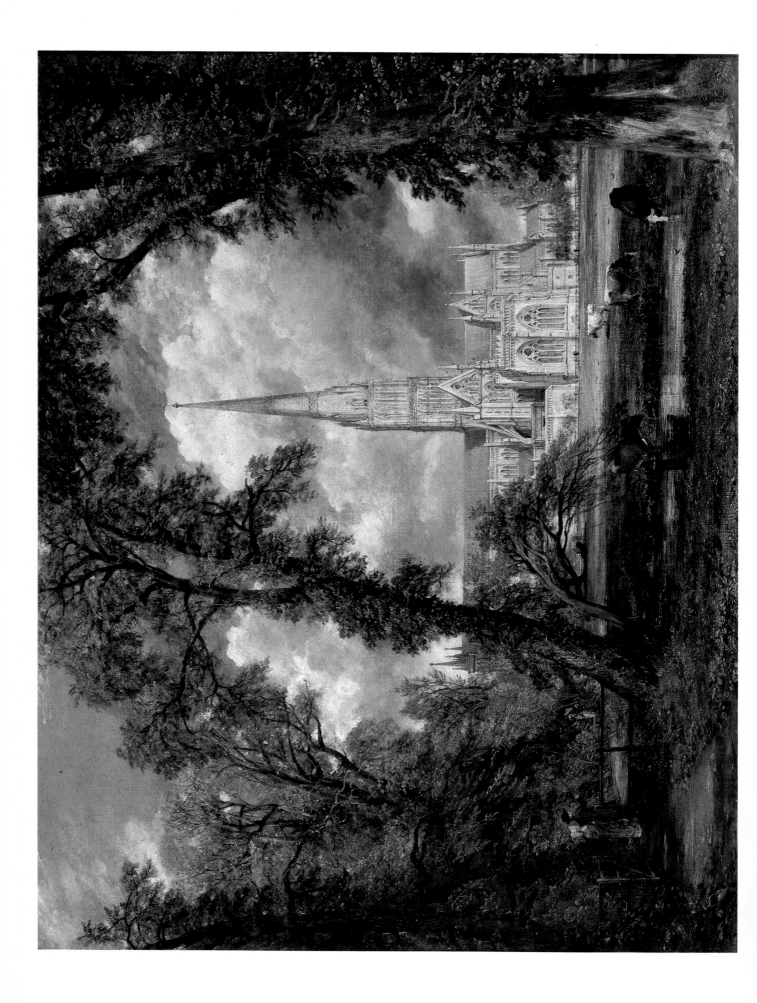

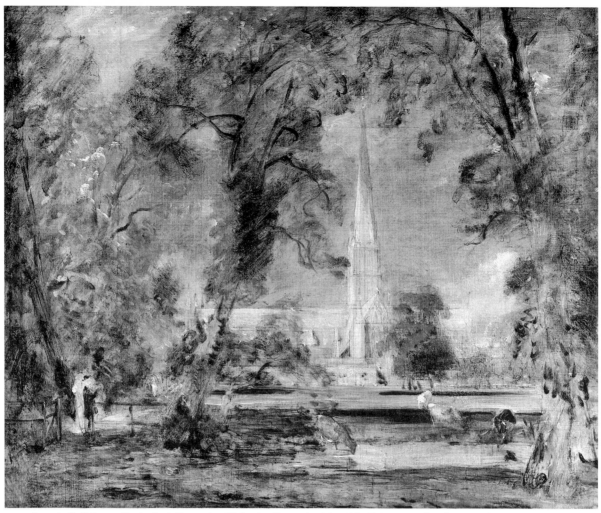

395. (23.3) *Salisbury Cathedral from the Bishop's Grounds (sketch)*, Private collection, on loan to the City Art Gallery, Birmingham, 61 × 73·7cm.

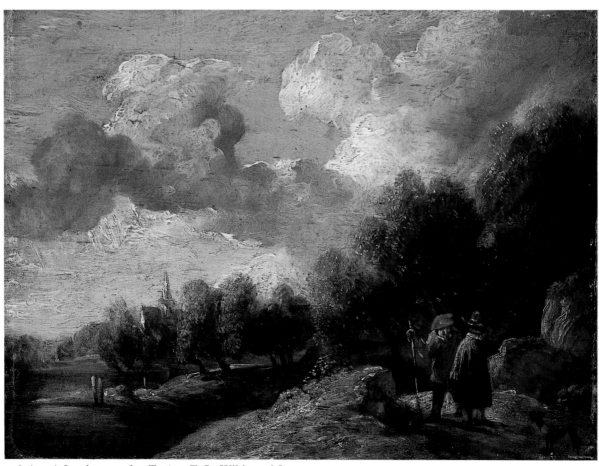

396. (23.7) *Landscape, after Teniers*, F. L. Wilder, 16·8 × 22.5cm.

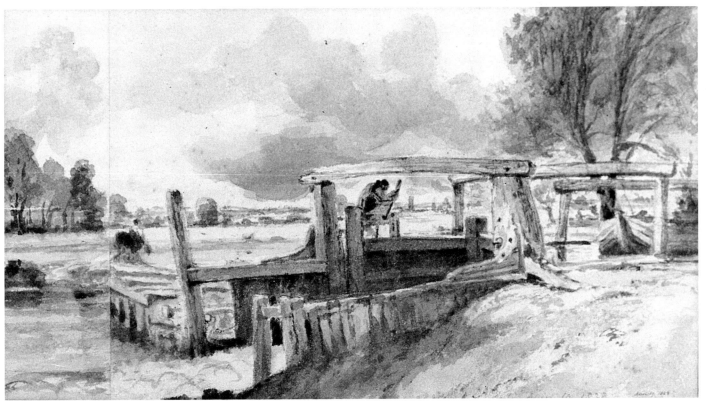

397. (23.8) *Flatford Lock*, Private collection, 16·8 × 30cm.

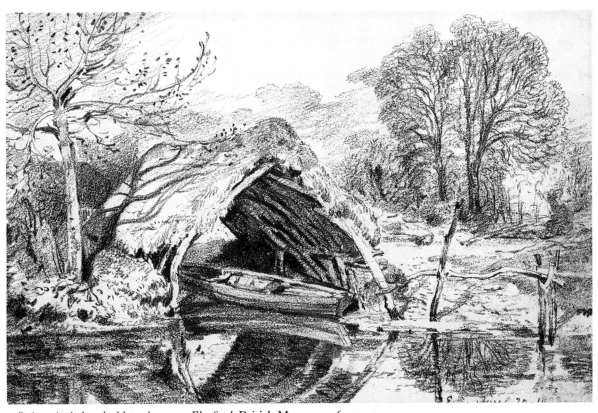

398. (23.9) *A thatched boat house at Flatford*, British Museum, 16·9 × 25·4cm.

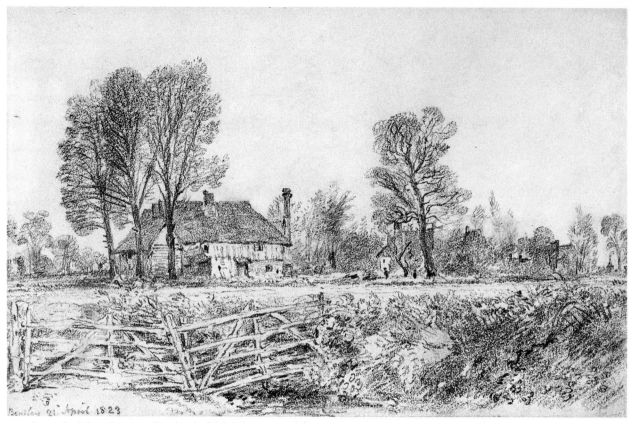

399. (23.10) *A farmhouse at Bentley*, British Museum, 16·8 × 25·4cm.

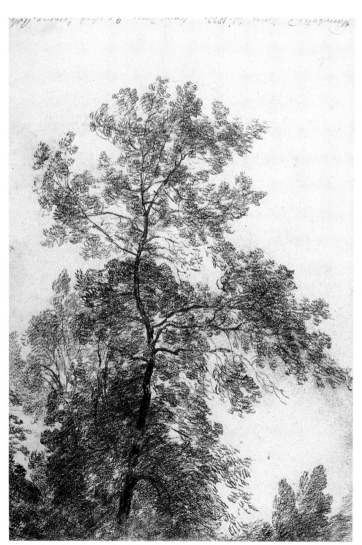

400. (23.11) *An ash tree*, British Museum, 25·9 × 17cm.

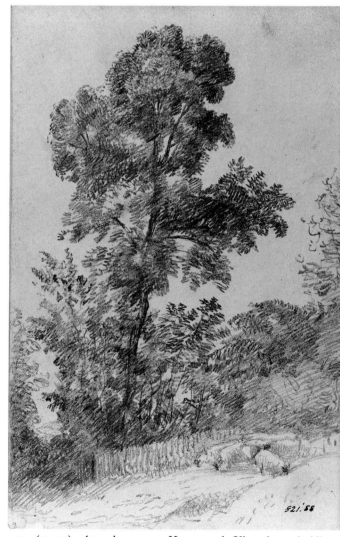

401. (23.12) *An ash tree at Hampstead*, Victoria and Albert Museum, 18·5 × 11·6cm.

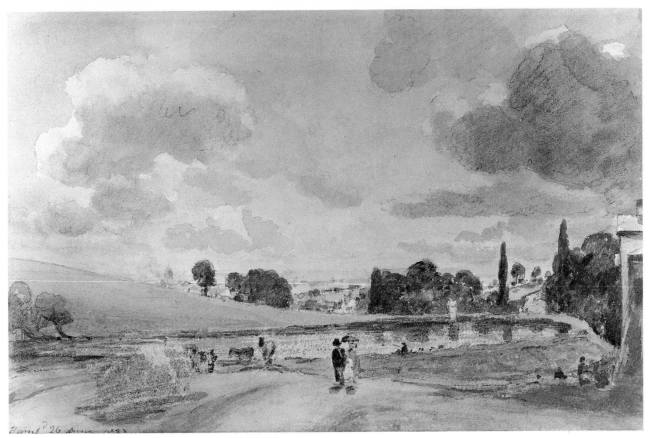

402. (23.13) *The Lower Pond, Hampstead*, British Museum, 16·9 × 25·3cm.

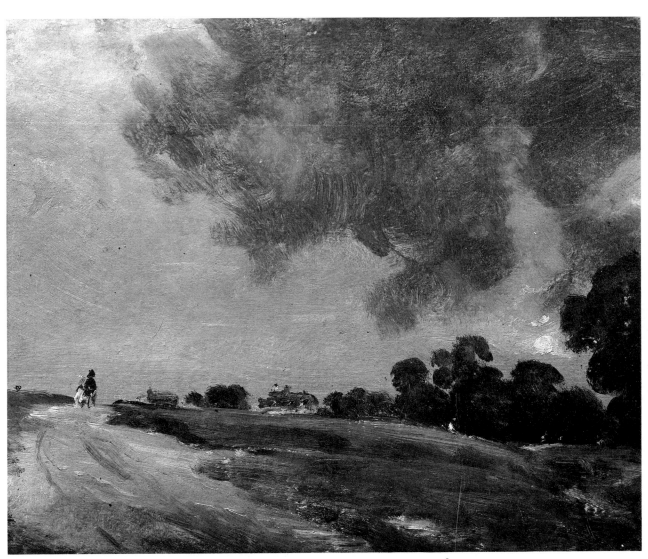

403. (23.14) *A view at Hampstead, looking due east*, Victoria and Albert Museum, 24·8 × 30·5cm.

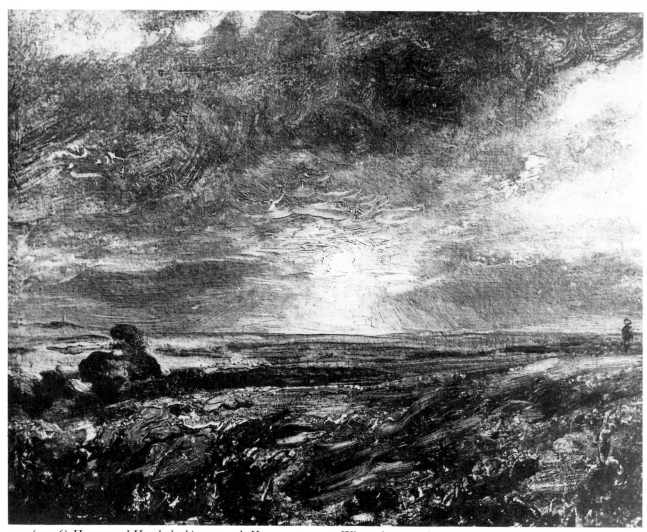

404. (23.16) *Hampstead Heath, looking towards Harrow at sunset*, Whereabouts unknown, 23 × 29cm.

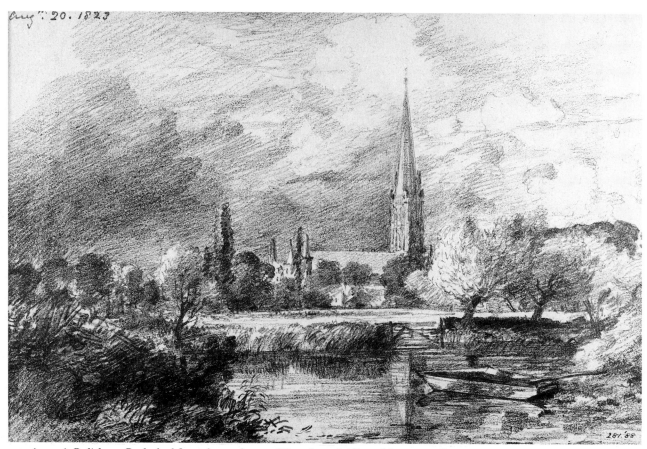

405. (23.17) *Salisbury Cathedral from the south-west*, Victoria and Albert Museum, 18·1 × 25·9cm.

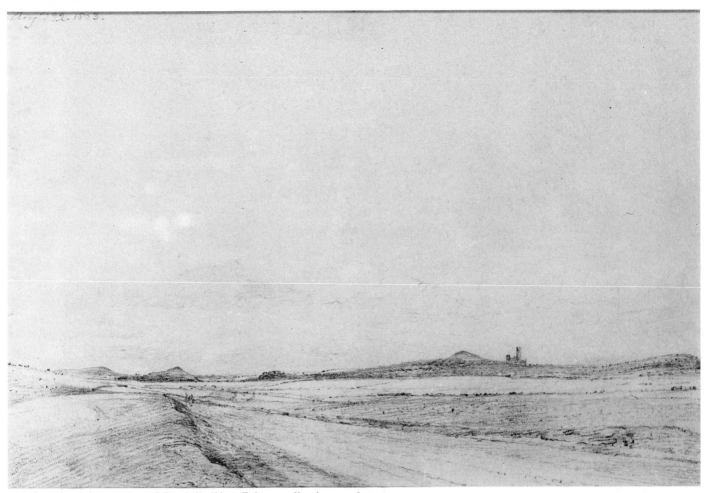

406. (23.18) *A distant view of Fonthill Abbey*, Private collection, 17·6 × 25·7cm.

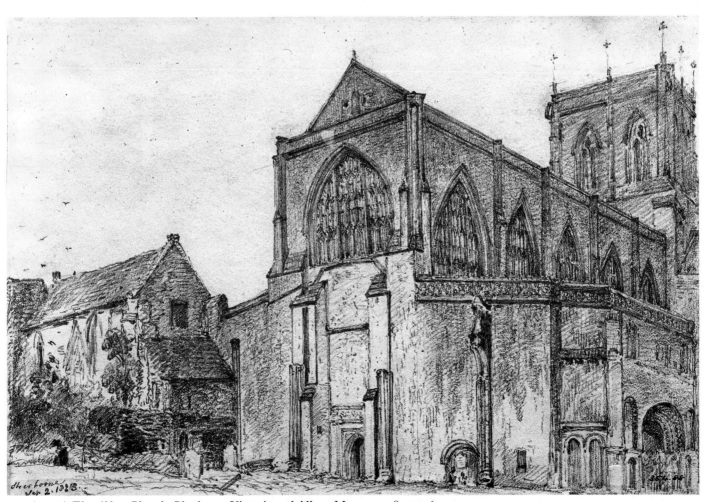

407. (23.19) *The Abbey Church, Sherborne*, Victoria and Albert Museum, 18·1 × 26·1cm.

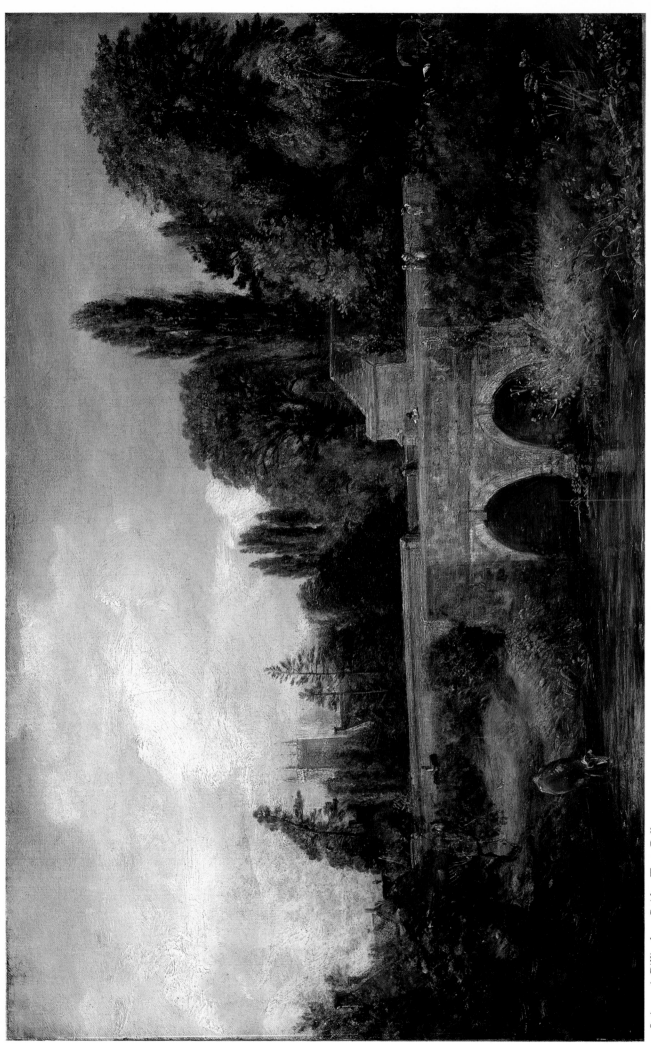

408. (23·20) *Gillingham Bridge*, Tate Gallery, 32·1 × 51·1cm.

409. (below) (23·23) *A house amidst trees: evening*, Victoria and Albert Museum, 25·1 × 30·7cm.

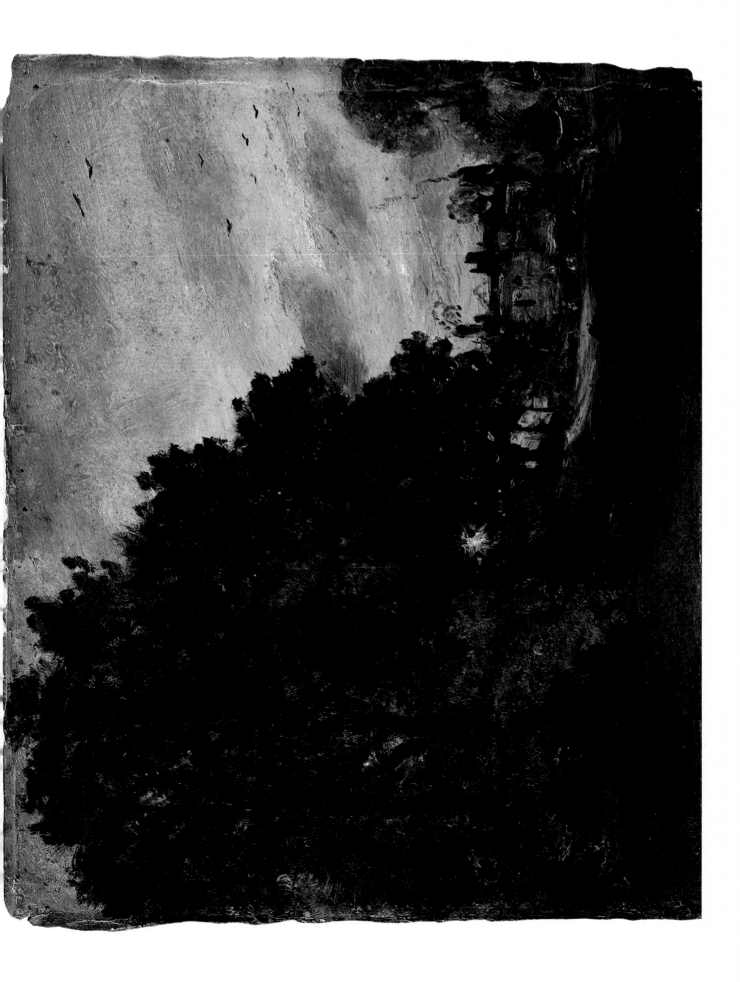

410. (23.21) *William Fisher*, Columbus Museum of Art, Ohio, 30·5 × 25·5cm.

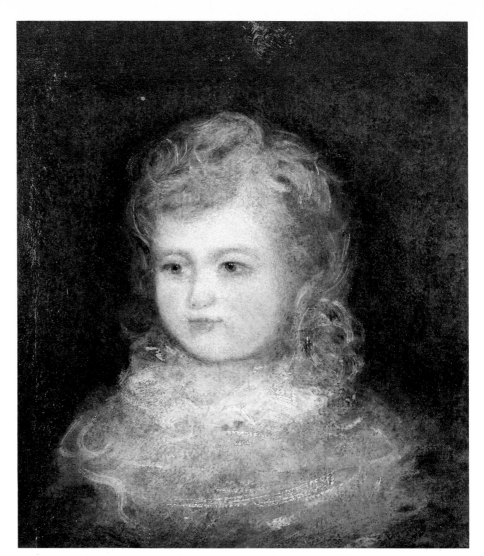

411. (below) (23.22) *Gillingham Mill*, Lord Binning, 25·4 × 31·6cm.

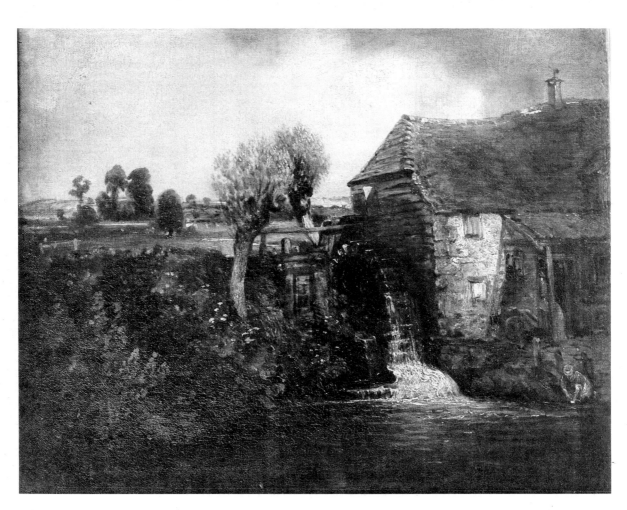

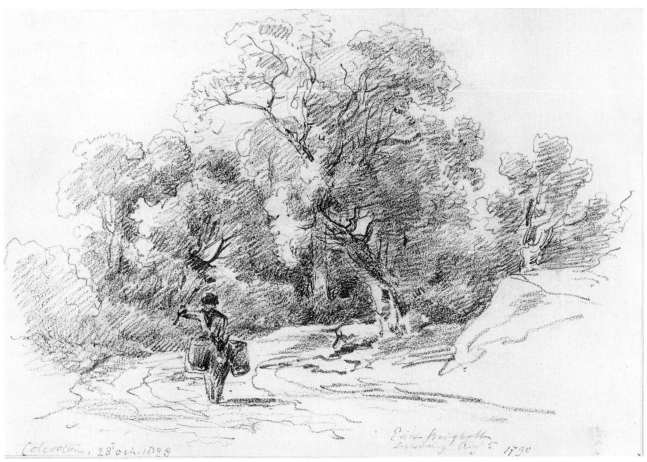

412. (23.24) *A path through a wood at East Bergholt, after Sir George Beaumont*, Private collection, 17·7 × 24·8 cm.

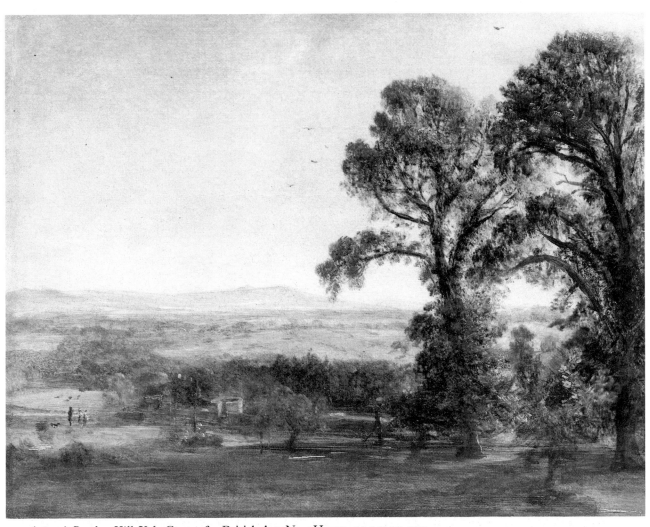

413. (23.25) *Bardon Hill*, Yale Center for British Art, New Haven, 20·3 × 25·4 cm.

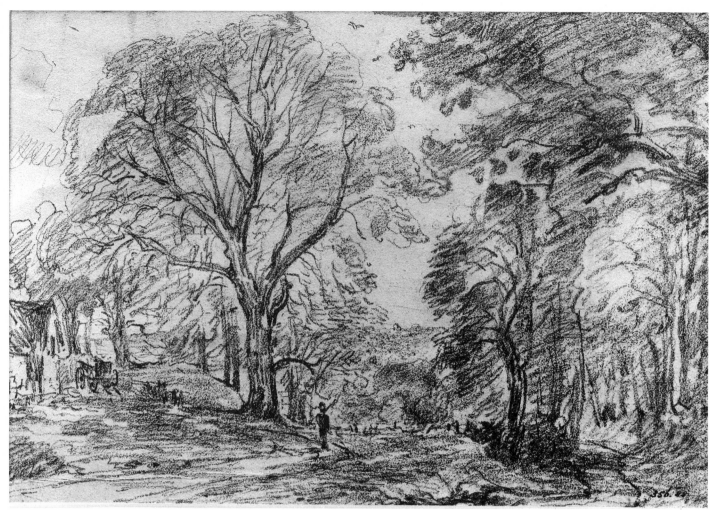

414. (23.26) *Trees in a lane at Staunton Harold, Leicestershire*, Victoria and Albert Museum, 18·1 × 26·2cm.

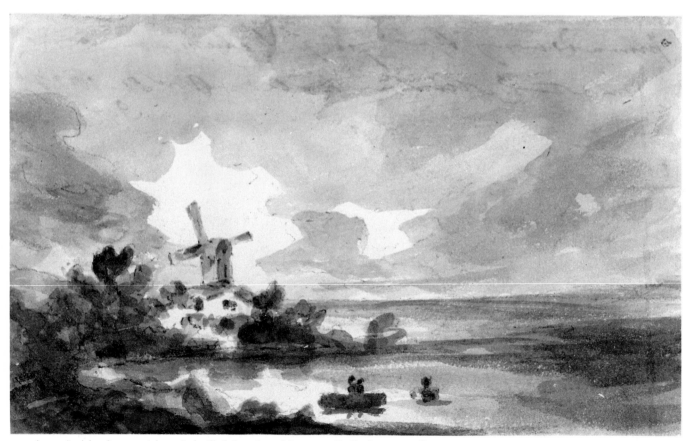

415. (23.27) *A landscape with a windmill*, Ashmolean Museum, Oxford, 11·2 × 18cm.

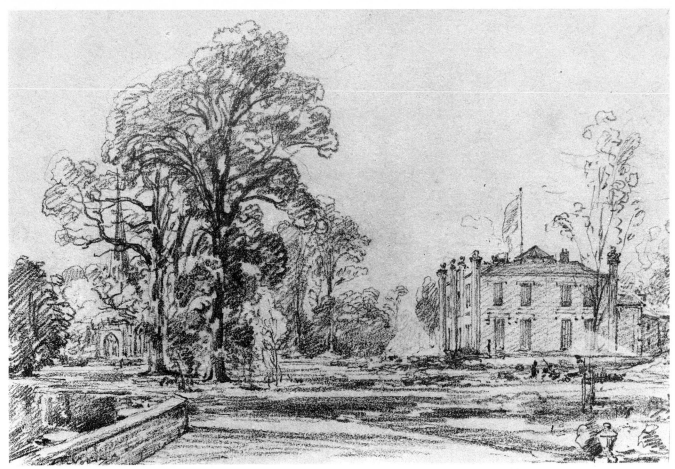

416. (23.28) *Coleorton Hall*, Private collection, 17·4 × 25·1cm.

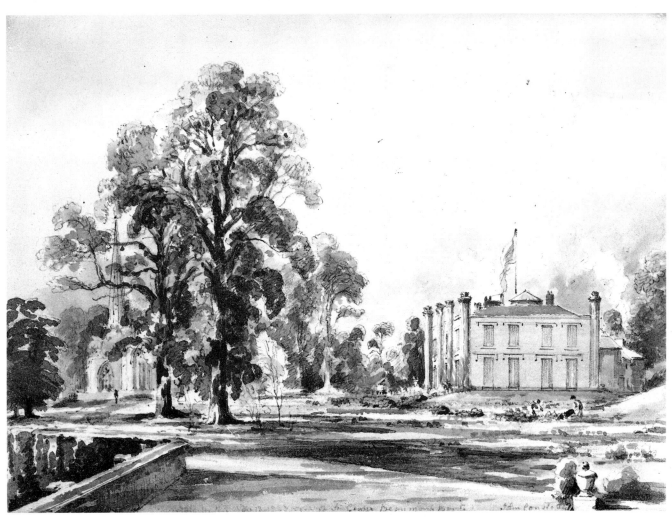

417. (23.29) *Coleorton Hall*, Avon County Reference Library, Bristol, 20·5 × 25·1cm.

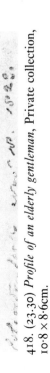

418. (23.30) *Profile of an elderly gentleman*, Private collection, 10·8 × 8·6cm.

419. (right) (23.31) *Cenotaph to Sir Joshua Reynolds in the grounds of Coleorton Hall*, Victoria and Albert Museum, 26 × 18·1cm.

420. (below) (23.32) *A stone dedicated to Richard Wilson in the Grove of Coleorton Hall*, Victoria and Albert Museum, 26·2 × 18·1cm.

421. (below right) (23.33) *A stone in the Garden of Coleorton Hall*, Victoria and Albert Museum, 25·5 × 18·1cm.

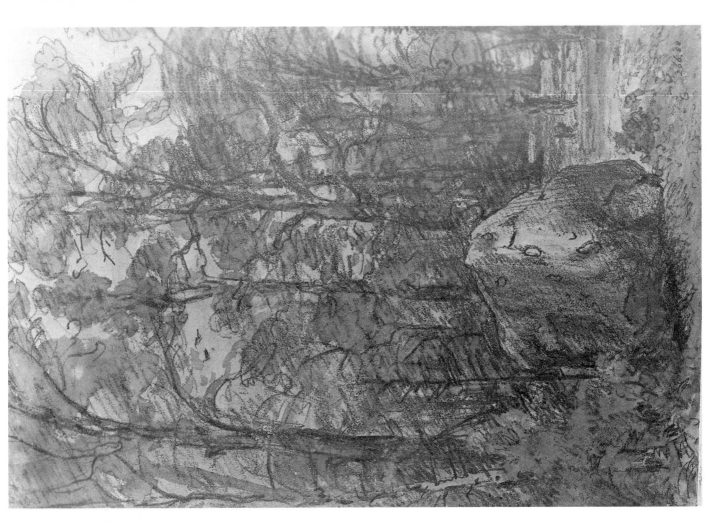

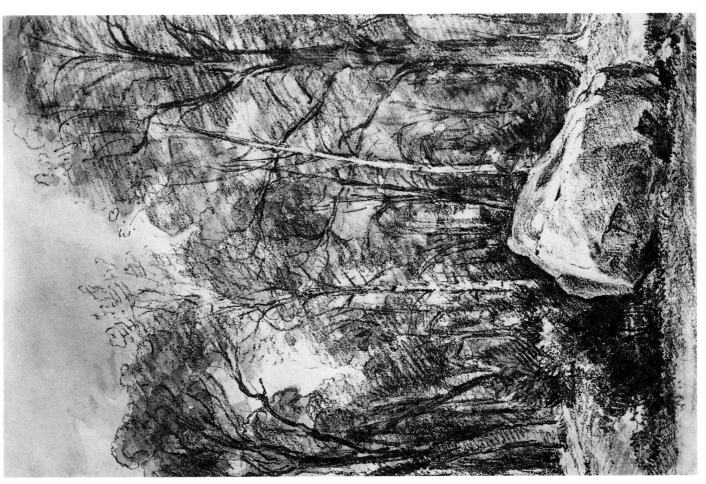

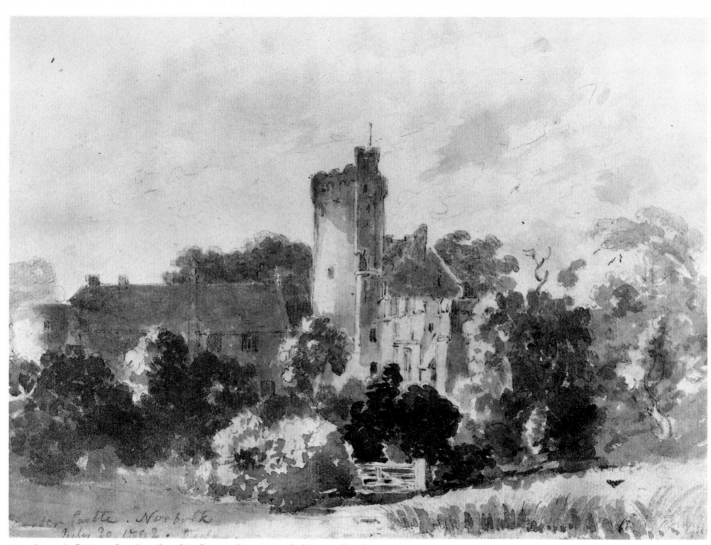

422. (23.34) *Caister Castle, after Sir George Beaumont,* Private collection, 19 × 25·5cm.

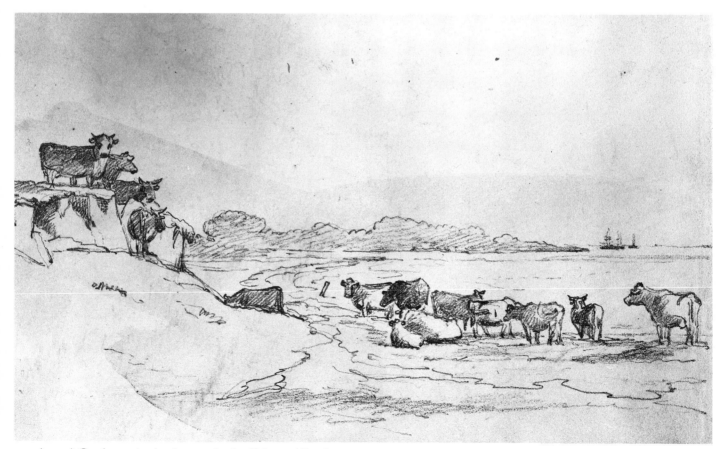

423. (23.35) *Cattle grazing by the water's edge,* Private collection, 13·9 × 22·5cm.

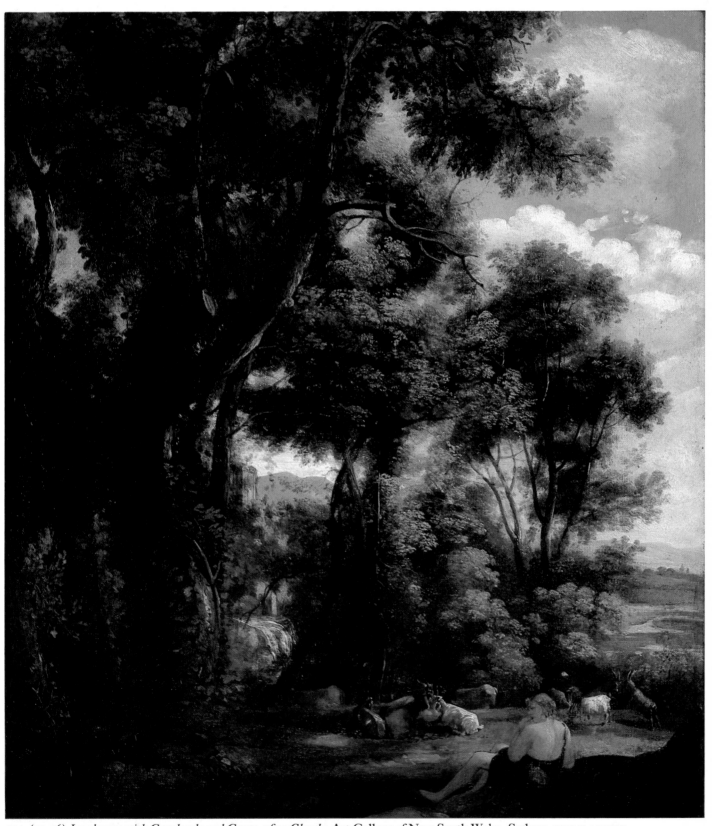

424. (23.36) *Landscape with Goatherds and Goats, after Claude*, Art Gallery of New South Wales, Sydney, 53·3 × 44·5cm.

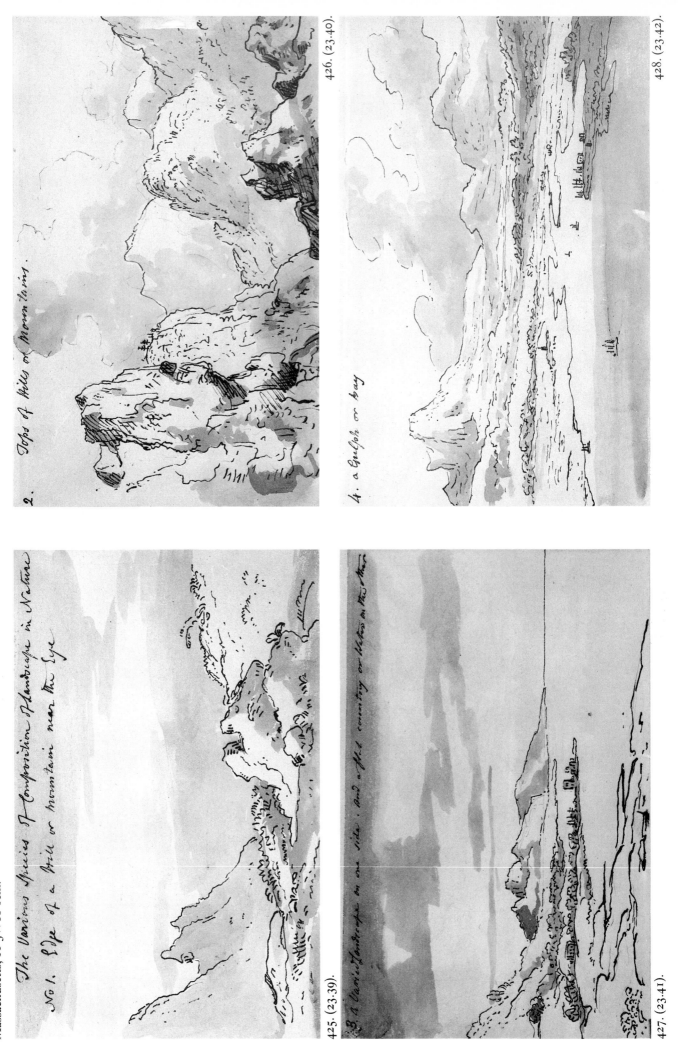

425–40. (23.39–54) *The Various Species of Composition in Nature, after Alexander Cozens*, (Nos. 23.39–53) Private collection; (No. 23.54) Fogg Art Museum, Harvard University, Cambridge, Massachusetts, 11·5 × 18·6cm.

The Various Species of Composition of Landscape in Nature

No 1. Type of a Hill or mountain near the Eye

425. (23.39).

2. Tops of Hills or mountains.

426. (23.40).

3. A Various Landscape on one side. And a flat country or Water on the other

427. (23.41).

4. a Gulloh or bay

428. (23.42).

431. (23.45). 432. (23.46).

9. Two Hills or Mountains, or Rocks opposite to each other.

433. (23.47).

10. A Road Track or River receding from the Eye.

434. (23.48).

11. Objects in Clusters & Objects standing on each side.

435. (23.49).

12. Flat Ground m a Piece of Water Surrounded by Objects.

436. (23.50).

437. (23.51).

13. A Hollow or Chasm.

438. (23.52).

439. (23.53).

15. A Landscape of a moderate extent, in which are one great impediment.

440. (23.54).

16. A Spacious or champaign Landscape.

441–60. (following pages) (23.55–74) *Twenty studies of skies, copied from 'A New Method of Assisting the Invention in Drawing Original Compositions of Landscape' by Alexander Cozens,* Courtauld Institute Galleries (Lee Collection), London, 9·3 × 11·4cm.

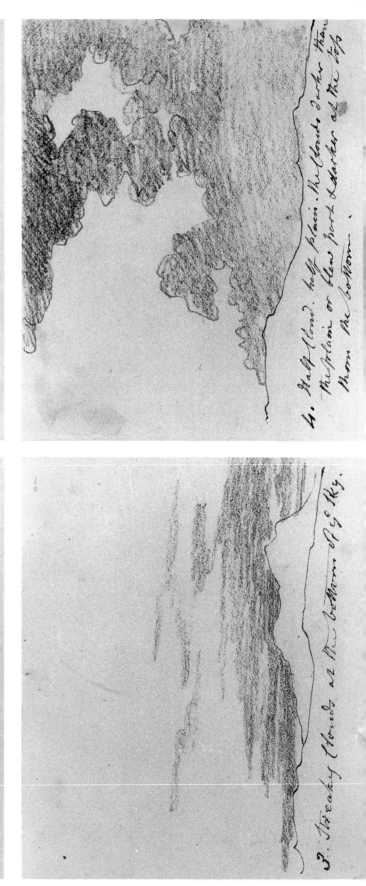

1. All Plain. Darker at the Top than the bottom. grey.

2. Streaky Cloudy at the tops of the Sky.

3. Streaky Clouds at the bottom of the Sky.

4. Half Cloud. half Plain. the Clouds darker than the Plain. or the part darker at the top than the bottom.

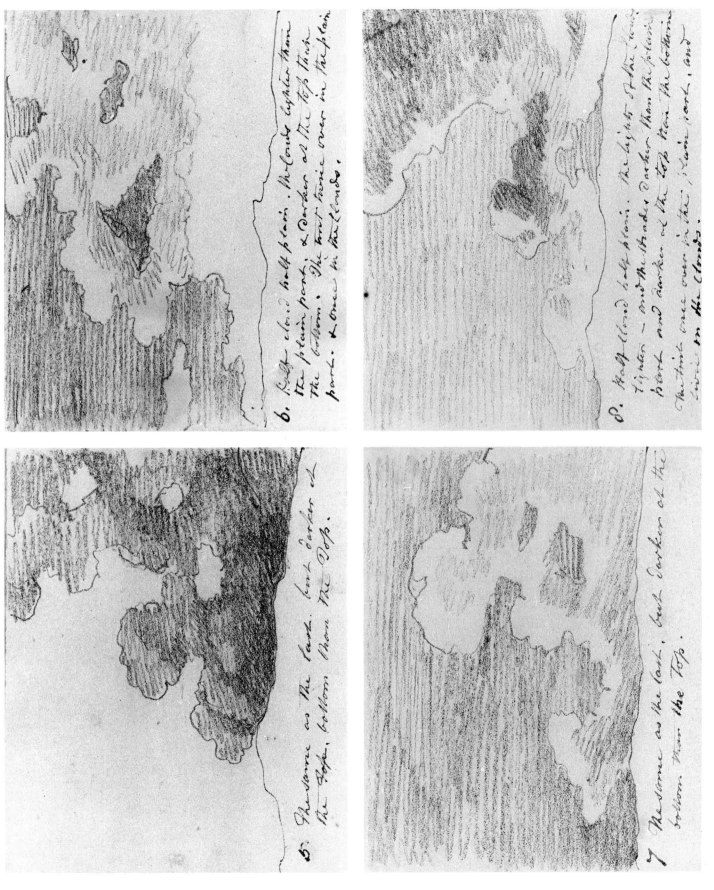

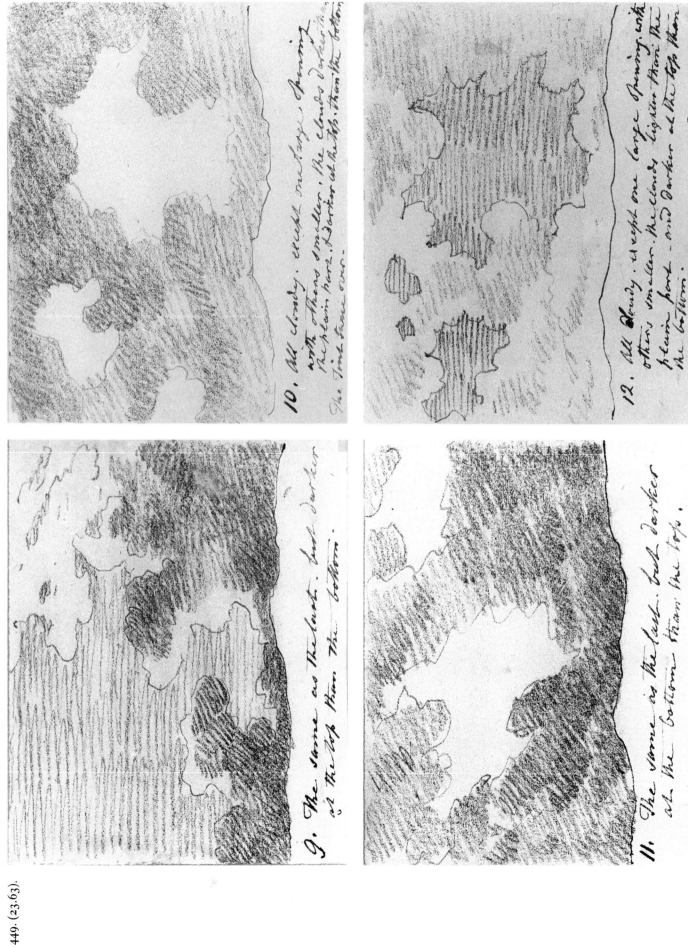

449. (23.63).

450. (23.64).

451. (23.65).

452. (23.66).

9. The same as the last, but darker at the top than the bottom

10. All cloudy, except one large opening, with others smaller, the clouds darker near the plain horz, & darker at the top than the bottom. The fine tone over —

11. The same as the last, but darker at the bottom than the tops.

12. All cloudy, except one large opening, with others smaller. The clouds lighter than the stain part, and darker at the top than the bottom. The fine tone in the openings, and receding tints.

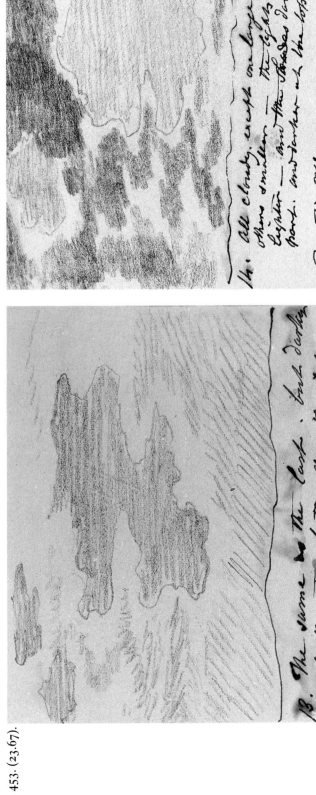

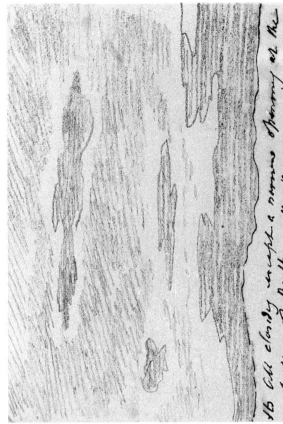

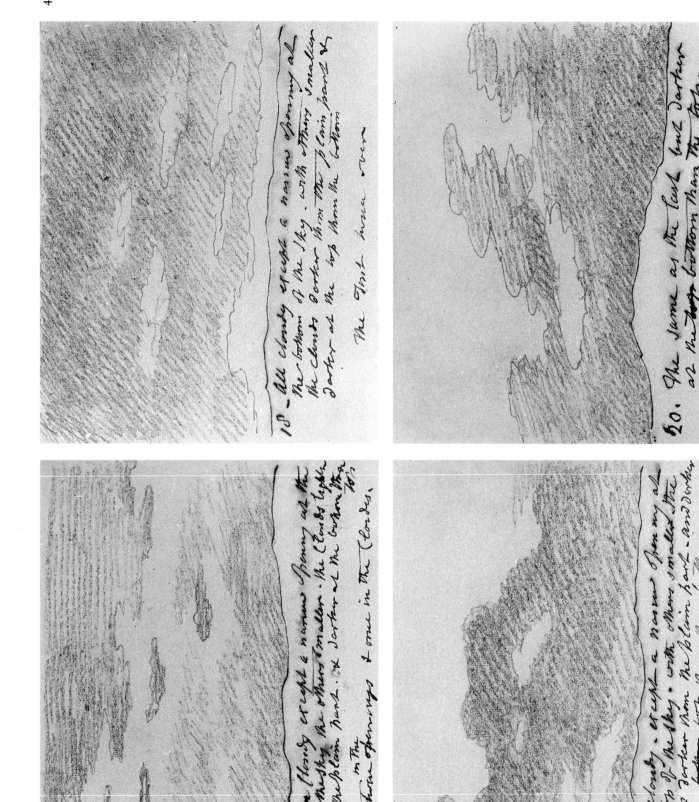

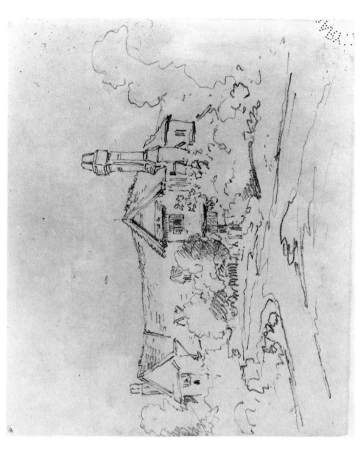

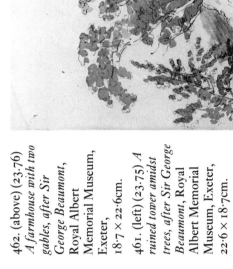

462. (above) (23.76)
*A farmhouse with two
gables, after Sir
George Beaumont,*
Royal Albert
Memorial Museum,
Exeter,
18·7 × 22·6cm.

461. (left) (23.75) *A
ruined tower amidst
trees, after Sir George
Beaumont,* Royal
Albert Memorial
Museum, Exeter,
22·6 × 18·7cm.

463. (right) (23.79) *A
cottage, after Sir
George Beaumont,*
Royal Albert
Memorial Museum,
Exeter,
20·5 × 25·2cm.

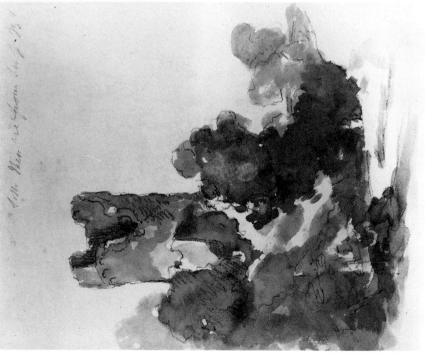

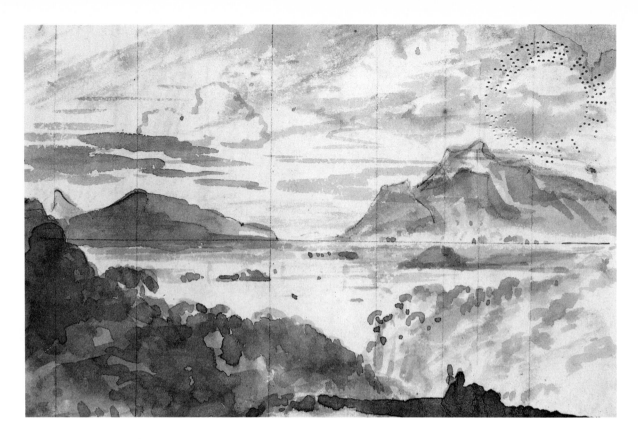

464. (above) (23.77) *A lake scene*,
Royal Albert Memorial Museum,
Exeter, 12·2 × 18·1cm.

465. (23.78) *A landscape study, after
Gainsborough*, Royal Albert Me-
morial Museum, Exeter, 18·1 ×
12·2cm.

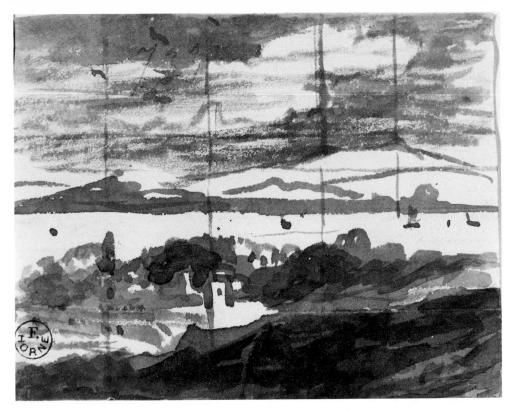

466. (23.80) *A lake scene*, Horne Foundation, Florence, 9 × 11·2cm.

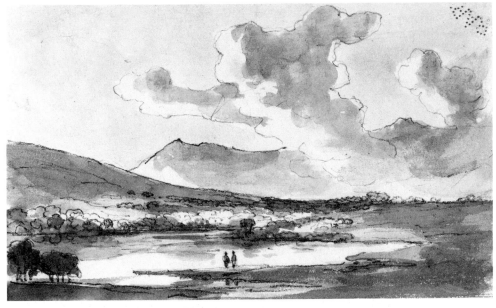

467. (23.81) *A lake scene*, Royal Albert Memorial Museum, Exeter, 11·1 × 18·3cm.

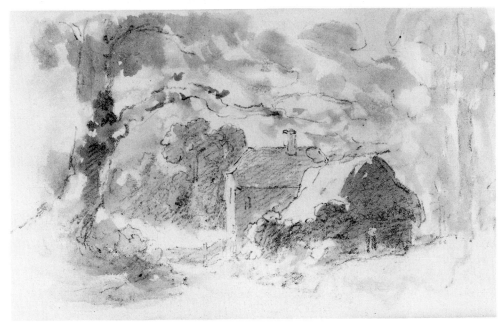

468. (23.82) *A cottage beneath a spreading tree*, Fogg Art Museum, Harvard University, Cambridge, Massachusetts, 11·4 × 18·2cm.

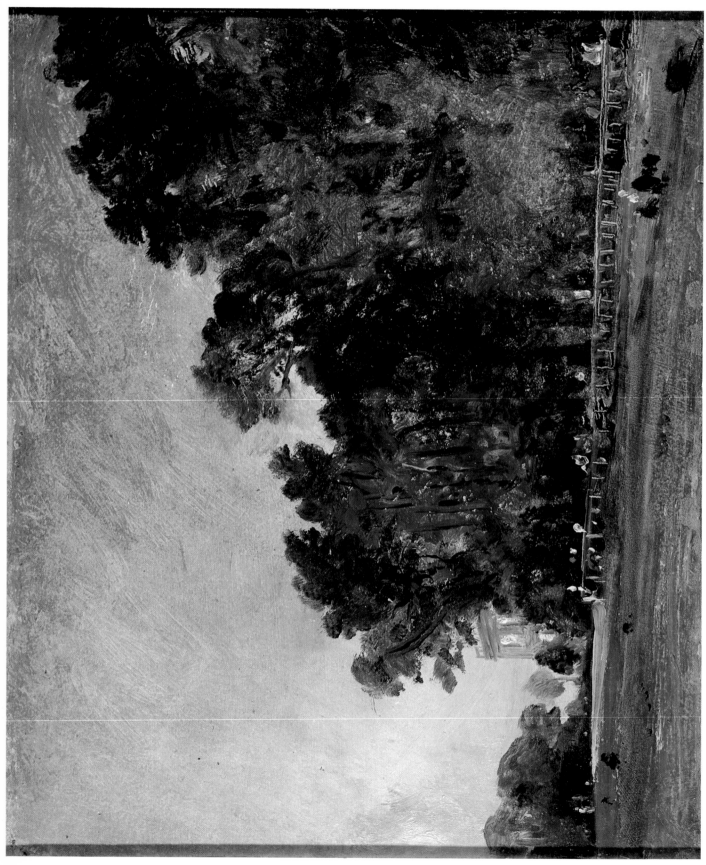

469. (23.85) *A scene in a park*, Royal Academy of Arts, London, 24 × 29cm.

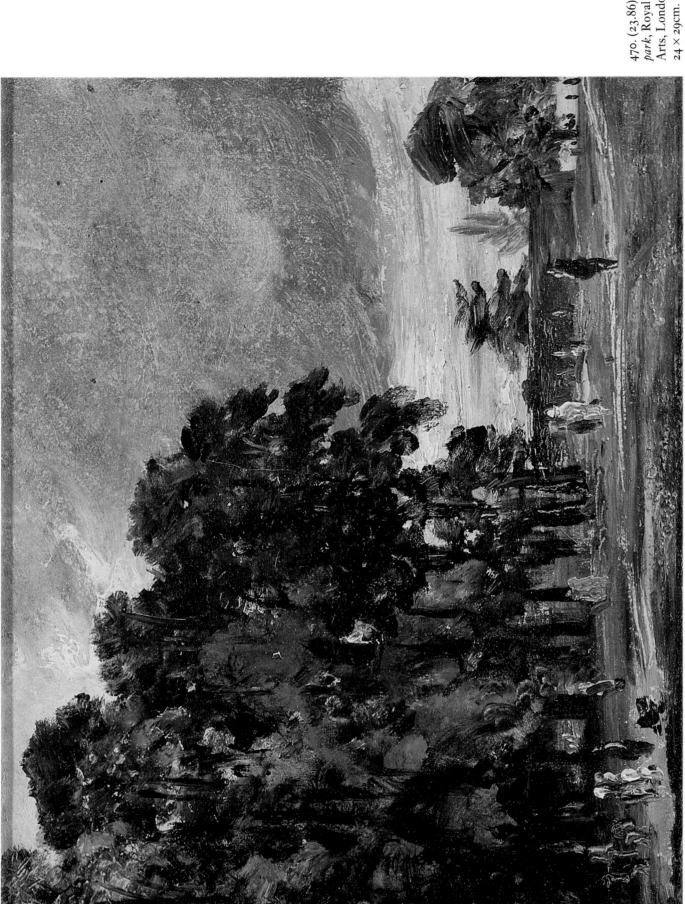

470. (23.86) *A scene in a park*, Royal Academy of Arts, London, 24 × 29cm.

471. (above) (23.83) *A house at Hampstead*, British Museum, 16·7 × 25·4cm.

472. (23.84) *An elm tree near a towered building*, Executors of the late Lieutenant-Colonel J. H. Constable, 8·2 × 6·4cm.

473. (23.87) *Maria Louisa Constable as a child*, Private collection, 30 × 21·6cm.

474. (below) (23.88) *John Charles Constable with Maria Louisa and Isabel: 'A Drive in the Nursery'*, Private collection, 8·4 × 18·9cm.

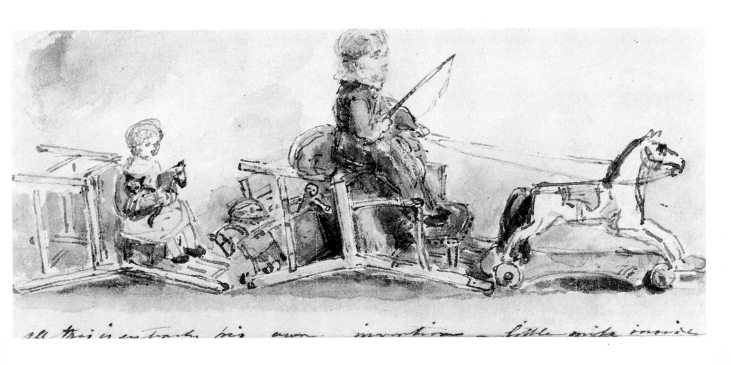

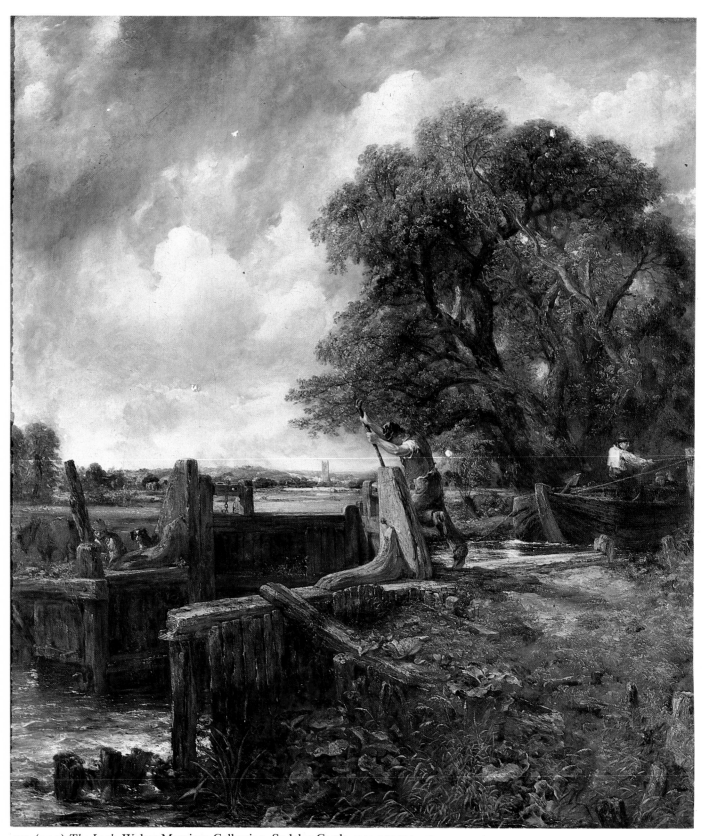

475. (24.1) *The Lock*, Walter Morrison Collection, Sudeley Castle, 142·2 × 120·7cm.

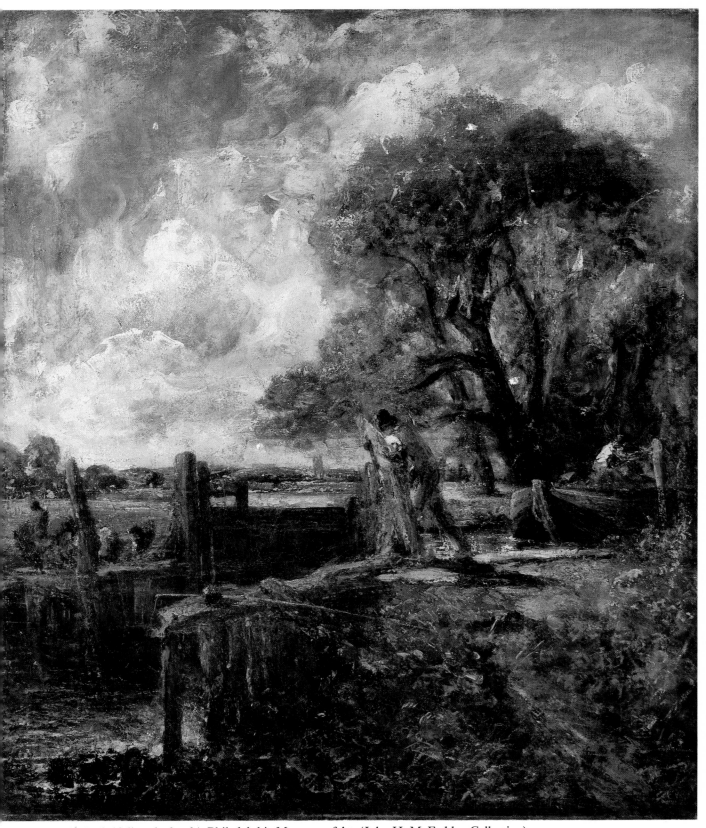

476. (24.2) *The Lock (full-scale sketch)*, Philadelphia Museum of Art (John H. McFadden Collection), 141·7 × 122cm.

477. (24.3) *Study of a girl's head*, Philadelphia Museum of Art (John H. McFadden Collection), 141·7 × 122cm.

478. (below) (24.5) *Osmington Bay*, Private collection, 32.3 × 50·8cm.

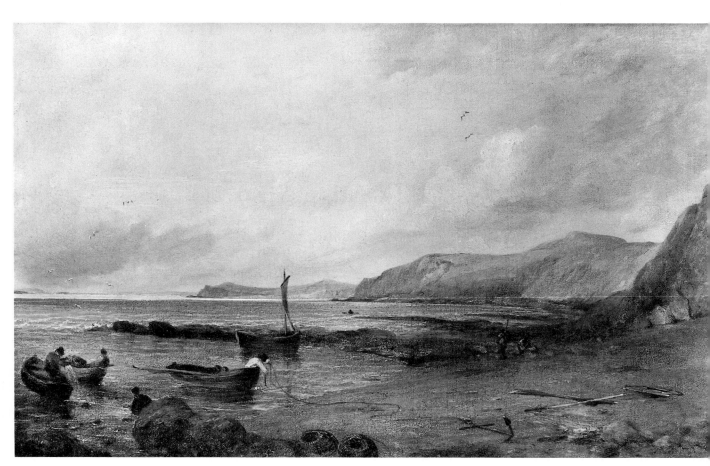

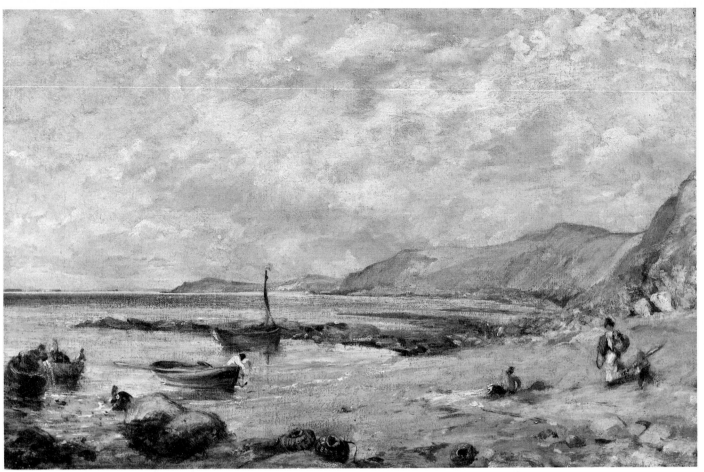

479. (24.6) *Osmington Bay*, Wadsworth Atheneum (The Ella Gallup Sumner and Mary Catelin Sumner Collection), Hartford, Connecticut, 34·5 × 51·8cm.

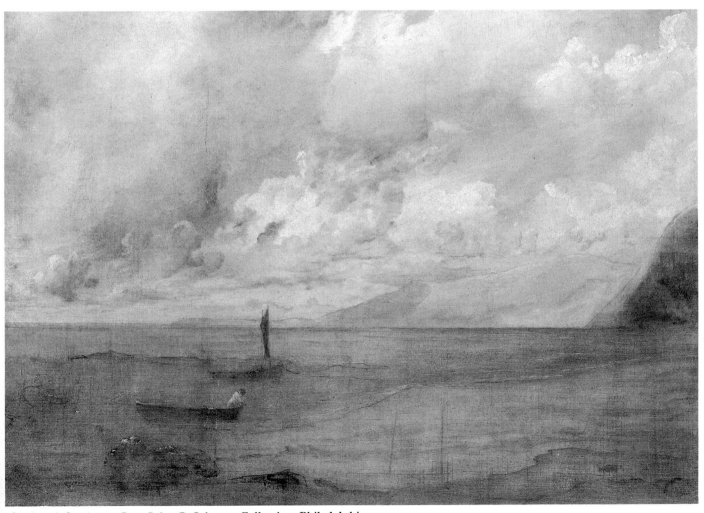

480. (24.7) *Osmington Bay*, John G. Johnson Collection, Philadelphia, 52·4 × 74·3cm.

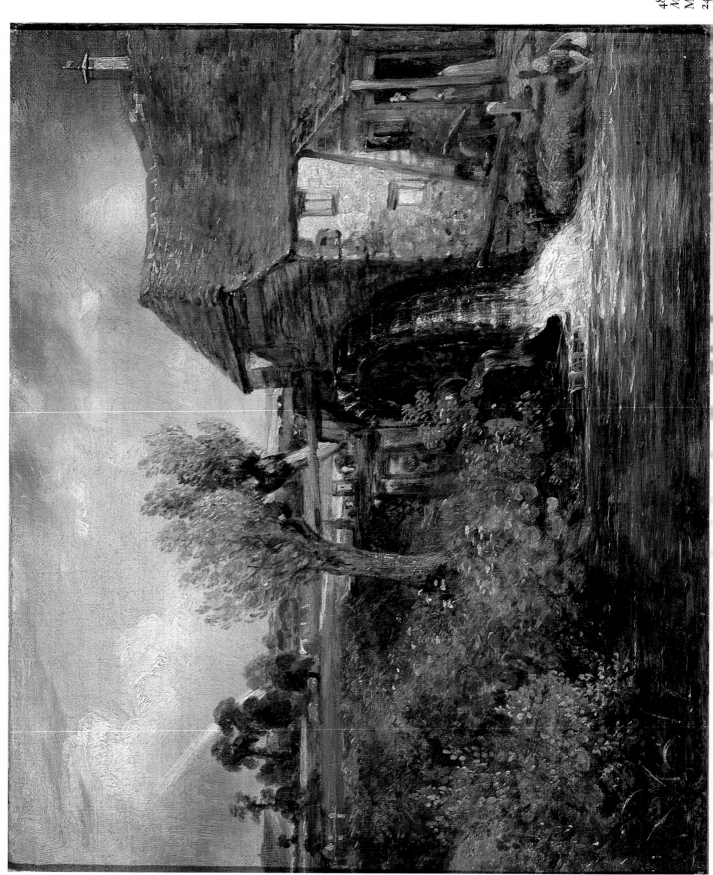

481. (244) *Gillingham
Mill*, Fitzwilliam
Museum, Cambridge,
24·8 × 30·2cm.

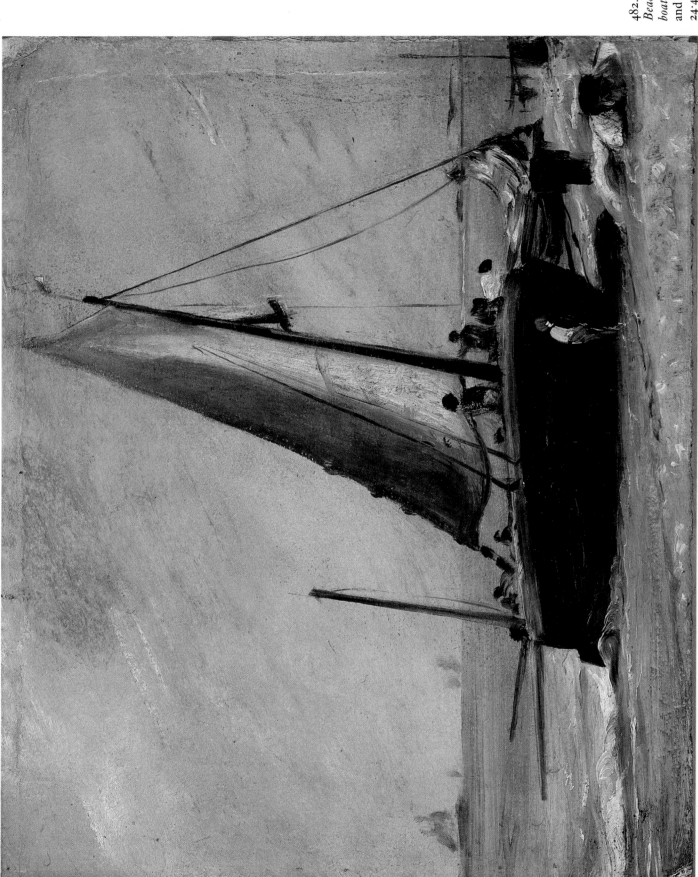

482. (24.8) *Brighton Beach, with a fishing boat and crew*, Victoria and Albert Museum, 24·4 × 29·8cm.

483. (24.13) *Storm clouds over the sea at Brighton*, Hugh Lane Municipal Gallery of Modern Art, Dublin, 22·2 × 38·1cm.

484. (24.16) *Brighton, looking towards Shoreham*, Castle Museum, Norwich, 11 × 29·8cm.

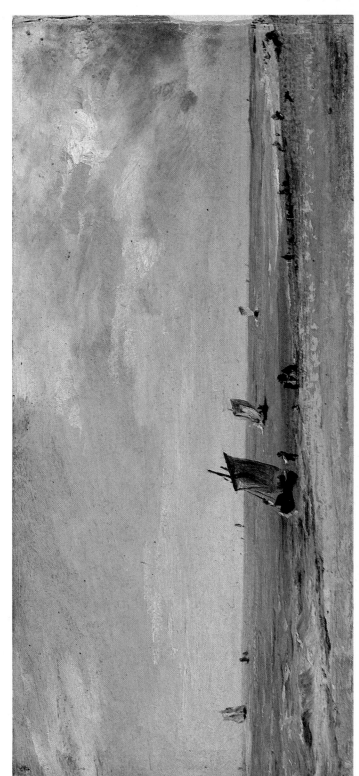

485. (24.9) *Brighton Beach*, Victoria and Albert Museum, 12 × 29·7cm.

486. (24.10) *Brighton Beach*, Victoria and Albert Museum, 13·6 × 30·2cm.

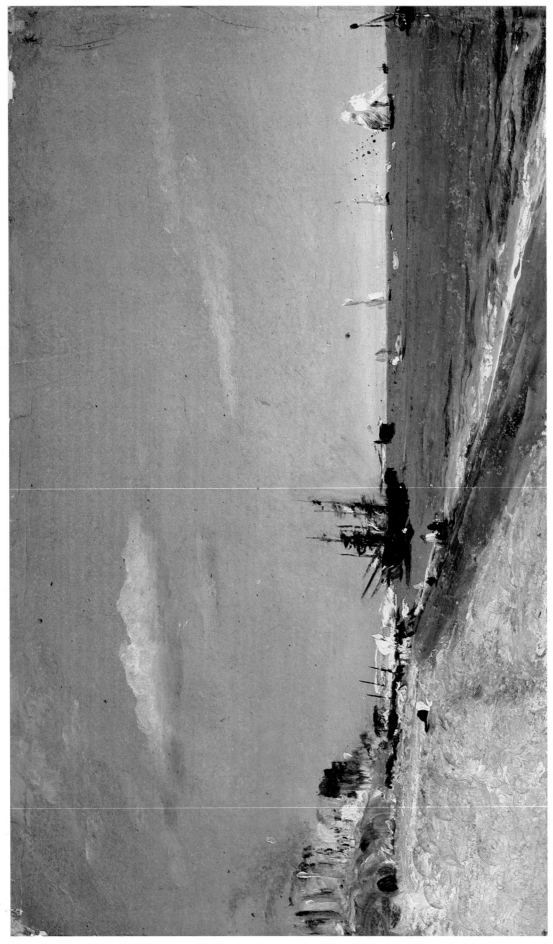

487. (24.11) *Brighton Beach, with colliers*, Victoria and Albert Museum, 14·9 × 24·8cm.

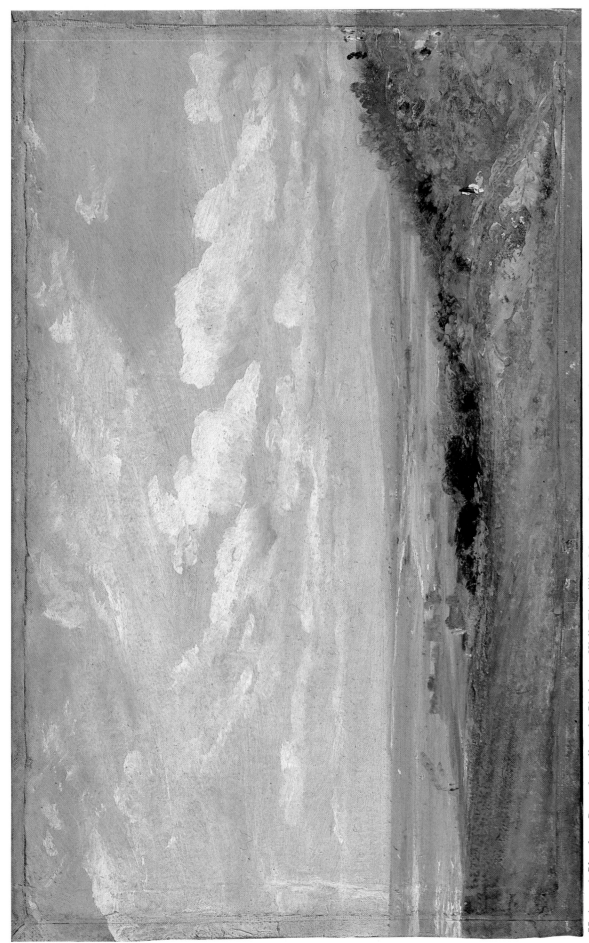

488. (24.12) *Shoreham Bay: the walk to the Chalybeate Wells*, Fitzwilliam Museum, Cambridge, 14.9 × 24.8cm.

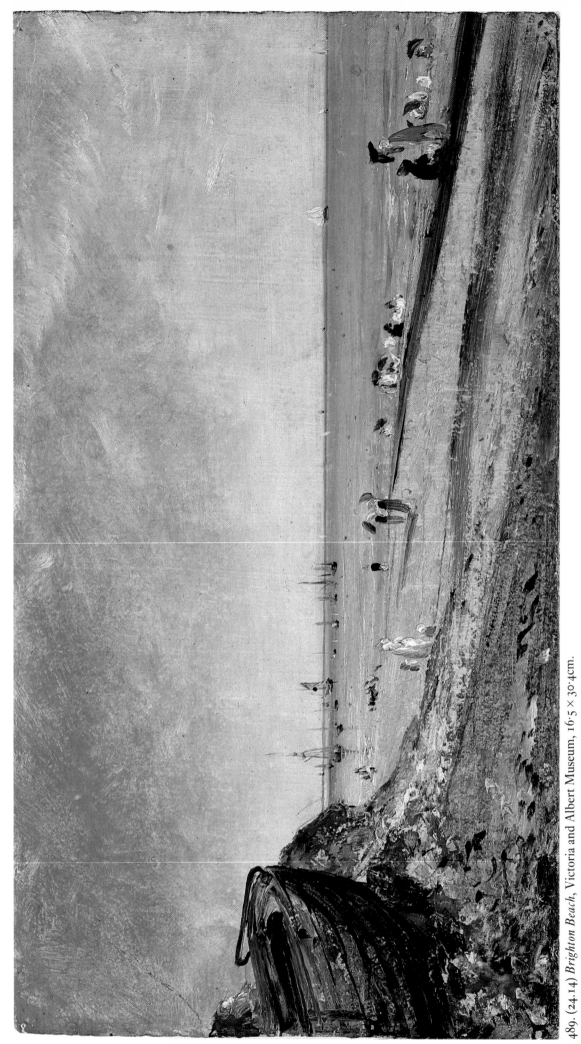

489. (24.14) *Brighton Beach*, Victoria and Albert Museum, 16·5 × 30·4cm.

490. (below) (24.15) *A windmill near Brighton*, Tate Gallery, 20·3 × 25·1cm.

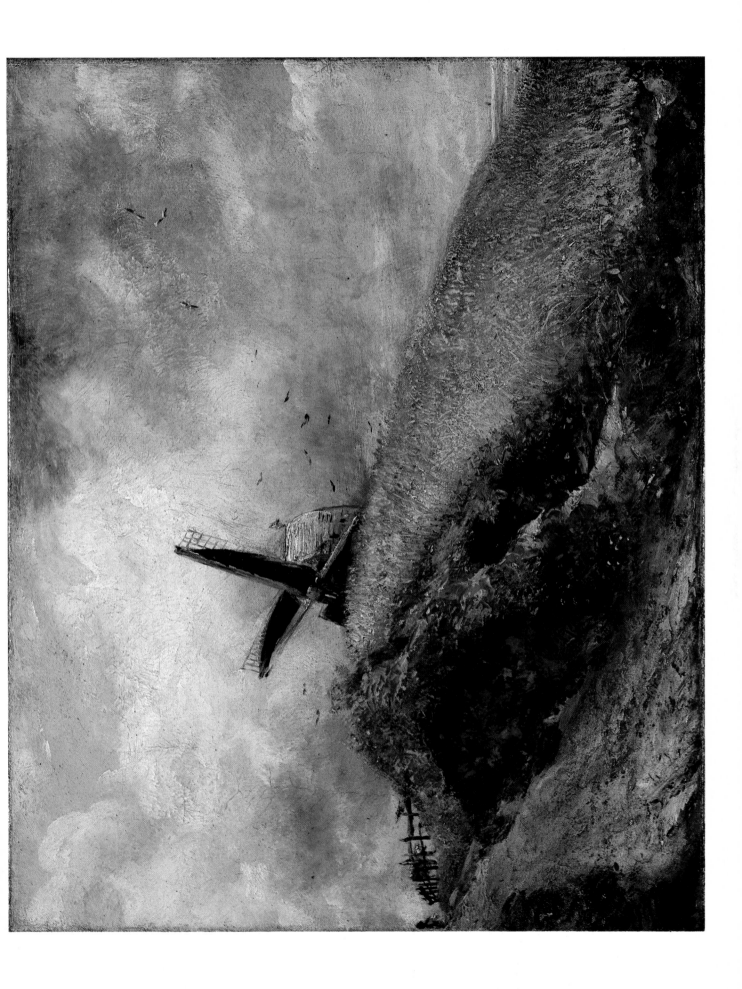

491. (above) (24.17) *A windmill near Brighton*, Victoria and Albert Museum, 16·2 × 30·8cm.

492. (left) (24.19) *Brighton*, Private collection, 11·5 × 15·2cm.

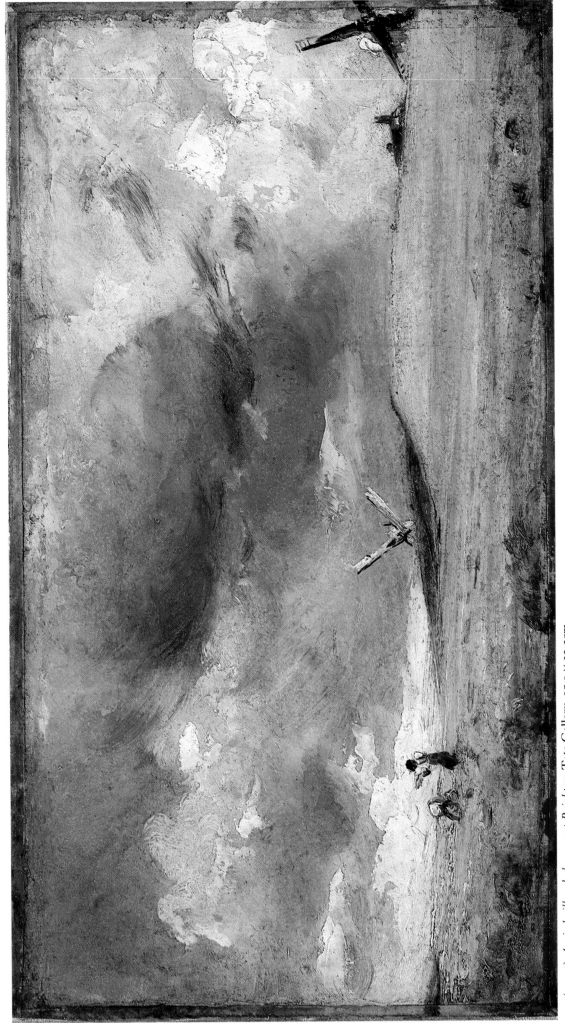

493. (24.20) *A windmill and gleaners at Brighton*, Tate Gallery, 15·9 × 30·2cm.

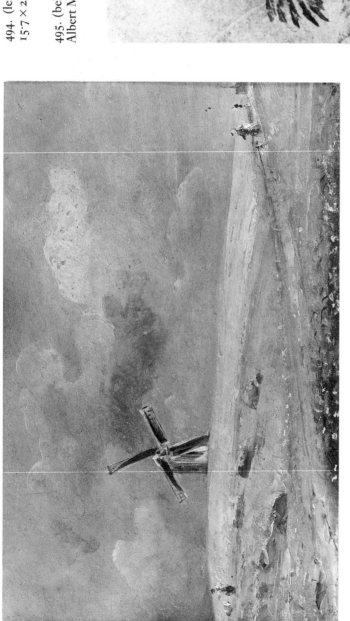

494. (left) (24.21) *A windmill near Brighton*, Victoria and Albert Museum, 15·7 × 24·4cm.

495. (below left) (24.22) *The Battery on the West Cliff, Brighton*, Victoria and Albert Museum, 15·7 × 24·4cm.

496. (24.23) *Two gleaners*, Private collection, 13·6 × 10cm.

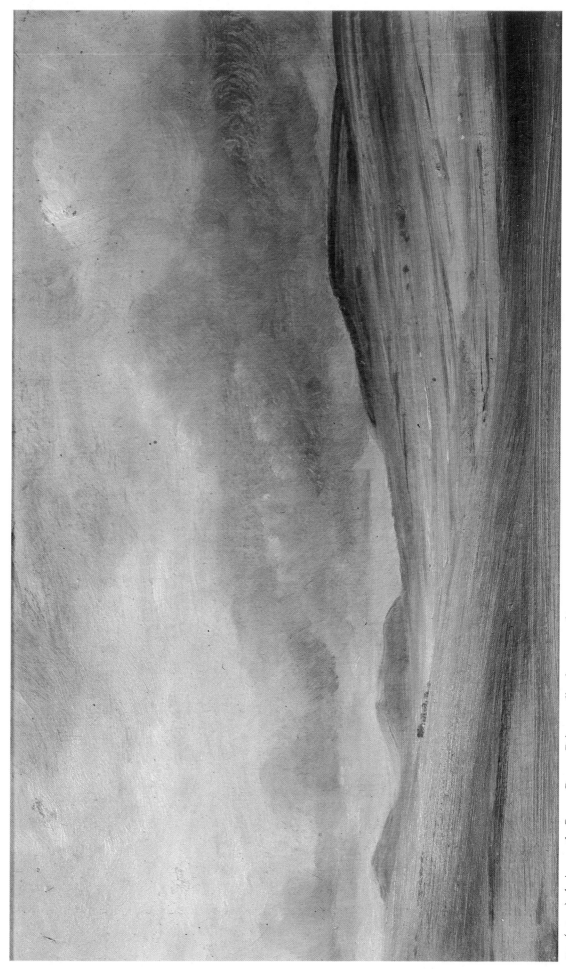

497. (24.24) *A view on the Sussex Downs*, Private collection, 15 × 26cm.

498. (24.25) *The Devil's Dyke*, Victoria and Albert Museum, 33·3 × 42cm.

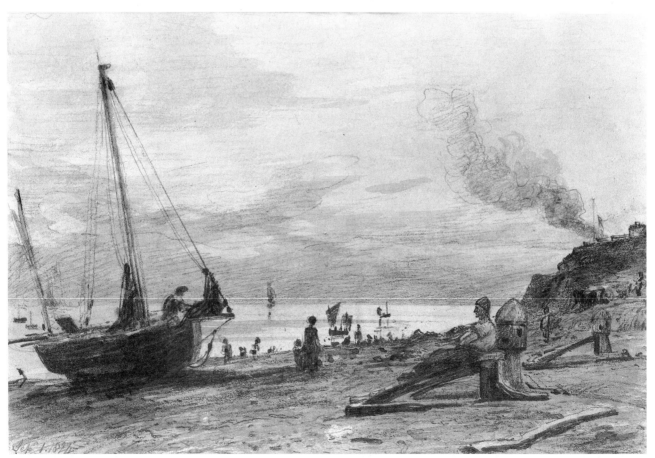

499. (24.26) *Brighton Beach, with capstan*, Private collection, 17·4 × 25·8cm.

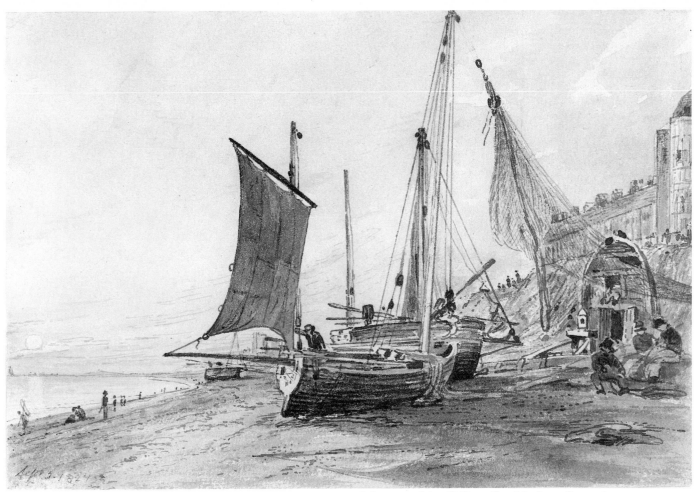

500. (24.27) *Brighton Beach with fishing boats*, Henry E. Huntington Library and Art Gallery, San Marino, 18·2 × 26·2cm.

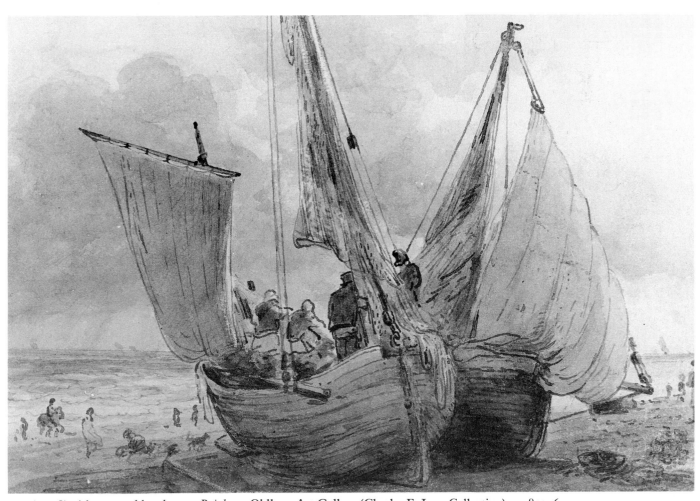

501. (24.28) *A lugger and hog-boat at Brighton*, Oldham Art Gallery (Charles E. Lees Collection), 17·8 × 26cm.

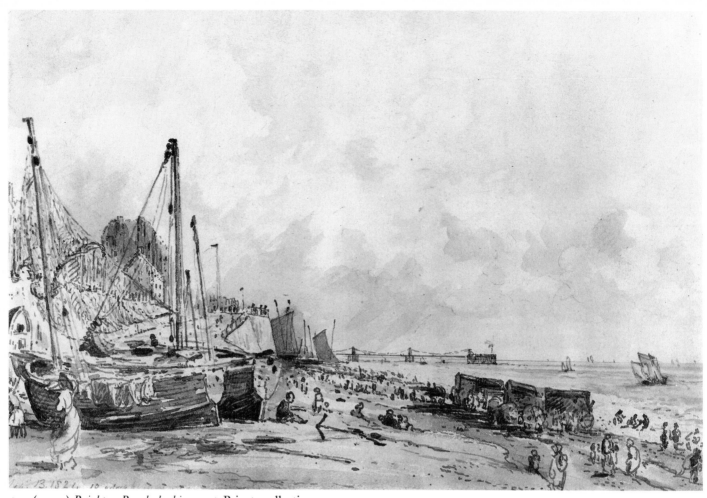

502. (24.30) *Brighton Beach, looking west*, Private collection, 17·5 × 25·5cm.

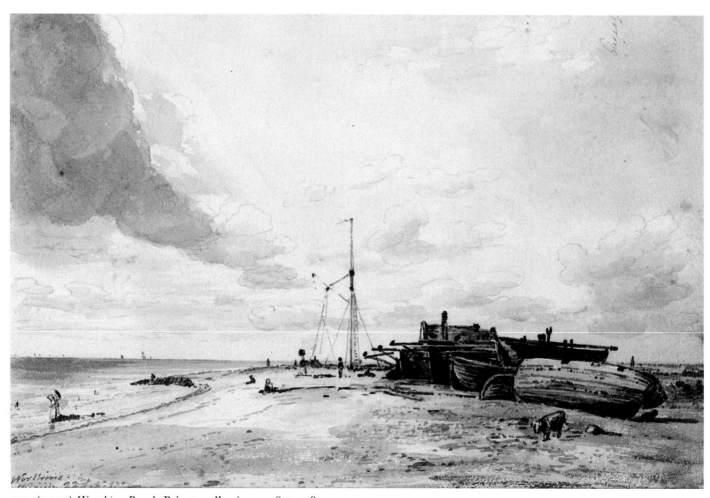

503. (24.31) *Worthing Beach*, Private collection, 17·8 × 25·8cm.

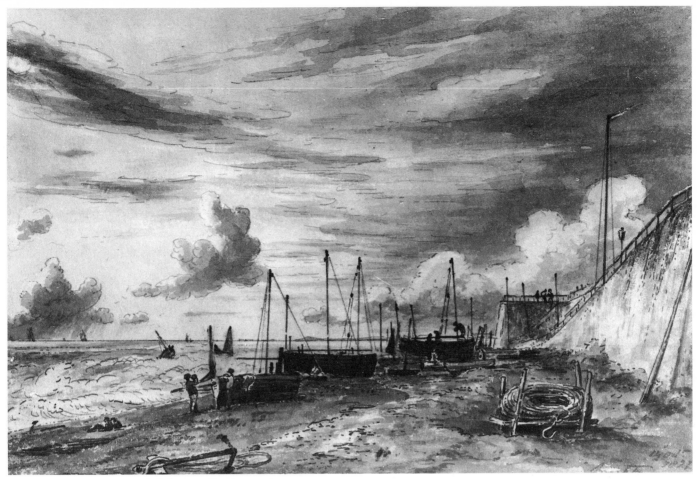

504. (24.32) *Brighton Beach*, Private collection, 17·5 × 25cm.

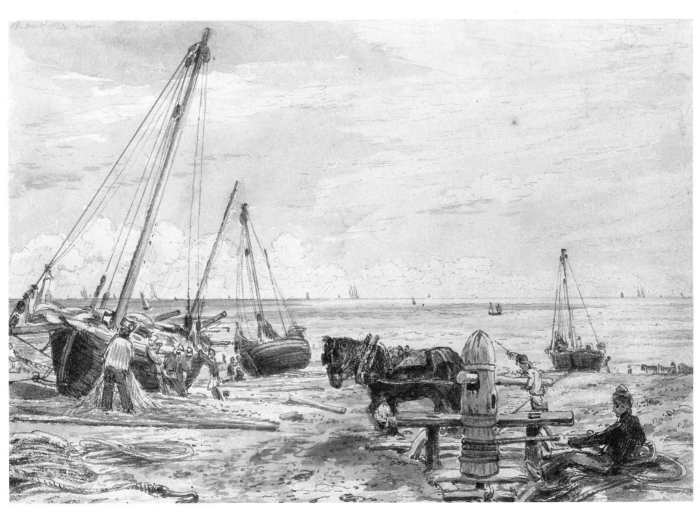

505. (24.33) *Brighton Beach, with a horse turning a capstan*, Fogg Art Museum, Harvard University, Cambridge, Massachusetts, 18 × 26cm.

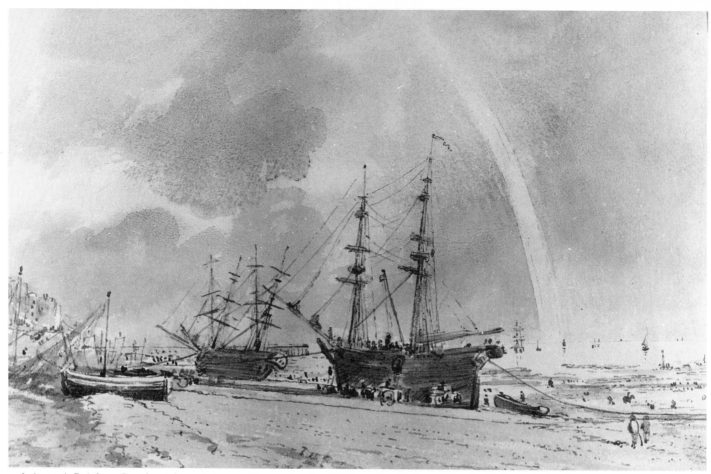

506. (22.34) *Brighton Beach, with a rainbow; colliers unloading*, Oldham Art Gallery (Charles E. Lees Collection), 17·3 × 25·7cm.

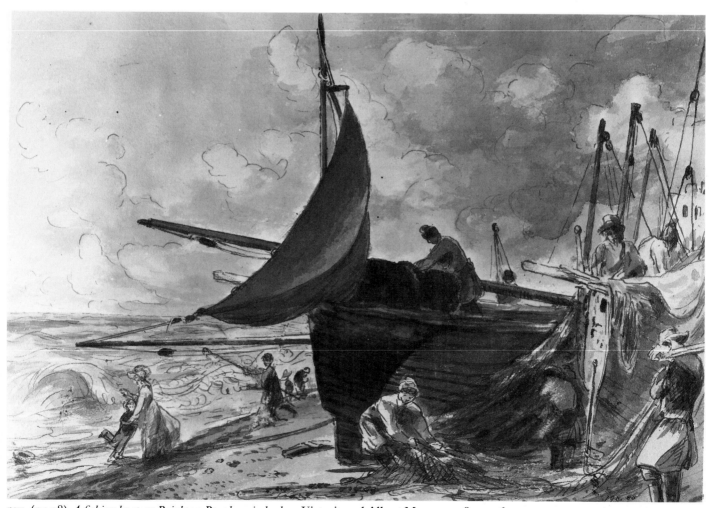

507. (24.38) *A fishing boat on Brighton Beach: windy day*, Victoria and Albert Museum, 18·1 × 26·4cm.

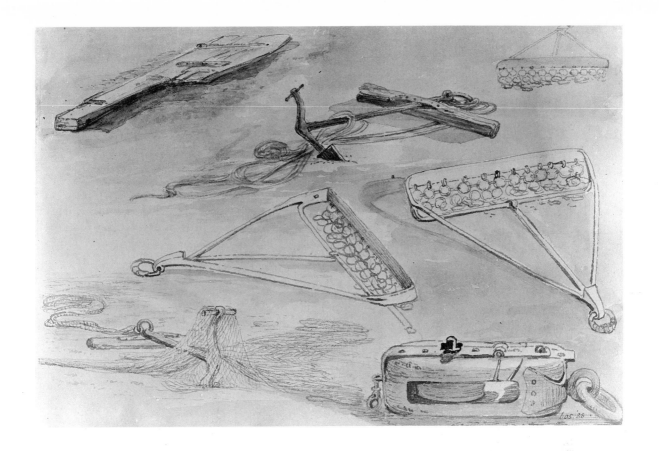

508. (above) (24.36) *Studies of
tackle on Brighton Beach*,
Victoria and Albert Museum,
18·1 × 26·4cm.

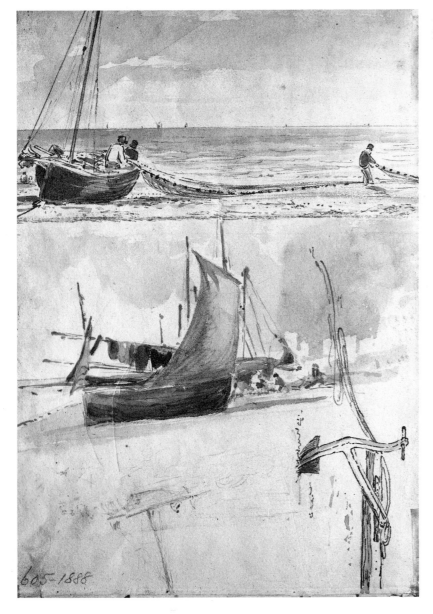

509. (24.37) *Sketches on the
beach at Brighton*, Victoria
and Albert Museum,
26·4 × 18·1cm.

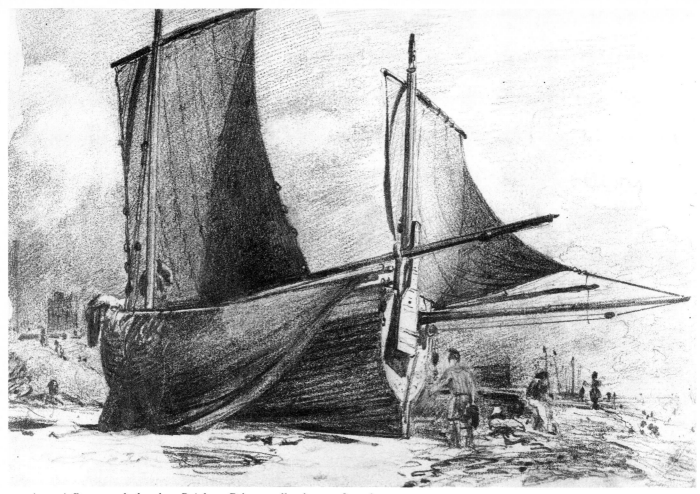

510. (24.39) *Boats on the beach at Brighton*, Private collection, 17·8 × 26·1cm.

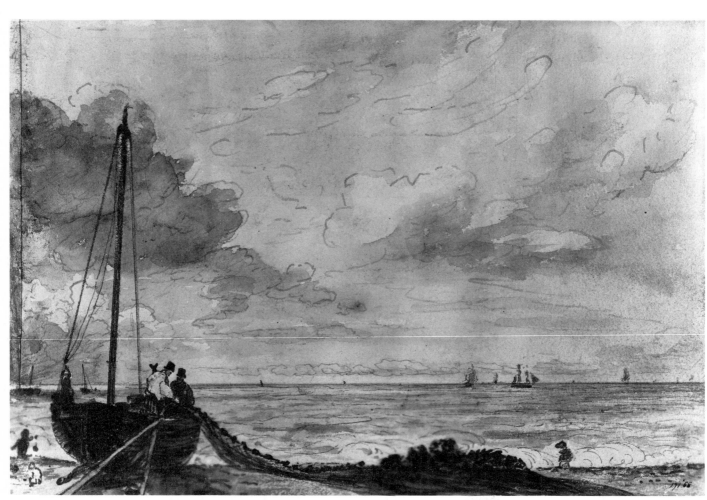

511. (24.40) *Brighton Beach: a fishing boat with a net*, Victoria and Albert Museum, 17·8 × 26cm.

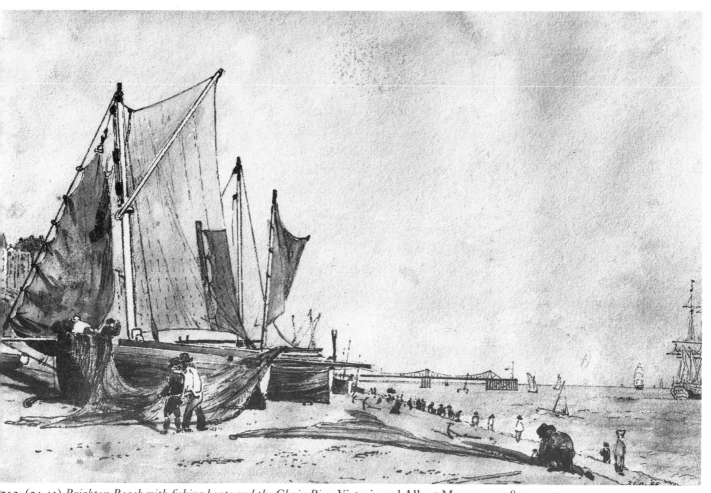

512. (24.41) *Brighton Beach with fishing boats and the Chain Pier*, Victoria and Albert Museum, 17·8 × 25·9cm.

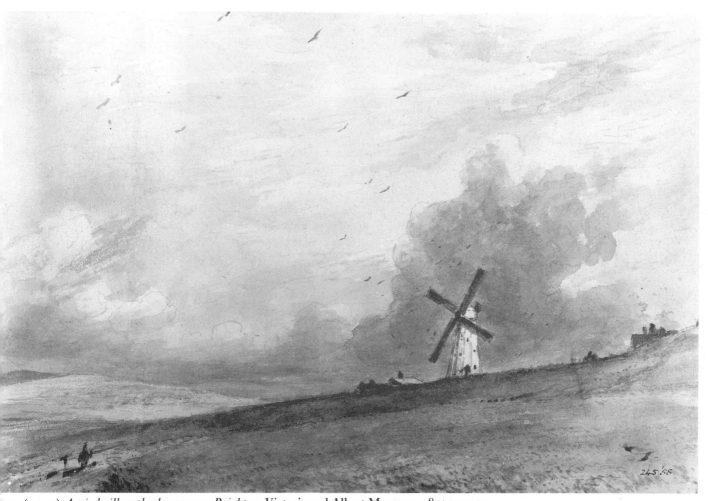

513. (24.42) *A windmill on the downs near Brighton*, Victoria and Albert Museum, 18 × 27·4cm.

514. (24.43) *A windmill near Brighton*, Horne Foundation, Florence, 18·2 × 24cm.

515. (24.44) *Scenes on the beach at Brighton*, Horne Foundation, Florence, 18·2 × 24cm.

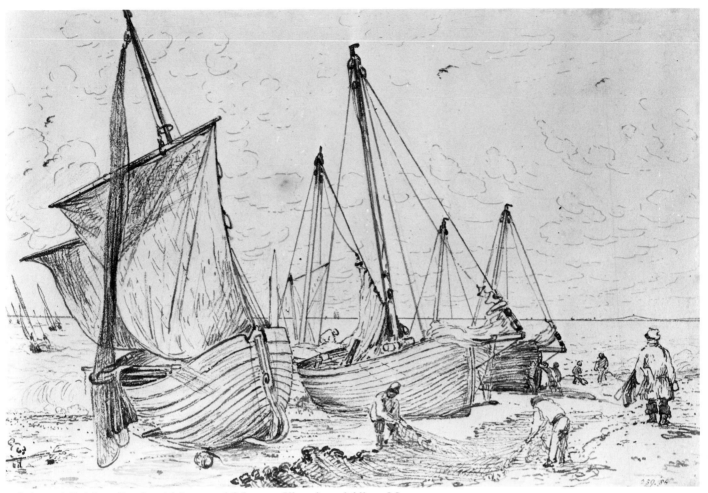

516. (24.45) *Brighton Beach, with boats and fishermen*, Victoria and Albert Museum, 17·9 × 25·7cm.

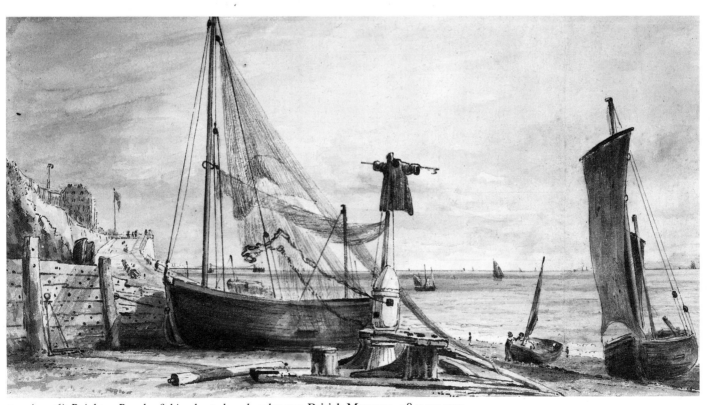

517. (24.46) *Brighton Beach: fishing boats by a breakwater*, British Museum, 18 × 32·4cm.

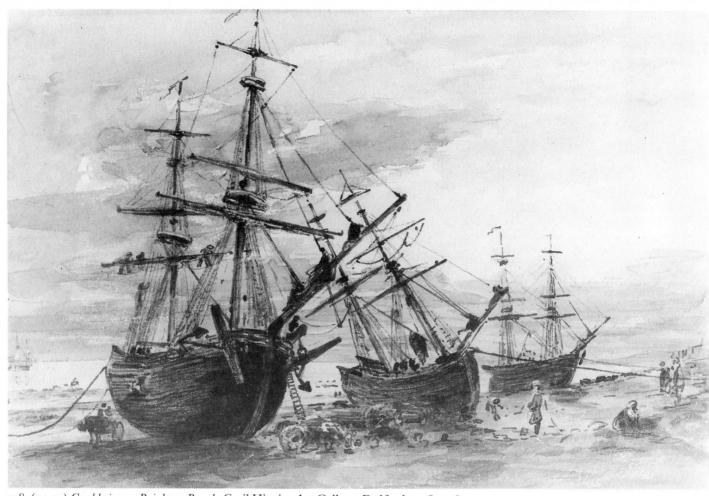

518. (24.47) *Coal brigs on Brighton Beach*, Cecil Higgins Art Gallery, Bedford, 17·8 × 26cm.

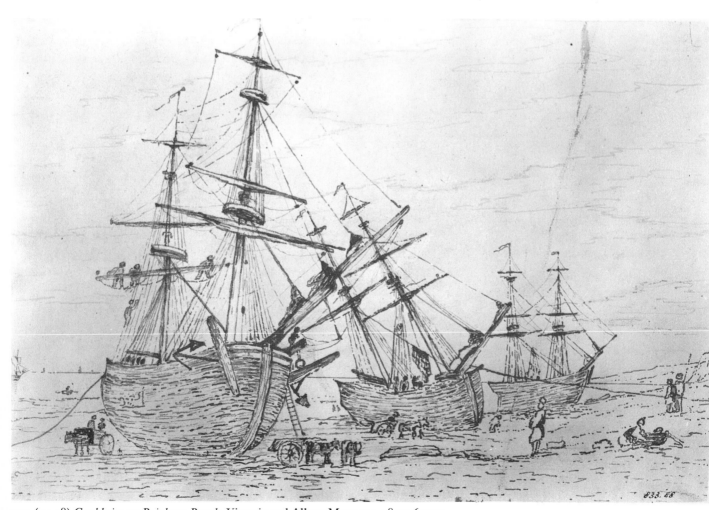

519. (24.48) *Coal brigs on Brighton Beach*, Victoria and Albert Museum, 18 × 26·1cm.

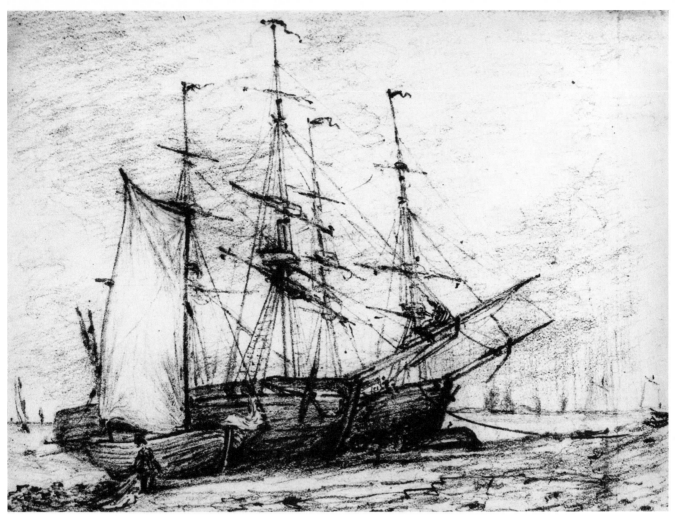

520. (24.49) *Shipping on the beach at Brighton*, Private collection, 17·8 × 26·6cm.

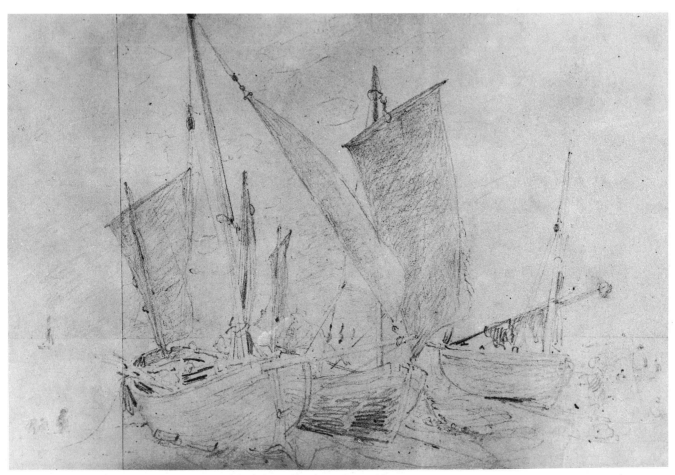

521. (24.50) *Fishing boats on Brighton Beach*, Private collection, 17·7 × 26·2cm.

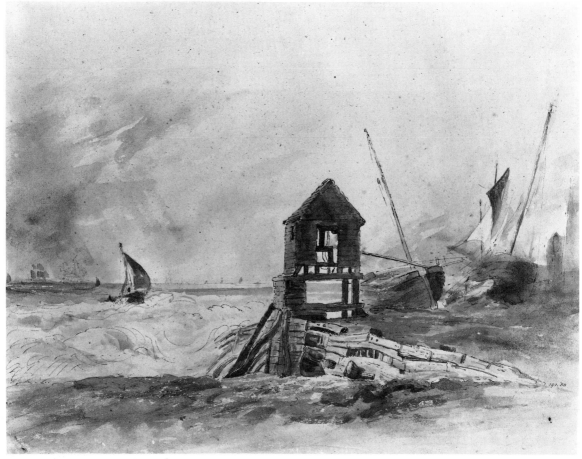

522. (24.51) *The beach at Brighton, with a belfy in the foreground*, Victoria and Albert Museum, 33·3 × 42cm.

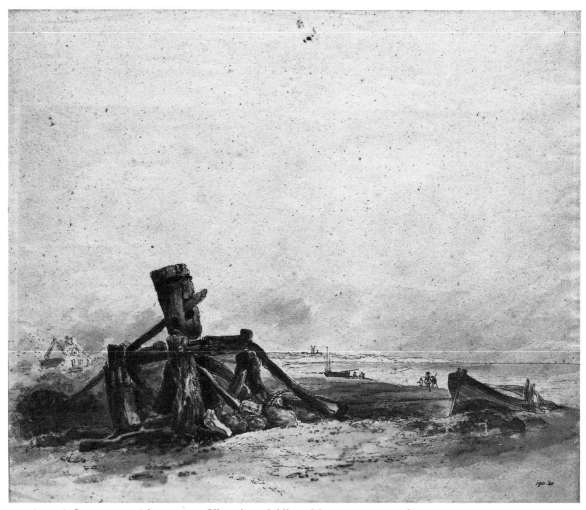

523. (24.52) *Coast scene with a capstan*, Victoria and Albert Museum, 33·2 × 38·2cm.

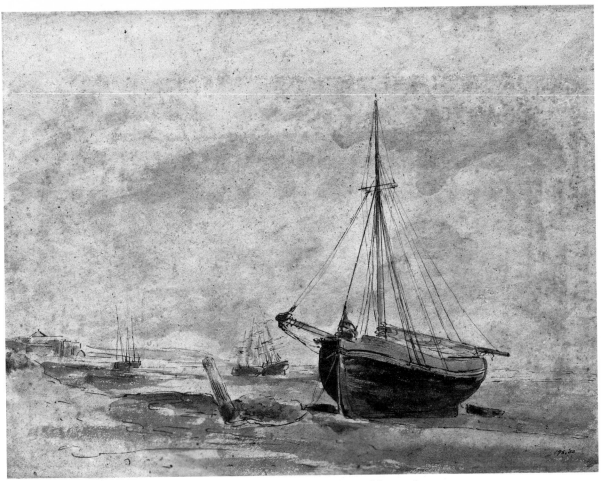

524. (24.53) *Coast scene with shipping*, Victoria and Albert Museum, 26.8 × 33·6cm.

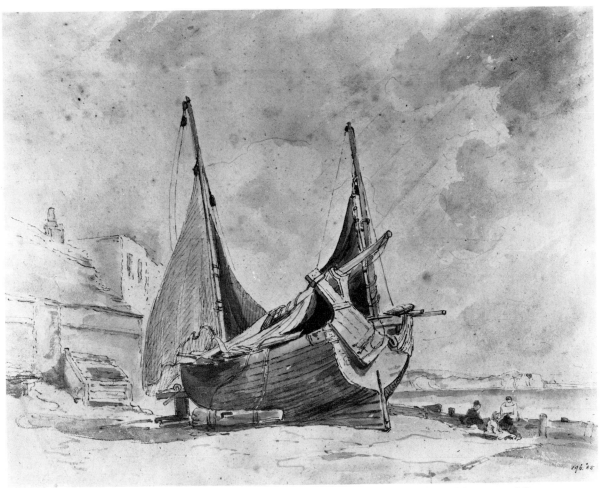

525. (24.54) *A coast scene with a fishing boat and a terrace of houses*, Victoria and Albert Museum, 26·8 × 33·7cm.

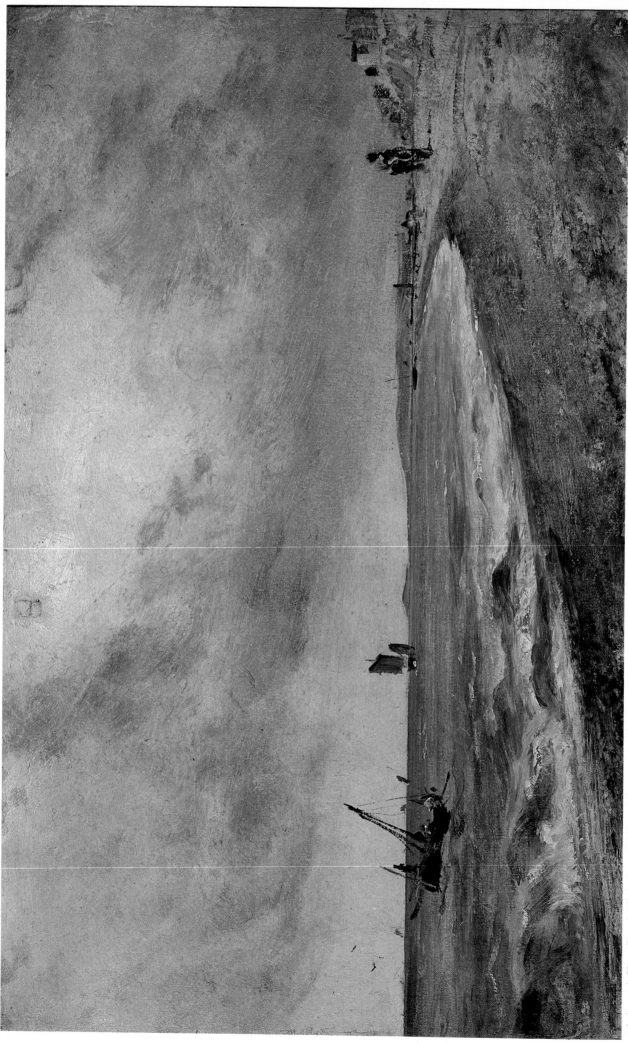

526. (24.59) *Hove Beach*, Victoria and Albert Museum, 29·8 × 49·2cm.

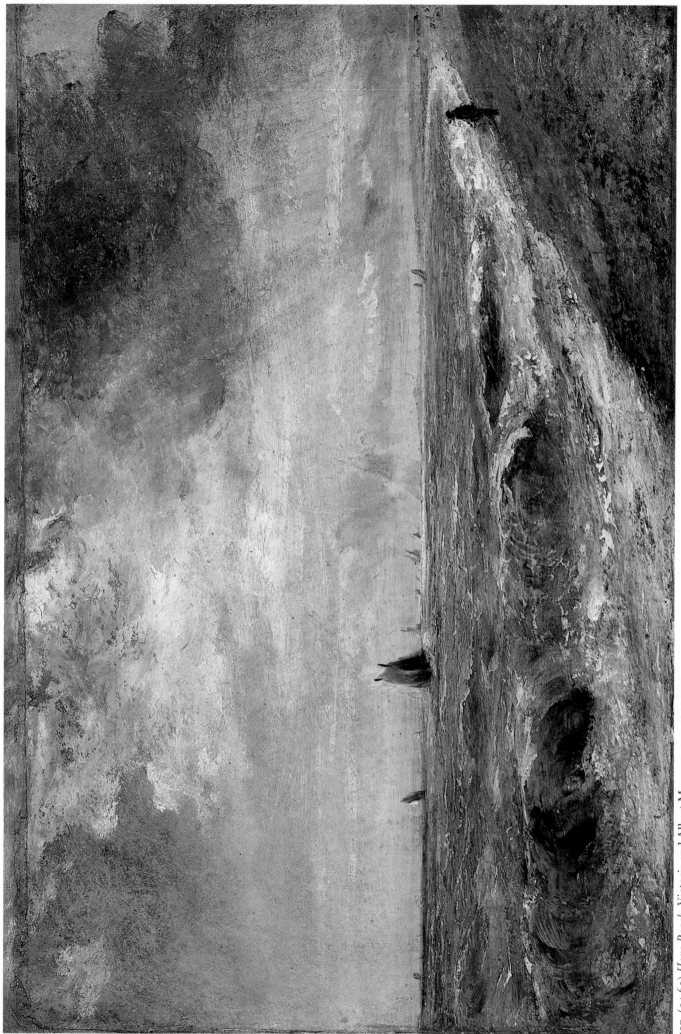

527. (24.60) *Hove Beach*, Victoria and Albert Museum, 31·7 × 49·5 cm.

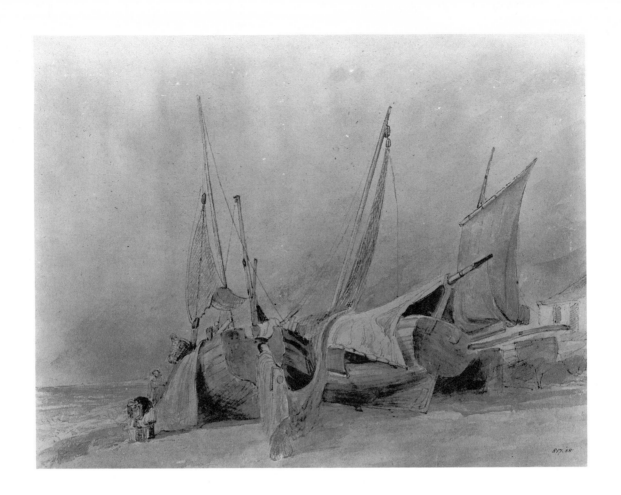

528. (above) (24.56)
*Coast scene, with fishing
boats drawn up on the
beach*, Victoria and
Albert Museum,
26·7 × 33·6cm.

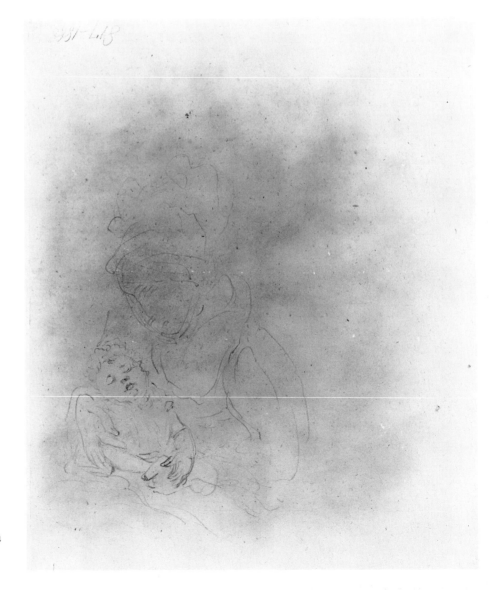

529. (24·57) *A woman
nursing a child*, Victoria
and Albert Museum,
26·7 × 33·6cm.

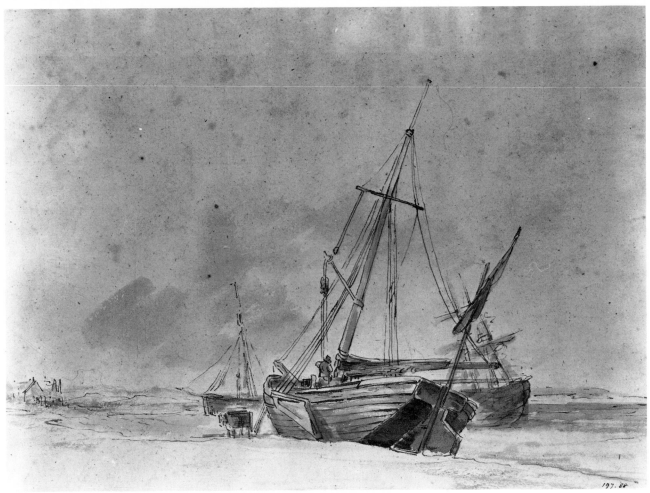

530. (24.55) *Coast scene with fishing boats on the beach*, Victoria and Albert Museum, 26·8 × 33·6cm.

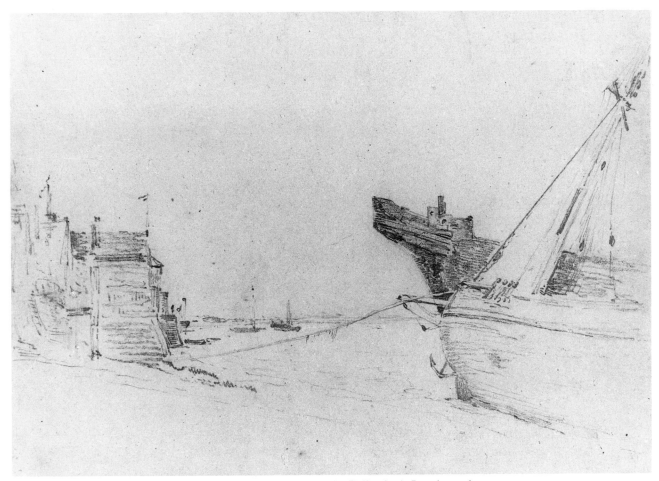

531. (24.58) *Brighton Beach*, Courtauld Institute Galleries (Witt Collection), London, 26 × 37cm.

532. (above) (24.61)
Hove Beach, Yale
Center for British Art,
New Haven, 23 × 36cm.

533. (24.65) *A coast
scene*, Royal Academy of
Arts, London,
19·7 × 24·1cm.

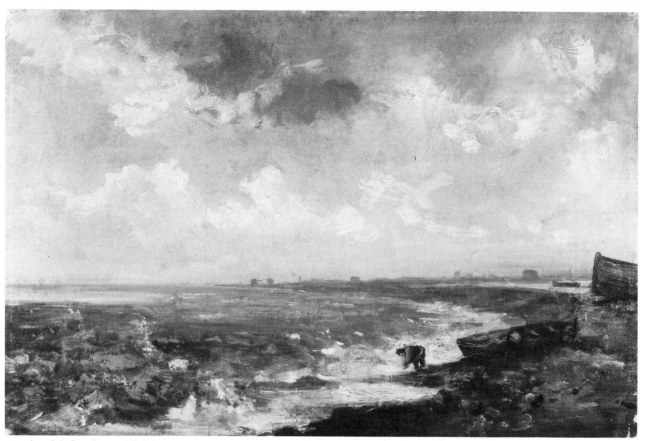

534. (24.62) *Seashore with fisherman near a boat*, Walker Art Gallery, Liverpool, 33 × 49·2cm.

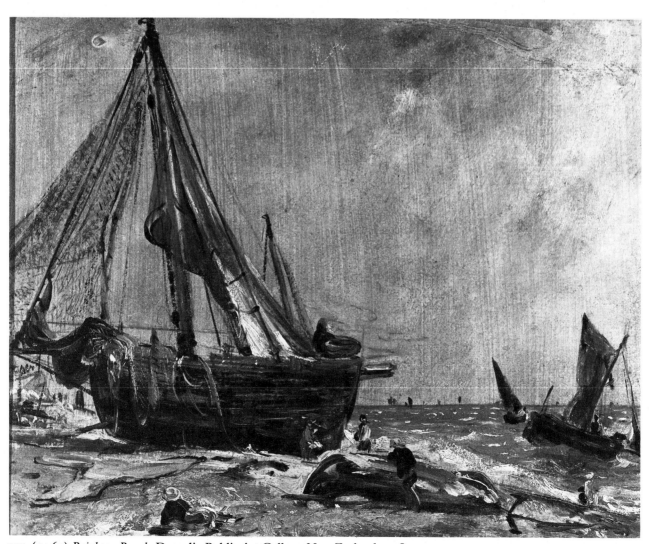

535. (24.63) *Brighton Beach*, Dunedin Public Art Gallery, New Zealand, 23·8 × 29·3cm.

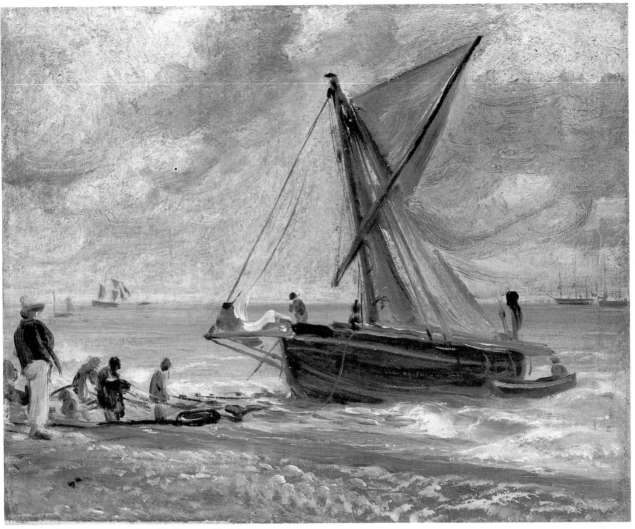

536. (24.64) *Beaching the boat*, Private collection, 25 × 30cm.

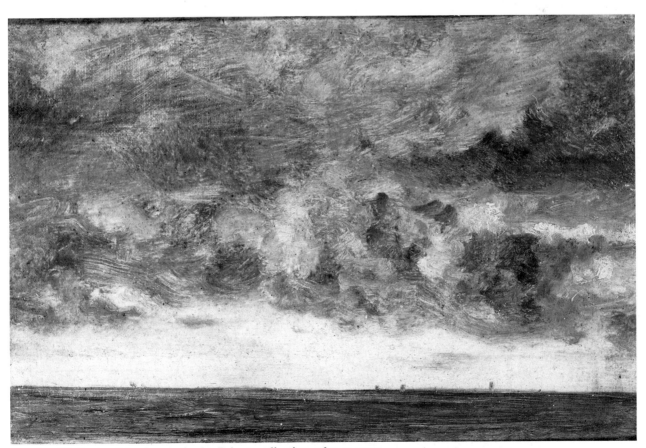

537. (24.68) *Study of clouds over the sea*, Private collection, 16 × 23·3cm.

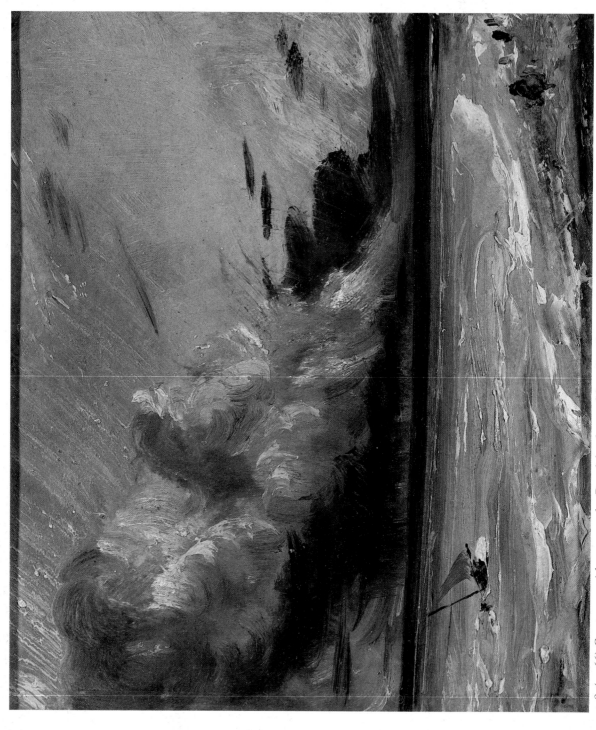

538. (24.66) *Coast scene with a stormy sky*, Royal Academy of Arts, London, 15·2 × 18·5cm.

539. (below) (24.67) *A rain storm over the sea*, Royal Academy of Arts, London, 22·2 × 31cm.

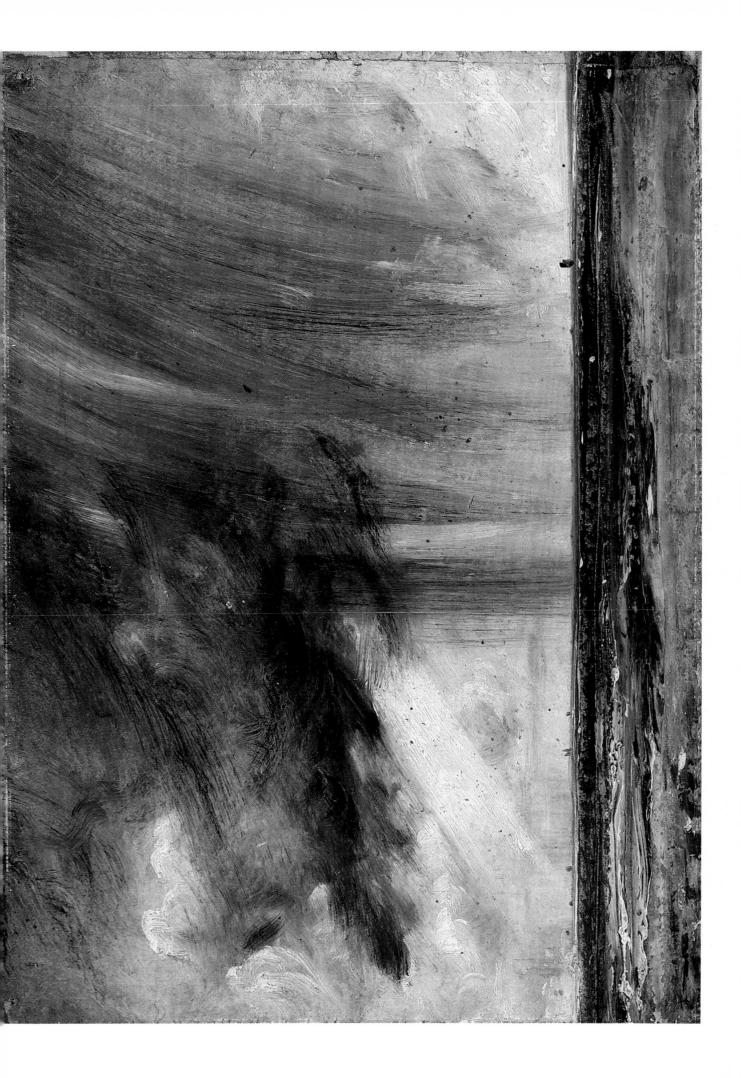

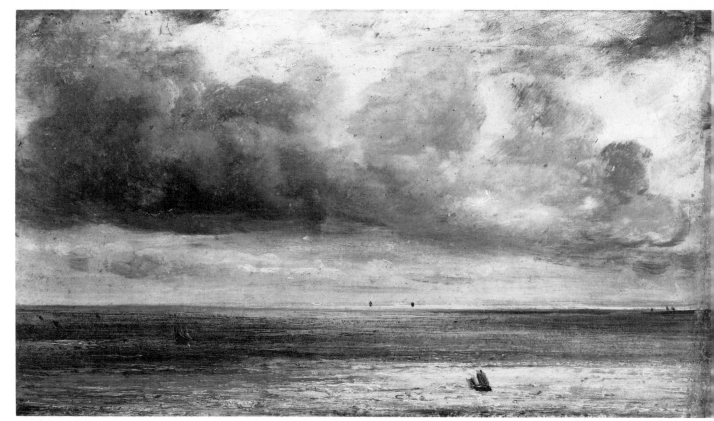

540. (24.69) *The sea off Brighton*, Private collection, on loan to City Museums and Art Gallery, Birmingham, 12·7 × 21·6cm.

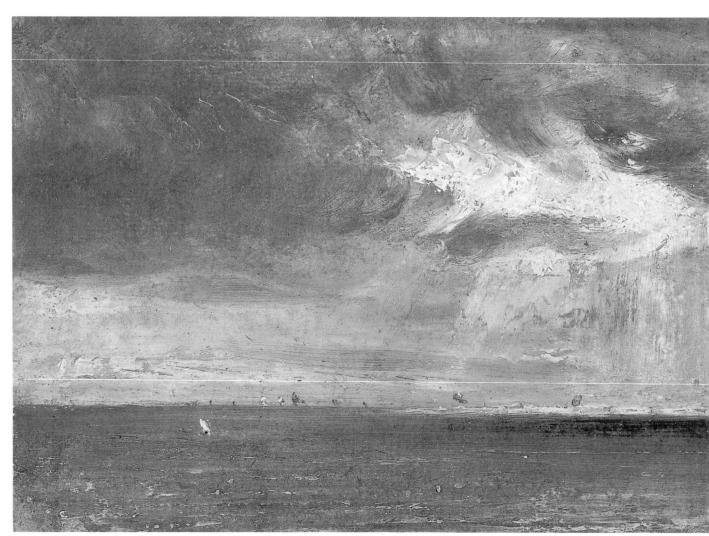

541. (24.70) *A storm off the coast*, Private collection, 14 × 19·5cm.

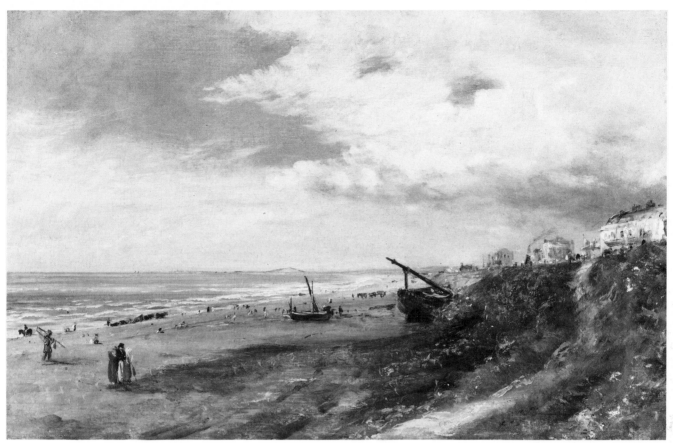

542. (24.71) *Hove Beach*, Fitzwilliam Museum, Cambridge, 33 × 50·8cm.

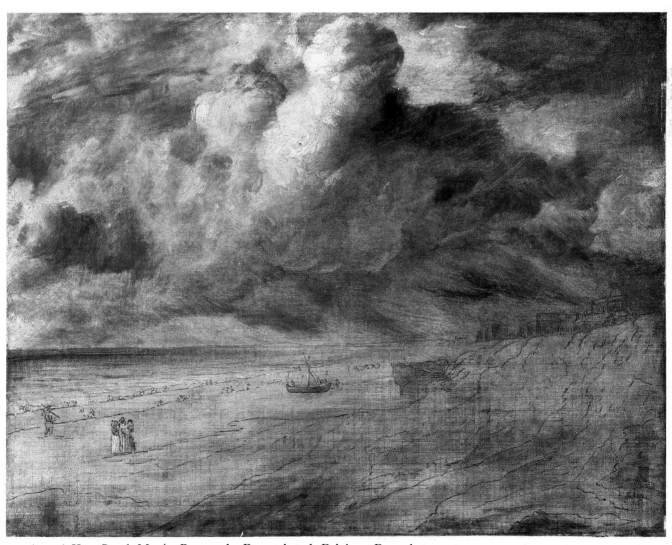

543. (24.72) *Hove Beach*, Musées Royaux des Beaux-Arts de Belgique, Brussels, 40·5 × 51cm.

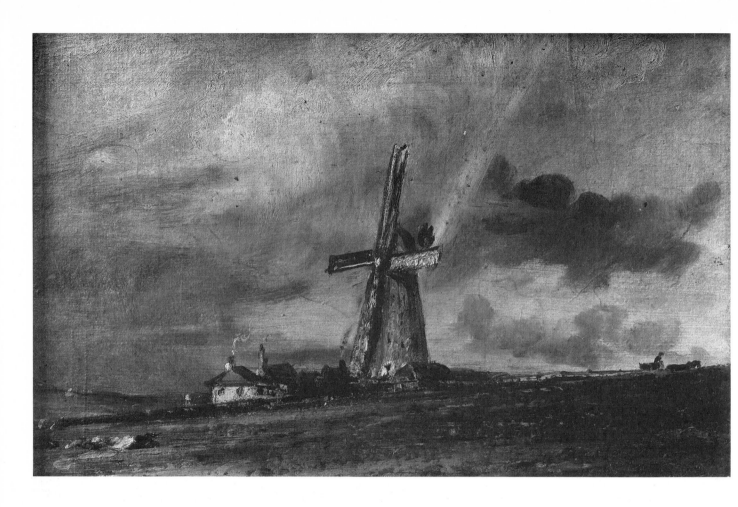

544. (above) (24.73) *A windmill on the downs near Brighton*, Victoria and Albert Museum, 21 × 30·4cm.

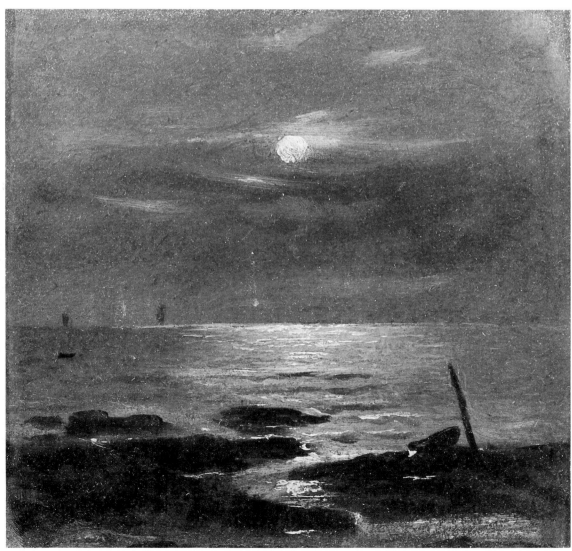

545. (27.74) *Moonlight over the sea*, Private collection, 14 × 15·2cm.

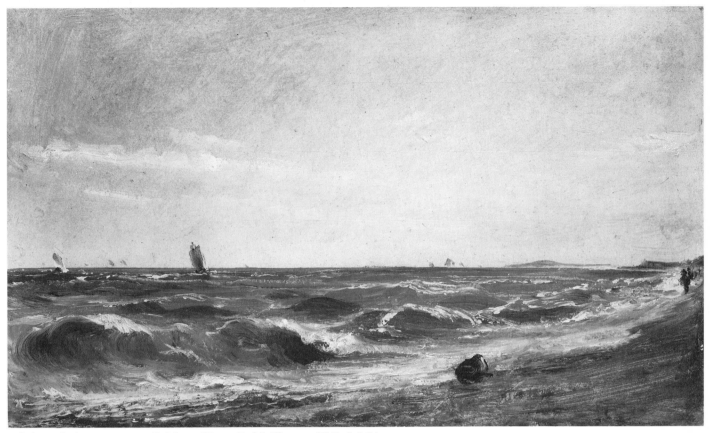

546. (24.75) *A coast scene at Brighton*, Henry P. McIlhenny, Philadelphia, 25·4 × 42·2cm.

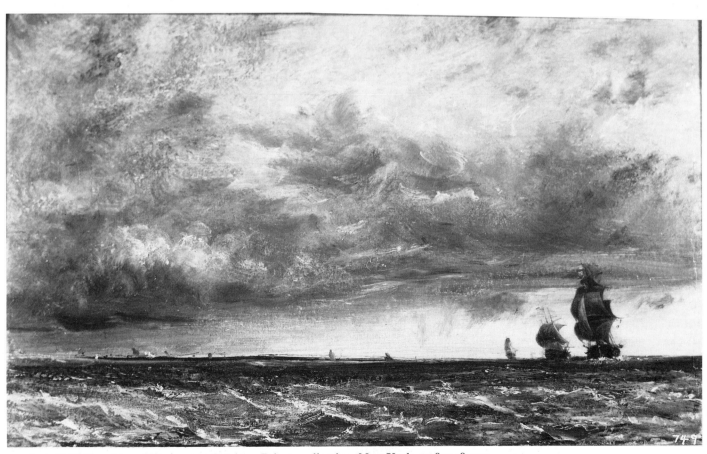

547. (24.76) *Sailing ships off the coast at Brighton*, Private collection, New York, 29·8 × 48·3cm.

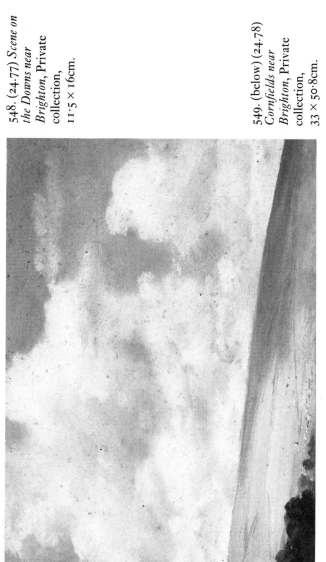

548. (24.77) *Scene on
the Downs near
Brighton*, Private
collection,
11·5 × 16cm.

549. (below) (24.78)
*Cornfields near
Brighton*, Private
collection,
33 × 50·8cm.

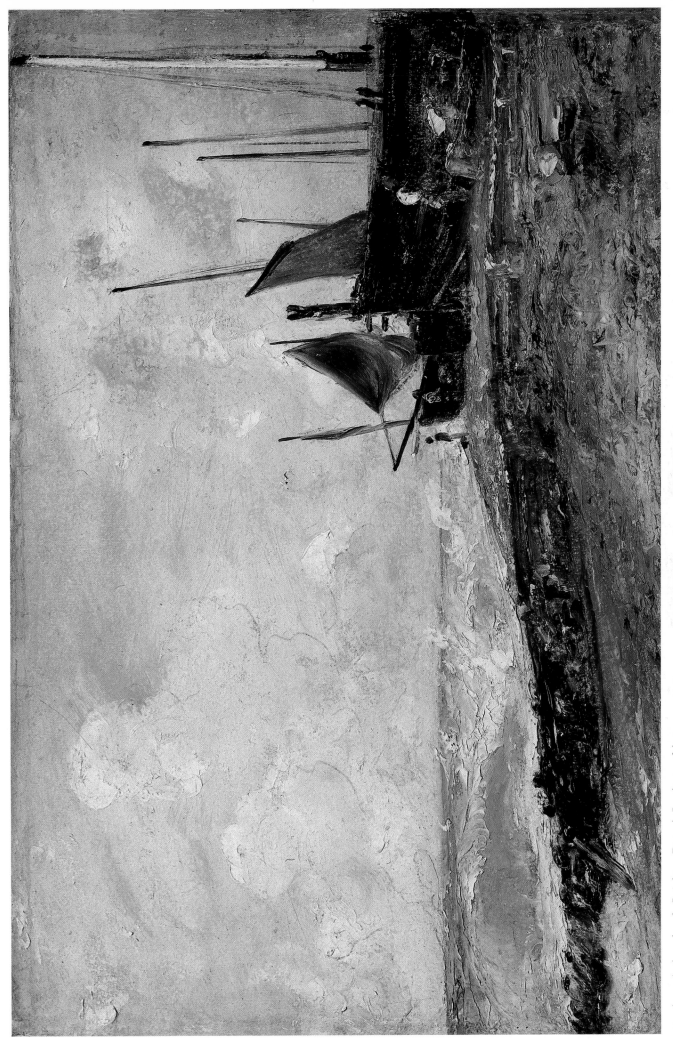

550. (24.79) *A sea beach, Brighton*, Detroit Institute of Arts, 32·1 × 50·2cm.

551-8. (24.80) *Intact sketch-book used at Brighton, Musée du Louvre, 8·3 × 11·5cm.*

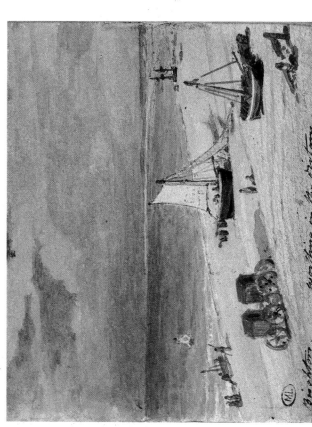

551. (p. 1) *Beach scene at Brighton.*

552. (p. 5) *A stormy seascape, with cliffs on the right.*

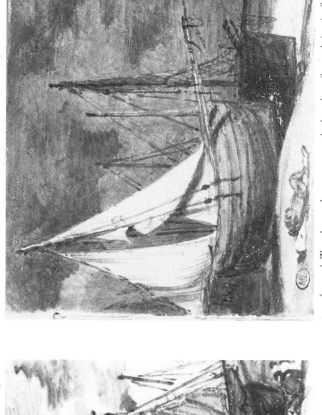

553. (p. 7) *A beach scene, with boats.*

554. (p. 11) *Two boats drawn up on the beach, a figure lying in front of them.*

555. (p. 15) *A boat on the beach.*

557. (p. 23) *A boat on a beach.*

556. (p. 17) *Thumbnail sketch of a man.*

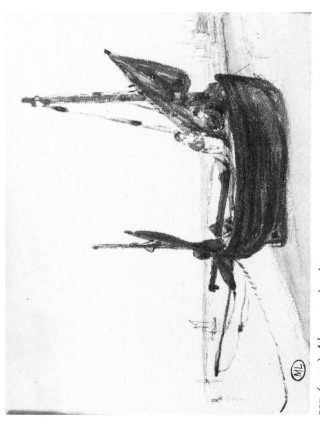

558. (p. 104) *Old Shoreham Church.*

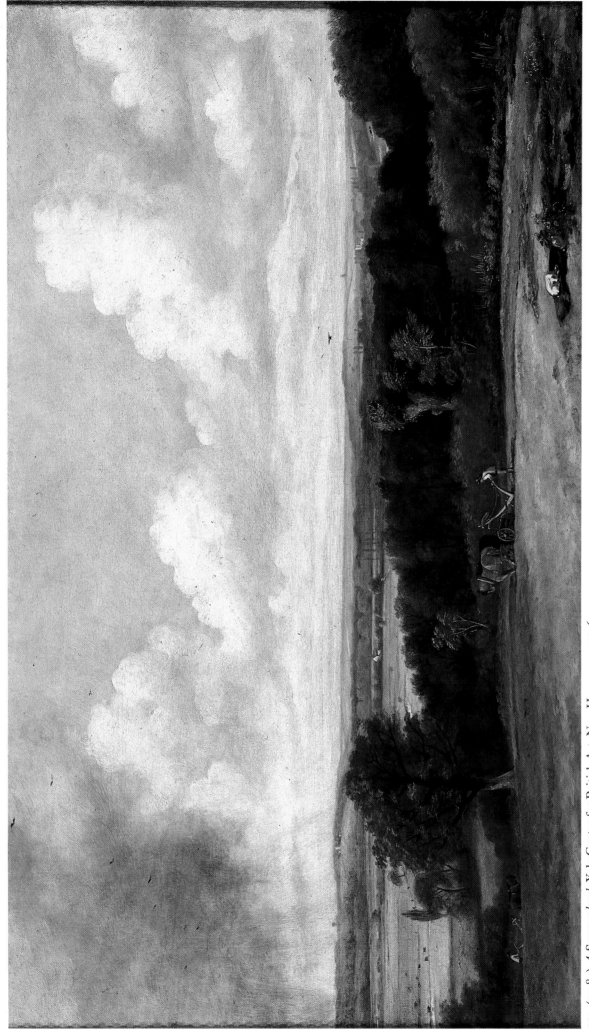

559. (24.81) *A Summerland*, Yale Center for British Art, New Haven, 42·5 × 76cm.

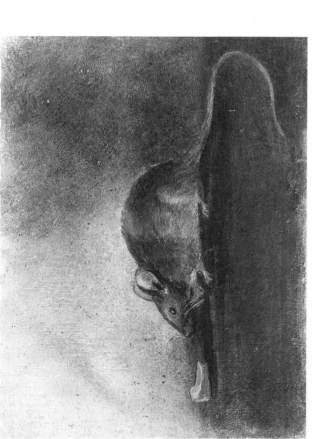

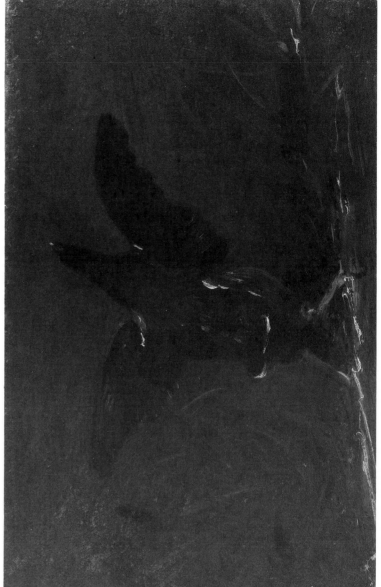

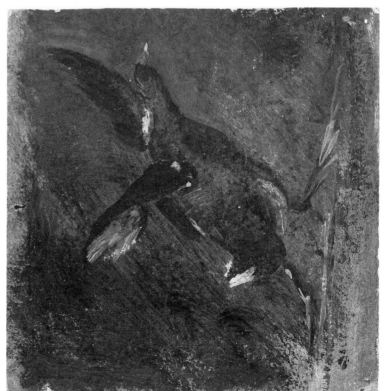

560. (right) (24.82) *A mouse with a piece of cheese*, British Museum, 10·1 × 13·3cm.

561. (far right) (24.83) *A mouse*, Executors of the late Lieutenant-Colonel J. H. Constable, 10 × 13·3cm.

562. (below) (24.84) *A moorhen startled from its nest*, Executors of the late Lieutenant-Colonel J. H. Constable, 14·6 × 15·2cm.

563. (below right) (24.85) *A moorhen flapping its wings*, British Museum, 11·2 × 17·8cm.

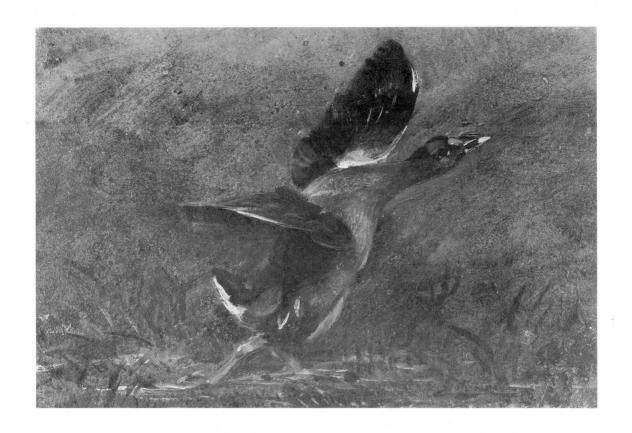

564. (above) (24.86) *A moorhen rising*, British Museum,
11·2 × 17·8cm.

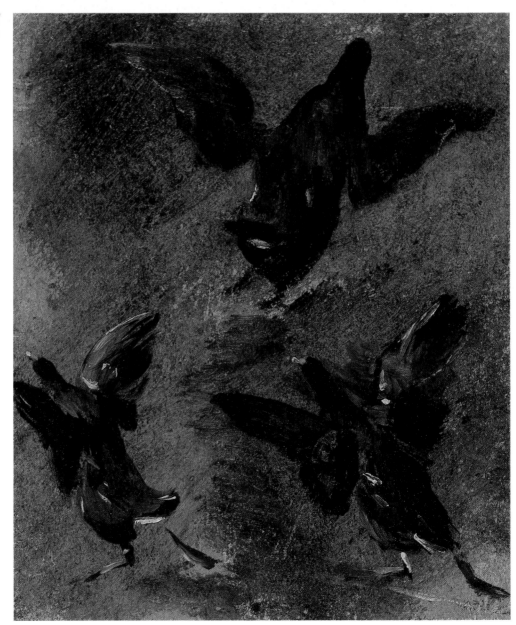

565. (24.87) *Three moorhens on the wing*, British Museum,
16·2 × 13·4cm.

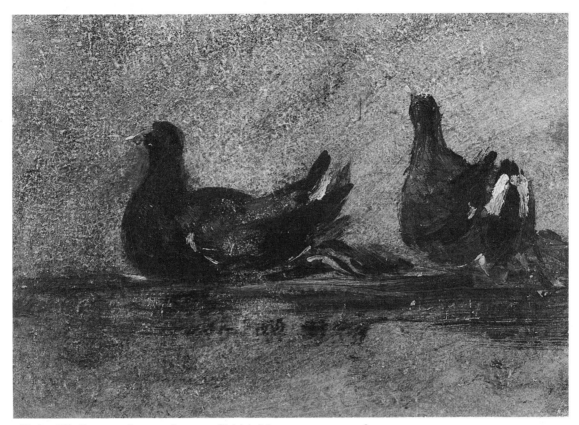

566. (24.88) *Two moorhens on the water*, British Museum, 10·5 × 14·8cm.

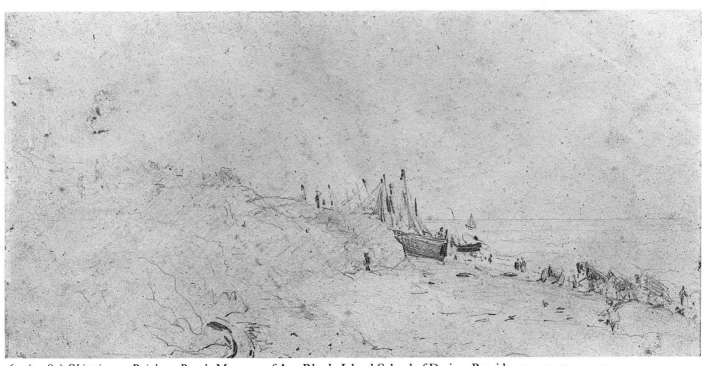

567. (24.89) *Shipping on Brighton Beach*, Museum of Art, Rhode Island School of Design, Providence, 15·7 × 29·9cm.

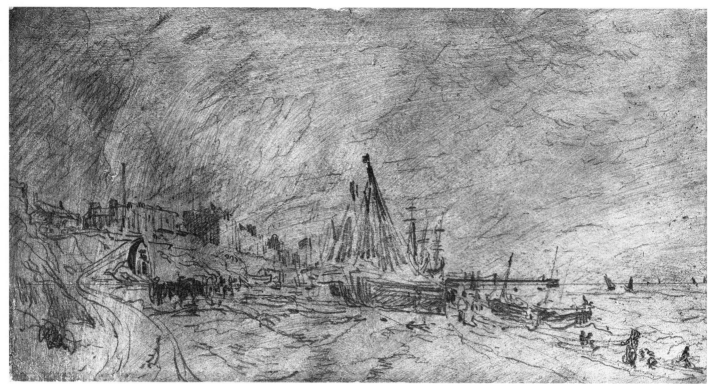

568. (24.90) *Shipping on Brighton Beach*, Museum of Art, Rhode Island School of Design, Providence, 15·7 × 29·9cm.

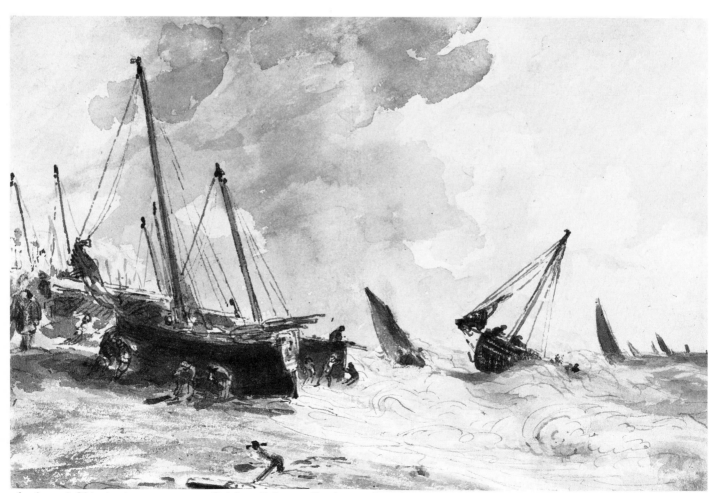

569. (24.91) *Shipping in a stormy sea at Brighton*, Private collection, 17·8 × 26cm.

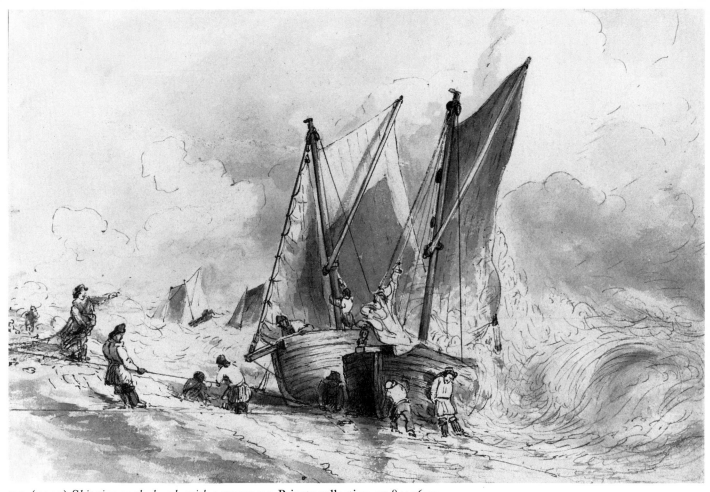

570. (24.92) *Shipping on the beach, with a stormy sea*, Private collection, 17·8 × 26cm.

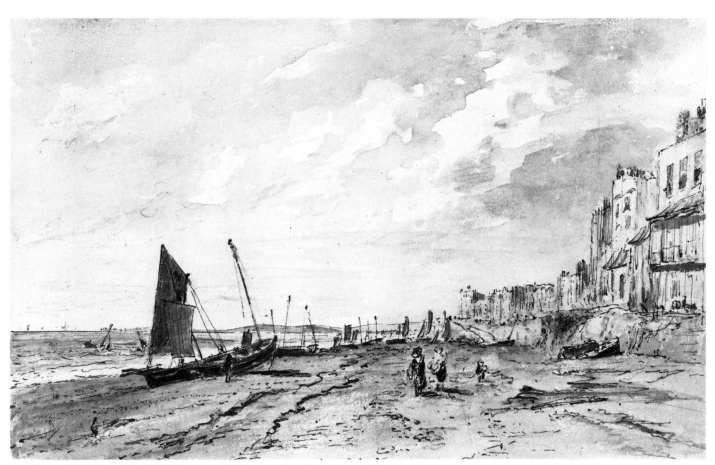

571. (24.93) *Brighton Beach, looking west*, Private collection, 11·5 × 18·1cm.

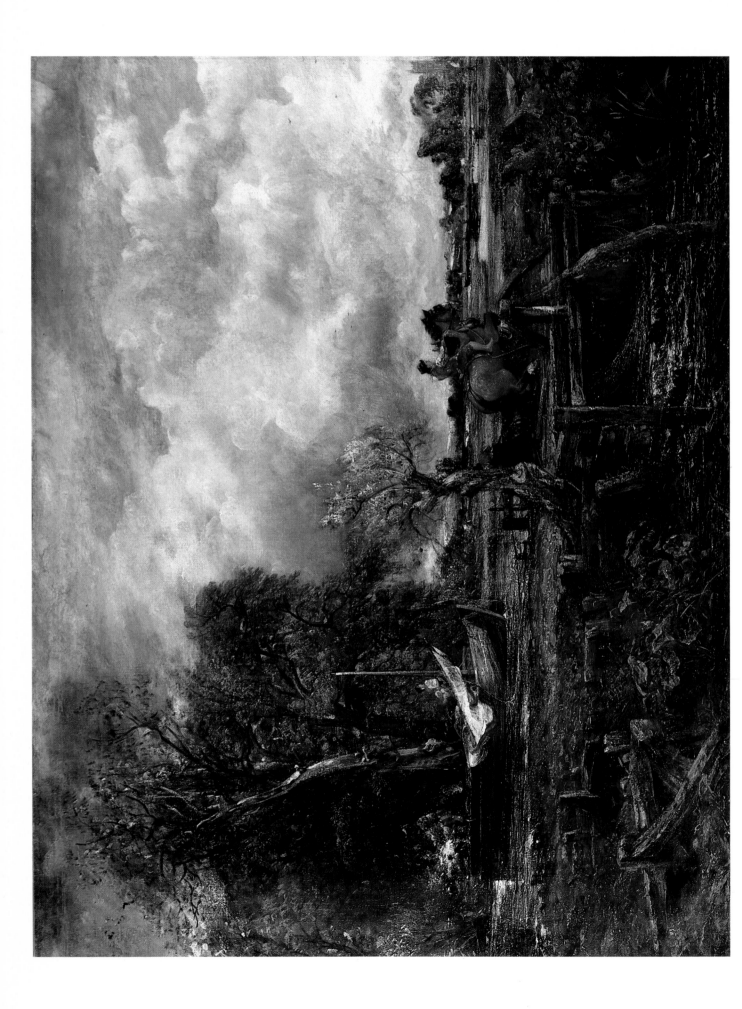

572. (above) (25.1) *The Leaping Horse*, Royal Academy of Arts, London, 142·2 × 187·3cm.

573. (25.2) *The Leaping Horse (full-scale sketch)*, Victoria and Albert Museum, 129·4 × 188cm.

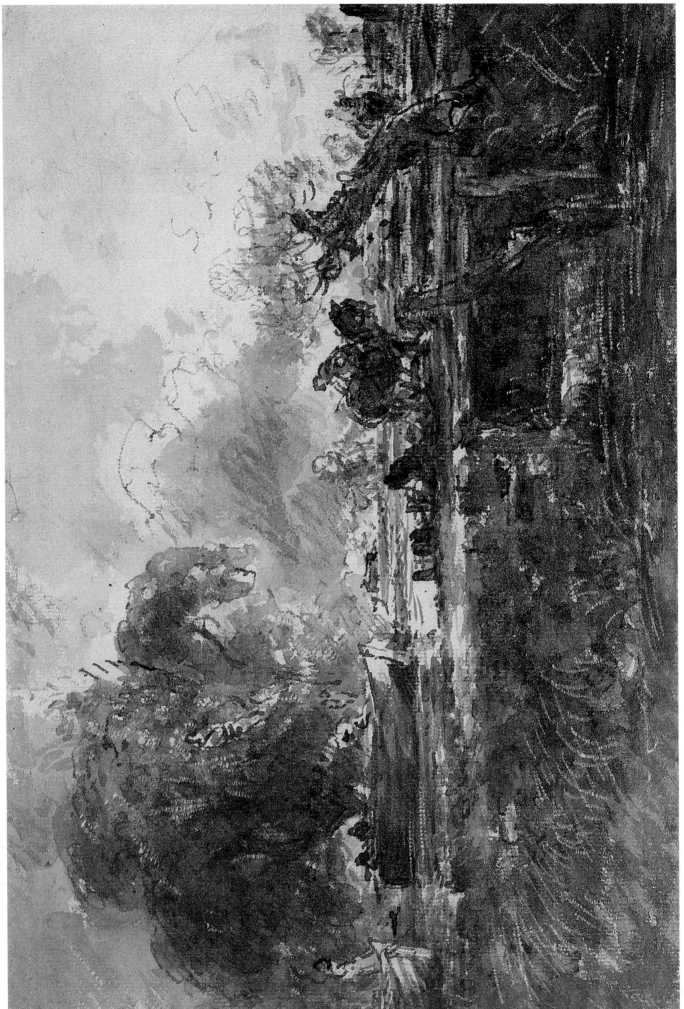

574. (25.3) *Study for 'The Leaping Horse'*, British Museum, 20·3 × 30·2 cm.

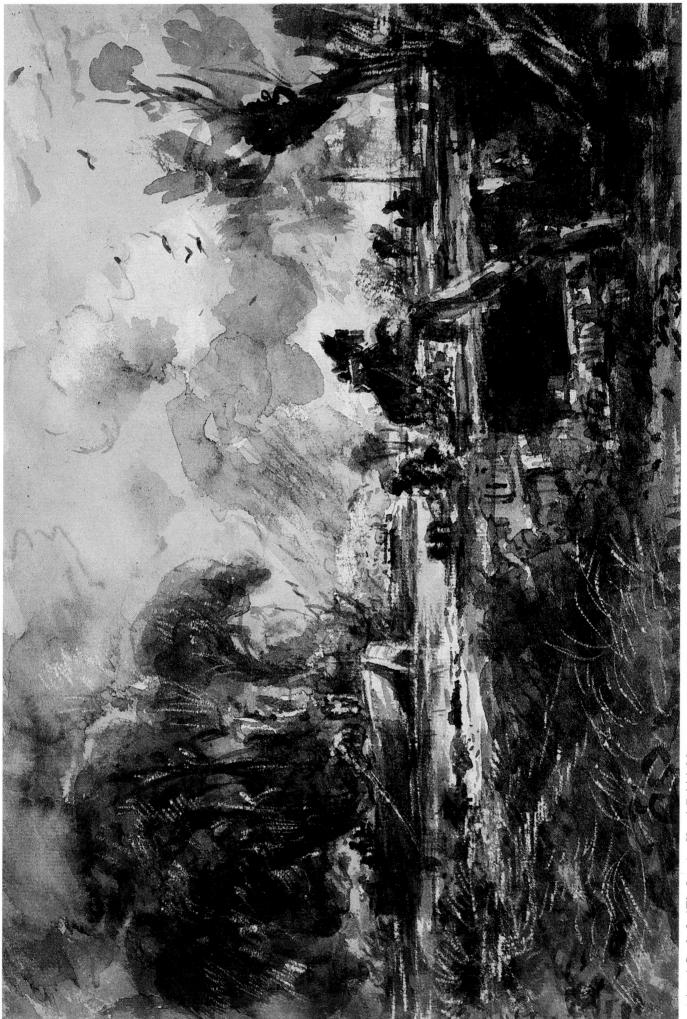

575. (25.4) *Study for 'The Leaping Horse'*, British Museum, 20·3 × 30·2cm.

578. (25.8) *Child's Hill: Harrow in the Distance,* Private collection, on loan to the Whitworth Art Gallery, Manchester, 59·6 × 77·4cm.

579. (below) (25.9) *Branch Hill Pond, Hampstead,* Tate Gallery, 53·6 × 76·8cm.

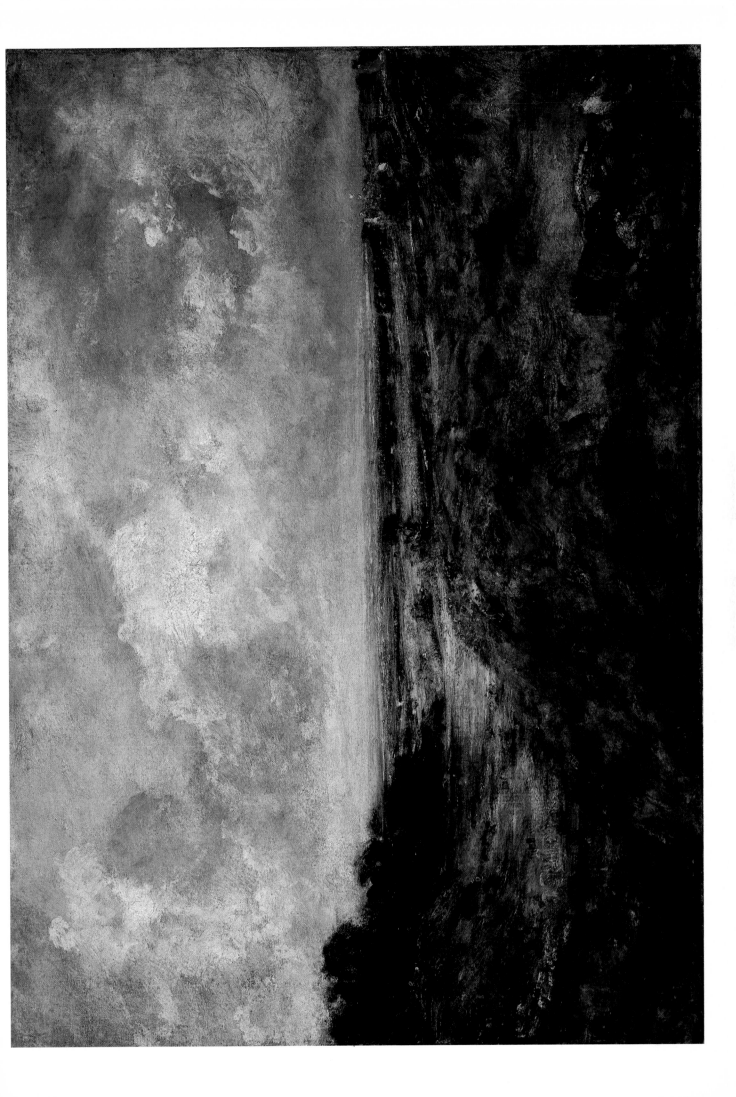

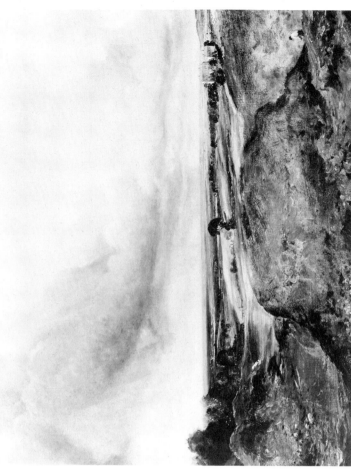

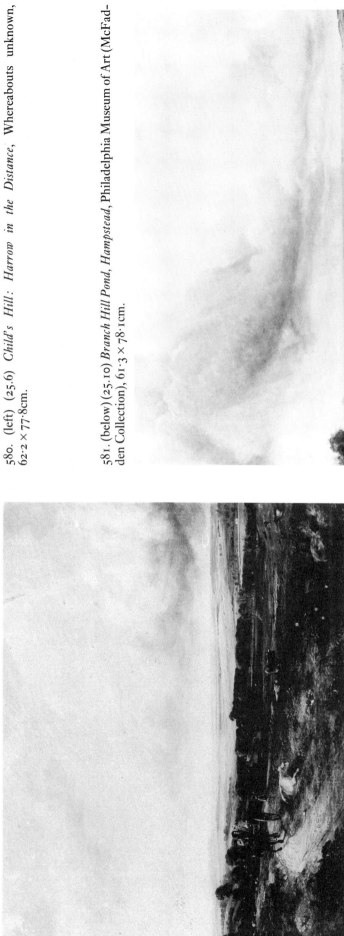

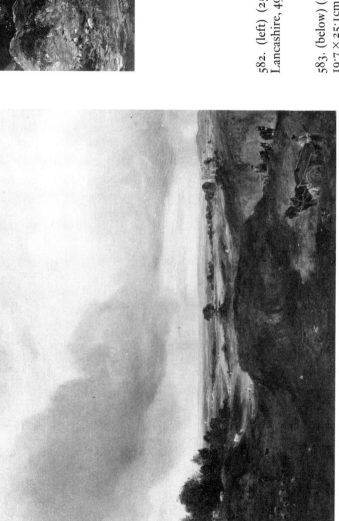

580. (left) (25.6) *Child's Hill: Harrow in the Distance*, Whereabouts unknown, 62·2 × 77·8cm.

581. (below) (25.10) *Branch Hill Pond, Hampstead*, Philadelphia Museum of Art (McFadden Collection), 61·3 × 78·1cm.

582. (left) (25.11) *Branch Hill Pond, Hampstead*, Bury Art Gallery and Museum, Lancashire, 49·5 × 61cm.

583. (below) (25.12) *Child's Hill: Harrow in the distance*, Victoria and Albert Museum, 19·7 × 25·1cm.

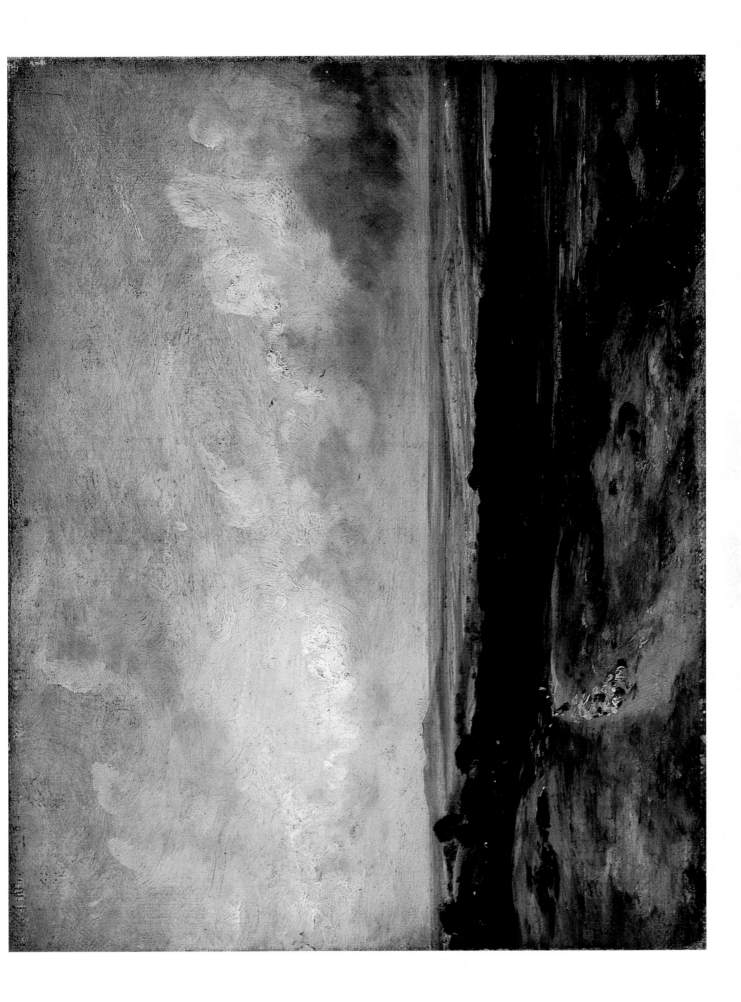

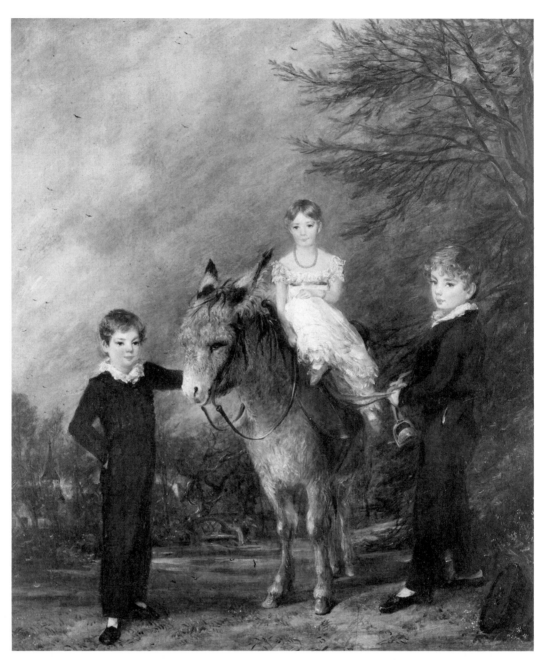

584. (above) (25.13) *Mary, William and George Patrick
Lambert*, Private collection, 61 × 50·8cm.

585. (25.15) *Mary, William and George Patrick
Lambert, with a donkey*, Executors of the late
Lieutenant-Colonel J. H. Constable.

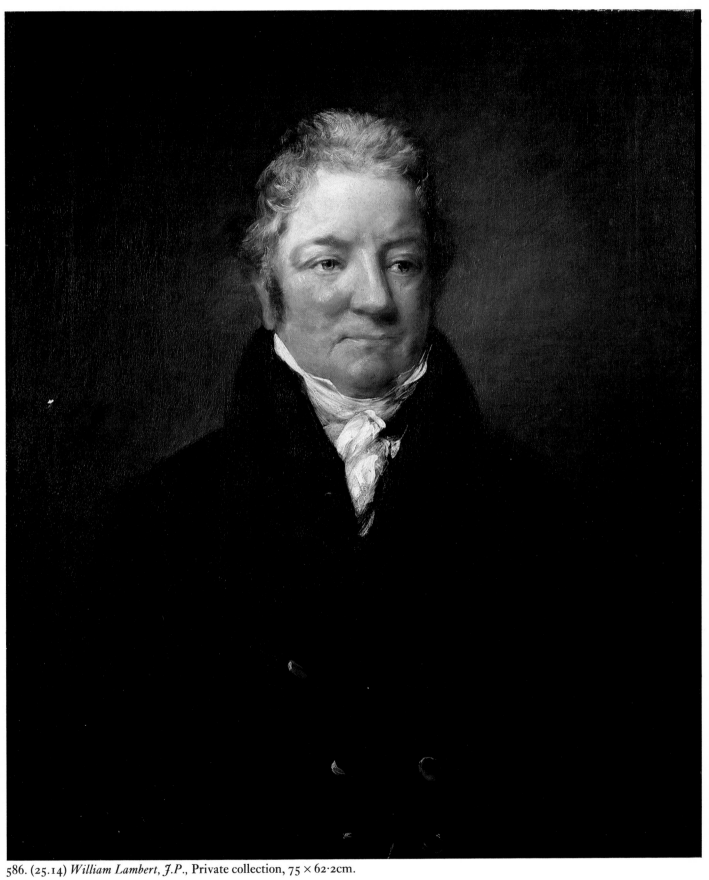

586. (25.14) *William Lambert, J.P.*, Private collection, 75 × 62·2cm.

587. (25.16) *A felled tree, lying on the ground*, Royal Albert Museum, Exeter, 8 × 22·8cm. (two pages, each of 8 × 11·4cm.)

588. (25.17) *A countryman lying on a bank*, Royal Albert Memorial Museum, Exeter, 8 × 11·4cm.

589. (25.18) *A countryman, leaning against a bank, seen from behind*, Private collection, 8 × 11·7cm.

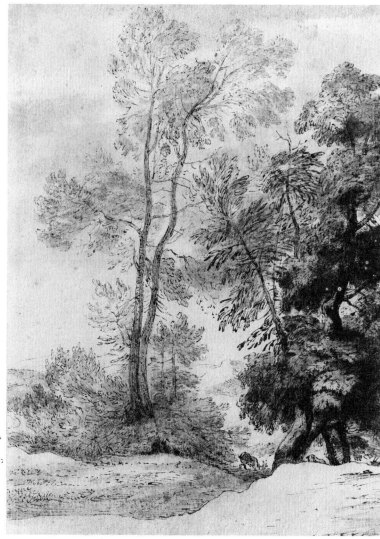

590. (25.19) *Trees and deer, after Claude*, Yale Center for British Art, New Haven, 28·8 × 20cm.

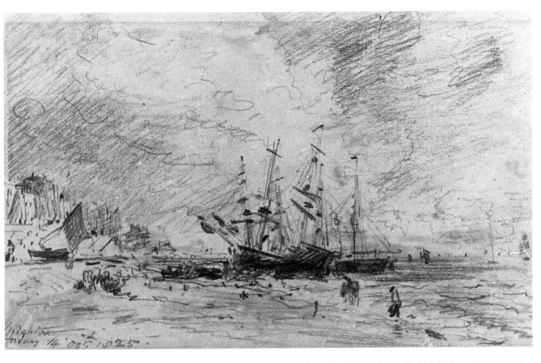

591. (25.20) *Brighton Beach with colliers*, Courtauld Institute Galleries (Witt Collection), London, 11·5 × 18·5cm.

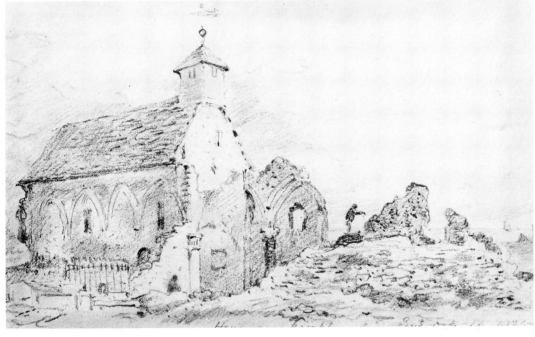

592. (25.21) *The Parish Church, Hove*, Private collection, 11·5 × 17·8cm.

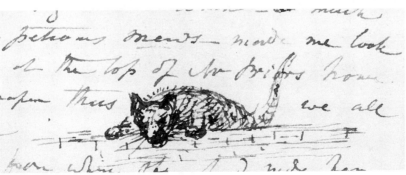

593. (25.22) *Constable's cat 'Mrs Hampstead'*, Private collection, on loan to the Tate Gallery, 4 × 9cm.

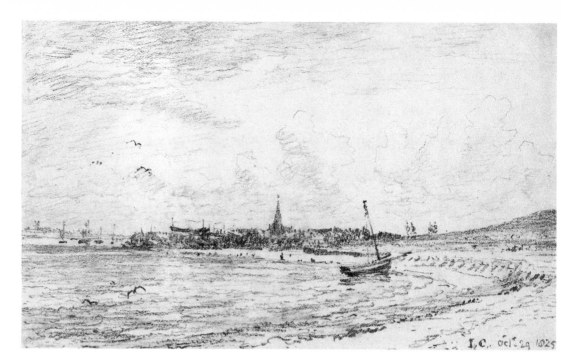

594. (25.23) *Harwich*,
British Museum,
11·3 × 18·2cm.

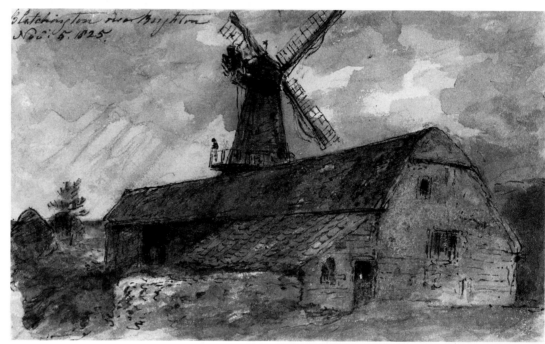

595. (25.24) *Blatchington
Mill, near Brighton*, Private
collection, 11·3 × 18cm.

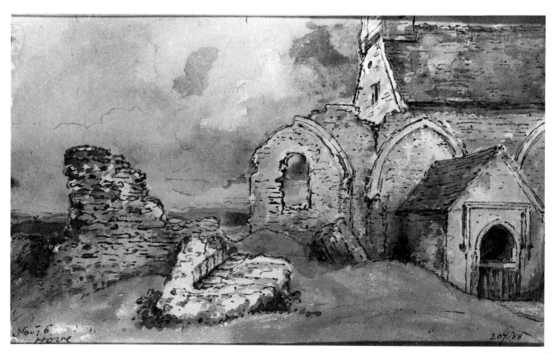

596. (25.25) *The Old Parish
Church, Hove*, Victoria and
Albert Museum,
11·4 × 18·6cm.

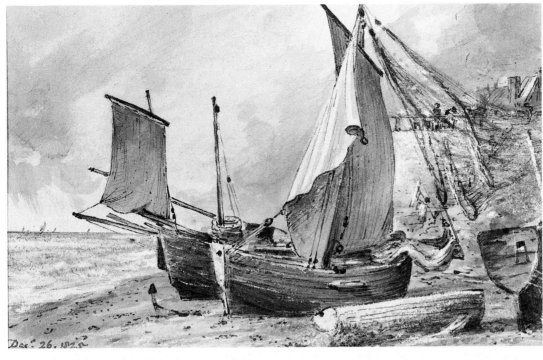

597. (25.26) *Brighton Beach, with fishing boats*, Ipswich Museums and Galleries, Christchurch Mansion Museum, 11 × 17·4cm.

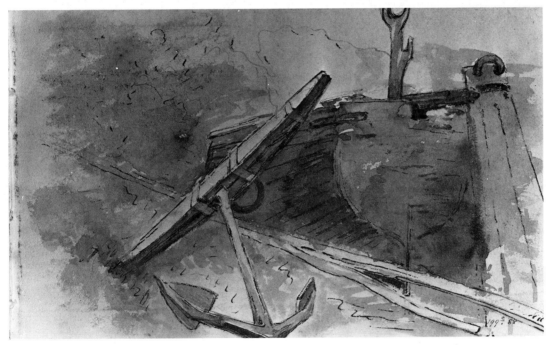

598. (25.27) *A boat and anchor on the beach at Brighton*, Victoria and Albert Museum, 11·5 × 18·5cm.

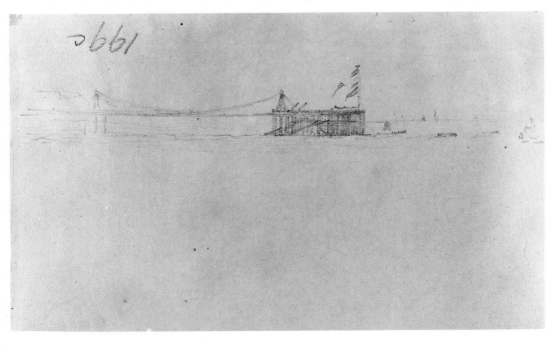

599. (25.28) *The Chain Pier, Brighton*, Victoria and Albert Museum, 11·5 × 18·5cm.

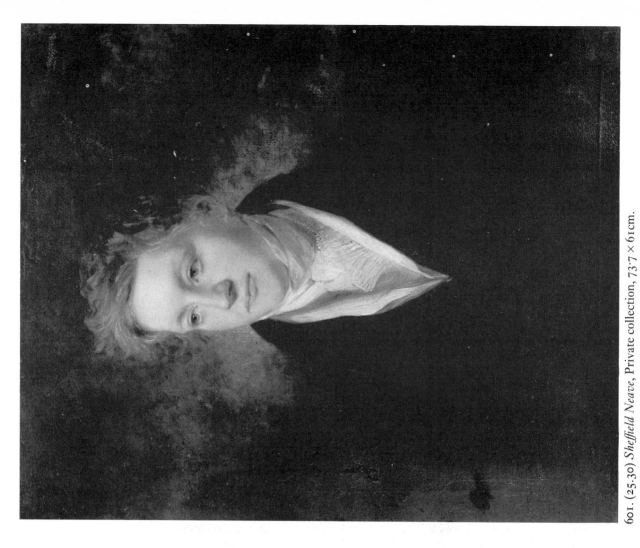

601. (25.30) *Sheffield Neave*, Private collection, 73·7 × 61cm.

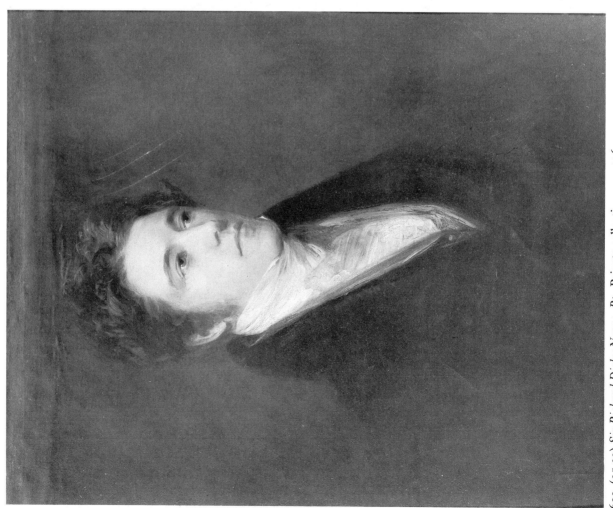

600. (25.29) *Sir Richard Digby Neave, Bt.*, Private collection, 73·7 × 61cm.

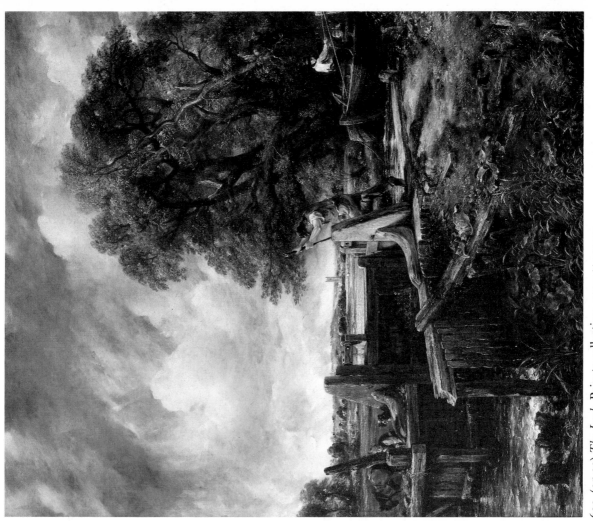

603. (25.33) *The Lock*, Private collection, 139·7 × 122cm.

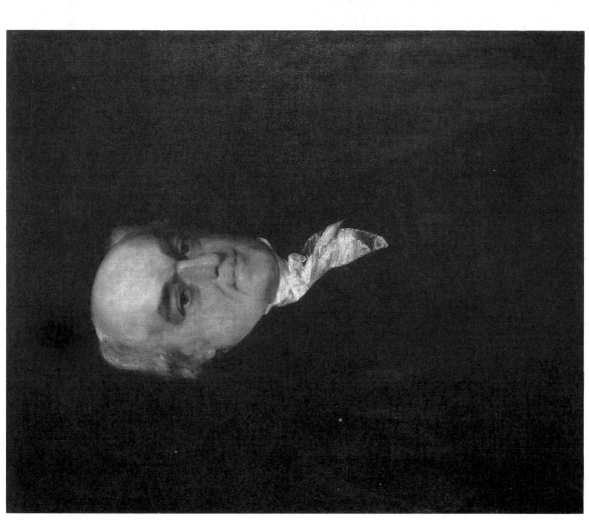

602. (25.31) *Charles Bicknell*, Executors of the late Lieutenant-Colonel J. H. Constable, 80 × 66·6cm.

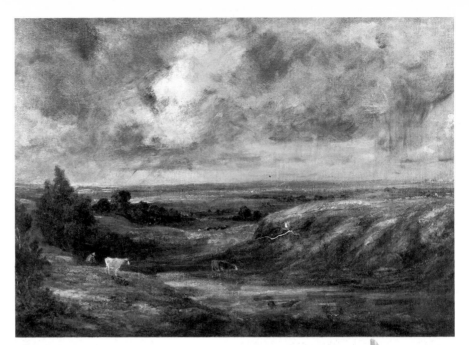

604. (25.34) *Hampstead Heath: Branch Hill Pond*, Yale Center for British Art, New Haven, 45·5 × 65cm.

605. (25.35) *The Thames Valley from Hampstead Heath*, Yale Center for British Art, New Haven, 25 × 35·5cm.

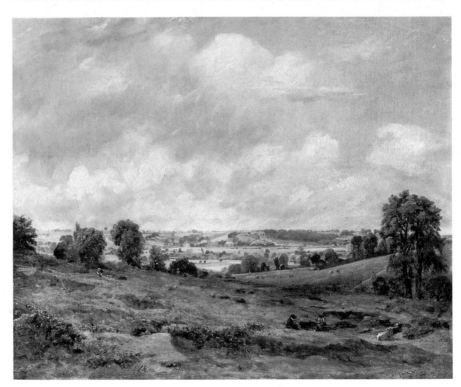

606. (25.39) *Dedham Vale*, Bayerische Staatsgemäldesammlungen, Neue Pinakothek, Munich, 45 × 54·6cm.

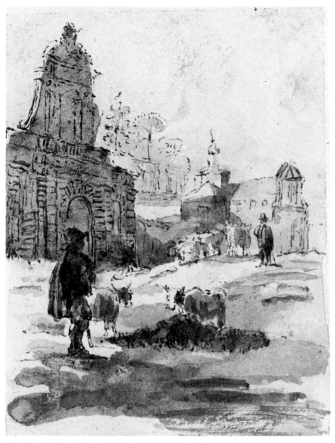

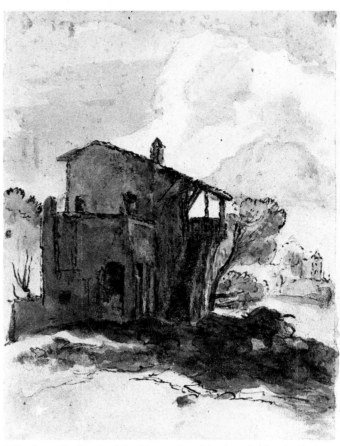

607· (25.36) *The Campo Vaccino, after Claude*, Musée du Louvre, 16·7 × 12·9cm.

608. (25.37) *A ruined building, after Claude*, Musée du Louvre, 17·9 × 12·7cm.

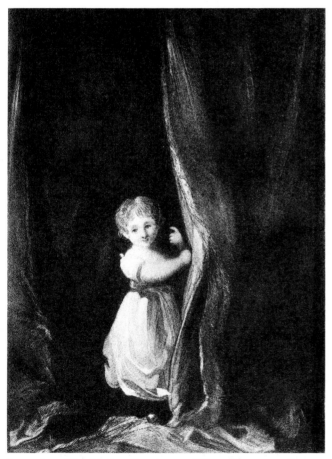

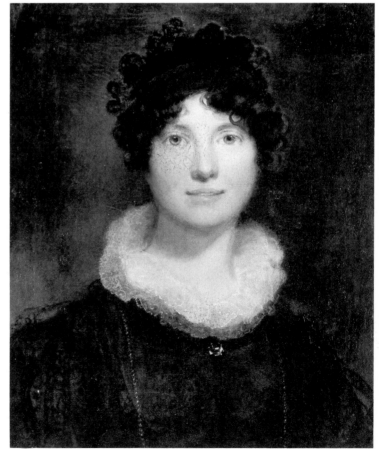

609. (25.38) *Little Roxolana*, Whereabouts unknown (reproduced from the mezzotint).

610. (25.40) *Mrs Roberts*, Private collection, 52 × 42cm.

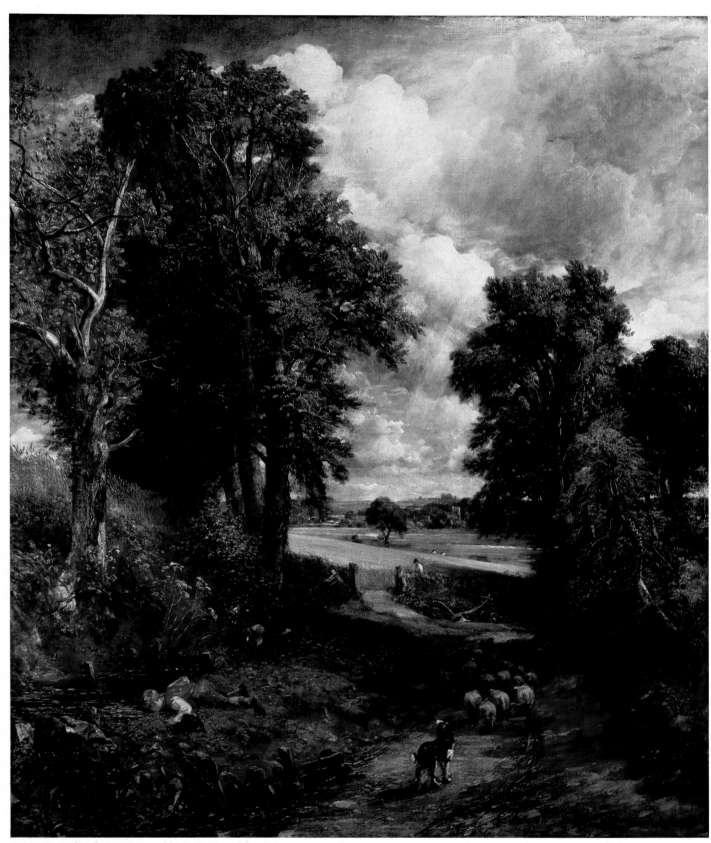

611. (26.1) *The Cornfield*, National Gallery, London, 143 × 122cm.

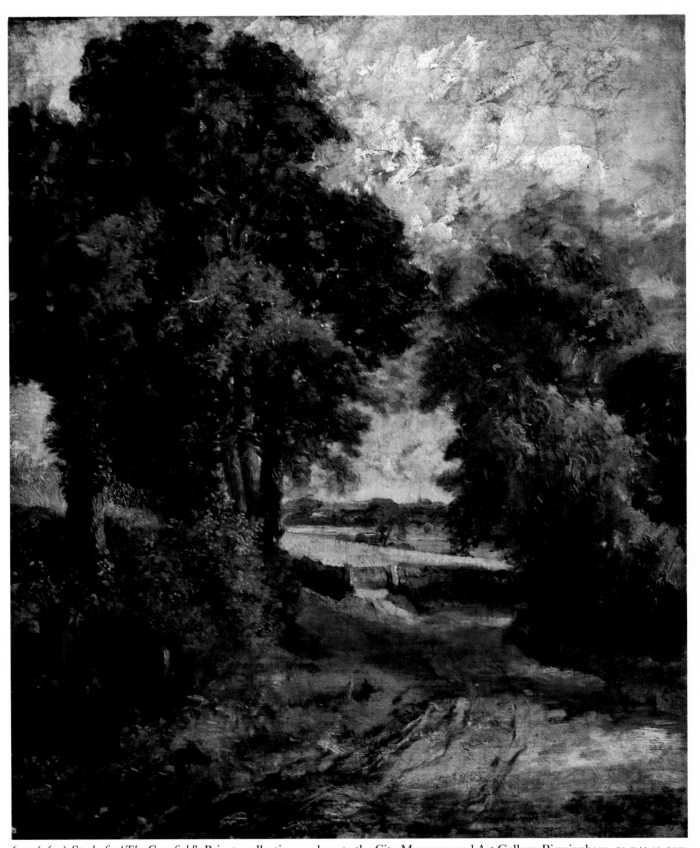

612. (26.2) *Study for 'The Cornfield'*, Private collection, on loan to the City Museums and Art Gallery, Birmingham, 59·7 × 49·2cm.

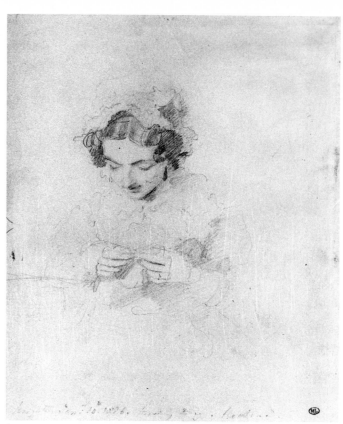

613. (26.3) *A donkey and foal*, Victoria and Albert Museum, 21·6 × 18·4cm.

614. (26.6) *A girl sewing at Brighton*, Musée du Louvre, 22·6 × 18·3cm.

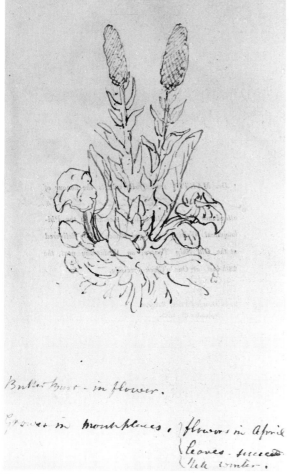

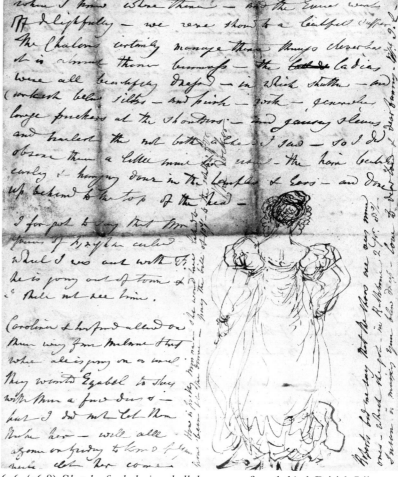

615. (26.7) *The butter burr in flower*, Courtauld Institute Galleries (Witt Collection), London, 19·3 × 11·8cm.

616. (26.8) *Sketch of a lady in a ball dress, seen from behind*, British Library, 14 × 8cm.

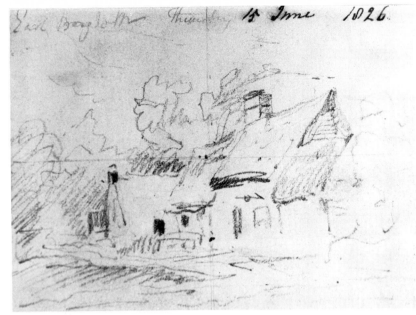

617. (26.9) *Cottages at East Bergholt*, Private collection, 8 × 11 cm.

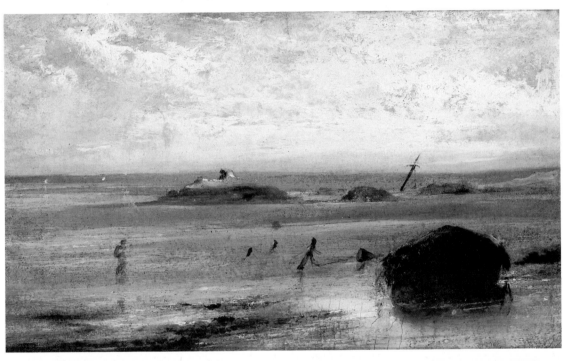

618. (26.11) *Sketch at Brighton (Williamstown Strand)*, Private collection.

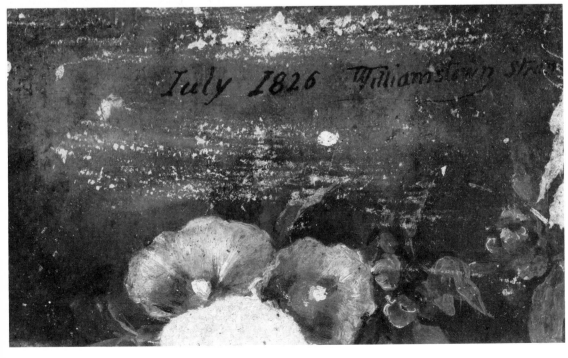

619. (26.12) *Hollyhocks*, Private collection.

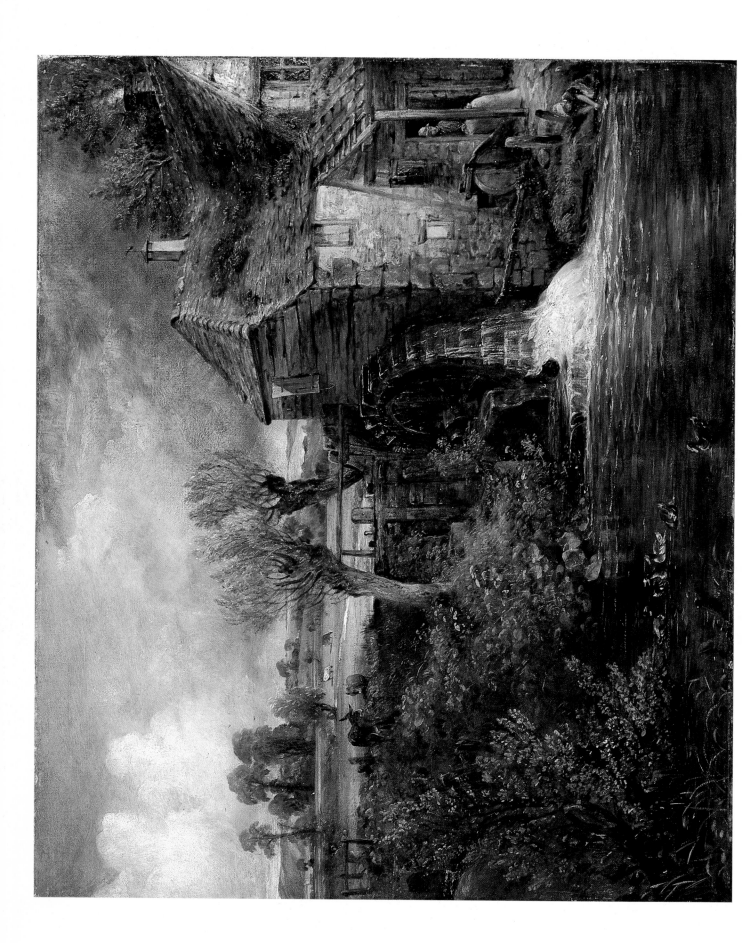

620. (above) (26.4) *Gillingham Mill, Dorset*, Yale Center for British Art, New Haven, 50 × 60.5cm.

621. (26.5) *The sea at Brighton*, Tate Gallery, 17.3 × 23.9cm.

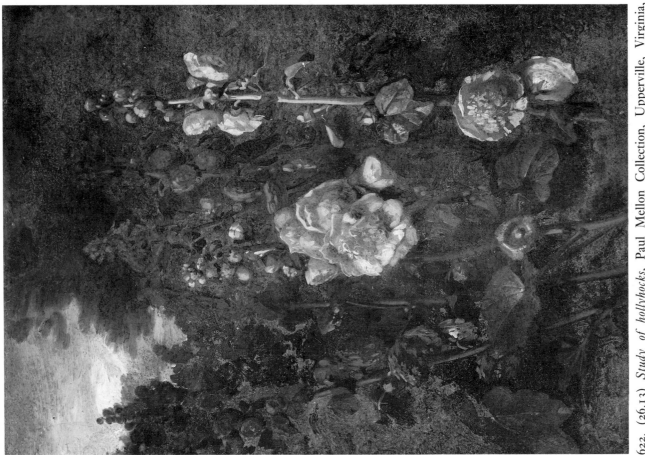

622. (26.13) *Study of hollyhocks*, Paul Mellon Collection, Upperville, Virginia, 22·8 × 16·8cm.

623. (right) *Brian's Cottage, Muswell Hill*, Private collection, 49·5 × 39·5cm.

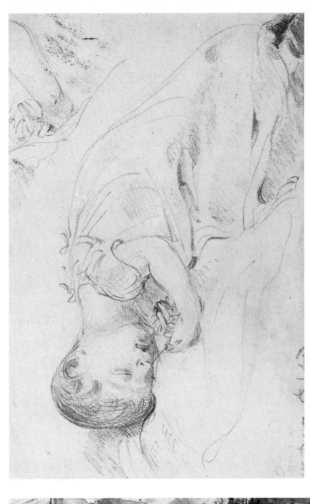

625. (26.22) *A child asleep*, British Museum, 11 × 17cm.

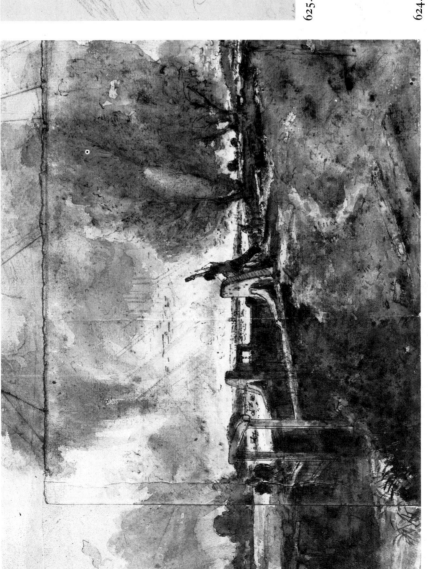

624. (left) (26.17) *Flatford Lock*, Fitzwilliam Museum, Cambridge, 28·7 × 36·4cm.

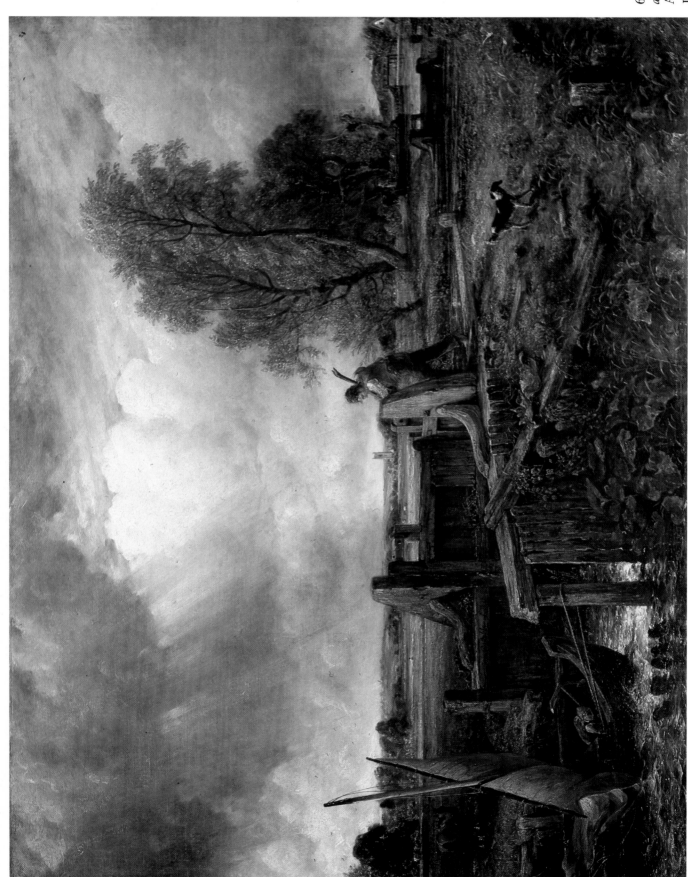

626. (26.15) *A Boat passing a Lock*, Royal Academy of Arts, London, 101·6 × 127cm.

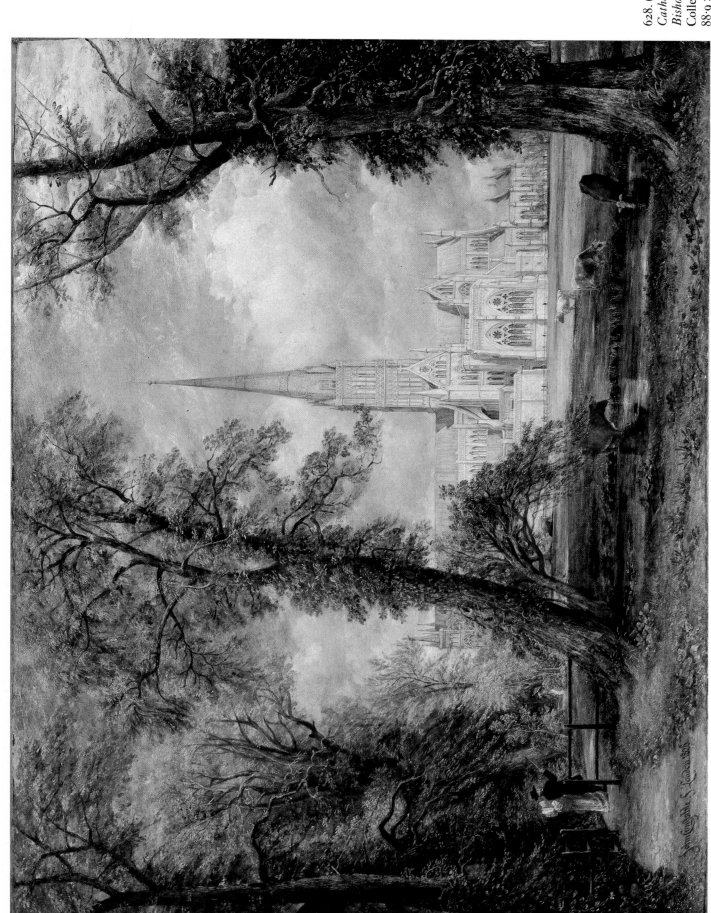

628. (26.18) *Salisbury Cathedral from the Bishop's Grounds*, Frick Collection, New York, 88·9 × 112·4cm.

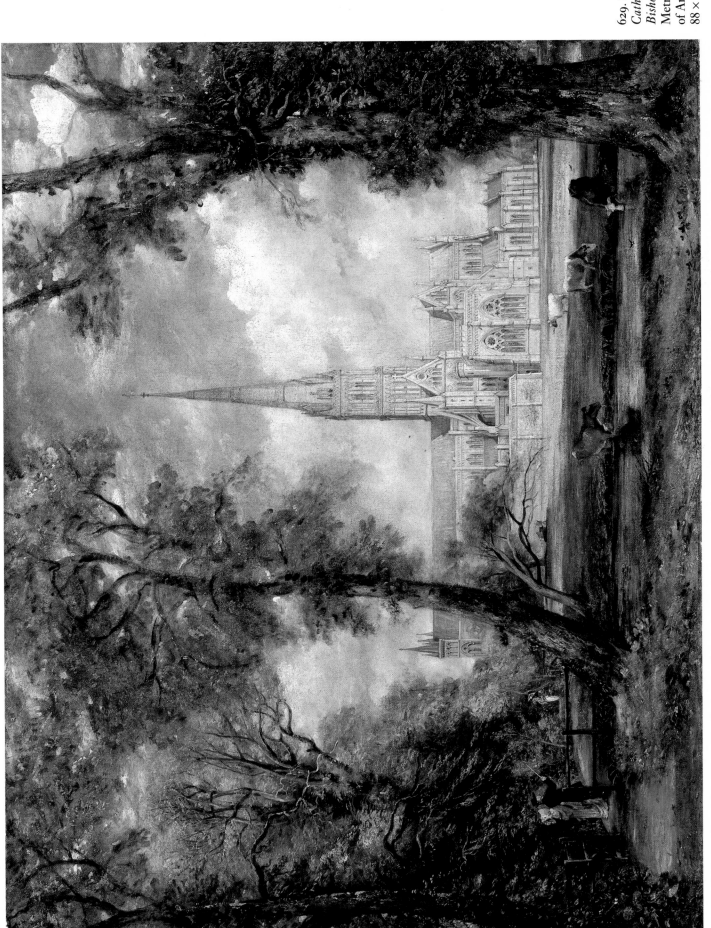

629. (26.19) *Salisbury Cathedral from the Bishop's Grounds*, Metropolitan Museum of Art, New York, 88 × 111·8cm.

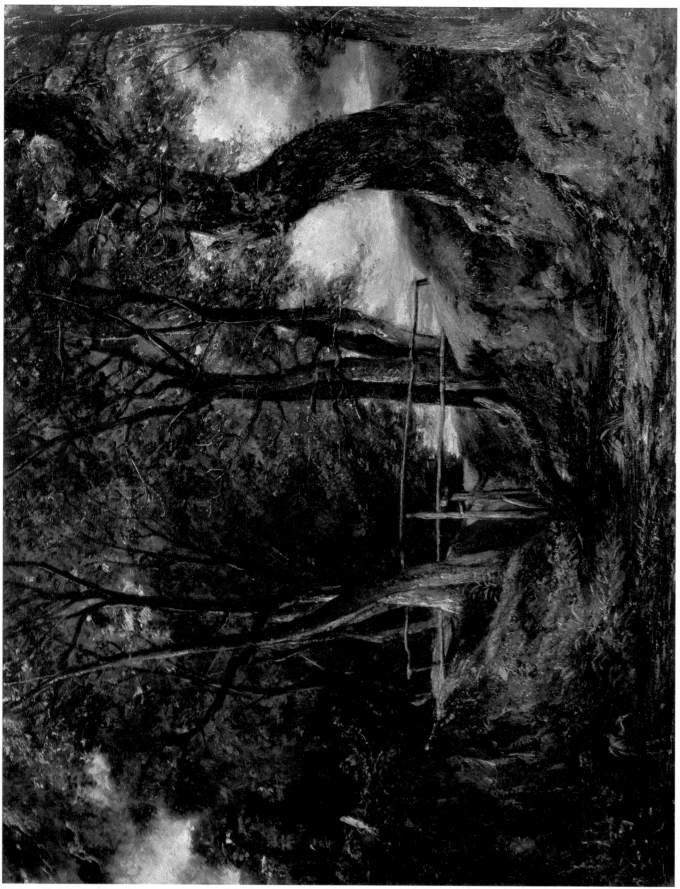

630. (26.21) *Helmingham Dell*, John G. Johnson Collection, Philadelphia, 70·8 × 91·5cm.

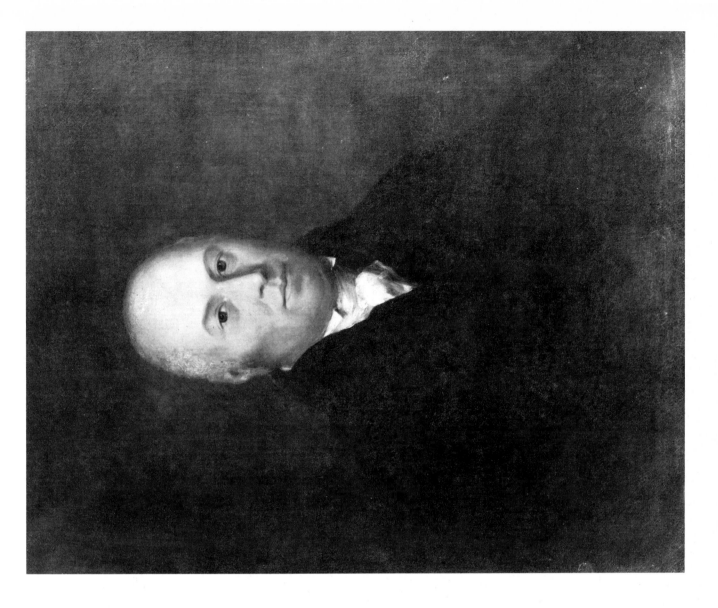

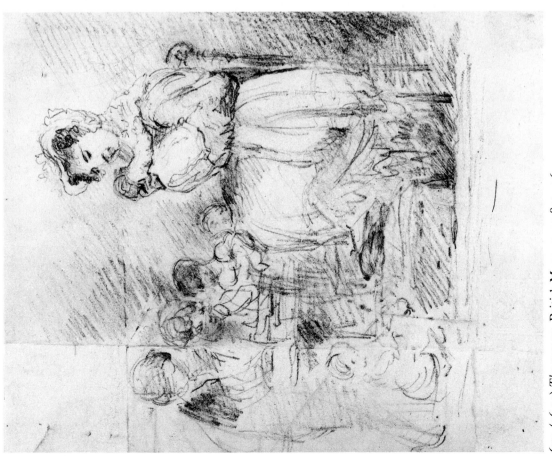

631. (26.23) *The nursery*, British Museum, 17·8 × 14·6cm.

632. (right) (26.24) *John Mirehouse*, Private collection, 76·2 × 63·5cm.

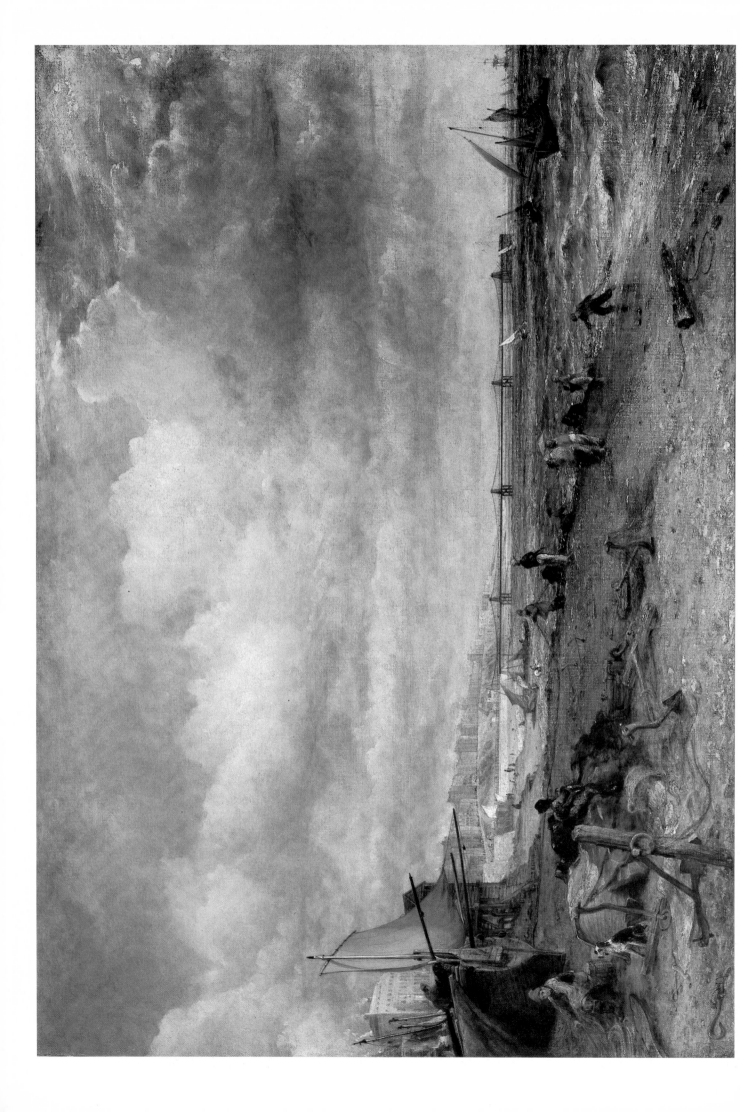

633. (above) (27.1) *The Chain Pier, Brighton*, Tate Gallery, 127 × 183cm.

634. (27.3) *Study for 'The Chain Pier, Brighton'*, John G. Johnson Collection, Philadelphia, 33 × 61cm.

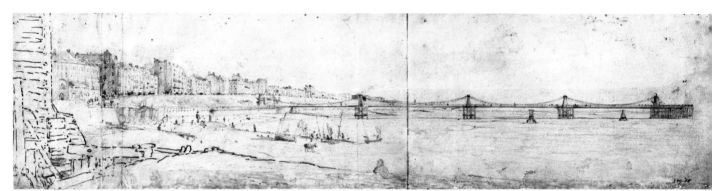

635. (27.2) *The Marine Parade and Chain Pier, Brighton*, Victoria and Albert Museum, 11·1 × 42·5cm.

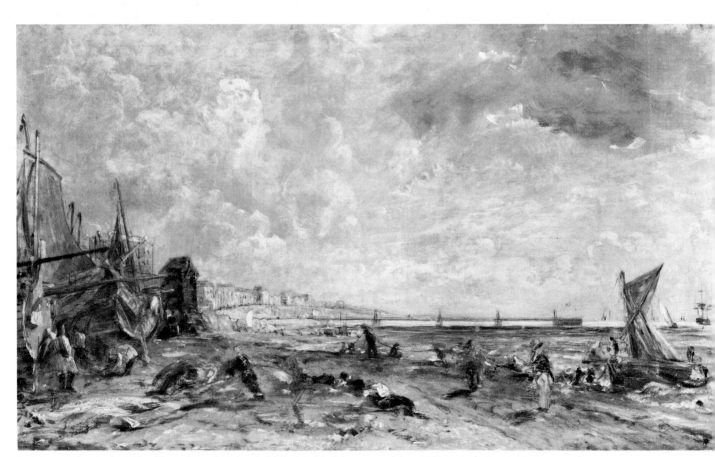

636. (27.4) *Study for 'The Chain Pier, Brighton'*, Philadelphia Museum of Art (Wilstach Collection), 62·4 × 98·4cm.

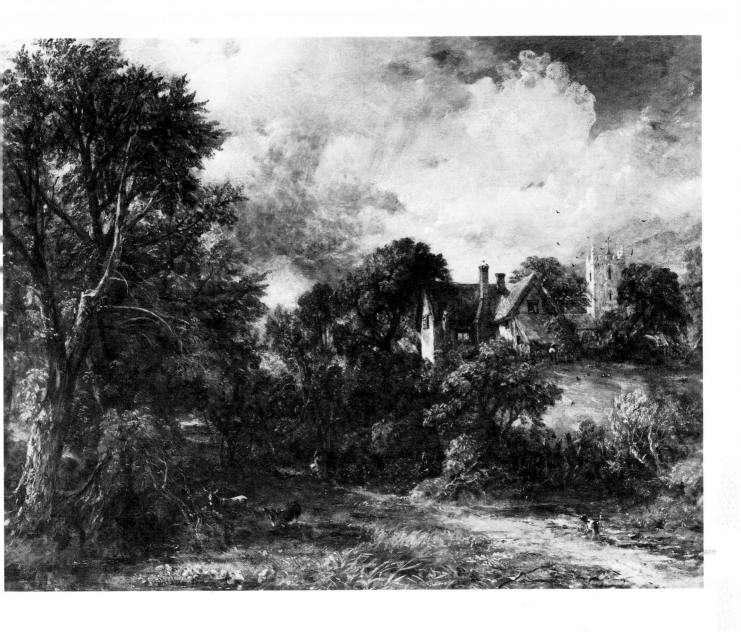

637. (above) (27.7)
The Glebe Farm,
Detroit Institute of
Arts, 46·5 × 59·6cm.

638. (27.10) *A
landscape with a
farmhouse*, Fogg Art
Museum, Harvard
University,
Cambridge,
Massachusetts,
18·4 × 24cm.

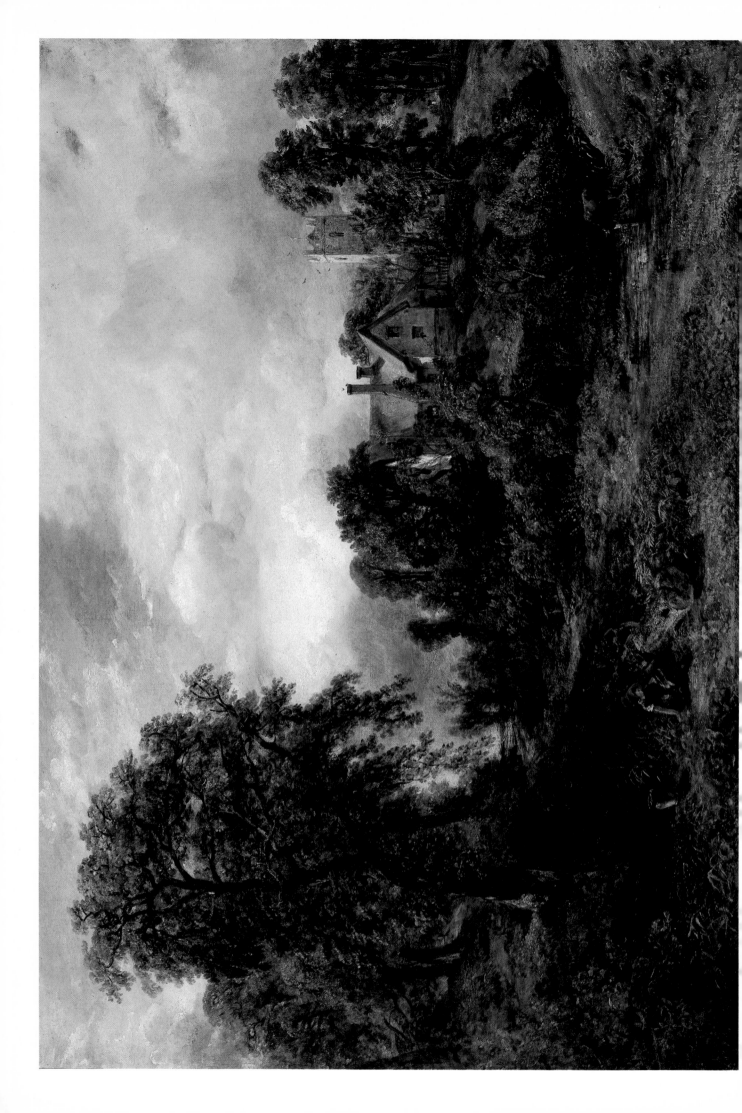

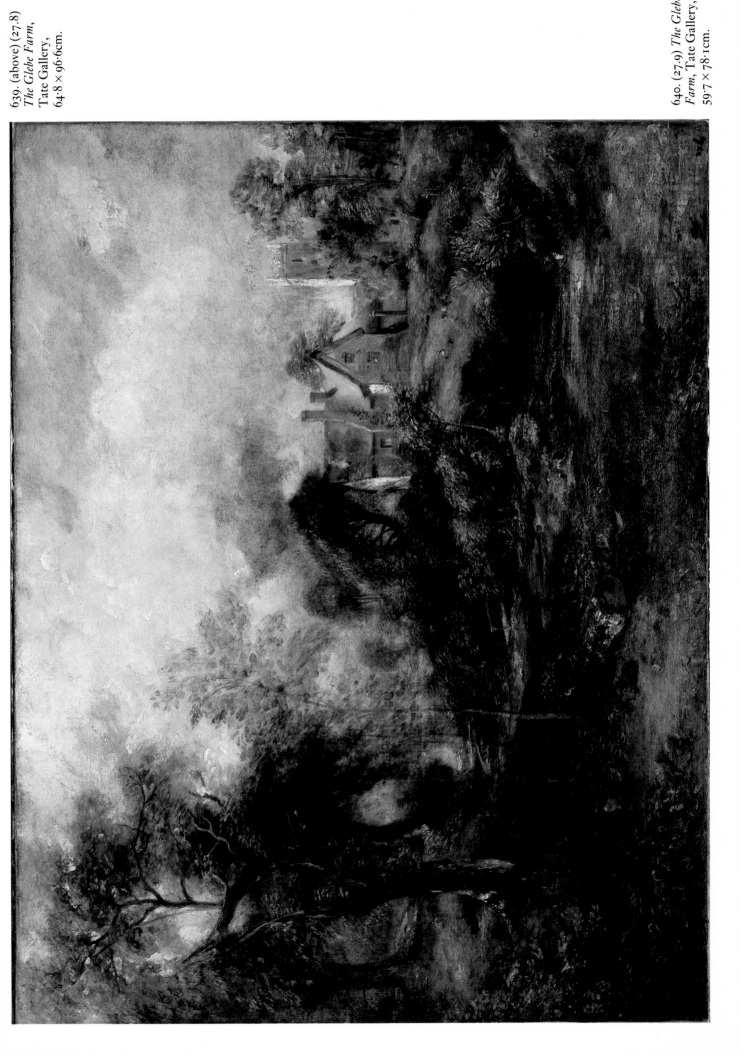

639. (above) (27.8)
The Glebe Farm,
Tate Gallery,
64·8 × 96·6cm.

640. (27.9) *The Glebe
Farm,* Tate Gallery,
59·7 × 78·1cm.

641. (above) (27.12)
*The fore-part of a
barge at Flatford*,
Victoria and Albert
Museum,
22·4 × 32·7cm.

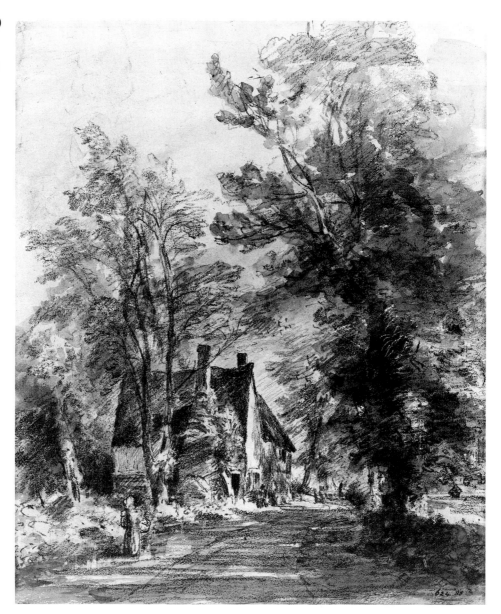

642. (27.13) *Water
Lane, Stratford St
Mary*, Victoria and
Albert Museum,
33 × 22·4cm.

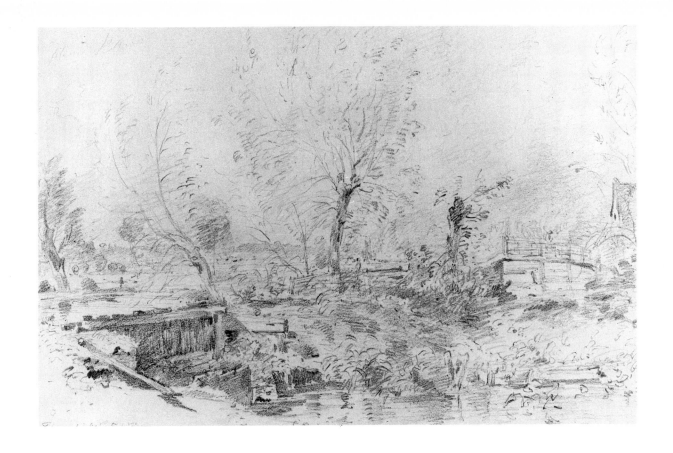

643. (above) (27.14) *A scene on the River Stour at Flatford*, National Gallery of Ireland, Dublin, 22·1 × 32·9cm.

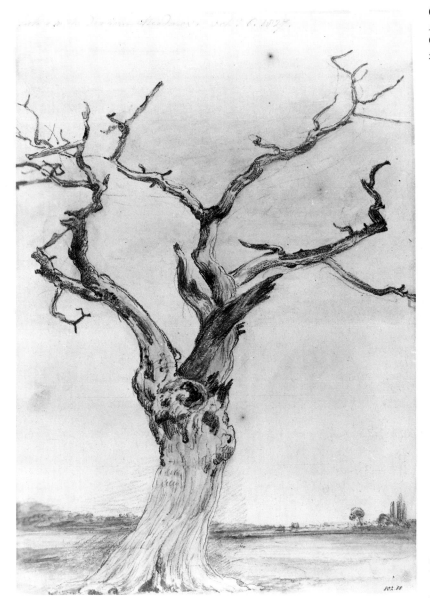

644. (27.16) *An oak tree, Dedham*, Victoria and Albert Museum, 33 × 22·5cm.

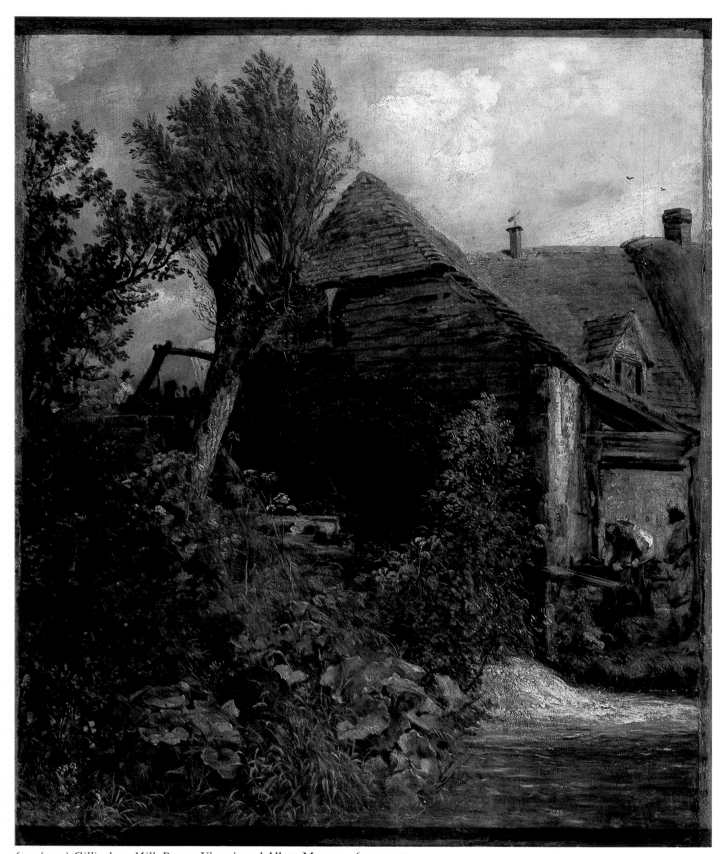

645. (27.5) *Gillingham Mill, Dorset*, Victoria and Albert Museum, 63 × 52cm.

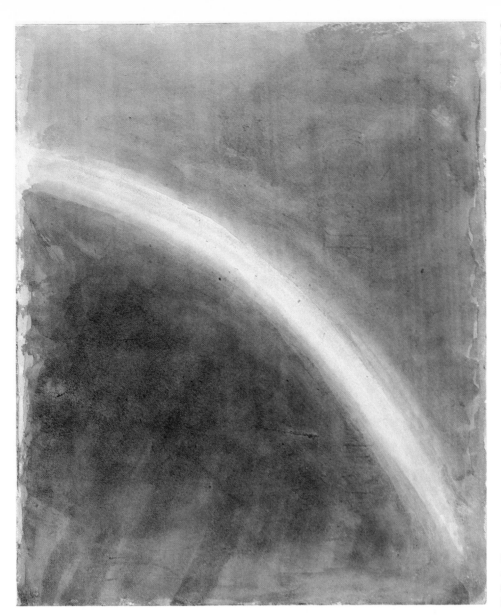

646. (27.11) *Sky study with a rainbow*, Yale Center for British Art, New Haven, 22·5 × 18·4cm.

647. (below) (27.17) *Flatford Lock*, Victoria and Albert Museum, 22·4 × 33·2cm.

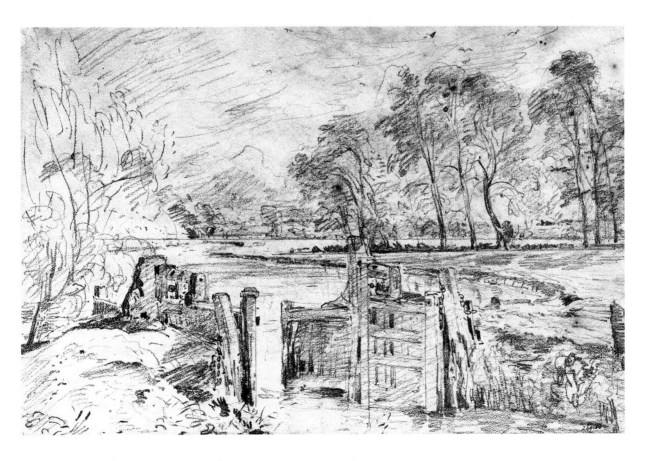

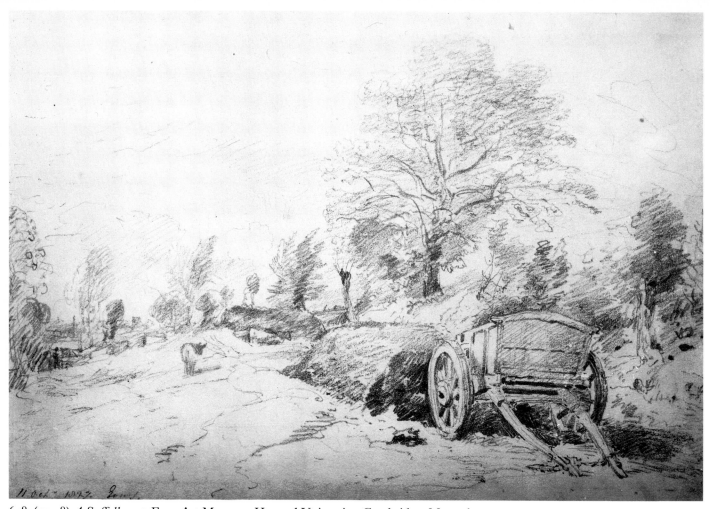

648. (27.18) *A Suffolk cart*, Fogg Art Museum, Harvard University, Cambridge, Massachusetts, 22·4 × 32·4cm.

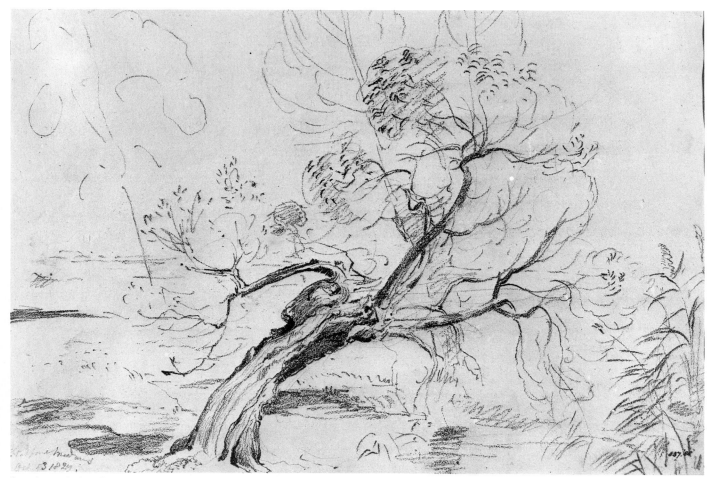

649. (27.19) *A willow tree in Flatford Meadows*, Victoria and Albert Museum, 22·4 × 33·1cm.

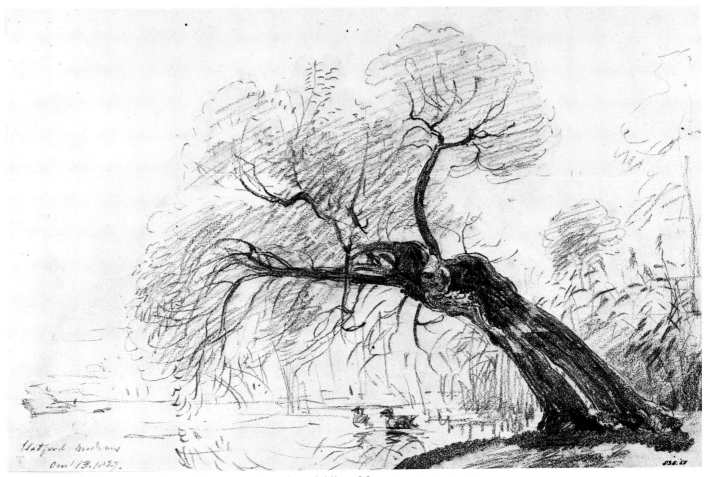

650. (27.20) *A willow tree in Flatford Meadows*, Victoria and Albert Museum, 22·4 × 33·2cm.

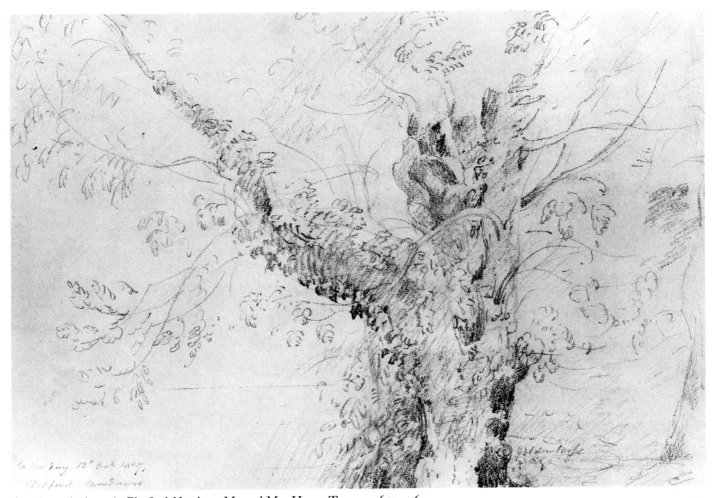

651. (27.21) *A tree in Flatford Meadows*, Mr and Mrs Henry Tang, 22·6 × 33·6cm.

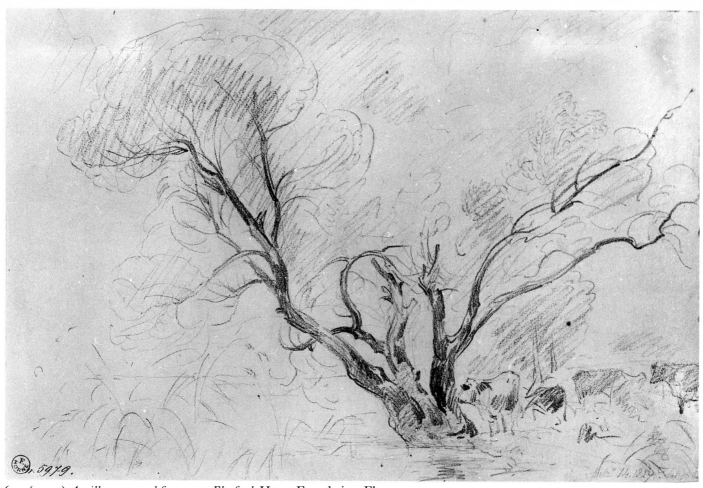

652. (27.23) *A willow tree and four cows, Flatford*, Horne Foundation, Florence, 22·3 × 33·1cm.

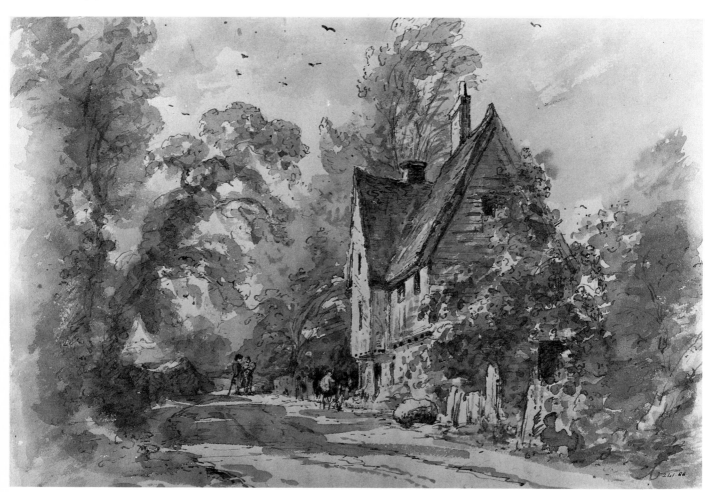

653. (27.24) *Water Lane, Stratford St Mary*, Victoria and Albert Museum, 22·4 × 33·1cm.

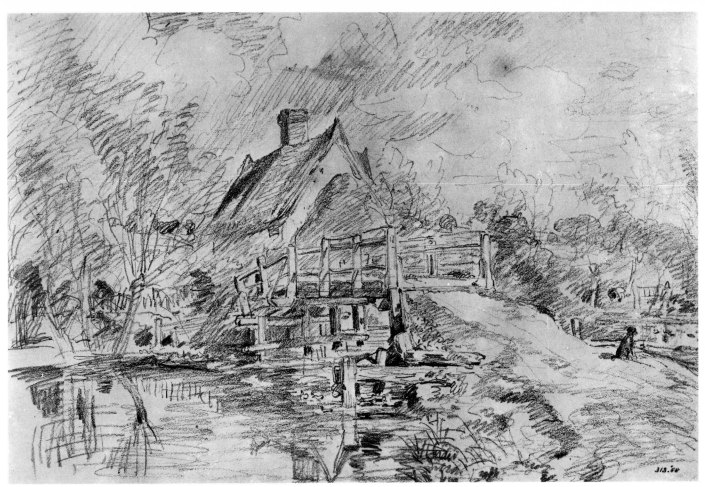

654. (27.25) *Flatford Old Bridge and Bridge Cottage*, Victoria and Albert Museum, 22·4 × 33·1cm.

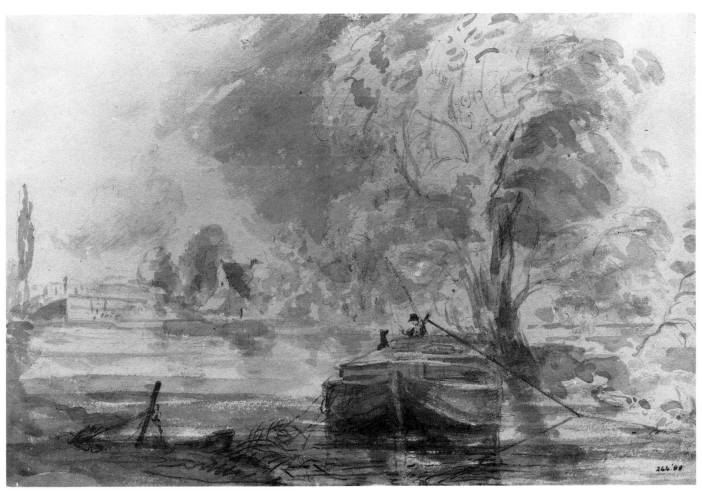

655. (27.26) *A barge on the Stour*, Victoria and Albert Museum, 22·4 × 33·1cm.

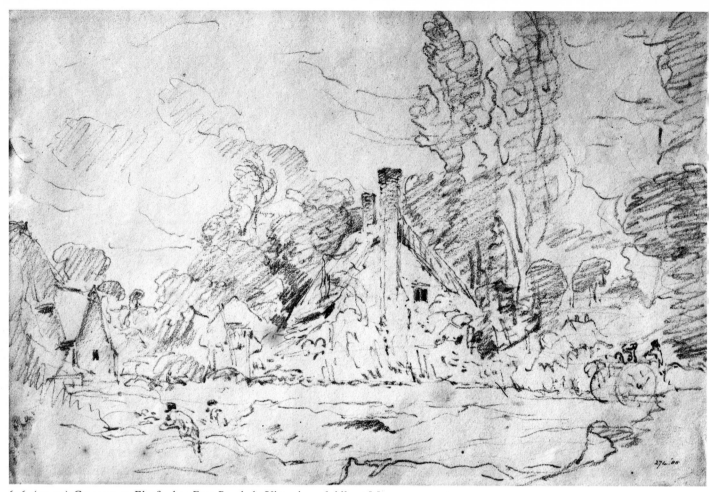

656. (27.27) *Cottages at Flatford or East Bergholt*, Victoria and Albert Museum, 22·5 × 33·1cm.

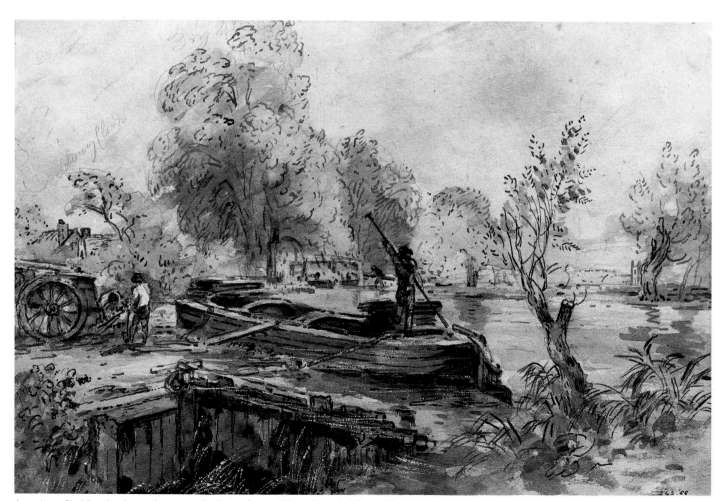

657. (27.28) *Men loading a barge on the River Stour*, Victoria and Albert Museum, 22·5 × 33.1cm.

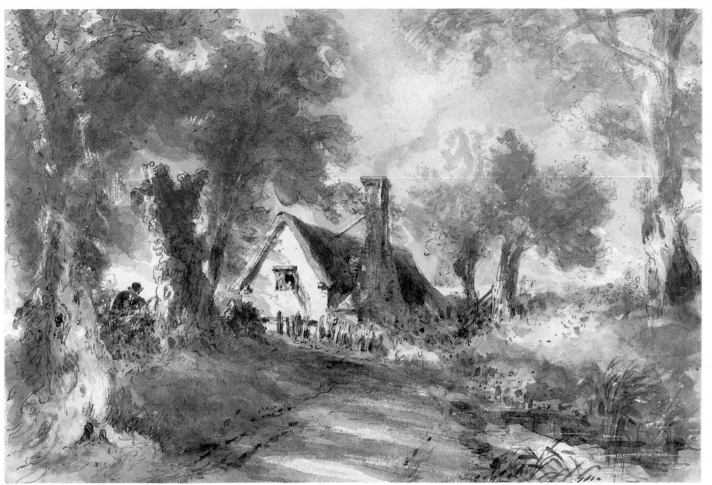

658. (27.29) *A cottage in a lane*, British Museum, 22·1 × 32·1cm.

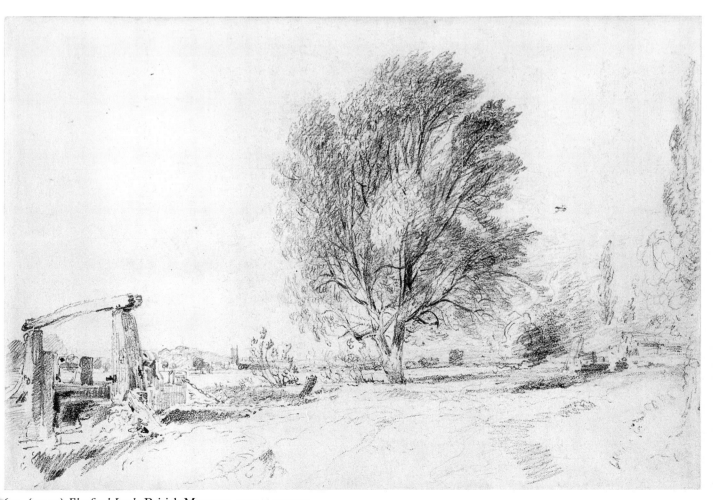

659. (27.30) *Flatford Lock*, British Museum, 22·2 × 32·7cm.

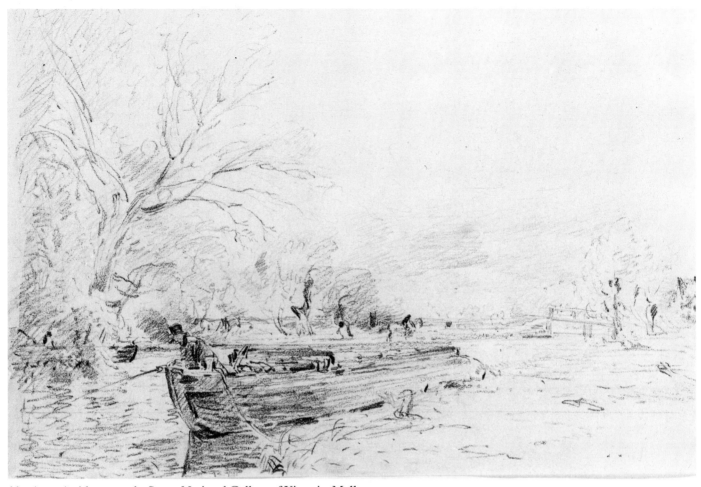

660. (27.31) *A barge on the Stour*, National Gallery of Victoria, Melbourne, 21·9 × 32·4cm.

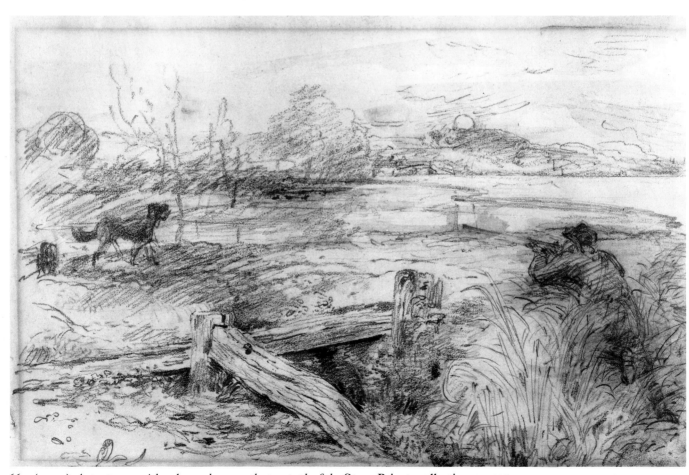

661. (27.33) *A sportsman with a dog and gun on the tow path of the Stour*, Private collection, 22·5 × 33·2cm.

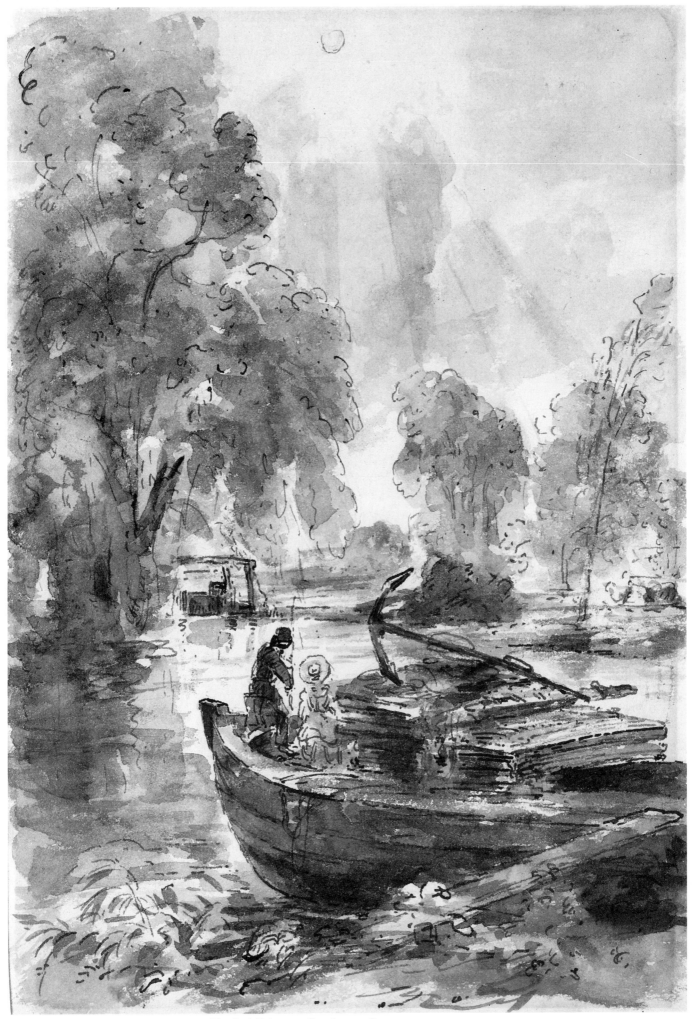

662. (27.34) *Two children on a barge at Flatford*, Private collection, 32·8 × 21·3cm.

663. (27.35) *Landscape with trees and a cottage*, Royal Albert Memorial Museum, Exeter, 22·2 × 32·7cm.

664. (27.36) *Several slight studies on one sheet, including two sketches of a gabled house with a portico with arched openings*, Royal Albert Memorial Museum, Exeter, 22·2 × 32·4cm.

665. (27.37) *A cottage at Flatford*, Royal Albert Memorial Museum, Exeter, 22·1 × 20·7cm.

666. (27.38) *Landscape study*, Royal Albert Memorial Museum, Exeter, 22·1 × 20·7cm.

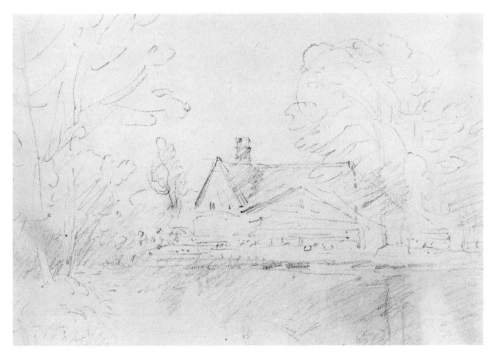

667. (27.39) *Landscape with a tree and bushes*, Royal Albert Memorial Museum, Exeter, 22·2 × 32·8cm.

668. (27.40) *A farmhouse by the water*, Fogg Art Museum, Harvard University, Cambridge, Massachusetts, 20·5 × 29·3cm.

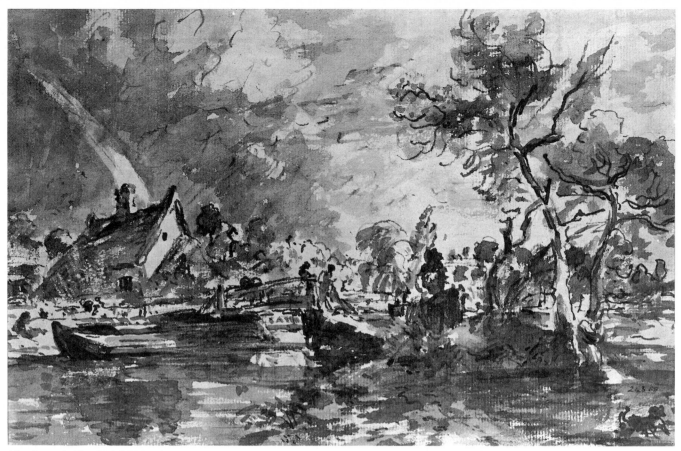

669. (27.41) *Flatford Old Bridge and Bridge Cottage*, Victoria and Albert Museum, 17·9 × 26·9cm.

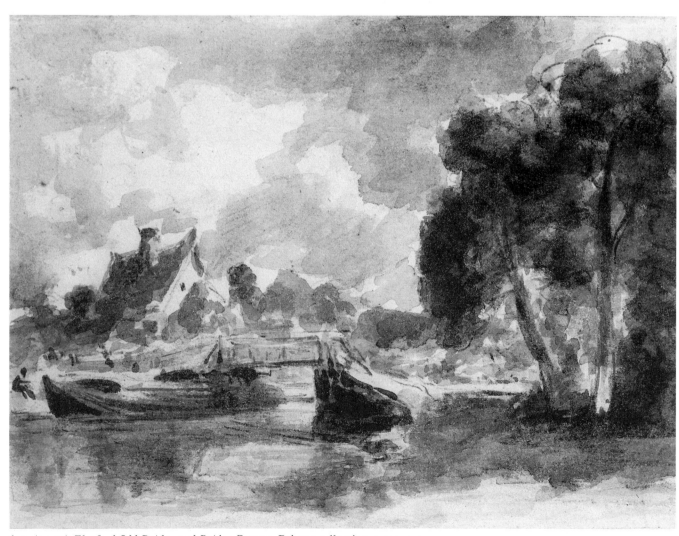

670. (27.42) *Flatford Old Bridge and Bridge Cottage*, Private collection, 15 × 19·9cm.

671. (27.43) *Diagram of Constable's drawing room at Hampstead, over a sky study with a rainbow*, Musée du Louvre, 17·4 × 18·4cm.

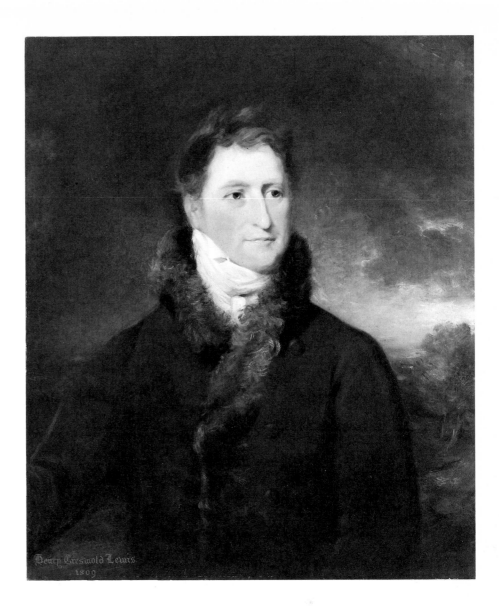

672. (27.44) *Diagram of rooms in No. 6 Well Walk, Hampstead*, Musée du Louvre, 18·4 × 17·4cm.

673. (right) (27.46) *Henry Greswolde Lewis*, Private collection, 78·8 × 66cm.

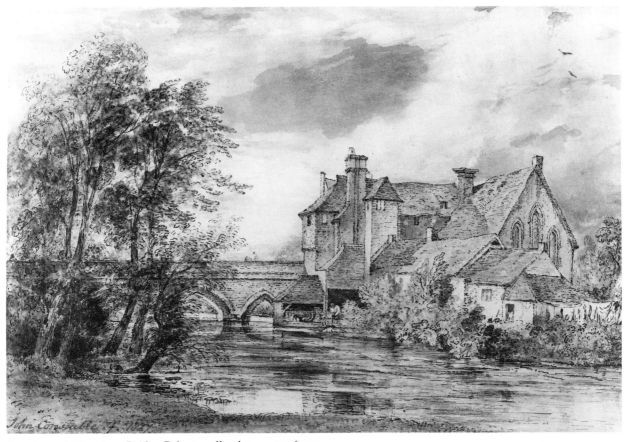

674. (27.45) *Harnham Bridge*, Private collection, 17 × 26·2cm.

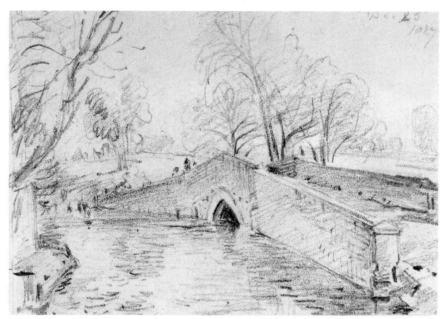

675. (27.47) *A bridge over a stream*, Hildegard Fritz-Denneville Fine Arts Ltd, 8 × 11·5cm.

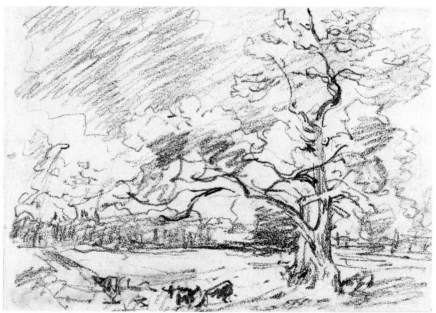

676. (27.48) *A landscape with cattle under a large tree*, Hildegard Fritz-Denneville Fine Arts Ltd, 8 × 11·5cm.

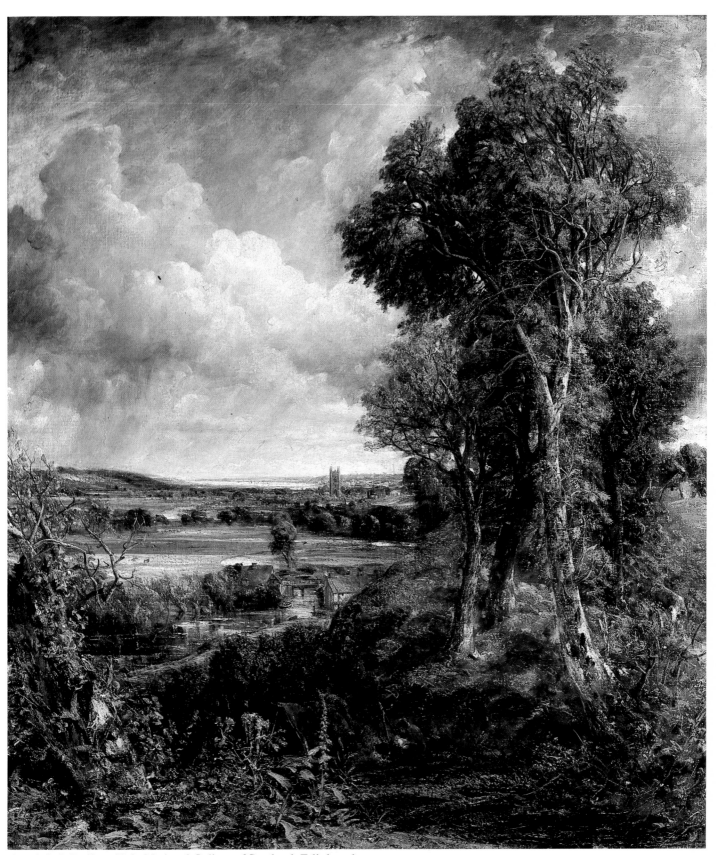

677. (28.1) *Dedham Vale*, National Gallery of Scotland, Edinburgh, 145 × 122cm.

679. (28.3) *Hampstead Heath: Branch Hill Pond*, Cleveland Museum of Art, 60·6 × 78cm.

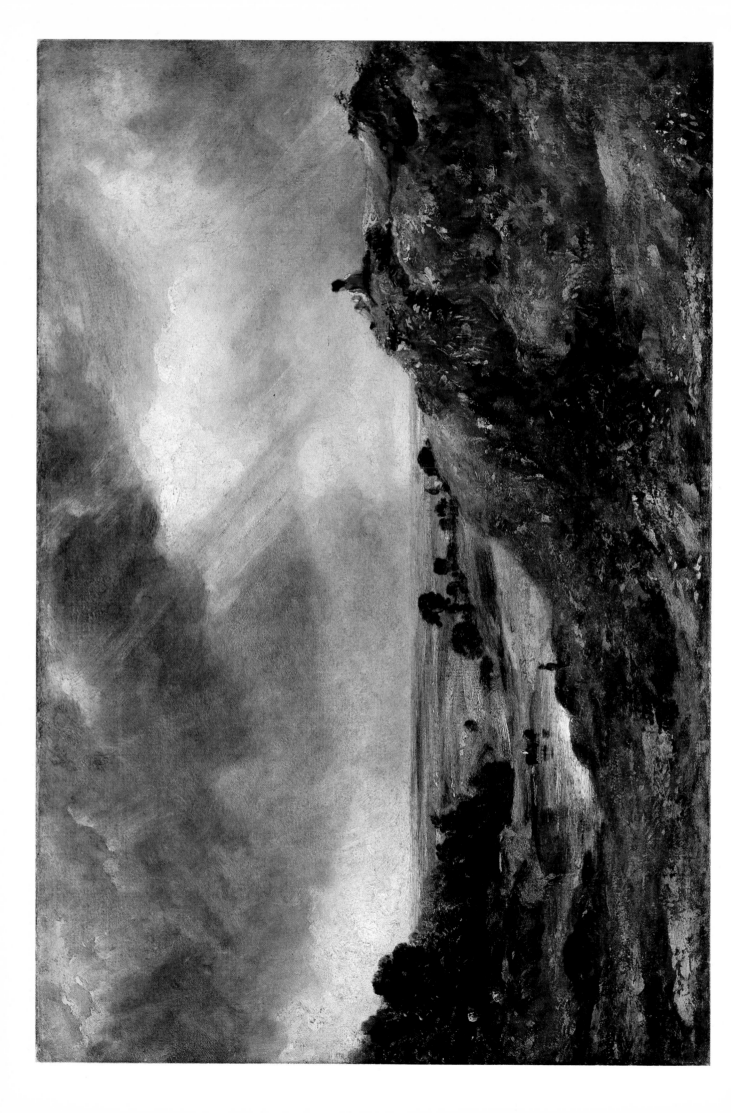

680. (above) (28.4)
Hampstead Heath : Branch Hill Pond, Tate Gallery, 33·3 × 50·2cm.

680. (above) (28.4)
Hampstead Heath : Branch Hill Pond, Tate Gallery, 33·3 × 50·2cm.

681. (28.7) *Shoreham Bay*, Victoria and Albert Museum, 20 × 24·8cm.

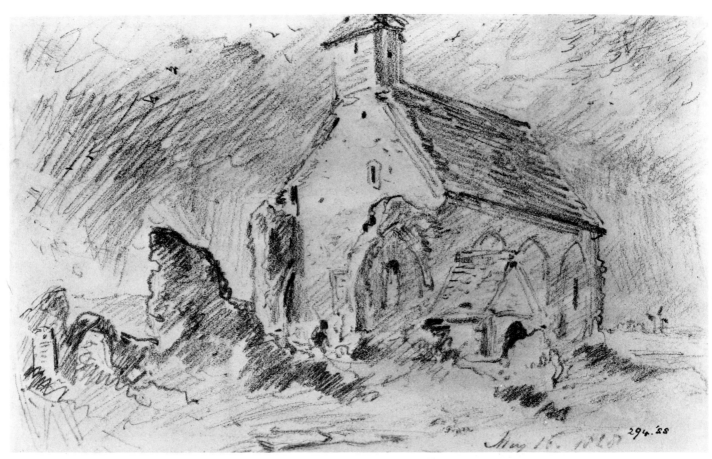

682. (28.5) *The Old Parish Church, Hove*, Victoria and Albert Museum, 11·5 × 18·6cm.

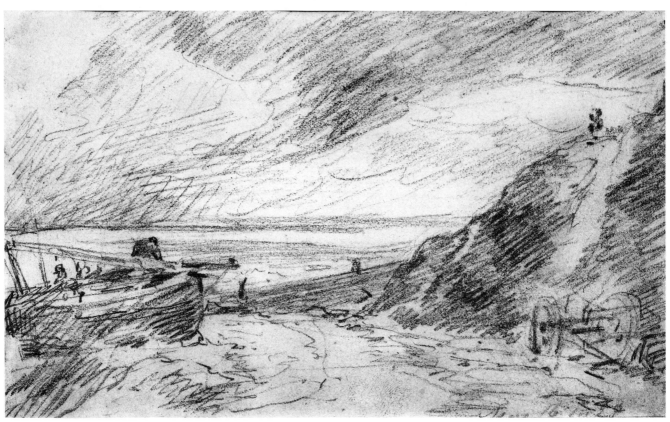

683. (28.6) *Scene on Brighton Beach*, Private collection, 10·7 × 17·7cm.

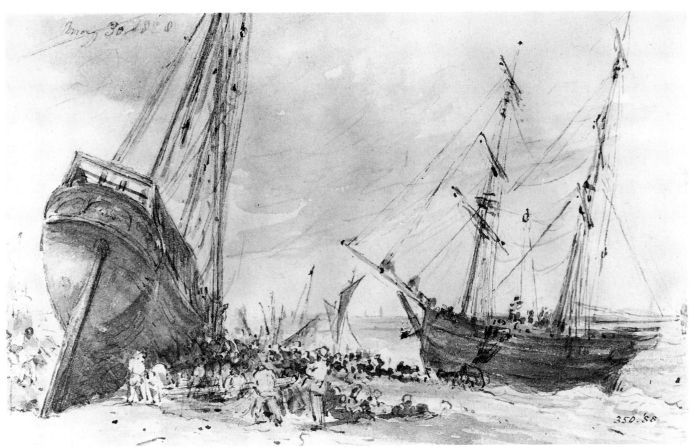

684. (28.8) *A coast scene with colliers on the beach at Brighton*, Victoria and Albert Museum, 11·5 × 18·1cm.

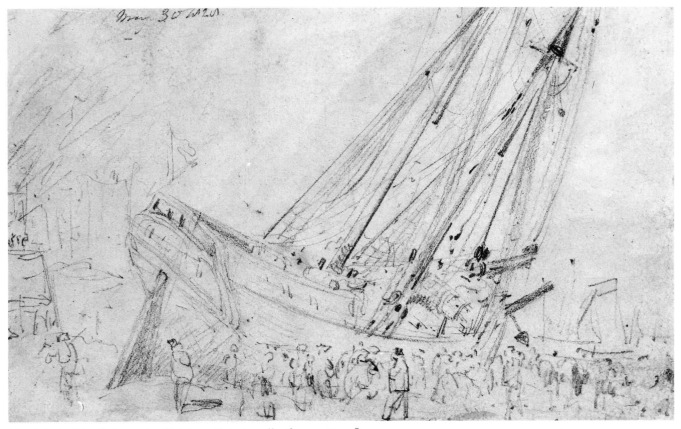

685. (28.9) *A beached vessel at Brighton*, Private collection, 11 × 17·8cm.

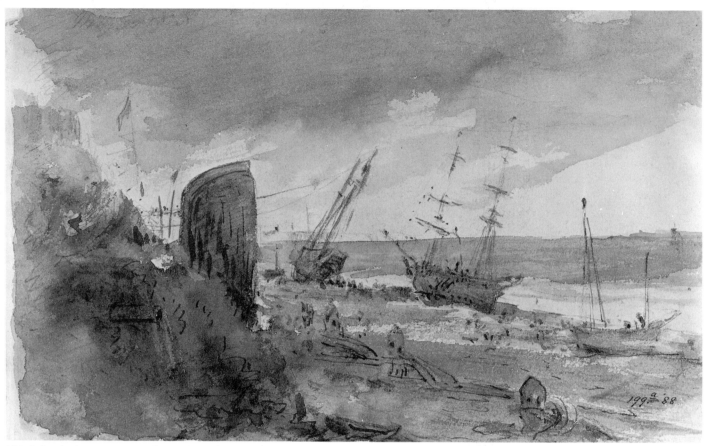

686. (28.10) *A coast scene with vessels on the beach at Brighton*, Victoria and Albert Museum, 11·5 × 18·6cm.

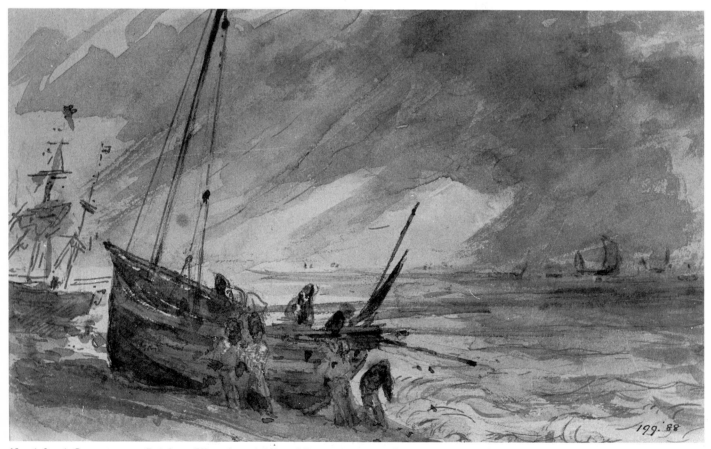

687. (28.11) *Coast scene at Brighton*, Victoria and Albert Museum, 11·5 × 18·7cm.

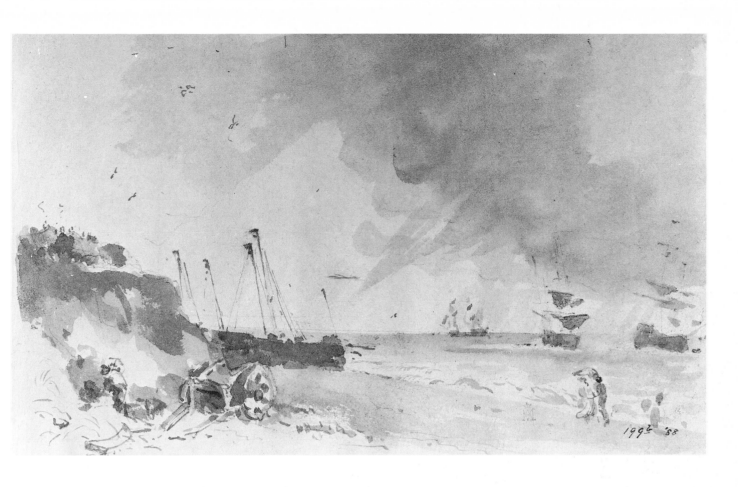

688. (above) (28.12)
Coast scene at Brighton,
Victoria and Albert
Museum,
11·5 × 18·6cm.

689. (28.23) *Two copies
of etchings by Herman
van Swanevelt on one
sheet*, Leonard Voss
Smith, 18·5 × 14·5cm.

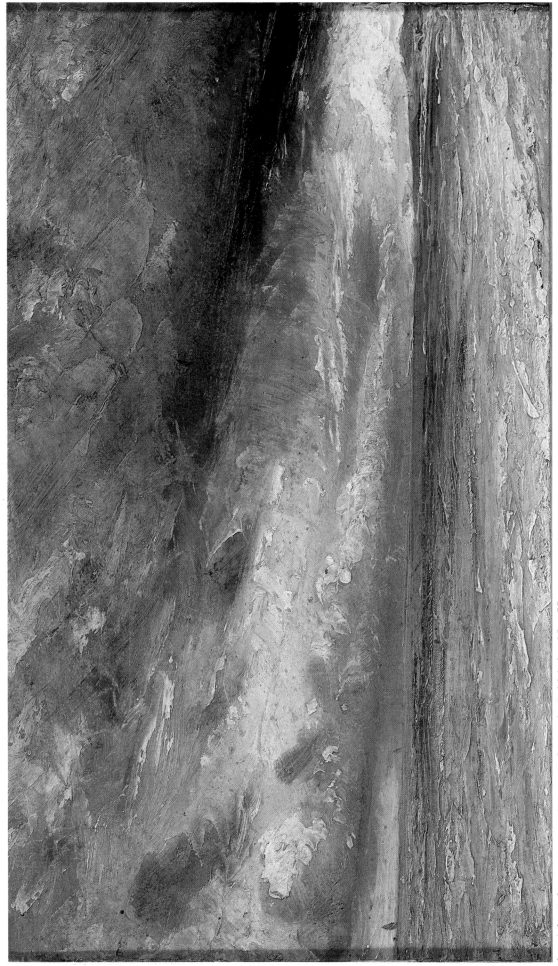

690. (28.13) *Stormy sea, Brighton*, Yale Center for British Art, New Haven, 14·5 × 25·5cm.

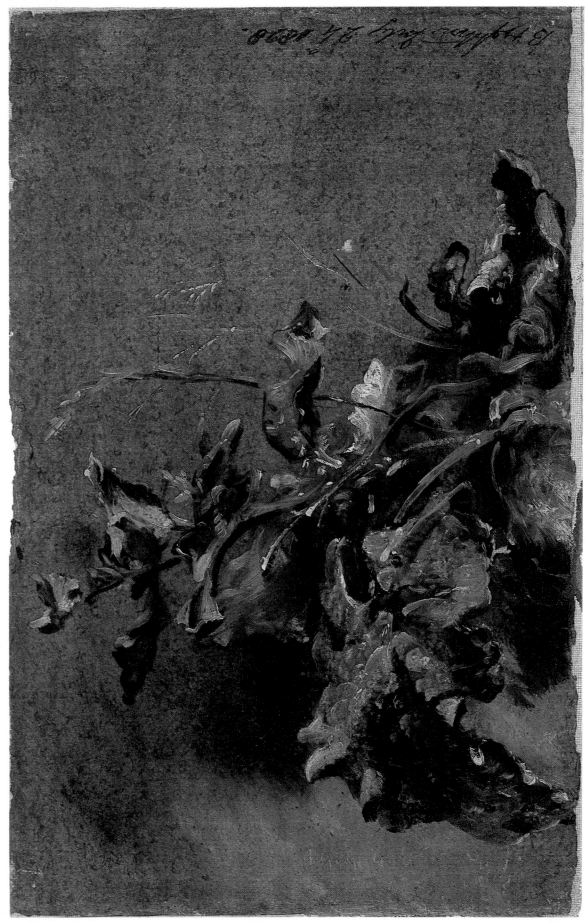

691. (28.14) *Study of docks and grasses*, British Museum, 15·2 × 24·1cm.

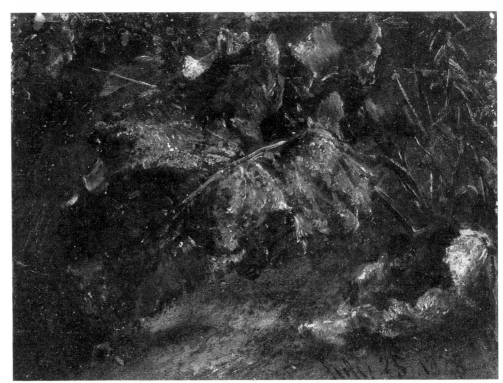

692. (28.15) *Study of dock leaves*, British Museum, 11·4 × 14·9cm.

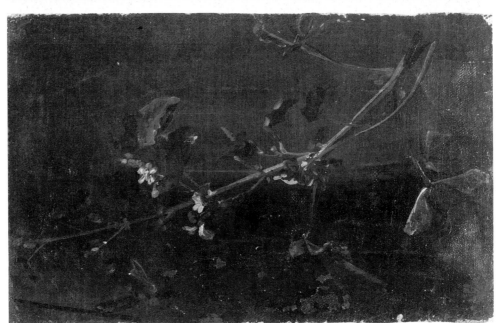

693. (28.16) *Study of ivy geranium*, British Museum, 15·2 × 24·1cm.

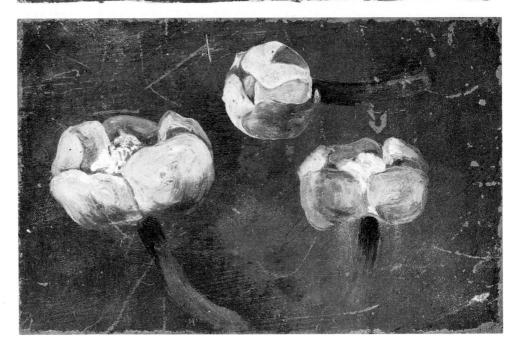

694. (28.17) *Study of yellow trollius blooms*, British Museum, 6·7 × 10·5cm.

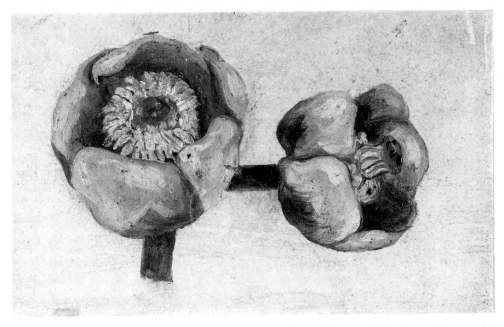

695. (28.18) *Study of yellow trollius blooms*, British Museum, 6·7 × 10·5cm.

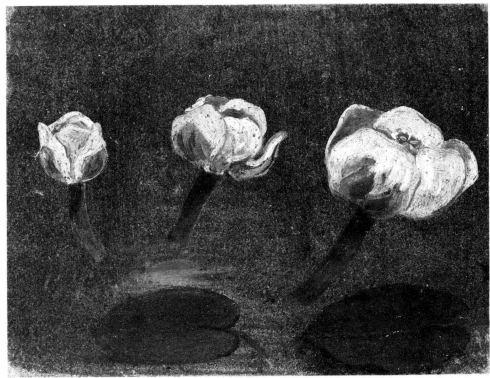

696. (28.19) *Study of yellow trollius blooms and two leaves*, British Museum, 8·6 × 12·1cm.

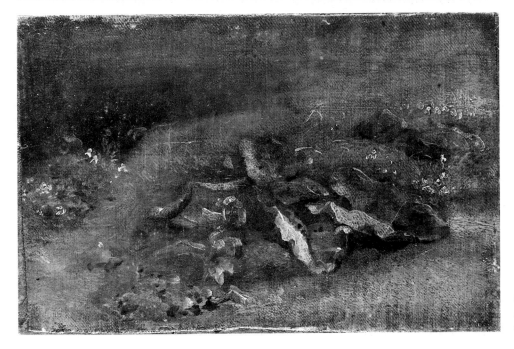

697. (28.20) *Study of a burdock*, Private collection, 18·5 × 27cm.

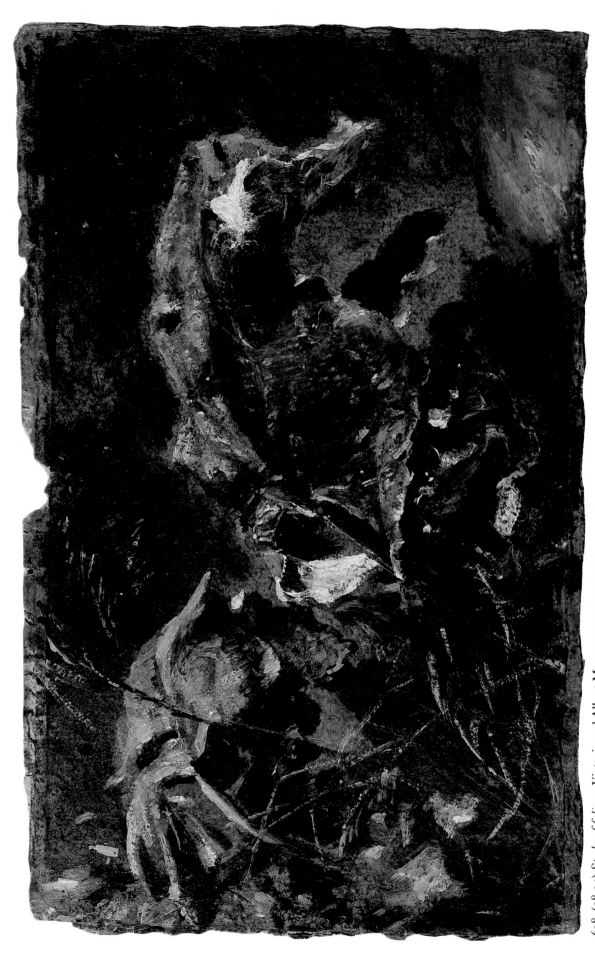

698. (28.24) *Study of foliage*, Victoria and Albert Museum, 15·2 × 24·2cm.

699. (below) (28.27) *Summer, Afternoon after a Shower*, Tate Gallery, 34·5 × 43·5cm.

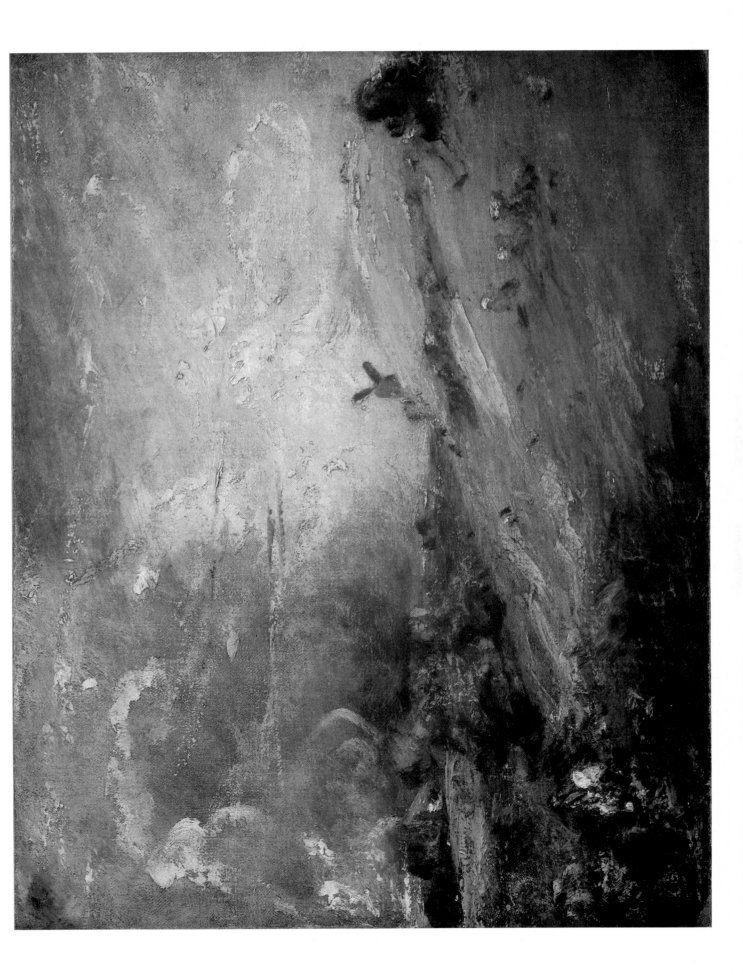

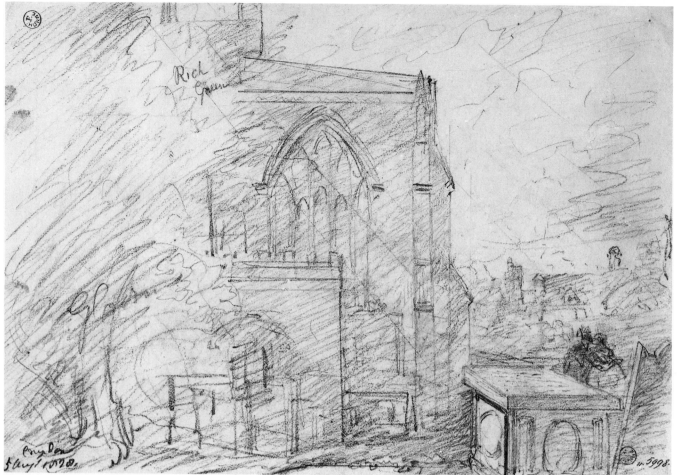

700. (28.21) *The Church of St John the Baptist, Croydon: the churchyard, with the Gooch family graves,* Horne Foundation, Florence, 23·3 × 33·2cm.

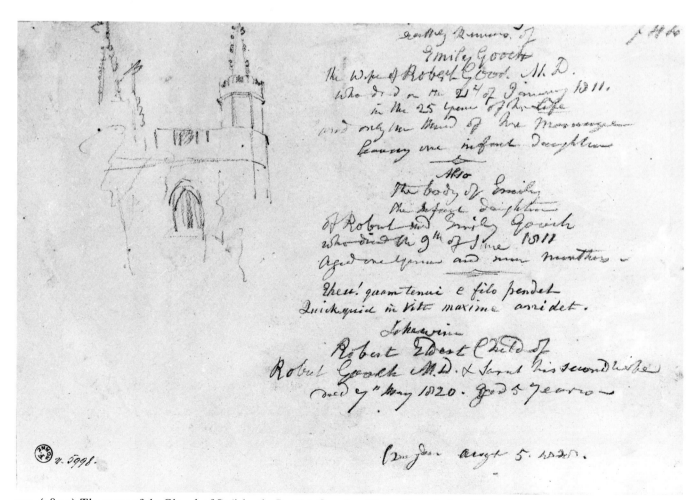

701. (28.22) *The tower of the Church of St John the Baptist, Croydon,* Horne Foundation, Florence, 23·3 × 33·2cm.

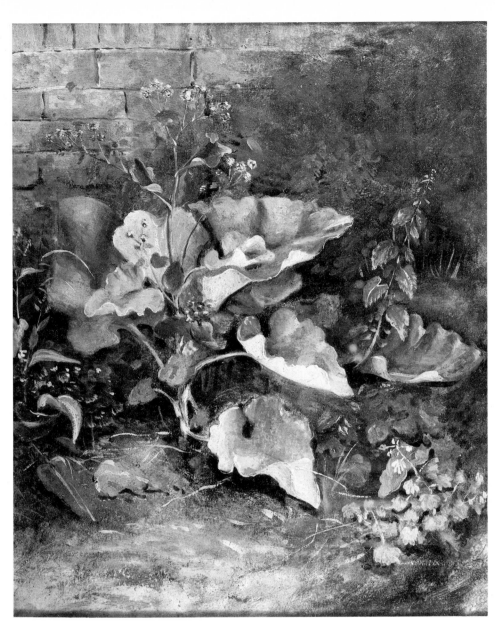

702. (28.25) *Plants growing near a wall*, Victoria and Albert Museum, 30·5 × 24·8cm.

703. (below) (28.26) *Brighton Beach, looking west to the Chain Pier*, John G. Johnson Collection, Philadelphia, 11·5 × 18·3cm.

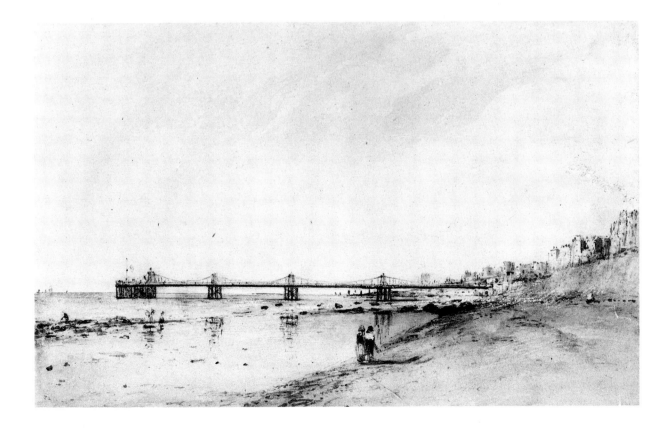

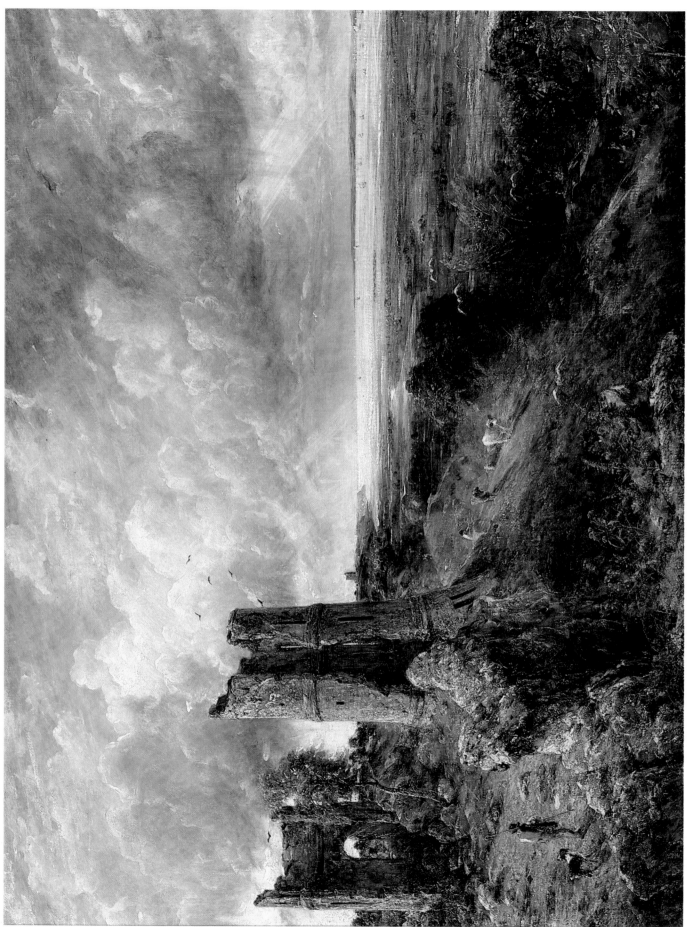

704. (29.1) *Hadleigh Castle*, Yale Center for British Art, New Haven, 122 × 164·5 cm.

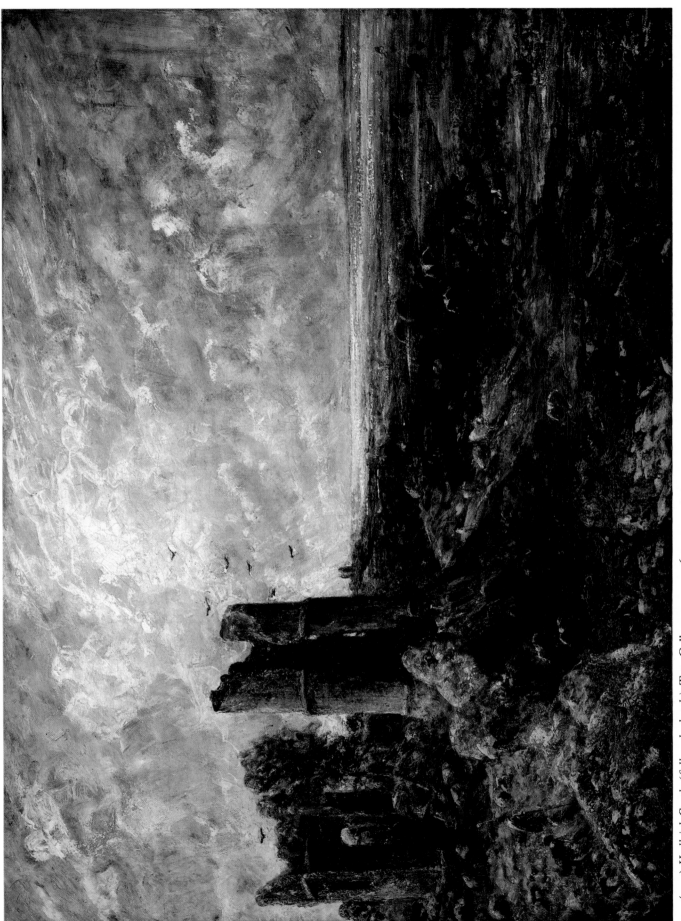

705. (29.2) *Hadleigh Castle (full-scale sketch)*, Tate Gallery, 122·5 × 167·4cm.

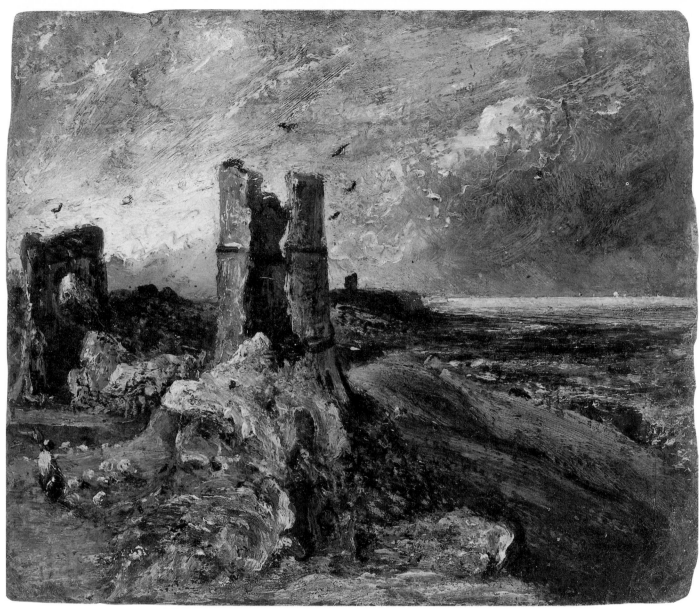

706. (29.3) *Sketch for 'Hadleigh Castle'*, Paul Mellon Collection, Upperville, Virginia, 20 × 24cm.

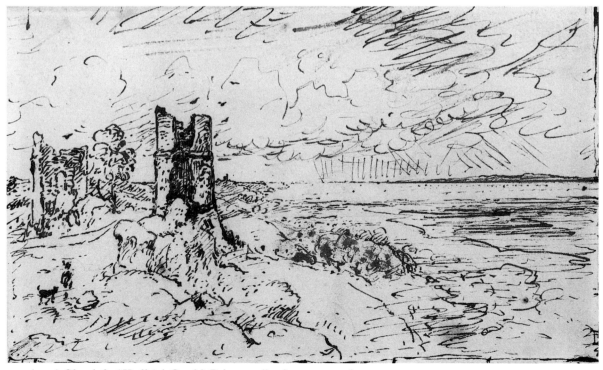

707. (29.4) *Sketch for 'Hadleigh Castle'*, Private collection, 10·2 × 16·9cm.

708. (left) (29.5) *A shepherd*, Horne Foundation, Florence, 15 × 8·7cm.

709. (29.11) *Landscape with nymphs listening to a piping satyr, after Herman van Swanevelt*, British Museum, 8·9 × 11·1cm.

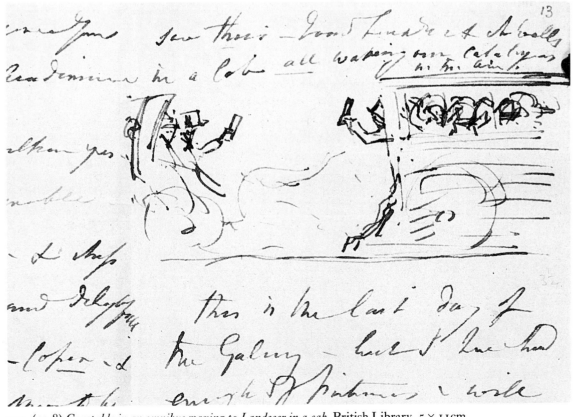

710. (29.8) *Constable in an omnibus waving to Landseer in a cab*, British Library, 5 × 11cm.

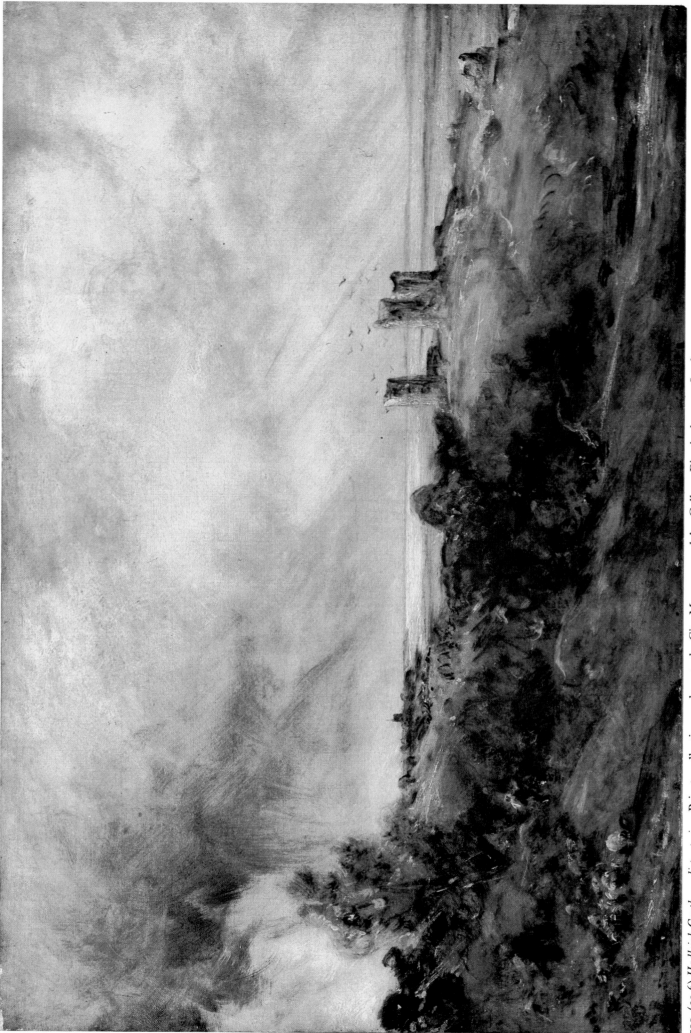

711. (29.6) *Hadleigh Castle : a distant view*, Private collection, on loan to the City Museums and Art Gallery, Birmingham, 41·8 × 62·2cm.

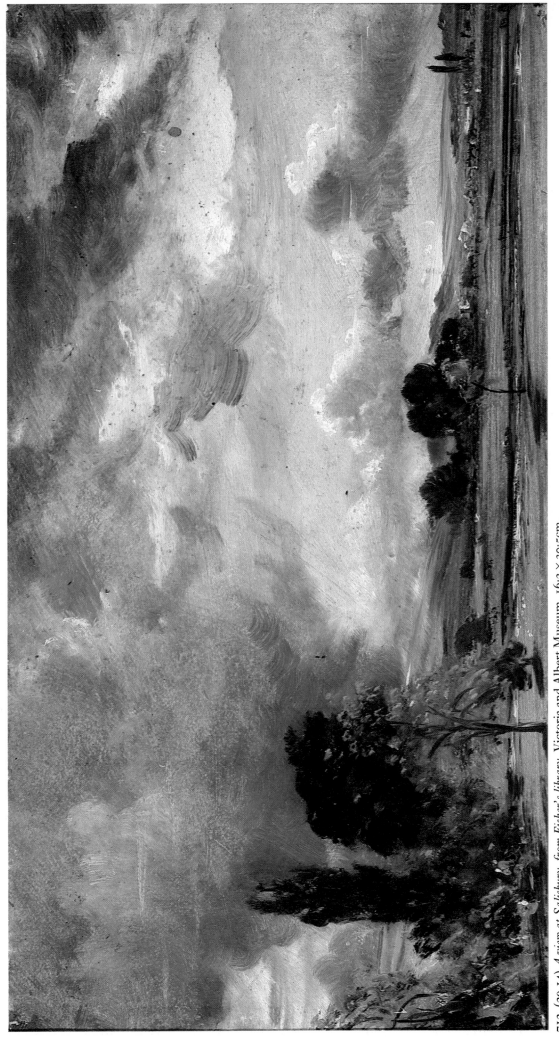

712. (29.14) *A view at Salisbury, from Fisher's library,* Victoria and Albert Museum, 16·2 × 30·5cm.

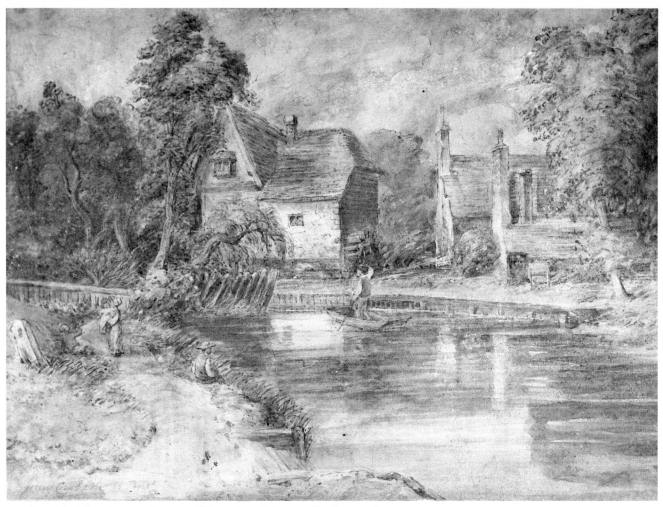

713. (29.12) *A farmhouse and watermill by a river*, Private collection, 17·8 × 23·4cm.

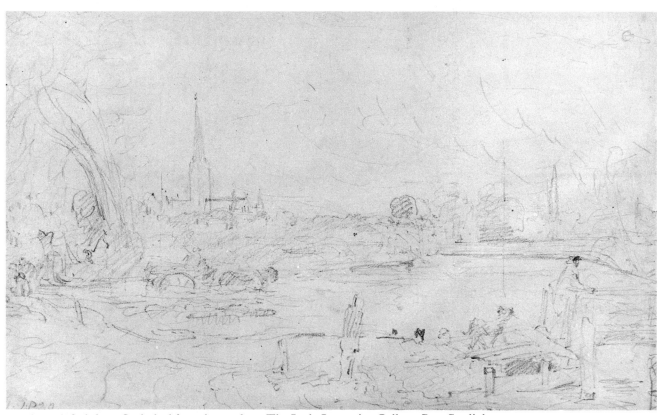

714. (29.13) *Salisbury Cathedral from the meadows*, The Lady Lever Art Gallery, Port Sunlight, 23 × 32·5cm.

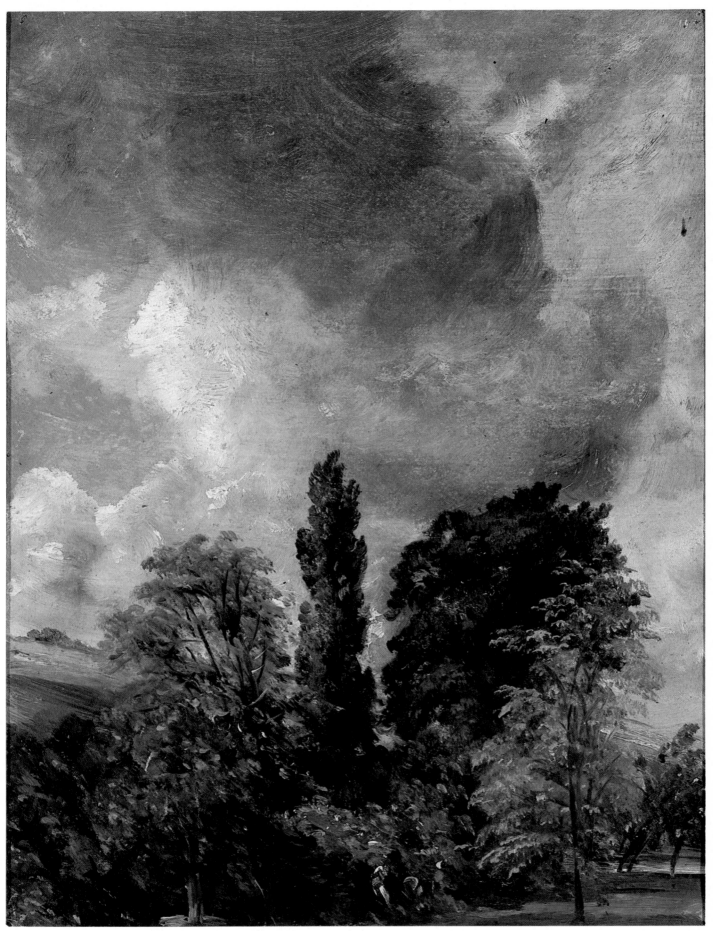

715. (29.15) *The Close, Salisbury*, Victoria and Albert Museum, 26·4 × 20·3cm.

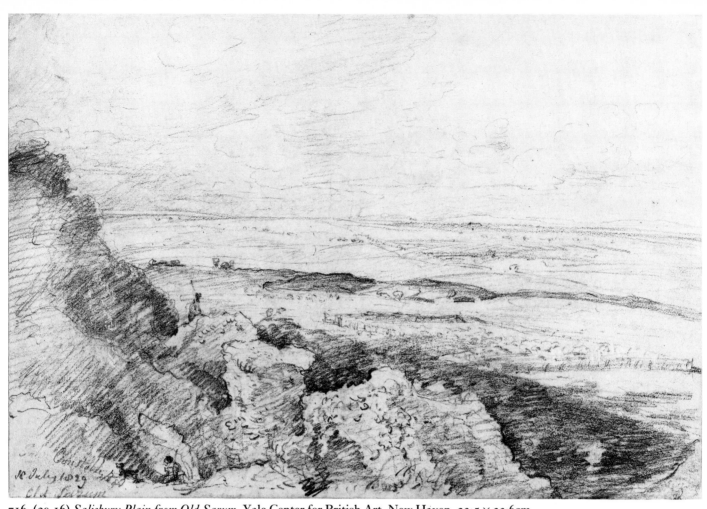

716. (29.16) *Salisbury Plain from Old Sarum*, Yale Center for British Art, New Haven, 23·5 × 33·6cm.

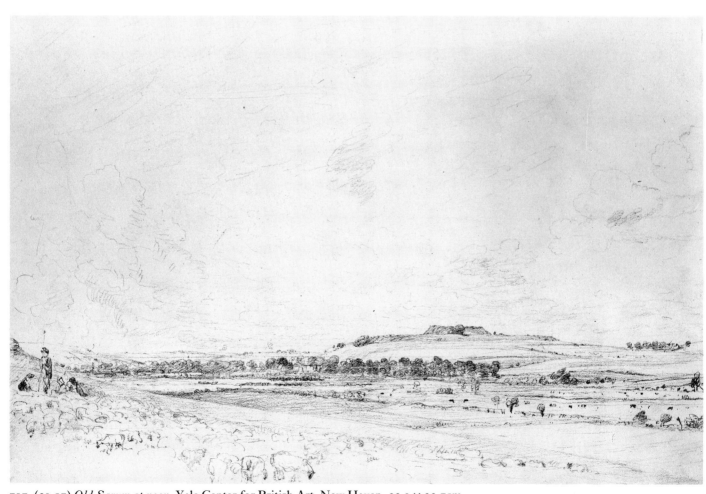

717. (29.17) *Old Sarum at noon*, Yale Center for British Art, New Haven, 22·9 × 33·7cm.

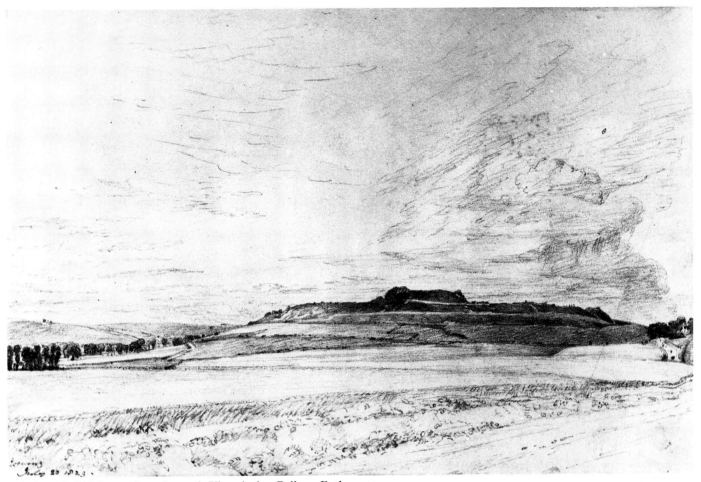

718. (29.18) *Old Sarum from the south*, Victoria Art Gallery, Bath, 23 × 33·2cm.

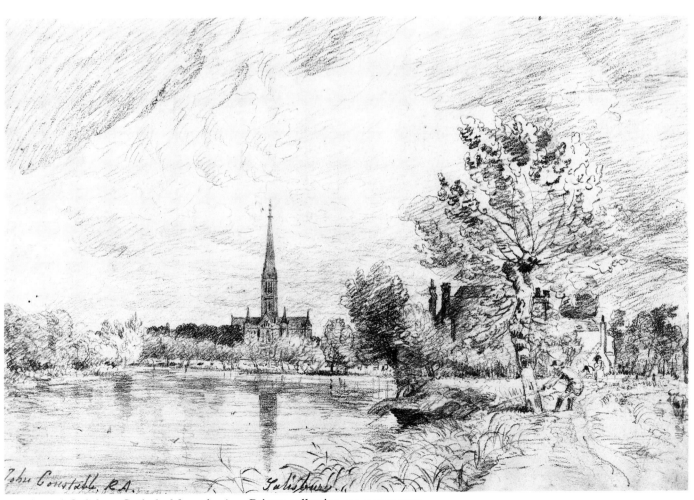

719. (29.20) *Salisbury Cathedral from the river*, Private collection, 23·4 × 33·5cm.

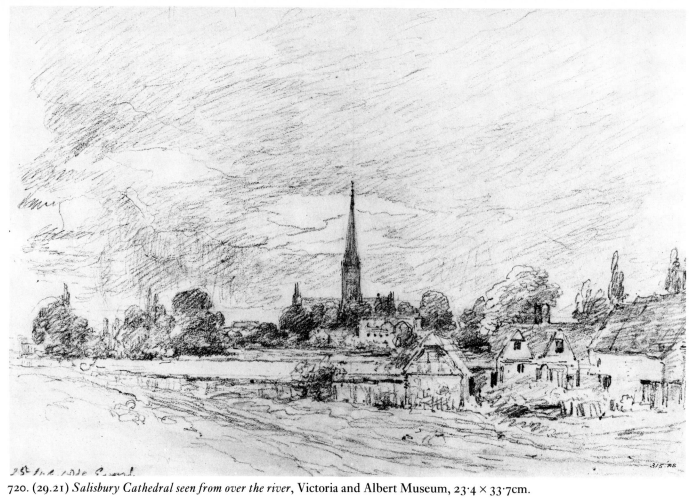

720. (29.21) *Salisbury Cathedral seen from over the river*, Victoria and Albert Museum, 23·4 × 33·7cm.

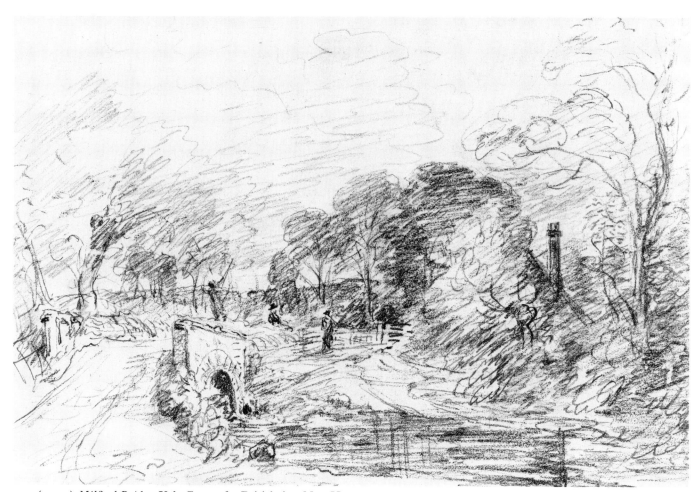

721. (29.23) *Milford Bridge*, Yale Center for British Art, New Haven, 22·9 × 33·2cm.

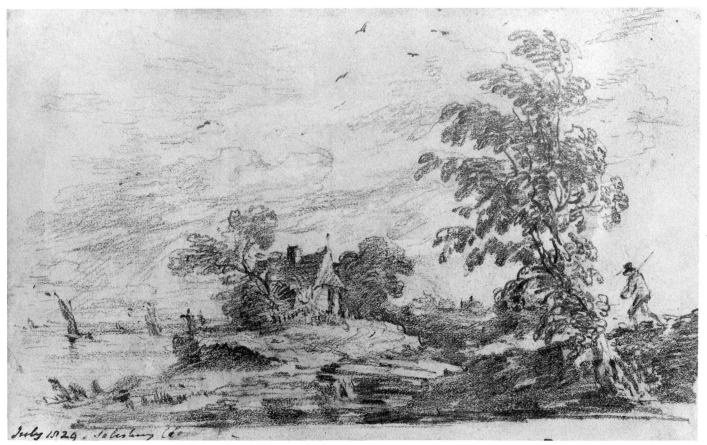

722. (29.24) *A coastal landscape with a cottage*, Private collection, 13·7 × 23·1cm.

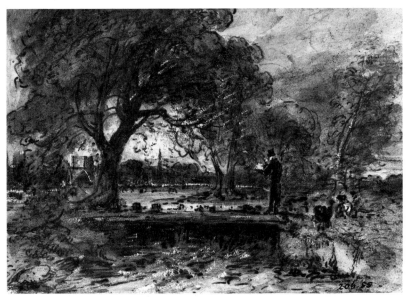

723. (29.19) *Archdeacon Fisher and his dogs*, Victoria and Albert Museum, 9·3 × 12·8cm.

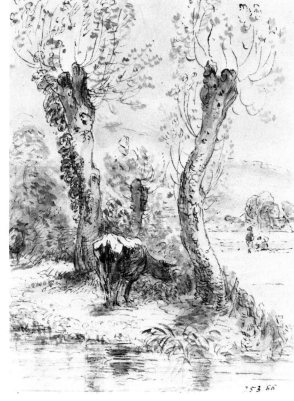

724. (right) (29.25) *Cows grazing, Salisbury*, Victoria and Albert Museum, 12·7 × 9·3cm.

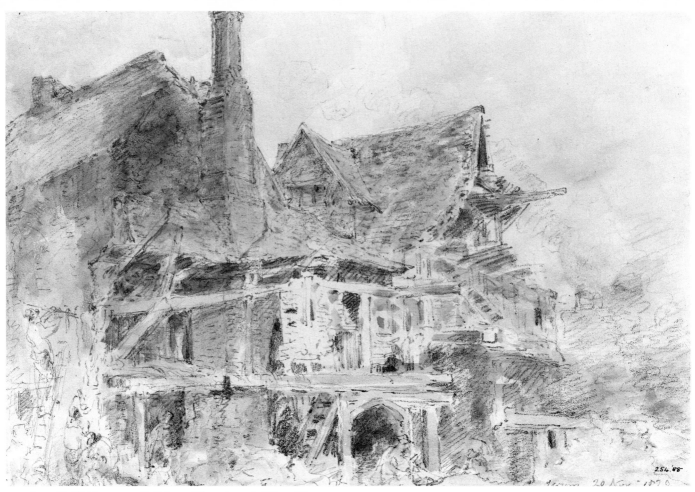

725. (29.26) *Old houses at Salisbury*, Victoria and Albert Museum, 23·4 × 33·5cm.

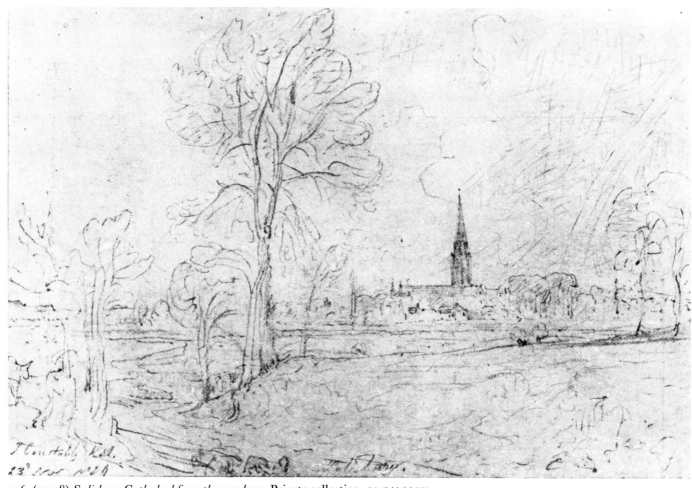

726. (29.28) *Salisbury Cathedral from the meadows*, Private collection, 21·5 × 33cm.

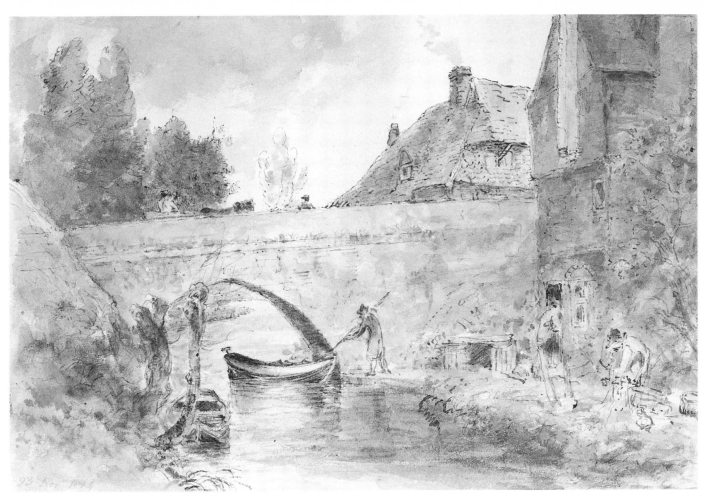

727. (29.29) *Harnham Bridge*, British Museum, 22·9 × 33cm.

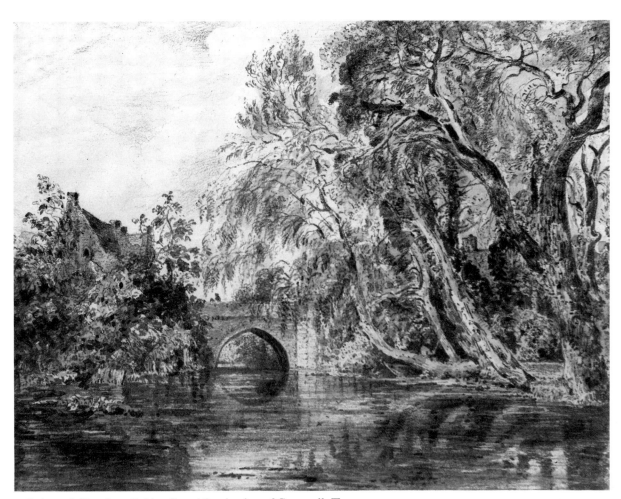

728. (29.30) *Harnham Bridge*, Royal Institution of Cornwall, Truro, 19·1 × 24·2cm.

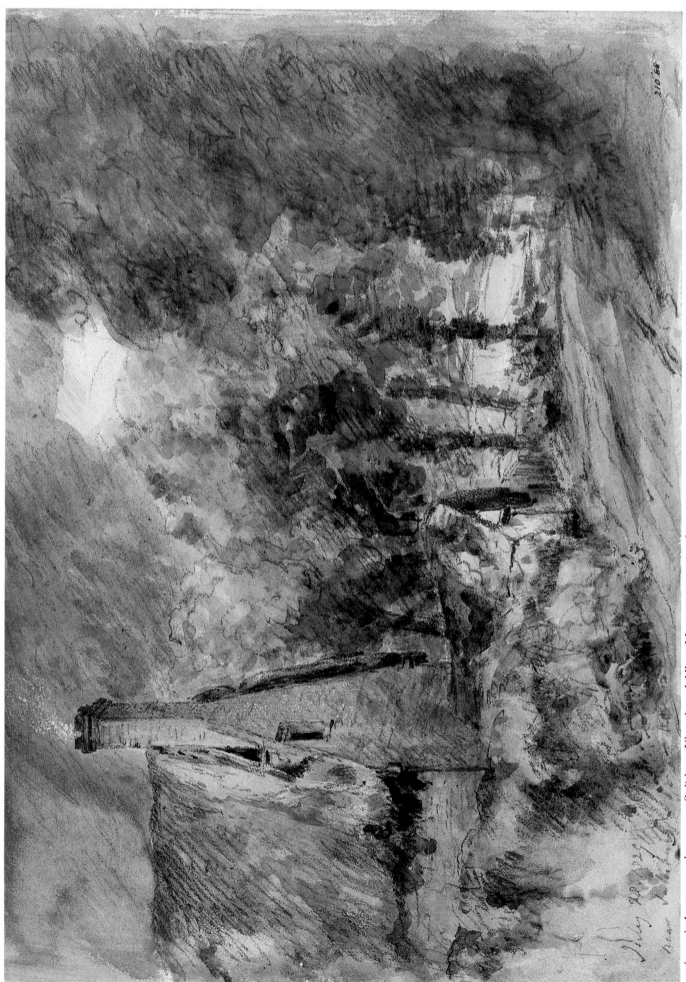

729. (29.22) *A cottage and trees near Salisbury*, Victoria and Albert Museum, 23·4 × 33·6cm.

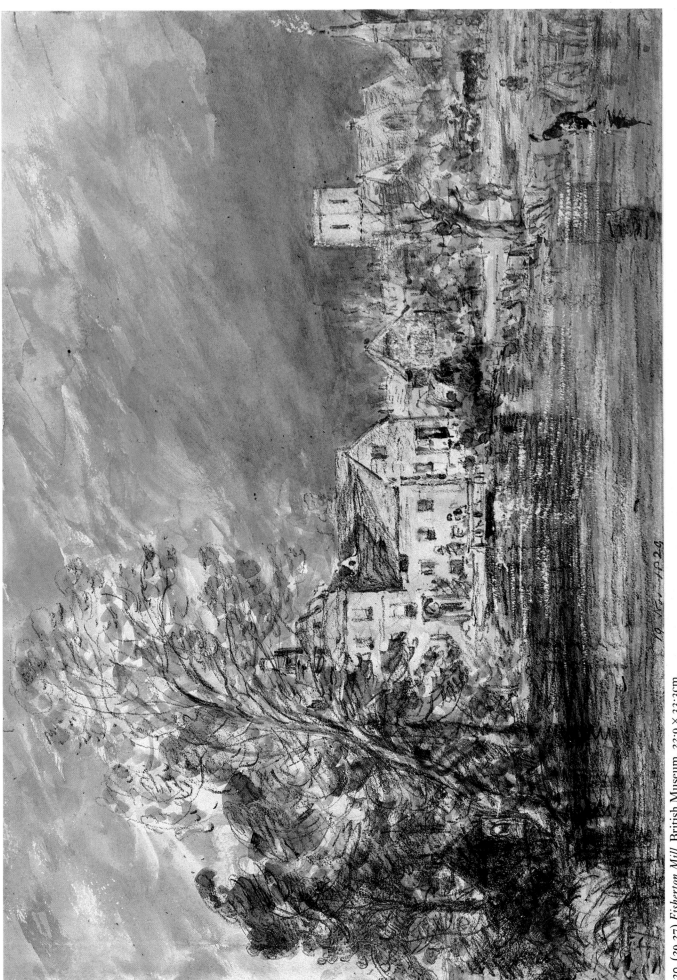

730. (29.27) *Fisherton Mill*, British Museum, 22·9 × 33·3cm.

731. (29.31) *Houses and trees by a river*, Horne Foundation, Florence, 23·2 × 33cm.

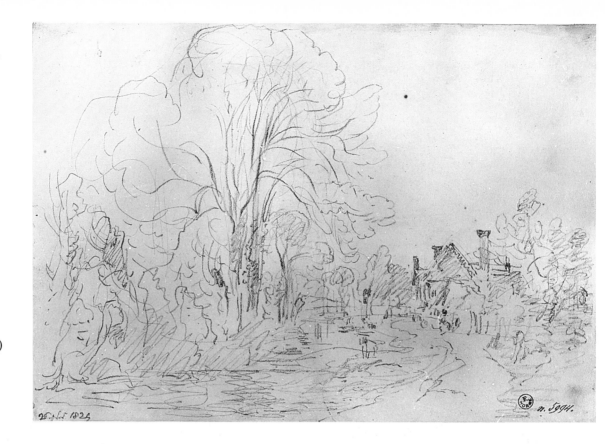

732. (below) (29.32) *Watermeadows at Salisbury*, Ashmolean Museum, Oxford, 32 × 38cm.

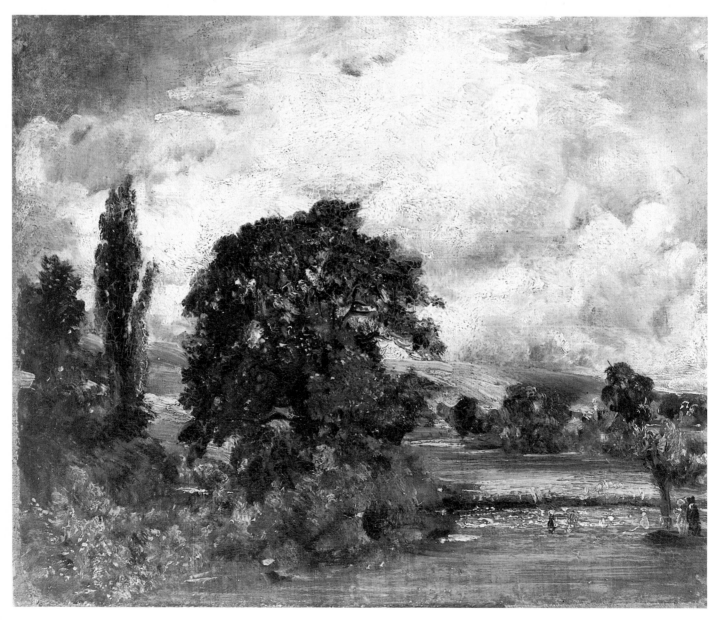

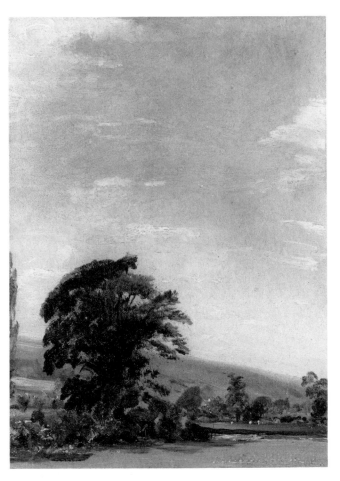

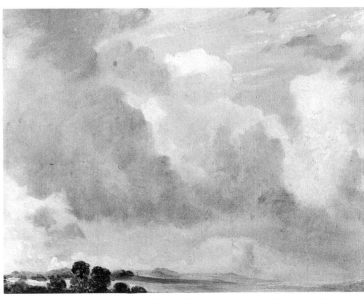

733. (29.33) *View at Salisbury*, Private collection, 20·3 × 14·3cm.

734. (29·37) *Harnham Ridge*, Hugh Lane Municipal Gallery of Modern Art, Dublin, 15·2 × 19cm.

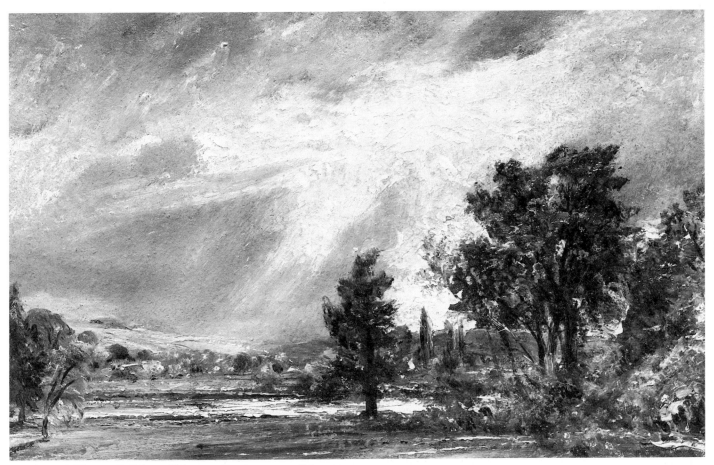

735. (29.35) *View at Salisbury*, Private collection, 19 × 28·6cm.

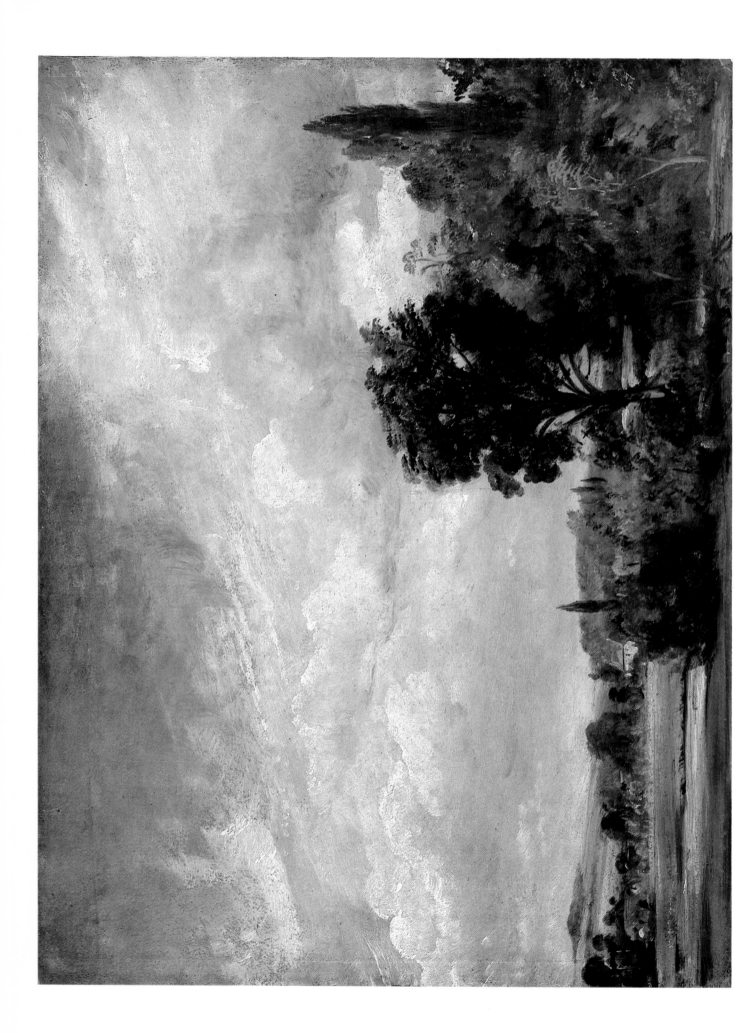

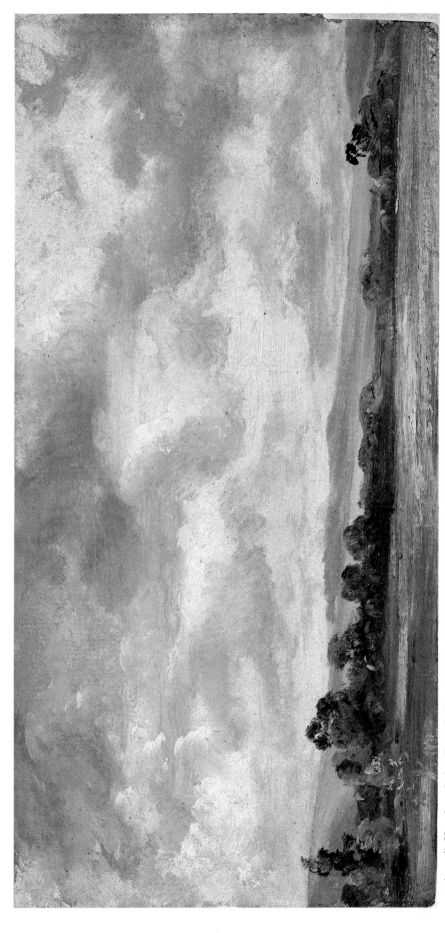

736. (above) (29.34) *Harnham Ridge from a window of Fisher's house*, National Gallery of Ireland, Dublin, 29·2 × 38·1cm.

737. (29.36) *Harnham Ridge*, Tate Gallery, 11·4 × 23·7cm.

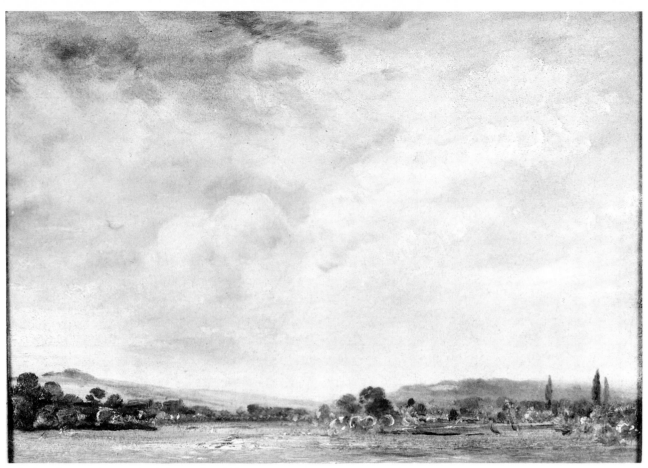

738. (29.38) *Harnham Ridge*, The National Trust, Upton House, nr Banbury, Oxfordshire, 19 × 27·6cm.

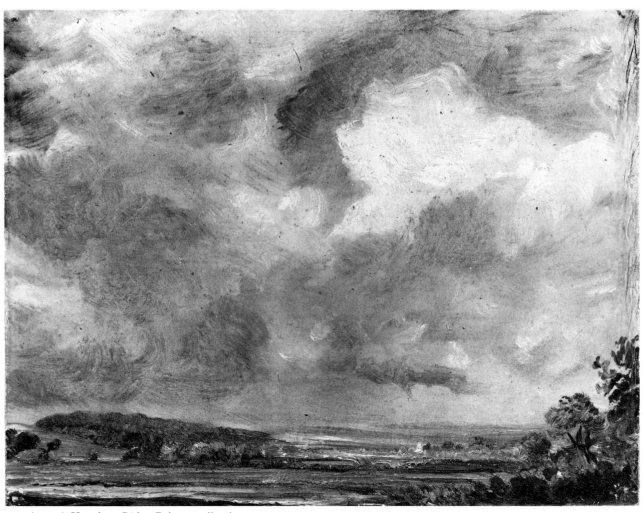

739. (29.39) *Harnham Ridge*, Private collection, 19·2 × 25cm.

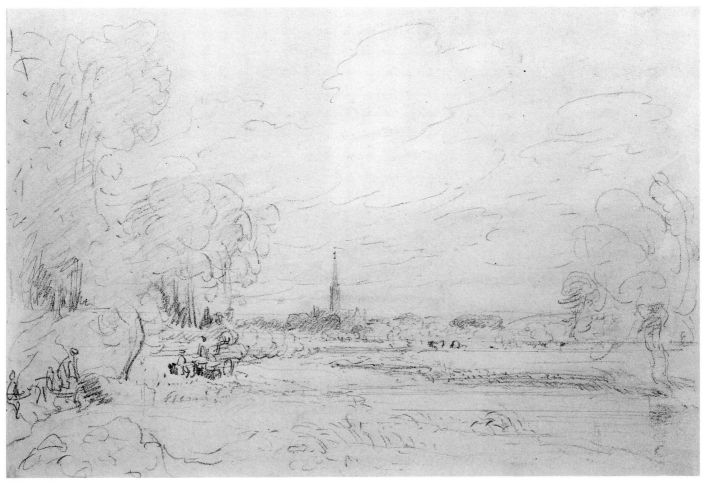

740. (29.42) *Salisbury Cathedral from the meadows*, Paul Mellon Collection, Upperville, Virginia, 23·4 × 33·9cm.

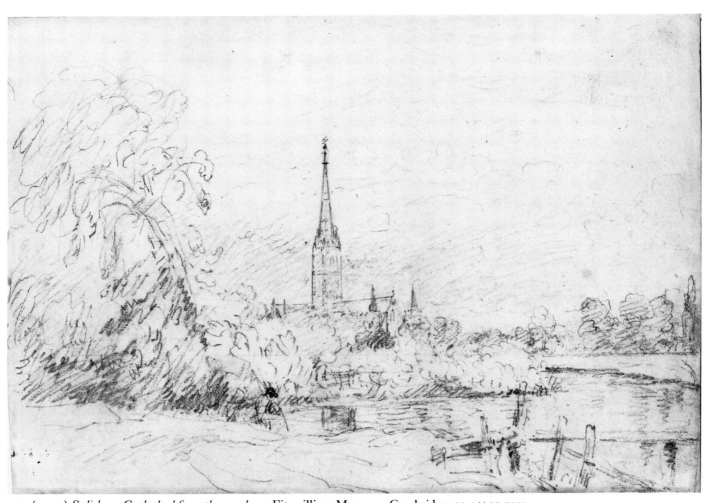

741. (29.43) *Salisbury Cathedral from the meadows*, Fitzwilliam Museum, Cambridge, 23·4 × 32·7cm.

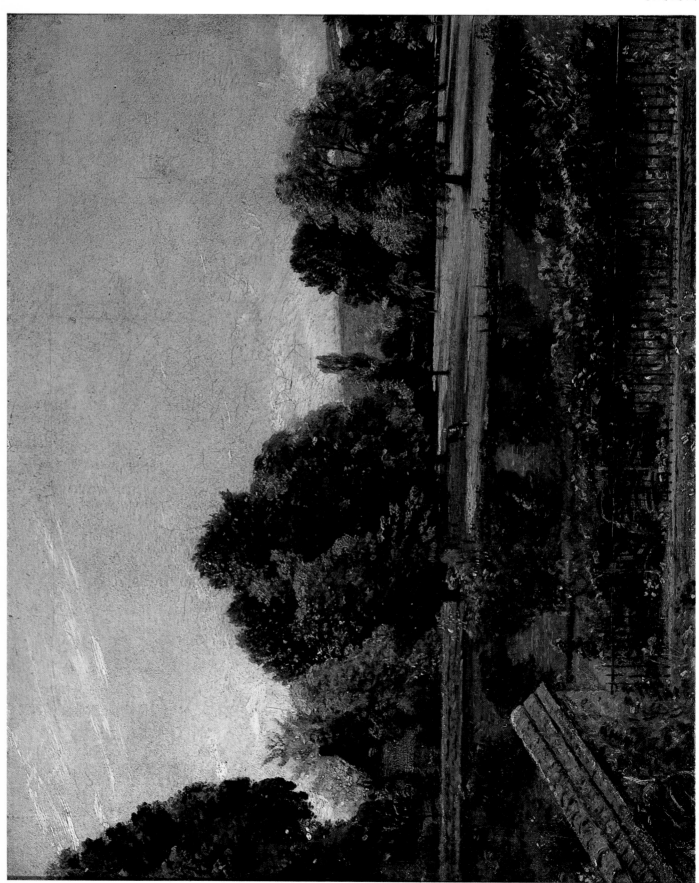

742. (29.40) *A view at Salisbury, from Fisher's house*, Victoria and Albert Museum, 20 × 25.1 cm.

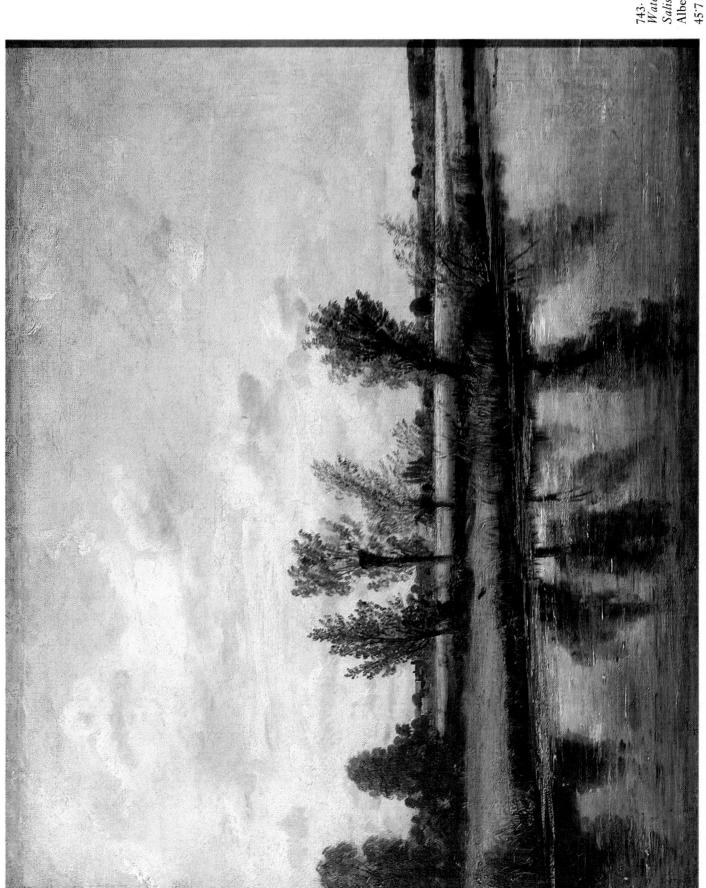

743. (29.41)
*Watermeadows at
Salisbury*, Victoria and
Albert Museum,
45·7 × 55·3 cm.

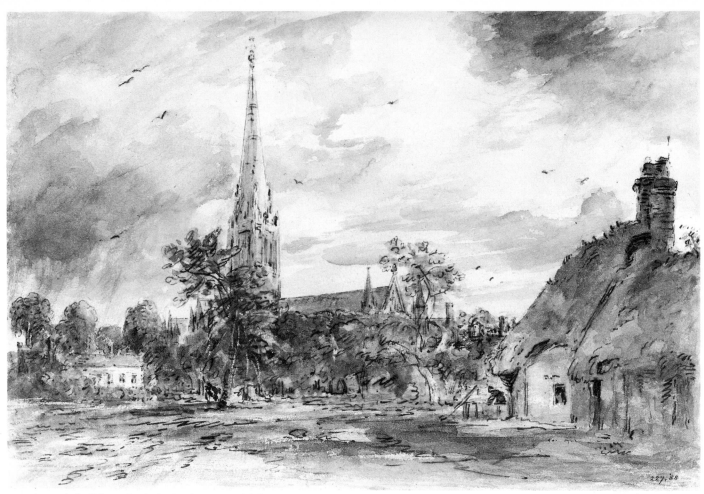

744. (29.44) *Salisbury Cathedral*, Victoria and Albert Museum, 23·4 × 33·7cm.

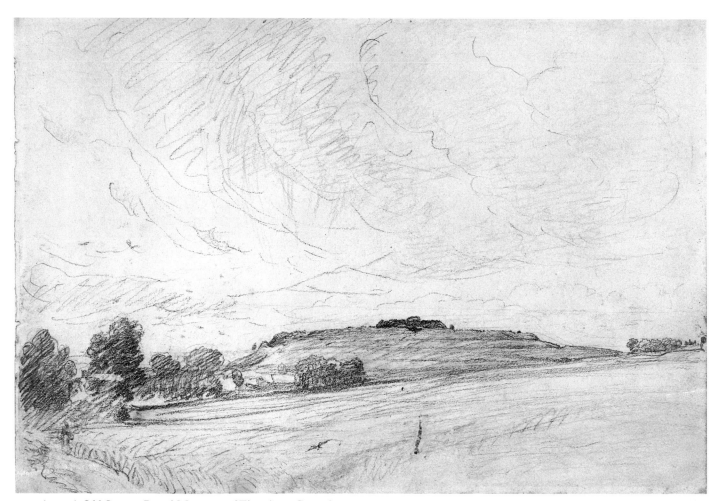

745. (29.45) *Old Sarum*, Royal Museum of Fine Arts, Copenhagen, 23·4 × 33·9cm.

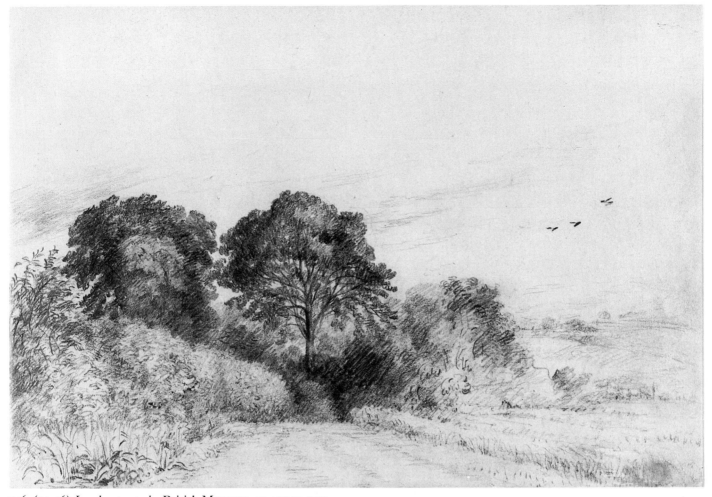

746. (29.46) *Landscape study*, British Museum, 22·7 × 32·5cm.

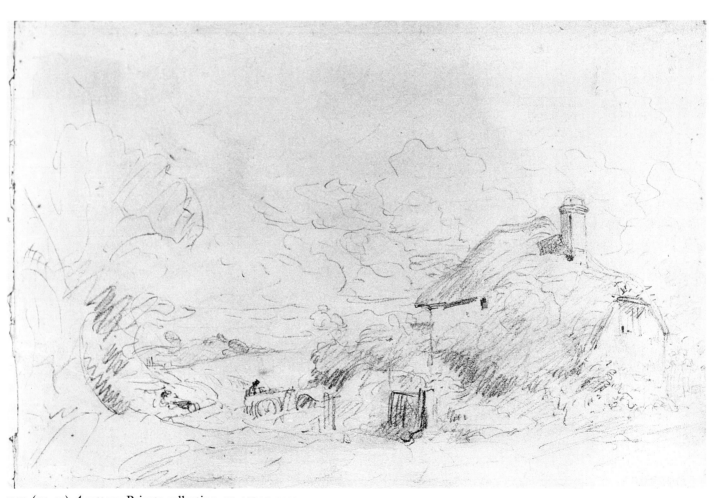

747. (29.47) *A cottage*, Private collection, 23·4 × 33·7cm.

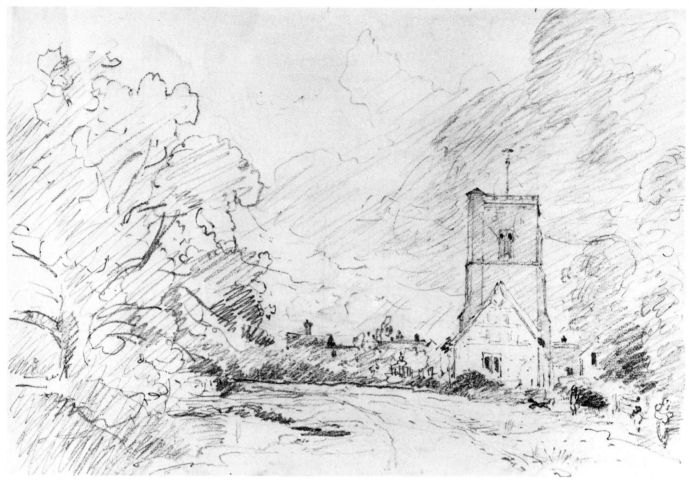

748. (29.48) *A church and cottage*, The Lady Lever Art Gallery, Port Sunlight, 23·1 × 33·4cm.

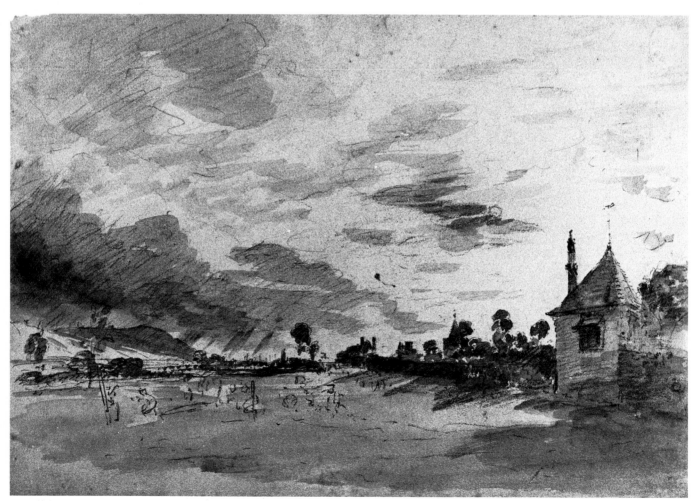

749. (29.49) *Landscape with passing storm clouds*, Private collection, 23·4 × 33·6cm.

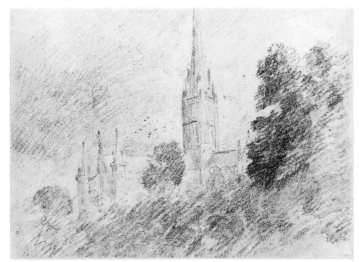

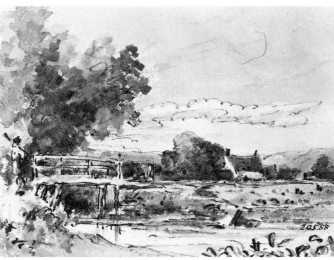

750. (29.50) *Salisbury Cathedral*, Courtauld Institute Galleries (Witt Collection), London, 9·2 × 12·1cm.

751. (29.51) *A bridge over a stream*, Victoria and Albert Museum, 9·3 × 12·5cm.

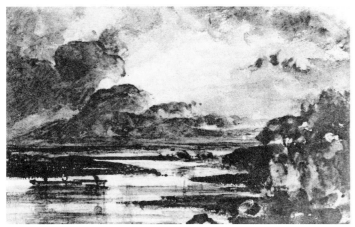

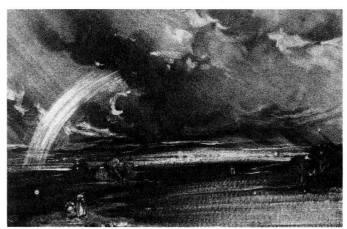

752. (29.56) *The Approaching Storm: View on the Thames*, Whereabouts unknown.

753. (29.57) *The Departing Storm: Sketch from Nature*, Whereabouts unknown (reproduced from the mezzotint).

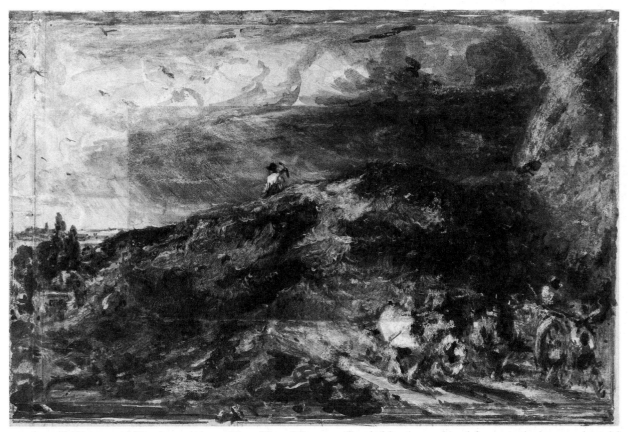

754. (29.58) *Hampstead Heath: a vignette*, Fitzwilliam Museum, Cambridge (reproduced from touched mezzotint with added drawing by the artist), 15·7 × 23·5cm.

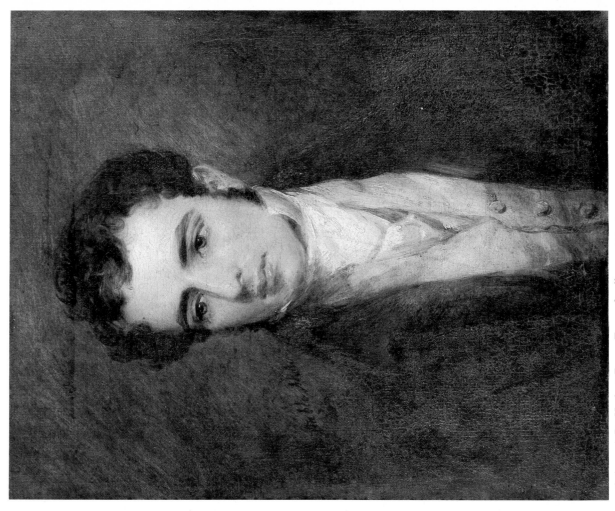

756. (29.53) *Dr Herbert Evans*, Evans family, 30·5 × 25cm.

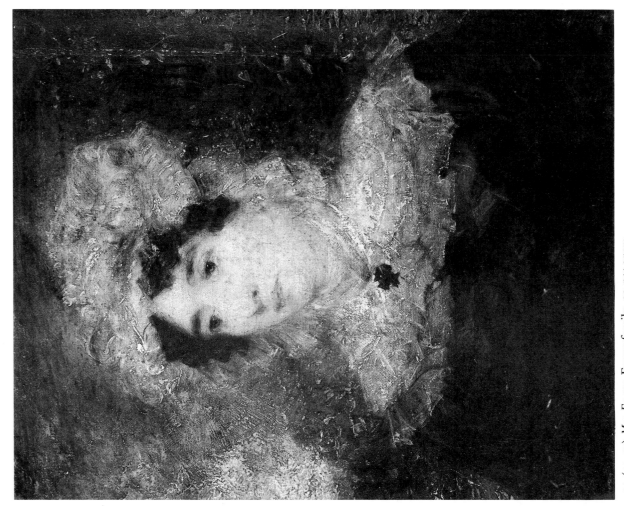

755. (29.52) *Mrs Evans*, Evans family, 30·5 × 25cm.

758. (29.55) *The farmhouse by a river*, British Museum, 18·4 × 22·2cm.

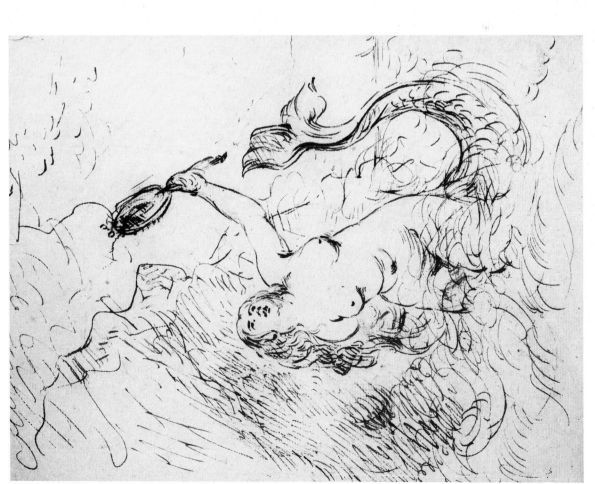

757. (left) (29.54) *The Mermaid: study for an inn-sign*, Executors of the Late Lieutenant-Colonel J. H. Constable, 25 × 19·4cm.

759. (29.59) *Dedham Mill*, Private collection, 18 × 30cm.

760. (right) (29.60) *A windmill near Brighton*, Victoria and Albert Museum, 14·6 × 11·4cm.

761. (below) (29.61) *Stoke-by-Nayland*, Victoria and Albert Museum, 24·8 × 33cm.

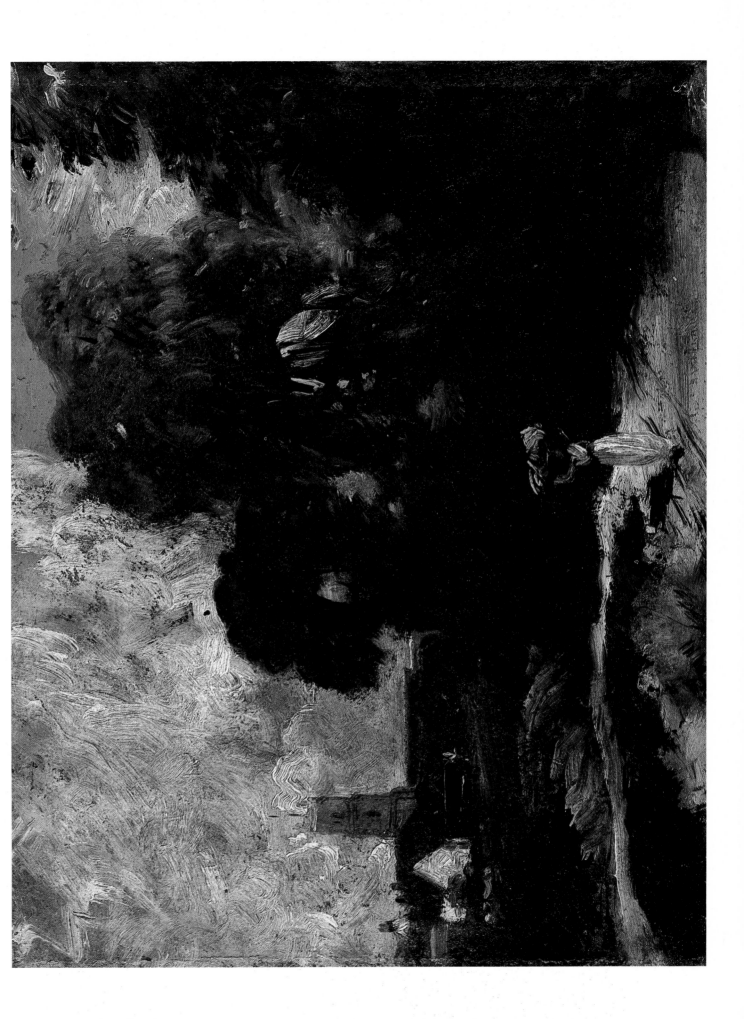

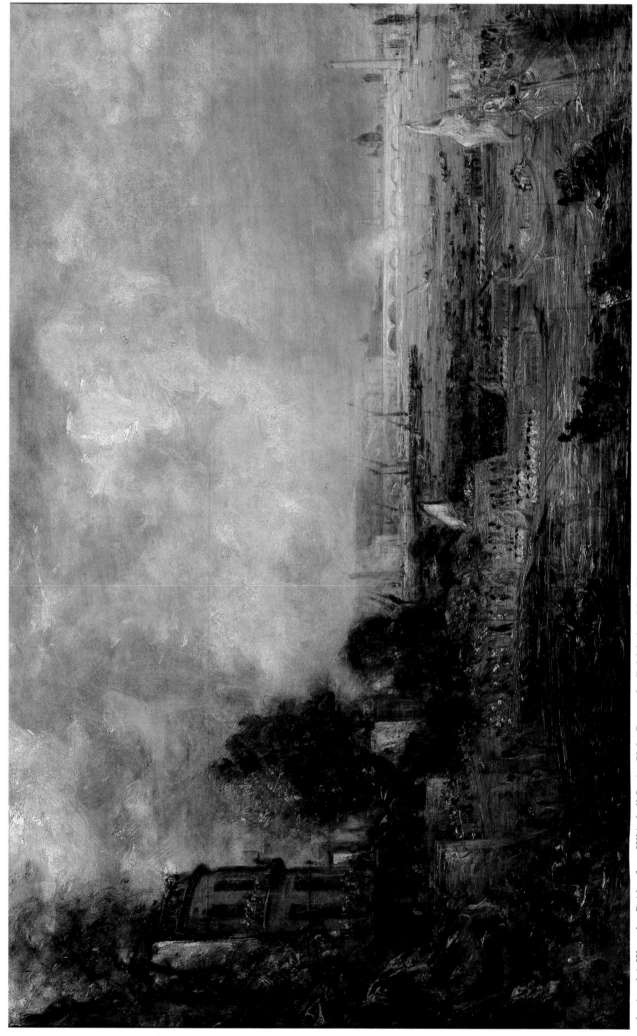

762. (29.63) *Waterloo Bridge from Whitehall Stairs*, Yale Center for British Art, New Haven, 62 × 99cm.

763. (29.65) *Old Sarum*, Victoria and Albert Museum, 14·3 × 21cm.

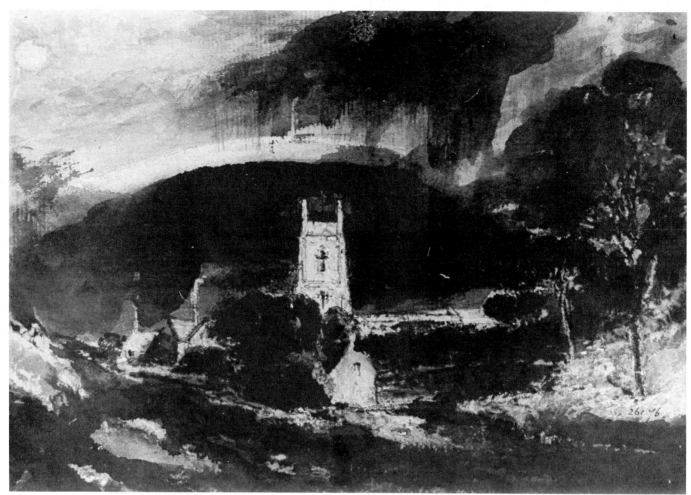

764. (26.62) *Stoke-by-Nayland*, Victoria and Albert Museum, 12·7 × 18·3cm.

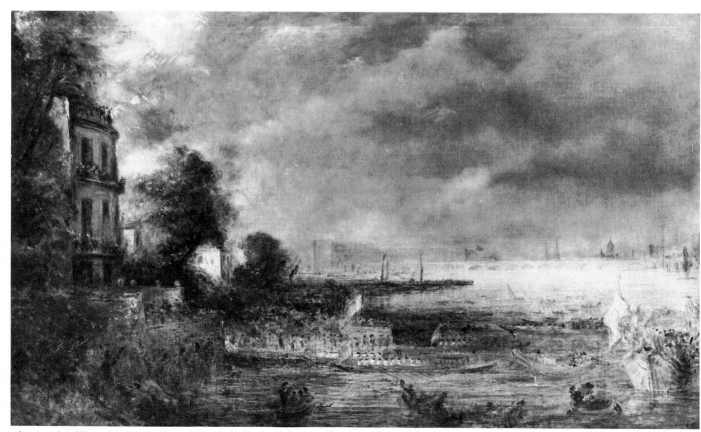

765. (29.64) *Waterloo Bridge from Whitehall Stairs*, Private collection, 58·5 × 97cm.

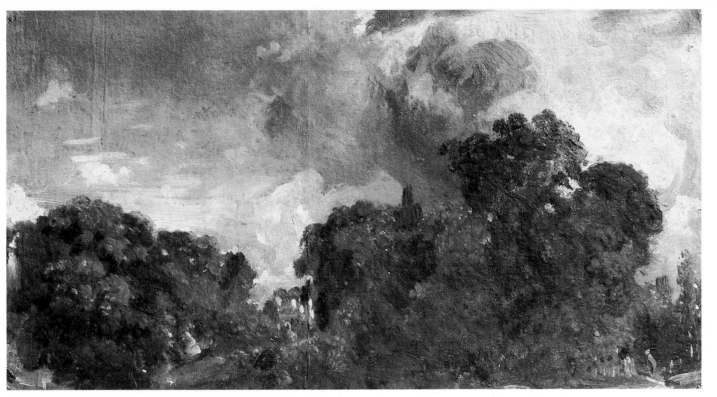

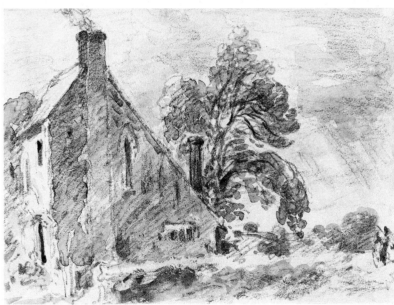

766. (above) (29.66)
On the edge of a wood,
Victoria and Albert
Museum,
16·5 × 30·1cm.

767. (29.68) *Cottages at
East Bergholt*, Ipswich
Museums and
Galleries, Christchurch
Mansion Museum,
9 × 12·4cm.

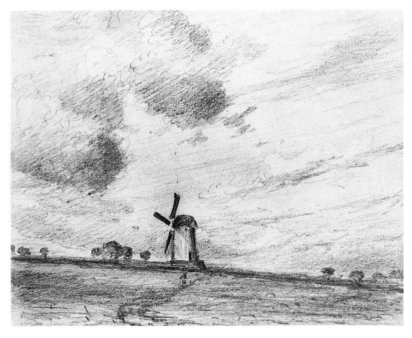

768. (29.69) *A windmill*,
Ipswich Museums and
Galleries, Christchurch
Mansion Museum,
10·4 × 13·2cm.

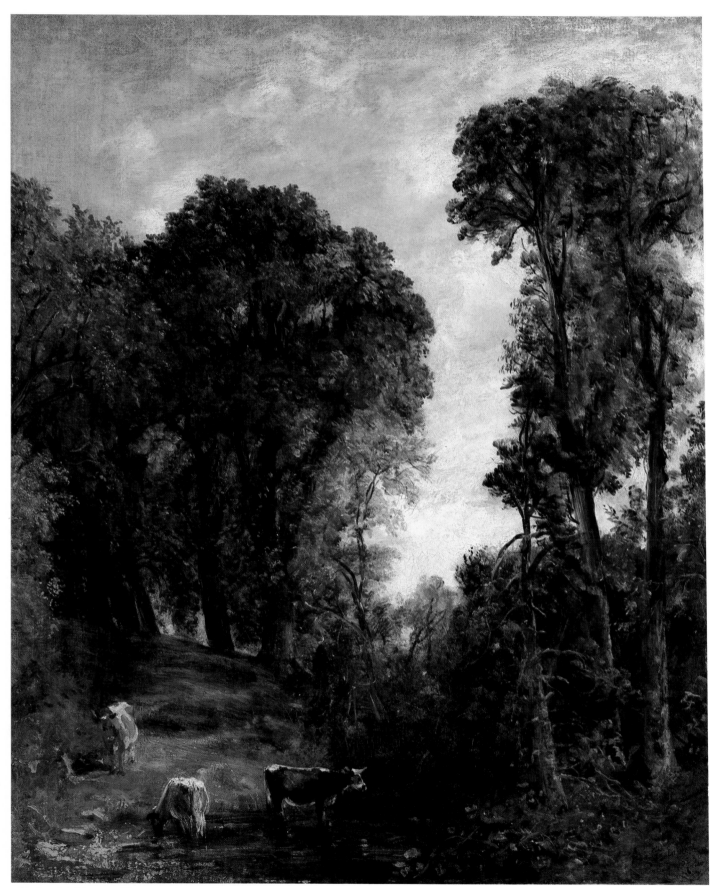

769. (29.67) *Trees at Hampstead*, Tate Gallery, 92·4 × 74cm.

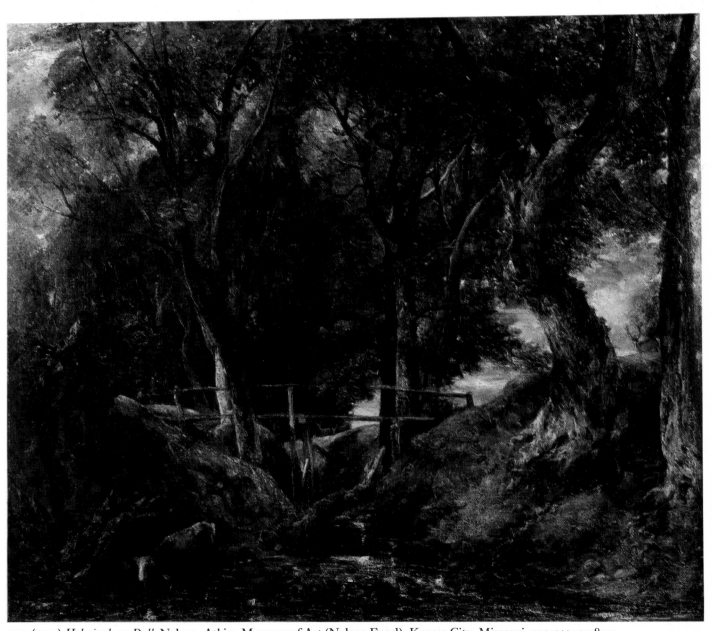

770. (30.1) *Helmingham Dell*, Nelson–Atkins Museum of Art (Nelson Fund), Kansas City, Missouri, 113·5 × 130·8cm.

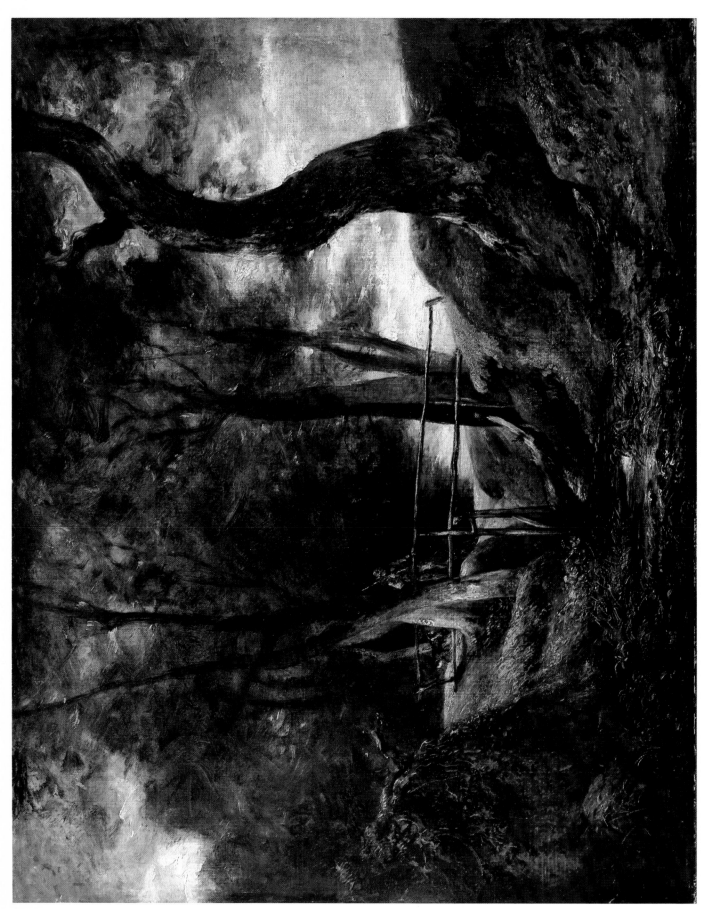

771. (30.2) *Helmingham Dell*, Private collection, on loan to the City Museums and Art Gallery, Birmingham, 71·2 × 92cm.

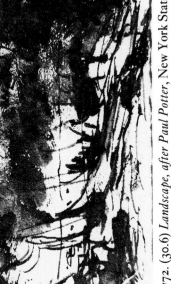

772. (30.6) *Landscape, after Paul Potter*, New York State Library (Thomas Cole Papers), Albany, 8·7 × 12cm.

773. (30.7) *A river valley*, Fitzwilliam Museum, Cambridge, 11·2 × 18·4cm.

774. (30.8) *A river valley*, Fitzwilliam Museum, Cambridge, 11·2 × 18·4cm.

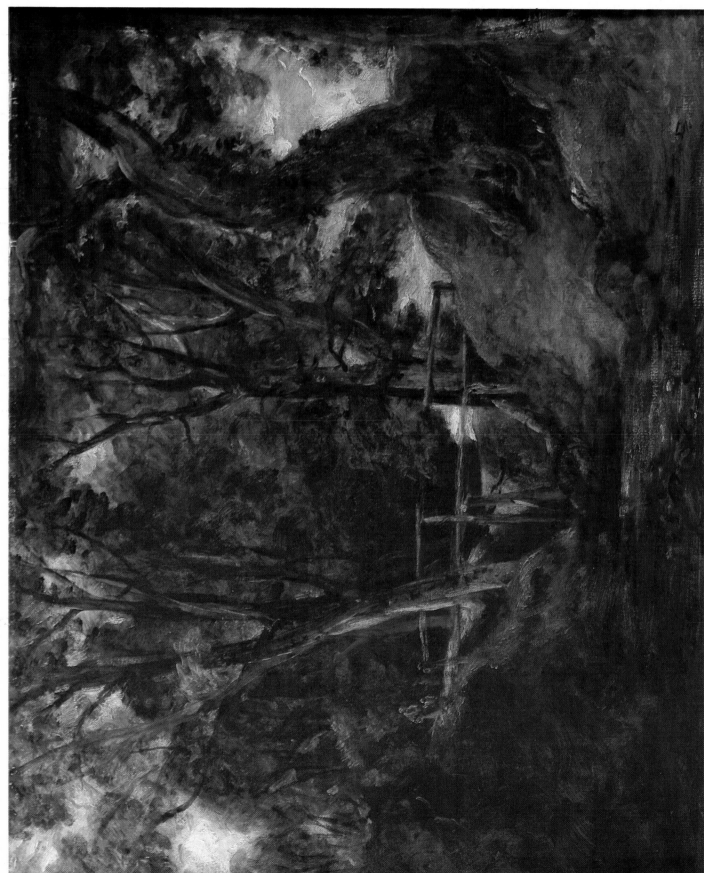

775. (30.3) *Helmingham Dell*, Musée du Louvre, 103 × 129cm.

776. (below) (30.4) *Hampstead Heath*, Glasgow Art Gallery and Museum, 64 × 96.5cm.

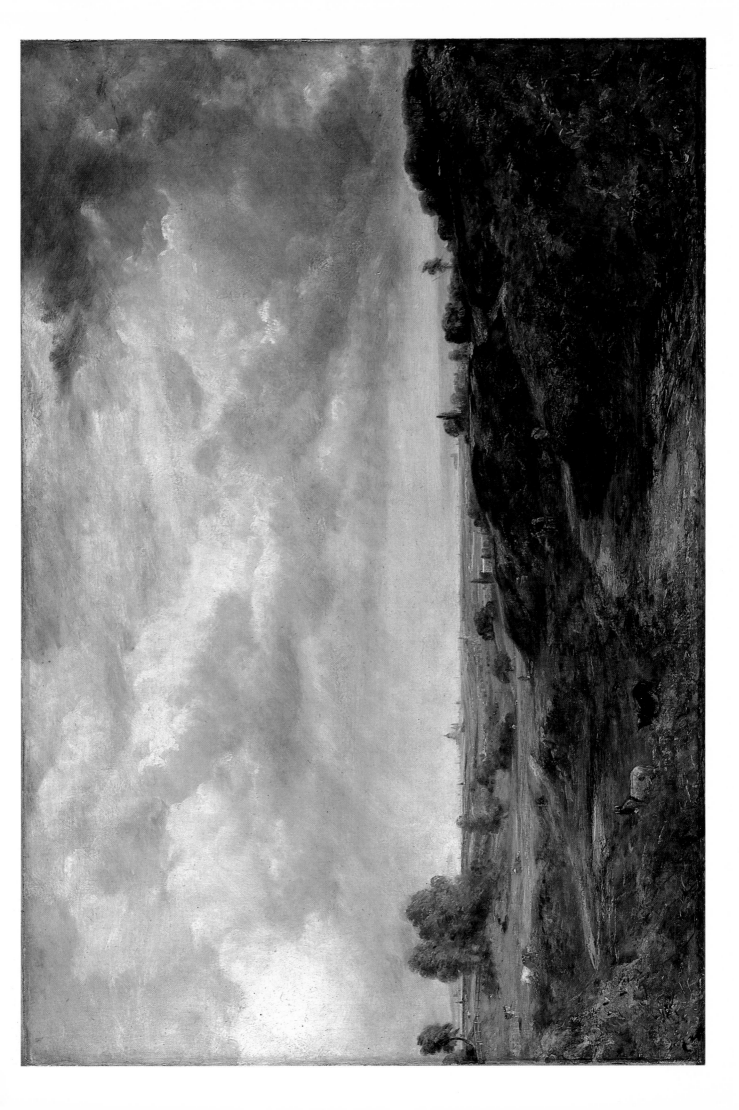

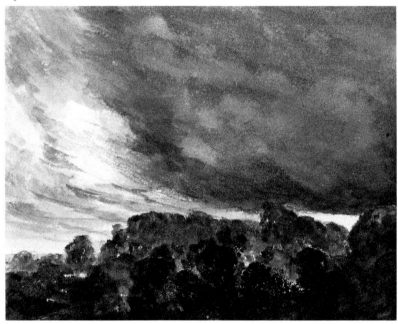

777. (left) (30.9) *The Holy Family, after Michelangelo's tondo*, Royal Academy of Arts, London, 11·2 × 12·7cm.

778. (30.10) *Study of clouds and woods at Hampstead*, British Museum, 8·9 × 11cm.

779. (left) (30.12) *Dedham Vale*, Philadelphia Museum of Art (Department of Prints and Drawings), 5·2 × 7·8cm.

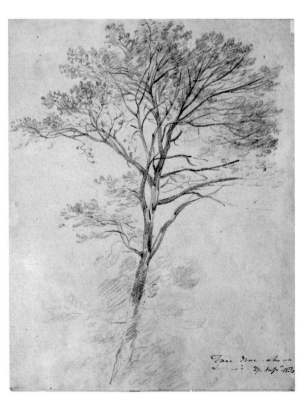

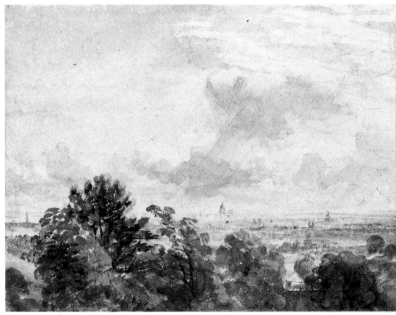

781. (30.14) *London, from the drawing room at Well Walk*, British Museum, 9 × 11·5cm.

780. (left) (30.13) *An ash tree*, Fitzwilliam Museum, Cambridge, 25 × 19·8cm.

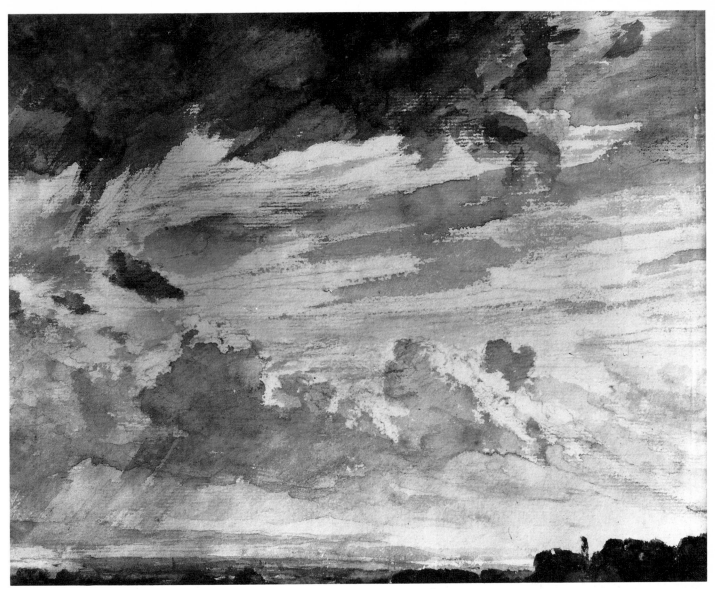

782. (30.11) *Study of clouds at Hampstead*, Victoria and Albert Museum, 19 × 22·8cm.

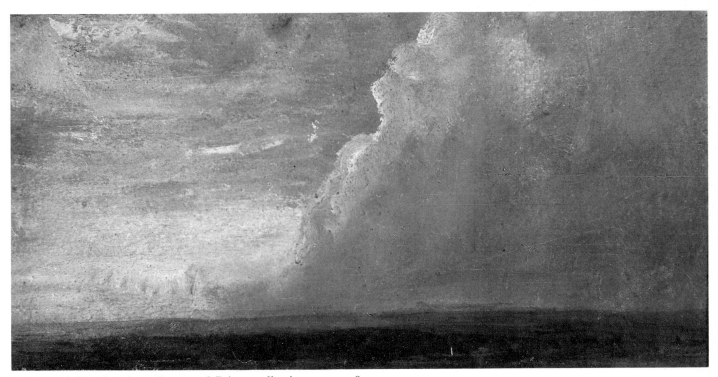

783. (30.15) *Cloud study at Hampstead*, Private collection, 19·7 × 38·4cm.

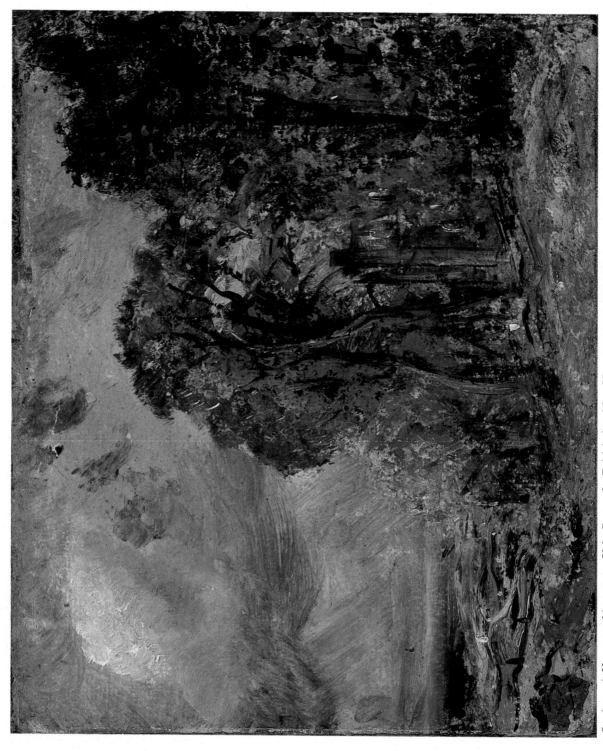

784. (30.17) *Hampstead in a storm*, Yale Center for British Art, New Haven, 15·5 × 19·5cm.

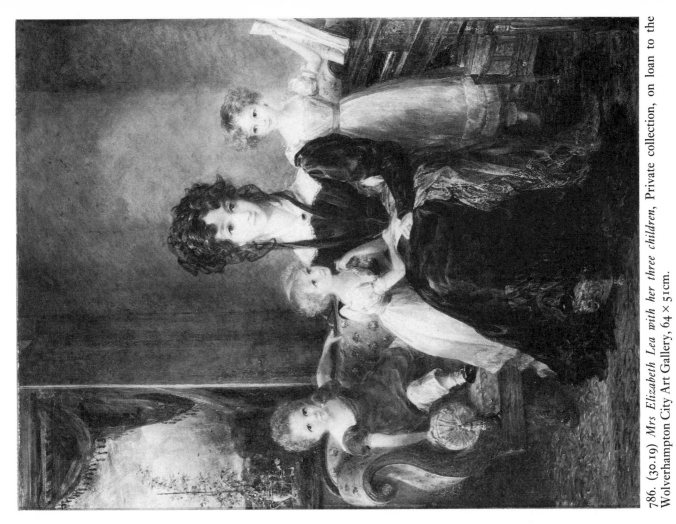

786. (30.19) *Mrs Elizabeth Lea with her three children*, Private collection, on loan to the Wolverhampton City Art Gallery, 64 × 51cm.

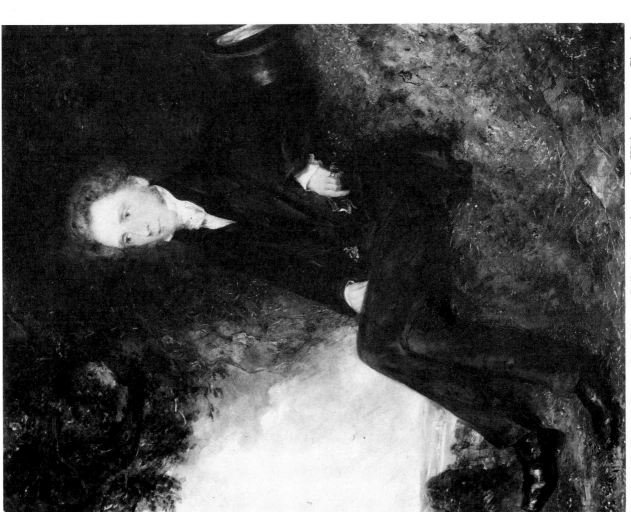

785. (30.18) *Thomas Simcox Lea*, Private Collection, on loan to the Wolverhampton City Art Gallery, 65 × 52cm.

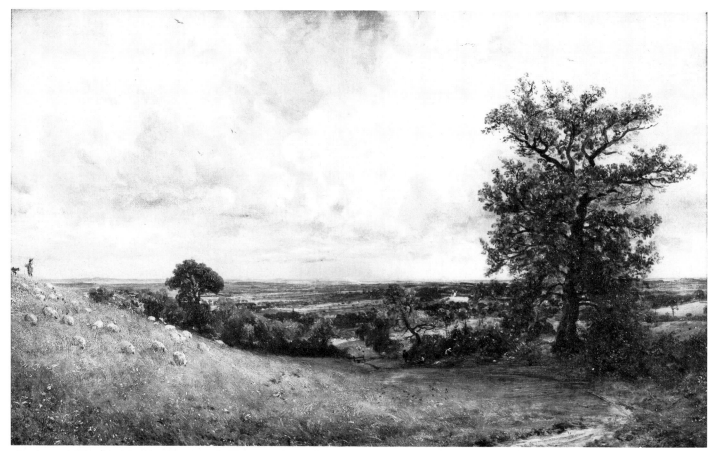

787. (30.20) *West End Fields, Hampstead : Noon*, National Gallery of Victoria, Melbourne, 33 × 52cm.

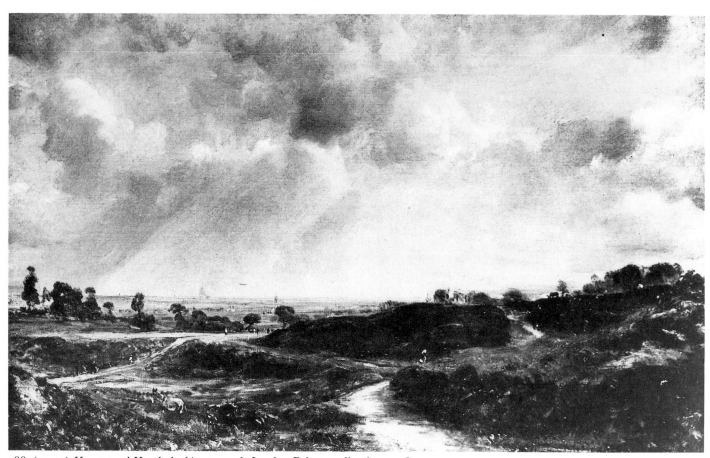

788. (30.21) *Hampstead Heath, looking towards London*, Private collection, 31·8 × 49·5cm.

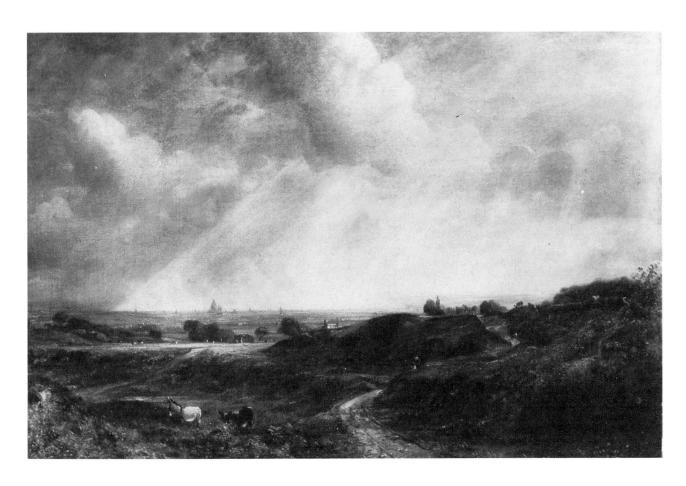

789. (above) (30.22) *Hampstead Heath, looking towards London*, Private collection, 14 × 20in.

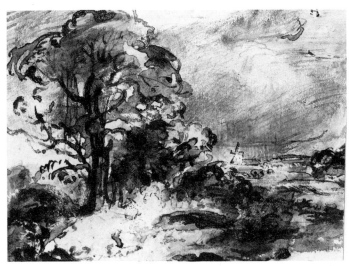

790. (30.23) *Landscape composition*, Fitzwilliam Museum, Cambridge, 10·6 × 14·2cm.

791. (right) (30.24) *The Skylark, Dedham*, Private collection, 23·7 × 20.2cm.

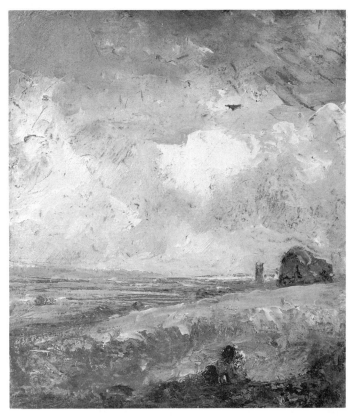

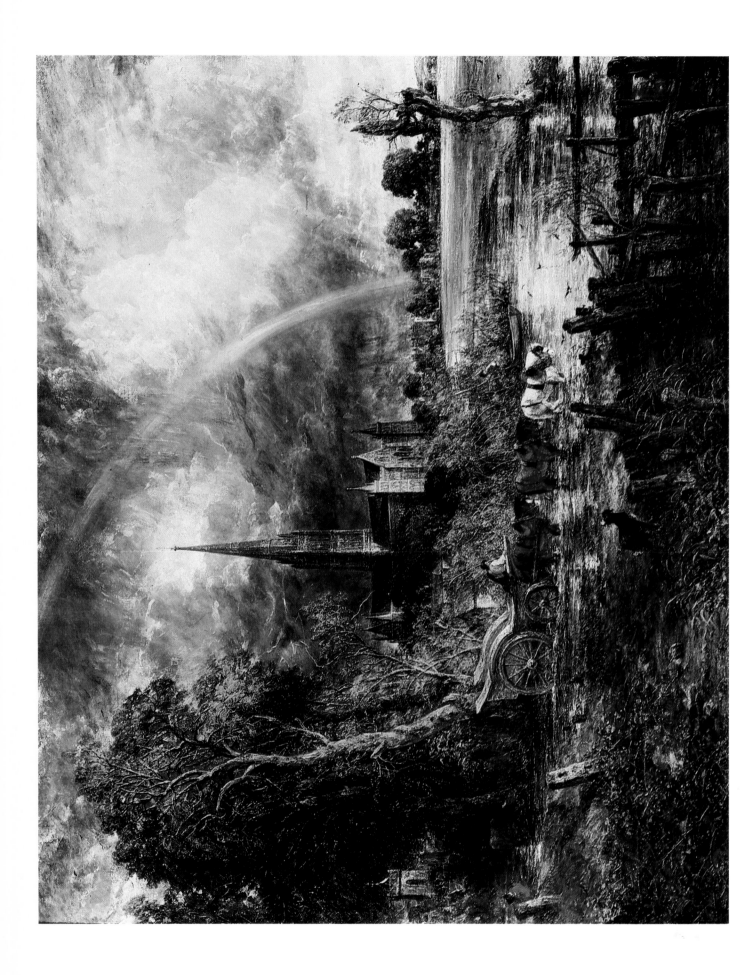

792. (above) (31.1) *Salisbury Cathedral from the Meadows*, Private collection, on loan to the National Gallery, London, 151·8 × 189·9cm.

793. (31.2) *Salisbury Cathedral from the Meadows (full-scale sketch)*, Guildhall Art Gallery, London, 135·8 × 188cm.

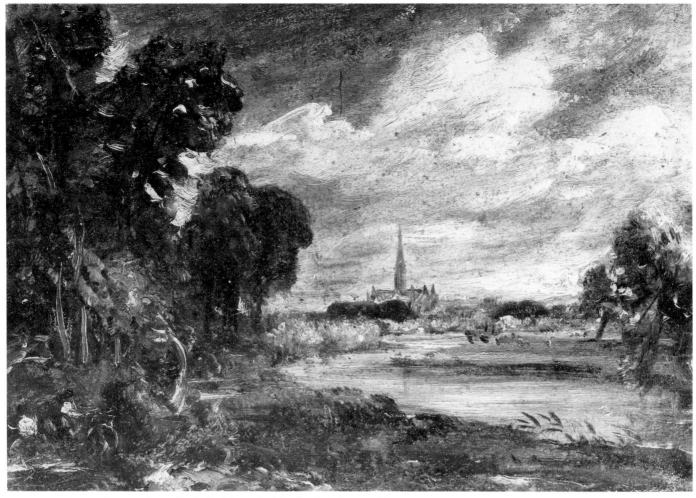

794. (31.3) *Sketch for 'Salisbury Cathedral from the Meadows'*, Private collection, 19·5 × 27·9cm.

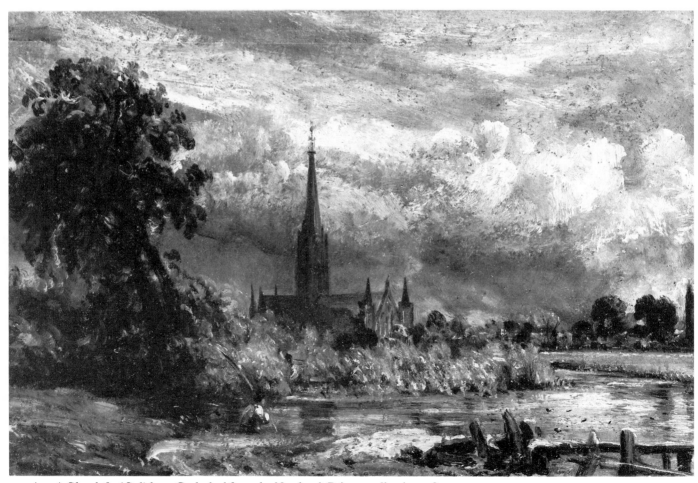

795. (31.4) *Sketch for 'Salisbury Cathedral from the Meadows'*, Private collection, 18·4 × 27·9cm.

796. (31.8) *The skyline of London from Hampstead,* British Museum, 19·6 × 32cm.

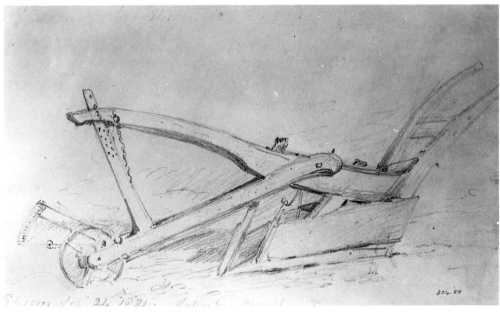

798. (31.13) *A plough at Epsom,* Victoria and Albert Museum, 11·5 × 19cm.

797. (left) (31.11) *Lord Brougham at the coronation of William IV, seen from behind,* British Library, 9 × 5cm.

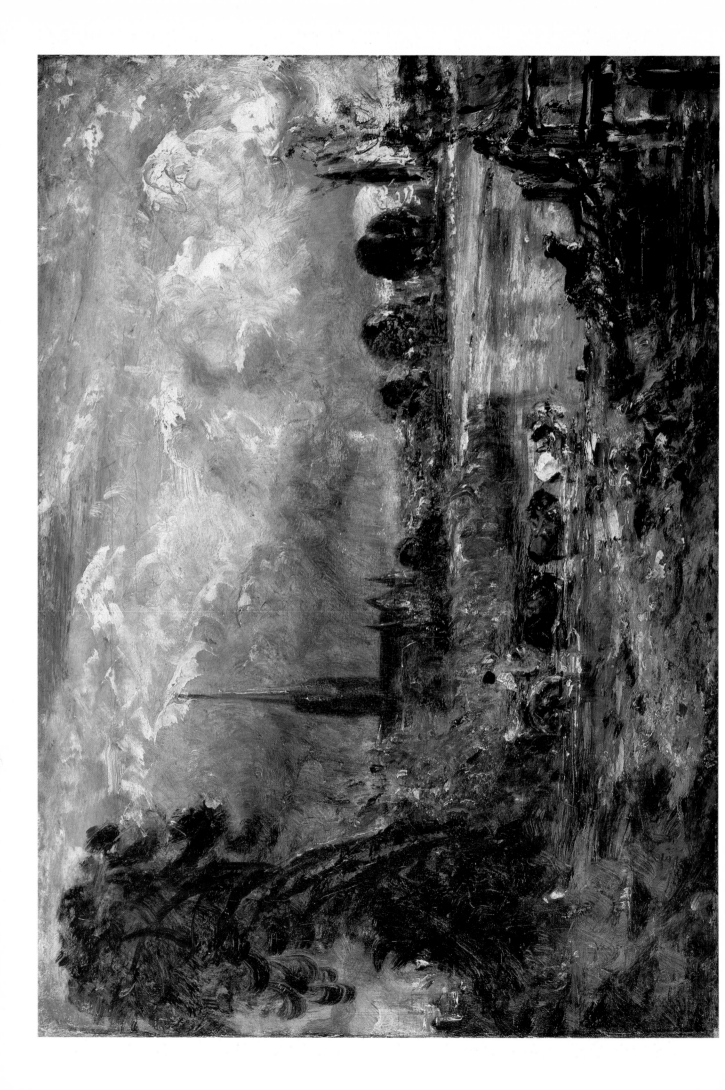

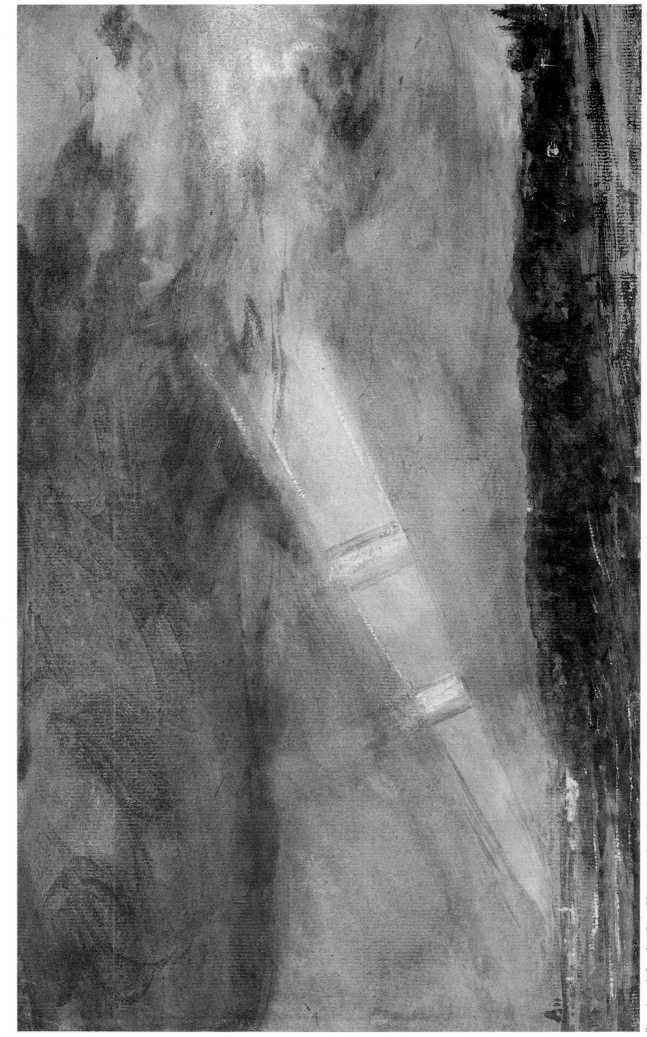

799. (above) (31.5) *Sketch for 'Salisbury Cathedral from the Meadows'*, Tate Gallery, 36.5 × 51.1cm.

800. (31.7) *London from Hampstead, with a double rainbow*, British Museum, 19.6 × 32cm.

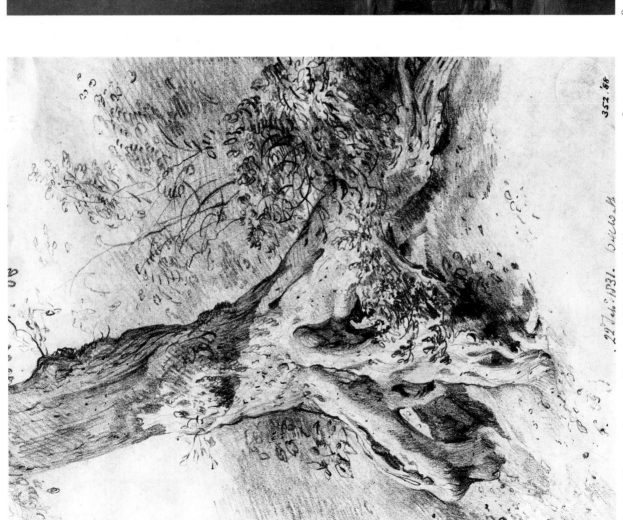

801. (31.12) *The root of a tree at Hampstead*, Victoria and Albert Museum, 22·7 × 18·5cm.

802. (31.15) *A Girl with Doves, after Greuze*, Private collection, 72·4 × 60·3cm.

803. (below) (31.9) *A dog watching a water-vole at Dedham*, Victoria and Albert Museum, 18·5 × 22·6cm.

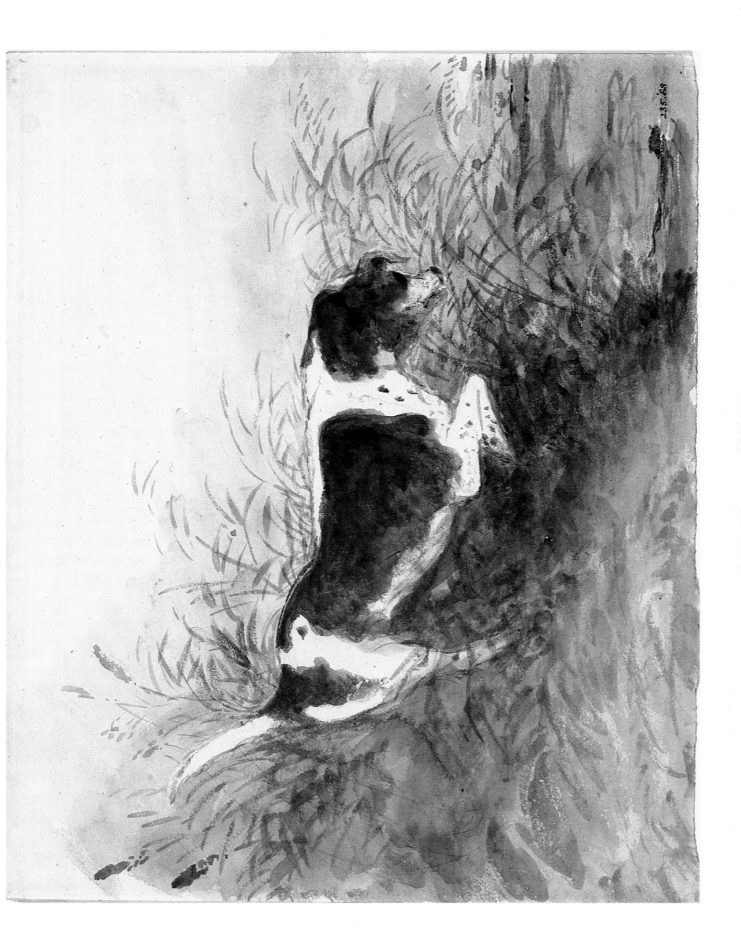

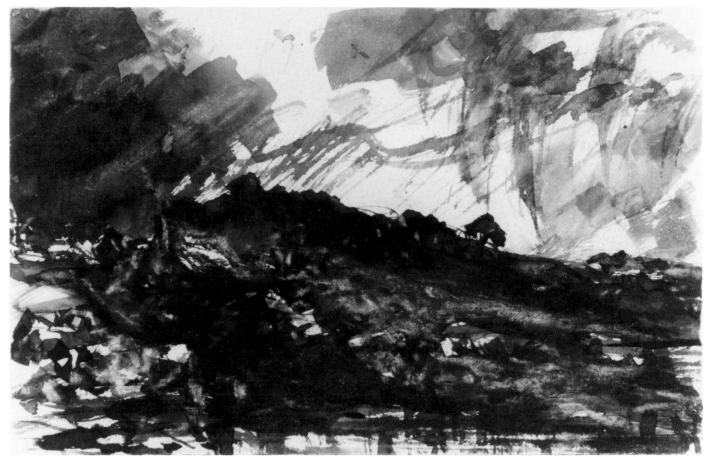

804. (31.16) *Stormy landscape*, Private collection, 11·7 × 8·5cm.

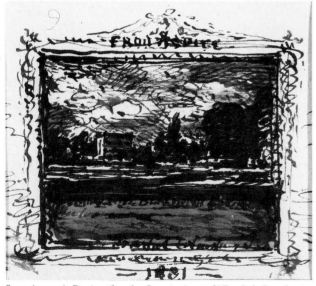

805. (31.17) *Design for the frontispiece of 'English Landscape Scenery'*, Private collection, 7·8 × 11·1cm.

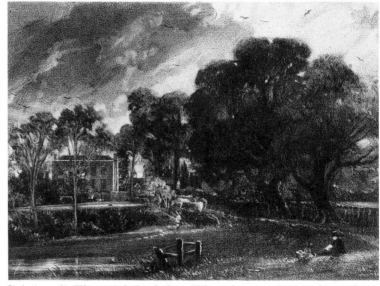

806. (31.18) *The artist's birthplace*, Whereabouts unknown (reproduced from the mezzotint).

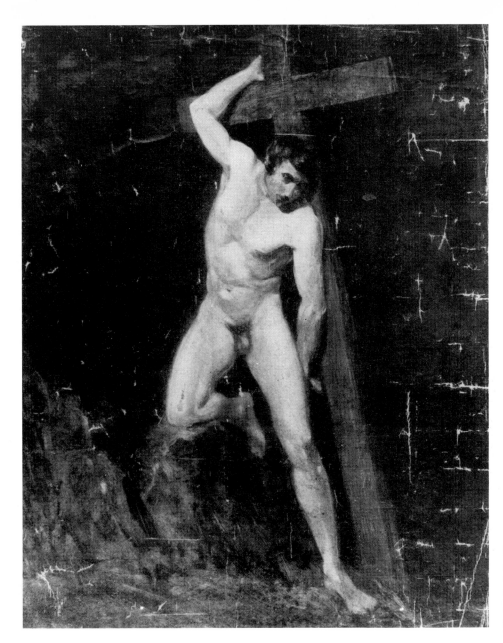

807. (31.19) *Study of the male nude*, Executors of the late Lieutenant-Colonel J. H. Constable, 91·5 × 70·5cm.

809. (31.21) *Study of rushes*, Leeds Art Galleries, 19·7 × 22·8cm.

808. (left) (31.20) *Head of Eve*, Private collection, 13·5 × 11cm.

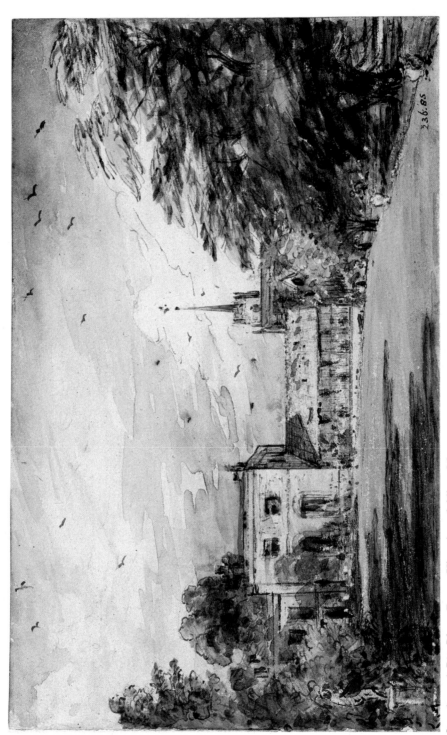

810. (31.14) *Pitt Place, Epsom*, Victoria and Albert Museum, 11·5 × 19cm.

811. (below) (31.28) *Henry VII's Chapel, Westminster Abbey*, Horne Foundation,
Florence, 33·6 × 20·8cm.

812. (below) (31.29) *Water Lane, Stratford St Mary*, Oldham Art Gallery (Charles E. Lees Collection),
22·7 × 17·7cm.

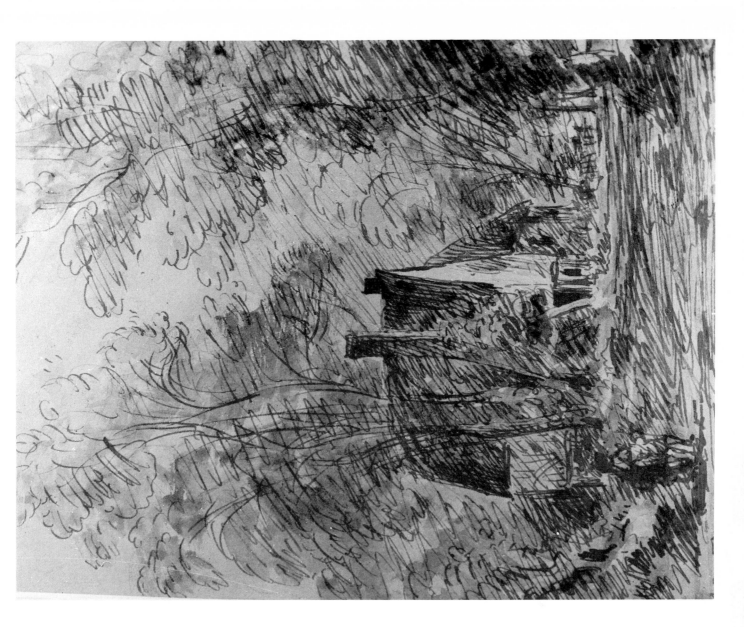

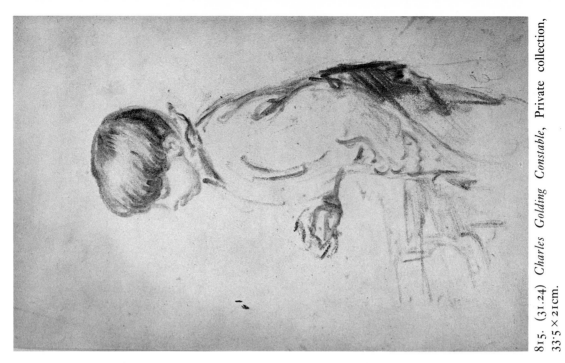

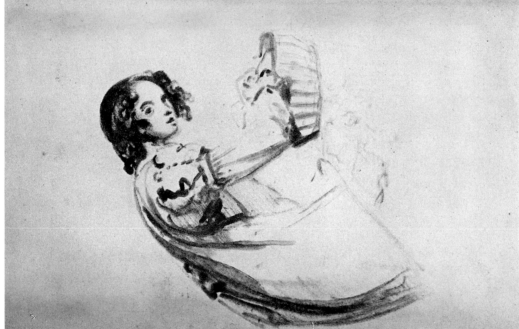

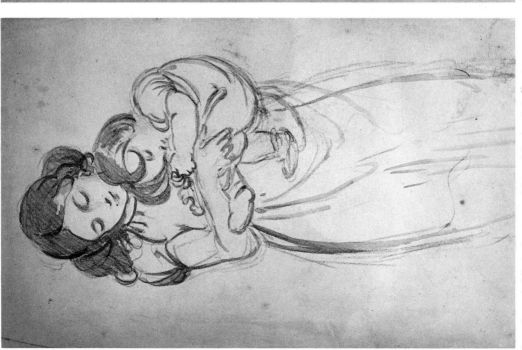

813. (31.22) *Maria Louisa and Lionel Bicknell Constable*, Private collection, 33·7 × 21·3cm.

814. (31.23) *Isabel Constable*, Private collection, 33·7 × 21·3cm.

815. (31.24) *Charles Golding Constable*, Private collection, 33·5 × 21cm.

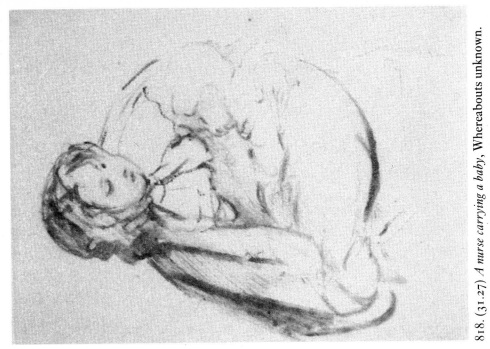

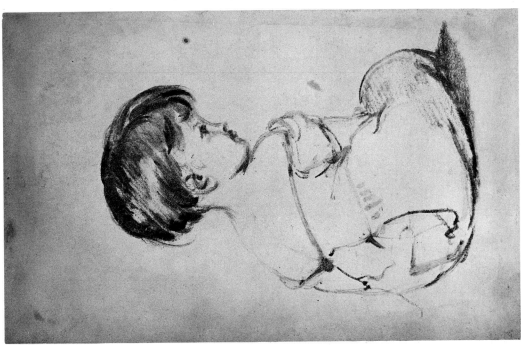

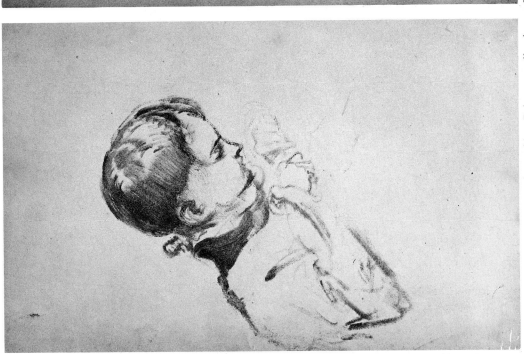

818. (31.27) *A nurse carrying a baby*, Whereabouts unknown.

817. (31.26) *Lionel Bicknell Constable*, Private collection, 33·7 × 21·3cm.

816. (31.25) *John Charles Constable*, Private collection, 33·7 × 21·3cm.

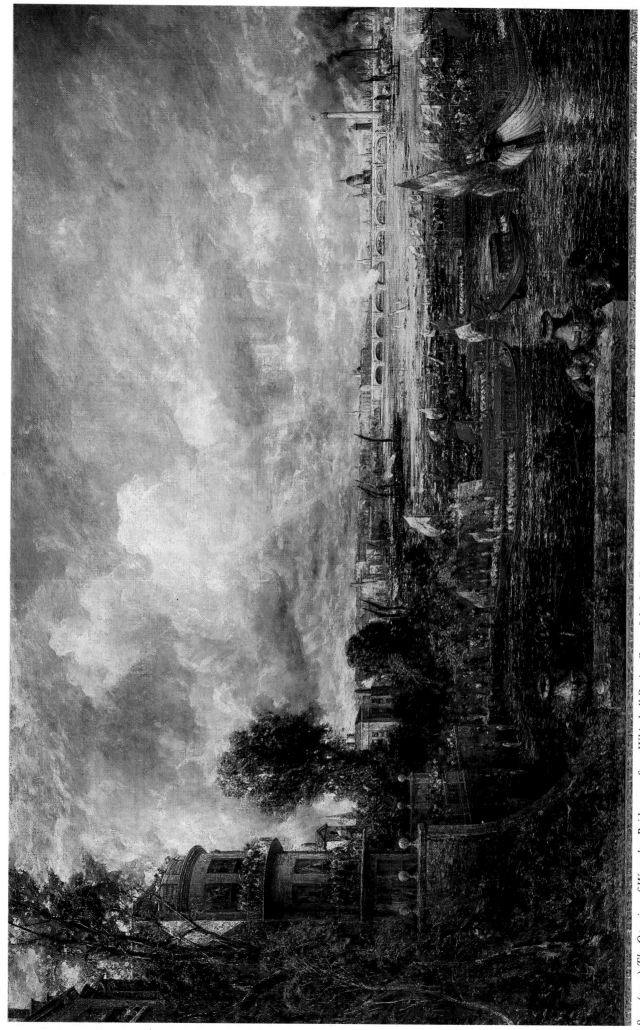

819. (32.1) *The Opening of Waterloo Bridge seen from Whitehall Stairs, June 18th 1817*, Private collection, 134·6 × 219·7cm.

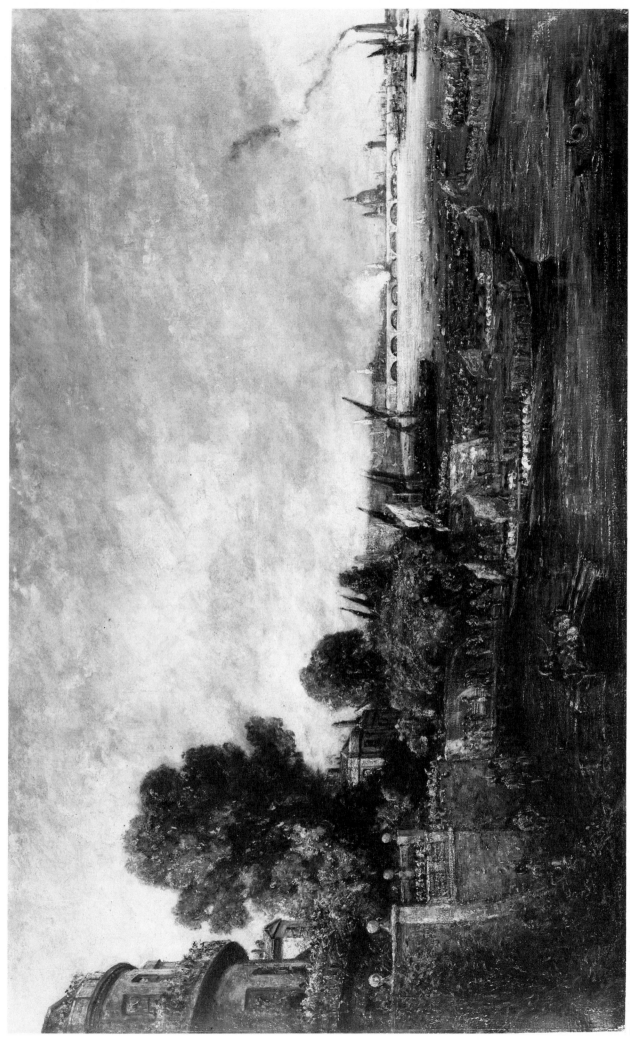

820. (32.2) *The Opening of Waterloo Bridge seen from Whitehall Stairs, June 18th 1813 (full-scale sketch)*, The National Trust, Anglesey Abbey, 153·6 × 243·8cm.

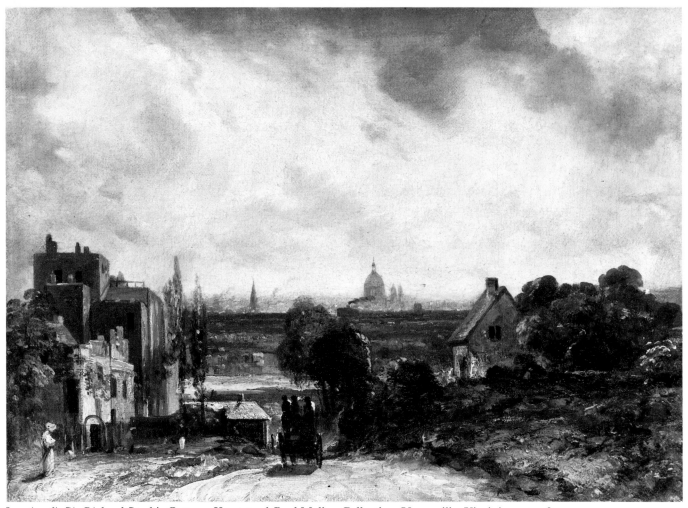

821. (32.6) *Sir Richard Steele's Cottage, Hampstead*, Paul Mellon Collection, Upperville, Virginia, 21 × 28·5cm.

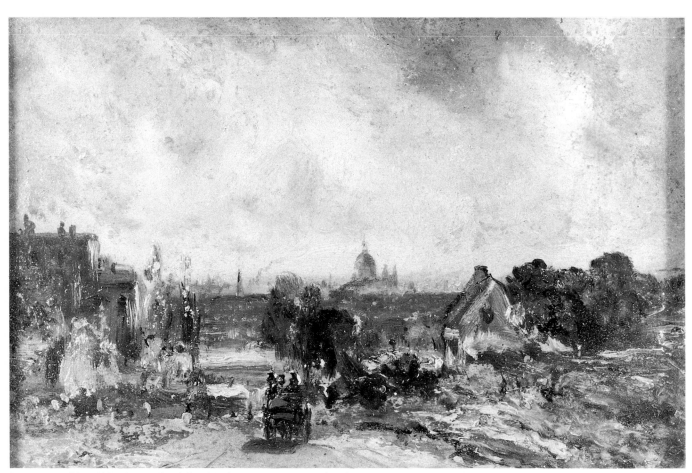

822. (32.7) *Sketch for Sir Richard Steele's Cottage, Hampstead*, Private collection, 14 × 20·6cm.

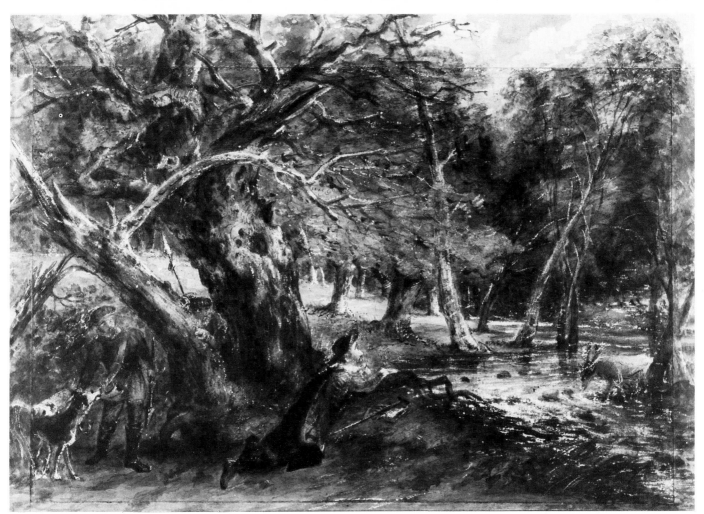

823. (32.10) *Jaques and the wounded stag*, Private collection, 19·7 × 30·2cm.

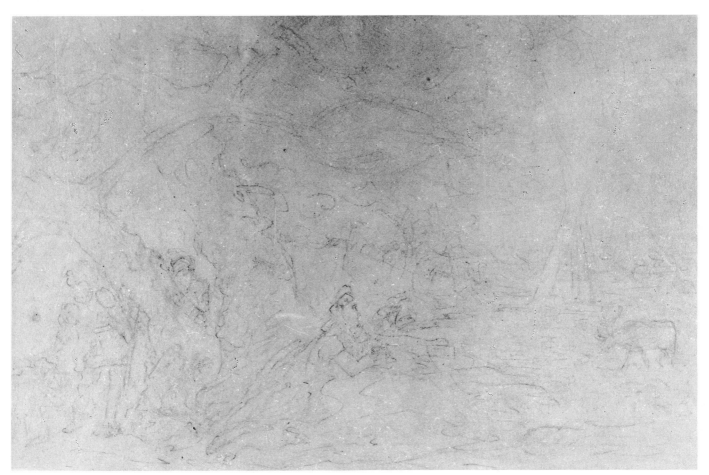

824. (32.11) *Jaques and the wounded stag*, Private collection, 23·5 × 32·5cm.

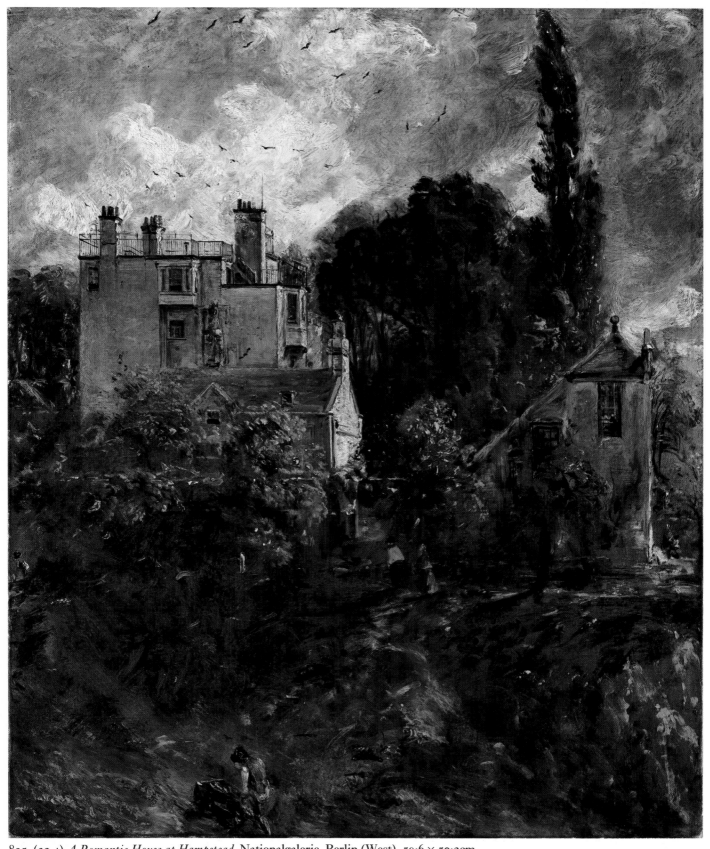

825. (32.4) *A Romantic House at Hampstead*, Nationalgalerie, Berlin (West), 59·6 × 50·2cm.

826. (facing page top) (32.14) *Stoke-by-Nayland*, British Museum, 14·4 × 19·6cm.

827. (facing page bottom) (32.17) *A farmhouse near the water's edge*, British Museum, 14·5 × 19·6cm.

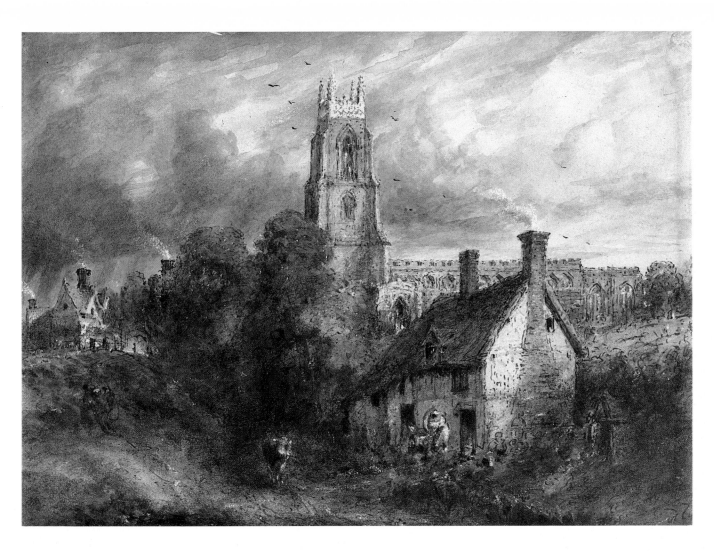

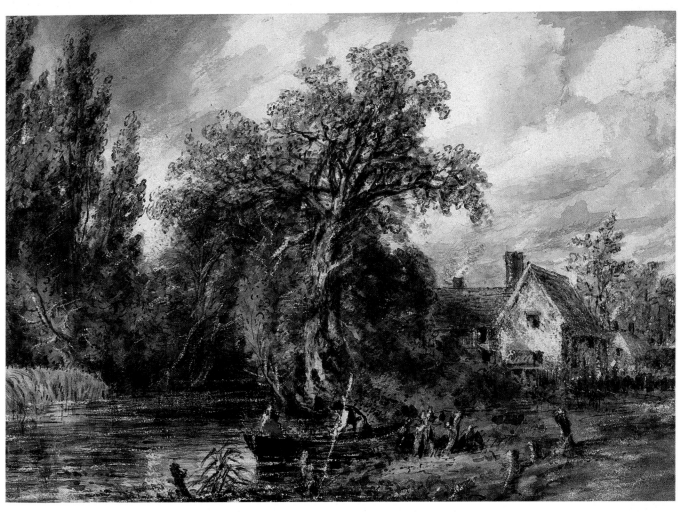

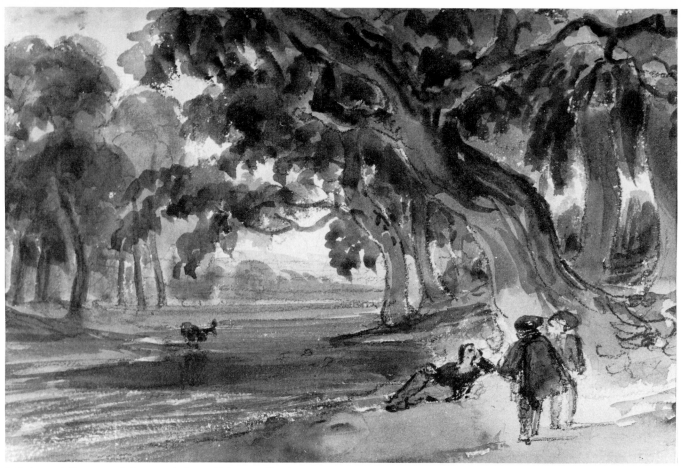

828. (32.12) *Jaques and the wounded stag*, Private collection, 14 × 20·3cm.

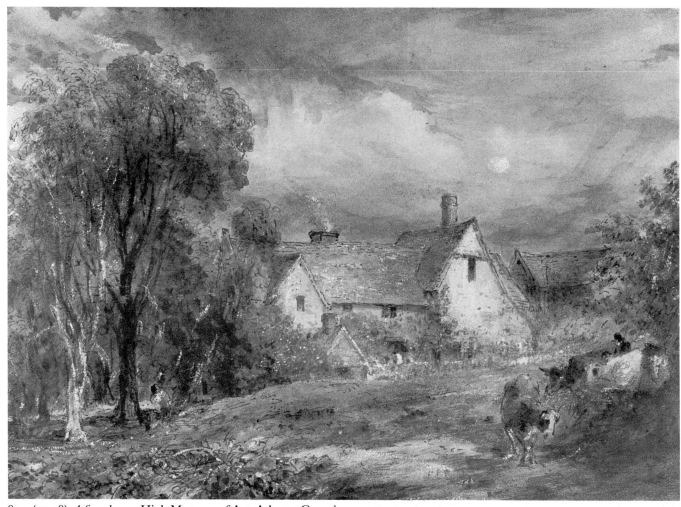

829. (32.18) *A farmhouse*, High Museum of Art, Atlanta, Georgia, 14·5 × 19cm.

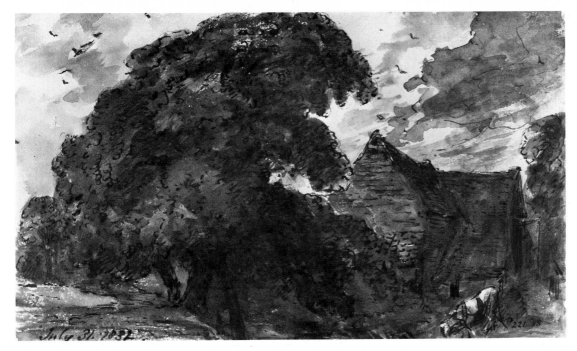

830. (32.20) *A barn, trees and a grey horse near East Bergholt*, Victoria and Albert Museum, 11·5 × 19cm.

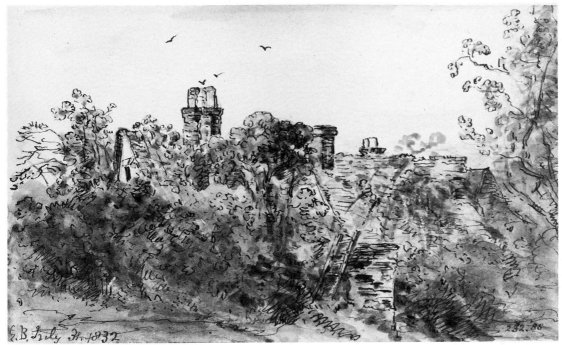

831. (32.21) *Cottages at East Bergholt*, Victoria and Albert Museum, 11·5 × 19cm.

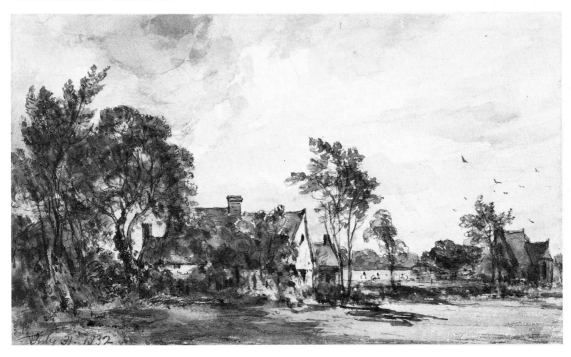

832. (32.22) *Cottages at East Bergholt*, British Museum, 11·2 × 18·8cm.

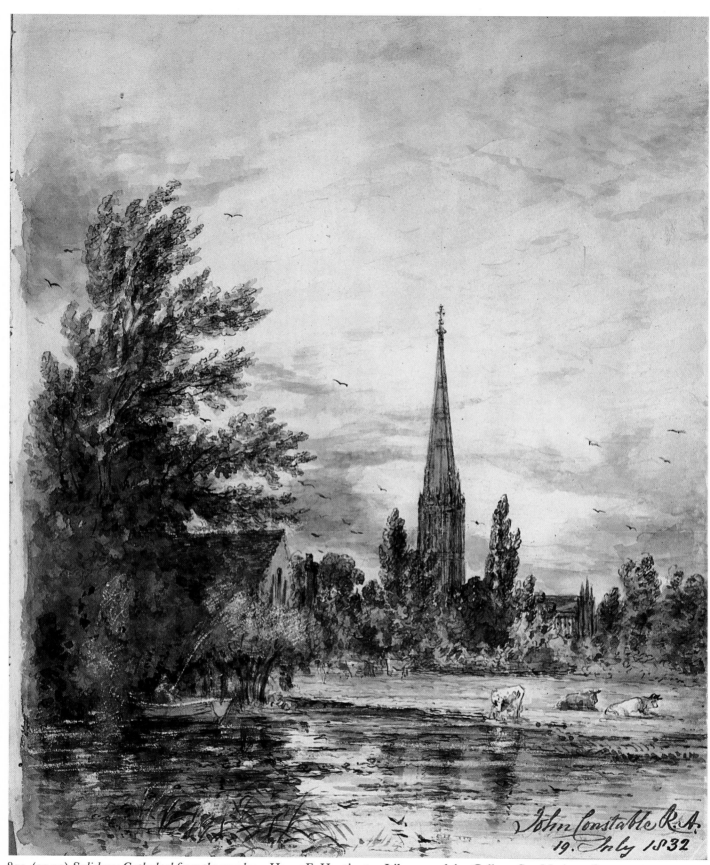

833. (32.19) *Salisbury Cathedral from the meadows*, Henry E. Huntington Library and Art Gallery, San Marino, 28·5 × 23·5cm.

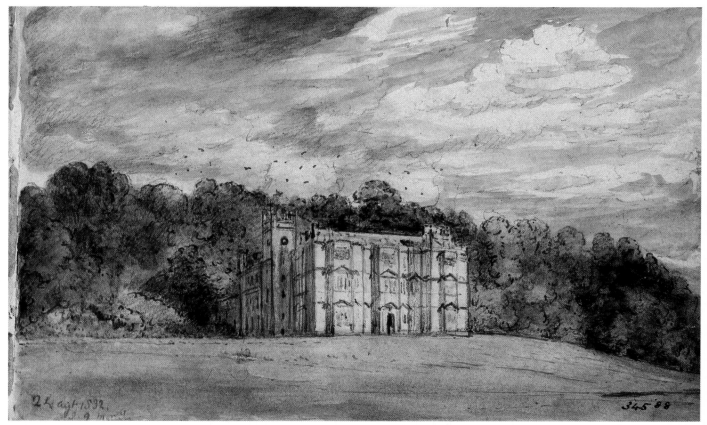

834. (32.23) *Englefield House, Berkshire*, Victoria and Albert Museum, 11·5 × 19·2cm.

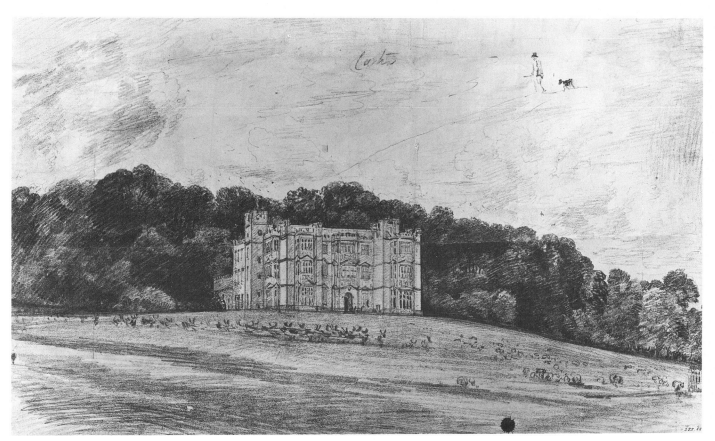

835. (32.24) *Englefield House, Berkshire*, Victoria and Albert Museum, 32·2 × 47·4cm.

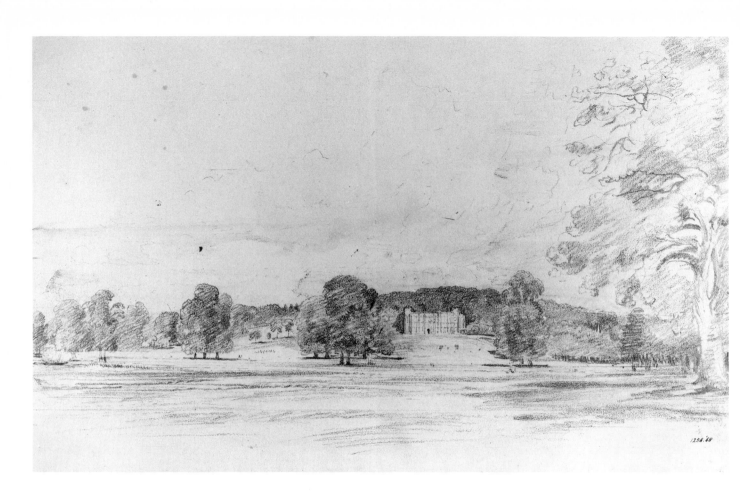

836. (above) (32.25)
Englefield House, Berkshire,
Victoria and Albert
Museum, 27·7 × 43·4cm.

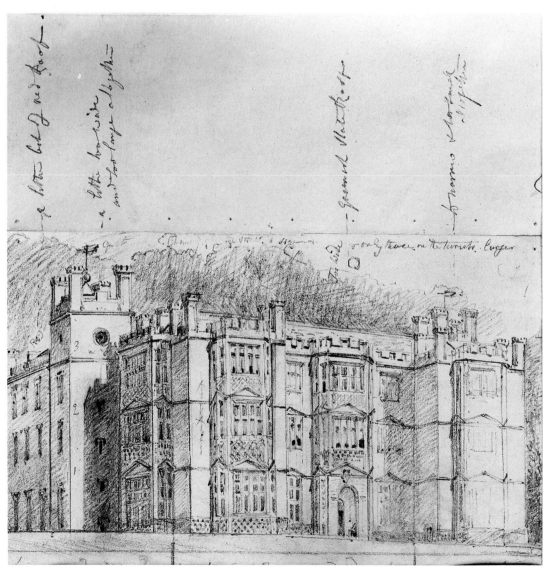

837. (32.26) *Englefield
House, Berkshire,* Victoria
and Albert Museum,
28·4 × 22·4cm.

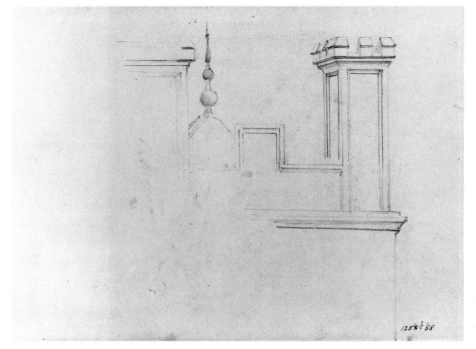

838. (32.27) *Englefield House, Berkshire: detail of the left-hand turret*, Victoria and Albert Museum, 14·1 × 22·4cm.

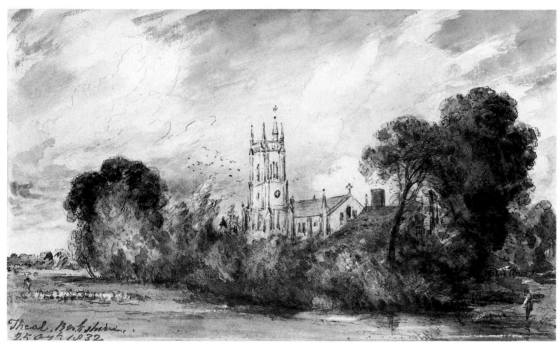

839. (32.28) *Theal, Berkshire*, British Museum, 11·3 × 18·8cm.

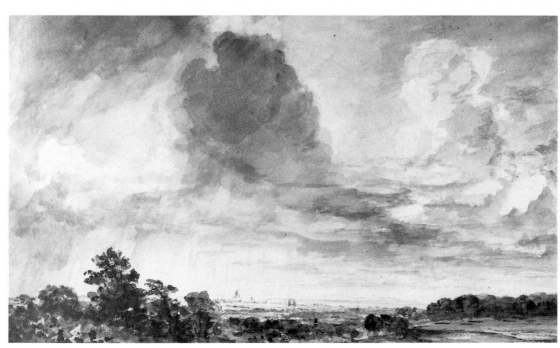

840. (32.30) *London from Hampstead*, British Museum, 11·1 × 18·7cm.

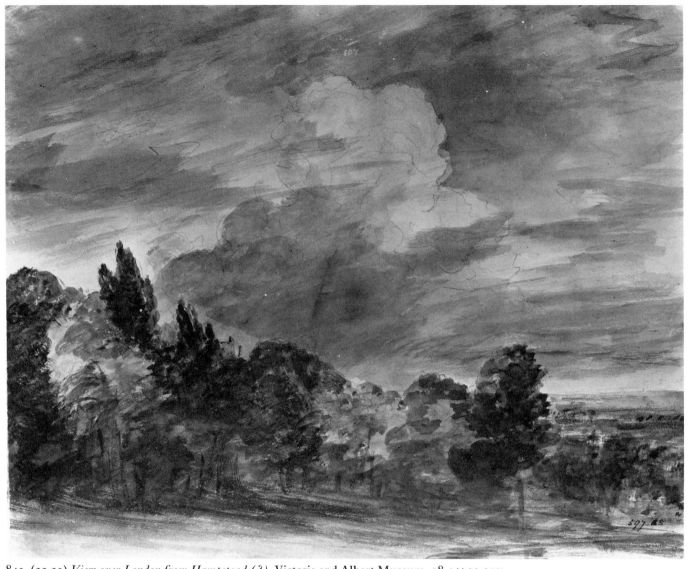

841. (32.31) *View over London from Hampstead (?)*, Victoria and Albert Museum, 18·4 × 22·3cm.

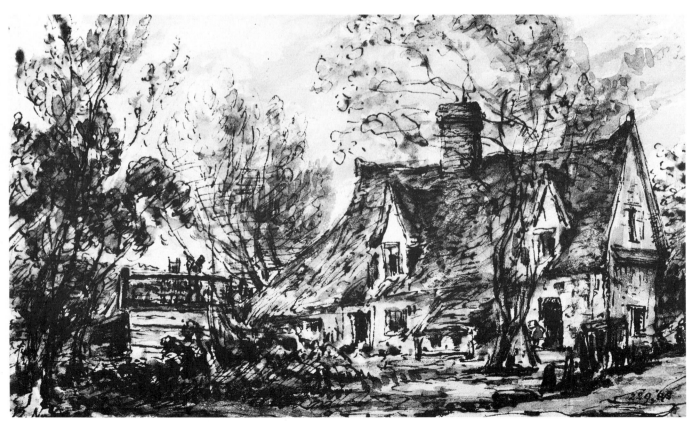

842. (32.32) *Bridge Cottage, Flatford*, Victoria and Albert Museum, 11·5 × 19·1cm.

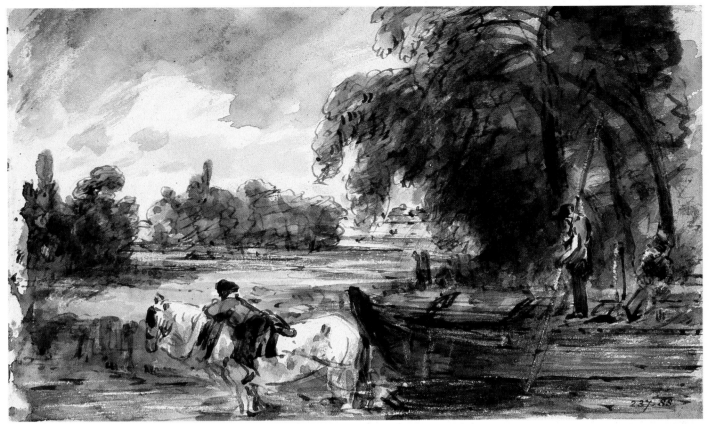

843. (32·33) *A barge on the Stour*, Victoria and Albert Museum, 11·5 × 19·2cm.

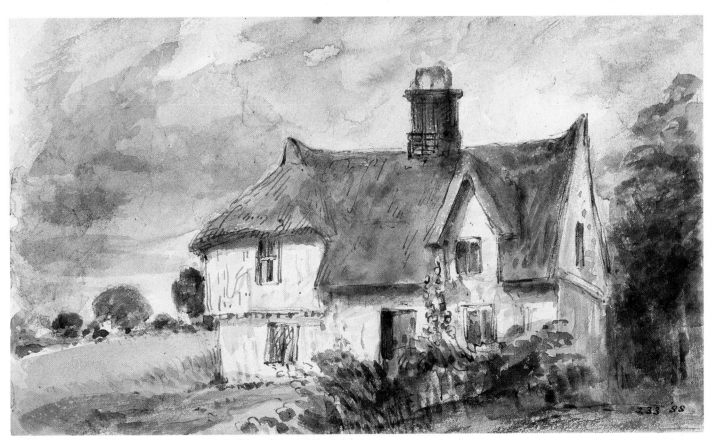

844. (32·36) *A thatched house by a cornfield*, Victoria and Albert Museum, 11·5 × 19·1cm.

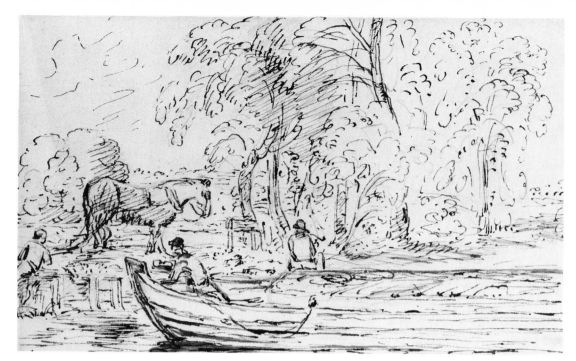

845. (32.34) *A barge on the Stour*, Private collection, 11·5 × 18·7cm.

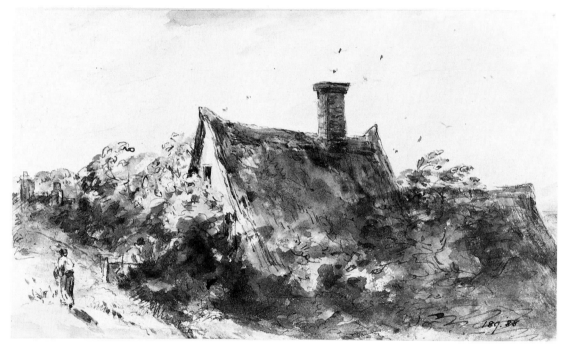

846. (32.35) *A thatched cottage near East Bergholt*, Victoria and Albert Museum, 11·5 × 19·1cm.

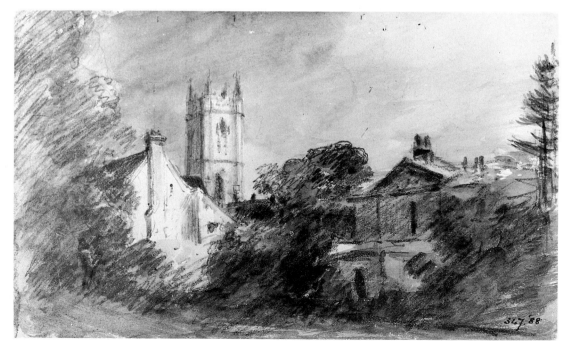

847. (32.37) *Octagon House, Dedham*, Victoria and Albert Museum, 11·5 × 19·1cm.

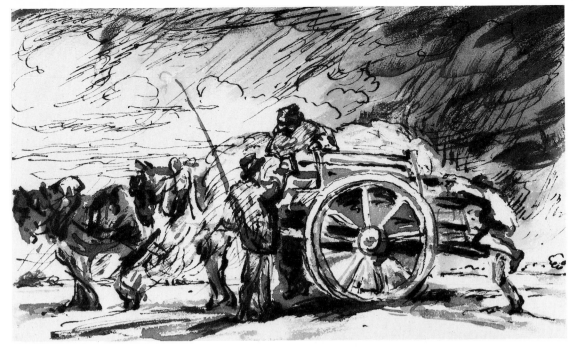

848. (32.38) *Men loading a cart*, British Museum, 11·1 × 18·1cm.

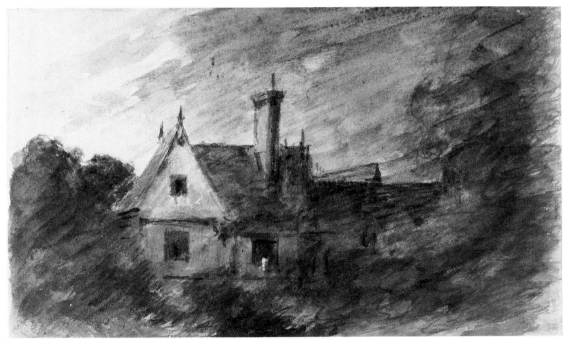

849. (32.39) *A house amongst trees*, British Museum, 11·2 × 18·8cm.

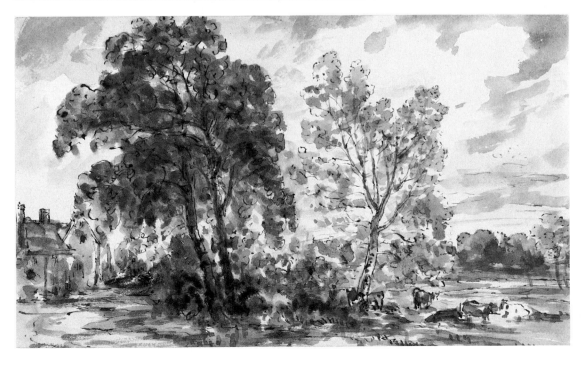

850. (32.40) *Landscape with trees and cattle*, British Museum, 11·1 × 18·7cm.

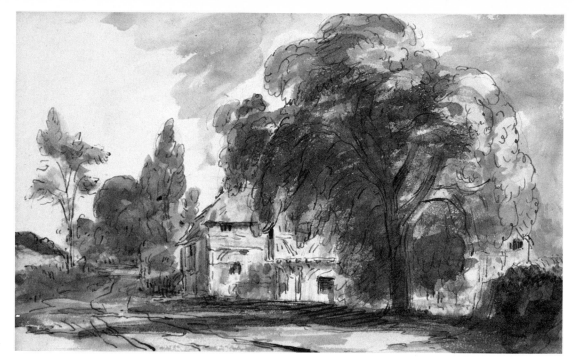

851. (32.41) *A country road with houses at East Bergholt*, Private collection, 11·5 × 18·7cm.

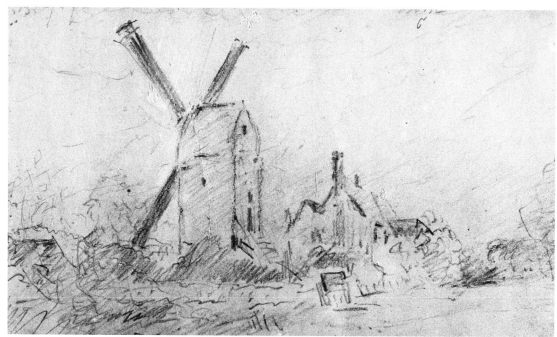

852. (33.42) *A windmill, with a house beyond (Stanway Mill)*, Yale Center for British Art, New Haven, 10·7 × 17·6cm.

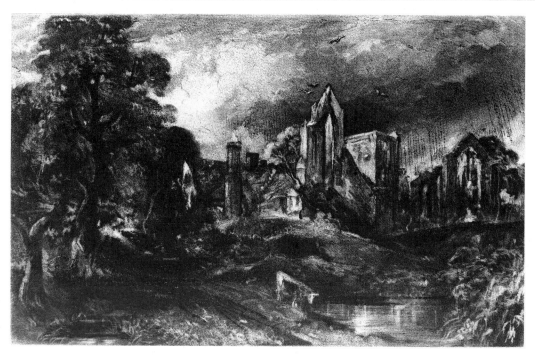

853. (32.45) *Castle Acre Priory* (mezzotint).

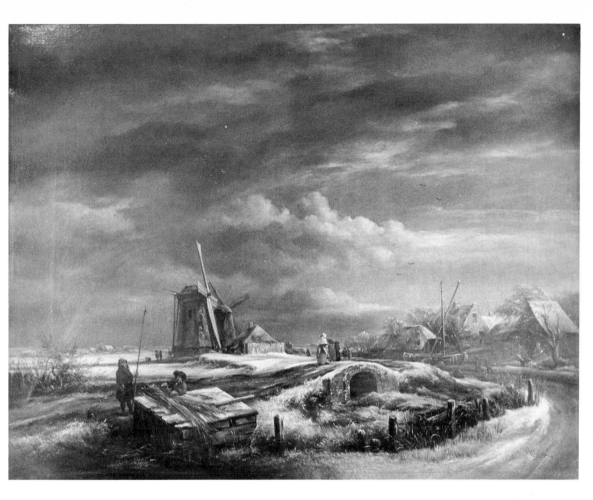

854. (32.43) *Winter, after Jacob van Ruysdael*, Private collection, 58·1 × 70·8cm.

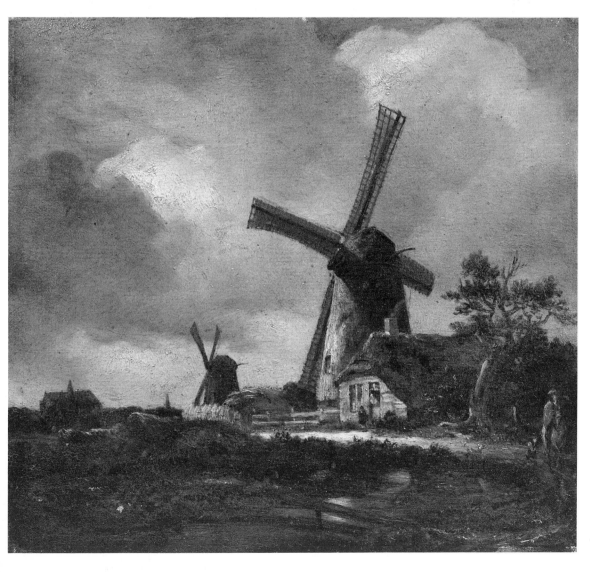

855. (32.44) *Landscape with Windmills, after Jacob van Ruysdael*, Private collection.

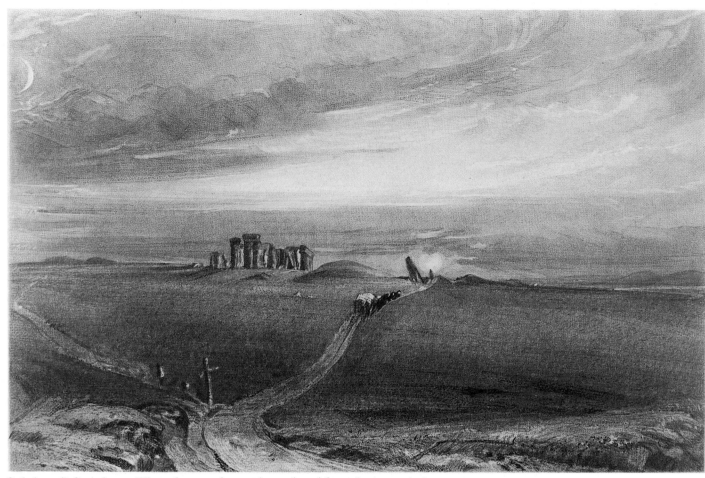

856. (32.46) *Stonehenge*, Whereabouts unknown (reproduced from the mezzotint).

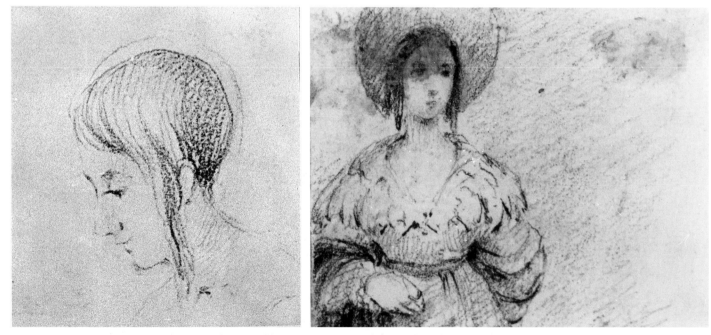

857–8. (32.47) *A girl's head ; and a copy from an old master painting*, Private collection, 20·3 × 14cm.

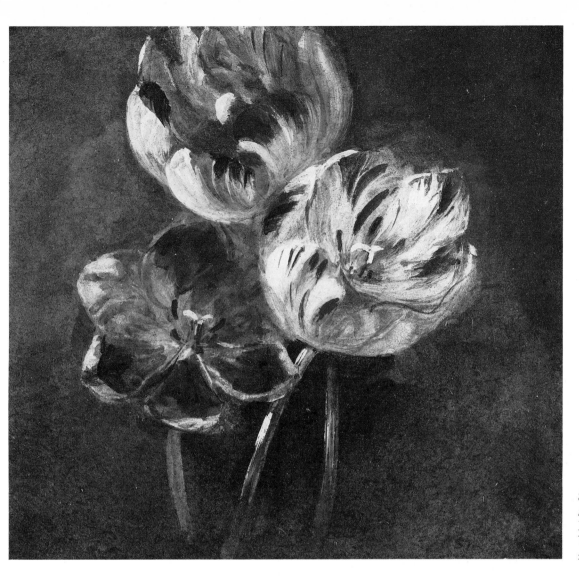

859. (32.50) *Study of three parrot tulips*, Paul Mellon Collection, Upperville, Virginia, 21·2 × 22cm.

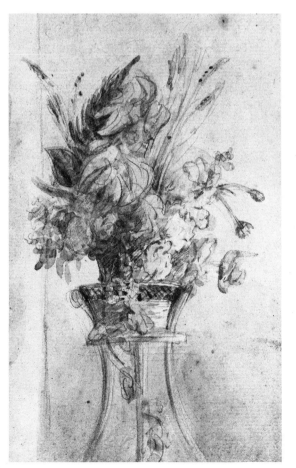

861. (32.52) *A country road with elm trees*, Victoria and Albert Museum, 8 × 11·2cm.

860. (left) (32.51) *Flowers in a basket*, Ipswich Museum and Galleries, Christchurch Mansion Museum, 17 × 9·8cm.

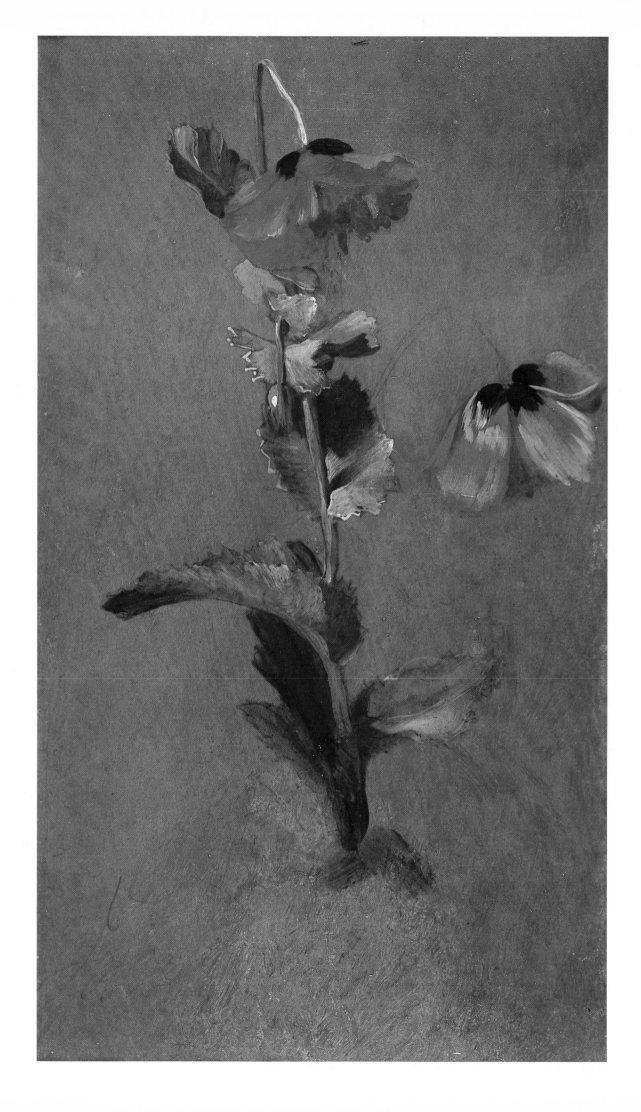

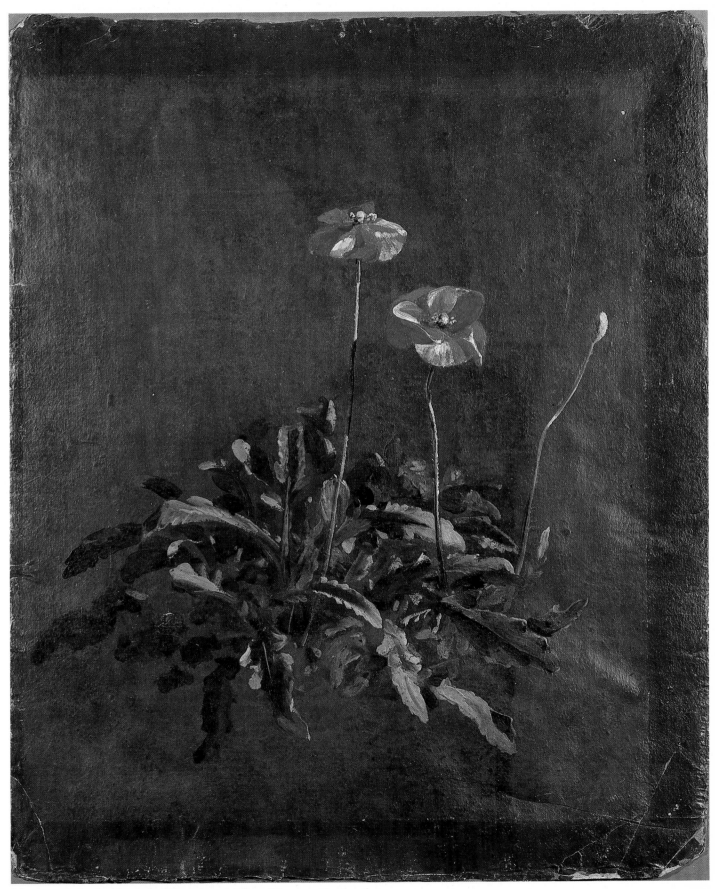

863. (32.49) *Study of poppies*, Victoria and Albert Museum, 60·5 × 48·7cm.

862. (left) (32.48) *Study of poppies*, Paul Mellon Collection, Upperville, Virginia, 38·7 × 21cm.

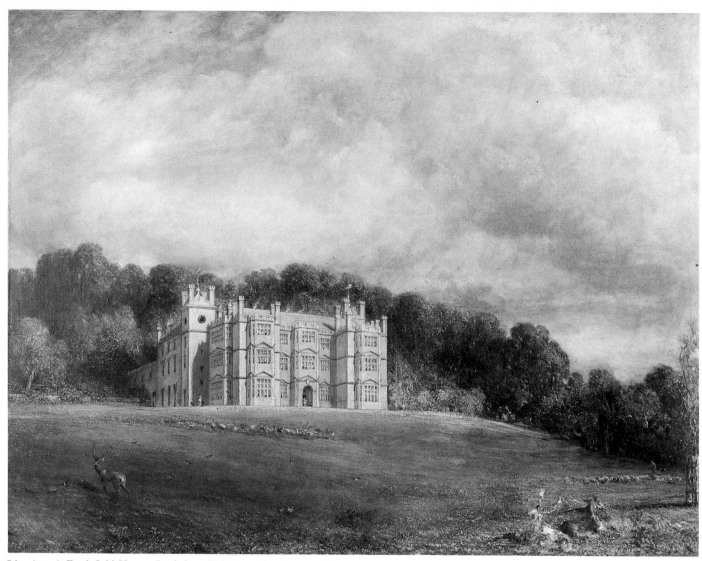

864. (33.1) *Englefield House, Berkshire*, Private collection, 101·6 × 129·5cm.

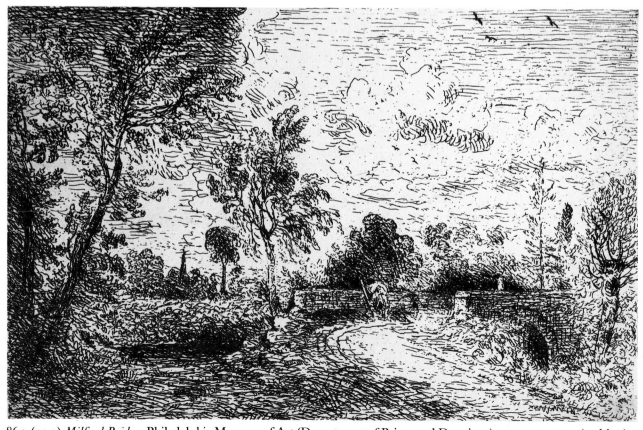

865. (33.9) *Milford Bridge*, Philadelphia Museum of Art (Department of Prints and Drawings), 13·5 × 19·1cm. (etching).

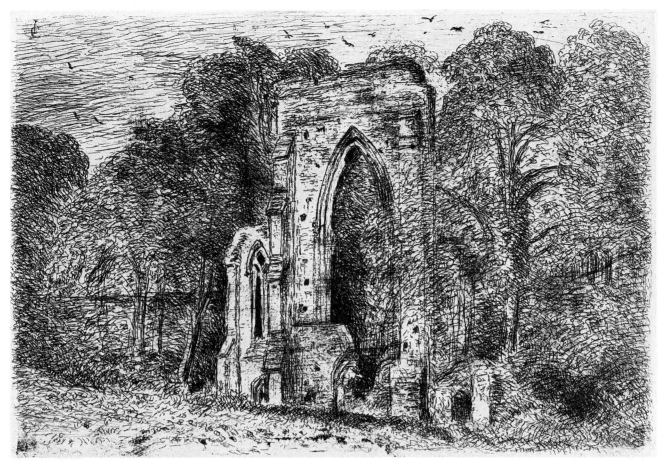

866. (33.10) *Netley Abbey: the west end*, Philadelphia Museum of Art (Department of Prints and Drawings), 13·5 × 19·1cm. (etching).

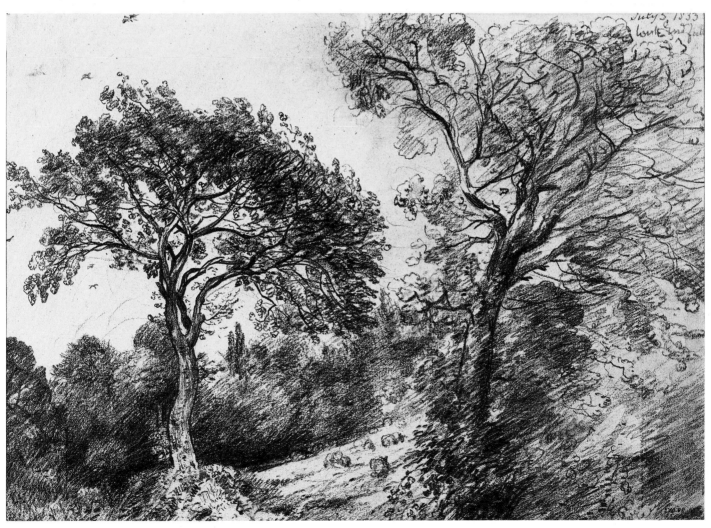

867. (33.12) *Trees in West End Fields, Hampstead*, Victoria and Albert Museum, 23·5 × 32·7cm.

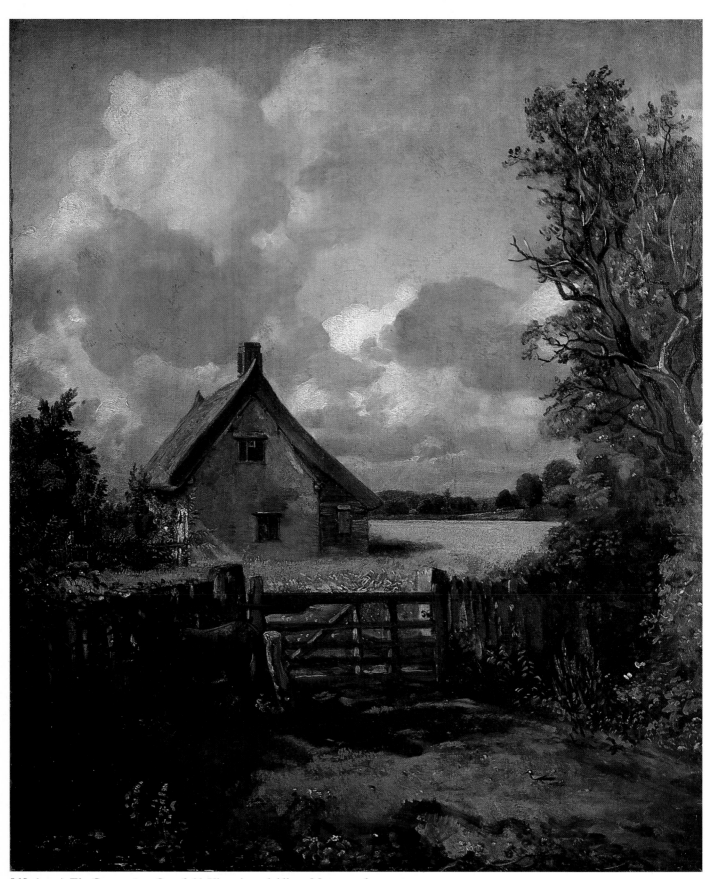

868. (33.3) *The Cottage in a Cornfield*, Victoria and Albert Museum, 62 × 51·5cm.

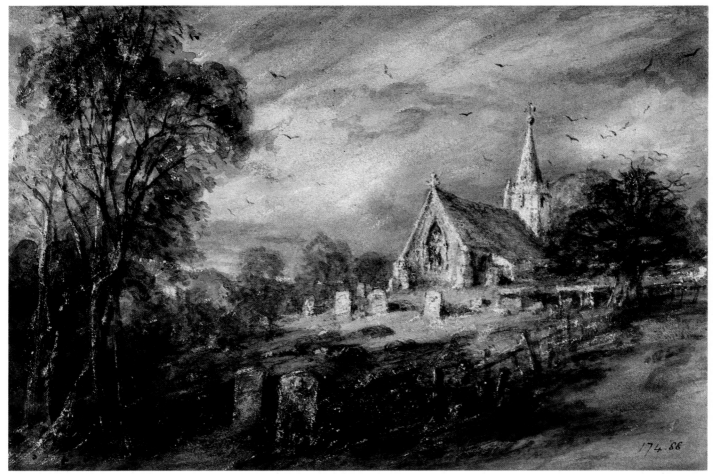

869. (33.13) *Stoke Poges Church*, Victoria and Albert Museum, 13·3 × 19·8cm.

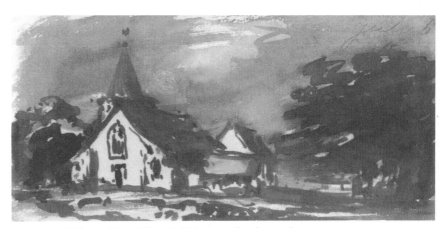

871. (33.14) *Stoke Poges Church*, Private collection, 7·6 × 15·9cm.

870. (left) (33.11) *The Holy Spirit: illustration to Watts's 'Songs, Divine and Moral'*, Victoria and Albert Museum (The National Art Library), 16·5 × 10cm. (size of page).

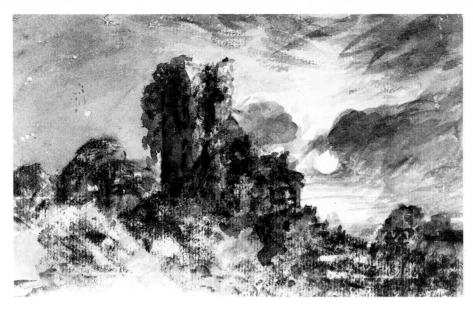

872. (above) (33.15) *Design for Gray's 'Elegy', Stanza III*, Victoria and Albert Museum, 10 × 16·2cm.

873. (above right) (33.19) *A churchyard*, Dr David Darby, 9·3 × 7·5cm.

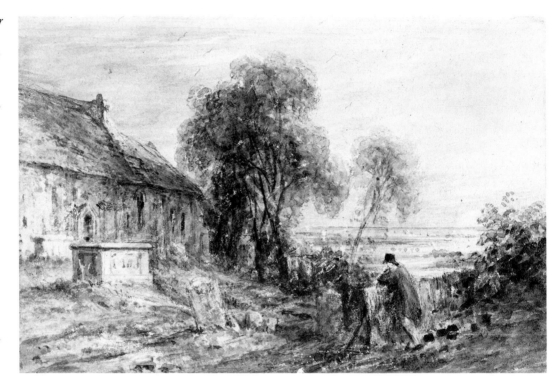

874. (33.16) *Design for Gray's 'Elegy', Stanza V*, British Museum, 11·7 × 17·4cm.

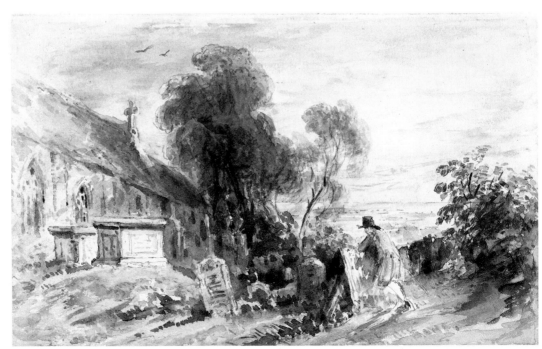

875. (33.17) *Design for Gray's 'Elegy', Stanza V*, British Museum, 11·4 × 18·2cm.

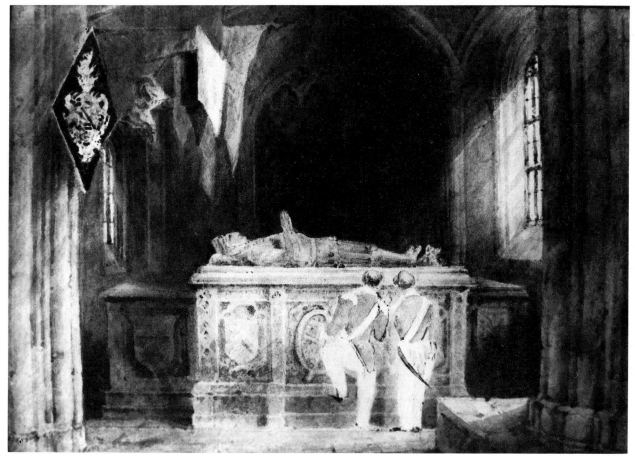

876. (33.18) *Design for Gray's 'Elegy', Stanza XI*, Younger daughter of R. B. Beckett, 13 × 18·5cm.

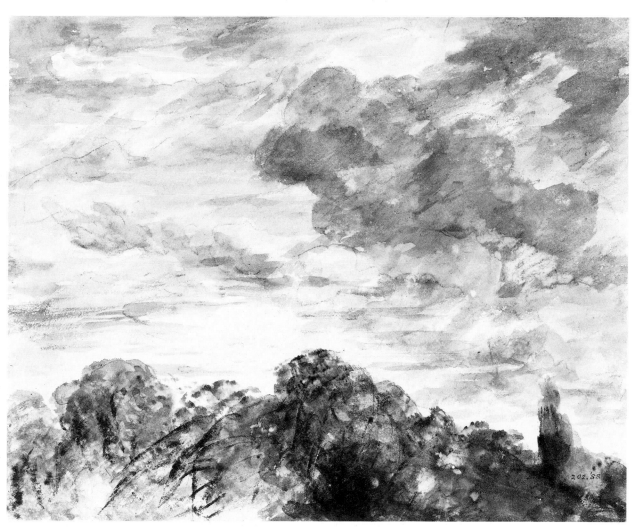

877. (33.20) *Study of sky and trees*, Victoria and Albert Museum, 18·6 × 22·9cm.

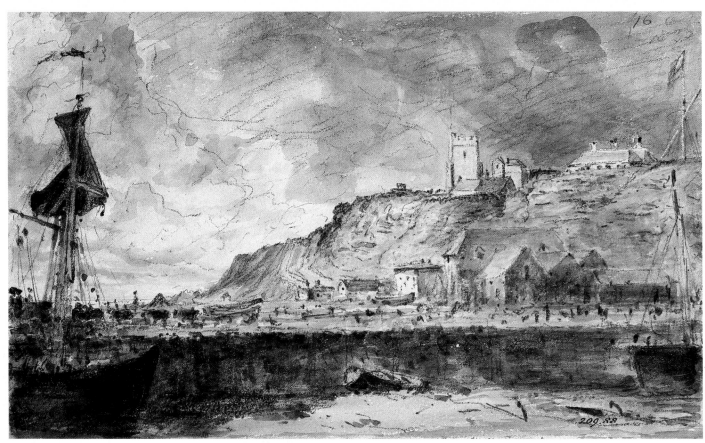

878. (33.21) *Folkestone Harbour*, Victoria and Albert Museum, 12·9 × 21cm.

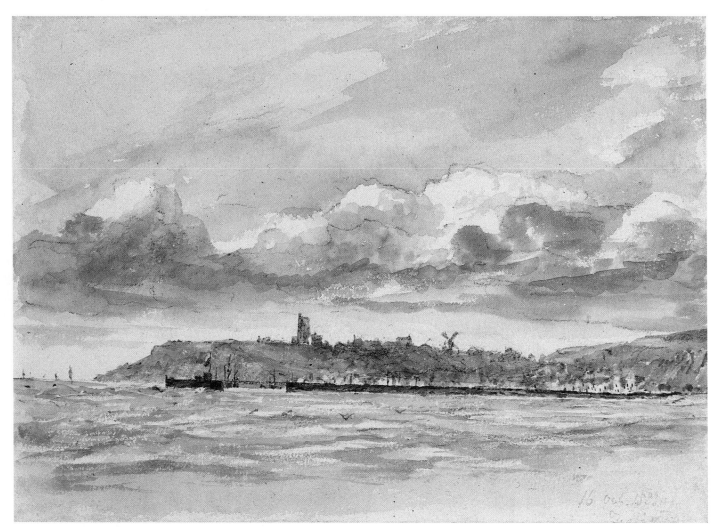

879. (33.22) *Folkestone from the sea*, British Museum, 12·7 × 21cm.

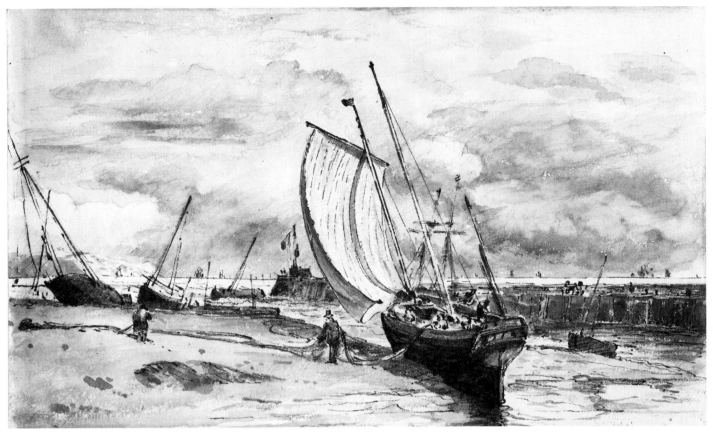

880. (33.23) *Folkestone Harbour*, British Museum, 12·7 × 21cm.

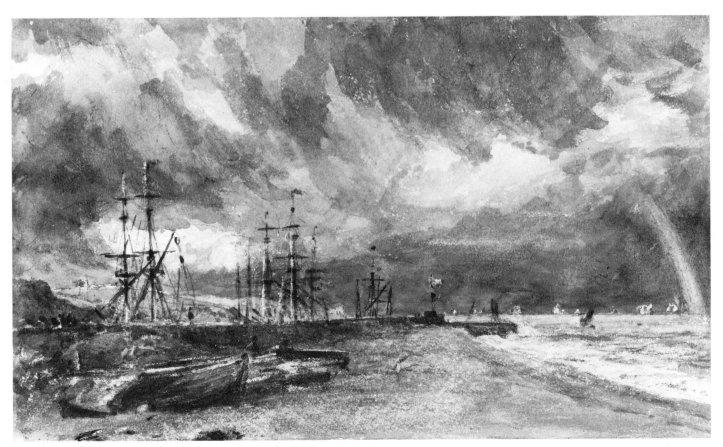

881. (33.24) *Folkestone Harbour, with a rainbow*, British Museum, 12·7 × 21cm.

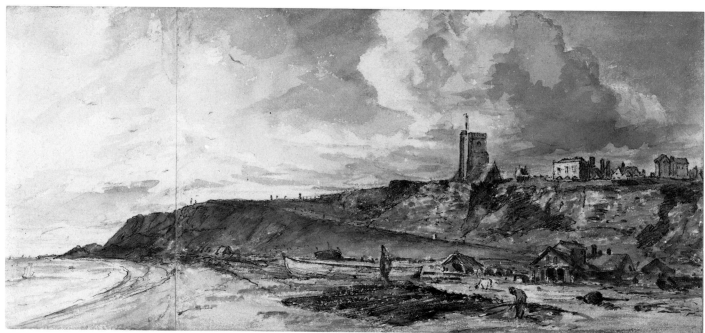

882. (33.25) *Folkestone from the beach*, British Museum, 13 × 28cm.

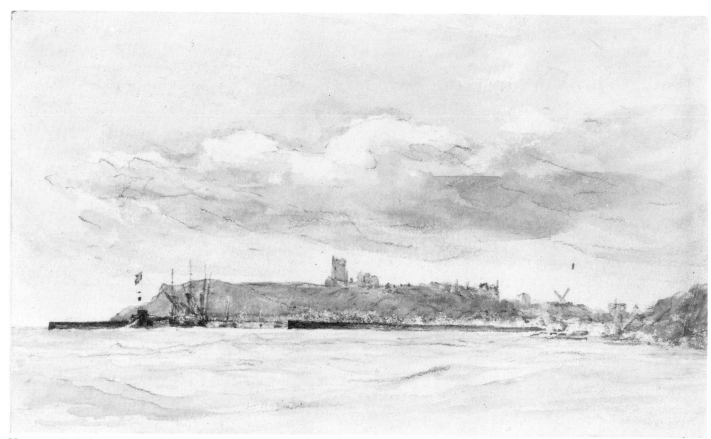

883. (33.26) *Folkestone*, British Museum, 12·4 × 20·5cm.

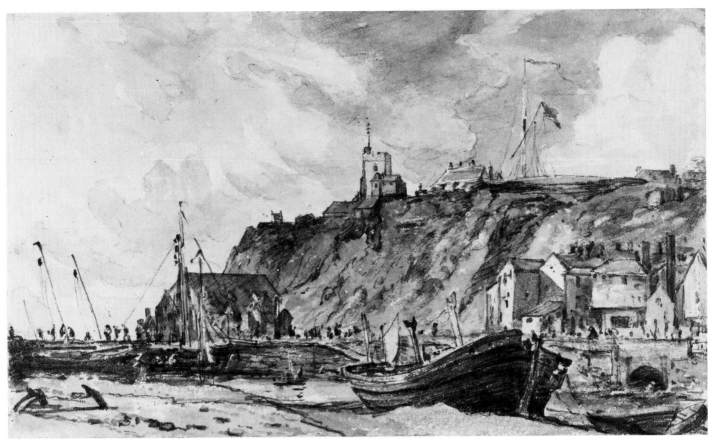

884. (33.27) *Folkestone: the harbour*, Fitzwilliam Museum, Cambridge, 12·7 × 21cm.

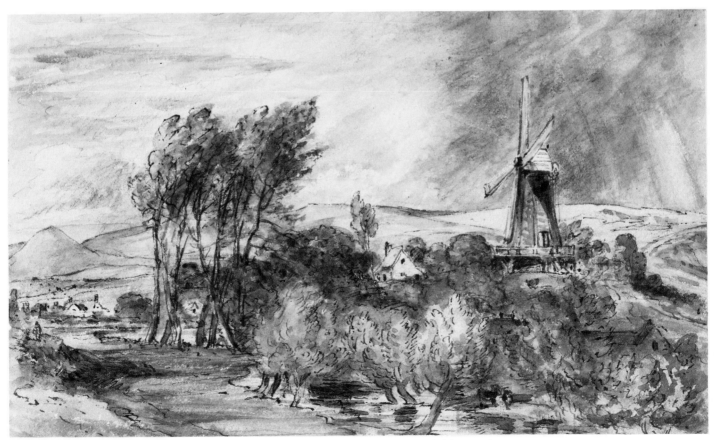

885. (33.28) *Folkestone: Ford Road and the Ropewalk*, Fitzwilliam Museum, Cambridge, 12·7 × 21cm.

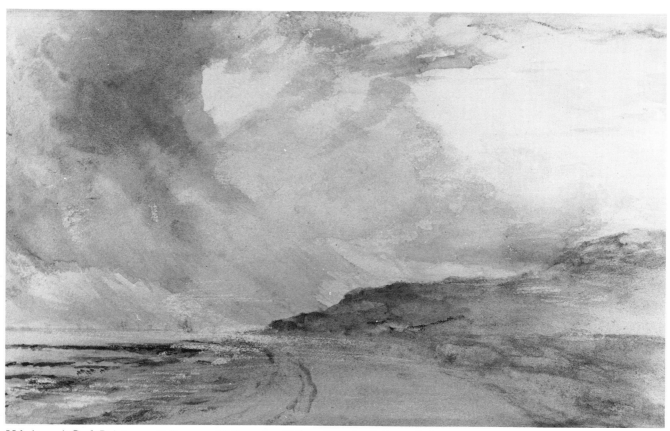

886. (33.29) *Cock Point, near Folkestone*, Oldham Art Gallery (Charles E. Lees Collection), 12·1 × 20·3cm.

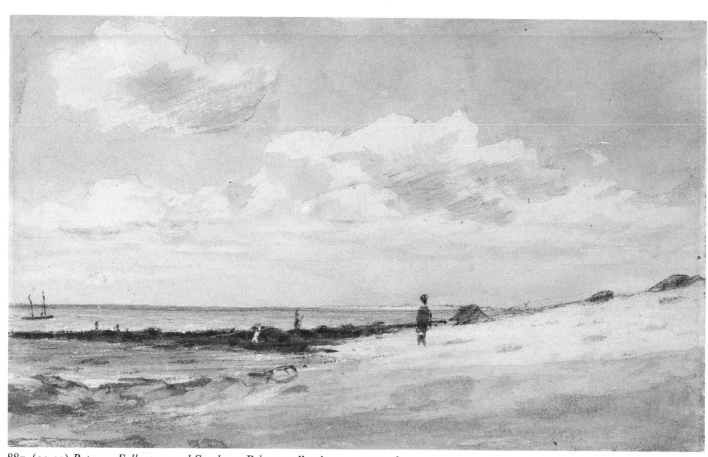

887. (33.30) *Between Folkestone and Sandgate*, Private collection, 11·7 × 19·6cm.

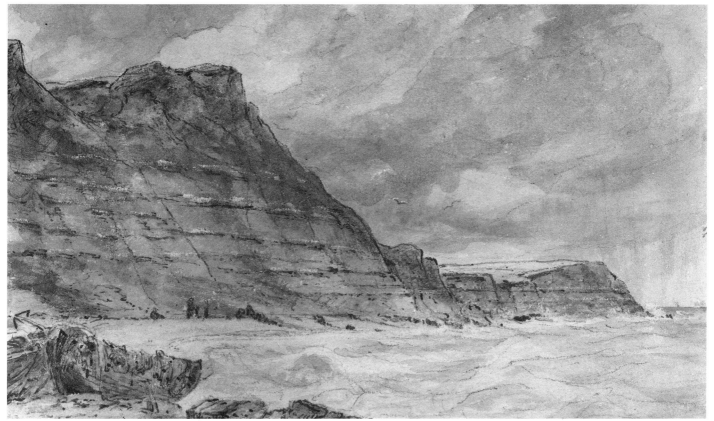

888. (33.31) *Cliffs near Folkestone*, Private collection, 12·9 × 21cm.

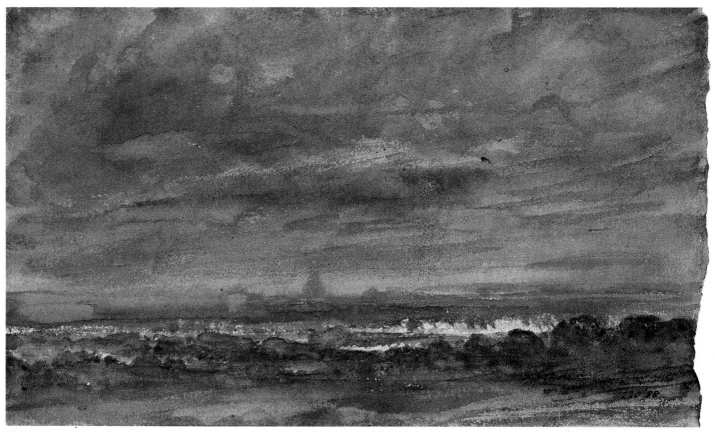

889. (33.32) *View at Hampstead, looking towards London*, Victoria and Albert Museum, 11·5 × 19cm.

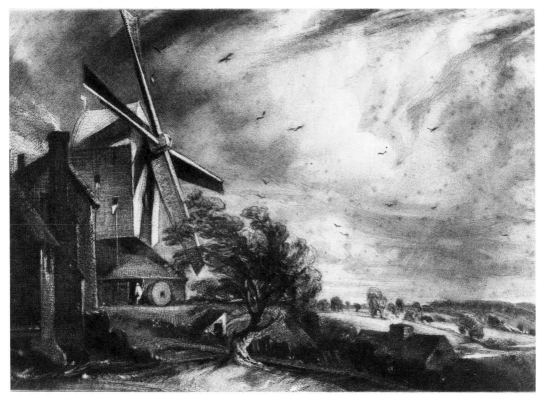

890. (33.34) *A mill near Colchester (Stanway Mill)*, Whereabouts unknown (reproduced from the mezzotint).

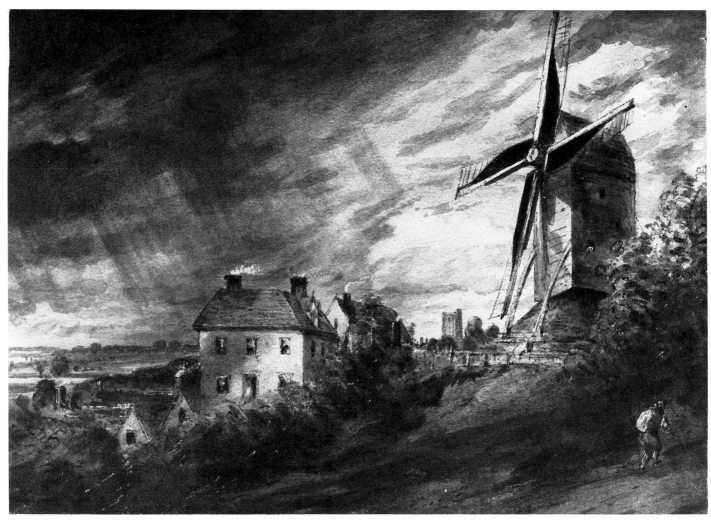

891. (33.35) *Stanway Mill*, Private collection, 14·3 × 19·1cm.

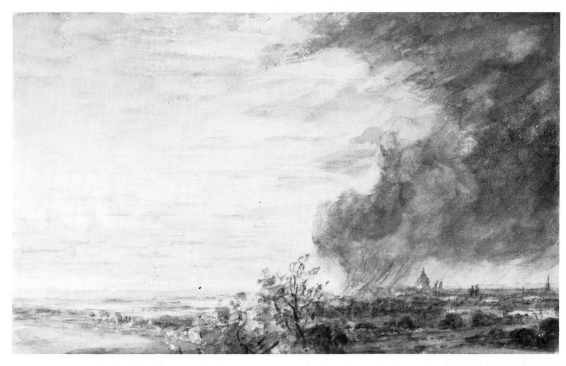

892. (33.36) *View over London from Hampstead*, British Museum, 11·2 × 17·8cm.

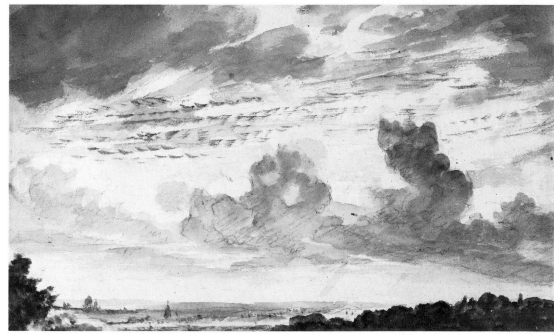

893. (33.37) *London from Hampstead*, British Museum, 11·2 × 18·7cm.

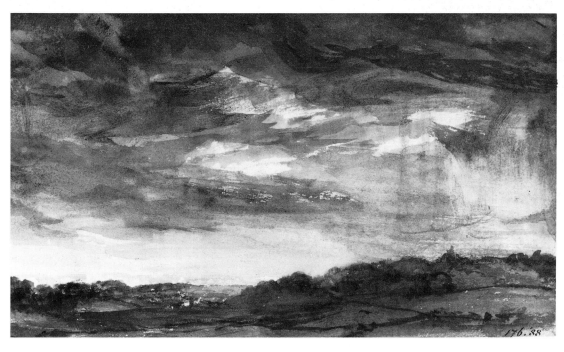

894. (33.38) *View from Hampstead*, Victoria and Albert Museum, 11·2 × 18·6cm.

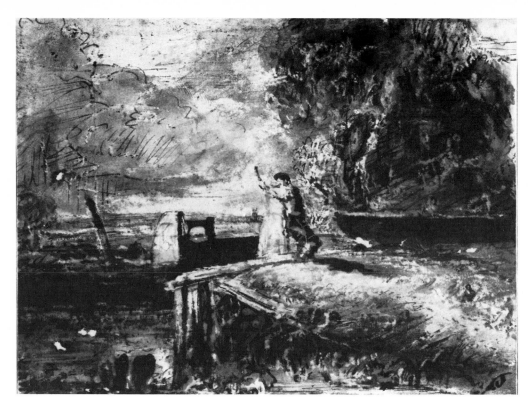

895. (33.39) *The lock*, Fitzwilliam Museum, Cambridge, 11·4 × 14·7cm.

896. (33.40) *Flatford Lock*, Fitzwilliam Museum, Cambridge, 5·4 × 4·7cm.

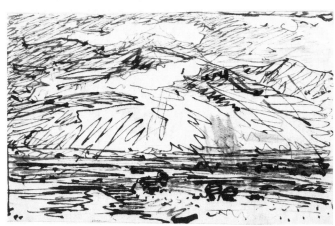

897. (33.41) *A heath scene*, Fitzwilliam Museum, Cambridge, 5·7 × 9cm.

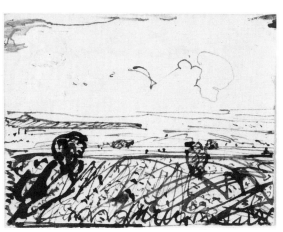

898. (33.42) *A heath scene*, Fitzwilliam Museum, Cambridge, 5·7 × 7·2cm.

899. (33.43) *Cottages*, Fitzwilliam Museum, Cambridge, 9 × 15·7cm.

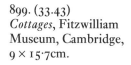

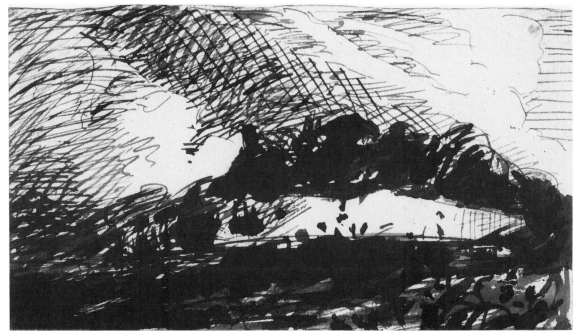

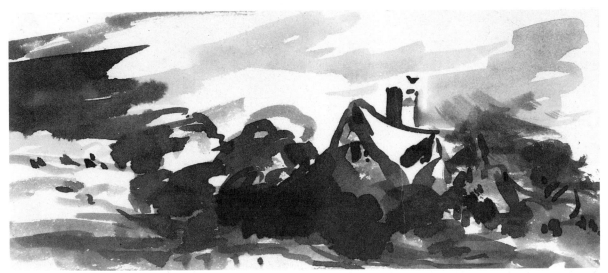

900. (33.44) *A thatched cottage*, Philadelphia Museum of Art (Department of Prints and Drawings), 7 × 15·8cm.

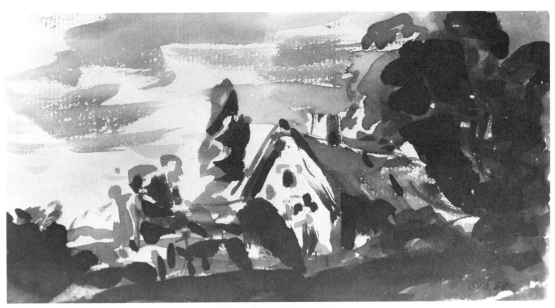

901. (33.45) *A country cottage amid trees*, Victoria and Albert Museum, 7·7 × 14·3cm.

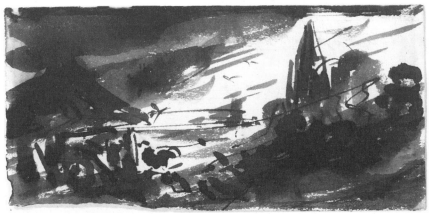

902. (33.46) *Landscape: dawn*, Yale Center for British Art, New Haven, 5·6 × 11·2cm.

903. (33.47) *Cloud study with verses from Bloomfield*, Tate Gallery, (33·5 × 21·1cm.

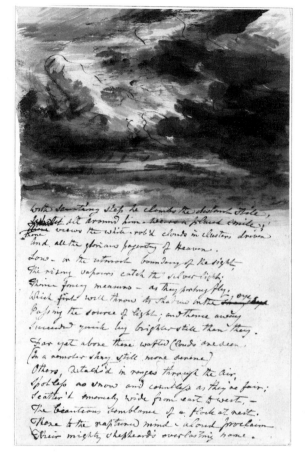

904. (far right) (33.48) *Storm clouds: two studies on one sheet*, Private collection, 32 × 18·7cm.

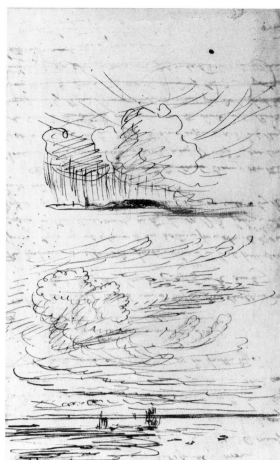

905. (33.49) *Diagram of the formation of a rainbow*, Executors of the late Lieutenant-Colonel J. H. Constable, 16·2 × 19·7cm.

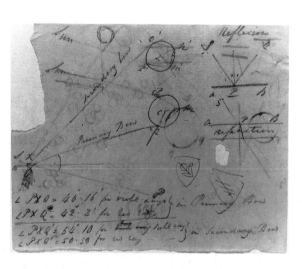

906. (far right) (33.50) *Diagram of the formation of a rainbow*, Executors of the late Lieutenant-Colonel J. H. Constable, 19·7 × 16·2cm.

907. (33.51) *Diagram of the formation of a rainbow*, Executors of the late Lieutenant-Colonel J. H. Constable, 16·2 × 19·7cm.

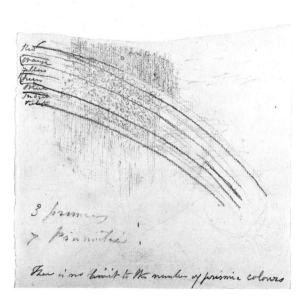

908. (far right) (33.52) *Diagram of the formation of a rainbow*, Executors of the late Lieutenant-Colonel J. H. Constable, 16·2 × 19·7cm.

909. (33.53) Entry deleted

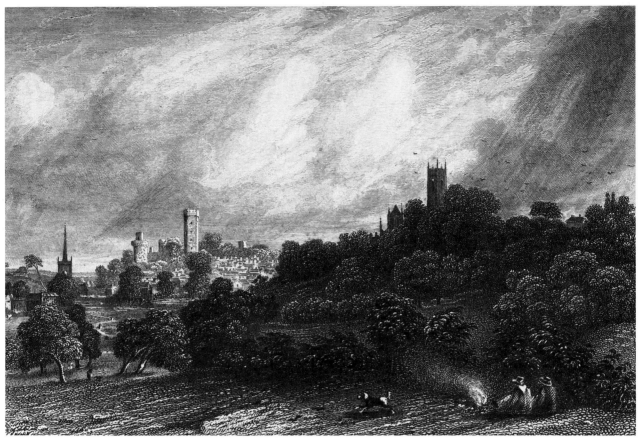

910. (33.54) *Warwick Castle*, Whereabouts unknown (reproduced from the engraving).

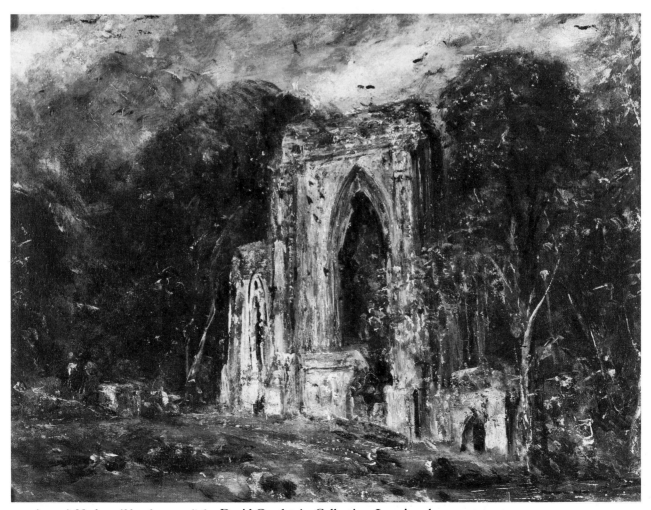

911. (33.55) *Netley Abbey by moonlight*, David Goodstein Collection, Los Angeles, 29·2 × 39·3cm.

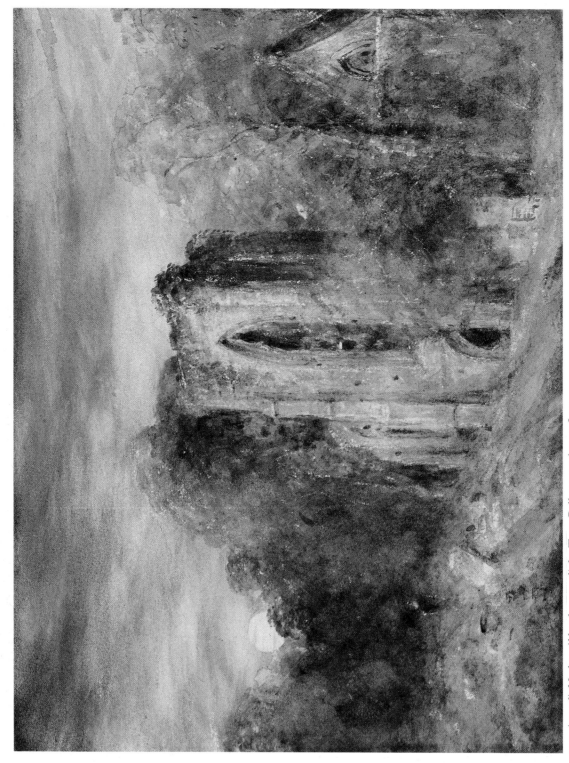

912. (33.56) *Netley Abbey by moonlight*, Tate Gallery, 14·6 × 19·8cm.

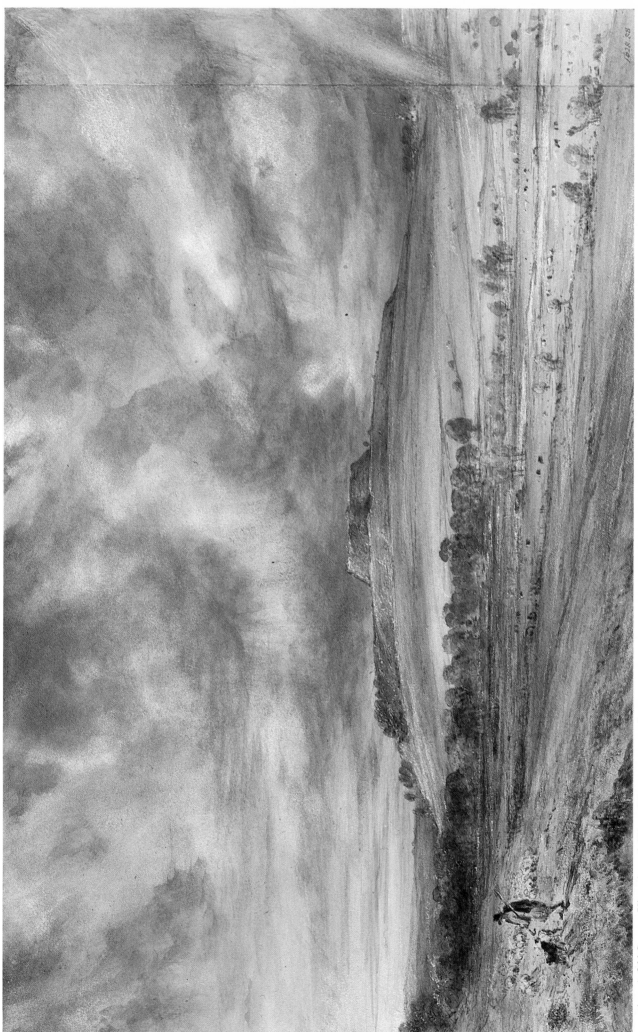

913. (34.1) *Old Sarum*, Victoria and Albert Museum, 30 × 48·7cm.

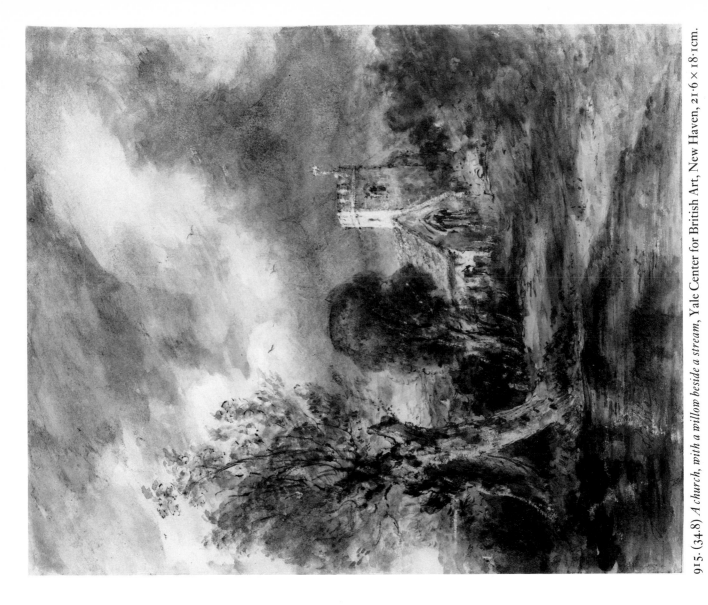

915. (34.8) *A church, with a willow beside a stream*, Yale Center for British Art, New Haven, 21·6 × 18·1cm.

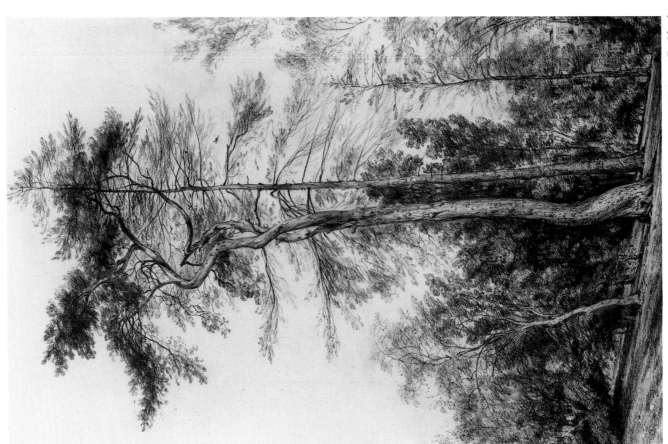

914. (34.3) *Study of trees at Hampstead*, Cecil Higgins Art Gallery, Bedford, 73·4 × 58·2cm.

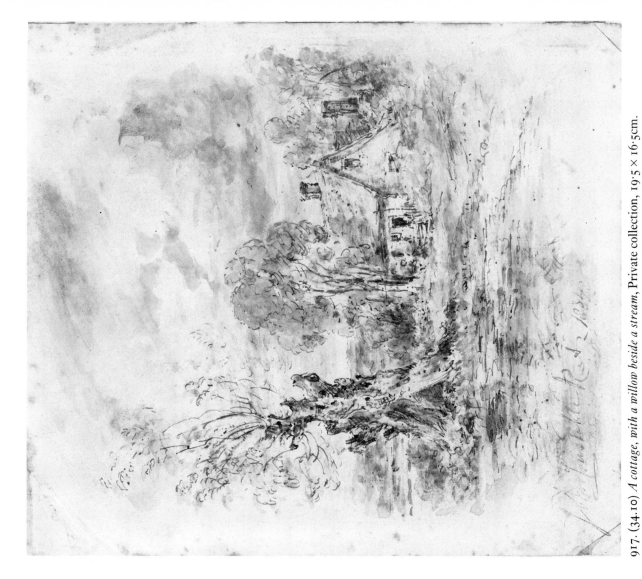

917. (34.10) *A cottage, with a willow beside a stream*, Private collection, 19·5 × 16·5cm.

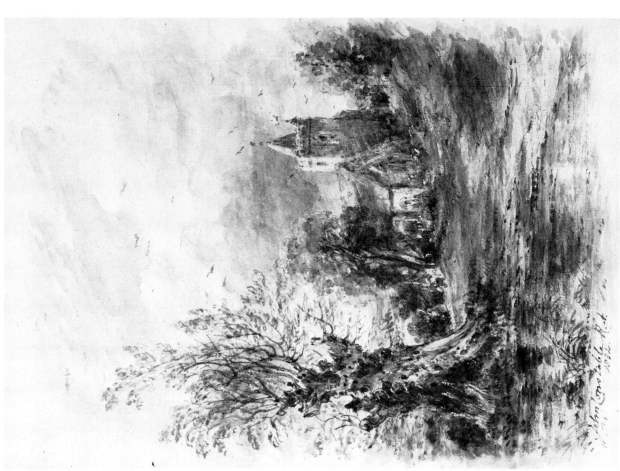

916. (34.9) *A church, with a willow beside a stream*, Private collection, 22·2 × 16·5cm.

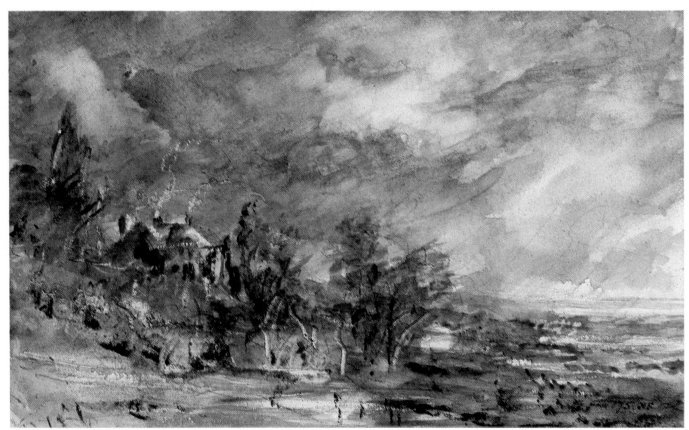

918. (34.6) *Hampstead Heath from near Well Walk*, Victoria and Albert Museum, 11·1 × 18cm.

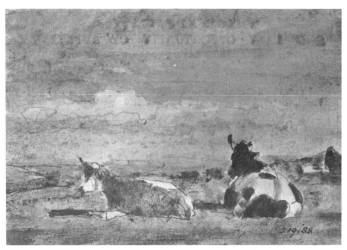

919. (34.7) *Cows at Hampstead*, Victoria and Albert Museum, 6·2 × 9cm.

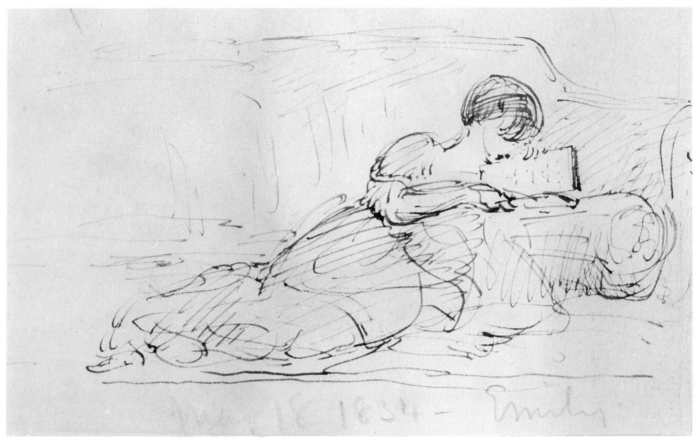

920. (34.11) *Emily on a sofa*, Courtauld Institute Galleries (Witt Collection), London, 10·7 × 18·2cm.

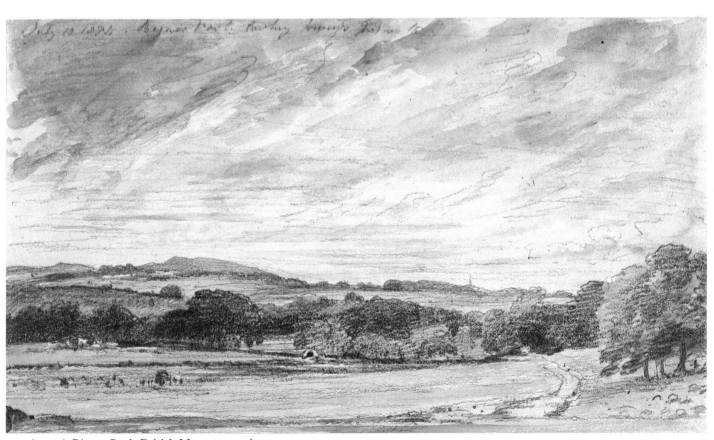

921. (34.12) *Bignor Park*, British Museum, 13·6 × 23cm.

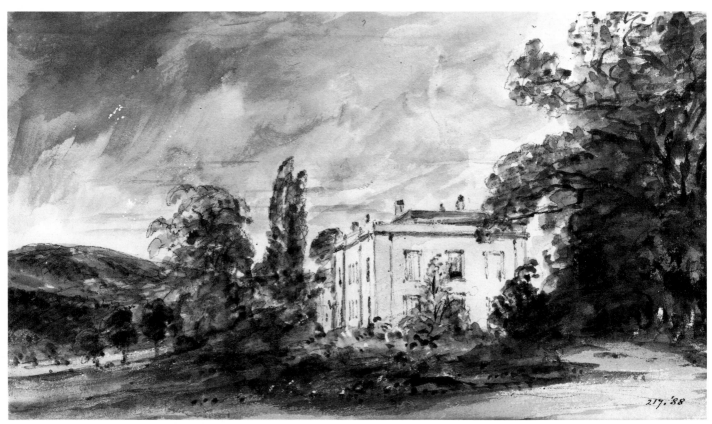

922. (34.13) *Bignor Park*, Victoria and Albert Museum, 14 × 23·5cm.

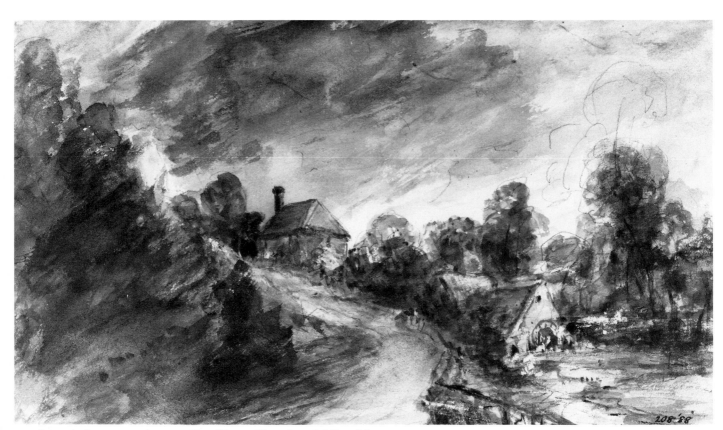

923. (34.14) *A cottage and watermill at Bignor*, Victoria and Albert Museum, 14 × 23·5cm.

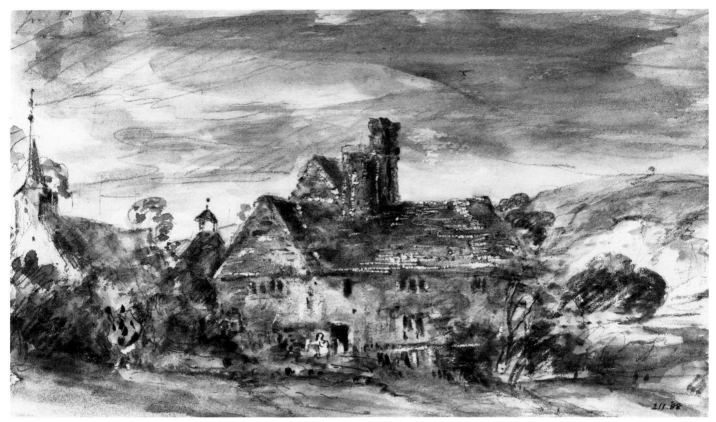

924. (34.15) *A farmhouse and church at Houghton*, Victoria and Albert Museum, 14 × 23·5cm.

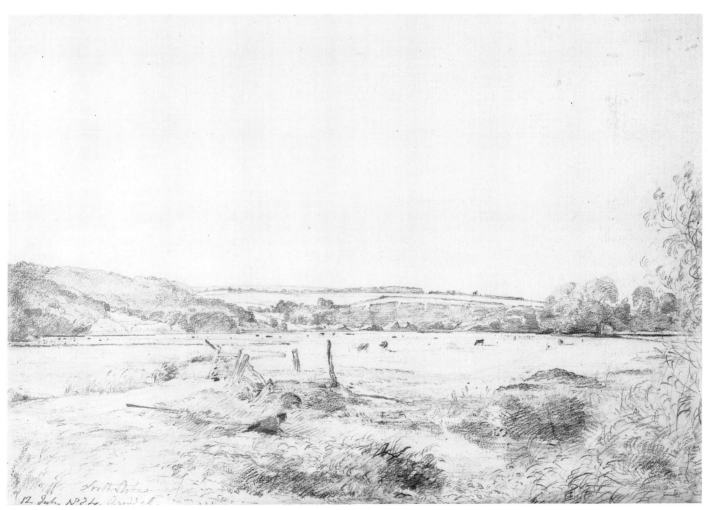

925. (34.16) *North Stoke, Sussex*, British Museum, 26·4 × 37·6cm.

926. (34.17) *An ancient British canoe at North Stoke*, British Library, 5 × 22cm.

927. (right) (34.20) *The bust of William III at Petworth*, Musée du Louvre, 23·4 × 14cm.

928. (34.18) *South Stoke, Sussex*, Private collection, 13·8 × 23·3cm.

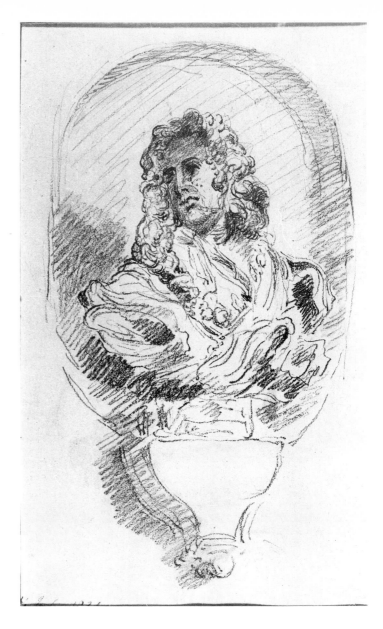

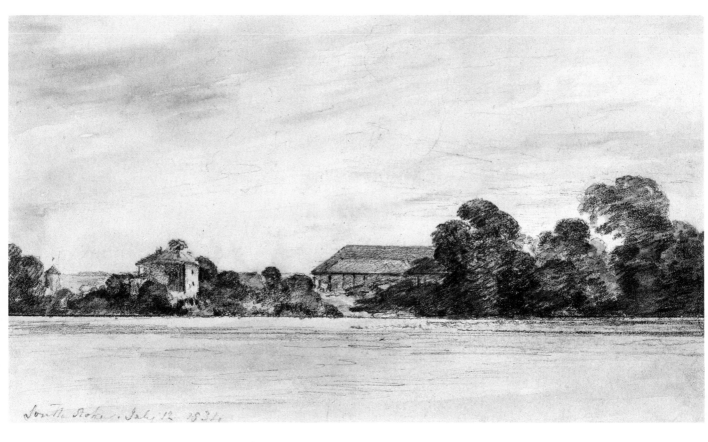

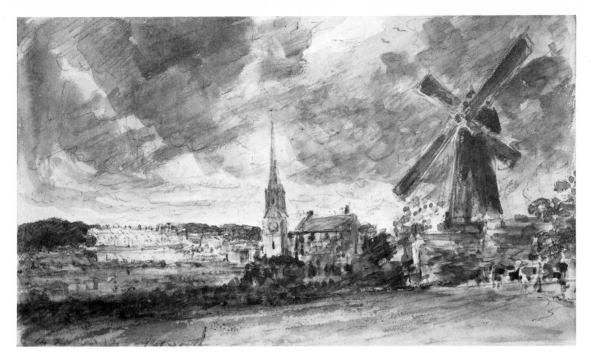

929. (34.19) *Petworth Church and windmill*, British Museum, 13·7 × 23·1cm.

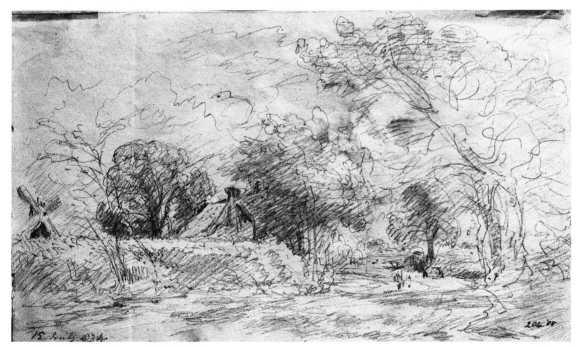

930. (34.21) *A road near Arundel*, Victoria and Albert Museum, 14 × 23·5cm.

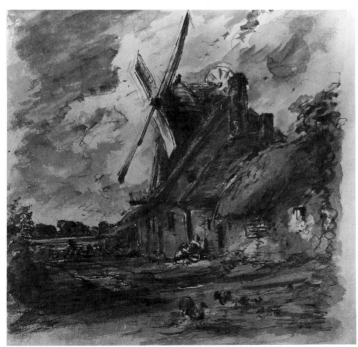

932. (34.23) *An old barn, Arundel*, British Museum, 5·5 × 19·5cm.

931. (34.22) *A windmill and cottages near Arundel*, Victoria and Albert Museum, 14 × 23·5cm.

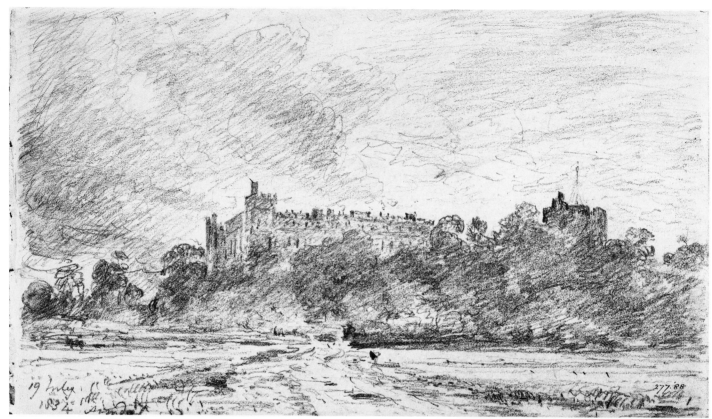

933. (34.24) *Arundel Castle from the east*, Victoria and Albert Museum, 14 × 23·5cm.

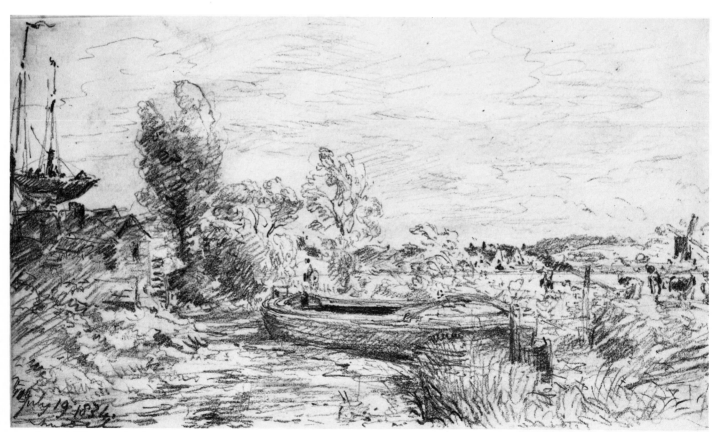

934. (34.25) *View on the Arun*, Private collection, 13·6 × 23cm.

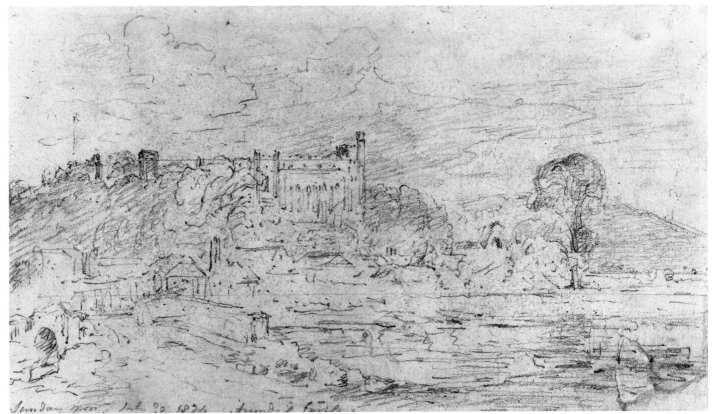

935. (34.26) *Arundel Castle*, Henry E. Huntington Library and Art Gallery, San Marino, 13·3 × 22·8cm.

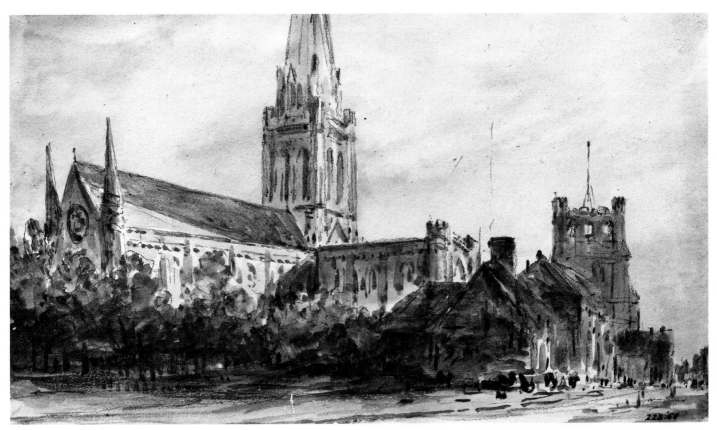

936. (34.27) *Chichester Cathedral*, Victoria and Albert Museum, 14 × 23·5cm.

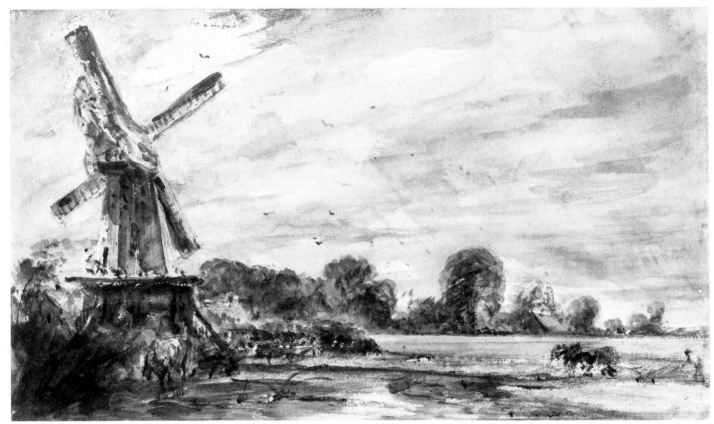

937. (34.28) *Windmill, with a man ploughing*, British Museum, 13·7 × 23·3cm.

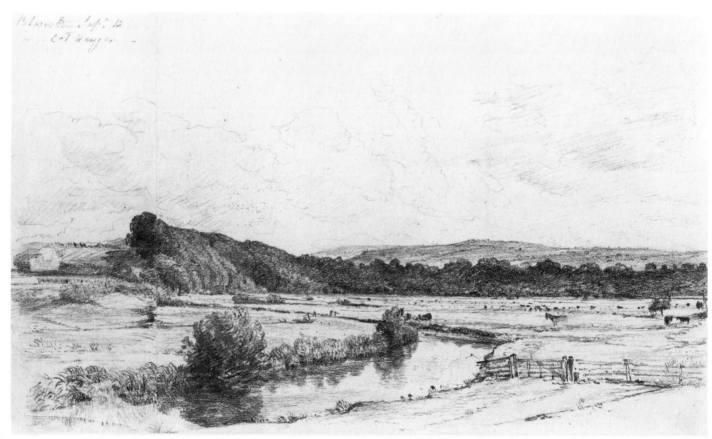

938. (34.31) *Cat Hanger*, Mr and Mrs Eugene Victor Thaw, 20·5 × 34·7cm.

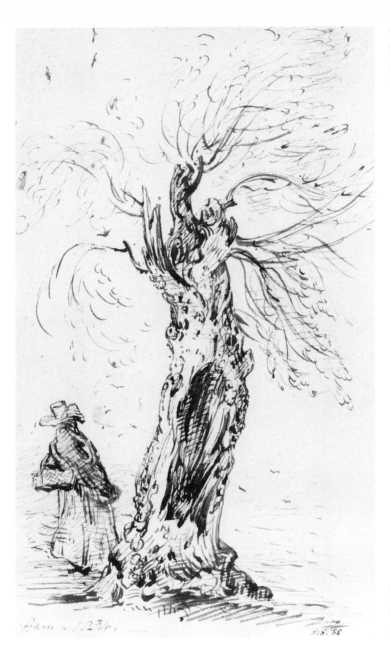

939. (34.29) *A woman by an old willow at Ham*, Victoria and Albert Museum, 23·5 × 14cm.

940. (below) (34.30) *The avenue of trees at Ham*, Victoria and Albert Museum, 14 × 23·5cm.

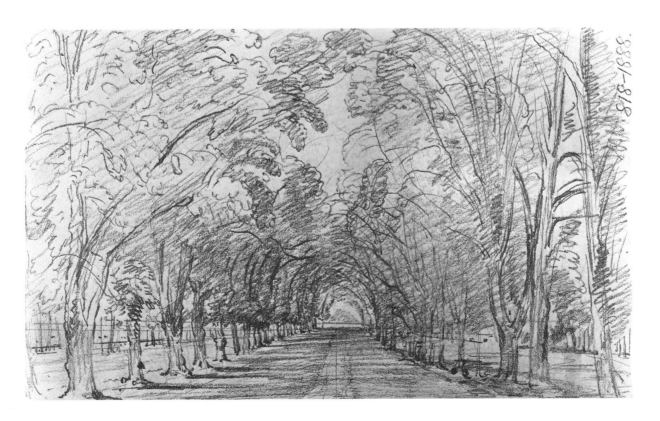

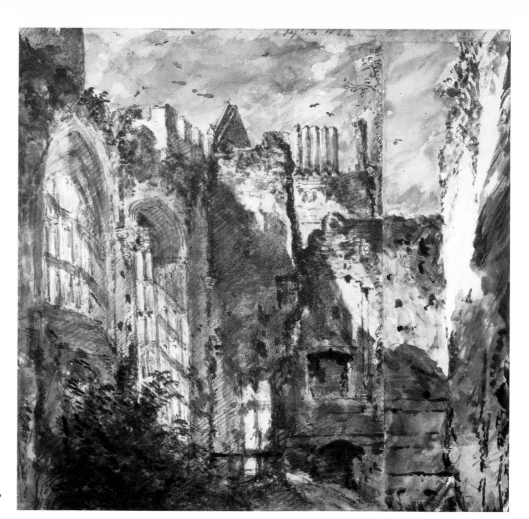

941. (34.32) *Cowdray House*, British Museum, 26·5 × 27·4cm.

942. (34.33) *Cowdray Castle*, British Museum, 27·4 × 26·5cm.

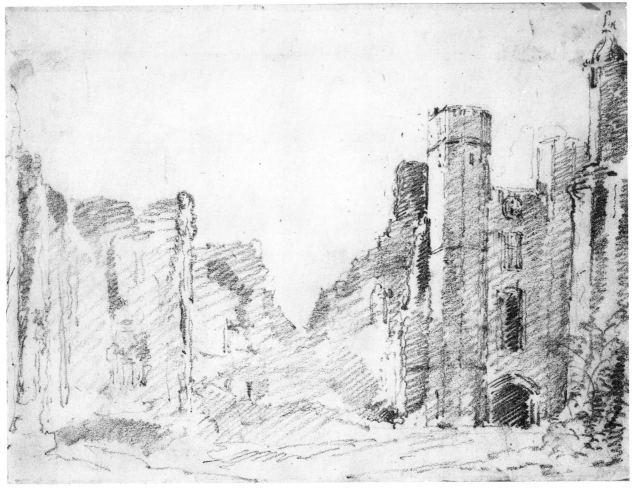

943. (34.34) *Cowdray House : the ruins*, British Museum, 20·3 × 26·5cm.

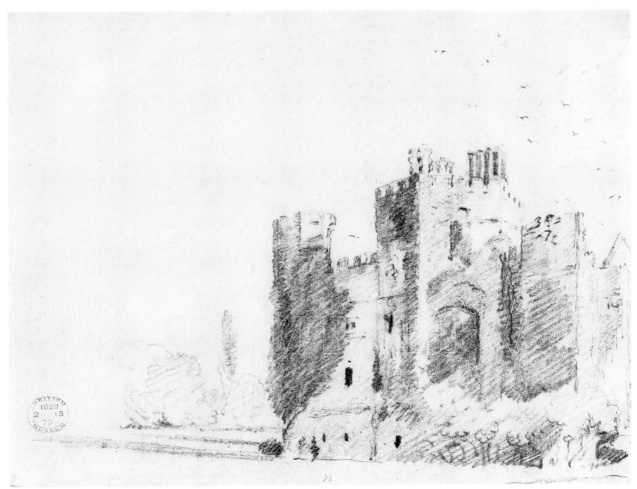

944. (34.35) *The ruins at Cowdray, with a tree*, British Museum, 20·3 × 26·5cm.

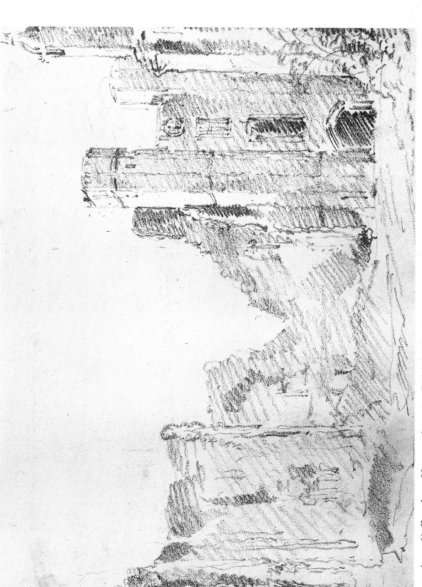

945. (34.36) *Cowdray House: the ruins*, British Museum, 20·3 × 26·5 cm.

946. (right) (34.37) *Cowdray House: a tree in a hollow on the right*, British Museum, 26·5 × 20·3 cm.

947. (below) (34.39) *Cowdray Park*, Victoria and Albert Museum, 20·7 × 27·2 cm.

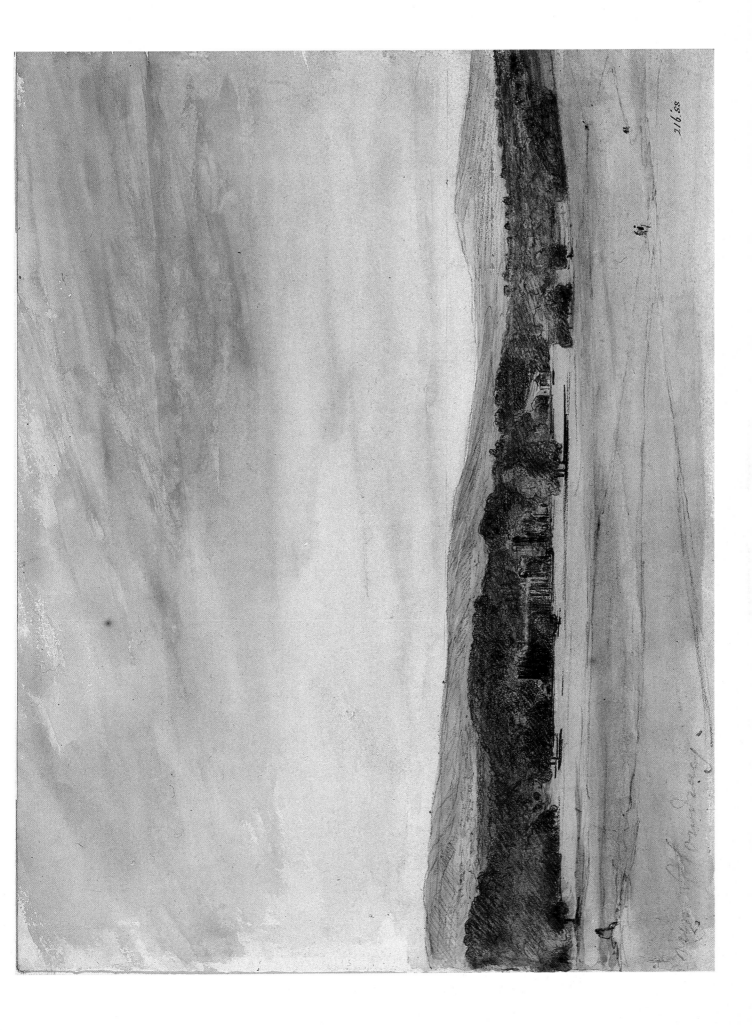

948. (34.38) *Cowdray House*, British Museum, 20·5 × 12·5cm.

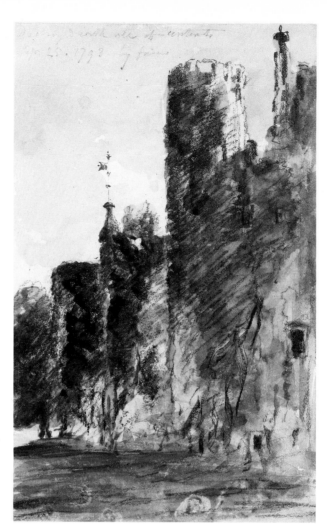

949. (below) (34.42) *Tillington Church*, British Museum, 23·2 × 26·4cm.

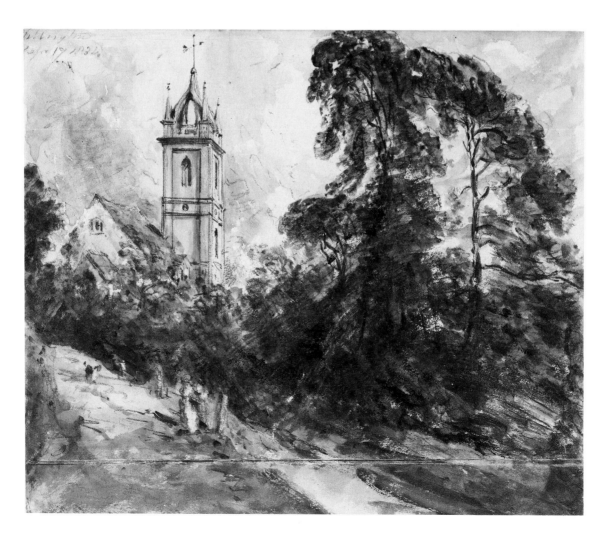

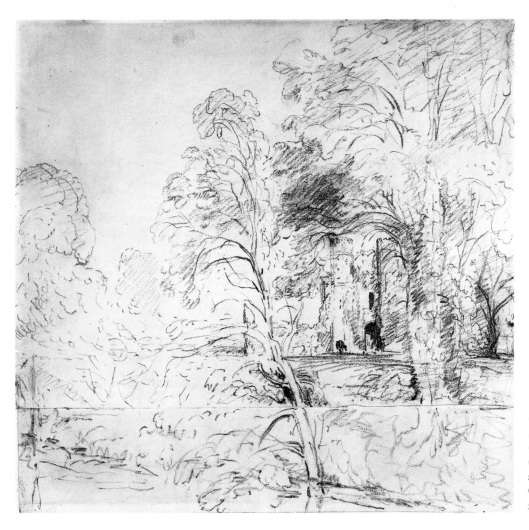

950. (34.40) *Cowdray House*, Royal Museum of Fine Arts (Department of Prints and Drawings), Copenhagen, 26·5 × 27·1 cm.

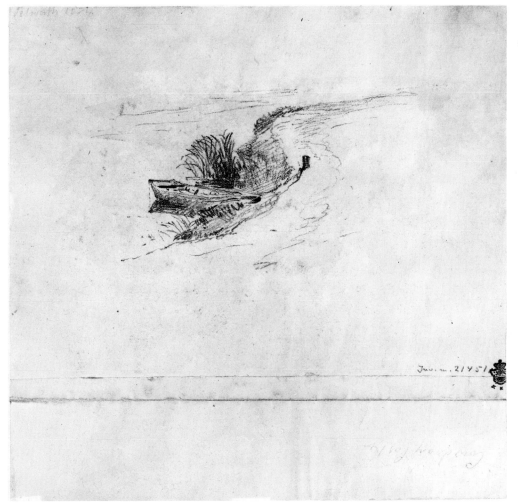

951. (34.41) *A boat moored on the River Rother*, Royal Museum of Fine Arts (Department of Prints and Drawings), Copenhagen, 26·5 × 27·1 cm.

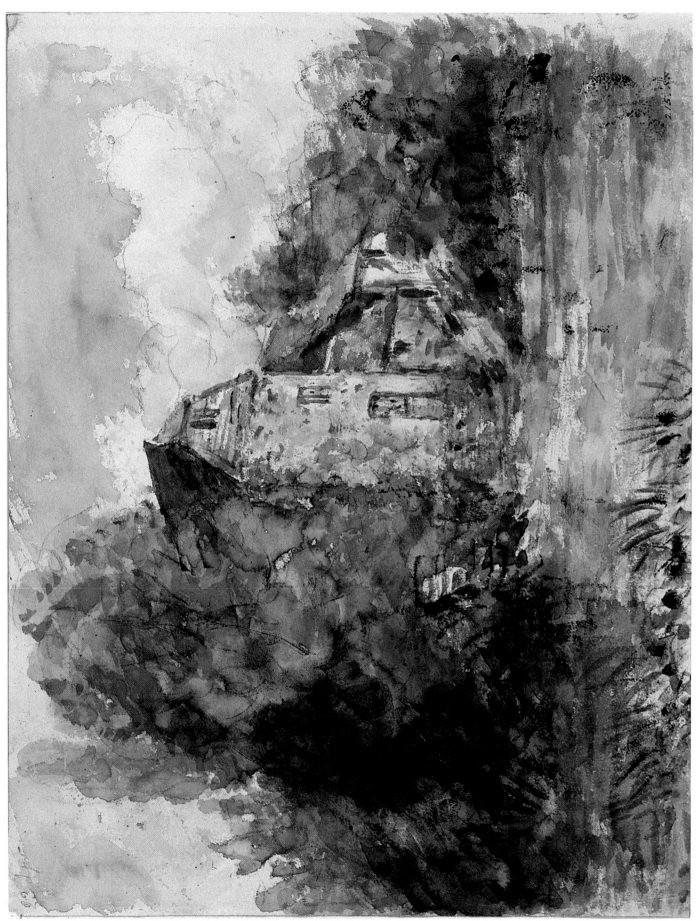

952. (34.46) *Fittleworth Mill*, Victoria and Albert Museum, 20·6 × 27·2cm.

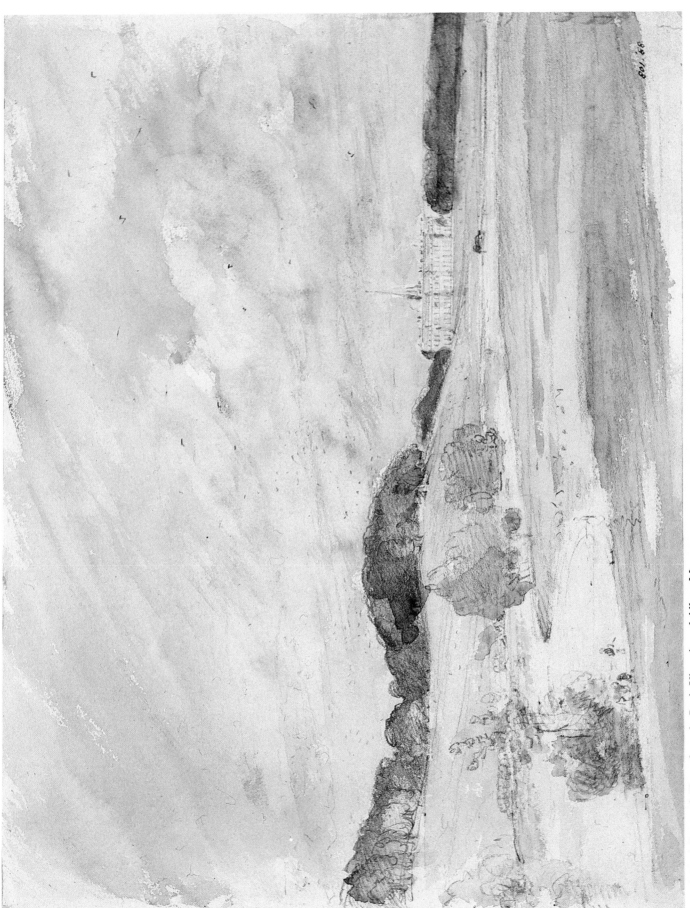

953. (34.50) *Petworth House from the Park*, Victoria and Albert Museum, 20·7 × 27·2cm.

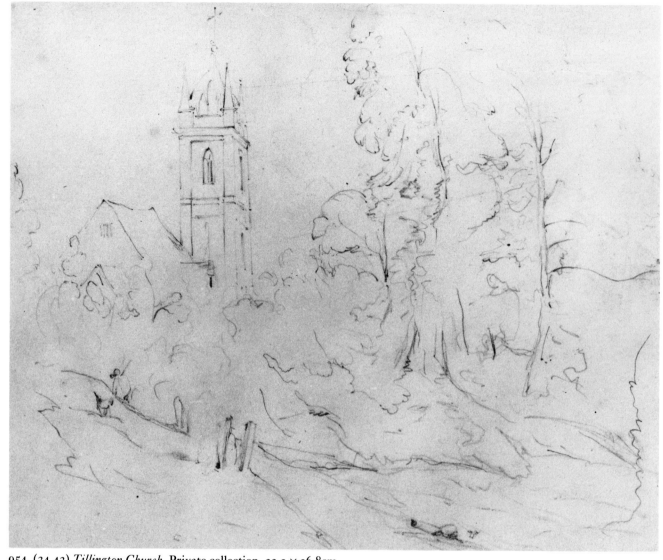

954. (34.43) *Tillington Church*, Private collection, 22.1 × 26.8cm.

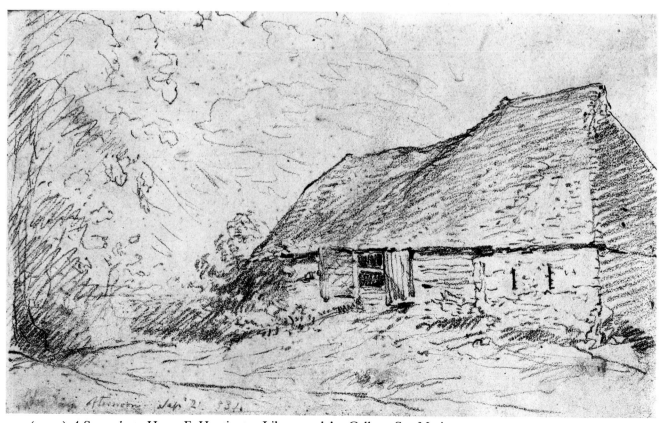

955. (34.44) *A Sussex barn*, Henry E. Huntington Library and Art Gallery, San Marino, 13 × 21.1cm.

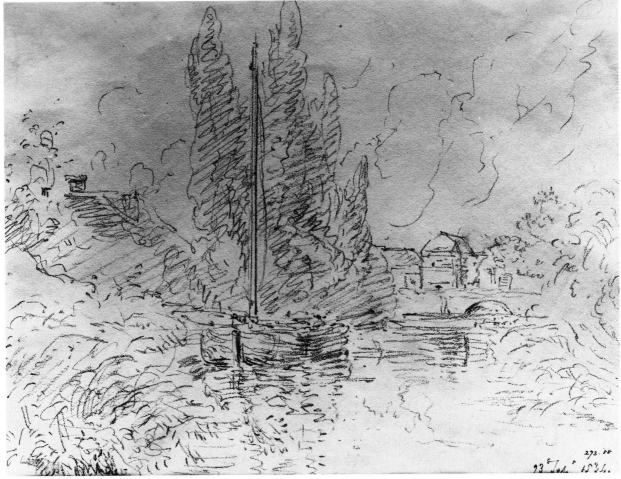

956. (34.45) *Fittleworth Mill*, Victoria and Albert Museum, 20·6 × 27·2cm.

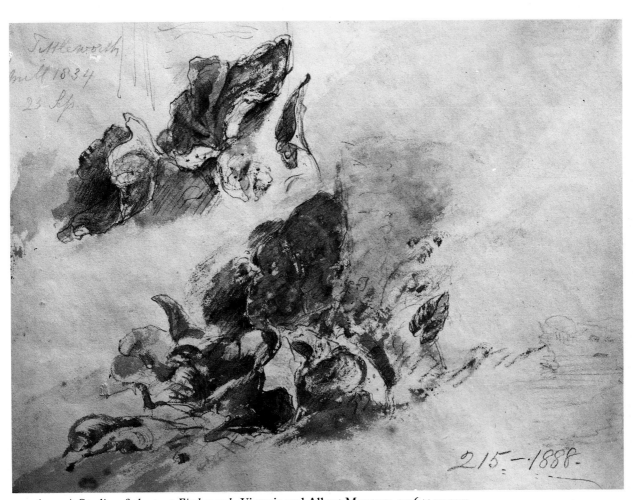

957. (34.47) *Studies of plants at Fittleworth*, Victoria and Albert Museum, 20·6 × 27·2cm.

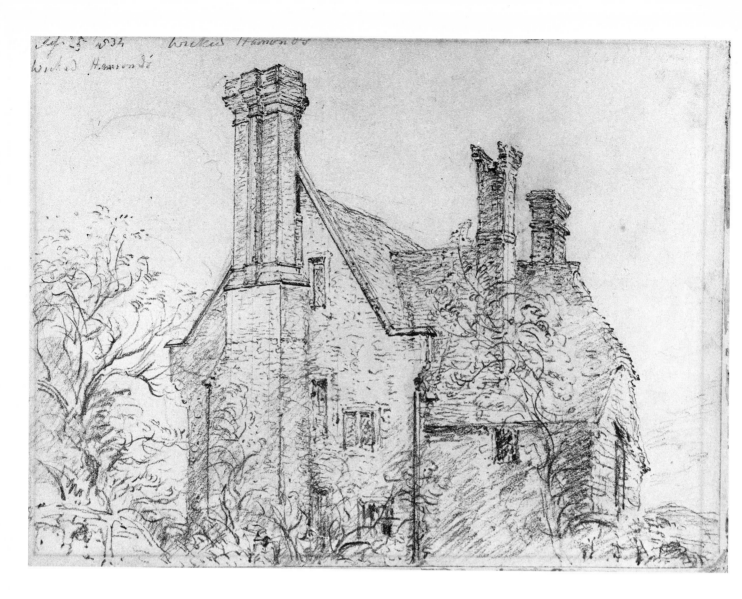

958. (above) (34.48)
*Wicked Hammond's
Farm*, The Lady Lever
Art Gallery, Port
Sunlight,
20·8 × 27·4cm.

959. (34.49) *A slight
sketch of trees*, The
Lady Lever Art
Gallery, Port Sunlight,
16 × 9cm.

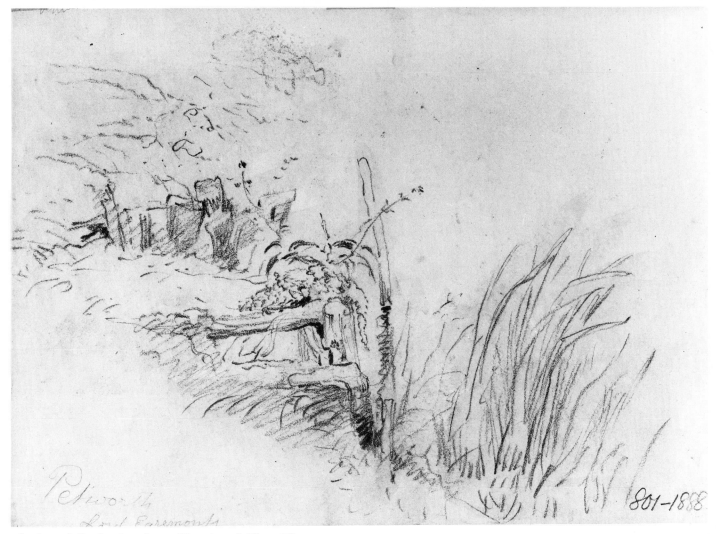

960. (34.51) *Study of weeds etc.*, Victoria and Albert Museum, 20·7 × 27·2cm.

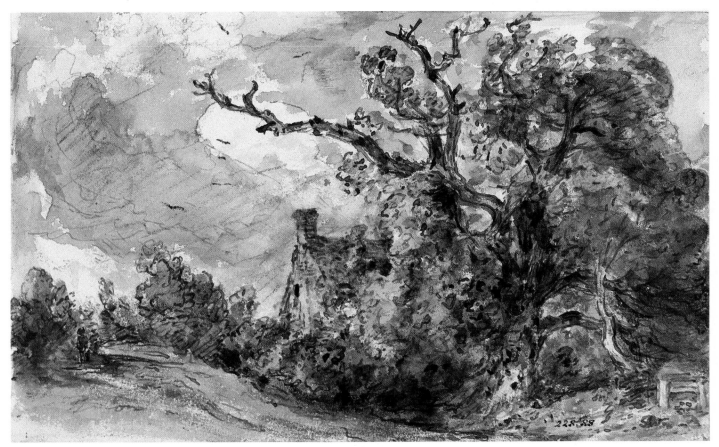

961. (34.56) *A cottage by a wood at Findon, Sussex*, Victoria and Albert Museum, 13 × 21·2cm.

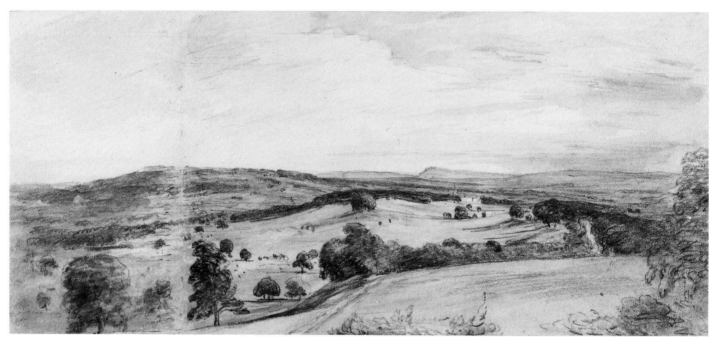

962. (34.52) *Petworth Park*, British Museum, 12·9 × 27·9cm.

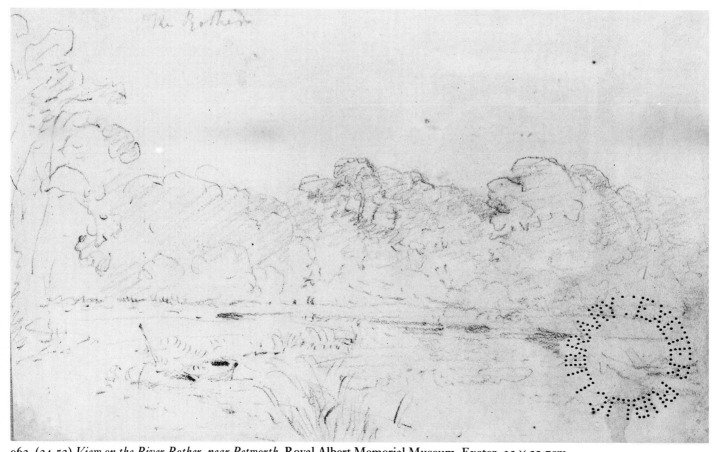

963. (34.53) *View on the River Rother, near Petworth*, Royal Albert Memorial Museum, Exeter, 13 × 20·7cm.

964. (34.54) *Cottages and church near Arundel*, Private collection, 12·9 × 20·8cm.

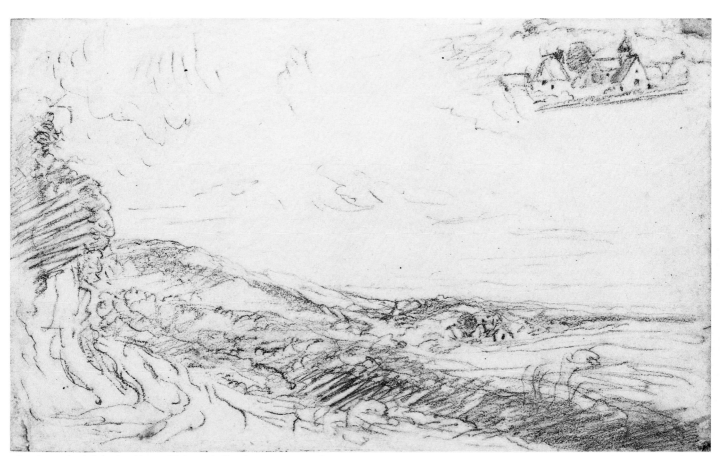

965. (34.55) *A downland scene*, Private collection, 12·9 × 20·8cm.

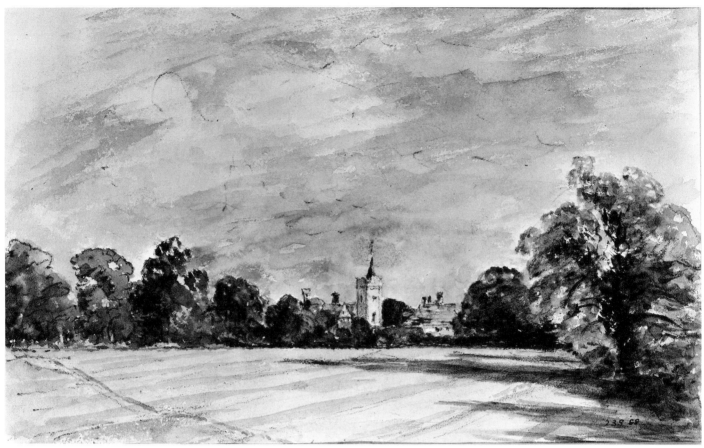

966. (34.57) *A village seen over a ploughed field,* Victoria and Albert Museum, 13 × 21·1cm.

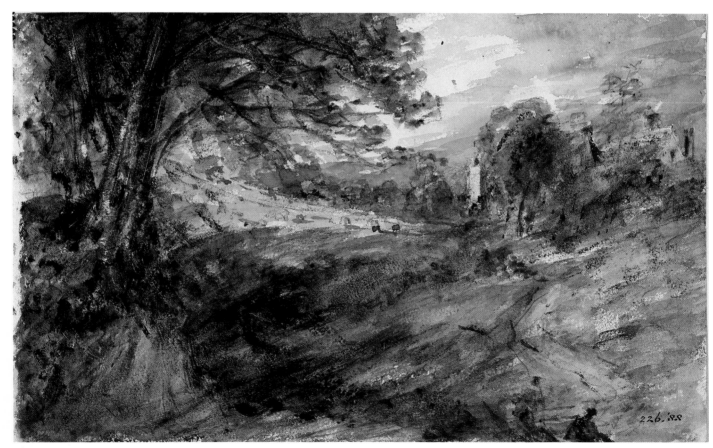

967. (34.58) *Cottages on high ground,* Victoria and Albert Museum, 13 × 21·1cm.

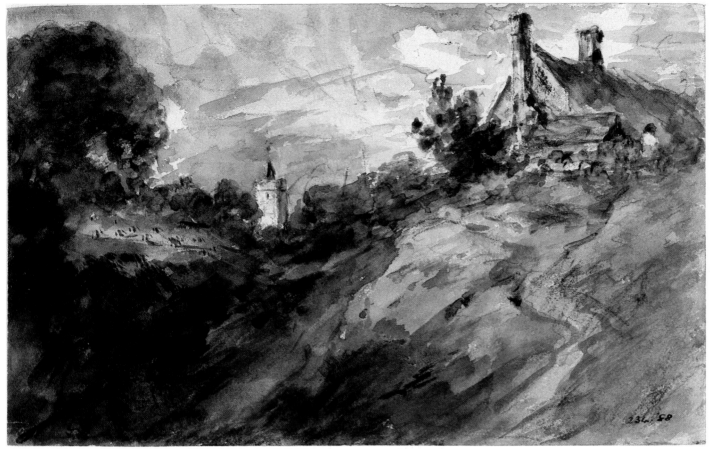

968. (34.59) *Cottages on a high bank*, Victoria and Albert Museum, 13 × 20·6cm.

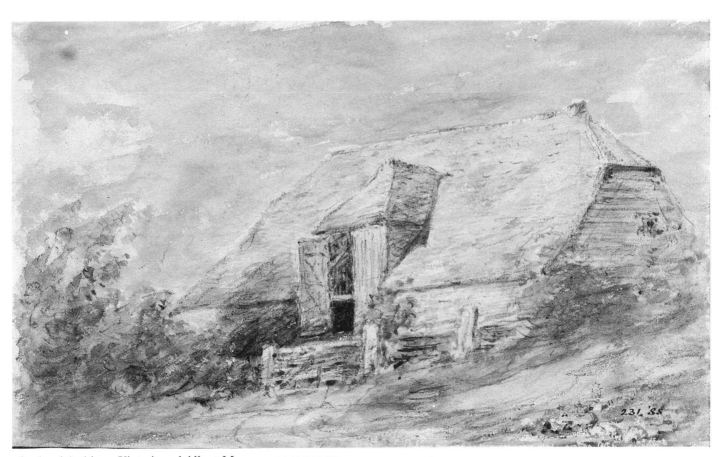

969. (34.60) *A barn*, Victoria and Albert Museum, 13 × 21·1cm.

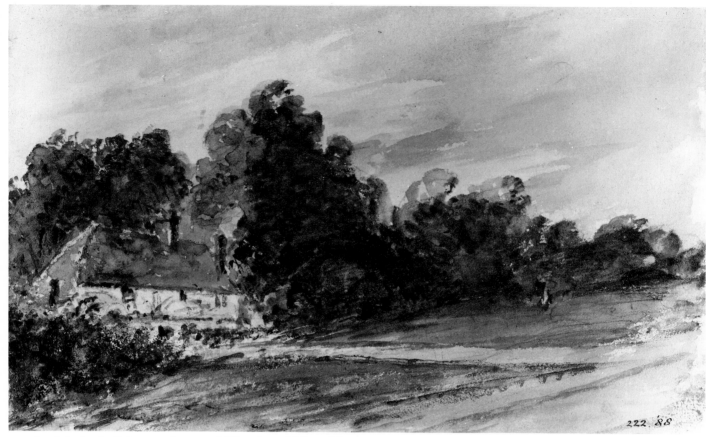

970. (34.61) *A red-tiled cottage by a wood*, Victoria and Albert Museum, 13 × 21·1cm.

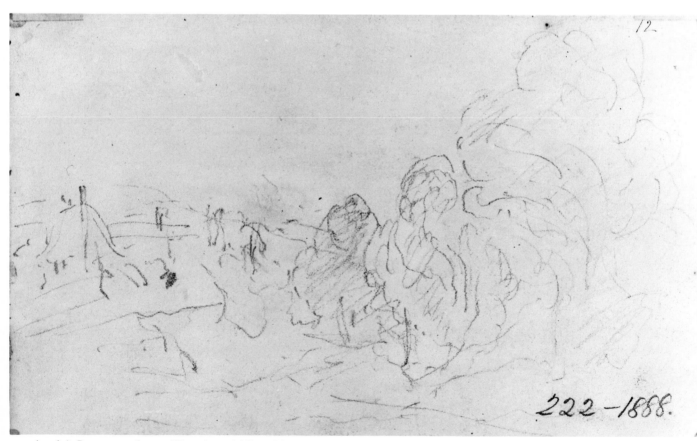

971. (34.62) *Cottages and trees*, Victoria and Albert Museum, 13 × 21·1cm.

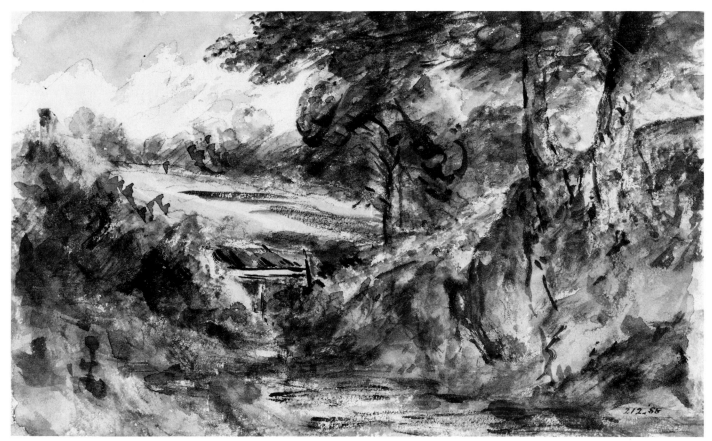

972. (34.63) *A brook with a high bank*, Victoria and Albert Museum, 13 × 21·1cm.

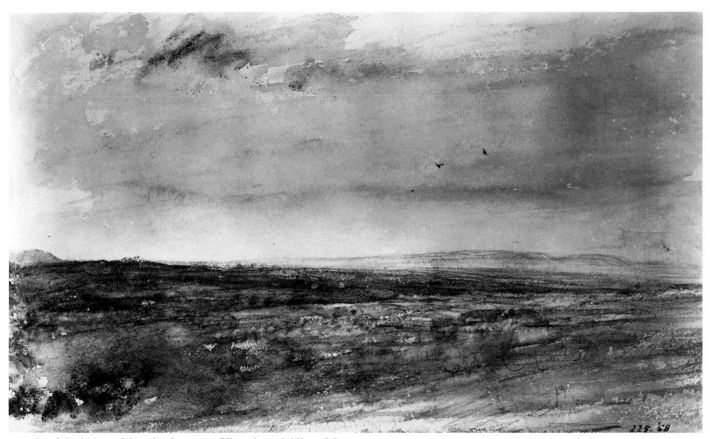

973. (34.65) *A view of downland country*, Victoria and Albert Museum, 13 × 21·1cm.

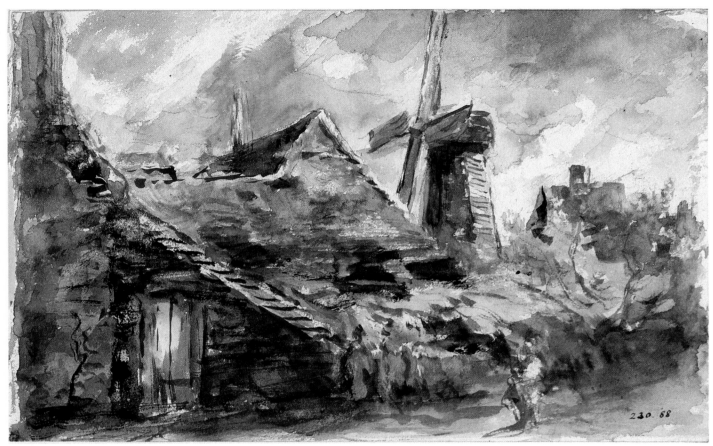

974. (34.64) *A village street with a windmill*, Victoria and Albert Museum, 13 × 21·3cm.

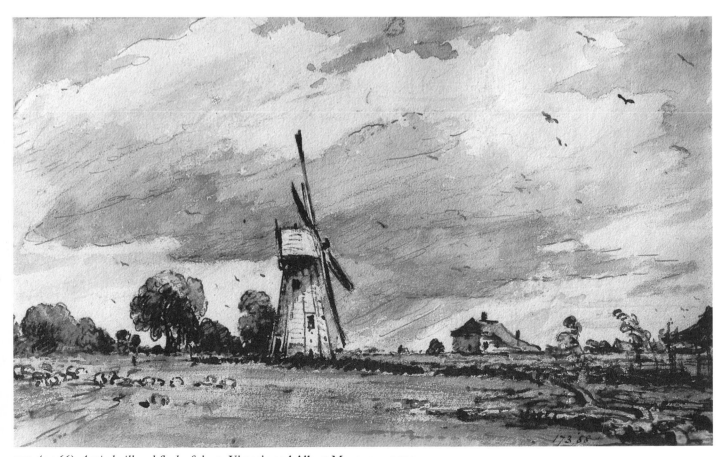

975. (34.66) *A windmill and flock of sheep*, Victoria and Albert Museum, 13 × 21·1cm.

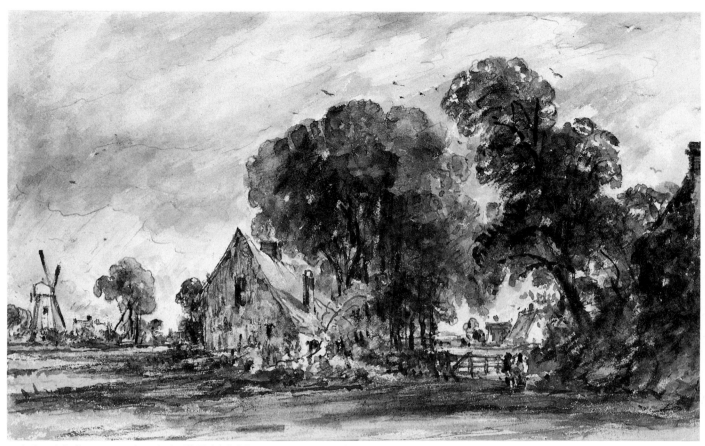

976. (34.67) *Cottages and a windmill*, British Museum, 12·7 × 20·6cm.

977. (34.68) *Landscape with trees and a cottage*, Royal Albert Memorial Museum, Exeter, 12·9 × 20·7cm.

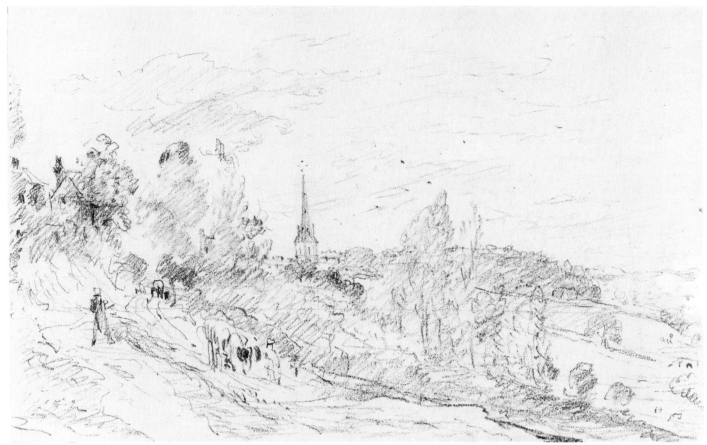

978. (34.69) *A view near Arundel*, Yale Center for British Art, New Haven, 13 × 21·1cm.

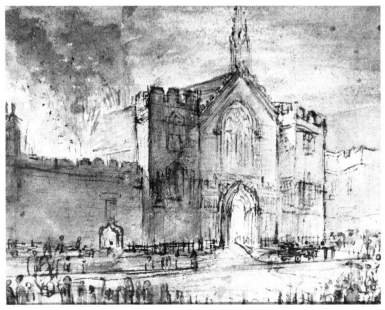

979. (34.71) *The Houses of Parliament on fire*, Executors of the late Lieutenant-Colonel J. H. Constable, 8 × 10cm.

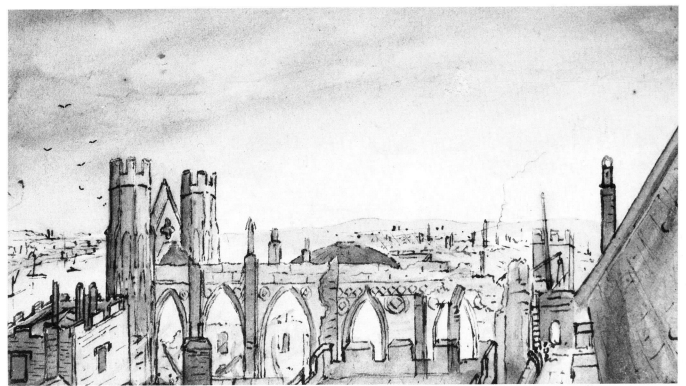

980. (34.72) *The Houses of Parliament after the fire*, Executors of the late Lieutenant-Colonel J. H. Constable, 9 × 18cm.

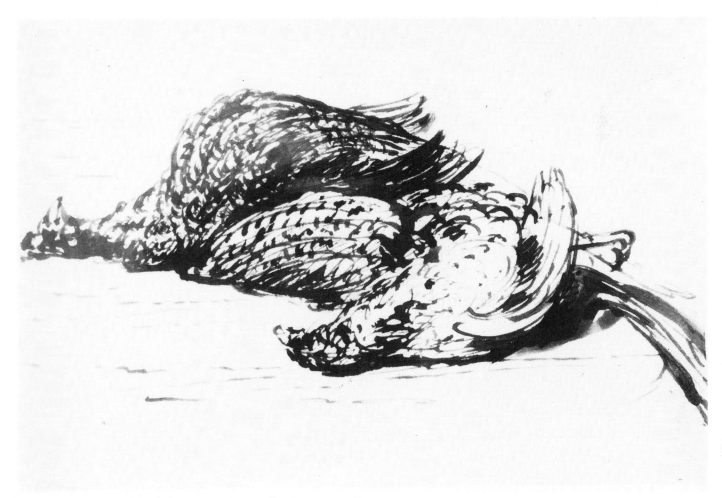

981. (34.74) *A brace of dead pheasants*, Private collection, 11·5 × 18·5cm.

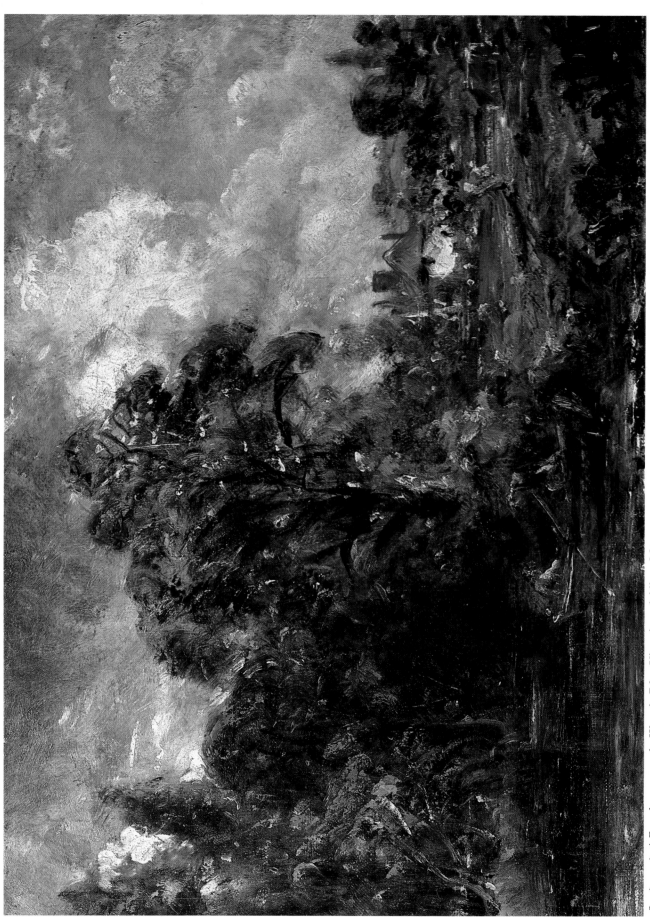

982. (34·75) *A Farmhouse near the Water's Edge*, Victoria and Albert Museum, 25·4 × 34·9cm.

983. (below) (34·76) *On the Stour: A Farmhouse near the Water's Edge*, The Phillips Collection, Washington D.C., 62 × 79cm.

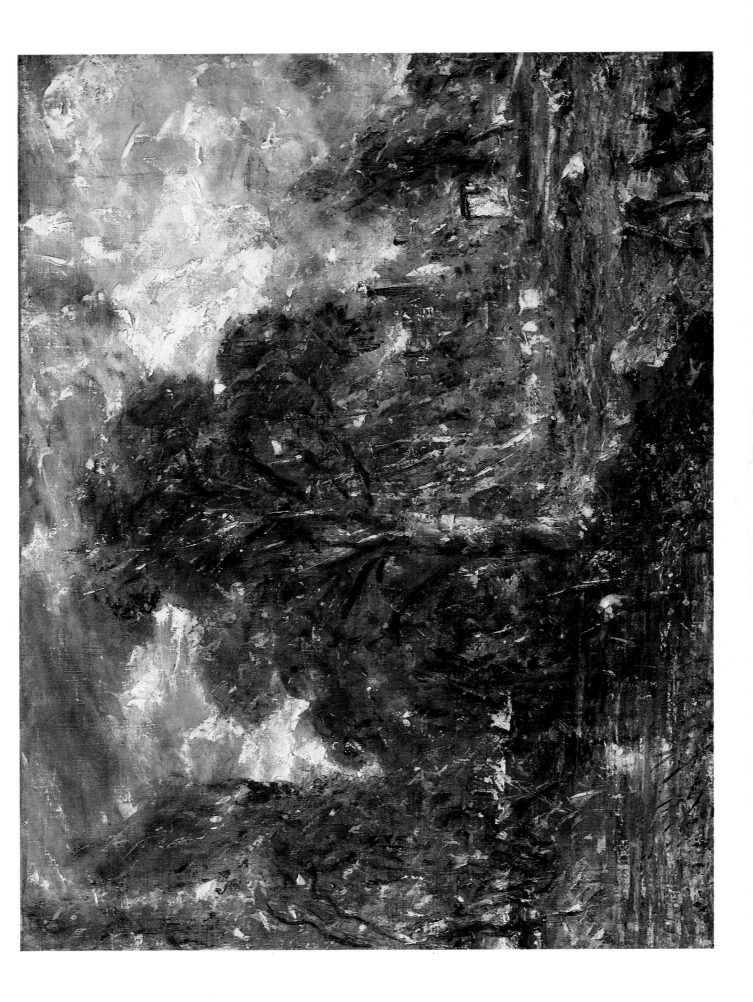

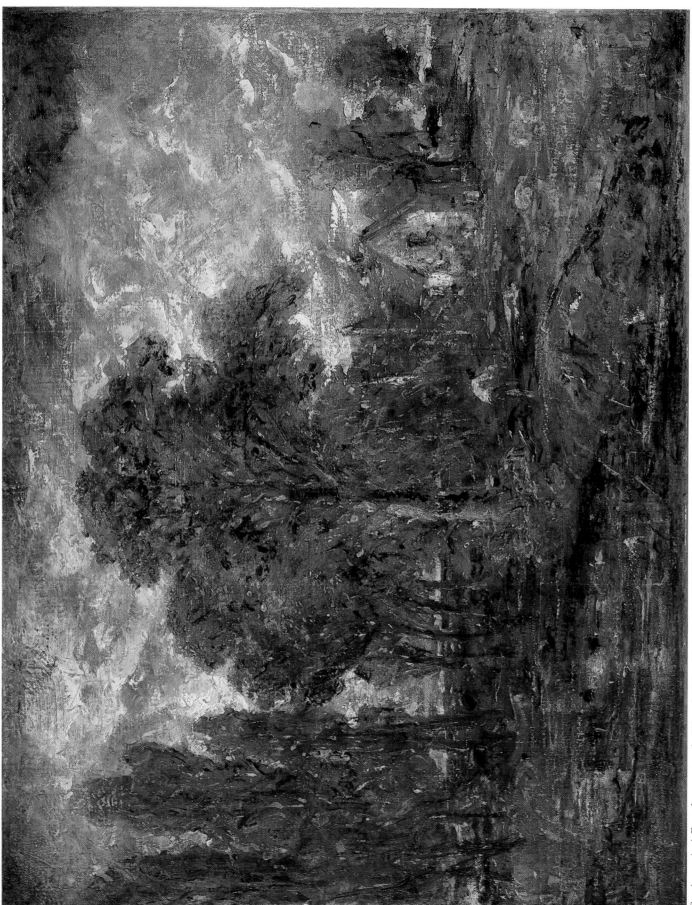

984. (34.77) *A Farmhouse near the Water's Edge*, University of California, Los Angeles, Frederick S. Wight Art Gallery, 65 × 85cm.

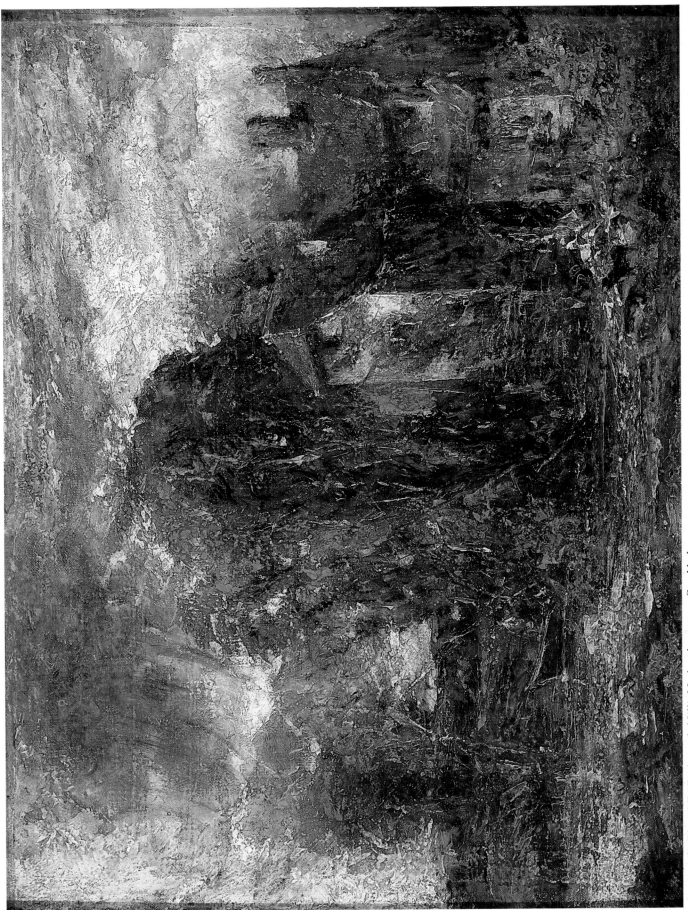

985. (34·78) *The Mill (Fittleworth Mill)*, Nationalmuseum, Stockholm, 33·5 × 44cm.

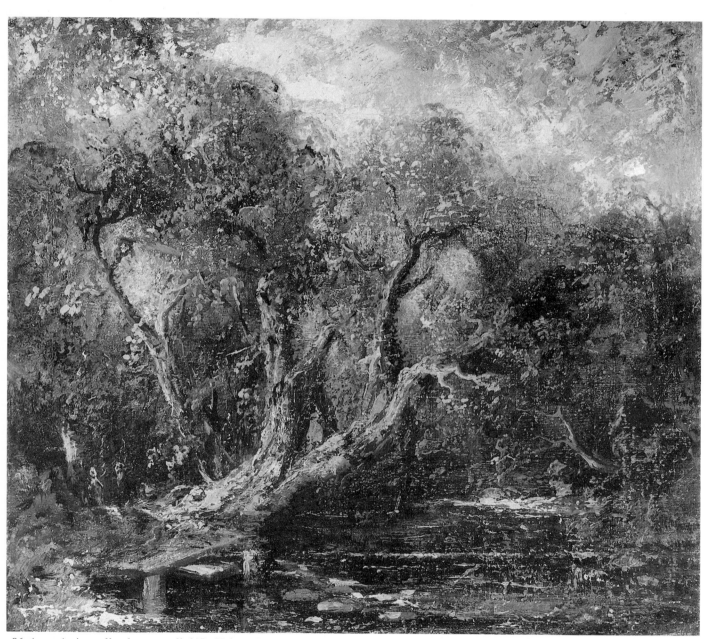

986. (34.79) *A woodland scene, called 'In Helmingham Park'*, Private collection, 39·5 × 45cm.

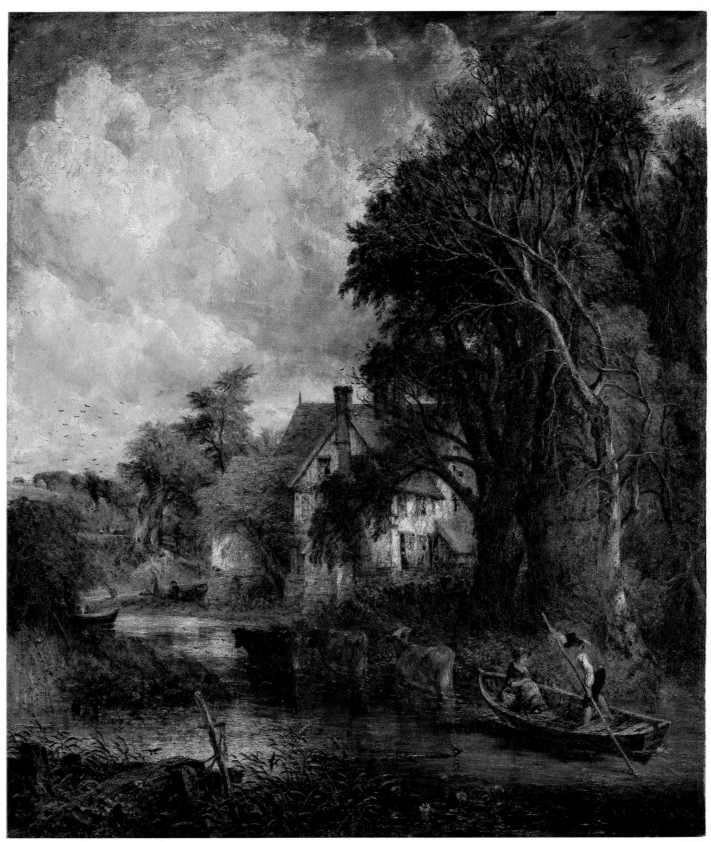

987. (35.1) *The Valley Farm*, Tate Gallery, 147·3 × 125·1cm.

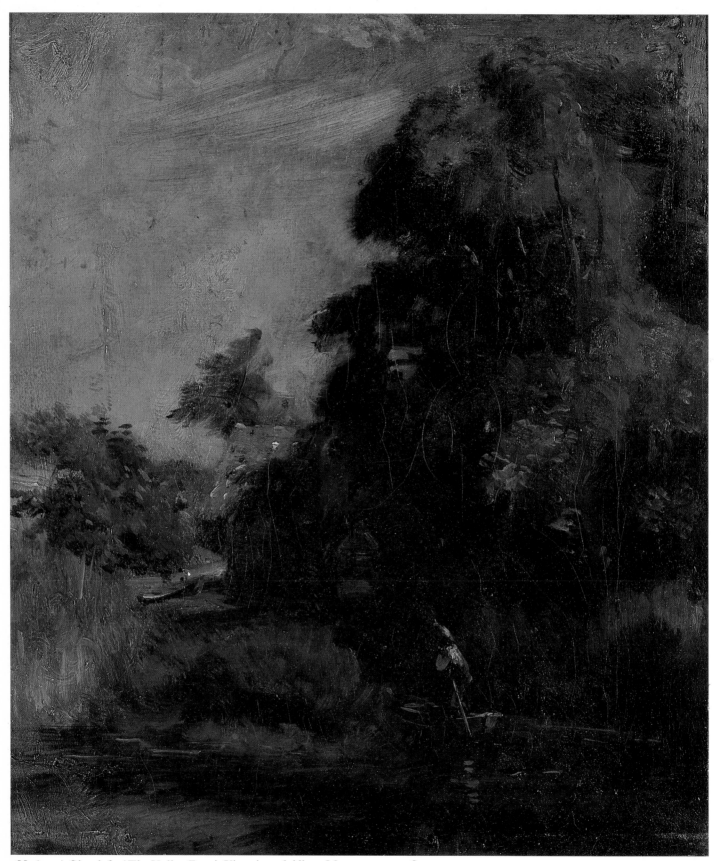

988. (35.2) *Sketch for 'The Valley Farm'*, Victoria and Albert Museum, 34 × 28cm.

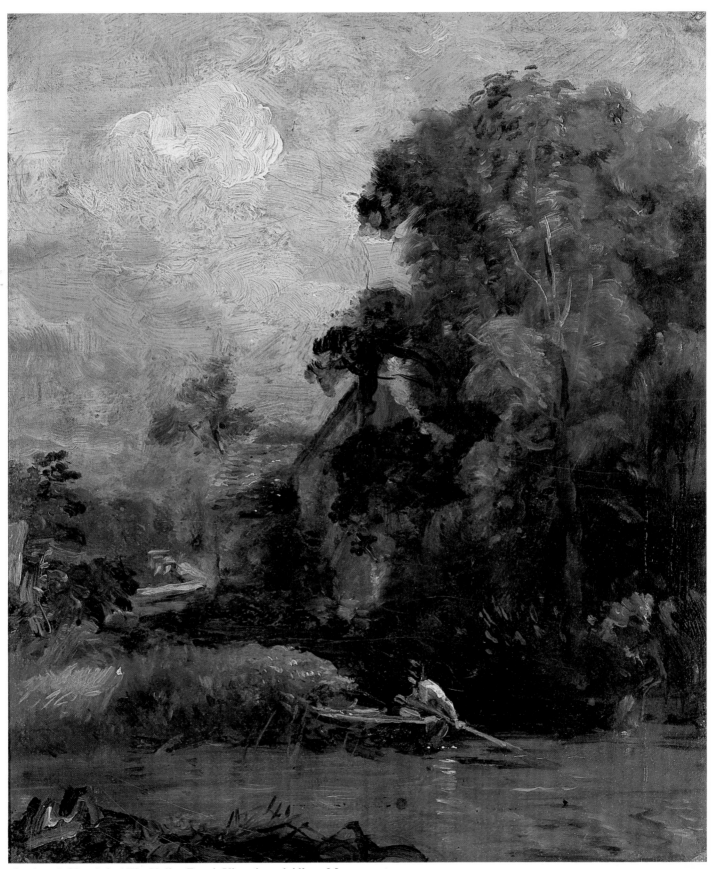

989. (35.3) *Sketch for 'The Valley Farm'*, Victoria and Albert Museum, 25·4 × 21cm.

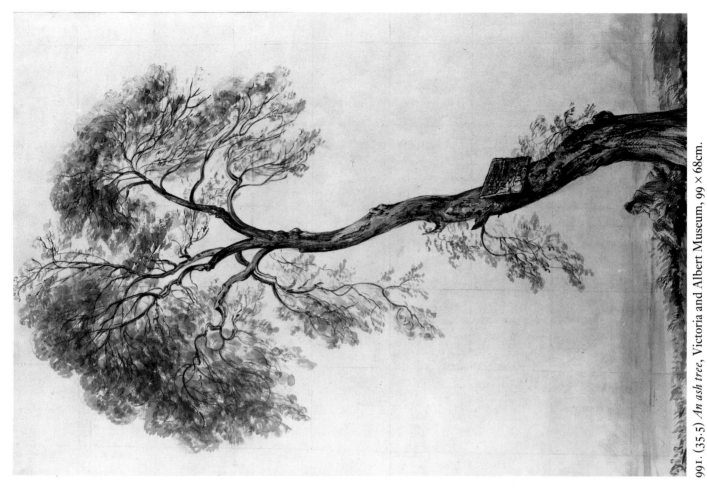

991. (35.5) *An ash tree*, Victoria and Albert Museum, 99 × 68cm.

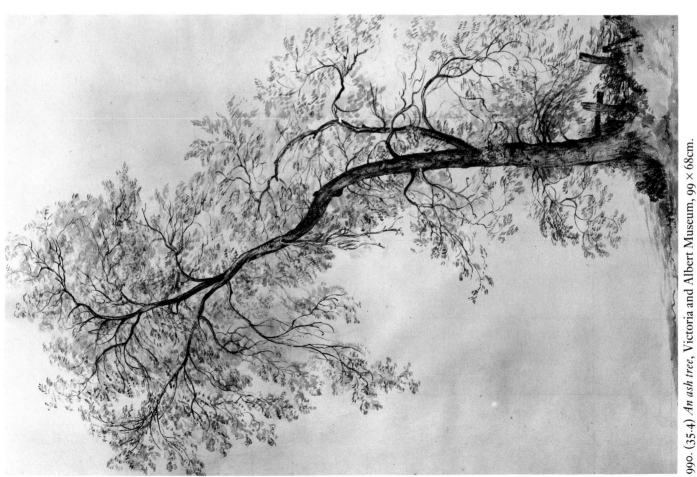

990. (35.4) *An ash tree*, Victoria and Albert Museum, 99 × 68cm.

992. (far left) (35.6) *A Suffolk child : sketch for 'The Valley Farm'*, Victoria and Albert Museum, 18·5 × 13·7cm.

993. (left) (35.7) *Sketch of 'The Valley Farm'*, Fitzwilliam Museum, Cambridge, 10·3 × 7·6cm.

994. (below) (35.8) *Ham House*, Private collection, 8·6 × 11·5cm.

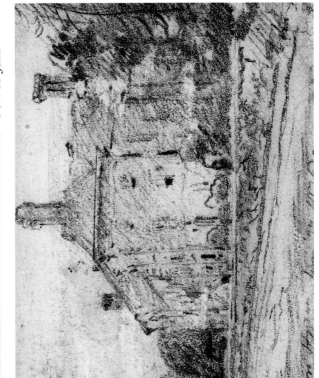

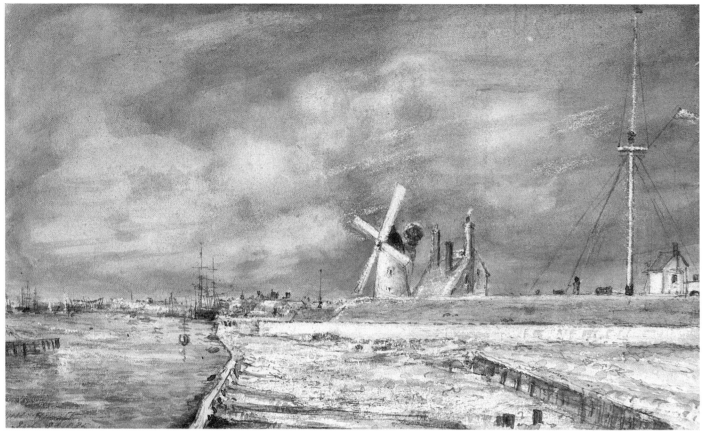

995. (35.9) *Littlehampton: stormy day*, British Museum, 11·3 × 18·5cm.

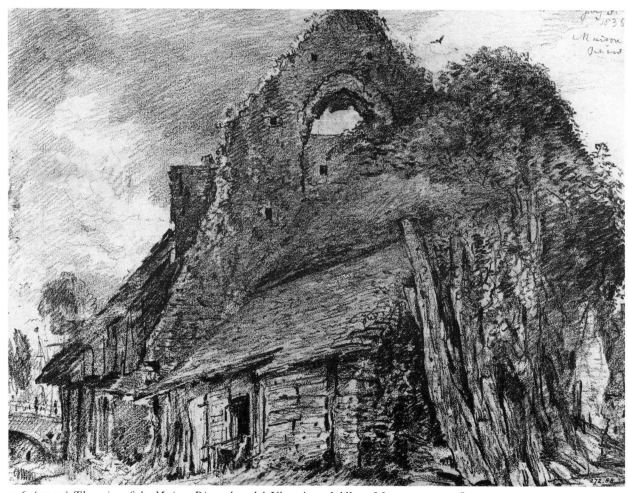

996. (35.10) *The ruins of the Maison Dieu, Arundel*, Victoria and Albert Museum, 22 × 28·1cm.

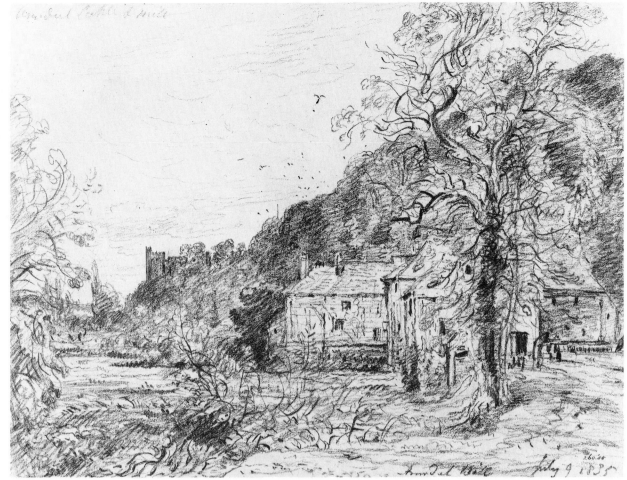

997. (35.11) *Arundel Mill and Castle*, Victoria and Albert Museum, 21·9 × 28·1cm.

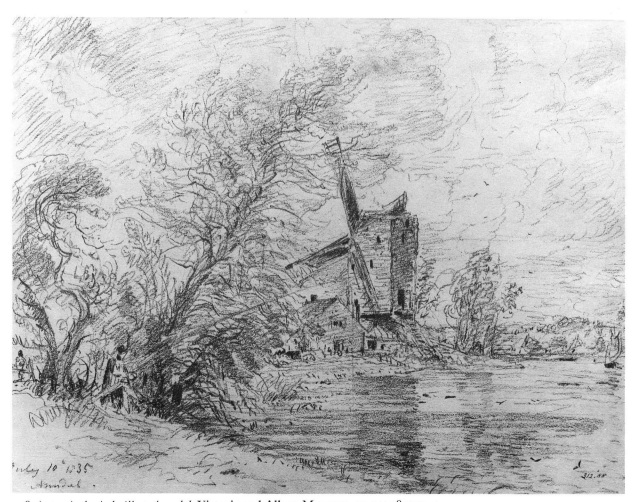

998. (35.12) *A windmill at Arundel*, Victoria and Albert Museum, 22·1 × 28·5cm.

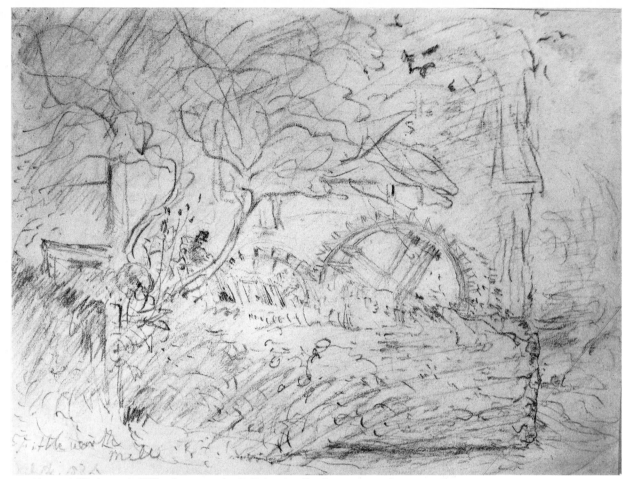

999. (35.13) *Fittleworth Mill: the waterwheels*, Private collection, 22·1 × 28·7cm.

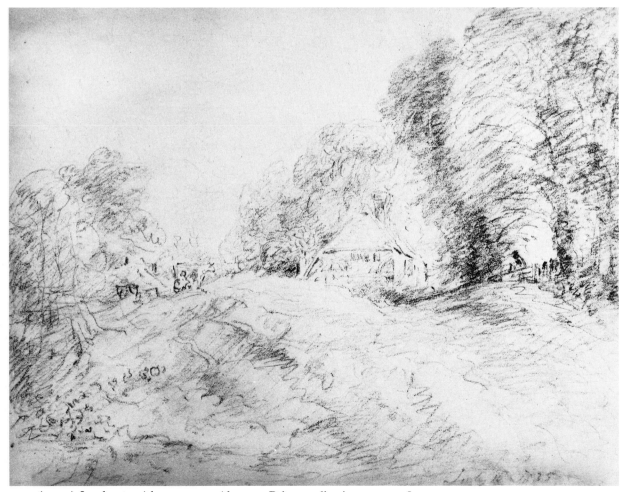

1000. (35.15) *Landscape with a cottage amidst trees*, Private collection, 22·2 × 28cm.

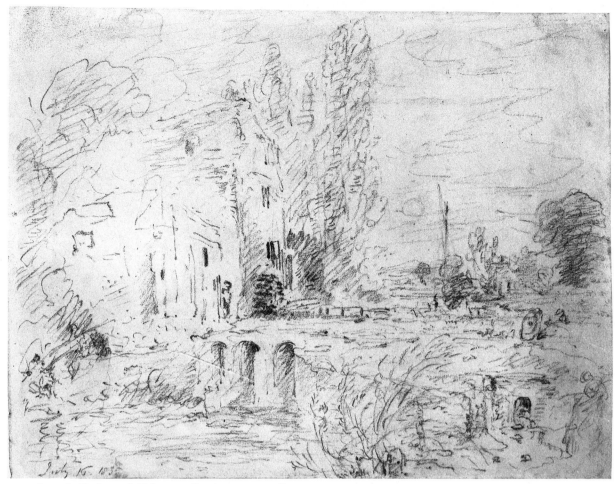

1001. (35.16) *Fittleworth*, Private collection, 22·1 × 28·5cm.

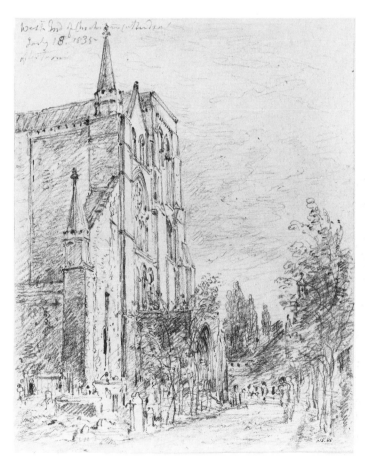

1002. (35.17) *Chichester Cathedral*, Victoria and Albert Museum, 28·7 × 22·1cm.

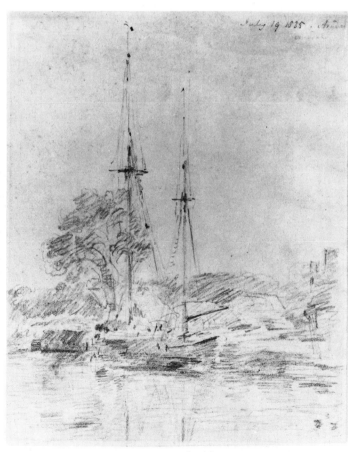

1003. (35.18) *Boats on the river at Arundel*, Private collection, 28·5 × 22cm.

1004–28. (35.19) *Intact sketch-book used in 1835,* Victoria and Albert Museum, 11·5 × 18·8cm.

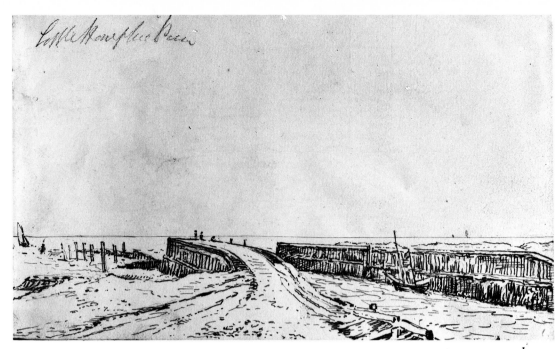

1004. (p. 1) *A view of the sea with wooden jetties in the foreground.*

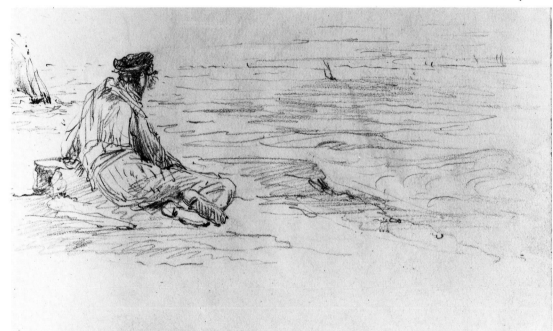

1005. (p. 3) *A man seen from behind lying on the seashore and looking out to sea, where boats are to be seen.*

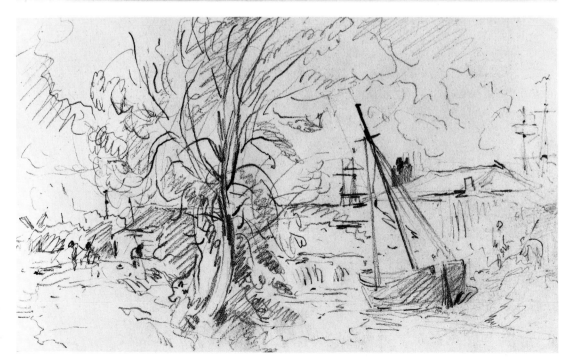

1006. (p. 5) *A view of a seaside village: a tree in the foreground, and buildings beyond, with a boat in a creek or basin to the right and the masts of other shipping beyond the buildings.*

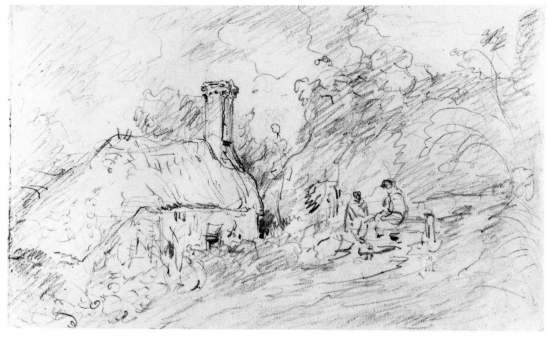

1007. (p. 7) *Left, a thatched cottage with a high chimney; right, figures seated on a stile or gate in the road, and trees beyond.*

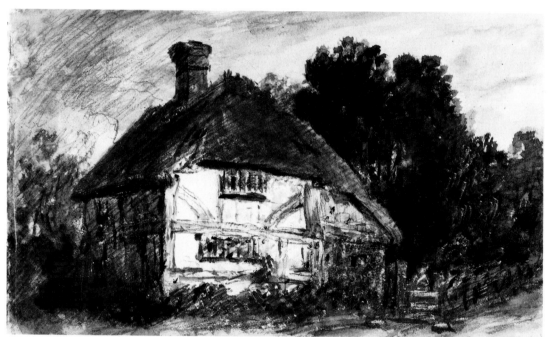

1008. (p. 9) *A thatched half-timbered cottage with a high chimney, and trees beyond.*

1009. (p. 13) *A chalk bank in Middleton churchyard, with the form of a skeleton in it.*

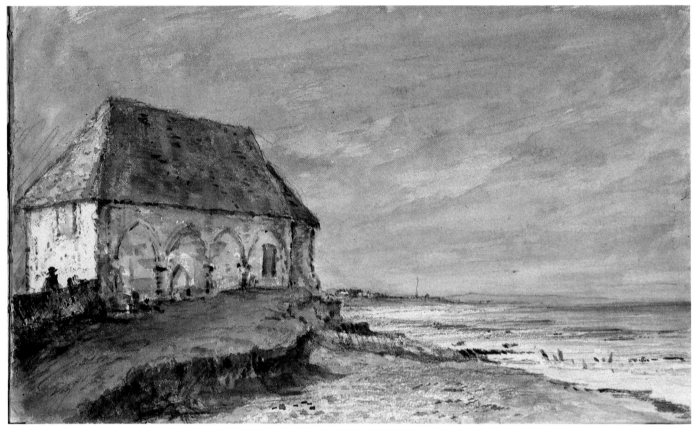

1010. (p. 11) *Middleton Church.*

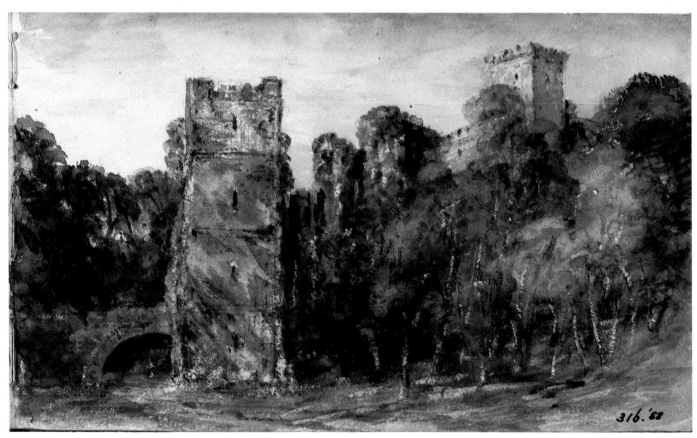

1011. (p. 17) *View in the grounds of Arundel Castle: in the centre foreground a square tower beside a bridge; on a ridge to right, above trees, another part of the castle.*

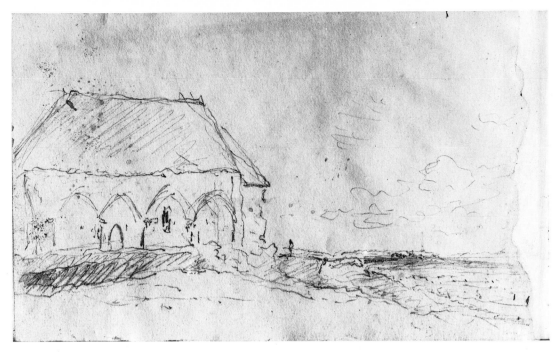

1012. (p. 14) *Middleton Church.*

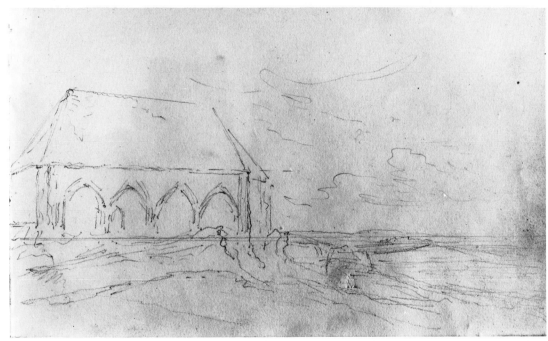

1013. (p. 15) *Middleton Church.*

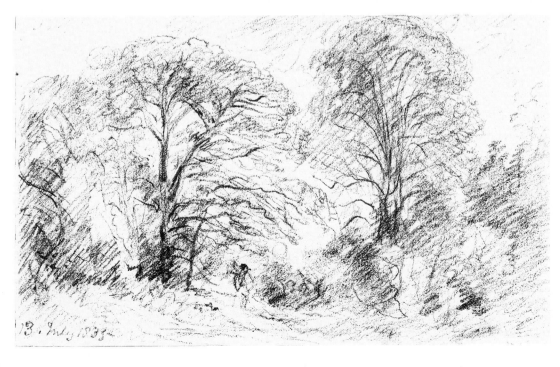

1014. (p. 19) *A woodland scene at Arundel : the sun setting between two trees.*

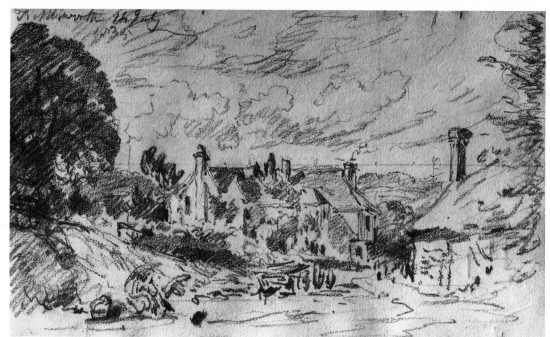

1015. (p. 21) *Fittleworth:
a village street.*

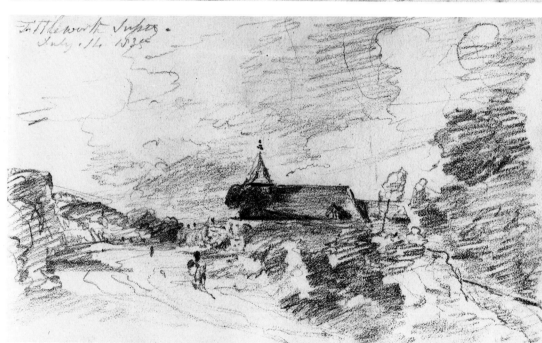

1016. (p. 23) *Fittleworth:
the village street with the
church on the right.*

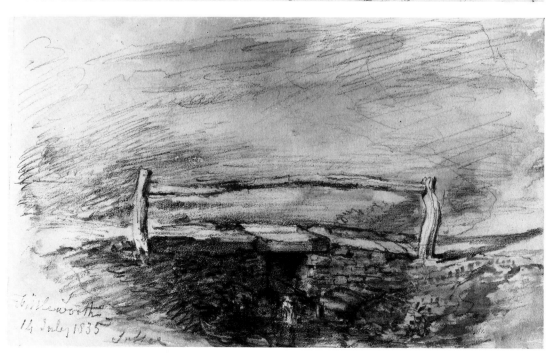

1017. (p. 25) *A small
bridge with a wooden
hand-rail over a stream.*

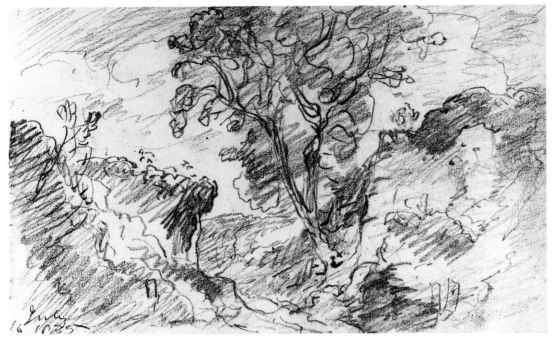

1018.(p. 27) *A lane between steep banks with a tree growing on the right.*

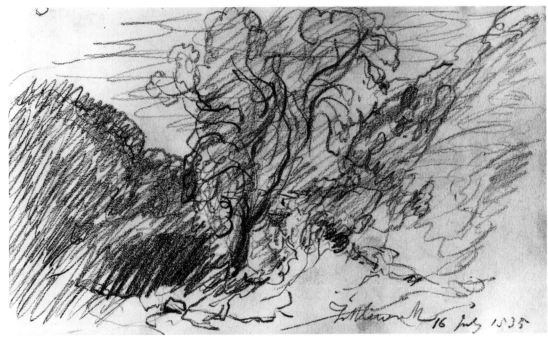

1019. (p. 29) *A tree growing in a hollow.*

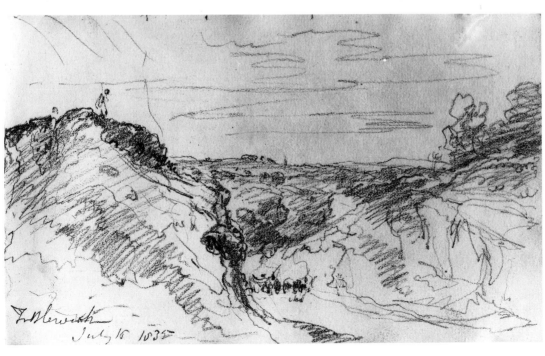

1020. (p. 31) *A sunken road, with a cart on it; left, a high bank with a figure at the top.*

1021. (p. 32) *Arundel Castle seen above trees.*

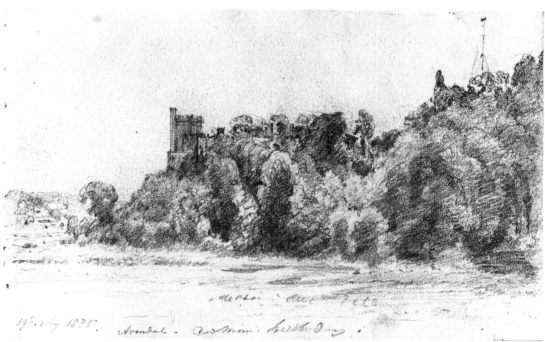

1022. (p. 33) *Arundel Castle.*

1023. (p. 35) *Arundel Castle seen above trees.*

1024. (p. 36) *A sketch of three cows.*

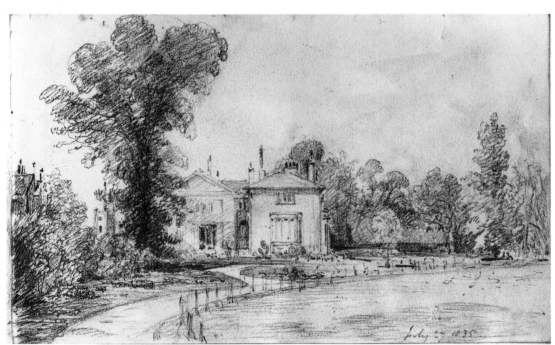

1025. (p. 37) *Canbury House, Kingston-upon-Thames: an Italianate villa seen from the garden, with a church tower beyond on left.*

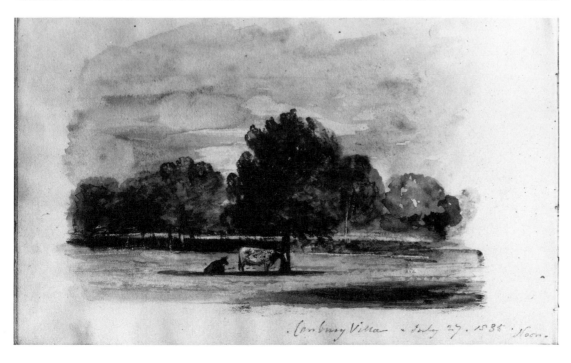

1026. (p. 48) *Two cows in the shade of a tree in a park.*

1027. (p. 46) *A small parrot perched on a gloved hand, eating.*

1028. (p. 50) *Two sketches on one page : a rough sketch of foliage ; a peacock on a mound.*

1029. (35.20) *A farmhouse with a thatched outbuilding*, Royal Albert Memorial Museum, Exeter, 11·2 × 18·8cm.

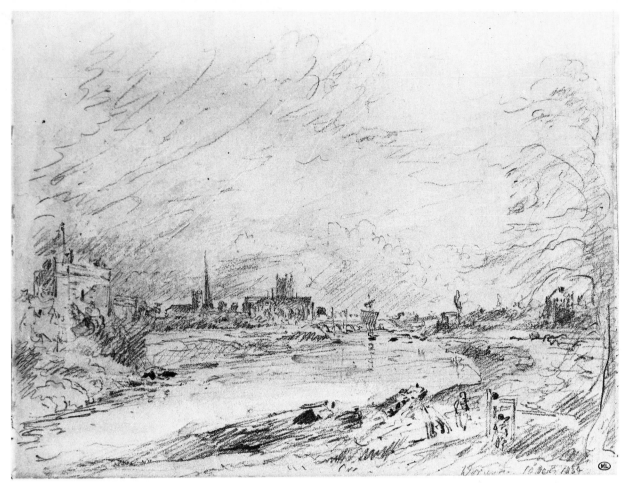

1030. (35.21) *Worcester*, Musée du Louvre, 22·3 × 29·2cm.

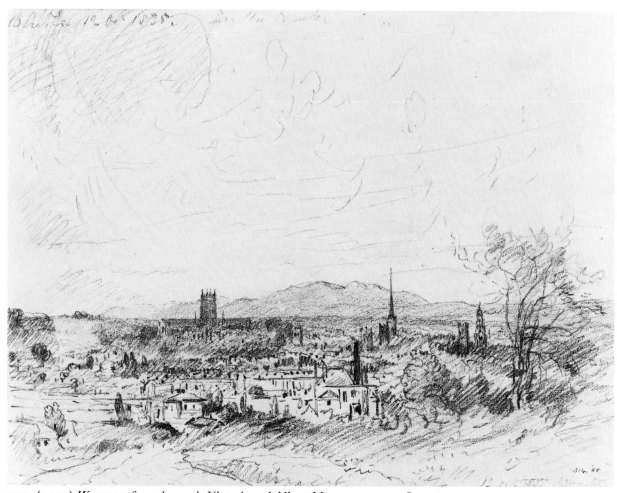

1031. (35.22) *Worcester from the north*, Victoria and Albert Museum, 22·1 × 28·4cm.

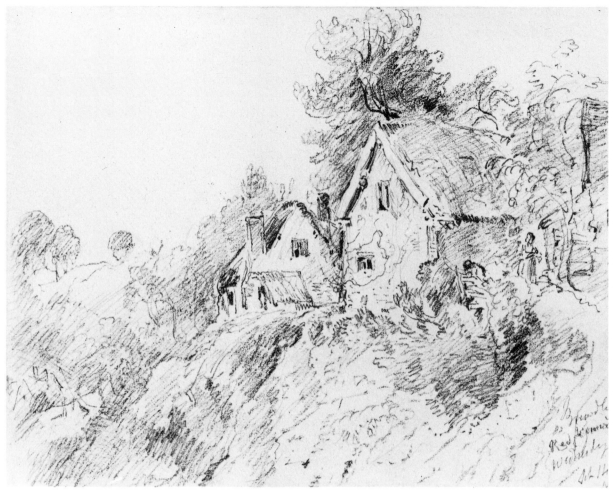

1032. (35.23) *Cottages near Bewdley*, City Museums and Art Gallery, Birmingham, 21·6 × 28·4cm.

1033. (35.24) *A plough at Bewdley*, Victoria and Albert Museum, 20·7 × 28·7cm.

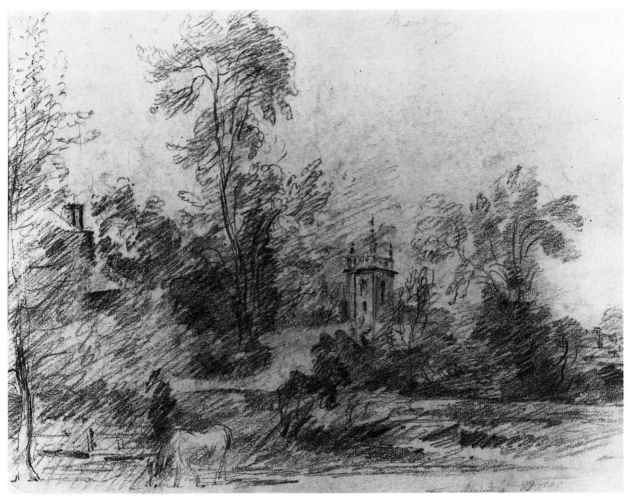

1034. (35.25) *View at Bewdley*, Ashmolean Museum, Oxford, 22 × 28cm.

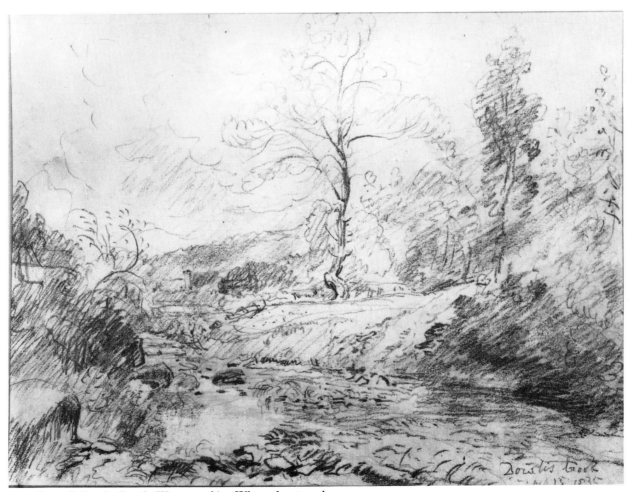

1035. (35.26) *Bowles Brook, Worcestershire*, Whereabouts unknown.

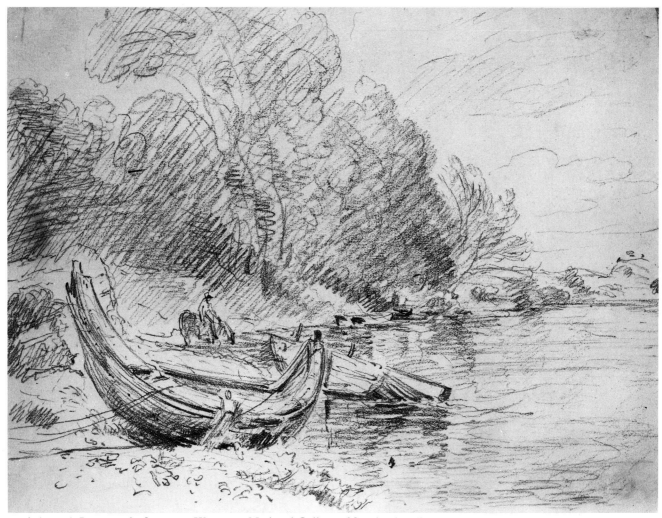

1036. (35.27) *Boats on the Severn at Worcester*, National Gallery of Scotland, Edinburgh, 21·8 × 28cm.

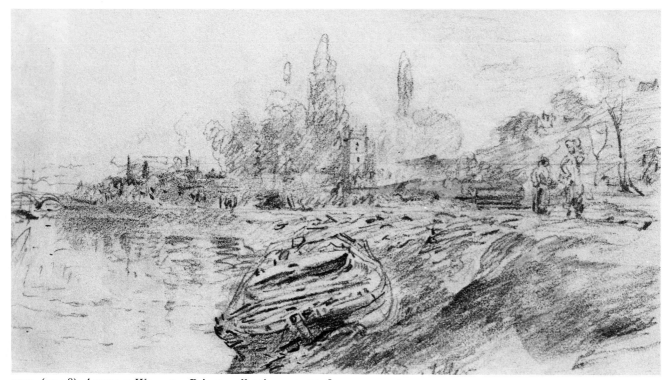

1037. (35.28) *A scene at Worcester*, Private collection, 15·7 × 28cm.

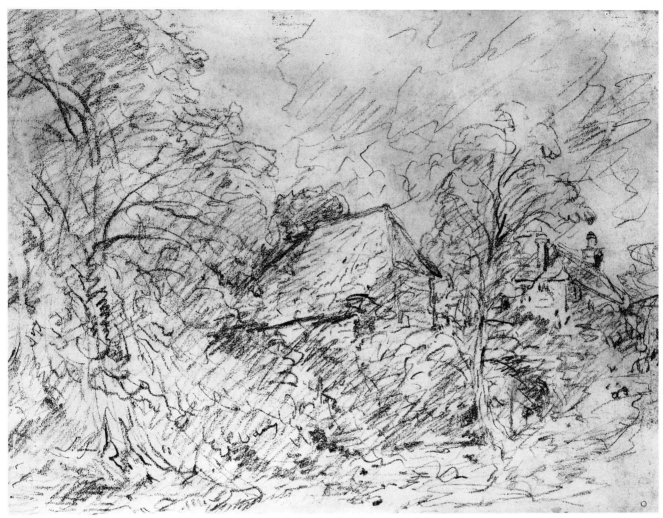

1038. (35.29) *A barn amid trees with a house beyond it*, Private collection, 22 × 26·8cm.

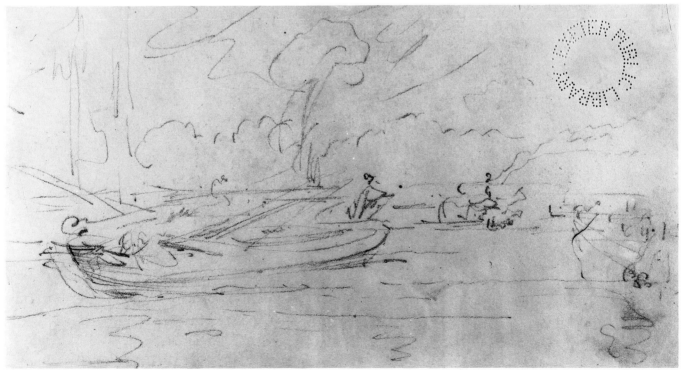

1039. (35.31) *Barges on a river*, Royal Albert Memorial Museum, Exeter, 15·6 × 28·5cm.

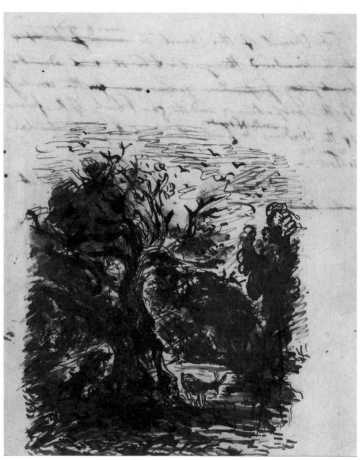

1040. (35.30) *A landscape with cottages*, Private collection, 13·8 × 15·1cm.

1041. (35.32) *Jaques and the wounded stag*, British Museum, 22·2 × 18·1cm.

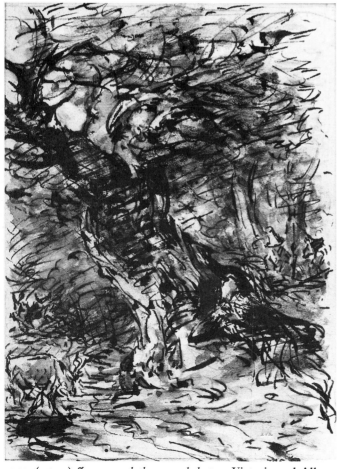

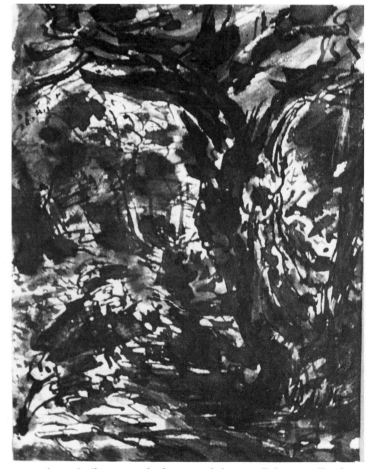

1042. (35.33) *Jaques and the wounded stag*, Victoria and Albert Museum, 14·9 × 10·7cm.

1043. (35.34) *Jaques and the wounded stag*, Private collection, 14·2 × 10·6cm.

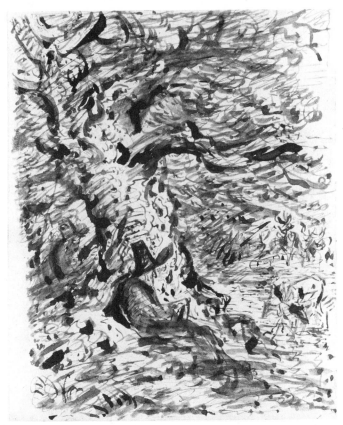

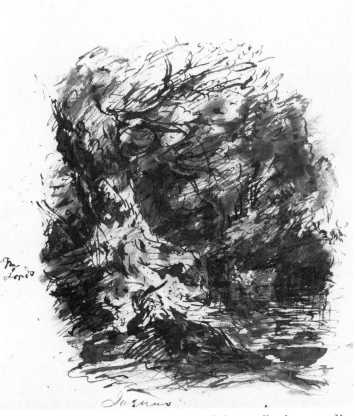

1044. (35.35) *Jaques and the wounded stag.* Private collection, 14·3 × 11·4cm.

1045. (35.37) *Jaques and the wounded stag,* Private collection, 9 × 7⅜in.

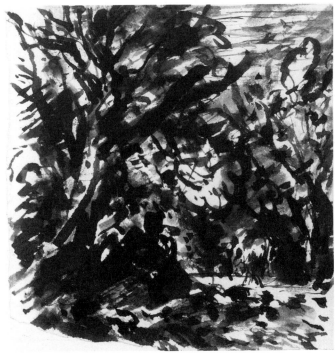

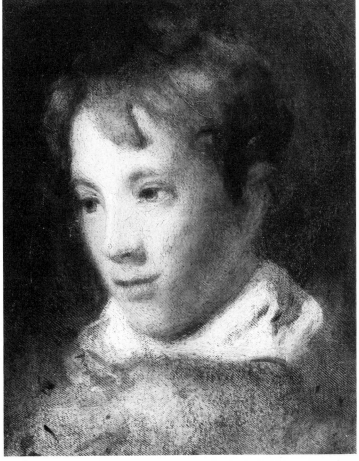

1046. (35.38) *Jaques and the wounded stag,* Private collection, 10·3 × 10·8cm.

1047. (35.39) *John Charles Constable,* Private collection, 38·7 × 30·5cm.

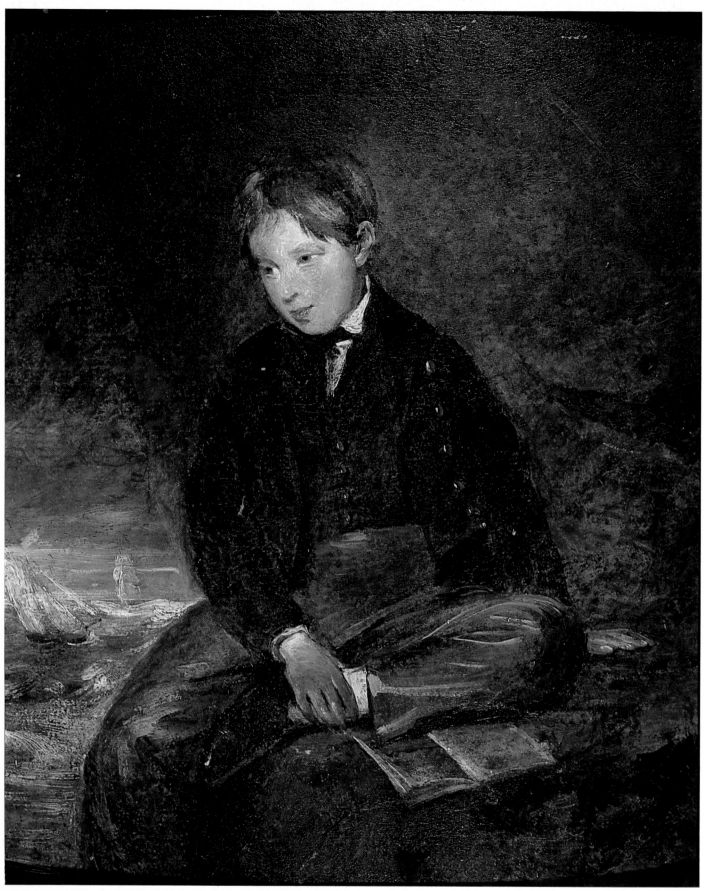

1048. (35.40) *Charles Golding Constable*, Private collection, 38 × 30·5cm.

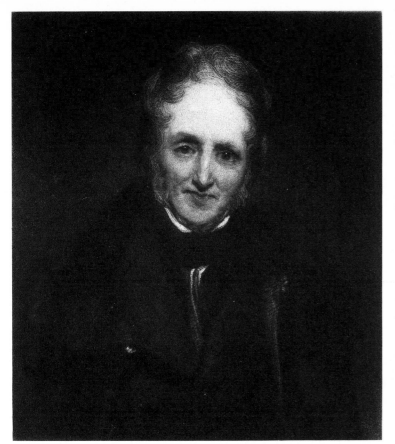

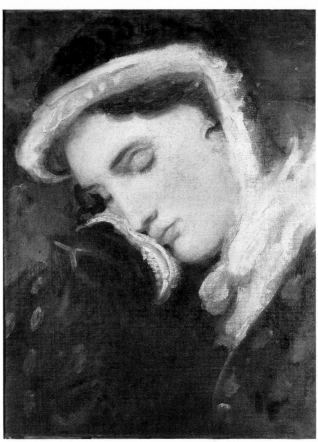

1049. (35·41) *George Field*, Whereabouts unknown (reproduced from the mezzotint).

1050. (35.42) *Supposed portrait of Ann Gubbins asleep*, Private collection, 47·5 × 34·9cm.

1051. (36.2) *The head of a stag*, National Gallery, London, 13·6 × 11cm.

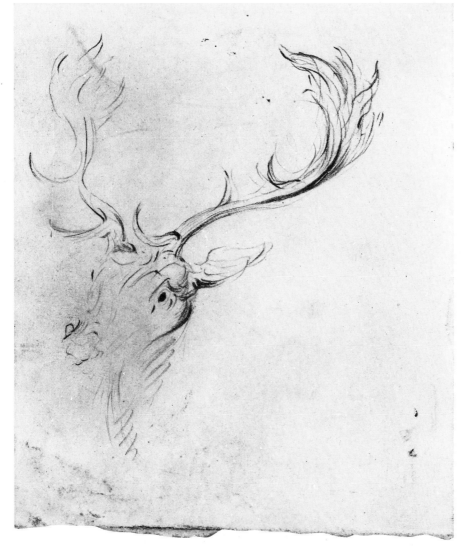

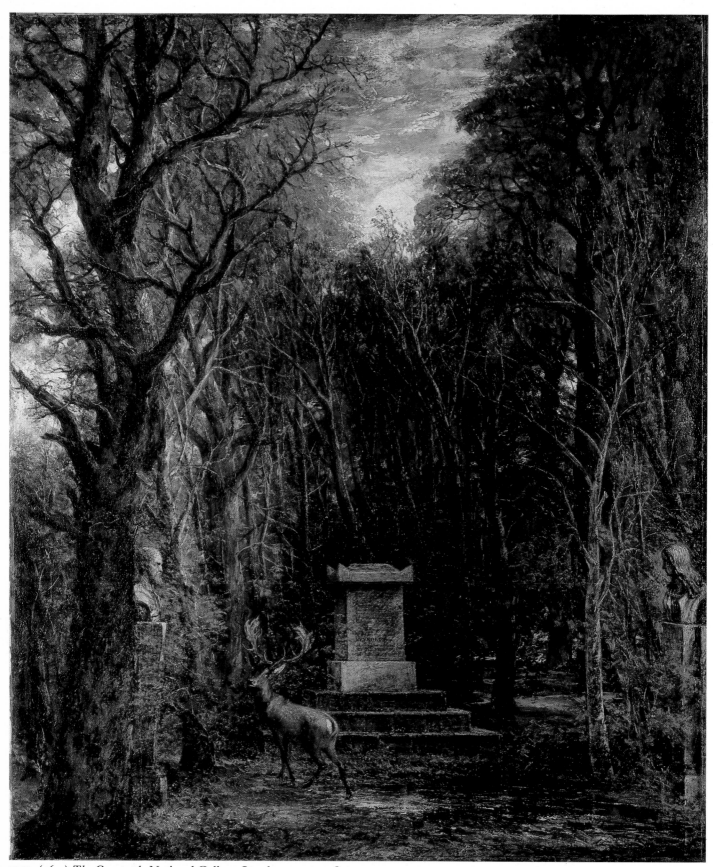

1052. (36.1) *The Cenotaph*, National Gallery, London, 132 × 108·5cm.

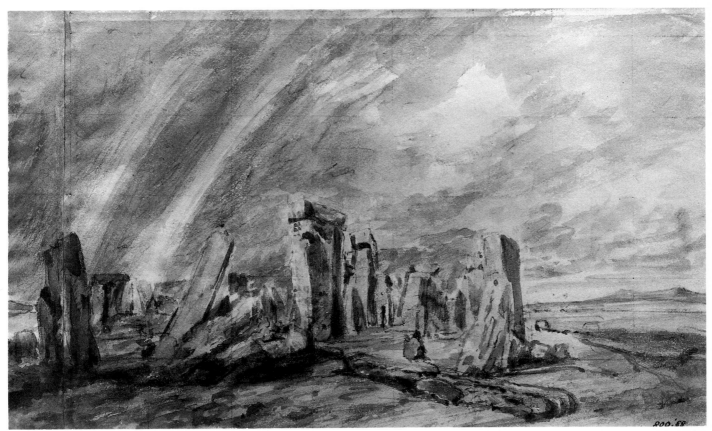

1053. (36.4) *Stonehenge*, Victoria and Albert Museum, 15·4 × 25·3cm.

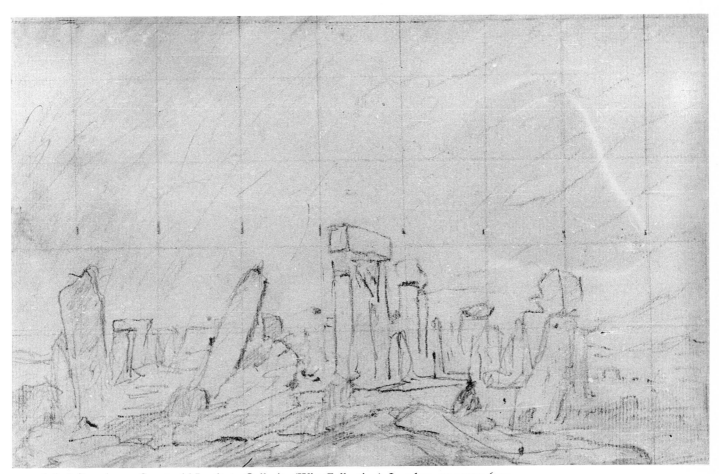

1054. (36·5) *Stonehenge*, Courtauld Institute Galleries (Witt Collection), London, 15·1 × 23·6cm.

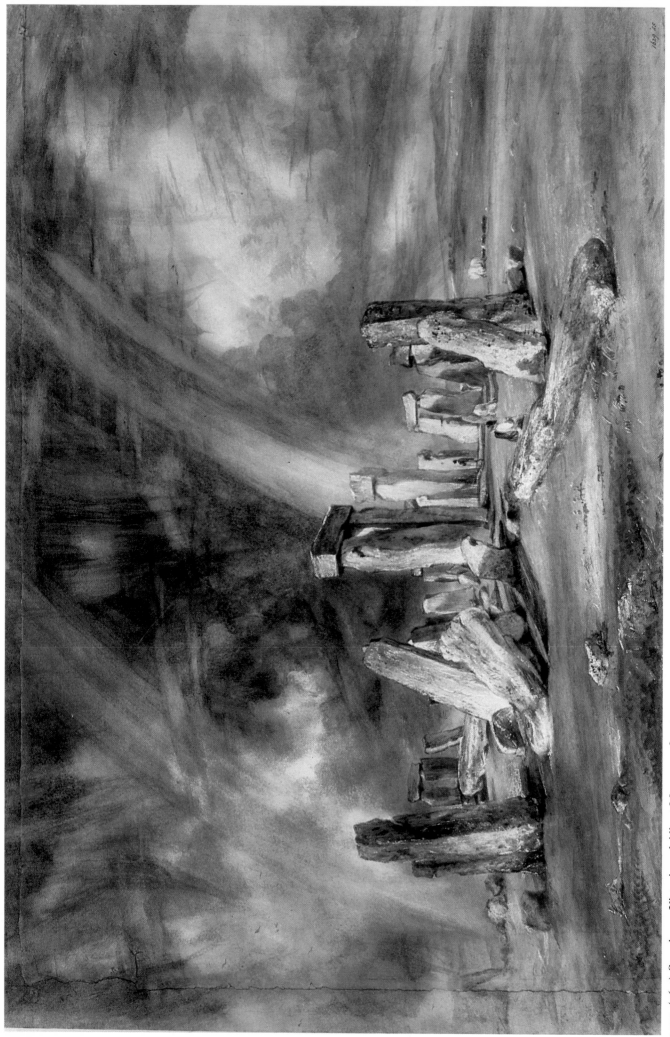

1055. (36.3) *Stonehenge*, Victoria and Albert Museum, 38·7 × 59·1 cm.

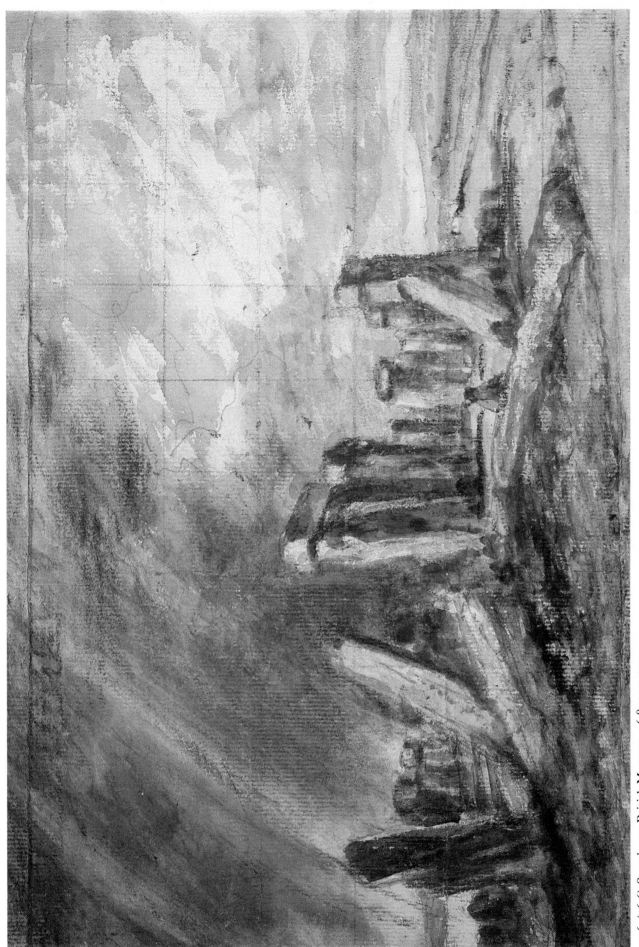

1056. (36.6) *Stonehenge*, British Museum, 16·8 × 24·9cm.

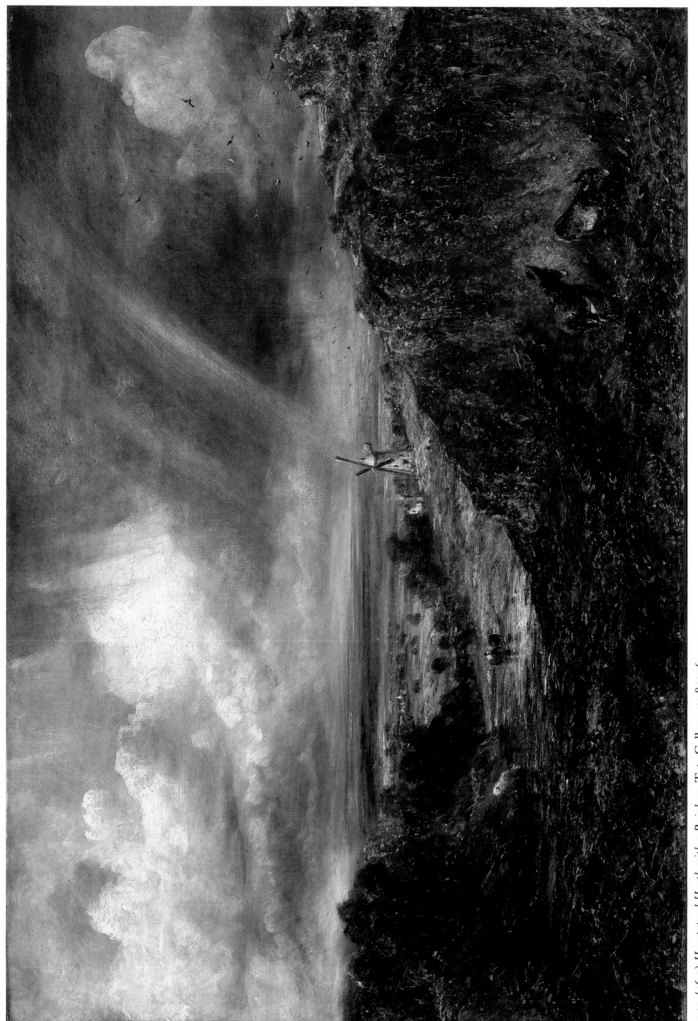

1057. (36.7) *Hampstead Heath with a Rainbow*, Tate Gallery, 50·8 × 76·2cm.

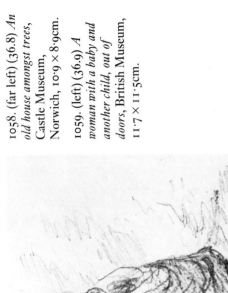

1058. (far left) (36.8) *An old house amongst trees,* Castle Museum, Norwich, 10·9 × 8·9cm.

1059. (left) (36.9) *A woman with a baby and another child, out of doors,* British Museum, 11·7 × 11·5cm.

1060. (below left) (36.10). *The rigging of a ship in a storm,* British Library, 12 × 6cm.

1061. (below) (36.11) C. R. Leslie, *Autolycus,* Victoria and Albert Museum.

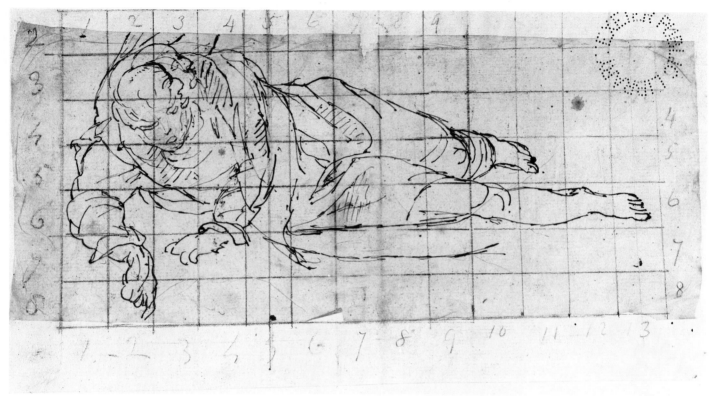

1062. (36.12) *St Peter Martyr, after Titian*, Royal Albert Memorial Museum, Exeter, 12·2 × 28·1cm. laid on 16·9 × 29·7cm.

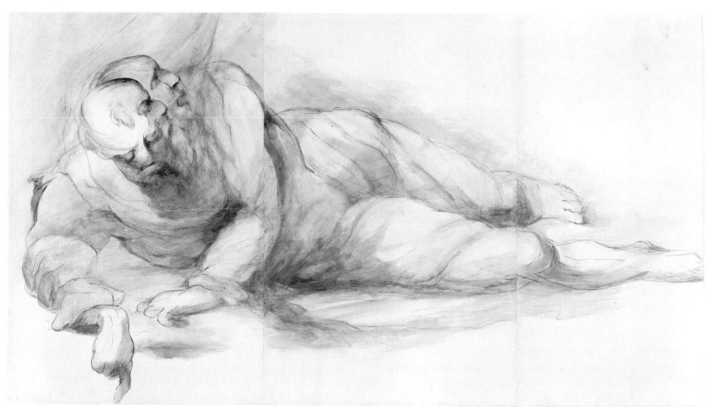

1063. (36.13) *The fallen figure of the saint in 'St Peter Martyr', after Titian*, Victoria and Albert Museum, 100·5 × 176cm.

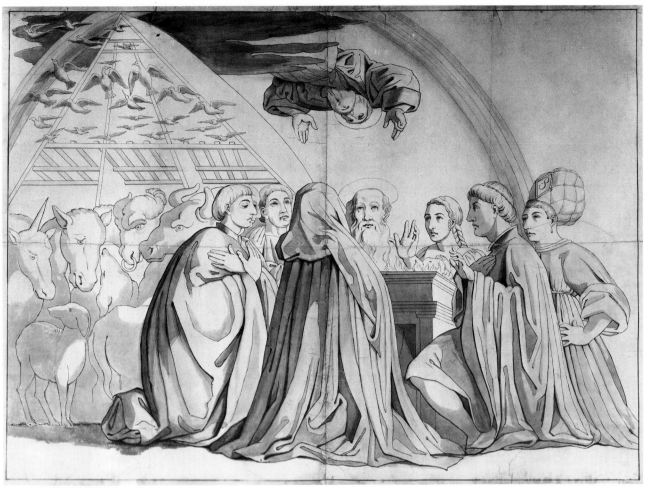

1064. (36.14) *The Sacrifice of Noah, after Paolo Uccello*, Victoria and Albert Museum, 100·6 × 141·5cm.

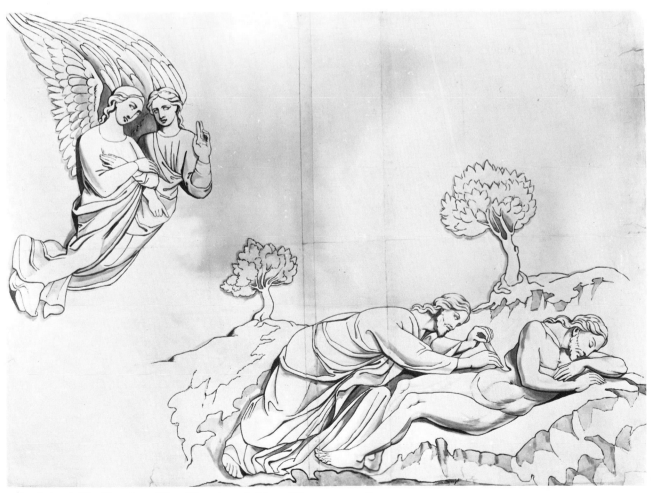

1065. (36.15) *The Creation of Eve*, Victoria and Albert Museum, 100·6 × 132·3cm.

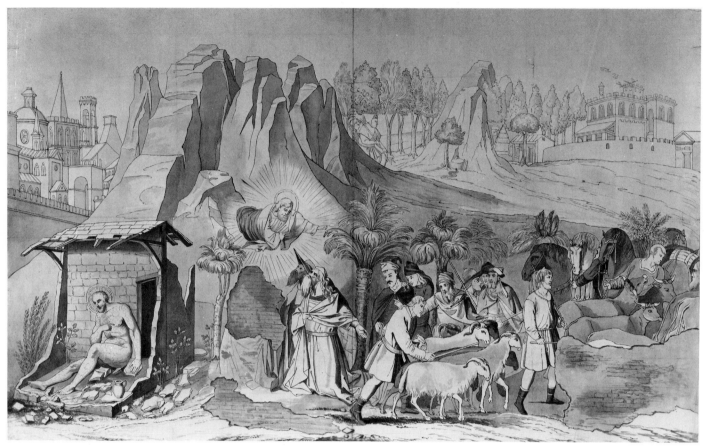

1066. (36.16) *Job and his friends*, Victoria and Albert Museum, 100·5 × 141·5cm.

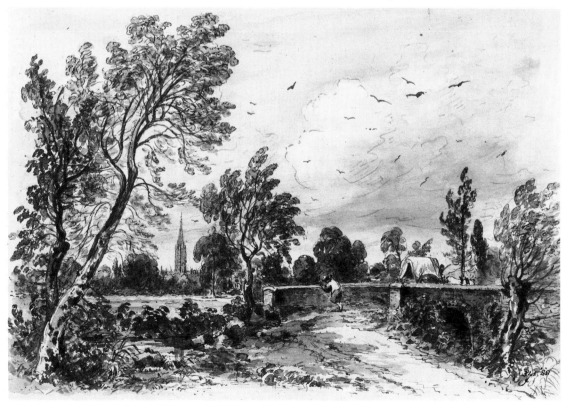

1067. (36.17) *Milford Bridge*, Victoria and Albert Museum, 18·2 × 24·1cm.

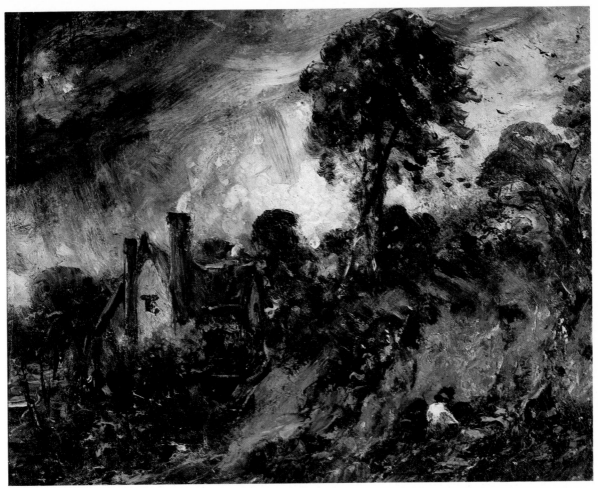

1068. (36.21) *A cottage among trees with a sandbank*, Victoria and Albert Museum, 17·8 × 21·9cm.

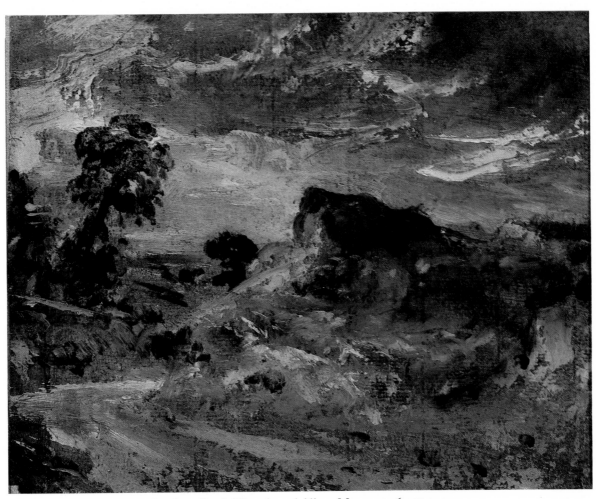

1069. (36.22) *A country road and sandbank*, Victoria and Albert Museum, 16·5 × 20·3cm.

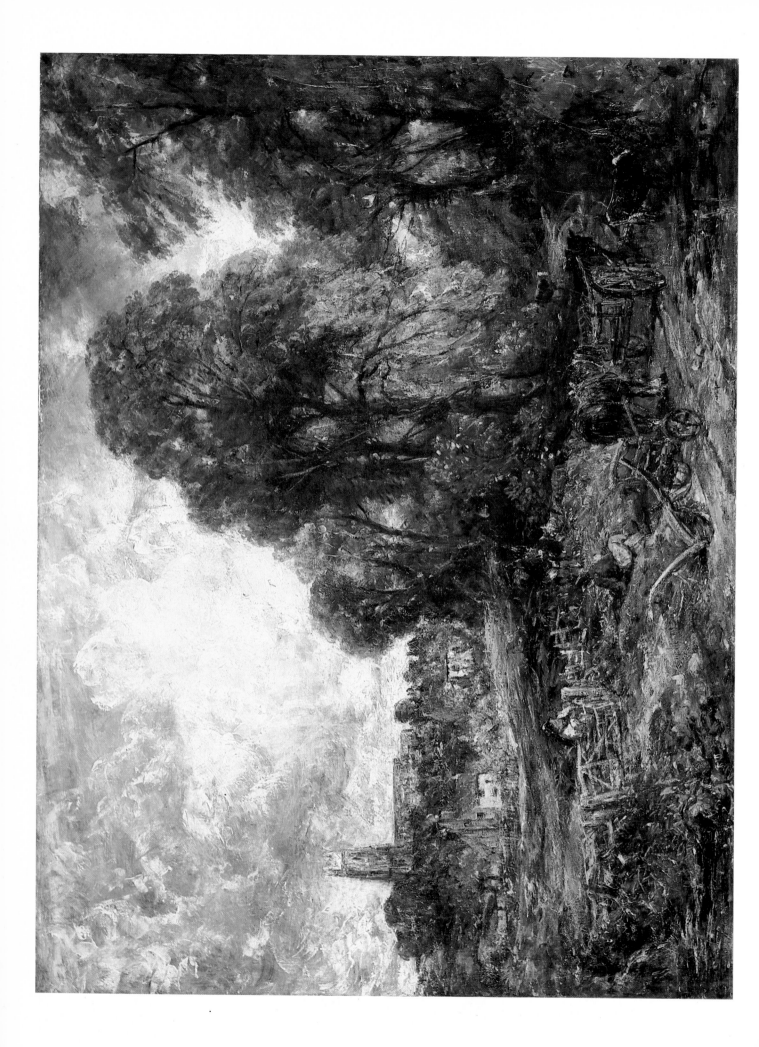

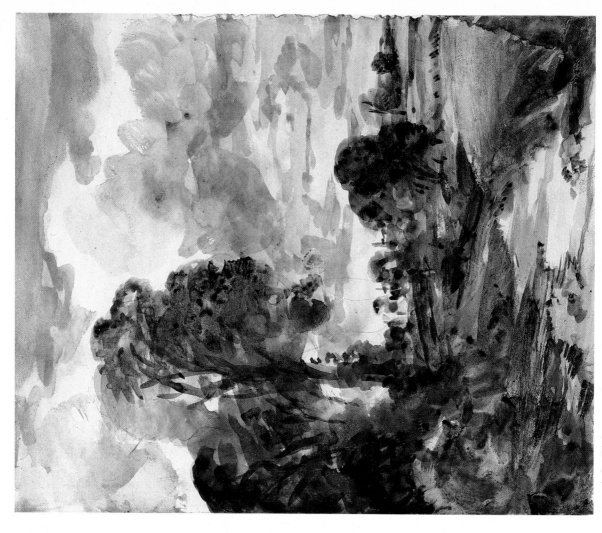

1073. (36.26) *A country lane leading to a church, Victoria and Albert Museum, 21·3 × 18·3cm.*

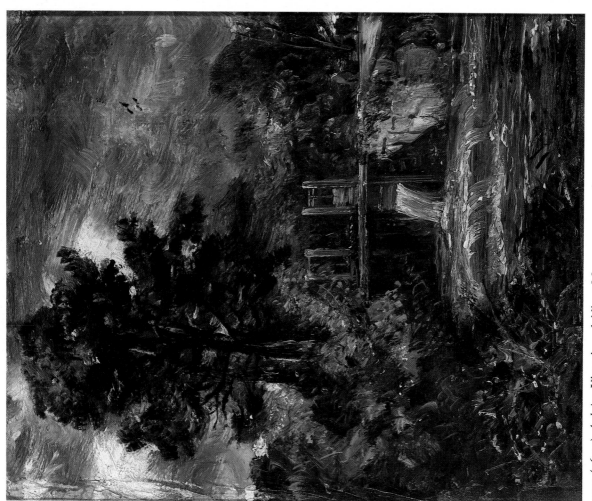

1072. (36.23) *A sluice, Victoria and Albert Museum, 21·9 × 18·7cm.*

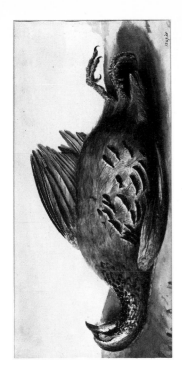

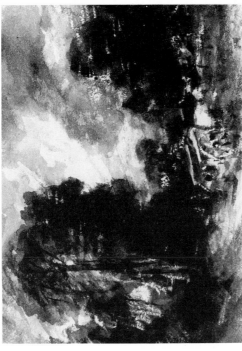

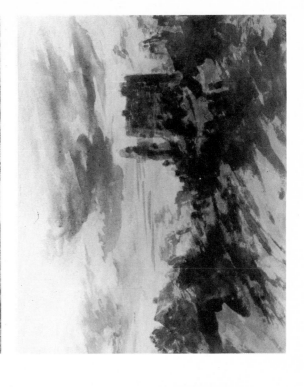

1075. (right) (36.25) *Study of a dead French partridge*, Victoria and Albert Museum, 14·9 × 30·5cm.

1078. (middle right) (36.29) *Landscape with a cart*, Royal Institution of Cornwall, Truro, 11·3 × 15·7cm.

1079. (bottom right) (36.30) *A house, cottage and trees: perhaps Golding Constable's house by moonlight*, Victoria and Albert Museum, 18·7 × 22·8cm.

1074. (36.24) *Study of clouds*, Victoria and Albert Museum, 14·9 × 30·5cm.

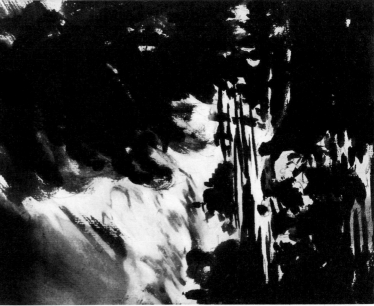

1077. (36.28) *A barge on the Stour*, Victoria and Albert Museum, 20·5 × 16·2cm.

1076. (36.27) *View on the Stour: Dedham Church in the distance*, Victoria and Albert Museum, 20·3 × 16·9cm.

1085. (37.3) *Recollections of the new Royal Academy*, Paul Mellon Collection, Upperville, Virginia, 117·7 × 18·4cm.

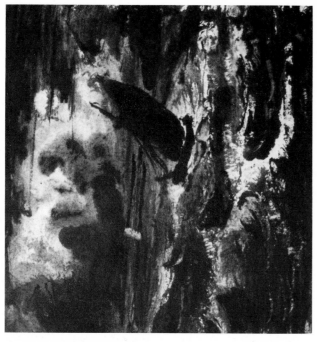

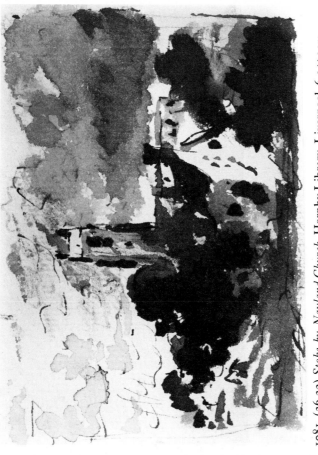

1082. (36.33) *Seascape: ships in a storm*, Private collection, 15 × 16cm.

1081. (36.32) *Stoke-by-Nayland Church*, Hornby Library, Liverpool, 6·3 × 9cm.

1084. (36.35) *Shipping off the coast*, Private collection, 6·5 × 10cm.

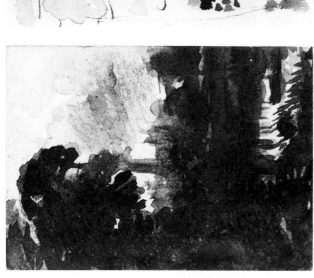

1080. (36.31) *Salisbury Cathedral*, Private collection, 7·6 × 5·5cm.

1083. (36.34) *Ships in a storm*, Courtauld Institute Galleries (Witt Collection), London, 13·6 × 19cm.

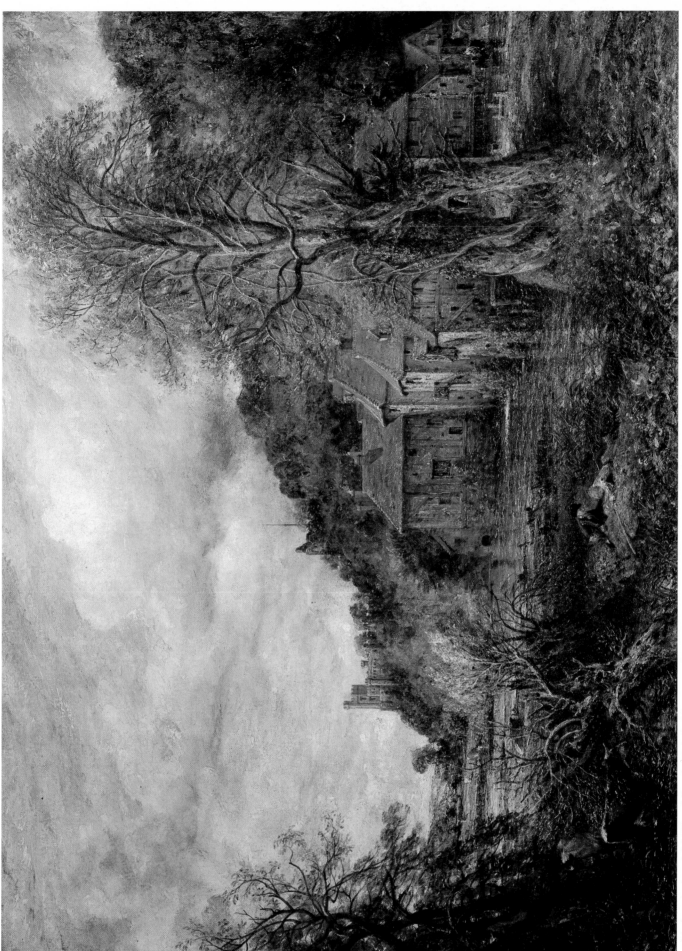

1086. (37.1) *Arundel Mill and Castle*, Toledo Museum of Art, Ohio, 72·4 × 100·3cm.

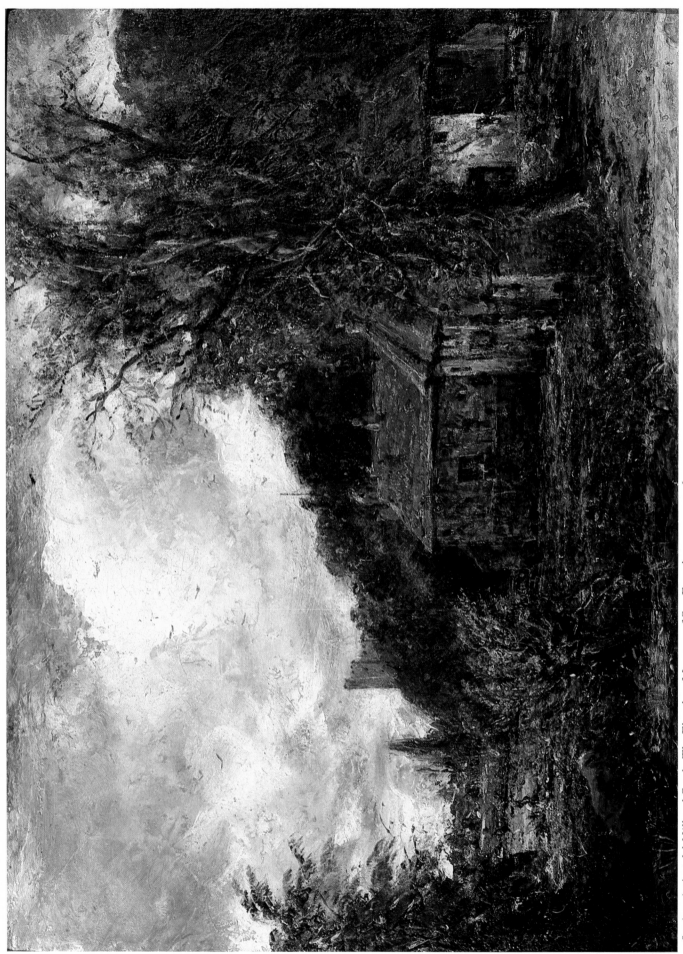

1087. (37.2) *Arundel Mill and Castle*, The Fine Arts Museum of San Francisco, 29·5 × 40·6cm.